THE
SECRET PUBLIC

by the same author

THE
SECRET
PUBLIC

How Music Moved Queer Culture from the Margins to the Mainstream

JON
SAVAGE

Liveright Publishing Corporation

A Division of W. W. Norton & Company
Independent Publishers Since 1923

To Paul Savill

Contents

Introduction

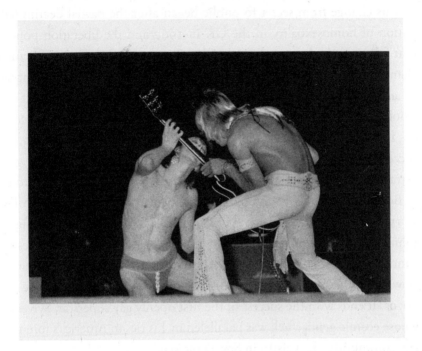

Homosexuality has been a part of post-war pop since its very inception in the 1950s. Until the early 1970s, however, it wasn't talked about openly in that world: it was coded, hidden, secret. This paralleled the status of homosexual men and lesbians in the wider societies of England and America – then the epicentres of mainstream pop – where, during the 1950s and '60s, they were outcasts, harassed by the police, demonised by the media and politicians, imprisoned simply for being who they were.

This book is called *The Secret Public* because for so long the topic of homosexuality and the realities of homosexual life remained secrets, albeit open ones.* The title also makes the point that gay men and

* In late 1977, New Hormones – Buzzcocks' record label, run by manager Richard Boon – published an all-image montage fanzine compiled by myself and Linder

lesbians *were* the public, a part of societies that, for a long time, desired to erase their existence. It also recognises that, in the early 1970s, what had once been secret became public knowledge, which was ultimately liberating for all.

This change from secret to public began after the partial decriminalisation of homosexuality in the UK in 1967 and the liberation politics that followed the Stonewall riots of late June 1969. It was the structural change of the former and the utopian energy of the latter that prompted an ambitious pop singer called David Bowie to be honest about the whole topic, declaring in the now famous interview with *Melody Maker* on 22 January 1972 that 'I'm gay, and always have been.' In turn, his success and obvious influence upon a generation of British teens gave extra confidence to the still embryonic British gay media and subculture.

Bowie thus stands at the pivot point of this book. It begins in late 1955, with the extraordinary success of Little Richard, the outing of Johnnie Ray and the ambiguous superstars James Dean and Elvis Presley; continues through early-1960s pop and pop art; and then moves on to Bowie and the omnipresence of that gay-derived style, disco, in the late 1970s. It ends with the success of the first openly gay superstar, Sylvester, whose cosmic genderfuck was paralleled by his ties to America's foremost gay community, the Castro in San Francisco.

With Bowie, what had once been implicit became explicit.

————

With *The Secret Public*, I am not attempting a definitive survey of gay culture in pop music; rather, I aim to focus on its influence as demonstrated through five particular moments in history, the themes that arise during those periods and the events that led up to them. For those wanting a first-class survey of who was or wasn't LGBTQ during this period in popular music and beyond, I would

————

Sterling that we called *The Secret Public*. The images inside explored various aspects of consumerism, urbanism, gender and sexuality. Although it didn't sell that well at the time, it has had a longer life than either of us expected back then. The images within now look like manifestos for the direction our work has taken in the intervening years.

recommend Martin Aston's *Breaking Down the Walls of Heartache*, which has a comprehensive list of gay male and lesbian performers and is the standard work on the subject.

There are a couple of caveats I should start with. It is not my purpose to out anyone, so I have not included performers who are still alive and who wish, as is their prerogative, to be non-specific about their sexuality. I have also taken care to be sympathetic towards people's declared orientation and the human ambiguity that surrounds the topic; indeed, the history of performance and pop culture throughout the centuries shows a spectrum of gender and sexuality that seems to both reflect and shape the human condition. Sharp readers will also note the preponderance of male homosexuals, as opposed to lesbians and trans people. To today's eyes, the attitudes towards gender and sexuality during the period covered in this book seem extremely archaic, and this was reflected in the pop charts and the pop media, which were overwhelmingly male-biased. In accordance with the gay politics of the time, women were underrepresented and rarely had the same latitude to experiment given to men. Openly lesbian pop stars were thin on the ground.

The explosion of diversity in pop music and pop writing over the last twenty to thirty years is extremely welcome. When I started writing about pop music professionally in early 1977, the climate was still overwhelmingly male. Despite the fact that punk seemed to offer the possibility of new gender roles – the assertiveness of female performers like Siouxsie, Poly Styrene, Pauline Murray and the Slits; the non-macho stance of Buzzcocks and the Subway Sect – homosexuality in general was rarely discussed.

While working at *Sounds*, I was very friendly with another writer, Jane Suck. We were both same-sex attracted, but we never talked about it, ever. When I went to San Francisco in early autumn 1978, I interviewed the pioneering synth punk group the Screamers, two of whose three members were gay. We talked about technology and the souring of punk rock, but about our mutual homosexuality, not a word. The music industry, apart from the brave stance of Tom Robinson, was still very closeted and averse to addressing the topic. I wish we had all been more open then, but that wasn't the time, for me at least.

This wall of silence began to crack in the early 1980s, when I met the gay writers Peter Burton and Kris Kirk. This was also the moment when pop began to encompass a new androgyny, with stars like Boy George, Grace Jones, Annie Lennox, Marc Almond and Phil Oakey. I wrote about this new trend in the June 1983 issue of *The Face*, in which I tried to artic-ulate my thoughts about what I saw and felt was the play of pop music, both at that time and throughout the 1960s and '70s:

> If pop's attitude to all kinds of sexuality has been confused and contradictory, then its expression of sexual divergence has been in part the history of the androgyne principle – the breaking down of society's codes of what is 'masculine and 'feminine' in favour of a less rigid, forced sexuality – making itself heard in one of the only places it can: exactly where it is thought not to matter, because it's only pop.

This was an attempt to articulate my own experience of pop music, one that is shared by many: namely, that it is a performance, an arena of play, alternatives, visions of the future. In my case, I was shaped as an early teen by the severe androgyny of the 1960s beat groups – the long hair and foppish dress of the Beatles, the Rolling Stones, the Kinks, the Byrds – which was so different from the images of masculinity I saw else-where in the culture, the short back and sides in particular.

Apart from being both exciting and reassuring, these images and feel-ings helped me to begin to come to terms – at least – with my own sexuality, which I had settled on at the age of thirteen. Throughout my teenage years, there was almost nothing positive in my family or the wider culture about the topic; just sneers, prejudice, bigotry. This was why David Bowie had such an impact. He was a total contrast: open, glamorous, playful, sexy, successful and a cultural leader.

The disparity between what came up through pop culture and what was propagated by the mass media remained throughout the timeline of this book. In the late 1970s, the images in mainstream culture were hos-tile or insultingly caricatured: the extreme camp of Larry Grayson and John Inman; the disastrously closeted Liberal politician Jeremy Thorpe. In contrast, Patti Smith – as captured by Robert Mapplethorpe on the

cover of her first album, *Horses* – Siouxsie, Buzzcocks and the like seemed beamed in from an ideal future.

As I engaged with performers, fans and other writers during the early 1980s and beyond, I realised that the topic was wider than just homosexuality. That might have been the key that unlocked the door, but the real play of pop was that it had the ability to liberate everyone: not just gay men, lesbians and trans people, but young heterosexual men and women who didn't accept the standard definitions offered, indeed imposed, by the dominant culture. It wasn't just about freedom for gay people; it was about freedom for all.

The stories in this book are dispatches from a different world, one that is revealed most noticeably in some of the language, which reflects the prevailing pejorative attitudes of the time. There are recurring themes – of demonisation, othering and prejudice – that, after years of progress, are unfortunately returning. The people depicted in this book displayed courage in insisting on being who they were, and by doing so they helped to bring about an easier future for LGBTQ people. It's an inspiring story, but a cautionary one, as these battles will have to be fought all over again.

PART 1
November
1955

1
Little Richard

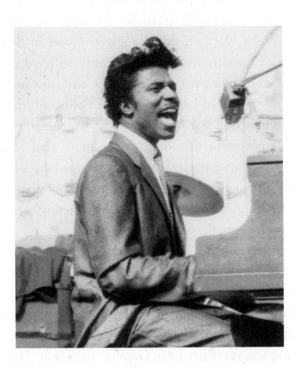

The young were living mostly in exile, but exile gave them possibilities of which they had seldom dreamed before. Everything around them became slightly abnormal, the new occupation, the environment, the dress they wore, the physical and emotional climate. The concrete things of the past, like post addresses, time-tables, road-signs, became less probable and friendships became all-important because it was unlikely they could last. Nearly all of them, willingly or unwillingly, became creatures of the moment, living in an everlasting present: the past had vanished, the future was uncertain.

Adam de Hegedus, writing as Rodney Garland,
The Heart in Exile, 1953

On 29 October 1955, *Billboard* – then the leading music industry magazine – included a release by the little-known Little Richard in its 'Reviews of New R&B Records'. These were ranked in order: at the top came Piano Red's jump boogie 'Gordy's Rock', followed by the Cadillacs' tricksy doo-wop song 'Speedoo'; sixth down, 'Tutti Frutti' was awarded 76 points – 'Good' in *Billboard* terms, 'a cleverly styled novelty with nonsense words delivered rapid-fire. The singer shows a compelling personality and an attractive vocal style.'

This partial hedging of bets indicates that although the anonymous reviewer – no doubt skilled in the pop and R&B idioms of the day – detected some potential, they didn't quite know what to make of the song. There was no sense that this would be a record that entered the pop charts, which were, at the end of October 1955, still dominated by solo singers and close-harmony numbers, with a smattering of more uptempo rock 'n' roll tunes – usually covers by white artists.

'Tutti Frutti' was Little Richard's first single for Specialty, a New Orleans-based independent label that by 1955 had become a major player in the R&B market. It was recorded at the city's J&M Studios, which, under the ownership of Cosimo Matassa, had been the engine room for hits by Fats Domino, Smiley Lewis and Lloyd Price. The New Orleans sound was very current in October 1955, but 'Tutti Frutti' was as different from the city's insinuating, sly groove as it was a departure from the Specialty roster of R&B, blues and gospel.

From the first eruption to the final exclamation, 'Tutti Frutti' had a harsh, relentlessly driving sound, with an unrestrained vocalist who punctuated the simple lyrics with gospel shrieks and weird outbursts. The song was barely explicable, but Specialty owner Art Rupe took a punt: 'The reason I picked it wasn't solely for the tempo. It was because of the wild intro, it was different – you know, Be Bop A Lop Bop, all that in front. You didn't hear things like that much on a record. I just thought it was a record that would sell very well in our Black market.'

———

'**A** *wop bop a loo mop a lop bam boom.*'
The song's hook is just ten syllables, eight short and two long, although Richard is so eager to get going that he elides the first 'A' in the intro. They add up to nothing but apparent nonsense – 'a cleverly styled novelty' – but, like the whole record, they represent a sophisticated synthesis of Black music past and present, a history and a tradition that Richard had lived. Although only twenty-two in autumn 1955, he had already been performing for nigh on a decade, travelling backwards and forwards through the byways of the American South.

'Wop' was the second word in the term 'doo-wop', a major trend in Black American music during 1955. A vocal style that ranged from street-corner glossolalia to smooth ballads, it contained sounds and syllables that appeared to make no sense individually but which contributed to a full, percussive overall sound. The Cadillacs' 'Speedoo' was only the latest example, while the Platters' 'The Great Pretender' – released on 3 November that year – would become one of 1956's biggest pop hits.

The word 'bop' had a long history in Black American music. It originated in scat singing – the often humorous and sometimes deliberately unsettling use of rhythmic vocal syllables, which went all the way back to ragtime. After Louis Armstrong's 1926 recording of 'Heebie Jeebies', improvised scat singing became a major trend in the late 1930s, on records by Slim & Slam, Duke Ellington and Cab Calloway – the latter of whom Richard saw play live in the 1940s, when he was working at the Macon City Auditorium.

Slim Gaillard was an avatar of the style, with his wild rhymes, surreal vocal explorations and warm, tricksy style. Together with bassist Slam Stewart, he hit big in 1938 with the tongue-twisting 'Flat Foot Floogie', a much-covered classic. The follow-up was 'Tutti Frutti' – an entirely different song to Richard's – which made #3 in the charts. In 1945, he re-recorded it in a fuller band version, featuring a bebop-style trumpet solo. It was, as the title suggested, about eating ice cream: 'Don't like vanilla, strawberry voodoo . . .'

'Bop' also had a specific post-war use, referring to the new, dissonant type of jazz that valued powerful riffs, complex melodic treatments and lightning-fast improvisation by featured virtuoso soloists like Dizzy

Gillespie and Charlie Parker. Thanks to the big swing bands, jazz had become mainstream pop. Not caring if it threw off the casual listener, bebop was directly opposed to this perceived dilution, becoming a byword for wild esoterica. In 1955, the emergent hard rhythm and blues style was often called 'bebop'.

Little Richard's chant continues in rhyming variations, like a Slim Gaillard scat improvisation: 'mop', 'a lop'. The final two syllables are something else, however: 'bam' and 'boom' have the force of a fist, a blow, an explosion – a caption from a superhero comic – and they leave no doubt as to Richard's intention. Growing up in Macon, Georgia, he had not only seen the stars of the day passing through the city, he had also been exposed to anonymous, unrecorded street performers, who became imprinted on his brain.

'I remember Bamalama,' he told his biographer Charles White, 'this feller with one eye, who'd play the washboard with a thimble. He had a bell like the schoolteacher's, and he'd sing, "A-bamalam, you shall be free, and in the mornin' you shall be free." See, there was so much poverty, so much prejudice in those days. I imagine people had to sing to feel their connection with God. To sing their trials away, sing their problems away, to make their burdens easier and the load lighter. That's the beginning. That's where it started.'

Born on 5 December 1932, Richard Penniman was the third of twelve children – and by far the most troublesome. With his right leg shorter than his left, he was partially disabled and, as he soon discovered, not the most normal male, becoming a target for the local boys because of his preference for playing with girls. He recalled that he felt like a girl and, after his first homosexual experience at a young age, Richard was known, as he remembered it, as 'a sissy, punk, freak, and faggot'.

Richard sang all the time, both inside and outside church, and predominantly gospel. When he was around thirteen or fourteen, he got a part-time job at the Macon City Auditorium, where he saw the major performers of the day. One day, he caught the attention of Sister Rosetta Tharpe, who was performing at the venue. Hearing Richard sing before the show, she invited him to open for her and paid him $40. It was his

first time in front of a big audience – and his first pay cheque – and he took to it like a duck to water.

Matters were difficult at home, however. His father constantly criticised Richard for his appearance and his effeminate friends, calling him 'only half a son'. To escape his father's regular beatings, Richard took off and joined a travelling troupe called Dr Hudson's Medicine Show. His wanderings had started, and they began in the folk origin of America's popular entertainment. Beginning in the late 1880s, medicine shows evolved out of the old minstrel shows and usually involved about eight to ten people, maybe a couple fewer, with musicians, comics and dancers who were often, but not always, Black. The songs – often variants on blues tropes – were interspersed with comic skits, bawdy double entendres and ruthless put-downs of the inevitable hecklers. A fast tongue and a good sense of how to read the crowd were all-important, as were the hard-sell commercials for whatever product the show was promoting – usually some cure-all concoction, cheaper than in the shops.

After a stint with B. Brown and His Orchestra, Richard joined Sugarfoot Sam's minstrel show, which was the first time he appeared in a dress. After short-lived stints with aggregations like the Tidy Jolly Steppers, Richard ended up in Atlanta with the Snakes Variety Show. There he met his first big inspiration, the blues singer Billy Wright, whose first record, 'Blues for My Baby', was a big R&B hit in autumn 1949.

Like Richard, Wright was born in 1932 and had also worked as a female impersonator in the medicine shows – among the very few places that were sympathetic to gender or sexual deviance during that period. A star at seventeen, Wright specialised in dramatic blues sides. Openly gay, he was flamboyant and unashamed when Richard met him, and made a considerable impression. Richard was so taken by his make-up, he began to use it himself.

It was through Wright that Richard got his hairstyle and his first recording contract, with RCA. In the space of just one year, between November 1951 and 1952, he released four singles, all of which show a strong vocal presence, including on occasion a certain sibilance, although they remain firmly within the blues/jump R&B style. 'Every Hour' got some local airplay, but none of the releases made the R&B charts. The

title of his third single might well have described his situation: 'Ain't Nothin' Happenin''.

After encountering the pianist Esquerita in the bus station in Macon, Richard started to focus on the piano. A skilled instrumentalist, Esquerita influenced his slightly older friend in his use of shock piano: rapidly repeating, very loud passages, with chords in the high register. His outrageous appearance – heavy make-up, sequinned sunglasses, hair teased right up high – also reinforced Richard's tendencies in that direction, as did their shared interest in male-on-male action.

The Macon bus station, where Richard worked, washing dishes, was a venue that allowed him to explore his penchant for homosexual encounters, voyeurism and orgies. In one of the frank declarations of his homosexuality in his memoir, he remembers: 'I used to sit around the all-night restaurant at the Greyhound bus station in Macon, watching people come in and trying to catch something – you know, have sex. I'd sit around there till three or four in the morning. Wasn't nothing else to do, 'cos everything was closed.'

By the age of twenty, Richard was thoroughly steeped in the secret codes of the gay underworld, with its own patois and upside-down world. Richard's recollections of his experiences in the entertainment underbelly of the Deep South are full of this sliding between gender and sexuality, of men who address each other as 'she' and 'her', or the ubiquitous 'Miss Thing'. Doubly outcast in 1950s America, Black homosexuals simply got on with it and did as they pleased.

After a brief spell at Peacock Records, Richard formed a new group called the Upsetters to play hard-driving R&B. His third attempt at having a recording career happened as the result of him meeting another R&B star, Lloyd Price, who had had a smash in 1952 with 'Lawdy Miss Clawdy', recorded at Cosimo Matassa's J&M Studios in New Orleans. Although it stayed in the R&B charts for half a year and sold over a million copies, it didn't make the pop charts – such was the climate of the time. Nevertheless, it was an era-defining record.

When Richard met him in Macon, Price was still a big star. Struck by the fact that he had a black-and-gold Cadillac, Richard struck up a conversation with the singer, who told him to send a tape of his material

to his label owner, Art Rupe, at Specialty Records in Los Angeles. After sending off a demo of two songs, Richard sweated it out in Macon, waiting for a response from Specialty.

The Upsetters were on the road in Tennessee when the call came from Specialty to meet in New Orleans. Instructed by Rupe to find another Ray Charles, Specialty A&R man and producer Bumps Blackwell had finally got round to playing the demo tape and knew that he was hearing star quality.

On 13 September 1955, Richard arrived at J&M Studios in Rampart Street. He was following in the illustrious footsteps of Lloyd Price and Fats Domino, but there was culture shock on both sides. The musicians were taken aback by his appearance – the singer wore 'his hair in the air and a lot of mascara and stuff', saxophone player Red Tyler remembered – while Richard himself was inhibited by the atmosphere. He remembered that the band thought him crazy and that Blackwell wanted him to sing the blues – not his bag.

Over two days they recorded eight sides, which were very much in the contemporary blues/R&B mode, albeit slightly behind the curve. They are not without merit – there is some great guitar in 'Wonderin'' – and Richard is as riveting a vocalist as ever, but they weren't what Blackwell was looking for. As he remembered it: 'The problem was that what he looked like, and what he sounded like didn't come together. If you look like Tarzan and sound like Mickey Mouse it just doesn't work out.'

So much recording in this period was done on feel. Sharp A&R men and label owners could taste the change in the air, but they didn't know what it was until they heard it. They were seeking something that had yet to be done, that was still to be caught. Sam Phillips had done it the year before, when he heard Elvis Presley fooling around with an old blues tune, and now Bumps Blackwell was about to have his eureka moment.

Nobody had considered 'Tutti Frutti' a candidate for being recorded, despite the fact that it was a live favourite. Rather underwhelmed by what they had recorded so far, the musicians and the producer took a break in the nearby Dew Drop Inn. Richard found the bar's piano and, with a ready audience, accessed his inner ham.

Honed in the dives and drag bars of the American South and informed by his thorough knowledge of the sexual underground, Richard's lyrics were a deliberate provocation: 'Tutti Frutti, good booty / If it don't fit, don't force it / You can grease it, make it easy . . .' In the volatile climate of 1955, they were also a barrier to any kind of wider exposure. Blackwell knew that a verse about sodomy would create such a storm as to kill both the record and Richard's career. Substitute lyrics were needed if the record was ever to get a chance of airplay.

Attending the session was a young songwriter called Dorothy LaBostrie. When Blackwell asked her for some alternative lyrics, she baulked. At the same time, Richard was too ashamed to record the song in its original form. After some ferocious persuasion from Blackwell, everyone went back to the studio, while LaBostrie cobbled together some blues phrases. It was crunch time: after two days on this try-out, Richard felt the opportunity was slipping away. Sitting down at the piano, he went hell for leather.

The recording was quick and explosive: fifteen minutes, two takes, and that was it. The musicians were confused: they thought it sounded either stupid or completely uncommercial. Bumps Blackwell got it, however. A couple of days after the session, he wrote to Art Rupe, comparing 'Tutti Frutti' to Chuck Berry's 'Maybellene' in terms of crossover potential; that week, 'Maybellene' was at #5 in the *Billboard* Top 100, its highest position. This was a major breakthrough: an authentic slice of black R&B shading into the big beat of rock 'n' roll.

The popularity of Black R&B with white teenagers engendered a huge backlash in the media and among local lawmakers in 1954 and 1955. America was still a highly segregated country, founded on racism, and to many people this new and unexpected turn of events threatened nothing but miscegenation. Both *Billboard* and *Variety* – the house magazines of the American music and entertainment industries respectively – conducted campaigns against what they deemed to be distasteful music.

In its April 1955 story about the new music – typified as rock 'n' roll rather than R&B – *Life* magazine observed the growing controversy created by the adoption of this Black musical form by white teenagers: 'In New Haven, Conn, the police chief has put a damper on rock 'n' roll parties and other towns are following suit. Radio networks are worried

over questionable lyrics in rock 'n' roll. And some American parents, without quite knowing what it is their kids are up to, are worried that it's something they shouldn't be . . . But hardly a teen-ager afoot had time to listen.'

With its roots in R&B, rock 'n' roll was becoming a ubiquitous symbol of the generation gap. Most adults did not understand its codes, its sound or its origins. It was the first instance in about twenty years – since the start of swing in the mid-1930s – that contemporary Black American styles had a direct influence on the pop charts, and it happened at a time when the campaign to end segregation and demand equal rights was building up a head of steam in the political sphere.

Nineteen fifty-five was the year of Emmett Till's brutal murder in Mississippi, a terrible event that galvanised the Black community into protest. It was after attending a meeting that addressed this case that Rosa Parks would refuse to give up her seat to a white person on the bus – a stand against segregation in the public transit system that would became a national cause célèbre. Things were on the move in the country, and they spilled over into pop music.

This was the climate into which 'Tutti Frutti' emerged. Specialty catalogue number SP-561-45 caught the lightning on seven inches. Even in its bowdlerised state, the essential elements of 'Tutti Frutti' were all there in the title phrase and hook line – ten syllables that held a powerful, albeit hidden, meaning for its performer. In 1952, Richard's father had been shot and killed just outside the bar that he ran, the Tip In Inn. Richard was forced to become the family breadwinner and took on a mundane job. He hated being subservient and answered back in a coded curse.

'I was washing dishes at the Greyhound bus station at the time,' he told David Dalton in 1970. 'I couldn't talk back to my boss man. He would bring all these pots back for me to wash, and one day I said, "I've got to do something to stop this man bring back all these pots for me to wash," and I said "Awap bop a cup bop a wop bam boom, take 'em out!" and that's what I meant at the time. As so I wrote "Tutti Frutti" in the kitchen, I wrote "Good Golly Miss Molly" in the kitchen, I wrote "Long Tall Sally" in that kitchen.'

Riffing off this basic phrase, Richard pounded the piano, yelled, shrieked and testified over just under two and a half minutes, and in doing so opened up the underground that he had inhabited. On one level, 'Tutti Frutti' was a nonsense heterosexual pop song, with a relentlessly repeated title and catchphrase. But, prepped by the dirty-lyrics scandal and listening to the singer's intense, slippery vocal, you could read a sexual subtext into its lines, particularly when Richard shrieked: 'She knows how to love me / Yes, indeed / Boy, you don't know what she do to me.'

And the song's gay origins are in there as an unseen foundation, hinted at in the title, 'Tutti Frutti' – all the fruits, the word 'fruit' being a popular slang term for gay men at the time. In 1955, very few people knew of the hidden history encoded in 'Tutti Frutti''s scats and shrieks, and Richard was canny enough not to make them too obvious: if he wanted a Cadillac, he knew he had to play the game. He was not put under intense scrutiny: there was very little pop coverage outside *Billboard* and *Cashbox*, and the scandal sheets left him alone. Too marginal, too weird.

But all you needed to do was look. With his pancake and his pompadour, Richard was hardly a shrinking violet. In his autobiography, written thirty years later, Richard equivocated around the question of his sexual orientation. He talked at length about his homosexual experiences, but at the same time emphasised his heterosexual voyeurism. In the end, though, the actual specifics of what turned Richard on are irrelevant. By his sheer presence in 1955, he opened up a world of difference, revealing a subterranean realm of great complexity and great vigour that was beginning to claim its time, along with teenagers and Black Americans. Liberation was in the air, and the freaks wanted in.

By early November, 'Tutti Frutti' had sold 200,000 copies, entering the R&B charts in the middle of the month at #12. It was the breakthrough sound of freedom, couched in an extreme androgyny. The game was on.

2
Johnnie Ray

For sheer unorthodoxy, the Johnnie Ray story probably has no parallel in entertainment history.

The Complete Life of Johnnie Ray: A Pocket Celebrity Scrapbook, 1955

The biggest star in the UK in 1955 was not a rock 'n' roller – it was too early for the new music to have reached the UK – but a twenty-eight-year-old American singer who had been making hits since early in the decade. Tall, partially deaf and bisexual, Johnnie Ray was an unlikely teen idol, but during his spring tour of the UK, young female fans besieged his hotel and screamed their hearts out at a set list that included hits like his cover of the Drifters' 'Such a Night' and standards like 'Alexander's Ragtime Band'. In one instance, they bunched together for 'an ecstatic rush' to the stage.

Ray's residency at London's Palladium that spring was marked by an unprecedented level of teen mania. Nothing like this had been seen before for a singing star. Outside the theatre, the police had to be brought in to control the kids trying to break down the stage-door barriers. For some young Brits, Ray was the first real taste of the pop explosion to come: as the eleven-year-old Londoner and future Rolling Stones manager Andrew Loog Oldham later remembered, 'Ray took music to a whole other level.'

Oldham was one of the crowd in Argyll Street that spring. 'I had bought his latest single, "Such a Night", and counted down the days until the "Cry Guy" arrived in town. I was among the hundreds of fans gathered outside the Palladium waiting for Ray when he arrived to rehearse his performance. I watched gobsmacked as Ray, flanked by ten soldiers he had befriended just that afternoon, was ushered into the venue. Then I hung around until he appeared later at the stage door to sign autographs.'

The American scandal sheet *Anything Goes* published a sensational report on Ray's Palladium residency: 'Johnnie Ray walks off to roaring applause. But now see what happens. As he steps through the curtains one hand reaches up convulsively and rips open his tie. Gasping for breath, he brushes past various busybodies and heads for his dressing room. Sweat pours from his forehead. As the fever heat of his stage appearance wears off, collapse takes over.'

Despite the fervour, this was not rock 'n' roll. Ray had begun his career by covering contemporary R&B and blues – and making it his own – but by 1955 his records were mainstream pop fare. Yet when he returned in September for his second UK tour of the year, his concerts were marked by an intense fan mania that had adults baffled. In Newcastle, a city

councillor called the singer's police escort a publicity stunt, while the veteran columnist/curmudgeon John Gordon inveighed against Ray's 'exhibitionism' as a public nuisance.

Ray's star might have faded in the US, but in the UK he was hot, with five records in the Top 20 during 1955, including 'Hey There' and, coinciding with his autumn visit, 'Hernando's Hideaway'. In early November, he appeared at the Royal Command Performance, alongside a raft of talent that included Lena Horne, the comedian Benny Hill, the actress Diana Dors and the popular singer Ruby Murray. The event was presided over by an apparently delighted Queen Elizabeth II. Ray had achieved the ultimate UK show-business accolade.

Ray's rabid fanbase was galvanised not so much by his material but by his vocals and his performance style, which he'd developed over his long years as an isolated teenager. Both aspects of his act drew on underground sources – Black American music and the gay underworld – which he honed into an impassioned frenzy that exhausted both his audience and himself. It was a paroxysm of repressed emotions that burst out all over.

———

B orn in January 1927, Johnnie Ray was raised in the Oregon countryside. With Native American ancestors in his bloodline, he retained an affinity for natural forces and the cycles of nature all his life. His childhood was happy enough, but a freak accident at the age of thirteen resulted in the loss of half his hearing: he was tossed in a blanket and landed heavily on his head in a prank that went wrong. Telling no one of his injury, Ray became an extreme introvert. His schooling suffered and he became, as he remembered it, 'the loneliest boy in the world'.

Like Little Richard, he got the impetus to go into show business after a chance encounter with a powerful female performer. He met his avatar Kay Starr backstage in Portland in 1947, and she offered him encouragement. Moving to Los Angeles soon afterwards, Ray tried to get a break but failed. 'I was starving to death in Los Angeles, working in

night clubs and just trying to keep a job,' he said later. 'And I couldn't keep a job, people kept saying "You're too weird for us", and they'd fire me on the spot.'

Persevering, Ray began to write songs that were a metaphor for his own situation, like the nature-saturated 'The Little White Cloud That Cried': 'Have faith in all kinds of weather / For the sun will always shine / Do your best and always remember / The dark clouds pass with time.' The upturn for Ray came in early 1951, when he got a regular gig at the Flame Show Bar, a prominent Black and Tan (Black and mixed-race) club in Detroit that had showcased names like Billie Holiday, Louis Jordan and LaVern Baker.

Performing in front of an integrated audience of Blacks and whites, Ray began to go deeper. R&B was becoming popular then, and he would interpret its liberating message in his own way. After cutting some demos in April 1951, Ray was signed by Okeh, a subsidiary of Columbia Records that specialised in Black R&B acts like Maurice King & His Wolverines and Chuck Willis. Ray's first single was a self-composed low-down blues with a hint of burlesque called 'Whiskey and Gin', which he sang in a high, husky voice. When label head Danny Kessler played it to the Columbia salesforce, they thought the singer was a girl 'who sounded like Dinah Washington'.

'Whiskey and Gin' was released on a Black artist-oriented label, but it quickly became obvious that it was selling to a white audience. In Cleveland, the record got the endorsement of key disc jockey Bill Randle, and when Ray arrived in the city he was mobbed by kids. He played at Moe's Main Street with Tony Bennett, who later remembered: 'He smashed all the rules. He did everything. He jumped up and down, jumped onto a curtain. He hit the audience with that piano, standing up at the piano, no-one ever did that.'

By then, Ray was bold enough to act on his homosexual impulses. His teenage alienation had been compounded by the knowledge that he was as attracted to men as he was to women, if not more so. In June 1951, he encountered a prime occupational hazard of his chosen life: entrapment. After finishing his set at the Flame that evening, he headed to a burlesque theatre called the Stone. He was still in his all-black stage clothes and was

wearing full make-up – base, powder and lipstick. Going downstairs to the men's toilet, he propositioned a likely-looking fellow in plain clothes.

This turned out to be one Officer Demmers of the Detroit Police. Ray was quickly booked and charged with soliciting and accosting. Brought to court the next morning, he pleaded guilty and was convicted. The police took a mugshot of the twenty-four-year-old, who looked dishevelled and furious: he had fought back vigorously when arrested. The sentence was a choice between thirty days in prison or a $25 fine (about $240 today). Ray paid and left Detroit as soon as he could. That was, to all intents and purposes, the end of it. He was still barely known.

This would soon change. In October 1951, Ray recorded his second single, a song called 'Cry', which had already been released by a singer from Boston, Ruth Casey. The gender switch did not faze him at all. Embedded in the warm sound of the Four Lads backing group, he began quietly in his own inimitable style, stretching out the words and phrasing on each syllable. There's a slight crack in his voice around eighty-five seconds in, then a short jazz-guitar break, before Ray ups the ante on the last verse, sliding all over the words, reaching the top of his range.

It's an impressive rendition that hints at strong emotions beneath the surface. As befits a song originally sung by a woman, Ray's performance is both sensitive and powerful, reminiscent of Dinah Washington and Billie Holiday, but definitely masculine. Released in November 1951, it entered the US chart of record, the *Billboard* Top 20, during the first week of December, climbing to #1 on 29 December. There it would remain until March 1952, selling over three million copies.

Suddenly, Johnnie Ray was the hottest pop star in America, with screaming female fans and the consequent media attention. On 14 March 1952, *Life* magazine ran a story on 'a tearful new singer' who 'leads his young followers to the brink of frenzy'. The accompanying photos showed Ray getting mauled and mobbed by a mass of young women. The text announced him as an era-defining performer for a new generation, a Sinatra for a more unbuttoned decade. 'He pants, shivers, writhes, sighs, and above all, cries. He is America's No. 1 public weeper.'

In early-1950s America, this was shocking. Real men did not cry. Overshadowing most aspects of life was the bitter Cold War with Russia,

carried on by proxy in the nuclear arms race and the ground battles on the Korean peninsula. The political and social tenor was paranoid and vengeful. Riding a populist, nationalist wave, the senator for Wisconsin, Joseph McCarthy, instituted inquisitions to root out communists and homosexuals from public life.

In the years following 1945, serving men were expected to adapt to civilian life by becoming fathers and company people. But, in the reality of seemingly permanent war, soldierly virtues still held sway: pragmatism, pugnacity, unquestioning loyalty to the nation, the lack of any overt emotional expression. At the same time, the recent world war remained powerful in popular culture, with films like *Flying Leathernecks*, a story about US Marine Corps pilots starring he-man actor John Wayne and directed by Nicholas Ray, perpetuating the requisite tough masculinity.

In contrast to this hard-edged militarism, Johnnie Ray's freakishness was accentuated. It wasn't just his complete absence of emotional restraint, his use of make-up or his identification with Black American female performers; in the *Life* article, he is photographed wearing his hearing aid – not hiding his disability but making it an important part of his image. This desire for self-revelation went hand in hand with his whole approach of emotional honesty and nakedness: by displaying it so openly, he expressed a vulnerability unique in popular culture.

Ray's determination not to hide his disability added to his strangeness, which, combined with the speed and scale of his popularity, resulted in a plethora of interpretations. In a *New York Times* review of Ray's April 1952 Copacabana residency, the critic Howard Taubman observed how 'this young man's style speaks for young people beset by fears and doubts in a difficult time. His pain may be their pain. His wailing and writhing may reflect their secret impulses. His performance is the anatomy of self-pity.'

But Ray knew exactly what he was doing. From his deep exposure to contemporary Black American styles – which he acknowledged where possible, itself an act of defiance in early-1950s America – he realised that emotion was all-important. That was the gift; that was the key. 'I just show people the emotion they're afraid to show,' he said in April 1952.

'People are too crowded inside themselves these days. They're afraid to show love. And boy, what is the primary existence for existing? It's beauty and love.'

Beauty and love: men sang about these topics, but they were not encouraged to inhabit them to the extent that Ray did every time he stepped on stage. The comparisons to Frank Sinatra were apt: Ray's fanbase was comprised almost entirely of young women, and they were attracted not to any machismo but to his vulnerability and intensity. Unlike Sinatra, however, his whole persona was unthreatening, androgynous – an archetype for almost every major post-war pop star to come.

———

The phenomenon of massed fandom at Ray's concerts, like those of Sinatra at the Paramount in 1943, brought public attention to the power of teenage girls and women in general. Despite the contemporary American mood of monolithic masculinity, women were at the forefront of consumerism in the post-war years, just as they had been since the 1890s. The economic boom of the 1950s and the drive towards the family re-emphasised their importance in American social and domestic life, but it was not fully expressed in the public sphere.

Johnnie Ray had several nicknames in the first flush of his career: the Nabob of Sob, the Cry Guy, the Prince of Wails and the Atomic Ray. The last was, perhaps, the most apt: America had focused its attention on the importance of the teenage market just as the Second World War was coming to an end with the dropping of atom bombs on Hiroshima and Nagasaki. As the reverberations of those apocalyptic events went round the globe, America was poised to dominate Western Europe, economically and culturally.

The latest American product to come off the production line in August 1945 was the teenager, defined as a new type of youth shaped by the war against fascism, a social democrat who was, at the same time, a hedonist and a consumer – not just a passive consumer, but one who was consulted by producers, who in 1944 began to use them in focus groups

Johnnie Ray, early 1950s

in order to shape their products. This was a delicate balance between exploitation and autonomy, one that was as subject to manipulation as it was to spontaneous manifestation.

In the years following the war, it was clear that the atomic bomb and the more powerful hydrogen bomb had changed consciousness. If the world could be blown up in an instant, then the only sane thing to do was to live for the day, to live for pleasure and damn the future. Very few Americans lived that way in the early 1950s, but homosexuals and teenagers were two groups that did. Neither was fully invested in American society. Whether by choice or by forced exclusion, their interests would coincide more than anyone wished to admit at the time.

In 1952, hydrogen bombs were being tested regularly as the post-war teenager began to fully emerge in America. Indeed, Johnnie Ray was the first trigger. Peter Stackpole's photos in *Life* of screaming, massing, devouring young women show them having a very good time. The fans are joyous, revelling in their temporary release and collective power. All of them are focused on Ray, but in one shot, a young woman catches the eye of the camera with a huge smile on her face, as if to say: 'This is just wonderful! Don't you wish you were here?'

However, becoming a teen idol carried a price. It was precisely his appeal to young women that had rendered Frank Sinatra's masculinity suspect in 1943 and 1944. Classified 4F – unfit for military service because of an ear injury sustained at birth – Sinatra was constantly attacked by the press for not being in uniform and resented by serving GIs for attracting female attention at home. As it happened, Sinatra didn't have any skeletons in his closet, or if he did, they weren't career killers. He appealed to women, but he was all man.

Ray definitely wasn't, and his lack of conventional masculinity was a matter of criminal record. He was haunted by the fear that his 1951 arrest would be made public. Realising in the intense scrutiny that followed his success that he was in danger of being exposed, he quickly married Marilyn Morrison, whom he had met in New York nightclub the Mocambo; she was the daughter of the owner. She knew of his attraction to men but had hopes of straightening him out, particularly as she was pregnant with his child at the time.

This apparent conventionality delayed the inevitable by only a few months. During 1952, Ray's pop career began to stall in the US. While audiences were still rabid, his records began to slip in the charts. After 'Walkin' My Baby Back Home' made #4 in the summer, 'All of Me' – together with its near-the-knuckle flip, 'A Sinner Am I' – only reached #12. Ray had long been a heavy drinker, but it started to become a problem, and he began using Dexedrine to cope with his still busy concert schedule.

In September 1952, Marilyn fell down a flight of stairs and lost her baby. Rumours about the marriage started to swirl. In December, an insider subscription sheet called *The Hollywood Life Newsweekly of the*

West printed the front-cover story 'Johnnie "Cry" Ray Arrested on Homosexual Charge', in which the singer was called a dangerous drunk and, repeatedly, a 'homo'. Although this was potentially damaging, the publication had a small circulation and could, in theory, be shrugged off.

But the damage was done when, in its second issue, dated April 1953, *Confidential* magazine ran a story titled 'Is It True What They Say About Johnnie Ray?' The copy was vicious: 'There were scores of persons in Detroit who could swear they had seen this youngster cavorting on the stage of a nightclub made up and outfitted down to the last scarlet fingernail in a girl's attire. A suave, sophisticated audience in New York's internationally known Copacabana Club had also seen him "in drag," a cynical Broadway term for a man who dresses as a woman.'

In its desire to police masculinity, *Confidential* went to the heart of the matter: Ray was simply not a man. In the claustrophobic sexual and gendered atmosphere of America in the early 1950s, any perceived deviancy was automatically suspect, and simply by who he was, Ray had handed the scandal magazines their story on a plate; indeed, he represented a social and psychological problem. As *Confidential* asked, 'Could a skilled psychiatrist revamp his personality to eliminate these outbursts of femininity?'

Such a suggestion was dynamite, and Ray struggled to deny the truth. While his pop career revived in America – 'Somebody Stole My Gal' made the US Top 10 in spring 1953 – he started to have greater success in Britain, where the lack of scandal magazines meant his sexuality and perceived lack of masculinity were not common knowledge. Between spring 1953 and spring 1955, he had four UK Top 10s (including the chart-topping 'Such a Night') and a fanbase as rabid as in his US glory days.

Yet spending more time in Europe did not bring surcease from the American scandal sheets. In August 1955, *Confidential*'s competitor *Lowdown* revived the four-year-old story of Ray's arrest, exposing the singer as having paid a $25 morals charge in Detroit; to add insult to injury, they printed his feral mugshot on the cover, together with his rap sheet. The magazine cloaked the exposé in fake concern: '*Lowdown* Demands Michigan Governor Pardon Johnny Ray', but in order to be pardoned you had to have been convicted, and there were the details for all to see.

The capper came with the November 1955 issue of *Confidential*, which published an article entitled 'Why Did Johnnie Ray Try to Break Down Paul Douglas' Door?' The piece referred to an incident from that April, when Ray, high on his triumph at the London Palladium, had got extremely drunk and at 3 a.m. banged on the door of what he thought was his suite, stark naked. In fact, it was occupied by the gruff, liberal actor Paul Douglas, who told him he was on the wrong floor and sent him away.

Confidential twisted this mistake into something eye-poppingly salacious. Calling Ray 'a strange Yankee creature who'd made millions out of being maudlin in front of a mike', they alleged that he was drunk and cruising for men. This 'secret urge' meant that his success was built on a lie: 'Hundreds of thousands of bobbysoxers wouldn't have believed their eyes if they'd witnessed the incident. For two weeks they'd mobbed the Weeper during his record breaking engagement at the Palladium. Their idol . . . the tenor with a million tears . . . making a pass at a man. Never!'

This was a deadly attack deliberately aimed at the heart of Ray's appeal. In fact, the singer was bisexual, but it was his homosexuality that mattered in late 1955. The question remains, however, of how much his teenage fans knew about his sexuality, or how much they cared. *Confidential* had a US circulation of over three million in 1955 and was popular among teenagers and fan-magazine addicts. Some would have been horrified, but for others it wouldn't have mattered at all, because their fandom involved a degree of mutual understanding.

For his female fans, Ray was already not as other men. He wasn't like most of their fathers or brothers. He was different, not just in terms of his sexuality, but in his vulnerability, his ability to tap into their secret thoughts and surging emotions. Ray wasn't a sex symbol; he was a vehicle that allowed them to act out, to explore who they were individually and collectively. He was at once thrilling and completely safe. If he was homosexual, bisexual or asexual, it didn't matter. He wasn't a predator but a product, an object, and if he was feminine, then he was just like them.

The question of his sexuality, in the end, was moot. Ray's teen career did begin to recede from late 1955 onwards, which could have been a result of *Confidential*'s revelations, but could equally have been due to his

advancing age, the fact that he had had his allotted three years at the top and the simultaneous emergence of rock 'n' roll. Within three months, a new star would emerge to soak up the passionate screams of teenagers and the outraged insults of adults.

In November 1955, however, Johnnie Ray was still at his summit, poised between glory and humiliation. As *Confidential* went on sale in America, spreading its poison, he was on the other side of the Atlantic, playing to packed houses, soaking up the adoration of screaming fans and being photographed in a friendly exchange with the Queen, every inch the perfect American with his perfect complexion and shining white teeth. Privately, he was undone. Nevertheless, his influence would be profound, not least on his immediate successor, Elvis Presley.

3
Scandal and Disguise

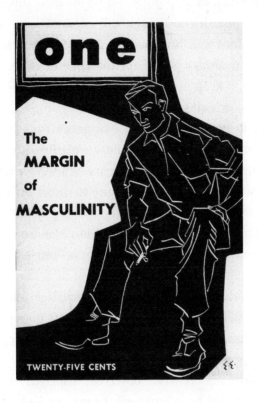

I made a critical survey of the bar. Of the six other male customers,
I knew two to be gay. Since the remaining four were unknown to
me and presented no cause for speculation, I assumed they were
not. The point was that nothing in the behaviour of the lot of them
made any one seem different from the rest, or from the hundreds
of males you would pass on the street.

James Douglas Margin, 'The Margin of Masculinity',
ONE magazine, May 1955

Mid-1950s America was full of stars who were not how they seemed – indeed, were not how they were promoted. Despite its monolithic appearance and rigid constructs, American masculinity was much more porous and fragile than anyone could have admitted at the time. It's as though the effort to keep up the hyper-masculine appearance was shadowed by real lives that were full of doubt and insecurity and always poised on the edge of calamity. The more intense the effort to keep up appearances, the greater the lie, and there was an industry in exposing those lies.

It wasn't just in pop music. On 9 November 1955, the Hollywood leading man and sex symbol Rock Hudson married Phyllis Gates in a ceremony arranged by his manager, Henry Willson. It was a publicity stunt. Hudson was under extreme pressure to dispel persistent rumours about his homosexuality – exacerbated, if anything, by the 3 October *Life* cover story that termed him 'Hollywood's Most Handsome Bachelor'. As the text inside ran: 'Fans are urging twenty-nine-year-old Hudson to get married – or explain why not.'

Hollywood insiders knew how fake the marriage was. Hudson was gay, and so was Willson, who, as one of the most powerful agents and managers in Hollywood, often used his position to sleep with poten-tial clients. He specialised in good-looking men – all of whom, as the film writer Gavin Lambert wryly observed, displayed 'that impeccable American sexuality and body structure, factory packed and returned to makers if not in perfect condition'.

Willson's 'boys' included actors like Tab Hunter, Nick Nolte and Nick Adams. The process was akin to a conveyor belt: Willson would spot the young men, seduce some, and then begin remodelling them into potential movie stars – a process that usually involved a heroic change of name. So Francis McCown was transformed into Rory Calhoun, Carmine Orrico into John Saxon, and Robert Moseley into Guy Madison. It was very American and very pop in its transformative and mythic aspects.

Willson put extra effort into Roy Harold Scherer, whom he renamed Rock Hudson in 1947. Hudson had been a truck driver and had the rug-ged look, but there was one major problem: he was obviously homosexual,

and had to be intensively reprogrammed into an all-American masculinity. As Willson's biographer Robert Hofler writes: 'Rock got his wrists slapped when they went limp, his hips smacked whenever they swayed. Legs were never to be crossed or pressed together when he sat down . . . any trace of effeminacy was identified so it could be eradicated.'

It was common for Hollywood actors to be physically remodelled. Even so, Willson's regime sometimes involved permanent damage. Deciding that Hudson's natural speaking voice was too high-pitched for his macho image, the agent hired a vocal coach to make the requisite change. Waiting until Hudson had a cold, the coach made him scream for hours until his vocal cords were permanently altered to produce a deeper – and hopefully more seductive – register.

The campaign slowly paid off. Hudson began getting small roles in 1948, but it wasn't until Douglas Sirk's *Magnificent Obsession* that he became a star. His stock rose further during 1954 and 1955 with two adventure films, and two melodramas: *One Desire* and Sirk's *All That Heaven Allows*, in which he played a young gardener who falls in love with an affluent widow. The drama of the piece lay in the conflict between personal freedom and societal expectation, and the heart won the day.

It wasn't all plain sailing. It was common knowledge in Hollywood – and certainly mooted among the actor's gay fans – that he was homosexual, and once he became famous the threats started. Hudson had been photographed having sex with men, and in late 1954, Willson was told that *Confidential* magazine was offering money to ex-friends and colleagues for any material that might expose the star. Two of his former clients were offered $10,000 to tell their story, but loyally refused. The matter wasn't over, however.

In May 1955, Mike Connolly ran a blind item in his *Hollywood Reporter* column, stating that a major star was being blackmailed over what he termed a 'silly escapade'. The blackmailer was threatening to expose Hudson in flagrante, and the affair was the talk of the town. Willson was terrified that *Confidential* would get hold of the photos. Although he hired muscle to beat up the blackmailer and recover the photographs, the magazine was so powerful that he felt forced to do a deal. So to protect Hudson he snitched on another of his clients.

Knowing that exposure was imminent, Willson opted for a pre-emptive strike in the May 1955 issue of *Confidential*, which ran the story 'Rory Calhoun, But for the Grace of God, Still a Convict'. In the late 1930s and early 1940s, Calhoun had been a teenage tearaway, robbing jewellery stores and hot-wiring cars – activities that resulted in a three-year prison term. By 1955, he had become a prominent actor, playing tough-guy roles in westerns and thrillers, reaching co-star status in films like *How to Marry a Millionaire*.

The Calhoun story was organised by Willson and the Universal–International studio, which obviously thought Rock Hudson more important. His career didn't suffer, partly because his criminal past had already been exposed two years previously. At the same time, his juvenile delinquency was well behind him and suited his tough-guy image. After some very public repentance, his co-starring role in his latest film, *The Spoilers*, was well received on its release in December 1955.

However, the second betrayal was far more serious. Tab Hunter – Arthur Andrew Gelien – had been a client of Willson's since 1950. The agent had renamed him and placed him in westerns and war films, where his clean-cut, blond good looks helped to make him an American arche-type. His breakthrough roles came in the 1955 war films *Battle Cry* and *The Sea Chase*; both would make the top ten in the end-of-year listings in America.

Hunter was hot in summer 1955, but by then he was no longer repre-sented by Willson. In early September that year, the *Hollywood Reporter* noted that the actor had sacked his agent, changing representation to Dick Clayton, who also represented James Dean. Willson was furious at this defection to a bitter rival and fed *Confidential* the details of Hunter's October 1950 arrest at a gay party in Los Angeles – an incident that com-pletely undermined Hunter's all-American, upstanding image.

Confidential duly published the story in its September 1955 issue: 'That "Disorderly Conduct" Charge against Tab Hunter!' Subtitled 'The Truth About Tab Hunter's Pajama Party', the magazine recounted the events of 14 October 1950 in salacious detail. After being picked up at a gay bar, a detective in plain clothes arrived at a 'queer romp' in Walnut Park. 'Milling around him were two dozen of the gayest guys

the vice squad had ever seen. There was one lone pair of women but their mannish attire and baritone voices only added to the novelty of the evening.'

Arthur Gelien, as Hunter was then known, was one of those arrested and booked. On 6 February 1951, he was fined $50 and placed on probation for a year. Just like Johnnie Ray, he was completely unknown at the time and received no publicity. But the conviction was there, like a ticking time bomb, ready for the unscrupulous to expose. Although supported by Warner Brothers, Tab Hunter's film career never quite recovered. Instead, he became a pop star: in early 1957, his first record, 'Young Love', stayed at #1 in the US for four weeks.

These high-profile exposés of prominent homosexuals like Tab Hunter and Johnnie Ray occurred at the height of the scandal magazines' influence. By 1955, they had become a major force in American publishing – *Confidential* sold five million copies per issue. Homosexuality wasn't their only focus: the November 1955 *Confidential* issue that exposed Ray also contained salacious stories about Liz Taylor and Mae West. But it was a major preoccupation, if not an obsession.

Confidential was the originator of the scandal craze. Founder Robert Harrison had made his name in the late 1940s by publishing very soft porn 'cheesecake' magazines. After some success with *Whisper*, a magazine that mixed true crime and scandal with pin-ups, he decided to launch an exposé publication that went all the way in revealing the secrets of the stars and, by direct implication, the depths of depravity and deviance that lay under the surface of American life. As the magazine's cover tagline went: 'Tells the secrets and names the names'.

Confidential regularly covered the topic of homosexuality in the most pejorative of terms. Its principal focus was TV and film, which they pursued in stories like 'The Lavender Skeletons in TV's Closet' (July 1953), 'Hollywood, Where Men Are Men – And Women, Too' (January 1954), 'The Untold Story of Van Johnson' (September 1954) and 'The Untold

Story of Marlene Dietrich' (July 1955), about Dietrich's alleged lesbian affairs with Margo Lion and others.

For a while, the magazine was untouchable. As the prime locus of mass popular culture during the period, Hollywood was a scandal magazine's prime target, and *Confidential* in particular worked to extort hush money from the studios. It was certainly fed stories by Hollywood insiders like Mike Connolly, who was a close friend of Henry Willson and had slept with a few of Willson's clients.

The success of *Confidential* inspired a plethora of imitators, many of which launched in 1955: *Hush Hush, Inside Story, Exposed* and *On the QT*. These magazines acted as informers and agents provocateurs, ruthlessly exposing and ridiculing anyone who was different. Using private investigators and a whole raft of researchers and informants, they would amplify the basics of a story – to the limits of the libel laws and beyond – in order to boost sales and make their subject look as depraved and ignoble as possible. The whole idea was punishment and humiliation.

There was, however, a paradox at their heart. They did track those who were different, those who bravely stood outside the norms at a time when the topic of homosexuality and gender difference was rarely covered in the mainstream media. There is evidence in the archives to suggest that these publications were consumed by gay men for that very reason: among the few visible outlets to mention homosexuals at all, they inadvertently provided news and commentary on aspects of gay life for gay people during the period.

———

As well as stars like Hunter and Ray and Dietrich – who were icons within the gay subculture – the scandal magazines went after other non-conforming figures. In September 1955, *Confidential* ran a story about Christine Jorgensen, under the title 'Jimmy Donahue's Private Peek at Christine'. Dripping with salacious glee, Richard Donaldson span out the thin tale of how Donahue, the gay playboy and Woolworth's heir, had tried to seduce actress Jorgensen, principally to find out what was going on 'down there': 'Was she a he, or was he a she?'

It was only the latest in a series of scandal magazine stories that sought to humiliate a young woman who had been through hell and back to find herself. Born George Jorgensen in May 1926, Christine had been, by her own admission, 'a frail, tow-headed, introverted child' with feminine mannerisms and 'sissified ways'. As she grew into adolescence, she admitted to 'acute feelings of loneliness. I felt like an outsider.' She fell in love with another boy but suffered anguish about her perceived homosexuality.

Drafted into the army at the age of eighteen, Christine began to experience intense gender confusion. She felt as though she were living in a 'strange, infernal limbo' as George. Since as far back as she could remember, she had felt she was a woman in a man's body. 'I – I've tried for more than twenty years to conform to the traditions of society,' she told a psychiatrist whom she hoped would cure her problem. 'I've tried to fit myself into a world that's divided into men and women . . . to live and feel like a man, but I've been a total failure at it.'

After a series of false starts and disappointments with doctors and psychiatrists in America, she heard about 'sex transformation' cases in Sweden and Denmark, and went to Europe in April 1950. In August that year, she began tests and treatments in Copenhagen's Statens Serum Institut with Dr Christian Hamburger, who told Christine that she was 'the victim of a problem that usually starts in early childhood, an irresistible feeling that you wish to be regarded by society and by yourself, as belonging to the opposite sex'.

This was the beginning of a long process that involved high doses of oestrogen, the removal of testicular tissue and a penectomy in November 1952. At each stage, there were careful assessments and documented formalities to be gone through. Meanwhile, Christine prepared for her transformation in stages. After building up her courage, she began wearing women's clothes in public in spring 1952, and shortly afterwards announced her change of sex to her parents. Remarkably for the time, they were supportive.

Thus far this had been a private matter, but in December 1952, Christine Jorgensen became a phenomenon, not for what she did, but for who she was. The story of her 'sex change' was leaked to the American press, who promptly and collectively lost their heads. In her autobiography, Jorgensen

quotes headlines like 'Doctor's Six Operations Turn Man into Woman', 'Ex-GI Who Became Girl Has Boyfriend' and 'Ex-GI Becomes Blond Beauty', and makes her disgust clear for the 'disgraceful degraded behaviour from news hawks' who threatened her parents.

Under intense pressure, Jorgensen did a deal with *American Weekly* to write six exclusive articles telling her own story. Naturally, this decision incensed the rest of the press, with three hundred reporters mobbing her when she arrived back in New York on 13 February 1953. Nothing would be the same again. 'In my long, painful search for a normal life,' she later wrote, 'I had created a paradox: a life that was to be, for me, abnormal and unconventional.' She became an instant celebrity, but with a twist: she wasn't famous for her achievements or her stardom but for her operation. She was regarded as a freak, an oddity, an indeterminate hermaphrodite who caused disturbances in theatres and was gawped at in restaurants. As an outlier, the level of incomprehension and insult she had to endure was intense.

Jorgensen was at once famous and notorious, a torturous situation which resulted in both a strange kind of privilege and a less surprising ostracism. When she decided to parlay her notoriety into a nightclub career, she was banned from several clubs on the grounds of immorality. She was told by the police in Washington not to use women's toilets. She was banned in Boston and had her hair yanked in Miami.

In May 1954, she had her final surgery, an extremely complicated operation that left her drained. Three months later, in August, she arrived in the UK, only to be viciously smeared in the English press, with quotes like 'what an amazing country is ours, [in which] . . . an act can be presented in which the prime attraction is the performer's sexual abnormality'. The American scandal sheets merely compounded this cruelty with headlines like 'Is Christine Slipping Back?'

Jorgensen's decision to go public was thrust upon her, but her decision to continue in the public eye was brave, if perhaps precarious with regard to her mental health. However, the press coverage of her inner struggle to achieve her true nature said more about the eye of the beholder than it did about her. Jorgensen was totally clear about her situation all the way through, but the idea that a man could change sex and become a woman

was so alien to American and British culture in the mid-1950s that the only way the press could interpret it was in terms of disgust and rejection.

———

T
he culture of fear and shame around sex and gender forced those who did not or could not conform to wear masks despite hiding in plain sight. In November 1955, another non-gender-conforming human was facing bad press. Liberace's first film, *The Man Who Played God*, opened in New York to poor reviews: 'Liberace spends an hour and fifteen minutes oozing dimpled sincerity from the screen,' wrote the *New York Times*, 'frequently skimming the glistening keyboard and bestowing his smile like a kiss.'

These coded, unmanly slurs were by no means the worst example of the abuse that the superstar pianist attracted after his rise to fame in 1953. Born in May 1919, an identical twin whose brother died at birth, Władziu Valentino Liberace was a child prodigy who, as an effeminate, poor youngster with a speech impediment, took refuge in the piano. As he honed his act in his early twenties, he decided to fuse his classical experience with contemporary pop modes.

A showman and a consummate master of publicity and his own iconography, Liberace developed an elaborate stage set, including his trademark candelabra, to go with his energetic mix of classics, show tunes, film melodies, Latin rhythms and boogie-woogie. By the time he found fame with his syndicated television show in 1953, he had refined his act down to an art, involving his family, talking to the audience through the camera and embracing a dizzying array of costume changes and dramatic gestures.

Schmaltz it might have been, but it was a sincere and technically dazzling experience, with Liberace as the consummate ringmaster. During 1953 and 1954, he reaped the rewards, with successful seasons in Las Vegas and massive viewing figures for his television appearances. An early highlight was a triumphal performance at Madison Square Garden in late May 1954 in front of an audience of 14,000, with a record-breaking gross of $138,000 (roughly $1.3 million in today's money).

The news reports noted that 75 per cent of the audience at Madison Square Garden were female, and therein lay the rub. Liberace's hypnotic appeal to women aroused male envy, compounded by the fact that the pianist was very obviously flamboyant and effeminate during his public performances, which in the mores of the time translated into a clear case of homosexuality. Insult and innuendo were brought into play, concentrating on the pianist's core appeal, which, in the twisted logic of the time, became his Achilles heel.

In spring 1954, *Time* magazine called his phenomenal success 'musical momism' – an explicit reference to Philip Wylie's best-selling book *Generation of Vipers*, which had bemoaned, inter alia, the adoration of the mother and the consequent emasculation of the American male. The *Los Angeles Mirror* questioned 'the sanity of the nation's women – particularly those in the middle and late years – who idolise him', calling Liberace 'the Candelabra Casanova of the keyboard, the musician actor who makes millions out of Momism'.

Within an intolerant climate, Liberace tried, rather fitfully, to dispel any rumours of his homosexuality by dating several women, including Joanne Rio, to whom he was briefly engaged, Mae West and, rather surprisingly given the climate of the time, Christine Jorgensen. He even gave an interview to *TV World* in December 1954, with the headline 'What I Want in a Woman'. All to no avail, as the slurs were unrelenting: 'Liberace: Don't Call Him Mister!' (*Rave*, August 1954); 'Liberace's "Forbidden Fruit"' (*Secret Life*, January 1955); 'The Men in Liberace's Life' (*Uncensored*, March 1955).

This 'masculine contempt' was hysterical stuff, full of envy and spite, almost an incitement to violence, but it reflected the scandal magazines' confidence and their explicit modus operandi: if you are in the public eye, you are fair game; step out of line and we'll harass, caricature and intimidate you. This was, and remains, a media mainstay, but perhaps the worst thing about the scandal magazines was the fact that they reflected and reinforced America's dominant values, albeit in an extreme and unpalatable form. They were the period's paranoid id.

The sexual and gender roles that these magazines were ruthlessly policing for men and women – in terms of homosexuality, their targets were mainly men – were constructed to be immutable, yet at the

same they were fearful of change, seeing threats and nonconformists everywhere. Christine Jorgensen had observed 'the many variations and combinations of masculinity and femininity . . . that exist side by side in the world', but any understanding of this complex reality was way beyond most of Britain and America in the mid-1950s.

This social pressure only amplified the vortex of concealment and betrayal that swirled around gay men during the period, as the pressure to be conventionally masculine seemed overwhelming. As Rodney Garland wrote in his 1953 novel, *The Heart in Exile*: 'The invert's whole life is spent hiding his real passion from the enemy. A double life becomes second nature to him; he learns the technique in his teens.' This double life had to be rigidly patrolled at all times; the penalties for a mistake could be severe.

This was parodied in the period's pioneering gay activist, or homophile, publication, *ONE*, which fearlessly proclaimed itself 'The Homosexual Magazine'. In the May 1955 cover story, 'The Margin of Masculinity', James Douglas Margin evolved his 'Theory of Masculine Deportment', in detailed phrases that could have come straight out of Henry Willson's remodelling of Rock Hudson. Setting the tale in a gay bar, the writer gave programmatic instructions to a fictional friend, Johnnie. In order to hide his homosexuality, Johnnie was advised 'to avoid the limp wrist as you would the plague', while cultivating a firm handshake and watching out for any tendency of the little fingers to wave about. Butchness could be achieved by learning how to strike a match and letting the cigarette dangle loosely from the mouth in 'a brutally tough effect'. He was to watch his language: no gushing, and cut the fizzing superlatives. Most importantly, he was to learn the upright position of masculine males and at all costs to avoid the hands-on-hips position.

The article was half serious, half a spoof on the degree to which homosexuals assumed the most extreme forms of masculinity, simultaneously as a method of concealment and a code of sexual attraction. Despite the oppressive nature of the times, Margin's conclusion was utopian: 'Such terms as "better half" and "weaker sex" . . . will disappear, while the words "masculine" and "feminine" become obsolete for sheer lack of meaning.' This would become a principal play of pop, but in the meantime, gay men and lesbians had a mountain to climb.

4
The Homosexual in America

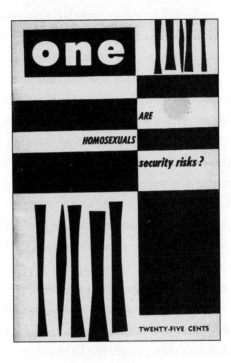

How do homosexuals themselves feel about their situation? As one man put it, 'I'm not going anywhere and I know it. There's no future in this kind of life. No one is basically satisfied with it, so the relationships never endure. It's a kind of quicksand that people are stuck in together. In their hearts, most of them would like to get out, if they knew how.'

Ted Berkman, 'The Third Sex – Guilt or Sickness?'
Coronet, November 1955

Pop and movies did not exist in isolation. During the mid-1950s, homosexual men were stigmatised as America's enemy within. Demonised as outcasts and, even worse, traitors in the Cold War panic of the period, they were denied access to government employment, arrested and sent to mental hospitals, regularly harassed and beaten by the police, and routinely vilified by the press. They were deemed the lowest of the low and were expected to accept their lot. Some did not.

The prevailing American attitude towards homosexuality was amply rehearsed by an article in the November 1955 issue of *Coronet*, a popular, digest-size monthly magazine owned by *Esquire*. The subhead promised frank answers to the perplexing question of whether the homosexual was 'an adult with child-like emotions, the victim of a physical imbalance – or a dangerous non-conformist?' Over five pages, Ted Berkman – an experienced journalist and screenwriter – explored all the angles in a prime example of mid-century masculine panic. His tone hovered just one notch above that of the scandal magazines, citing drag queens and unofficially designated gay beaches as examples of more open proliferation. He noted the homosexual's status in law: 'simply and flatly a criminal to be punished; a violator of the common human code'. However, by citing Freud and his successors in the article, he reflected the mid-decade shift towards a more medicalised model of treating the problem in America. In this view, homosexuality was not just a criminal activity, but an illness. Berkman's article rehashed contemporary pseudoscience in support of this thesis: a deficiency in hormones produced by the pituitary gland; a feminising malfunction of the adrenal gland; stunted emotional growth; a deep mother fixation. He then went further, into the malaise of post-war life: high-tension city living, the aggressiveness of career women and the environmental factor – 'the frequency of homosexuality wherever large groups of men are confined together, as in prisons, army camps'.

Ending with an eight-step advice programme for parents to safeguard their children against homosexuality, Berkman conflated various then-current patterns of anti-homosexual prejudice: the seduction of minors; the mother fixation; the lack of conventional masculinity, shading into drag, transvestism and even gender confusion; and, finally,

arrested development – 'In the psychiatric view, the homosexual suffers from stunted emotional growth; he has a child-like emotional equipment in the body of a grown man'.

Berkman's article broadcast the period's prejudice: the homosexual as bogeyman and scapegoat, a total pariah. And, despite the considerable difficulties faced by lesbians and trans men and women, it was male homosexuals who still bore the brunt of this institutional and social prejudice. This was partly due to numbers – the millions revealed by Alfred Kinsey – partly due to the increased visibility of gay men, and largely due to a particularly vicious phase of power politics.

Kinsey had documented the increasing prevalence of homosexuality, but his research had the unintended consequence of it increasingly being seen as a threat. In 1955, ten years after the end of the Second World War, there was another war being waged, not against fascism but against communism. This time it was partly internal, and the enemies were not just home-grown communists, but homosexual men. The November 1955 *Coronet* article was only the latest in a series of ideological statements that, on the ground, translated into extreme legal repression. These were well publicised in the press, reinforcing a spiral of hatred, fear and hopelessness.

In early September 1955, there was a purge in Sioux City, Iowa. 'Crackdown on "Queers" Has Begun' ran the headline in the local press. Using agents provocateurs – a process they called 'fruit picking' – and applying heavy pressure on the gay community to name other homosexuals, the local police netted twenty-two men in a concerted operation. This sweep was triggered by the unsolved murders of two young children in the area in 1954 and 1955. None of those arrested had anything to do with the murders, but the local authorities' inability to solve the case made them useful scapegoats.

In a series of trials throughout the month, the twenty-two men were deemed 'criminal sexual psychopaths' and committed to the Mount Pleasant State Mental Hospital. This was enacted by a law passed in late January 1955 by the Iowa House of Representatives 'to provide for the confinement of persons who are dangerous criminal sexual psychopaths'. Anyone convicted of this crime would be committed to the state

mental hospital, then detained and treated indefinitely or until certified as 'cured'.

By late September, all twenty-two men – in occupations ranging from businessman and management trainee to hairdresser – had arrived in Mount Pleasant for an indefinite stay. In one sense, they were lucky. They were all confined in the same ward and were not subjected to the 'treatments' used by other institutions: ECT, hormone treatment and aversion therapy. All of them would be quietly released within a few months, but in the meantime Judge O'Brien crowed in the *Des Moines Register*: 'The word is out they [sexual deviates] are not welcome in Sioux City anymore.'

Small-town America was prone to purges. In early November, the city of Boise, Idaho, erupted in a gay scandal, with headlines such as 'Crush the Monster', phrases like 'evils of moral perversion' and talk about how the city had to be 'thoroughly cleaned and disinfected'. This was a complex affair involving local politics and the use of homosexuality to smear opponents and create a moral panic. One of the men arrested had been accused of 'an infamous crime against nature' with two males aged seventeen and fifteen, and that was used to justify a purge of all the city's homosexuals.

There had been several recorded incidences of underage sex in Boise in 1955, most of them involving young male prostitutes aged between fifteen and seventeen; some were indeed gang members turned blackmailers. The problem was not just the individual cases, but the automatic conflation of homosexuality with the seduction of minors. It was this that coloured events in Boise, even though almost all of the ensuing cases had nothing to do with underage males. It was enough, in the eyes of the city council, to be living outside of the law.

Open season was declared on the city's homosexuals. There were public meetings on the topic, curfews for teenagers aged sixteen and under, denunciations and cases of entrapment by plain-clothes policemen. In his trial for an alleged homosexual act, one of those arrested, Gordon Larsen, gave evidence to the effect that he had been led on by the policeman concerned, and that during his interrogation one of the officers had claimed: 'I could tell when you were walking in the door you were a

homo by the way you walk.' You had only to look like a homosexual to
be guilty.

The affair made the national press. In its 12 December 1955 edi-
tion, *Time* magazine published an article called 'Idaho Underground',
which revealed 'a widespread homosexual underworld'. This hyperbolic
prose perfectly summarised the mainstream American attitude towards
homosexuality in 1955: it was unmanly, predatory, underhand, covert
and, above all, omnipresent. Like the plot of a contemporary, paranoid
science-fiction film, America was under threat from a shadowy, alien
presence. This was the true invasion of the body snatchers, and it could
be you and yours next. Within such a climate, it was hardly surprising
that most of the men arrested in Boise went to prison for up to ten years.

———

How had things got to this point? The demonisation of homo-
sexuals began with opportunistic politicians riding the wave of
reaction and retrenchment under the guise of the Cold War. An
inquisitorial momentum developed into a full-blown attack on anyone
who was seen to be un-American: first of all communists, then left-
wingers, then homosexuals, who, with their perceived weakness, softness
and feminine ways, were considered a threat to the ideal of martial mas-
culinity – 'lavender lads', as the right-wing senator Everett Dirksen called
them in 1952.

During the Second World War, conscription had brought together gay
men and lesbians from all over America. Many had found freedom away
from their home environments and, realising that there were many others
like them, togetherness in these new possibilities for association. The *carpe
diem* atmosphere of wartime also loosened sexual constraints. This in turn
fostered the basic building blocks of the post-war gay world: sympathetic
venues, insider code language – the Second World War saw the term 'gay'
begin to replace 'homosexual' – and ideas of equality and freedom.

America was at war against fascism, therefore its democratic qualities
were propagandised at every turn: not just in military propaganda, but
in the mass consumer ideal of the teenager. Fighting against a common

enemy and risking their lives, the minorities – African Americans, homosexual men and lesbians – could have been forgiven for thinking they deserved an equal share of the American pie once the conflict was over. Indeed, in 1945 a few gay veterans formed a social and campaigning organisation called the Metropolitan Veterans' Benevolent Association. By 1950, however, that was shown to be a vain hope. The hardening of the Truman government's policies towards Russia resulted in a suspicious and vindictive approach towards dissidence and nonconformism. Government and State Department employees were under particular scrutiny, with the first dismissals for homosexuality – thirty-one in all – occurring during 1947. With the rise of McCarthyism and the deepening involvement of the FBI, these snowballed after the turn of the decade.

In February 1950, Senator Joseph McCarthy gave his famous speech about the infiltration of the State Department by communists. The figures changed, but the numbers were significant. Shortly afterwards, he gave another talk, in which he singled out two cases of 'sexual deviance' in government, thus helping to link homosexuals with communists in the public eye as political subversives. As a correspondent wrote to President Truman that March: 'The best thing for our country and our foreign policy is for you to get rid of . . . the "Reds" and "Homos".'

Things escalated quickly. In April, the FBI got involved when J. Edgar Hoover forwarded the names of nearly four hundred people arrested in Washington on 'charges of sexual irregularities' to the State Department and initiated the 'Sex Deviates Program', created to root out homosexuals at every turn. In May, the Wherry-Hill subcommittee was formed to investigate the 'Infiltration of Subversives and Moral Perverts into the Executive Branch of the United States Government'. When the liberal *New York Post* columnist Max Lerner interviewed Senator Wherry that June, he found a man who, thumping his desk, vowed to 'take full responsibility for cleaning them all out of the government'.

Sympathetic journalists amplified the message. In the November 1950 issue of *Coronet*, one Ralph H. Major lifted the lid on 'This New Moral Menace to Our Youth', equating the homosexual with the psychopath. The next month, the Wherry-Hill subcommittee delivered its report,

recommending that homosexuals were not to be employed in government as they were security risks: 'such behaviour is so contrary to the normal accepted standards of social behaviour that persons who engage in such activity are looked upon as outcasts by society generally'.

From 1951, the FBI stepped up its policy of informing the government about known homosexuals in its employ, while slowly expanding its field of operations to universities and the public sector in general. In 1953, President Eisenhower signed off on Executive Order 10450, which barred homosexuals from working in federal government. This also included every department and agency, and – in a major expansion of the state's role – every private corporation with a government contract, thus placing millions of gay men and lesbians at potential risk of losing their livelihoods.

It is estimated that around 5,000 gay men and lesbians lost their jobs as a result of this order, with the additional threat of exposure and potential ostracism. In the next couple of years, this punitive ambit was extended to state and federal government employees, pulling millions more into the climate of fear. Anti-homosexual legislation thus became a major policy thrust of the first Eisenhower presidency. As a prominent Republican senator stated in 1954, concerning the congressional election campaign, the 'Republican battle this fall is against reds, pinks, psychopaths and homosexuals'.

In January that year, Max Lerner wrote a series of articles in the *New York Post* about 'The Ordeal of the Gay'. He noted the inconsistent maximum sentencing policy for homosexual acts in different states: possible life imprisonment in Georgia and Nevada; thirty years in Connecticut; sixty years in North Carolina; a year in New York, if both parties were consenting and over eighteen. He considered these punitive provisions 'barbarous' and lambasted legal terms like 'sodomy, lewdness, carnal indecency', etc., for including 'most of the acts that a majority of Americans practise in private'.

Lerner also criticised the drive against homosexuals in government as creating opportunities for blackmail: 'the social penalty of exposure has become far more drastic than ever'. He concluded that gay men were 'caught between the powerful sexual impulses which our society forbids

and the hazards of predatory men who exploit their vulnerable situation. And they are helpless in trying to change the laws which hang over them, since to speak out openly would be to expose themselves to social penalties far worse than the legal ones.'

However, by 1954 there was the start of a fightback, which Lerner noted in his article of 25 January. Under the pressures of an extremely hostile world, homosexuals tended to become 'a combination of fraternal order, secret society, underground resistance movement, defence association, literary and artistic clique, and a minority group lamenting its state and asking for its civil liberties'. Rejection had the paradoxical effect of strengthening their bonds, as they associated together in their ghetto and thus promoted a new kind of homosexual consciousness.

This was the slow forging of a discrete homosexual world. The FBI and the police might have driven it underground, but there were voices – right at the height of the purge – looking towards the future and speaking plainly about the gay experience. The first document from within was Donald Webster Cory's *The Homosexual in America*, published by the specialist imprint Greenberg in 1951. A groundbreaking work, it was thorough and inspirational, yet written as if from within a tiny room, looking regretfully at the hostile, uncomprehending world outside.

Cory began by self-identifying as a homosexual, a brave step, albeit understandably qualified, amid the climate of the time, by his use of a pseudonym. His work was a survey that moved from the personal to the general, giving information about a minority who were 'outside the pale of the mainstream of life, unable to enjoy the benefits of civilisation side by side with their fellowmen'. Being a homosexual, Cory wrote, was to live constantly with the existence of something that was 'inescapable', that affected 'every aspect of life'.

'It is apparent that the condemnation of homosexuality is today almost universal,' he stated, and went on to delineate the deep damage that this did to the psyches of gay men and lesbians: 'Constantly and unceasingly we carry a mask, and without interruption we stand on guard lest our secret, which is our very essence, be betrayed.' Cory argued that action was necessary: 'Until we are willing to speak out openly in defense of our activities, and to identify ourselves with the millions pursuing these

activities, we are unlikely to find the attitudes of the world undergoing any significant change.'

While Cory was preparing his book, the second post-war homophile organisation was formed: the Los Angeles-based Mattachine Society, with founder members who included the long-time activists Harry Hay, Dale Jennings and the designer Rudi Gernreich. They took their name from the Société Mattachine, a medieval masque group that travelled around France dramatising injustice through songs and plays. It was used in the 1950s context to emphasise the fact that gay men and women were a 'masked people, unknown and anonymous'.

Mattachine aims included public education 'toward an ethical homosexual culture paralleling the cultures of the Negro, Mexican and Jewish peoples'. The society gradually spread, with branches forming around the country – in Chicago, Washington DC, New York and San Francisco. After an ideological split in 1953 caused by the radical-left slant of the organisation, the various factions – defined along political and gender lines – began to publish their own monthly magazines: *ONE* magazine, founded in 1952 by Dorr Legg and Dale Jennings; the *Mattachine Review*, founded in 1955 by Hal Call; and *The Ladder*, formed in 1956 by America's first organised lesbian group, the Daughters of Bilitis.

These magazines had small circulations: *ONE* sold around 5,000 copies, the *Mattachine Review* 2,000, *The Ladder* 500. But they were part of something bigger: not just agitation, but the start of a gay consumer culture that would grow much larger in the decade to come. By the mid-1950s, there was a recognisable, if underground, gay subculture that centred on bars; one that, however dangerous and risky the location might have proved, offered a temporary safe haven from a hostile world outside.

In 1957, Helen Pyle Branson published *Gay Bar*, a memoir about her own experience of opening a bar that catered to the homosexual community. Setting up on Melrose Avenue in Los Angeles in mid-decade, she carefully policed her clientele, looking out for off-duty cops, hustlers, dope dealers and flamers, such was the prejudice of the day. With a discreet entrance down a side alley, the bar catered to professionals, executives, motion-picture and TV people, composers and writers, bus drivers, mechanics and truck drivers. As she wrote: 'I try to sell safety.'

While heterosexual, Branson's observations on this underworld were sharp and sympathetic. She talked to her customers and entered their dilemmas: 'John Bailey's problem is one that many, many gay fellows have. He lives a lie. It keeps him constantly on guard. He has to . . . watch his speech and be ready with a quick explanation if he does let something slip.'

By 1955, there was a small, underground but growing market for gay products, which sold to gay men in particular. *ONE* carried a small number of adverts for, inter alia, a Long Beach gay bar called the Rendezvous, Mr Raoul shampoo for men ('Ladies use it too'), trinkets like gay bells and outré camp fashions from WIN-MOR: dubbed 'the styles of tomorrow for the man of today', these included thongs, bolero jackets and 'harlequin sail cloth fancies' in voodoo red, black, yellow or beige corduroy.

There were also records aimed at the gay market, principally albums by risqué females like Ruth Wallis and drag queens such as Rae Bourbon, reflecting the importance of female impersonation bars such as Finocchio's and the Jewel Box Revue as underground meeting places. Both artists were prolific in the early to mid-1950s. Wallis issued insider-code songs like 'Queer Things', while Bourbon kept up a dizzying sequence of albums – one of which was recorded at the Jewel Box Revue – containing cuts like 'Queen of the Y.M.C.A.', 'Back in Drag Again', 'Peter Pan' and 'Queen of the Navy'.

Female impersonation and various forms of drag were the prime agents of gender variance during this period, not just in the gay underground, but also in popular culture, with figures like Gorgeous George, the TV wrestler who wore his hair long in platinum curls and entered the ring in extravagant robes trimmed with sequins, lace and fur, realising that the way to fame was by enraging the audience. Although married and, to all intents and purposes, heterosexual, George hammed up the effeminate act to great effect, having an indelible influence on performers as diverse as Bob Dylan and James Brown.

Nineteen fifty-five also saw the flourishing of the physique magazine market, led by the originator, photographer Bob Mizer. His quarterly publication, *Physique Pictorial*, specialised in photos of young muscle men and athletes clad in alluringly small posing pouches. Mizer's innovation was to pepper these examples of soft pornography with details

about his models – this one a wrestler, that one a law student, and even, in the autumn 1954 issue, a Hollywood star: a promo picture of a bare-chested and sultry Tony Curtis in the Universal swashbuckler *The Black Shield of Falworth*.

If you looked further into the comments beneath the pictures, Mizer's magazines also contained hard-nosed political comment. In the autumn 1955 issue, for instance, he wrote an editorial titled 'Obscenity and Politics': 'It's unfortunate that obscenity accusations and prosecutions are often used as a tool by grafting officials and petty politicians, who are not a whit concerned with the moral issues involved but will play on the taboos and prejudices of the populace for personal gain or perhaps to cover-up for their own scandalous behaviour.'

In contrast, the consciousness-raising magazines shunned erotica. *Mattachine Review* was sober, while *ONE* was more radical and assertive, with excellent covers and design by Eve Elloree (real name Joan Corbin). It offered news about the legal and social status of the homosexual man and the lesbian – the latter in a regular feature called 'The Feminine Viewpoint' – while running stories, poems and articles that illuminated the gay condition. There were book reviews, adverts for gay-oriented products and a regular news column, 'Tangents', that collected gay-related stories from America and Europe.

The magazine's biggest coup was in hustling Norman Mailer – by then a famous author – to contribute in early 1955. Mailer's article, 'The Homosexual Villain', was in part a mea culpa for his own unsympathetic treatment of gay men in his novels, and a stunned realisation – after reading Cory's *The Homosexual in America* – that 'homosexuals are people, too'. As he admitted: 'For the first time I understood homosexual persecution to be a political act and a reactionary act, and I was properly ashamed of myself.'

The regular letters page gave a window onto the readers' fears and hopes. All were printed with a false name (e.g. Mr B, Mr D, Miss A, Miss L, etc.), and they oscillate between criticising the then more public world of gay bars – the falsity, the swishes; this was a common complaint in the mid-1950s, as many gay men tried to assume a conventional masculinity – and thanking the magazine for giving them a voice. As Mr E from

San Diego wrote in late 1955: 'Thank those who are responsible for being brave enough to hold the light that others may not be left in the dark.'

In a huge country like America, resistance was, by necessity, localised. Nevertheless, it occurred. On 1 October 1955, a popular Baltimore gay bar called the Pepper Club was raided by the police, who found the place so crowded they could hardly get in. Inside, they found a completely dark back room, where they discovered several people having sex. It was a major operation, involving five police cars and six wagons. Everyone was arrested, including the bar staff, the owners and the patrons, both gay men and lesbians – 162 arrests in all.

During the mass arrest, however, there were disturbances inside and also outside the club, where a large crowd – described as a 'mob' by one local paper – had gathered in the streets. In court the next day, the defendants were, despite the seriousness of the situation, unruly and defiant. As the head of the vice squad observed, 'The majority of these people seem to regard the whole incident as a great big joke.' All of the charges were dropped, except for those relating to three men and two women. Four were convicted of disorderly conduct and one woman was charged with resisting arrest.

Shortly afterwards, the police were heavily criticised for the raid's 'nasty implications' by a local legislator, who held that they had no right to set themselves up as 'censors of community morals'. When the owners were put on trial for 'keeping a disorderly house', they were acquitted. The *Baltimore Sun* reported Judge James K. Cullen's declaration that the police should be condemned for making such a mass arrest and that the questionable legality of such an action counted against their testimony in trying to make the charge of running a disorderly house stick.

Just as the wave of persecution reached its peak in the mid-1950s, the tide began to turn towards thoughts of liberation. The prize was huge – changing the law to decriminalise homosexuality, changing society to remove stigma and shame – and it would take a decade or more to come to pass. But the seeds that came into fruition in the later 1960s were sown during this seemingly barren and hostile period, in terms of both homosexual and lesbian activism, and also an underground economy that sold specialised goods to a ready market.

This exclusively gay world was expanding in the mid-1950s and continued to have some similarities to the teenage market, which was growing at the same time, with spending on novelties and trinkets that nevertheless reinforced the buyer's membership of a defined group that felt itself to be marginalised. Here, in the early days of democratic consumerism and mass culture, particular objects became totems: if not just luxuries or baubles, then emblems of possible freedoms to come.

There was also the question of consciousness. In 1951, Donald Cory had observed that 'the interests of the invert are short lived. His cultural loves are to be as fickle as his physical ones. His entire life seems motivated by restlessness and characterised by rootlessness.' This was a charge commonly levelled at America's teenagers, and to some extent the gay underworld began to assume some of the new youth culture codes. Helen Pyle Branson observed that many of her predominantly gay male clientele adopted 'a common language like teenagers' "bop" and "jive" talk'.

Cut off from the values of mainstream society by hostility and prejudice, many gay men in 1955 simply lived for the instant, allaying guilt and shame with immediate pleasure, whether it be the consumption of products or other male bodies. They coexisted with the moment when, in America, the teenager fully arrived with shocking force as a separate social cohort. Although defined in 1944, the fifteen-to-twenty-four age group had slipped from prominence as the demands of returning veterans and post-war reconstruction took precedence; however, by the mid-1950s, it had become a national preoccupation.

America's attitude to its youth was typically schizophrenic: teenagers were to be at once indulged – with pop music and other youth-specific products – and condemned for their much-publicised propensity for violence. Living in a society that was not adapting fast enough to their needs and desires, many teenagers felt confused and alienated. Sexuality was an important part of this, not just the overt sexuality of rock 'n' roll as it emerged – with its hints of a taboo miscegenation – but the fact that several major pop and film stars were homosexual or sexually nonconformist.

Partly that was due to the nature of the music and entertainment industry, which had always provided a safer haven for people who were

sexually and socially marginal, offering the possibility of visibility and validation that was unavailable in other arenas. It was also due in part to sensibility. Quite apart from the influence – and actuality – of homosexual film and pop stars, teenagers shared a similar kind of liminal social and psychological space as gay men. Like these outcasts and outsiders, they lived for the moment, in direct defiance of the religious tenet of deferred gratification.

In 1952, Max Lerner had witnessed a vision of the future, while observing his thirteen-year-old daughter's 'teen-age world'. As he was informed by his wife: 'You get to understand that the glittering new arts of our civilisation are directed to the teenagers, and by their suffrage they stand or fall.' He was exposed to their choice of records on repeat – Kay Starr, Guy Mitchell and Doris Day – and recorded their chat: 'And have you oh, have you heard Johnnie Ray do "Cry" and "Brokenhearted" and "The Little White Cloud That Cried"?'

Innocent enough, but the rise of an autonomous peer culture made adults uneasy. Growing levels of disposable income had afforded American youngsters unprecedented independence from the constraints of family life, while loosening the restraints of wartime had made a return to pre-war deference more difficult. There was a distinct sense that the full onset of consumerism was dissolving the old puritan disciplines, resulting in a mindset – conflated at the time with that of the psychopath – that wanted everything immediately.

The impact of gay artists like Johnnie Ray contributed to this adult unease. Not that Ray's homosexuality was public, but his whole affect was novel, unsettling, subtly subversive. The huge impact of the atom bomb – and the continuing, endlessly amplified hydrogen bomb tests – had completely dissolved the pre-war world. Teens were attempting to make sense of a decisive perceptual break that put all previous social tenets and attitudes into question. The freer expression of emotion and sexuality was an integral part of this soft revolution.

5
Against the Law

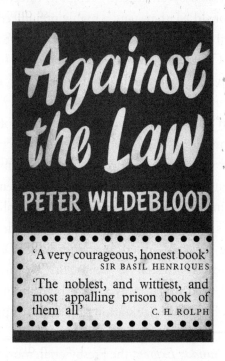

The enemy was everywhere. One never knew. The war between the underground and society never paused for an armistice: it just went on.

Adam de Hegedus, writing as Rodney Garland,
The Heart in Exile, 1953

I n the early 1950s, the situation for male homosexuals in the UK ran parallel to that in the US. Cold War paranoias – triggered by the defection to Russia of diplomats Guy Burgess and Donald Maclean in May 1951 – were amplified by an ardently religious director of public prosecutions, Sir Theobald Mathew, and a highly prejudiced home secretary, Sir David Maxwell Fyfe, who held that homosexuals were dangerous corrupters of youth. Gay men were about to face the full force of the state.

This hostile environment was boosted, as ever, by a puritanical and vicious popular press. In May 1952, the *Sunday Pictorial* ran a series entitled 'Evil Men', the first major exposé in the UK of what was called 'the homosexual problem' – 'an unnatural sex vice which is getting a dangerous grip on the country'. During 1953, prosecutions for gay offences rose by 50 per cent, and to compound the punishment, they were frequently reported in the papers, a symbiosis between police and press that ruined reputations and, on occasion, resulted in suicide.

The moralising reflected American extremes. In October 1953, the actor John Gielgud was arrested for 'persistently importuning' in a public toilet. Gielgud tried to get away with it by claiming that he was an anonymous clerk, but the police station tipped off the press. Every single newspaper ran the story. Gielgud got away with a fine, but the backlash was severe. In the *Sunday Express*, the Presbyterian moralist John Gordon wrote about homosexuality in terms of a 'moral plague', demanding action: 'there must be sharp and severe punishment'.

That same month, the writer Rupert Croft-Cooke went on trial for 'acts of indecency'. With his companion, Joseph Alexander, Croft-Cooke lived in a small Sussex village, Ticehurst, where his open homosexuality aroused comment and hostility. In July of that year, the couple had picked up two young navy cooks in the notorious London pub the Fitzroy Tavern and taken them to Sussex for company and sex. On their way back home, the two men got drunk and found themselves in a brawl. To avoid prosecution, they turned Queen's evidence and agreed to testify against Croft-Cooke.

Although the two men later retracted their statements, Croft-Cooke was prosecuted. In his book, *The Verdict of You All*, he observed the tightening grip of a freshly imposed conformity. He was informed by

a magistrate friend that 'the age of individualism was dead and you will simply not be allowed to live as you wish'. This was a new, harsh climate, and Croft-Cooke was sharp enough to see the parallels with what was going on in the US: 'This beastly form of McCarthyism will make life impossible for anyone who does not actively support it.'

The author spent six months in Wormwood Scrubs. On his release in April 1954, he was chased across London by a crowd of reporters. Within three days, he had to endure one more example of the 'bedlam of noxious prejudices which the Home Secretary encouraged'. He was visited at home by a man, who did not give his name, who warned him against going public with his experiences with a threat: 'a second conviction is much easily obtained than a first, especially when the first has been well-publicised'. Croft-Cooke threw him out.

As far as homosexuality was concerned, there were eight separate offences on the statute book in the 1950s, most from the nineteenth century, including sodomy, indecent assault, gross indecency, procuring acts of gross indecency and importuning for immoral purposes. When arrested, gay men were often charged with several offences at the same time, a cluster of charges that meant very few pleaded not guilty. The legal establishment showed, as the historian Patrick Higgins has observed, an 'extraordinary degree of hostility' towards homosexuals in this period.

The contemporary police attitude was expressed by the Scotland Yard detective Robert Fabian, who called 'homosexuality an offence against decency'. Nevertheless, familiarity made Fabian more nuanced than most: 'Most people think of the "pansy" as a lisping, mincing creature who uses perfume and nail varnish. This is not correct. Of all the men I have seen convicted for offences of homosexuality, I would defy anybody to pick nine out of ten of them from any ordinary assembly of men. Quite a number of them are married.'

The Croft-Cooke case was eclipsed in the press by the big show trial of the period: the case involving Edward Montagu, Michael Pitt-Rivers and Peter Wildeblood, which began in March 1954. The authorities were targeting Montagu, a hereditary peer who was openly bisexual; a December 1953 trial for a previous alleged offence had ended inconclusively. Shortly afterwards, the authorities brought in two young airmen,

Edward McNally and John Reynolds, who, under duress, were prepared to testify against the three men on a variety of sexual offences.

Class and age both played a part in the case. The three defendants were all older than the two airmen and from the upper and upper-middle class, as opposed to the working-class servicemen. McNally had had a relationship with Wildeblood, then the diplomatic correspondent of the *Daily Mail*, so the law had been broken on that score at least. All three were arrested in early January 1954, in a well-coordinated operation. At the same time, the police had conducted searches of their properties without a warrant. They were also refused legal representation.

In March 1954, the trio faced a total of nineteen charges at Winchester Crown Court, including sodomy, attempted sodomy and gross indecency. Montagu and Pitt-Rivers were charged with counselling and procuring homosexual acts, while Wildeblood was charged with aiding and abetting the commission of such acts. There was also a charge of conspiracy – that the three had worked in concert to procure sexual partners – the first time it had been used since the Oscar Wilde trial of 1895, which had blighted homosexual life for decades.

Like that notorious event, this trial was meant to extirpate male homosexuality from the public sphere. But, as Patrick Higgins argues persuasively in his survey of this period, *Heterosexual Dictatorship*, the impulse came as much from the press as it did from politicians concerned about the Cold War. The three men were constantly in the news from their arrest until the trial, and the papers were not above making them look more effeminate: the *Daily Mirror* touched up a picture of Wildeblood to make it look like he was wearing lipstick.

The comprehensive list of charges bore results, as the three were imprisoned for terms that ran between twelve and eighteen months. When the participants in the case left the courtroom, however, the bulk of public opprobrium fell on the prosecution witnesses. Press comment was split between those who questioned the verdict and the methods of the police, and those who began to realise that, as the prominent journalist Hannen Swaffer wrote in the *People*, 'imprisonment is no cure for abnormality'.

———

s convictions for homosexual offences reached a peak, the wheels
began to turn for a change in the law. Shortly after the Montagu
trial, talks began to set up a commission or, later, a Home
Office committee to discuss a change in the law relating to homosex-
ual offences. Chaired by Jack Wolfenden, the Departmental Committee
on Homosexual Offences and Prostitution first met in September 1954.
Comprising the chairman and fourteen other professionals – with no gay
men or lesbians – the Wolfenden Committee would meet sixty times in
three years.

As the institution of the committee had been partly stimulated by
the furore around his case, Wildeblood was determined to get involved.
Right from the beginning of his legal travails, he had resolved to come
clean in order to counter the shame of the Wilde case. 'I was determined
to admit that I was a homosexual. This was not bravado: it was deliberate
planning for the future. I would be the first homosexual to tell what it
felt like to be an exile in one's own country. I might destroy myself, but
perhaps I could help others.'

During his time in prison, Wildeblood had recorded his impressions.
He regarded his trial as being part of a high-level witch-hunt, and pre-
pared his forthcoming book as an act of revenge. After being released in
March 1955, he made sure that he was invited to testify to the Wolfenden
Committee – one of only three gay men to do so – even though the
chairman himself had no time for him as a convict. Taking care to dis-
tinguish himself from pederasts and 'pathetically flamboyant' pansies, he
presented himself as a 'good' homosexual – if that were possible.

Nevertheless, Wildeblood's June 1955 testimony included some sharp
and personal points. He firmly stated that homosexuality was neither a
crime nor a disease; that police tactics against suspected homosexuals
were scandalous; that the laws against homosexual sex in private were far
from being a dead letter, as he could confirm from bitter personal experi-
ence; that homosexuality was largely tolerated in prison; and that any
attempts at curing homosexuals were 'farcical'.

Wildeblood's testimony was both brave and effective. It was also a
welcome counterpoint to the other witnesses – policemen, lawyers, polit-
icians – who generally perceived homosexuality as being a distinct threat

to society. The British Medical Association regarded the homosexual man as 'an enemy of the state, attached to an alien ideology'.

Autumn 1955 was a particularly busy time for the Wolfenden Committee. On 29 October, a small delegation met Dr Alfred Kinsey during his visit to London. The American countered the generally held conflation of homosexuality with pederasty, while pointing out the difference between morality and reality. He was certain that 'your incidence of a thing like homosexual activity in this country cannot be too radically different from what it is in the United States and again it would be a minute fraction of one per cent of such conduct ever apprehended'.

On 31 October, the committee heard evidence from the British Medical Association. Anxious to promote the idea of homosexuality as an illness, all three doctors interviewed suggested various methods of treatment, including massive doses of oestrogen to 'cure' the homosexual person. In the day's record, Wolfenden sounded quite confused by the topics of sex and gender: 'We are bedevilled throughout all these discussions by these confounded words and having to pin a label to various types of things when it is terribly hard to see where the boundaries come.'

In Britain, homosexual rights were pursued in an establishment manner: through book publishing and small departmental committees. The idea was to influence the power structure directly, which would be easier in a smaller country rather than in the US. In the meantime, there were bars, clubs, a few shops and a series of networks, but almost no grass-roots activism: no publications like *ONE*; no pressure groups like the Mattachine Society or the Daughters of Bilitis. This difference and public diffidence would mark British gay life until the later 1960s.

———

Beyond all the scare stories, there was another way in which gay life impacted on society at large in post-war Britain, and that was in fashion, the product of a metropolitan milieu. Like the new teenage society, which was just beginning to come on-stream in the UK during the mid-1950s, the gay world offered a chance both to step outside allotted class roles – indeed, to move across the class divide in a

way that was still unusual in British society – and to indulge in the new American ideal, where eternal youth and luxurious consumerism were intertwined.

In his 1953 state-of-the-nation gay novel, *The Heart in Exile*, Rodney Garland described the nuances of the period's homosexual clothing. He observed what he called the 'Spiv' style, which included 'a sky blue jacket with twelve-inch shoulders' and a 'pure regency haircut'. A young gay man wearing that style – which included 'a dark jacket, obviously "semi-drape", a spearpoint collar and a dark tie in a Windsor knot' – could at first glance have 'been any variation of Atlantic Youth – American, French, English, the prototype being Guy Madison or Burt Lancaster'.

As well as this forward-looking transatlantic influence – floated in the UK in 1948 by Cecil Gee's collection, the 'American Look' – there was a home-grown style that crossed the tightly patrolled barricades of class and sexuality. Originating as an attempt by the established world of British tailoring to counter the American menace, it rebounded in an entirely unexpected way, passing through Savile Row to the gay world, before it became associated with the first teenage-era generation of British working-class delinquents.

In September 1948, *Tailor & Cutter* also promoted what it called the 'Edwardian Look', a style that harked back to the 1900s (King Edward VII) and the mid-1930s (the brief reign of dandy King Edward VIII), and whose value lay in the fact that it was defiantly British. In this first phase, jackets were cut long and trousers were narrow and 'often with no turn-ups'. Within this elongated silhouette, the obvious symbols of dandyism were the ornate brocade waistcoat and the velvet collar.

This style was aimed at the upper and the upper-middle classes and was taken up by young men about town, Oxbridge undergraduates and openly gay dandies like the couturier Neil 'Bunny' Roger. One major feature of the Edwardian style was the tight-fitting nature of the coat's chest and waist. This wasp-waisted silhouette translated well into the gay world of the time, and, according to Nik Cohn in his survey of post-war fashion, *Today There Are No More Gentlemen*, it 'became associated with queerness'.

That was the kiss of death for Edwardian as a fashionable style, but during 1952, something unexpected happened. The precise origins of

the early-Edwardian youth cult are lost in the mists of time, but what seems to have occurred is that some bright sparks from inner South London – from the Elephant and Castle – saw the style in the West End and decided to convert it for their own ends. Class warfare was a part of this, but the assumption of such a flamboyant, and potentially queer, style was in itself an act of rebellion.

What the working-class 'new' Edwardians did was to marry the detail of the Savile Row style – the narrower jackets and trousers, the velvet collar and the fancy waistcoat – with the broader shape of the American drape and a long, slicked-back haircut. There were also elements from the existing delinquent style associated with the Cosh Boys, violent gang members named after their weapon of choice; these items included bright ankle socks and shoes with thick crepe rubber soles (later known as 'brothel creepers'). Their female counterparts wore their hair in a DA – slicked back like a duck's arse – and added a pencil skirt and a black bebop sweater.

It was in summer 1953 that the Edwardians got their first coverage in the mass media, with the Clapham Common Murder Case. When a local youth, John Beckley, was murdered by a gang that July, the principal protagonist, Michael Davies, was pictured in the press reports as wearing a three-piece Edwardian suit. In their report on the trial, the *Daily Mirror*'s headline, 'Flick Knives, Dance Music and Edwardian Suits', linked lethal criminality to 'flashy' clothes. After this connection of their costume to violent crime, the adherents of the style became public enemy number one.

In the UK, crimes of violence committed during 1954 by boys under twenty-one had risen by 300 per cent since 1938. At the heart of this shocking statistic were the Teddy Boys, as they were soon dubbed. As a November 1954 report from Brighton warned: 'Strong action is expected by both police and dance hall managements to prevent any repetition of the gang fight started at the week-end by "Teddy Boys" from London in which three innocent bystanders received nasty injuries.'

At the same time, Teddy Boys were deliberately visible symbols of difference and an inchoate breaking-down of class barriers. This was still the age of military conscription – a two-year period of national service was

compulsory for eighteen-year-olds – and in the eyes of the authorities their defiant dandyism was transgressive. As the chief of Blackpool CID said in 1954: 'They seem unconscious of how ridiculous they look in their drainpipe trousers, light socks, long jackets with flattering padded shoulders and effeminate mops of hair.'

This was the barely spoken secret at the heart of the moral panic around the Edwardians. Their concentration on clothes and their long hair was seen as unmanly and, possibly worse, an echo of the style's origins in the still subterranean gay subculture. This was the first post-war link between fashionable gay men and antinomian working-class youth subcultures – a troubled, if fertile, crossover that would gain increasing influence in the pop 1960s to come. In the meantime, there was mythology to make.

6
James Dean

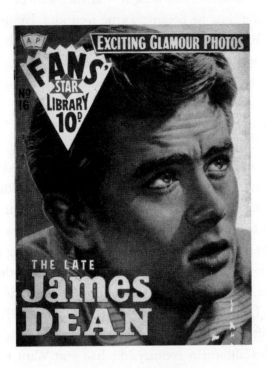

James Dean, who deserves posthumous Oscar for powerfully sensitive Caleb role in film of Steinbeck's mighty *East of Eden* and who according to rumours had done well in *REBEL WITHOUT A CAUSE* and *GIANT*, reputedly wanted Bdwy. return before his sudden death. He'd gotten Bdwy. start in Gide's *IMMORTALIST* [*sic*] and was considering lead in Van Druten's new *DANCING IN THE CHECKERED SHADE* . . .

Dal McIntire, 'Tangents', *ONE*, November 1955

n 1955, the Teen Age found its prime masculine icon, a symbol of all its confusions and pleasures, its heedlessness and magnificence. James Dean wasn't a pop singer but an experienced actor who was – to his simultaneous discomfort and delight – at the heart of the Hollywood machine. By the time he became a true teen idol, late in the year, his life was over, but he almost immediately became a myth. Above all, he embodied the strange restlessness of the emerging adolescent generation, and his highly ambivalent sexuality helped to define the parameters and possibilities of youth culture.

On 2 November 1955, *Rebel Without a Cause* entered *Variety*'s weekly US box-office Top 10 at #3, after just one week of release. The estimated gross for those seven days was $52,000, and the picture was being held over for another week in cinemas in cities like New York, Baltimore, Boston, Buffalo, Cleveland, Pittsburgh and Washington DC. The popularity of youth movies had been established by the earlier success of *Blackboard Jungle* and *East of Eden*, but even so, this was an immediate phenomenon.

There had been intensive pre-publicity, but much of the initial surge came from the fact that *Rebel Without a Cause* was the first new picture to star James Dean since his death on 30 September. His sudden and violent end, after crashing his Porsche 550 Spyder at high speed in the remote North Californian countryside, had sent Warner Brothers into a flat spin. They had a film ready to go, with a dead star at its heart. There was little precedent for this situation, but the company executives decided to press ahead, despite concerns about fan hysteria.

'Nobody will come and see a corpse,' was Jack Warner's brutal verdict, but he was confounded. The campaign went ahead, with minor alterations, and the film premiered in New York on 26 October. The reviews followed over the next couple of weeks. Any potential disapproval on the part of the critics about this juvenile-delinquency vehicle was completely blindsided by Dean's tragic death.

Dean and the film that he starred in were immediately seen as emblematic. In his *Los Angeles Mirror-News* column, Bob Thomas thought that Dean 'was as much in the public consciousness as when he had lived'. This was the rub. Dean's death had not damaged the impact of *Rebel Without a Cause* one whit. Indeed, it cemented him as a teenage archetype

at the exact moment, in November 1955, when post-war youth culture emerged to have a major impact on Western society – and, indeed, his life and death helped to crystallise that emergence.

————

L asting seven months during spring and summer 1955, the production of *Rebel Without a Cause* encompassed a turbulent time in American social history. Just as the plot's timescale compressed a mere twenty-four hours into a full-blown melodrama that seemed to last for days, so the film captured the rapid and turbulent growth pains of a new, powerful yet unreadable cohort. As morbid, unpredictable, sexually ambiguous and unformed as he appeared on screen, Dean was fixed as the Ur-teen both in both life and death.

In March 1955, when production started, Dean was on the cusp of stardom. A year previously, he had signed a major, nine-picture deal with Warner Brothers, and the first result of that contract was on the point of fruition. On the 9th, a preview showing of *East of Eden* was held in New York, and a week later in Los Angeles, with the general release to follow in April. The pre-publicity machine was already in action, and there was no doubt who was the centre of attention, with the studio handing out buttons that said: 'James Dean Must Be Seen'.

On 15 March, the *New York Times* published a long interview with Dean by Howard Thompson, in which the naturally suspicious actor was comparatively open and unguarded. To the young journalist, he already seemed to embody an American archetype: 'The slender frame and boy-ish features suggested a Booth Tarkington hero.' More candid than usual, Dean admitted that he had found his first year in Hollywood very difficult: 'The problem for this cat – myself – is not to get lost.'

Earlier that month, *Life* magazine had published a major feature on the young actor, with stark, high-contrast, black-and-white photographs by Dennis Stock that emphasised the tagline 'Moody New Star'. Stock had spent three weeks with Dean on location in New York and his highly conservative home town of Fairmount, Indiana. It was an emotional, evocative shoot. Stock later reflected that Dean's 'meteoric' rise to fame

had 'cut him off forever from his small-town Midwestern origins, [so] that he could never really go home again'.

Dean's experience of Fairmount was bittersweet. Like Little Richard and Johnnie Ray, he was the product of a troubled family background. His mother died when he was nine, a shattering event that he was never quite able to process: as an actress friend, Christine White, later said, 'He had a leak in his heart.' Sent off to live with his aunt and uncle on their farm, his facility at sports enabled him to fit in, but as his music teacher at Fairmount High, Don Martin, remembered, he was 'an introvert. He had a terrible complex.'

It was at Fairmount that Dean encountered the first of the nonconformist influences in his life. Falling into the orbit of a gay clergyman, James DeWeerd, he was educated in books, music and yoga, and instilled with a penchant for expensive fast cars. Thanks to the older man's influence, Dean got a glimpse of the outside world and decided he wanted out of Fairmount. After graduation, he headed out to California to live with his father and stepmother and further his theatrical ambitions. It did not go well.

Winton Dean thought that acting was not a manly profession and 'the movies were full of pantywaists', and he freely transmitted his views to his son. After leaving home, Dean lived the life of an ambitious but struggling student actor. Although he occasionally got bit parts in radio and television shows, as well as a Pepsi commercial, he was, more often than not, unemployed. A snapshot of this time sees him expelled from his fraternity at UCLA, Sigma Nu, after getting into fist fights and refusing to participate in group activities.

After quitting UCLA in 1951, Dean was working as a parking valet in Hollywood when he met his second gay mentor, the wealthy, older advertising executive and director Rogers Brackett. As a mentor and possible lover, Brackett resolved Dean's ongoing difficulties with the draft board, paying for a psychiatrist to say that the young man was homosexual (although he may well have been rejected because of his poor eyesight), as well as supporting the impoverished actor and boosting his career.

In early 1952, Dean moved to New York and, with contacts provided by Brackett, quickly found himself a place to stay and, through a casting

agent, got work in radio and television, including five jobs with CBS in March. Manhattan was a revelation to Dean, who loved its pace and opportunities. Ambitious and restless, he was already moving very fast, picking up unusual people and future contacts.

He was developing his acting style, as his friend and fellow actor Robert Stevens remembered: 'The way he worked was that all the personal feelings that he had in himself would just come up through the parts he was playing – it was like a massive psychological ejaculation. Made me think of what I'd read about the way Soutine painted: the individual tearing himself apart – kind of a volcano of emotions – but restrained, too, and fitting right into whatever he was doing.'

After a brief flirtation with the Actors Studio – whose director, Lee Strasberg, thought him doomed and destructive – Dean was given his first lead role in a TV drama called *A Long Time Till Dawn*, written by the future *Twilight Zone* creator, Rod Serling. That same month, Dean played the part of Bachir in *The Immoralist*, a theatrical adaptation by Ruth and Augustus Goetz of André Gide's 1902 novel, which sought to unravel the hysteria that surrounded the topic of homosexuality. Although not a principal character, the insinuating servant Bachir was played by Dean as a more contemporary hustler – an interpretation that evinced mixed opinions. Although he got good notices, Dean crossed swords with the replacement director and left the cast after two weeks – a sign of things to come.

However, it was his brief stretch in *The Immoralist* that got him the attention of Hollywood. Through a friend of the playwrights, Dean was introduced to the director Elia Kazan, who was hot after his film version of *A Streetcar Named Desire*, featuring Marlon Brando, had won four Oscars in 1951. By early 1954, he was deep into the production of *On the Waterfront*, starring Brando and Karl Malden, but he was already beginning to make preparations for the film of John Steinbeck's biblical story of rivalry and redemption, *East of Eden*.

Kazan remembered that on their first meeting in February 1954, Dean endeared himself to the director by not indulging in flattery or obsequiousness. Indeed, Dean was perfect for the role of Caleb Trask, one of the twin sons of the wealthy Adam Trask. In an echo of the actor's family

history, Cal's mother has disappeared, and in her place Adam favours the more conventional Aaron. The two brothers are involved in a deadly sibling rivalry for their father's attention, and it is Cal who loses.

As in fiction, so in reality, as the relationship between Dean and Richard Davalos, who played Aaron, was vexed. At the film's end, Cal, in seeking his father's final approval, is rejected once again and explodes into violence. Kazan frankly exploited his star's damaged psychology in this climactic explosion. 'I thought he was an extreme grotesque of a boy, a twisted boy,' he said. 'As I got to know his father, as I got to know about his family, I learned that he had been, in fact, twisted by the denial of love.'

By nature awkward and contrary, Dean found Hollywood a struggle. He was at once a farm boy – his origins accentuated in his early press releases – and an upcoming name, fit to associate with the other human deities of this modern Olympus. On the one hand he was privileged; on the other he was a self-defined outcast. Part of his unease was caused by his sexual fluidity, if not ambivalence. From the word go, he attracted the interest of older homosexuals, being mentioned as the protégé of known gay actor Clifton Webb and getting introduced by co-star Julie Harris to the author Christopher Isherwood and the painter Don Bachardy. At the same time, he was pursuing an intense affair with the young Italian actress Pier Angeli, which resulted in a bitter public stand-off when her parents disapproved.

In Hollywood's eyes, Dean was the new Marlon Brando, and as the new teenage rebel *du jour* some attitude was expected, but the pressures of Hollywood only amplified Dean's ambivalence between ambition and autonomy. To become a star was also to become a demigod, and that involved the warping of a personality that was erected on shaky ground. In a letter to his friend Barbara Glenn that summer, he expressed his extreme distrust of Kazan and other Hollywood insiders, referring to how they could take advantage of people. He signed it 'H-bomb Dean'.

As soon as filming was over, Dean returned to New York, where he did some television work and met up with his old friends, including Barbara Glenn and Frank Corsaro, who had directed Dean in an off-Broadway production of *The Scarecrow* in 1953. Corsaro observed his friend's difficulties with Hollywood, and thought that they stemmed from his own

ambiguities, which were being highlighted under intense pressure at the same time as they were coming under even more intense scrutiny.

'Jimmy's is a highly sexualised image,' Corsaro said. 'He's a younger version of what someone said of Brando, the brute "with girl's eyes". Jimmy, Brando and Clift knew how to play the field; how to project a unique mixture of "delicate macho" – "save me, but don't come too close." Jimmy lived a complex, shady existence. Emotionally, he was a male hustler. Jimmy couldn't help the androgyny, he was glorified for it while being told at the same time to stamp it out. His cruelty arose out of that conflict.'

Dean's life was quickening. On 6 December 1954, the first of two unannounced public previews of *East of Eden* was held in Huntington Park, Los Angeles. Kazan remembered that women started screaming as soon as Dean appeared on screen. The second was held in Encino, where the audience exploded with excitement.

The critics and columnists quickly fell into line. Hedda Hopper referred to Dean as 'the brightest new star in town', while Mike Connolly also called him 'Hollywood's brightest new star', deeming him to be 'at the very top with the all-time greats'. This sudden, massive acceleration informed the initial stages of development on *Rebel Without a Cause*. By this stage, the screenwriter Stewart Stern had been pulled into the project, and he was spending a lot of his time with his cousin Arthur Loew, Dean and Nicholas Ray. His observations on the young actor as he ascended to stardom were acute: 'He was constantly fucking himself over by behaviour designed to alienate people. This kid had no experience! At the core of this, I sensed a terrible, yawning feeling of inadequacy and emptiness and yearning, and I told him that.'

Stern had been hired as the third screenwriter on *Rebel*. Fascinated by the topic of juvenile delinquency, Ray had been mulling the project throughout 1954, even writing an early treatment called 'The Blind Run', based on a list of horrific teenage crimes delineated in *Newsweek* that September. He had already gone through two writers, both of whom had been suggested by the studio: Leon Uris and *Amboy Dukes* author Irving Shulman, who would turn his version of the script into the 1956 novel *Children of the Dark*.

The film was very personal to the director. By late 1954, Ray was forty-three, with several years of successful films behind him, ranging from film noir (*They Live by Night*, 1948) and war films (*Flying Leathernecks*, 1951) to westerns (*Johnny Guitar*, 1954). He was at once a man's man and strangely insecure: bisexual, prone to depression, with poor impulse control and over-involvement in his professional projects. *Rebel Without a Cause** was an opportunity to revisit and prolong his

* The title *Rebel Without a Cause* came from a 1944 book by the radical psychologist Robert M. Lindner. This faithfully reproduced the results of a forty-five-hour-long hypnoanalysis course practised on 'Harold', an adolescent imprisoned for a serious crime of violence. This was a very early appearance of the term 'psychopath', which was defined by Lindner as 'a rebel without a cause, an agitator without a slogan, a revolutionary without a program'. This made a big splash on publication and was optioned by Warner Brothers, who kept the title on file.

In November 1955, Lindner was preparing for the publication of his fifth and final book, *Must You Conform?*, collecting a series of lectures he had held in California the year before. These included 'Homosexuality and the Contemporary Scene', 'The Mutiny of the Young', 'Must You Conform?' and 'The Instinct of Rebellion', which, presented as the Hacker Foundation Lecture during that month, had aroused a storm of controversy.

Lindner's basic thesis was that half a century in, life in the new Mass Age engendered a grinding, soul-destroying conformity: 'The Mass Man, of course, is the psychopath *in excelsis*. A mechanised, robotised caricature of humanity, it is he who finally tears down around his own head the house of his culture. A slave in mind and body, whose life signifies no more than an instrument of his master's power, a lost creature without separate identity in the herding collectivity . . . it is he who finally inherits the earth and runs it to ruin.'

His purpose was to examine how the rigid imposition of social norms affected the behaviour of various marginal groups, including homosexuals and teenagers. Seeking to emphasise the cause rather than the symptom, he observed 'how social illusions are created and employed for the preservation of conservatism and even reaction under the guise of progress, and how protean are the devices available to human intelligence when it lends itself to the persistence of the conformist error'.

Lindner thought that attitudes to homosexuality had not substantively altered since the middle of the nineteenth century and considered American puritanism to blame. He questioned why homosexuality had to be legislated against at all. He also regarded the repressive nature of the 'reigning sex morality' as being responsible for a rebellious and nonconformist streak in homosexual lives, which was beginning to crystallise into the creation of a self-identity and the struggle for rights.

Adolescence was the main focus of his polemic, however. Responding to the contemporary moral panic about teenage behaviour, his lectures were informed by his

own youth, as well as explore his radical thoughts about delinquency.

In James Dean, he saw a mirror image of his own deep sexual and social ambiguities. In explaining Dean, as he later did, he was partly explaining himself. To work with the actor meant 'exploring his nature, trying to understand it; without this, his powers of expression were frozen. He retreated, he sulked. He always wanted to make a film in which he could personally believe, but it was never easy for him. Between belief and action lay the obstacle of his own deep, obscure uncertainty.'

On 9 March 1955, *East of Eden* premiered in New York. Dean did not attend. The reviews went both ways, but the reaction of teens was immediate and visceral, and within a week of release, the film had shot to #2 in the weekly US box-office Top 10. A couple of weeks later, shooting began on *Rebel Without a Cause*. In a switch reminiscent of leaving Kansas for Oz, the film stock was changed after three days from black and white to the new 'Warnercolor' process, a decision that gave the movie much of its allure. The widescreen colour was almost over-saturated. As well as colour-coding the characters (most notably in the warning hues of Dean's red jacket), it gave the film a heightened quality that persists. It is both artificial and hyperreal – a fevered dream.

The shoot lasted for two months; there was intense time pressure because Dean was scheduled to appear on the set of his next film, *Giant*, at the end of May. During that period, there were tectonic shifts in the world outside. As the cast prepared to shoot one of the film's key scenes – the chicken run – the Warsaw Pact was ratified, ensuring the Russian domination of Eastern Europe and upping the stakes in the Cold War. The *New York Times* reported that Cold War tensions were one of the principal factors in the rise of juvenile delinquency.

In mid-May, the whole of the West Coast was put on nuclear alert. Sirens wailed and radio stations went off the air, but it was a false alarm. On 15 May, the last in the sequence of nuclear tests called Operation Teapot occurred at 5 a.m., while the cast were finishing up the chicken-run

almost daily contact with young people in schools, clinics, courtrooms and prisons: 'What marks the youth of this day as different to his predecessor is a tendency to act out, to display, his inner turmoil. This trend, I think it can be agreed, is in direct contrast to the suffering out of the same agitation by adolescents of yesteryear.'

sequence – another kind of brinkmanship. As the night sky dissolved in a nuclear sunburst, the cast were bathed in hydrogen light, giving the lines in Stern's script extra force.

Much of this knife-edge atmosphere translates into the film, despite the demands of a Hollywood melodrama. Stern's script was unusually psychological and schematic for the period: in his character notes, he cast Dean's character, Jim, as 'the angry victim . . . Because of his "nowhere" father, he does not know how to be a man. Because of his wounding mother, he anticipates destruction in all women. And yet he wants to find a girl who will be willing to receive his tenderness.'

Rebel Without a Cause contains traces of Ray's original working notes. Beneath the apparently bland surface of American suburbia, there are scenes of drunkenness, gang violence and intimidation, stabbing and shooting, vandalism and the chicken run – an echo of Dean's fascination with fast cars and speed. Ray and Stern took the attitude that although they were not condoning these crimes, teenagers were simply acting out, in a raw and unpalatable form, the death drive of 1950s America.

The script is peppered with references to dying or impending death. 'Who lives?' says Judy during her first encounter with Jim, and this existential question hangs over the entire film. The central trio, Jim (Dean), Judy (Natalie Wood) and Plato (Sal Mineo), are adolescents without an anchor, buffeted by poor parenting and their own convulsive emotions. They are threatened by the gang and hemmed in by the police. Both of these malign forces wear leather jackets and adhere to a standard, unthinkingly violent machismo, in contrast to the sensitive outcasts.

Plato is the film's wild card. Twenty minutes in, he opens his school locker to reveal a bevelled mirror and a pin-up of action hero Alan Ladd. To those who were watching carefully, this immediately suggested that the character was homosexual. Stern wrote Plato as sexually ambiguous – 'the kid in school who would have been tagged a faggot', he later stated – and he was played by Sal Mineo, who was perfect: still unformed at sixteen and unaware of his own homosexuality.

This caused problems with the Production Code Administration, the industry's self-censorship body. From the start, the production of Ray's film had been bedevilled by the moral panic about juvenile delinquency

that had already engulfed Marlon Brando's outlaw biker vehicle *The Wild One* and *Blackboard Jungle*, a stark but melodramatic portrait of the cleavage between the generations that had risen to #1 in *Variety*'s weekly US box-office Top 10 at the end of April and sent its opening tune, 'Rock Around the Clock', to #1 for eight weeks.

Blackboard Jungle was popular with teens and excoriated by adults. In his *New York Times* review, the influential critic Bosley Crowther called it 'a full-throated, all-out testimonial to the lurid headlines that appear from time to time, reporting acts of terrorism and violence by uncontrolled urban youths . . . the emphasis is wholly on impudence, rebellion and violence.' Calling the topic of juvenile delinquency 'social dynamite', Crowther opined that the film went beyond entertainment and reportage to act as a 'desirable stimulant spread before the young'.

With the Senate subcommittee examining the phenomenon of juvenile delinquency in spring 1955, Warner Brothers was forced to tread carefully. As far back as March, the script of *Rebel Without a Cause* had come under scrutiny from the film industry's chief censor, Geoffrey M. Shurlock of the Production Code Association, who itemised nineteen objections. These included violence, disrespect to the police and dubious sexuality: 'It is of course vital that there be no inference of a questionable or homosexual relationship between Jim and Plato.'

On 16 June, with shooting on *Rebel* wrapped, studio head Jack Warner appeared at a hearing in Washington that had been called by Senate subcommittee chairman Estes Kefauver to examine the relation between film violence and juvenile delinquency. Kefauver heard testimony from the Hacker Foundation, which held that the gratuitous violence in these films was actually 'hostile manifestations of a perverse sexuality', and Hollywood figures, including the president of Paramount Pictures and the actor Ronald Reagan.

Kefauver presented the studio head with a 'dirty dozen' list of films that he deemed 'too violent, sexually oriented, or too pro criminal'. *Blackboard Jungle* was at the top, with the unreleased *Rebel Without a Cause* also included. Warner deflected the criticism by stating that the film was still in the editing stage, and thus incomplete. He did, however, drop a major howler by stating that the film highlighted 'the juvenile

delinquency of parents' – a clever inversion that although it represented the film's psychological underpinning, did not help his cause.

Indeed, Dean seemed to deliberately lean into the suggestion of a 'questionable' relationship between Jim and Plato. Mineo remembered that Dean said to him when they were getting into their roles: 'You know how I am with Natalie. Well, why don't you pretend I'm her and you're me? Pretend you want to touch my hair but you're shy. I'm not shy like you. I love you. I'll touch your hair.' Transmuted into affection rather than overt sexuality, this underlying dynamic was encouraged by Nicholas Ray and gives the eternal trio of Jim, Judy and Plato much of its complexity.

The question then arises about Dean's own sexuality. In the six decades since his death, there have been many biographies itemising his gay affairs, sometimes salaciously, sometimes in a matter-of-fact manner. At the same time, he had many relationships with women. Nothing was reported at the time, and very few people would have thought Dean homosexual in 1955 – largely because of the taboo still surrounding the topic. And, with all parties now dead, it is impossible to be certain about anything, should anyone wish to be.

Which is how Dean would have wanted it. It is clear that he had close friendships with gay men and that that was part of his ability to stand outside contemporary norms. Whether or not any homosexuality he had was latent or consummated is impossible to fully ascertain. It is likely that it was the latter – and he certainly had gay fans – but in the end it isn't that important. Dean's projected bisexuality was an important element in his androgynous image; it was, as David Dalton writes, 'part of his general wandering in and out of different personalities'.

Within the context of the 1950s, Dean was a shape-shifter, travelling between all kinds of opposites so fast that he would never be caught, caged or pinned down. He was at once attractive to men and women; he was both a farm boy and a hot movie star; he oscillated between New York and Los Angeles, the theatre and the movies; he could be charming and abrasive. During his lifetime, he never quite settled; he was a person and persona in flux, which made him perfect for the position of teenage avatar.

Thus far on film, Dean had been the sharpest point in any triangle, but in *Rebel Without a Cause*, that role was taken by Plato. As a teen effectively without parents, he is the most troubled. The disturbance that the others play with is real in his case. Friendless, outcast, the victim of a beating by the gang, he finds a temporary haven with Jim and Judy in a deserted mansion, where they are, briefly, free to discover a world of their own – a vision of the teenage future in which sex and gender roles begin to shift and blur.

The mansion had been used as the principal set in *Sunset Boulevard*, and the hidden reference fostered the idea that this was a new generation taking its place. As the trio dance, float and dip, in a Cocteau-like narcotic reverie, through the deserted grandeur of the mansion and its swimming pool, they mockingly play with adult identities and imagine what a world without trouble and pain could be like. In a key scene, Judy is cradling Jim, while Jim affectionately ruffles Plato's hair: the eternal triangle at peace.

As the central character, Jim's masculinity is key. He stands alone and holds his ground, exercising his own authenticity. His willingness to nurture and shield the obviously troubled and probably homosexual Plato is very different from the machismo of the leather-jacketed gang. It is also in opposition to the corrosive influences at home, where his father is emasculated by his domineering mother and her own mother; where his father, played by Jim Backus, is wearing an apron as he fusses around the house.

Masculinity was a vital part of Stern's approach to the script, as he later admitted: 'it also informed my writing of *Rebel* – especially this whole question of the masks we feel we need to wear in front of others – and what exactly defines a "man"'.

Dean embodies this brilliantly. Caught between momism and machismo, Jim painfully finds a third way that does not deny his tenderness, softness, even possible homosexuality. He is attempting to transcend the conforming, militaristic model of masculinity in the 1950s, as Judy recognises in the climactic scene: after asking Jim what he thinks a girl wants in a man, she insists on a man 'who can be gentle and sweet . . . and someone who doesn't run away when you want them. Like being Plato's friend when nobody else liked him. That's being strong.'

This would be one of the principal elements of mass youth culture as it developed during the 1950s and beyond. Different attitudes to sex and gender – whether arising from the lives or the performances of key participants – were an integral part of this new Teen Age. This was not just because of the milieu – show business – from which it originated, but because it was what outliers like Dean wanted. They perceived that the old ways were not working, and they wanted change. The alchemy was that millions of others wanted the same thing.

Rebel Without a Cause did not go so far as to suggest that the triad of two men and one woman could continue. As the sexually suspect link in the triangle, Plato is dispensable, indeed has to die in order for the heterosexual idyll of Jim and Judy to be consummated without distraction. However, the film's final scenes, with Jim in tears, covering his dead friend with his red windcheater in a final act of tenderness, pack a considerable punch. The idea of a teenage sacrifice was potent, and on the point of realisation.

Dean was alive, almost preternaturally so: as Kazan had stated, he 'had the shine and shiver of life, you could call it, a certain wildness, a genuineness'. In *Rebel Without a Cause*, his reactions are lightning fast, up and down like a switchback, always mobile, never static. In his life and his art, he was burning up, embodying the intensity of the moment to such a pitch that, on screen, it attained an everlasting present. In his interviews for the film, it felt as though he was trying to pack as much life as he could into his allotted time. The clock was always ticking.

In late August 1955, just after *Giant* had finished shooting, Dean gave an audience to Mike Connolly. He turned it on for the cynical, seen-it-all, gay reporter, inviting him into his San Fernando Valley home, which was full of records and books and dominated by a large hi-fi system. Completely charmed, Connolly presented a restless soul in a timeless, almost prelapsarian idyll. Dean offers him raisin-and-honey bread and cream cheese, while inviting in a group of young neighbours, aged between seven and eighteen, to whom he gives peaches.

Connolly did observe an element of the macabre, however: 'a hangman's rope hanging from one of the living room beams with the sign "We Also Remove Bodies"'. This was only the latest of Dean's unsettling jokes.

On the shoot with Dennis Stock in Fairmount, earlier that year, he had insisted that the photographer snap him lying inside a coffin: 'It's one thing not to be afraid of death and to be realistic about it, but he was afraid, afraid,' the photographer remembered. 'And his way of dealing with it was to laugh in the demon's face, to make fun of it, tempt it, taunt it.'

Dean's hunger for life was balanced by a profound death wish, expressed in his obsession with fast motorcycles and fast cars, which he drove with considerable skill and recklessness. He was fond of misquoting a line from Nicholas Ray's 1949 film *Knock on Any Door*: 'Live fast, die young and have a good-looking corpse!' This was a combustible mix, and in his compulsion to live and race as hard as possible, H-bomb Dean was chasing death as hard as he was life. He was an accident waiting to happen.

Premiered with grieving co-stars and released in the wake of tragedy, *Rebel Without a Cause* was, and remains, a haunted and haunting film. All three of the major players – James Dean, Natalie Wood, Sal Mineo – would die before their time, in circumstances that were both mysterious and violent. In a similar way, Nicholas Ray's career would become stalled, as if he was struck by this fatal spell. He would never again find the community of youthful spirit that helped to make the film the masterpiece that it is.

At the same time, Dean's death cemented him as the ultimate teenage icon. There had always been morbidity in youth culture, going back to the Romantics' celebration of the poet and forger Thomas Chatterton – dead by his own hand at the age of seventeen – and carrying through to the extraordinary scenes that surrounded Rudolph Valentino's death in summer 1926, when thousands of sheiks and shebas thronged the streets of Manhattan to look at the corpse in its open coffin. Similar morbidities and sexual ambiguities would soon attend Dean.

There was one odd omission in the film, however. Unlike *Blackboard Jungle*, there was no rock 'n' roll on the soundtrack. Despite the identification of rock 'n' roll with youth culture during 1955, the score was handled by the classically trained Leonard Rosenman, who had also worked on *East of Eden*. The movies were still the leading culture industry in 1955, but in 1956 their dominance would be challenged by a new form of youth music, rock 'n' roll, spearheaded by a young man of twenty-one who sought to be the inheritor of James Dean's mantle.

1956

Mr. Presley initially disturbed adult viewers—and instantly became a martyr in the eyes of his teen-age following—for his striptease behavior on last spring's Milton Berle program. Then with Steve Allen he was much more sedate. On the Sullivan program he injected movements of the tongue and indulged in wordless singing that were singularly distasteful.

Jack Gould, 'Lack of Responsibility Is Shown by TV in Exploiting Teen-Agers', *New York Times*, 16 September 1956

Nineteen fifty-six was the year when rock 'n' roll took over from the movies as the prime motivator of youth culture. It was propelled not only by Black originators like Little Richard, but by the incredible rise of a white interpreter of Black R&B, who combined a definite element of race mixing – as it was called then – with a seemingly overripe, if not effeminate, appearance that scandalised adults and set the template for waves of successive pop stars to come. The new teen audience wanted difference, and androgyny was part of that package.

The year started slowly, with little hint of the avalanche to come. In the first *Billboard* chart of 1956, the highest-ranking record associated with rock 'n' roll was Gale Storm's 'I Hear You Knocking' at #3, with Kay Starr's 'Rock and Roll Waltz' at #21. Bill Haley & His Comets had a couple of records further down the charts, but there were no Black proponents of the new style to be seen. With Dean Martin, Frank Sinatra and Bing Crosby in the Top 20, it was still possible to see rock 'n' roll as a youthful fad, a brief interruption to business as normal.

On 18 February, Little Richard's 'Tutti Frutti' rose to #21 in the *Billboard* Pop 100. The record had been hovering in the Top 5 of the Rhythm and Blues charts since November, rising up to #3 that week, still stuck behind the perennially popular 'The Great Pretender'. Entering the charts in mid-January, it suffered from competition with Pat Boone's hasty cover version, which stood nine places higher at #12 on that mid-February chart. Stimulated by Richard's success, Boone's cover had been released only a couple of weeks previously.

Attitudes were split at Specialty Records. Art Rupe was sanguine: he thought Boone's version was 'pasteurised', but that it might have 'opened the door for subsequent sales of Little Richard records'. It's fair to say that Richard was not pleased. Although silent at the time, he later rightfully raged against the hypocrisy and racism, saying: 'They needed a rock star to block me out of white homes because I was a hero to white kids. The white kids would have Pat Boone upon the dresser and me in the drawer 'cause they liked my version better, but the families didn't want me because of the image that I was projecting.'

In February 1956, rock 'n' roll hadn't fully broken through. Bill Haley & His Comets had already had several big hits, the biggest of

which was 'Rock Around the Clock' – #1 for eight weeks that summer. This was some kind of shift, but Haley's band was basically a western swing outfit with a heavier beat. Meantime, the Black American originators of the style – apart from Chuck Berry, who had a Top 5 hit with 'Maybellene' – found it difficult to cross over to the mainstream. Then Richard came along.

At any given moment, there is the pop sound of the day. In February 1956, it was easy listening: songs that began with a brief choral or orchestral sequence, moving into standard romantic scenarios delivered by 'good', recognisably adult singers. There were travelogues and close-harmony groups: the Dream Weavers, the Four Lads, the Crew-Cuts. The #1 record in mid-February was a more authentic doo-wop number, the Platters' 'The Great Pretender', but even that fit within the close-harmony template.

Even the more teenage-styled records, which circled ever closer to rock 'n' roll, lacked basic fire: Gale Storm's cute cover of Smiley Lewis's 'I Hear You Knocking', Kay Starr's 'Rock and Roll Waltz' and Pat Boone's version of 'Tutti Frutti', a force of nature turned into a novelty. But Richard was not to be denied. With its famous opening chant, his 'Tutti Frutti' arrived as a rude rupture in this collective swoon. The whole effect was of abandon, of release, of something that had been suppressed but was now released into the populace.

For the next two months, throughout February and March, both versions of 'Tutti Frutti' – the one pseudo-sacred and the other profane – danced around each other in the *Billboard* charts. Boone's version peaked several places above Richard's original and lasted several weeks longer in the Top 100. As Bumps Blackwell later remembered: 'The white radio stations wouldn't play Richard's version of "Tutti Frutti" and made Boone's cover number one.'

With the early-March release of Richard's second Specialty single – and the near certainty of a bowdlerised cover by Boone or someone else – the producer and the singer decided to take revenge. It needed some work. A couple of takes of 'Long Tall Sally' had already been recorded in Los Angeles right at the end of November 1955, under the title of 'The Thing' – a typically provocative Richard reference to the

1951 horror film *The Thing from Another World*. They were groovy shuffles, funky enough but not explosive.

'Long Tall Sally' had originated on a scrap of paper proffered by a teenage girl. Blackwell remembered that he got a call from an influential DJ, Honey Chile, insisting that they meet. When he arrived, he found the DJ with a scrubbed sixteen-year-old called Enotris Johnson, who had written a few lines about her family situation: her aunt was sick and needed money for her care, and her uncle was running around. She wanted to draw attention to this fact, and Honey Chile thought that Blackwell could make something of the scenario.

After seeing the *Billboard* chart positions in late January, Blackwell got Richard back to New Orleans and sped the song up. In his account, the fact that 'Tutti Frutti' had been covered by Pat Boone, with Richard's version losing out heavily in terms of coverage, made Blackwell frustrated and determined to get his own back. Finding the lyric 'ducked back in the alley' running around his head, Blackwell took it to Richard, who added the hook – 'gonna have some fun tonight' – and a hint of drag ambiguity in the line 'Well, I saw Uncle John with bald-headed Sally.'

The resulting song is a joyous explosion, full of Richard's trademark vocal shrieks and oohs, and with the key phrase drilled so that it sounds like the rat-tat-tat of a machine-gun burst. Richard's anger at Pat Boone comes through loud and clear: *Top this, motherfucker, if you can get your lips around the words.*

In 1955, 'gonna have some fun tonight' was a phrase to live by, and 'Long Tall Sally' quickly became a teenage anthem. Released in early March 1956, it got an advert and lead review in the 17 March issue of *Billboard*: 'Little Richard has a sock follow-up to "Tutti Frutti" in this two-sided hit . . . "Long Tall Sally" is an equally effective rhythm–novelty team with humorous lyrics and another great warbling job by the artist.' Within days, Boone rushed out his cover version. The race was on.

The problem for Boone – and for any censors – was that 'Long Tall Sally' sounded like an affront, but exactly why was not clear. Boone garbled the 'ducked back in the alley' section, while adding the nonsense filler 'Long Tall Sally's got a lot on the ball / Nobody cares if she's long and tall.' At the same time, the censor at NBC threw his hands up in the

air when assessing the 'spicy new disk' for the teen National Radio Club shows, saying, 'How can I restrict it when I can't even understand it?' The teen audience voted it #1 in that week's new releases.

The dance resumed in April and May. Richard's original entered the charts in early April and maintained its lead over Boone's cover throughout its sixteen-week stay in the *Billboard* Pop 100. It reached a peak of R&B #1 and Pop #13 on 12 May, with Boone trailing by a few places. Blackwell and Richard's ploy had worked. When Boone's version failed to make the top twenty, *Billboard* noted the shift in the audience's response: 'It certainly looks as tho [*sic*] the public is beginning to show a decided preference for originals – regardless of their origin.'

———

That spring, however, the big pop news in *Billboard* was the performance of 'Heartbreak Hotel', the first single Elvis Presley had recorded under his RCA contract, which was sweeping the board, at the top of store sales and jukebox and disc-jockey plays. By mid-May, the record was well into its eight-week run at #1, an unprecedented success that turned Elvis, and the youth culture that he was coming to represent, into a national and international phenomenon. The Teen Age had finally arrived, and music was at its heart.

'Heartbreak Hotel' had been recorded in early January 1956, and it was an unusual choice for a singer who had made his name with five uptempo singles on Sun Records. It was a doomy, slow-paced blues that, in the repeated piano doublets, had a hint of burlesque. Elvis's heavily echoed vocal was foregrounded, emphasising both his status as the star and the dark, haunted lyrics. Although it was very different from anything he'd recorded before, Elvis believed in the song. It caught the post-Dean teen mood of morbidity.

The song's storyline had been sparked, according to its writer, Mae Boren Axton, by a news report about an anonymous suicide, headlined 'Story of Person Who Walked Lonely Street'. She played the song to Presley when they met for the second time, in Nashville on 10 November 1955. Axton had already encountered the singer when she worked as his

publicist during a stint in Florida in May that year. When she asked a fan about his appeal, they replied: 'Awww, Miz Axton he's just a great big beautiful hunk of forbidden fruit.'

After signing to RCA Records for $35,000 that November, Elvis set to work in the new year, recording eleven songs in three New York sessions. They included his first single, as well as covers of R&B and blues songs like Arthur Crudup's 'My Baby Left Me', the Drifters' 'Money Honey' and Little Richard's 'Tutti Frutti' – rearranged for a small, guitar-based combo. Backed by the industry might of RCA, 'Heartbreak Hotel' was quickly reviewed on its release, gaining a prominent mention in *Billboard*'s 'Review Spotlight' column.*

In January 1956, Elvis did his first major interview with a young wire reporter. During their brief twenty-five-minute-or-so session, held at RCA's studio, Fred Danzig found Elvis fairly inarticulate but willing to please: 'I was very surprised to hear him talk about the black performers down there and about how he tried to carry on their music.' Elvis also mentioned that he 'wanted to go out to Hollywood and become the next James Dean. And I thought, "Yeah, well, come on, kid . . ." But that was obviously his goal.'

From late January to late March 1956, Elvis made six appearances on the nationally networked CBS programme *Stage Show*, hosted by Jimmy and Tommy Dorsey. Apart from three performances of 'Heartbreak Hotel', he played mainly blues, R&B and rock 'n' roll, including 'Money Honey', 'Blue Suede Shoes' and 'Tutti Frutti' twice. The hype was on: as Bill Randle introduced the young singer on the first show, 'We think tonight that he's going to make television history for you.'

Presley's appearance and performances on these shows were radically different from those of any previous pop performer on national TV. His hair was long for the period, while his clothes were loud and, for those in the know, derived from Black American styles. His movements were uninhibited as, lost in the music, he thrust his hips in bumps and grinds

* *Billboard*, 11 February 1956: 'Presley's first Victor disk might easily break in both markets. "Heartbreak Hotel" is a strong blues item wrapped up in his usual powerful style and a great beat. Presley is riding high right now with network TV appearances, and this disk should benefit from all the special plugging.'

Elvis, 1956

that to many adults suggested the animalistic and exaggerated move-
ments of a female burlesque performer. It was not the way that men
were supposed to behave, and critics took note. As one Jas W. Atkins
reviewed Presley's 4 February appearance: 'Elvis not only sings, but he
adds a much-emphasized swing, a sway and a shake of the head to boot.
While doing "Little Girl I Want To Play House With You", he got more
motion than [female burlesque artist] Sally Rand ever did. He weaved
and rattled his head and did another thing that he said everybody would
recognize called "Tutti Frutti." The chorus of this thing ended up with
an un-coherent chant that sounded to me like: "Oooh la ba lop, a rim,
bam boo."'

In March 1956, Elvis's first album was released and included his ver-
sion of 'Tutti Frutti'. In their reviews, the critics' immediate reaction was
to refer back to the most recent emoter, Johnnie Ray. Shortly afterwards,
Ray met Presley in Las Vegas and was not impressed by either him or his

stage show. Ray felt that he was doing 'something that about 300 other black guys had done before him'. This was a little harsh, if not totally unfair, and not reciprocated: Elvis was impressed by Ray's passion for Black music and his performing intensity.

In the first half of 1956, Elvis took over from Ray as pop star weirdo number one. He was young, working class, an atomic-age Li'l Abner from the Deep South, and massively successful. His love of Black music and fashion was obvious and, in a highly segregated country, deemed deeply suspect. Indeed, his flamboyant appearance was so strange and so outside the mainstream that it spoke of an effeminacy that, although not rooted in sexuality, would soon be used by critics as a weapon against him.

Thus far, Elvis had avoided any major scrutiny, but that all changed after his 5 June performance on *The Milton Berle Show*. During a ferocious performance of his next single, 'Hound Dog', he splayed out his wrists, which at various points fluttered or hung limply – a sign of a homosexual – and, in the half-time coda, undertook a thorough examination of the whole concept of bump and grind. This was a major breach of TV etiquette, an eruption of sexuality and Black music within a family medium – a subterranean world suddenly exposed.

With this one performance, Presley became a media sensation. For the next few weeks, the press frothed itself into a poisonous foam. In the *New York Daily News*, Ben Gross opined that 'Presley, who rotates his pelvis, was appalling musically. Also, he gave an exhibition that was suggestive and vulgar, tinged with the kind of animalism that should be confined to dives and bordellos.'

To mainstream America and its self-appointed guardians of morality, Elvis arrived as a total freak in mid-1956. Unknowingly, he had transgressed the strict boundaries of race, class, sexuality and masculinity in the Cold War freeze. The next few months would see him attain new heights of success, at the same time as suffering a barrage of hostile criticism. In one fell swoop, Elvis had become the lightning rod for American fears about juvenile delinquency, race and deviant sexuality.

———

Masculinity was the key issue. The subtext of the burlesque jibes was that Elvis was not a man but a woman, and not just any woman, but the most degraded female possible: a prostitute, a stripper, someone who sold sex for money – someone to be discarded and despised. At the same time, he was, according to *Billboard*, hot as a pistol: active, dangerous, explosive. The singer was bewildered by all the fuss and did a good job of defending himself where possible, but he was subject to forces outside his control: during the first half of 1956, America was still aggressively policing race and sexuality.

It was still open season on homosexuals, sex deviates and all those who did not cleave to narrow definitions of normality. In January, *On the QT* continued the scandal magazine attacks on Johnnie Ray with the headline, 'Why Johnnie Ray Likes to Go in Drag: An Odd Inclination to Dress Like a Woman May Be the Psychological Key to Ray's Success'. All the old pseudo-psychological tropes were rehashed: Ray's loneliness, his appeal to fundamentally sad people, his mother fixation and an allegation that he was seen in Los Angeles wearing a dress.

At the same time, fears about juvenile delinquency continued to reverberate on both sides of the Atlantic. Some of these centred around the cult of James Dean – still indelibly associated with youth and trouble in the minds of the public and the authorities. Although by January 1956 *Rebel Without a Cause* had slipped out of the box-office Top 10, Warner Brothers announced that the dead actor had received thousands of letters that month. Dean was more popular – and more valuable – dead than alive.

The link between the film and the topic that it purported to examine was taken seriously in the UK, where it was finally granted a licence in January, in similar circumstances to *Blackboard Jungle*: the knife-fight scene between Jim and Buzz was cut, while heavy edits were made to the chicken-race scene and the shots of Jim grappling with his father. It was, again, granted an X certificate, which meant that it could be seen only by members of the public who were over eighteen, thus denying it access to its principal market.

The American scandal magazines sniffed a fresh victim in Dean – conveniently, one who could not answer back. The number of articles about

the dead actor rose dramatically. In February, *Whisper* ran a silly story, shrouded in ghoulish hints of the occult, about Vampira, Dean's 'Black Madonna', who claimed a relationship with the star. In the April issue, the teens struck back. Many were hostile: as one Elaine Hoffman wrote, 'I think the name of your magazine should be *TRASH* instead of *Whisper*.'

That month, the scandal magazines ran more stories about 'sex deviates'. *Top Secret* ran another item about the newly married star of *Giant*, 'Rock Hudson and the Girls He Spurned'. *Dare* magazine ran a feature that asked, 'Do You Have the Homosexual Urge?', advising the reader to check their 'homosexual tendencies'. Among the prominent deviates pictured were actor Van Johnson, Johnnie Ray and English trans woman Roberta Cowell, a Second World War fighter pilot who was the first person in the UK known to have had sex reassignment surgery.

It was in April, as well, that the simmering rage about the influence of Black music on white American youth boiled over. On the 10th of that month, the highly popular and definitely unthreatening Nat King Cole was attacked onstage in Birmingham, Alabama. Six men rushed the stage while the singer was performing in front of the Ted Heath Orchestra; he received minor back injuries and a psychic shock. The whole sorry affair was presented in the media as a clash between a campaigner for equal rights and hardcore racists.*

In early May, just as 'Long Tall Sally' was reaching its chart peak, Little Richard was involved in a major riot at the American Legion Auditorium

* Alabama had long been a hotbed of recidivism. In January, the state legislature declared that the Supreme Court decision of May 1954, which de facto desegregated public schooling, was null and void. In February, the sole Black student at the University of Alabama, Autherine Lucy, was forced to leave after serious rioting by white segregationists. In March, several Alabama senators signed the Southern Manifesto, which declared an implacable opposition to enforced integration.
The rising popularity of Black American music was an important trigger for this reaction. Local politician Asa Carter told *The Southerner* that it was 'a short hop from the sly night club technique vulgarity of Cole to the openly animalistic obscenity of the horde of Negro rock 'n' rollers'. Shortly after the attack on Cole, Carter was quoted in the 23 April edition of *Newsweek*, in an article titled 'Alabama: Who the Hoodlums Are': 'Rock 'n' roll is the basic, heavy beat of Negroes. It appeals to the very base of man, brings out the animalism and the vulgarity.'

in Roanoke, Virginia, while playing on a bill with the Cadillacs, Ruth Brown and headliner Fats Domino. The event was over-subscribed, with both Black and white youths crammed into the venue; whites were seated in the balcony, while Blacks were on the main floor. When around 2,000 white fans sought to escape the crush by moving downstairs, the trouble started.

As Domino was finishing up his set at 1.15 a.m., a bottle was thrown from the balcony down onto the main floor below. The place erupted in violence between Blacks and whites, which continued outside in the venue's parking lot and around the hotel where the performers were staying. Whether the incident was explicitly racially motivated or just simple hooliganism is not totally clear, but the former seems more likely, as it was reported in the local paper the next day under the headline 'Racial Disturbance Climaxes Dance'.

The Roanoke incident was one of several disturbances at rock 'n' roll shows that year, which were seized on to fuel the reaction against both the music and race-mixing. Places such as Santa Cruz and Jersey City banned rock 'n' roll performances through local ordinances. Rock 'n' roll was called 'a communicable disease', and the censors tightened their grip. Radio stations began to drop it from their playlists, while the major networks like ABC, CBS, Mutual and NBC banned dozens of records – if they could decipher the lyrics, of course.

The way in which the behaviour of the youth was seen as a hydra-headed problem was dramatised by the August issue of the pocket magazine *Pose!*, which was entitled 'U.S. YOUTH ON A BINGE!' The text blamed wartime negligence, as these 'war orphans' had grown up without guidance: 'The arrival of the teenage hoodlum and pervert on the national scene has created tremendous problems for law enforcement and education authorities not geared for the sudden youthful crime wave,' which included dope, murder, vandalism, gang wars and homosexuality.

Behind all this adult excitation was the reality that the Teen Age market was becoming a fact of life. In a country that understood money and commerce above almost everything, the fact that teenagers were flexing their consumer muscles meant that they were beginning to acquire social recognition and generational power. Already there were teen magazines

like *Dig*, now well into its first year, and a greater sense of the music industry's competitive focus on the 45 rpm single format in the *Billboard* Top 100, expanded from the Top 20 late in 1955.

The elevation of this long-dormant cohort met with considerable opposition, partly because of adult fears and partly because grown-ups felt that the fresh prominence of teenagers was being gained at their expense. Rock 'n' roll was at the heart of this generational power shift, and as its most visible symbol, Elvis Presley continued to attract negative attention. In early August, critic Herb Rau reviewed his shows in the *Miami Daily News*, calling him 'the biggest freak in show business history. Elvis can't sing, can't play the guitar – and can't dance.'

The simple fact was that, for all the bluster and venom, the youth of America didn't care much about what adults thought. They had found a music that reflected how they saw the world. And it was not a flash in the pan: as 1956 wore on, other rock 'n' roll singers came to prominence besides Elvis, Bill Haley, Fats Domino and Little Richard: Carl Perkins, Gene Vincent, Frankie Lymon and the Teenagers. It wasn't just a fad but a whole new way of being.

At the Teen Age zenith was Elvis – supreme, untouchable, the music industry sensation of the year. On the *Billboard* Top 100 chart for 1 September 1956, he had three records in the Top 10: 'I Want You, I Need You, I Love You' at #10, 'Don't Be Cruel' at #4 and 'Hound Dog' at #2. That same week, RCA issued seven singles at once, taken from Elvis's albums and EPs. This 'sensational release' included his version of Carl Perkins' 'Blue Suede Shoes', with 'Tutti Frutti' on the flip. *Cashbox* tipped all fourteen sides as chart probables.

That first week of September 1956 also saw the full entry of rock 'n' roll and teen culture into the UK. With restricted radio and no live performances by American acts, it had been hard to hear the music at all. This made its impact on film even more powerful. In the third week of September, Bill Haley & His Comets had five records in the UK Top 30, including 'Rockin' Through the Rye' at #3, 'Saints Rock 'n Roll' at #11 and the reissues 'Rock Around the Clock' at #17 and 'See You Later, Alligator' at #21. The major factor in this chart takeover was Haley's starring appearance in the Alan Freed vehicle *Rock Around the Clock*, which

featured several songs by the Comets, including 'Razzle Dazzle', 'See You Later, Alligator' and the title tune.

Hearing rock 'n' roll on a loud cinema speaker system must have been a revelation at the time, and it was this sonic environment that helped to cause trouble in early September, when the film was released in the UK. In America, Haley had already been eclipsed by Elvis, but he and his Comets fit the bill for excitement-starved British teens. On 4 September, *The Times* reported that the film was causing 'noisy behaviour' in South London cinemas. What this seems to have described was young fans, including some Teddy Boys, dancing in the aisles and ignoring the cinema staff when they tried to calm them down. In England during 1956, this relatively mild youth behaviour, while high-spirited and anti-authoritarian, was a new phenomenon, and was interpreted as a riot. The press certainly thought so, as did the police: during the rest of September, there were disturbances at cinemas in London and Manchester, where police ejected fifty unruly teens. The film was banned in several cities around the country, including Birmingham, Belfast, Liverpool and Bristol, and reports on 'the riots' even made the *New York Times*.

September 1956 also saw the launch of Britain's first rock 'n' roll star. On the 16th, the *People* – a Sunday newspaper with a massive circulation of around 4.5 million – ran a story titled 'Rock 'n' Roll Has Got the Debs Too', which featured a young Tommy Steele playing for an audience of rich young things. The whole thing was a complete set-up by one of Steele's three managers, a freelance photographer and hustler called John Kennedy, who had seen the nineteen-year-old play in the tiny basement of Soho's 2i's Coffee Bar. After the *People* splash, Steele's career quickly accelerated. Along the way, he picked up another manager, Larry Parnes, who was tired of the rag trade and wanted to get into the music industry. Both Kennedy and Parnes were gay and well connected, and they plugged Steele into the heart of the British showbiz milieu.

Parnes had been inspired to enter showbiz by seeing Johnnie Ray at the London Palladium in spring 1955. 'I used to see all the big stars that came in at the Palladium, Frankie Laine, Tony Martin, Billy Daniels, Johnnie Ray. The others were older, and when I saw what was

happening in the audience, the reaction, the screaming when Johnnie Ray was there. Great Marlborough Street was blocked off, cars couldn't get through because of the fans, he'd come out onto the roof at the back of the building and wave. People think that started with the Beatles, but it didn't.'

Masquerading as a tough rocker, Steele was in fact a conventional enough singer and performer. His first single for Decca Records, co-written by the young composer Lionel Bart, went into the UK charts in October 1956. 'Rock with the Caveman' was ersatz, but it was a start. After another rock 'n' roll quickie, 'Doomsday Rock', totally flopped, he covered Guy Mitchell's pop country hit 'Singing the Blues', which would eventually rise to #1 in January 1957, sharing chart space with Johnnie Ray's last big hit, 'Just Walking in the Rain'.

September also saw the triumphal visit of Liberace to the UK to play at the Palladium and the Royal Albert Hall. On the 25th, he was greeted by thousands of adoring females at Waterloo Station, mob scenes that were repeated when he arrived at the venue to perform for *Sunday Night at the London Palladium*. These sights aroused the imme-diate ire of William Connor, who had a regular opinion column in the *Daily Mirror*, under the pseudonym of Cassandra. Nearly fifty, Connor wrote in the tone of a bluff, gruff man's man and clearly had no truck with momism incarnate. Liberace was still being targeted by the scandal magazines in America – the September issue of *On the QT* had a story called 'Mama's Boy in Curls' – but the ferocity of the choleric columnist was something else. Over several hundred words, Connor poured vitriol on every aspect of the pianist's looks and sexuality, calling him 'a deadly, winking, sniggering, snuggling, chromium-plated, scent-impregnated, luminous, quivering, giggling, fruit-flavoured, mincing, ice-covered heap of mother love'.

Cassandra's conclusion was perhaps nearer to the mark than anyone would have wanted to admit: 'He is the summit of sex – the pinnacle of Masculine, Feminine and Neuter. Everything that He, She and It could ever want.' But that was exactly the point: the new conditions of fan-dom gave power to women, young and old, and the biggest stars were those men who knew how to appeal to them. And they wouldn't do so

necessarily by being rough and tough. The new requirement of the market meant that they had to be, in some way or other, feminised.

———

I n the last *Billboard* chart of 1956, Elvis had a staggering ten records in the Top 100, with 'Love Me Tender' peaking at #2. This was the theme tune to Elvis's first Hollywood movie, a musical drama of the same name. At the film's end, Elvis's character, Clint Reno, dies in a shoot-out: with this fated ending, he had achieved his ambition to follow in James Dean's footsteps. The film was released in mid-November, the day after Elvis attended Liberace's opening show at the Riviera Hotel and Casino in Las Vegas. A staged photo op saw the pair clowning around on guitars.

In late November, the number-one movie in the US was James Dean's last film, *Giant*. Starring Rock Hudson and Elizabeth Taylor, it was the hit of the season. It was a strange movie for the teenage icon to be involved in: a sprawling three-hour Hollywood epic set in the dust and heat of Texas. Dean had clashed repeatedly with the old-school director George Stevens: this was not the collegiate teen commune of *Rebel Without a Cause*. In his final scenes, he played a wizened and bitter old man – a whole life cycle played out on the screen.

Number two at the box office that same week was *Love Me Tender*, the release of which occasioned more assaults on Elvis's masculinity. *Films in Review* published a vicious attack by Henry Hart: 'The face which Presley presents to his public is not merely devoid of character, it has an overtly insolent cast. The weak mouth seems to sneer, even in repose, and the large, heavily-lidded eyes, seem open only to be on the look-out for opportunities for self-indulgence. The long hair is one of today's badges of the psychologically feminized male.'

Little Richard managed to dodge this hostile scrutiny. It was an index of Elvis's white privilege that Richard hadn't appeared on *The Ed Sullivan Show* or even in the scandal magazines, but the lack of mainstream media exposure helped him to stay under the radar. His American chart career had stalled somewhat after his initial one–two punch: his June release, 'Rip It Up', had topped *Billboard*'s R&B chart but had made

only #27 Pop, and his mid-October follow-up, 'Heeby-Jeebies', didn't make the Pop chart at all. Nevertheless, Richard continued to attract 'standing-room-only crowds'.

Richard had crossed over to the white audience, which pleased him: 'They'd want to get to me and tear my clothes off. I've always thought that Rock'n'Roll brought the races together. Although I was black, the fans didn't care.' While his performances were wild, his persona aggressive, almost punk, and his private life lurid, Richard was canny enough to moderate the full horror in his media appearances, usually emphasising his coy, flirtatious side in order to defuse any potential trouble.

The range of his personae can be seen in the two films that Art Rupe managed to place the star in during 1956, figuring that if television wasn't going to come to Richard, then Richard was going to the movies. *Don't Knock the Rock* was a quick musical vehicle with a nominal plot starring Bill Haley & His Comets. Introduced by Alan Freed, Richard stands there with a huge smile, before launching into 'Long Tall Sally', with the Upsetters lined up behind him. His performance, in front of white teenagers, is restrained until the second verse, when he jerks back, arms flying.

During the sax solo, Richard puts his leg on the piano and continues to play, looking skywards – a picture of innocence. 'Tutti Frutti' sees him strangely static at the piano, as the Upsetters, all dressed in white suits, execute a series of synchronised band moves on the stage. Richard's fixed stare could speak of many things: concentration, irritation at the set-up or simply his mood for the day. His long hair and V-shaped eyebrows draw his face into a sharp point; there is the sense that he could turn at any moment.

The Girl Can't Help It was much more substantial. Richard performs two songs, 'Ready Teddy' and 'She's Got It!', in luscious Technicolor. Just like in *Don't Knock the Rock*, he looks off-camera throughout, and both clips are intercut with the undulations performed by featured star Jayne Mansfield. As was the norm, critics dismissed the film, but Frank Tashlin's movie entered the *American Weekly* box-office charts at #5 at the end of 1956, remaining in the Top 10 for six weeks. Richard's title theme went to #49 Pop – not a stellar success.

The film's real impact occurred in the UK. When it was released on 11 March 1957, it made Richard into a huge star. His UK release schedule had trailed behind the US: the deal to license Specialty products on London American Records was only finalised in autumn 1956. First up was 'Rip It Up', which just scraped into the UK Top 30 late in 1955. In February, the coupling of 'Long Tall Sally' and 'Tutti Frutti' entered the charts, and the film sealed the deal: in mid-March 1957, Richard had three singles in the UK Top 20, with 'Long Tall Sally' peaking at #4.

In America, Richard had been one of several performers thrown up by rock 'n' roll. In the UK, he was second only to Elvis. *The Girl Can't Help It* was the first time that anyone in the UK had witnessed an authentic, first-wave, Black, flamboyant rock 'n' roller in performance. Despite being subject to the machinations of the plot, Richard's realness came over loud and clear. He was a freak, an alien, the thing from outer space, and he imprinted his profound dramatisation of excitement and difference onto a whole generation.

Sexuality was an important, if occluded, part of this. The young men and women listening to Richard's records and even seeing him on screen didn't necessarily take in the fact that he was gay or bisexual, but his very appearance and sound made sex and gender difference part of the pop package. They had long been implicit in mainstream entertainment, but with rock 'n' roll and the teenage market they were made more explicit and broadcast to a wider, younger audience. Richard was the start, but many would follow.

PART 2
September
1961

8
John Leyton and Joe Meek

Right now the big sound of 1961 is that of a deep, bass-y, echoing, drawn out YAWN. True, the standard of records has gone up and up. They are, on the whole, better arranged, better produced, better sung than they ever have been . . . But in the words of the Immortal Bard – 'So what?' I'd swap all the polish, the class, the sleek mohair-suited success of popular music, for just one, tiny untarnished NEW IDEA.

Jack Good, 'NO NEW IDEAS – It's All So Boring Now',
Disc, 28 January 1961

n early September 1961, John Leyton's third single was in its first week at #1 in the *Record Retailer*, then the UK's only trade music paper. Other music magazines had their own chart rundowns, and 'Johnny Remember Me' had already gone to the top in *Disc*'s chart of 12 August, but the *Record Retailer* chart is the one of record, and on 19 August the track made a huge leap from #18 to #2, held off the top by Helen Shapiro's tricksy and sophisticated 'You Don't Know'.

The UK Top 20 that week was an eclectic mix of exciting American records – Gary U.S. Bonds' 'Quarter to Three', Del Shannon's 'Runaway' – together with a clutch of US teen idols and their UK counterparts: Cliff Richard, Adam Faith and Billy Fury. It wasn't a bad chart: people were trying something new within what was, as *Disc*'s featured columnist Jack Good had already intuited, a fairly tame pop climate – filled with what Roy Orbison accurately termed 'a bunch of second-hand Elvis Presleys'.

'Johnny Remember Me' was something else: a force of nature. It was a huge, immediate hit, Leyton's first after two complete flops. In summer 1961, he was twenty-two, a good-looking young man with swept-back hair, a chiselled face and plentiful stage experience. Unlike the other teen idols of the day, however, he did not break through with a muted rocker, a teen courting ritual or a big Italian ballad. 'Johnny Remember Me' was haunted, futuristic – and unstoppable.

In appearance, Leyton was not unusual for the time, fitting in well with the malleable, post-Cliff Richard mode of UK pop stars, but he was inventively packaged by a buccaneering Australian manager and the UK's foremost independent producer. The combustible collaboration between Robert Stigwood and Joe Meek announced a new kind of force in the British music industry, one that was both media savvy and interested in pushing the limits of what was then acceptable.

The record begins with a brief fanfare. A guitar strums along to an echoed female voice, before the full instrumentation comes in at a western-style gallop. The mood is immediately set by the lyrics: 'When the mist's a-rising / And the rain is falling / And the wind is blowing cold across the moor'. This is the wild, open landscape of popular Americana recalibrated into English gothic. The whole song is saturated in savage, untamed nature.

The scenario is simple: the singer is haunted by the memory of a girl he has loved and lost. Her part is brilliantly played by the singer Lissa Gray, whose high, ghostly vocals enact the feeling of the lyrics. The galloping backing, by Joe Meek's in-house group, the Outlaws, thoroughly explores the fantasy of western space that saturated the UK's psyche during that period, in both films and TV series like *The Searchers* and *The Lone Ranger*, and on records like the Ramrods' cover of 'Ghost Riders in the Sky' – a Top 10 hit earlier in the year.

Despite these antecedents, 'Johnny Remember Me' was unique for the time. Its fusion of feeling and sound was completely successful; its melodramatic touches were matched by production that was extreme for the time, full of echo and compression, highlighting not just Leyton, but also Gray's keening vocals. It introduced a particular ambiguity too: although Gray performs the song's title during the chorus, Leyton also sings the phrase. Exactly who is remembering Johnny, then?

Joe Meek and Robert Stigwood were homosexual – although not publicly so – and their sexual orientation found its way into the outer edges and deeper implications of this melodramatic song. After all, Leyton does sing the words 'Johnny remember me'. It's a quote (he's hearing the wind sighing the phrase), but the singer noticed this ambiguity at the time: 'I didn't like the title. It didn't seem right that I, a man, should sing a song with that title.'

———

But that was the way performers were treated at the time. John Leyton was given a song and told to get on with it. Like the most successful British manager of the time, Larry Parnes, Stigwood was a moulder of young talent. The fact that he was Australian made him an outsider in the small, tight-knit world of the British music industry, a situation that he, typically, turned to his advantage. Unconstrained by ideas of knowing your place, Stigwood was a pirate – happy to cut corners and bend the rules – with a preternatural knack for spotting hits.

Born in April 1934 to a working-class family in Adelaide, Stigwood was eleven when his parents divorced. During his teens, he immersed

himself in the world of theatre and was scheduled to go to university, before his electrician father refused him permission. After working for a subsidiary of the *Adelaide News* and an advertising agency, he began mounting theatrical productions, which he continued to do with some success until his departure for the UK in 1956. Characteristically, he was breaking the law by skipping his national service obligations.

On arrival in the UK, Stigwood hosted rent parties, before finding a variety of jobs that included stints as a door-to-door vacuum salesman and a spell as a housemaster in Hollesley Bay Borstal. In late 1959, he formed a theatrical agency with businessman Stephen Anton Komlosy, to whom he confided that he wanted to manage a pop star, but in the meantime Robert Stigwood Associates made a good income, supplying up to 40 per cent of the actors seen on UK commercial TV.

In 1960, Svengali met his star. Stigwood was a tease and a charmer, and he pulled in an ambitious young actor who was just on the first rung of his career ladder. 'A friend happened to tell me there was a guy coming to town from Australia who was possibly looking for new people,' John Leyton told the writer Kieron Tyler. 'I called up and made an appointment. It was a little office in Monmouth Street. He had what he called his drama side of this new little agency. That's the side I joined. He was remarkably creative, adventuresome – a true entrepreneur.'

Quickly securing his young charge a prime role as Ginger in Granada Television's popular children's series *Biggles*, Stigwood envisioned how TV success could translate into record sales. After failing an audition at Pye Records, Leyton was taken along to the Holland Park flat of the independent producer Joe Meek, who had just had his first hit on his own Triumph label – an instrumental by the Fabulous Flee-Rakkers called 'Green Jeans'. Having had his protégé rejected by the 'official' British music industry, Stigwood decided to try another maverick.

Leyton remembered that the producer had a casual, almost 'amateurish' set-up at Holland Park. He had no illusions about his own skill as a singer. 'I think Joe loved a challenge,' he told Tyler, 'and I think somebody that came to him that had no idea about music and even better still, who couldn't even sing a note, I mean, Joe loved that, because he could play with his machines and do all this amazing electronic mixing that he did.'

In the late spring of 1960, Meek was thirty-one years old. Like Stigwood, he was an Aries, a maverick and a homosexual, but there the resemblance ended. Whereas the Australian was confident and Tiggerish, a born entrepreneur and risk-taker, Meek was introverted and awkward, obsessive and without social graces, half in the mundane world and half in the world of his fevered imaginings. But he had the ability to turn these imaginings into something at once concrete – a vinyl record – and metaphysical: sound productions that worked on the soul.

———

Born in April 1929, Joe Meek was sensitive and volatile. His instability was exacerbated by his father, who suffered explosively violent fits after experiencing shell shock in the First World War. Dressed as a girl by his mother until the age of four, and uninterested in most boyish pursuits, Joe was called a sissy and shunned by most of his peers.

This difference, coupled with his hair-trigger temper, led to the start of the persecution complex that lasted for the rest of his life. Around the age of ten, he began tinkering with wirelesses, cameras and gramophones. In his teenage years, Meek began working in the local dance halls, playing 78s through his home-made sound system, until he discovered the delights of electricity. 'I wanted a magnetic pick-up which I connected to the gramophone. Then I wanted to amplify this and I made my first one-valve radio and then of course my first one-valve amplifier.'

After doing his national service in the RAF, he worked as an electrical engineer, while continuing to work as a mobile DJ under the name RGM Sound, which was taken from his initials – Robert George Meek (Joe was a nickname). After cutting his first record in 1953 – a collection of sound effects – he moved to London, working at a radio shop in Edgware Road, before finally landing a job recording and editing the Radio Luxembourg shows held in theatres around the country.

Working for the Independent Broadcasting Company (IBC), the country's leading recording studio, Meek eventually found himself recording studio sessions, despite the disapproval of the higher-ups. His first full date was with the Ivy Benson Band, on an album called *Music*

for Lonely Lovers, but his breakthrough came in summer 1956, with the success of 'Bad Penny Blues' by the Humphrey Lyttelton Band, which reached the UK Top 20 – one of the first trad hits, and one of the first jazz records to be produced rather than just recorded.

Meek was attuned to different vibrations, not just in the musical sphere, but in his fascination with the occult. His life was permanently altered by a January 1958 tarot-card reading, during which he was informed that Buddy Holly would die on 3 February. The date passed without incident, but when the singer died a year later on the day predicted, Meek was shocked to the core. His biographer John Repsch notes that 'that night a tearful get-together was held at Joe's flat, playing the Holly records. At this point the admiration he had for the man and his music suddenly became a mild fixation, and was richly nourished on seances he began holding to contact Holly's spirit.'

During 1959, relations between IBC and Meek were deteriorating – Meek felt stifled by the hierarchy and undermined by some of the anti-homosexual prejudice expressed by his colleagues – and in November 1959, he stormed out of a session and was sacked. A quote from his boss, Dennis Preston, reveals the attitudes of the era: 'You could have times with Joe when he could be the nicest, most lovely, friendly, beautiful guy in the world, but if something crossed him he was like a jealous woman: quite impossible to deal with.'

As if freed from a straitjacket, Meek plunged into the first evocation of the sounds and the alien landscapes that swam around in his head. He started recording a concept album about the existence of life on the moon, which, as the space race between the US and the USSR began to intensify, was just beginning to impinge on the global consciousness as a physical rather than a metaphorical satellite. His imagination ran riot as he envisioned the physical landscape of this alien environment and the gravity-free life of its people.

Using a group from Ealing called the Cavaliers, he produced twelve tracks that mixed the instrumental sound of the day – basic guitars, drums and bass – with a hint of exotica, chanted vocal melodies and lashings of reverb, compression and tape loops. The inhabitants of the moon, variously called the Dribcots, the Saroos and the Globbots, were rendered in

sped-up voices, uncomfortably like the comedy puppet duo Pinky and Perky, which remains the one misstep in the whole extraordinary project.

The real deep-space quality was rendered by two elements. In October 1959, Meek had bought a primitive proto-synthesiser called the clavioline, which emitted a high-pitched, rough, electronic sound. Otherwise, all manner of sound effects were created by Meek distorting and warping simple household sounds – produced by manipulating combs, knives or glasses of water – through his patented patch of compression and echo.

The title song pulled the whole project together in a tide of emotion. Sung straight – with those sped-up backing vox echoing each phrase – the lyrics reveal some of Meek's inner turmoil: 'I hear a new world / . . . Haunting me, haunting me / How can I tell them / What's in store for me?' Like many outsiders before and since, Meek found that one way of dealing with a hostile world was to project himself, in his imagination at least, into another one.

Soon afterwards, Meek launched his own record company with backer William Barrington-Coupe. Triumph Records was to be completely independent, a brave move in a music industry dominated by the big four companies: EMI, Decca, Pye and Philips. Thus far, only Oriole and Polygon had been able to place hits and break this cartel, albeit sporadically. Although distributed by Saga Records, a budget classical label, Triumph would face problems with pressing and distribution from the off.

Disc covered the launch in March 1960, positioning Meek as 'pinning his flag to youth. He himself is only 28 and almost all the artists he has signed up are younger than himself.' The news story directly quoted the producer: 'Because we're young we know what the pop fans like. I'm a pop fan myself, so I should be able to tell. I don't think the big companies do know what the youngsters want . . . it's more of a case of hit and miss with them.'

Triumph's early releases included an EP from the *I Hear a New World* project, as well as teen pop by Yolanda and by Ricky Wayne. Despite being a tiny independent, the label had three hits in 1960: the Fabulous Flee-Rakkers' 'Green Jeans' made the Top 30; 'Ballad of a Teenage Girl', by *West Side Story* star George Chakiris, scraped into the Top 50; and in the early summer, Michael Cox's light, winsome 'Angela Jones' went to

#7. By August, however, Triumph was over, a victim of logistics, budgetary issues and Meek's short fuse.

Meek had already found a new backer, one Major Banks, and in late June, new premises that were larger and more discreet than his Ladbroke Grove apartment: a three-floor flat above a shoe shop at 304 Holloway Road, North London. On the first floor was his living room, office and waiting room. On the second was his studio, which measured thirteen by seventeen feet, and a small back-bedroom control room. There were three rooms at the top of the house: one where he slept and two for junk. The flat was comprehensively renovated and soundproofed.

Securing a deal with EMI subsidiary Top Rank, Meek now had a team that included local instrumental group the Stormers – soon to be renamed the Outlaws – and a whizz-kid teenage musical director, Charles Blackwell. Both group and arranger quickly became skilled at translating Meek's tuneless melodies into attractive pop songs, although this work was never credited.

———

I t was at this point that Robert Stigwood brought in John Leyton, who was quickly given a huge American hit by Ray Peterson to cover. 'Tell Laura I Love Her' was a classic death disc – an unsubtle genre of teen melodrama established by songs like 'Endless Sleep' and 'Teen Angel' – but the record was delayed in the UK because of the topic's sensitivity. When the dust settled, EMI found themselves with two versions on their release schedules. They decided to promote another cover by Ricky Valance, which went all the way to #1 in early autumn.

Another 1960 single, 'The Girl on the Floor Above', also flopped, but the record came to the attention of *Disc*'s Jack Good, the most perceptive music-paper critic of the period, who called it 'Captivating', referring to Blackwell as 'the master-mind' and '[s]urely the only teenage MD [musical director] in the business.'

In spring 1961, Stigwood booked Leyton to appear in a very popular series, *Harpers West One*, a soap opera about an upscale department store modelled on Selfridges. With a regular audience of around ten million

viewers, it was a prime promotional spot, especially since Stigwood had secured Leyton the role of a pop star opening an in-store record shop. What was even better was the fact that the pop star he would play, Johnny St. Cyr, would be singing his new song as part of the cameo.

The only problem was that the song was not yet written. Both Stigwood and Meek were in a panic as the deadline approached. The solution came from a twenty-three-year-old writer from Reading, Geoff Goddard, who had already placed an instrumental called 'Lone Rider' with the renamed Flee-Rekkers. Given the brief, Goddard quickly composed 'Johnny Remember Me'. When Stigwood heard it the day after its composition, he gave it the go-ahead.

Goddard's input was crucial to the record's gothic atmosphere. Like Meek, he was obsessed with the occult, and freely talked about channelling Buddy Holly and receiving messages from beyond the grave: 'Buddy said he would help me, and soon after that I started getting better ideas. I wrote my first recorded song, "Lone Rider", and then I wrote "Johnny Remember Me" . . . Buddy said it would reach number one – I believed him.'

The recording took a while, with Meek whipping up the galloping beat provided by the Outlaws. The main production work was in balancing Leyton's vocals and those of the classically trained Lissa Gray, which had to be overdubbed afterwards. There was also an issue with the BBC, who refused to play the record, objecting to the original line 'the girl I loved who died a year ago'. Leyton had to return to Holloway Road to dub the line 'the girl I loved and lost a year ago'.

On 24 July, Leyton's segment aired on *Harpers West One*. The clip still exists. Leyton, dressed in a leather jacket and a stripy, bohemian T-shirt, is in front of a record-shop set. The females in attendance start to scream and to touch him. There is a strange, dreamy quality in the slow-motion footage. On the words 'until the day I die', there is a big scream to cover up the lyrics. As the clip continues, the girls look like they want to devour him. Leyton crouches and emotes to more and more screams.

The clip is a classic pop wish-fulfilment fantasy. Leyton is not a star but is playing one in a performance that will ensure he fulfils his dream. The promotional opportunity afforded by this exposure was highlighted

in the press release for the record, which mentioned that 'in the episode of *HARPERS WEST ONE* in which he appears, John Leyton will make a personal appearance at the Store and his record will be strongly featured. This can be justly claimed as Britain's biggest ever record play.'

On 29 July, the day after the release of 'Johnny Remember Me', the press campaign started to bear fruit. *Disc* ran a review of the single, picking up on its cowboy influence – 'like a youthful Frankie Laine' – as well as a news story about the *Harpers West One* appearance. The same day, the record was reviewed on the BBC pop panel show *Juke Box Jury*. The singer was behind the scenes as the panel voted it a miss. 'Is that "Ghost Riders in the Sky"?' asked Spike Milligan, while the jazz musician and critic Benny Green observed that 'it should be in quarantine'.

But the reaction of the public and music industry professionals was instantaneous. 'Johnny Remember Me' was a new, distinctive sound matched to a new, innovative, cross-media campaign. In Liverpool, the manager of the city's principal record shop took notice. Instructed to watch the broadcast of *Harpers West One* by his boss, Brian Epstein, NEMS's assistant manager Alistair Taylor thought it forgettable and suggested that just five copies per shop would suffice.

Epstein, however, was taken by the record's dramatic impact. When the Top Rank rep came to NEMS to try to persuade the shop to take more copies, Epstein had it played again and again before ordering 250 copies – making NEMS the only north-western outlet to stock the record in bulk. As Taylor summarised: 'Thanks to Brian's ear for a hit, we had a sales rush. Brian was delighted and the rep confided that Brian's taste was rarely wrong. Orders from NEMS were always carefully examined in the London offices of the big record companies.'

'Johnny Remember Me' refined the otherworldliness of *I Hear a New World* into an irresistible teen tearjerker, and its rapid success brought attention not just to John Leyton but to the back-room boys involved with the record: Joe Meek, Charles Blackwell and Robert Stigwood. 'The tearaway climb of "Johnny Remember Me" has been a great delight to me,' wrote Jack Good on 26 August, 'not just because I like the record but because it backs up a number of ideas and people that this column and many of its readers have been rooting for for months.' He also thought

the inclusion of the song in *Harpers West One* looked forward to a new kind of peak-time presentation of pop music that went beyond the traditional light-entertainment setting.

'Johnny Remember Me' wasn't just a hit record; it was the product of a dynamic new team, a maverick mixture of youth and marginality intent on shaking up a hidebound British music industry. As if to cement his status as an innovator and outlier, in early September, Meek released one of his most terrifying recordings to date. Beginning with a scream, wailing winds and the sound of a coffin opening, the Moontrekkers' 'Night of the Vampire' was trailed as 'unsuitable for people with a nervous disposition' and was promptly banned by the BBC.

On 16 September 1961, with 'Johnny Remember Me' still at #1, Meek was the subject of a long interview in *Disc* – a rare honour for a producer in a pop economy obsessed with personalities and stars. After describing his studio to John Wells, he went on to say: 'To survive as an independent A&R man I've got to produce records that are different. This is the only advantage I have over the big companies, and working as a small unit like this I can do it.'

On the crest of a wave, the Leyton team released the follow-up while 'Johnny Remember Me' was at the top of the charts. One great pop nostrum, then and now, is that you don't fuck with the formula, but the best follow-ups extend it. This is exactly what 'Wild Wind' did. Pursuing a similar, elemental feel, with the galloping beat and high female vocals, the song plunges the listener straight into the maelstrom – 'Hear him howling, way across the plain / He's taking back his sister rain' – and continues, with no let-up, for just over two minutes.

If 'Johnny Remember Me' was melodramatic enough, the production on 'Wild Wind' is completely hysterical. Leyton hated the sound of his voice, but the production is an overwhelming evocation of loss and pain. Beginning quietly in the verses, the volume jumps in the choruses, where Leyton struggles against the heavily echoed, high-pitched female choir, and in the instrumental break the volume jumps even further to highlight Geoff Goddard's sped-up, out-of-control piano solo.

'Wild Wind' remains one of the most extreme records ever to reach the top of the charts. Along with the sheer infernal noise of the original

seven-inch single, which was cut extremely loud, there are the super-natural lyrics, which go beyond the tropes of teenage melodrama into somewhere disturbing and death-haunted: 'Hey there, wild wind, when my time is done / Carry my soul beyond the sun.' It's compulsive, an eruption of otherness and unease, a record that is truly queer in the widest sense.

The reviews were routine, but 'Wild Wind' was released with fantastic pre-orders. Interviewed in *Disc* that month, Leyton revealed that his ambition was 'a lasting career, naturally. There I'm happy to be advised by my manager, Bob Stigwood.' Indeed, Stigwood was in overdrive that early autumn: as well as the new single, there was the recording of Leyton's first album, the prospect of a film role and a well-publicised substitute spot on Larry Parnes's 'Star Spangled Nights' concert tour, after headliner Billy Fury had collapsed.

During October, 'Wild Wind' played tag with 'Johnny Remember Me' in the UK Top 20. By the 21st, both were in the Top 10. On 4 November, 'Wild Wind' reached its peak position of #2 – stymied this time by Helen Shapiro's 'Walking Back to Happiness', another force of nature and another of the year's biggest records. With his productions of 'Tribute to Buddy Holly' by Mike Berry at #24, 'Johnny Remember Me' at #28 and 'Night of the Vampire' at #50, Joe Meek was hot.

It was a golden moment. As well as four records in the Top 50, Meek had two albums ready to go: *The Two Sides of John Leyton* and the Outlaws' *Dream of the West*, the summation of his western fetish and the last with star drummer Bobby Graham. Then there was the question of Leyton's follow-up to 'Wild Wind', which had to be out before Christmas. Stigwood planned another splashy multimedia campaign, this time centred around a nine-minute short that could be shown in cinemas.

Released to coincide with Leyton's new single, the film was designed, in the singer's words, to take 'you inside the rehearsals for a show'. It was but one of several mooted film projects, including a guest appearance in *It's Trad, Dad!* and a major role in a full-length feature, *The Great Escape*. *The Johnny Leyton Touch* captures the singer at the peak of his success. It's a strange document – studied, camp, yet curiously innocent – with some outrageous make-up and, in Leyton's case, a striking striped sports shirt.

The film opens with a shot of Meek's new house band — soon to be known as the Tornados — playing in front of a full orchestra, directed by Charles Blackwell. The instrumental is a version of 'Taboo', a Cuban song from the 1930s reinvented by Arthur Lyman as an exotica classic, and it's a good one. After lip-synching his most recent hit, Leyton introduces a guest spot by Iain Gregory, another Stigwood protégé and Meek artist who hoped to reproduce Leyton's success, a hope dashed by the dreadful 'Can't You Hear the Beat of a Broken Heart'.

The film climaxes with Leyton introducing his new single. Having taken off his leather coat, the singer's striped shirt and cantilevered quiff take centre stage in what is a change of pace for the singer: 'Son, This Is She', a midtempo ballad with more traditional romantic lyrics – 'She you will love for all eternity.' This being a Geoff Goddard song, there's a hint of the supernatural, but the whole effect is conventional, surprisingly so after the innovations of the previous two records.

Everything was coming together. Reviewed effusively in *Disc* on 9 December, 'Son, This Is She' crashed straight into the paper's charts at #10 – a feat usually reserved for Cliff and Elvis. The triumvirate of Meek, Stigwood and Blackwell had pulled off a spectacular heist, but it was dependent on an impact that could not be fully repeated. The only option was for Meek to go even more extreme, to the limits of the sound that could be reproduced, and that was not possible with the material he was given.

Meek had succeeded in translating the gay experience into peerless pop melodrama, but it was achieved with an unstable coalition. It would be a short-lived triumph.

9
Billy Fury and Larry Parnes

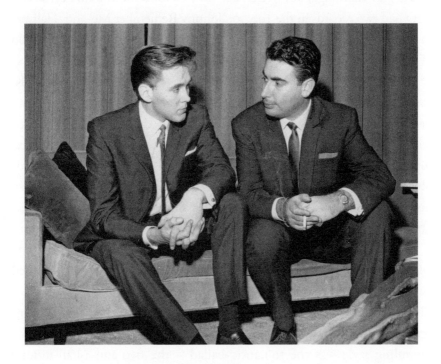

These singers are not remote stars, like Garbo, but tangible idealisations of the life of the average teenager – boys next door, of humble beginnings, almost certainly of working-class family, who have like the Greek gods done their 'labours' as van boy, messenger, truck-driver, film-cutter or clerk in a routine occupation (that is if they have not come straight from the 'labours' of the classroom). What makes the difference in himself and his fellows is that . . . he's got 'something' and luck – in the shape of John Kennedy or Larry Parnes, say – has come his way.

Stuart Hall and Paddy Whannel, *The Popular Arts*,
Chapter 10, 'The Young Audience', 1964

While 'Johnny Remember Me' was at its second week on top of the charts, Billy Fury's 'Halfway to Paradise' reached its peak position of #4. During that September, the two singers continued to play chart tag. Four weeks later, on 5 October, both John Leyton and Fury had two records in the Top 30: 'Johnny Remember Me' and 'Halfway to Paradise' were on the way down, while their respective sequels – 'Wild Wind' and 'Jealousy' – were going up, the latter to its peak of #2.

By the early autumn of 1961, Billy Fury was a big star in the UK, threatening to join Cliff Richard and Adam Faith at the top. It had been a long haul for the twenty-one-year-old singer, who was blessed with extraordinary looks – all chiselled cheekbones and moody glances, topped with an enormous quiff – but who had struggled to actualise his obvious potential. Although he'd begun as a sneering, sensational rocker, his full breakthrough came with his tenth single, 'Halfway to Paradise', a bouncy Goffin/King number in the teen mode of the time.

Fury's success epitomised the state of English pop in 1961, a time when the original energy of the first rock 'n' rollers had been subsumed within the music industry, which had realised, in the five years since Elvis's breakthrough, how to successfully market youth music to teenagers without so much of rock 'n' roll's primal, disruptive threat. The prevailing style was the romantic ballad – the two-and-a-half-minute teenage opera – which was aimed directly at the all-important female audience.

Intimacy and frenzy were the twin poles of this style. The ballad seemed to satisfy the longings of young women, evoking fantasies that sustained them in the secret solitude of the bedroom or, if they were lucky enough, elicited their screams alongside hundreds of their peers in ballrooms and theatres around the country. Pop was still a teenage culture then, underestimated, if not actually dismissed, by most adults in the UK and patronised by the men in record companies who had grown up with swing and Sinatra and who hated rock 'n' roll.

A new breed of younger, more marginal entrepreneur had rushed in to fill the gap. The Petri dish for British rock 'n' roll – and, as it transpired, British pop in general – was the launch of Tommy Steele in autumn 1956. Co-managed by John Kennedy and Larry Parnes, with

songs supplied by Lionel Bart, Steele had a dynamic and, as it happened, all-gay team behind him that – thanks to Bart and Parnes in particular – would propel him to almost instant success and go on to dominate British pop in the 1960s.

In 1956, Bart was already in his mid-twenties, gay, a jobbing songwriter for theatre and radio. A native East Ender, he used to attend to parties at a pop-up club called the Cave, which, he told writer Royston Ellis, was in a student house in Waterloo Road known as 'The Yellow Door'. 'A few fellows got together at the Cave and formed a skiffle group called the Cavemen. I teamed up with two of them, Mike Pratt and Tommy Steele, and we wrote a number called "Rock With The Caveman".'

Written as a send-up of Bill Haley, 'Rock with the Caveman' was a turning point in Bart's career. It peaked at #13 on the UK singles' chart, and Bart credited Steele as his 'ticket to ride'. Steele's first huge hit, however, was a cover of the American country song 'Singing the Blues', which competed in the charts with the original by Guy Mitchell. And there was the rub. What was the result of a complex process in the US appeared as a novelty in the UK. The early years of British rock 'n' roll involved a long, drawn-out struggle to input some individuality into what was an alien form. Covers of American records were fine and, indeed, provided most of the British rockers' material, but how to make it original?

The 1960s saw an explosion of home-grown rockers. While Tommy Steele settled down into his native cockney stylings, there was a succession of moody young teenagers, fans plucked from obscurity, who were prepared to take on the American style. The first and most successful was Cliff Richard, whose second single, the tough rocker 'Move It', defined what British rock 'n' roll could be. His first #1, however, was 'Living Doll': written by Lionel Bart, it was a light, dreamy ballad that defined the singer's strange malleability.

'I felt I had to broaden out,' Cliff told me in 1995. 'We had a rock 'n' roll hit, "Move It", which was number 2, and "High Class Baby", which went to number 7. But my first number 1 hit was "Living Doll". And it became obvious to me that, although everyone was talking about rock 'n' roll, they weren't buying it by the multi-million at all. They were still into ballads, and I went very heavily into ballads. When we sang, "Rock

'n' roll is here to stay," we didn't know it would turn out to be true. We hoped it was true, but we didn't know it.'

With the lack of radio play, television was all-important, and early UK rockers were given exposure on a sequence of programmes directed by Jack Good: *Six–Five Special, Wham!!* and *Oh Boy!* Classically educated and theatrically trained, Good realised that this new, exciting music should be presented in a new, exciting format. Through the use of lighting, pacing and set design, he created the model for how pop music should be presented on television. Key to this was schooling the untrained young singers in the basics of theatrical presentation.

British pop began by aping rock 'n' roll but quickly transmuted into something different: a form of performance in which packaging was as important as content. The key record in this was 'Living Doll', which stayed at #1 for six weeks, from July until mid-September 1959. Not only did it define the subsequent career trajectory for many UK singers – from rockers to balladeers – but, as far as Lionel Bart was concerned then, it opened up the market for home-grown material: 'Now after Living Doll there are many British songs among the top tunes.'

As the music industry began to cater to a younger generation stimulated by rock 'n' roll, it was hamstrung by its existing values and tastes. After a couple of fierce rockers, young performers were expected to conform to acceptable standards and move towards traditional show business. As Cliff Richard remembered, 'Norrie Paramor, who came from that big band era, wanted me to go into the studio and sing with an orchestra. So I went in and sang all these standards: "Idle Gossip", "That's My Desire", all standard, classic ballads.

'I don't know how well I sang them, my voice was very immature. But Norrie got me to sing in a certain way, and I was grateful for that, a way into the "legitimate" music. I knew that it was the right thing to do, I knew that we would sell a lot of records if I did this because we were on that cusp, still in variety but rock 'n' roll as well, and we were having to get the mums and dads on our side. Because deep down we knew that the mums and dads had the money. "Living Doll" got me a mum and dad audience.'

———

T he prime packager and the most important manager of the period was Larry Parnes, who quickly built on the success of Tommy Steele to sign and market a dozen or so young men who had all been touched by the rock 'n' roll bug. 'To be quite honest with you, there was no industry,' he told me when I interviewed him in 1985. 'Record companies were coming up with the same type of song, the same type of singers, nothing was changing. As a young man, you had doors closed in your face, people frowned on you.

'These old-timers would look over their glasses at you and they didn't know what you were talking about. They didn't know what rock 'n' roll was, they didn't have the slightest idea what was happening. I don't think the idea of a personal manager had been invented, because artists never had personal managers, they had ten-percenter agents. The music publishing industry was based in Denmark Street. I imagine it still is. However, I found that the only people that were perhaps looking for a change were the music publishers.

'I remember a very nice man at Peter Maurice Music Company who was an old-timer, but he had the instinct that something was going to change. Then Hugh Mendl at Decca, then Dick Rowe, and Johnny Franz at Philips, and I believe Norman Newell and Norrie Paramor at EMI, they were the first people in my opinion to recognise that a change was about to take place. But there were very few people. Enormous resistance. It was a barrier that you had to break through, and then within two years, these dusty old agents had started to sign people.'

Born in September 1929, Parnes had worked in retail – ladies' fashion – before getting involved with the Soho scene in the mid-1950s. He financed a play called *The House of Shame*; the publicist was John Kennedy, who created a scandal by dressing up the actresses as prostitutes and having them parade outside the theatre. With Steele up and running, safely tucked into traditional show business, Parnes started casting around for other clients. In 1957, Jack Good pointed him towards a young man from Blackheath called Reginald Smith.

Parnes explained to me the process of transmuting suburban teenagers into pop gold: 'Let's start with Marty Wilde, who was Reginald Smith, but the odd thing was that when he was playing at Sunday school, he

called himself Reg Paterson, and when I met him, to me, that sounded more like a boxer. I felt that Marty was a big, tall, strong fellow, and sometimes people get the wrong impression about big people, they think that big people are not friendly, so I thought he needed a friendly name.

'At the time there was a film out called *Marty*, I believe it was with Ernest Borgnine. Now because Marty was very religious, he didn't like the idea of moving onstage because he thought it was indecent. I tried to explain to him that it wasn't indecent, it was motivation, adrenalin, and I thought he needs a surname that might just bring him out of his shell, and I thought, what about "Wild"? Just for luck, because Steele had a lucky "e" on the end, I tagged an "e" on the end of Wild.'

Wilde remembered the effect of the transformation: 'I got back to my parents and said to my old man, "You'll never guess what my name is going to be . . ." He just looked, and in one second Reginald Leonard Smith had melted to the ground and here was this freak, Marty Wilde.' Within a few months, Wilde had a #4 hit with an excellent cover of Jody Reynolds' 'Endless Sleep' – one of the few great British rock 'n' roll records – and more successes followed in early 1959: three Top 3 hits, all covers of American songs – 'Donna', 'Sea of Love' and 'A Teenager in Love'.

Thus encouraged, Parnes quickly signed a number of other performers, all remodelled and renamed: Roy Taylor became Vince Eager, John Askew became Johnny Gentle, Richard Kneller became Dickie Pride, and Ronald Wycherley became Billy Fury. 'At the odd little dates he was doing when he wasn't working on the ferry boats, he called himself Stene Wycherley,' Parnes remembered. 'I didn't like that at all when I auditioned him. He was always a very shy, loveable person, and he needed a loveable, friendly name.

'Now Billy Cotton and his band were just the most loveable people around, and I thought, what could be better than Billy? Now because he was so shy, he had to have a surname which motivates him, and hence, Fury. And I wanted to put an "e" on it. Making FURIE. Every time I wrote it down, it didn't look right, so it had to be FURY. Then, funnily enough, along came the film director, Sidney Furie . . . There was always something to do with their personality, psychoanalysing people and thinking, they need this.'

What Parnes did brilliantly was to set out a range of emotional possibilities that were directly encoded into each performer's identity. Other impresarios, most notably Henry Willson, had renamed and reshaped their raw material, but Parnes's clients were launched directly at the heart of the teenage girl. The intent was not sexual but dramatic: 'I can't think of a single name I made up that was sexually motivated or had anything to do with sex. I don't know: Wilde, Fury, Eager, Pride, Gentle . . . I don't know, maybe there is, but it certainly wasn't intended.'

Parnes was charming and paternalistic, but also authoritarian and stubborn. He kept his 'boys' on a short leash, controlling their money and shaping their material and presentation. He offered two types of contract to cover his expenses for overheads and development: a straight percentage or a guaranteed salary over five years and 60 per cent of the record royalties. While some of his artists have since complained about his tight-fistedness, Marty Wilde felt that he had a fair deal: 'Until he signed too many artists, most of the people that went with him had success.'

To a degree that was unusual in the UK at the time, Parnes lavished attention on his young protégés, taking over their lives with careful grooming, a new wardrobe and control of their finances. Most of his Stable of Stars – as they became known – were Londoners and remained in London with their parents. However, Eager and Fury were from Grantham and Liverpool respectively, and so they stayed with Parnes at his flat on Gloucester Road. Fury had the room next to Parnes, while Eager was down the corridor.

This was a major life change for the disadvantaged young men, particularly Fury, who was brought up poor in Liverpool's inner-city Dingle area. The interior of Parnes's flat was lavish, with, as Fury's biographer David Stafford explains, 'classical pillars, gilt chairs covered in silk and a massive marble-topped table. The master bedroom was a riot of fluffy pink, with lambskin rugs, lacy lampshades and a kidney-shaped dressing table.'

Perhaps Parnes was unwise to invite the BBC into his flat for a *Panorama* programme called 'Beat Svengali'. The commentary, by future Tory MP Christopher Chataway, oozed class condescension. 'In the

staid, respectable district of Kensington,' he opens, 'there's a nice, upper-income-bracket block of flats. Inside, a doormat, over which pass some rather flashy feet. The doormat belongs to Mr Laurence Maurice Parnes, who also owns a batch of golden boys. He creates them, and manages them and their money.'

With Chataway accentuating Parnes's name and words like 'nice' and 'flashy', the direct inference was that this was not a respectable industry; indeed, it was a highly marginal one. Parnes radiated paternalistic charm in this rather exotic environment, referring to the regime he put his protégés through, from clothing them to ensuring they were well fed and rested. Meanwhile, Johnny Gentle, Vince Eager, Billy Fury and Duffy Power lounged on or around a large sofa. Behind them was a framed picture of Tommy Steele.

The four young men looked similar in the clip, with their quiffs, open-necked shirts and slightly surly demeanour. Chataway smelled a rat and asked the assembled stars whether or not they felt that they were being manipulated like puppets. Fury reminded him that each performance was down to the individual singer rather than the manager, that he was onstage rather than Parnes, while Eager claimed that 'it all amounts to having faith in your manipulators'.

This was catnip for the actor and humourist Peter Sellers, who sent the whole thing up in his wicked skit, 'So Little Time'. Included on his second album, *Songs for Swingin' Sellers* – a Top 3 hit in early 1960 – this was a parody interview with 'horse dealer' Major Rafe Ralph and his stars Lenny Bronze, Clint Thigh, Matt Lust, Twit Conway, the Fleshpots and the Muckrakers.

While undetectable to many listeners, the homosexual implications were clear. Interviewee Nancy Lisbon was a parody of well-known lesbian journalist Nancy Spain, while the major talks about the boys and him having 'a very beautiful relationship'. Parnes professed not to mind: 'Peter Sellers did a satire on me. I thought it was very funny. I never minded those kinds of things.'

Parnes was as open about his sexuality as you could be in that period, and he wasn't the only homosexual involved in UK pop in the late 1950s and early '60s. Once he had become a subject for the mainstream

media, the stories and the parodies tiptoed around the question, and in this way the idea of the gay manager began to gain currency beyond a tiny show-business clique. It wasn't just Parnes either: the British music industry, like the theatre and the arts in general, was a safe haven for those deemed sexually and socially deviant during this period.

There were several other reasons why pop was so attractive to the marginal. Because rock 'n' roll had been such a rupture, the pop economy that followed it favoured the young and the ambitious, simply because the established industry found it hard to comprehend, let alone market and sell. The fast-talking Soho hustler became another archetype of the period, whether John Kennedy, Larry Parnes or the fictional figure of Johnny Jackson in the successful stage show *Expresso Bongo*, which was filmed in 1959, starring Laurence Harvey and Cliff Richard.

Men like Parnes or Joe Meek, denied opportunities in more established fields, rushed to capitalise on this new form of music and, by accident, helped to change the British music industry. Less committed to traditional mores because of their sexuality and socially marginal status, they were better placed to seize the opportunity and shape it into an expression of their own desires – which happened to coincide with those of the all-important female audience.

It wasn't entirely cynical or opportunistic, for, although slightly older than the rock 'n' roll generation – both were nearing thirty – Parnes and Meek loved pop music and the excitement it generated. It spoke to something inside of them that wanted more out of life, that maybe even divined a more relaxed and free future. Whether it be Parnes transfixed by the crowds around the Palladium, screaming for Johnnie Ray, or Meek holding seances for the dead spirit of Buddy Holly, they were fans. They were in it, obsessed.

In the early-to-mid-1950s, when Henry Willson was producing stars to order, the model had been all-American, rugged and macho, whatever the reality of the situation. By the time that Parnes was industrialising the process in the later 1950s, the model was definitely post-Elvis, moody, slim and yet slightly feminised to suit their audience – indeed, not too dissimilar from the young men pictured in the physique magazines aimed at the emerging gay market during this period.

Much like Willson had done a few years before, Parnes was not averse to sampling the merchandise. His secretary, Muriel Walker, remembered that 'there was always a troupe of boys in and out of Larry's flat, but not the singers, not the acts. He always separated business from pleasure – road managers, perhaps, hangers-on and helpers, but not the acts.' In contrast, the embittered Vince Eager has insisted otherwise: 'He fancied all of us.' Whether or not that translated into sexual activity is not recorded.

Parnes was frank about his power within the industry and his desire to manipulate the market in favour of his charges. In August 1959, the *Melody Maker* reported that when the jazz critic Bob Dawbarn asked Parnes whether he thought teenage tastes had changed much over the past couple of years, Parnes replied: 'They have not so much changed as had their tastes changed for them.' Ordinary boys turned into celebrities were an important part of this process.

The gay influence on British pop was referred to in an extraordinary book published in early 1961. Written by the young Beat poet Royston Ellis, *The Big Beat Scene* was the first-ever history of British pop from within. Later identifying as bisexual, Ellis was sensitive to the sexual undertones behind what he called the current vogue for 'the Big Beat stars to be promoted as ordinary people. Through efforts to convince the public that their guitar-strumming hero is just like the boy next door, fans are brought closer to their idol.' The reality was quite different.

Born in 1941, Ellis had had his head turned in the mid-1950s by seeing *Rebel Without a Cause* and *Blackboard Jungle*. In the late '50s, he gravitated towards the Soho scene: he wanted to promote his poetry in a contemporary format – 'properly, like a pop star'. In 1959, he published his first book of poetry, *Jiving to Gyp*, and, after meeting Cliff Richard, fell into the circle that surrounded Ray Mackender, a gay Lloyds' underwriter with entrepreneurial ambitions and a Chelsea flat.

Mackender had hopes of becoming Cliff Richard's manager. It never happened, but Ellis became drawn into Cliff's orbit, to the extent that the Shadows' Jet Harris and Tony Meehan backed the young poet on a couple of occasions, including an event called 'Rocketry – Rock and Roll Poetry'. Ellis spent so much time with the group that, in 1961, he wrote

their first biography, *Cliff Richard and the Shadows*. The canny Cliff gave little away about his motivations, but admitted that he was part of the process of 'cleaning up' rock 'n' roll with 'Living Doll'.

After working with the Shadows, Ellis sought other musicians to back him. On one occasion, he worked with a young guitarist from South-West London, Jimmy Page. In June 1960, he went up to Liverpool to give a lecture called 'Jazz and Poetry' in the basement coffee bar at Liverpool University. John Lennon, Stuart Sutcliffe and George Harrison were in the audience, and Harrison invited him to stay at Lennon's Gambier Terrace pad for a few days. Ellis was impressed by its beatnik quality: 'a glorious communal atmosphere'.

He found them eager for any information he could give them about the London music industry. To the jaded Soho-ite, the young Liverpudlians were not very streetwise. They didn't even know how to get high, and were impressed when he showed them how to break open a nasal inhaler to extract the Benzedrine within. They became fast friends, and the Beetles – as he described them to the press at the time – backed him in a performance of music and poetry at the Jacaranda, most notably of his ode to buggery, 'Break Me in Easy'.

Ellis began *The Big Beat Scene* with a day-in-the-life of a fictional pop musician, Tavy Tender, and his group. The musicians meet in Soho, inhale some Benzedrine and pack up for an out-of-town gig. They're not top-flight, but 'for the people in the dance halls, Tavy and his hip-twitching friends serve as a welcome substitute for their unobtainable real idols'. On the way back from the show, the group sing 'the words of a song that won't make the hit parade but every beat musician knows':

> Larry fucks our arses
> Our arses, our arses
> Larry fucks our arses
> And we become stars

This passage was remarkably frank, if not libellous, for 1961, and cut from the book's original edition. Ellis wasn't finished there. At the end of *The Big Beat Scene*, in a chapter centred on Larry Parnes and Billy Fury, he wrote: 'The situation where good-looking boys are managed and guided

by older men is comparable to the days of Ancient Greece when handsome young athletes were feted by maturer adults . . . Homosexuality is certainly common in the big beat business . . . various aspects are discussed, joked about and even practised among some of the stars.'

This was also censored, quite rightly so, as at the time any such activity could well have made the people concerned liable to blackmail, exposure or prison. However, *The Big Beat Scene* did retain another passage which hinted at the influence of the gay world on the music scene: 'New words have seeped into the [young beatsters'] conversation by way of the Soho gutters, Italian exiles and imaginative jokers. Using these words, the beat musicians have invented their own language . . . "Varda (look at) the mystery" a Big Beat singer might say.'

What Ellis went on to describe was the long-established gay code of Polari. He quotes examples like '"it was cod: there were deviations and we played kinky notes". This can be translated by reading "horrible" for COD, "setbacks" for DEVIATIONS, and "wrong" for KINKY. Baffling, but the teen stars' secret slang seems to have more to recommend it than the phoney shrieks of "Way out, daddy-o" beloved by film producers searching for authenticity.'

———

Within the Larry Parnes stable, Fury was *primus inter pares*. 'Billy and I had a very, very special, brotherly friendship,' Parnes told me. 'He was a very private person. He would finish his act on stage, take his applause, very rarely go back for an encore, go straight off stage, into his car and away. He had a heart of gold. I suppose he was a very vulnerable person, because he was so sensitive and shy. Billy never went to nightclubs, discotheques, bars or anything. He was Ronald Wycherley the moment he came off stage. Yet he had a great affection for his fans.'

Despite his looks and obvious talent, Fury's rise to the top was slow. He was initially given the latitude by Parnes to perform his own compositions rather than have songs foisted on him: five out of his first six singles were written by him, and three of them were Top 20 hits. He also

released one of the great British rock 'n' roll albums, *The Sound of Fury*, in May 1960, writing every one of the ten tracks in a tour de force not repeated until 1964, with the Beatles' *A Hard Day's Night*.

Slowly, Fury was making the required transition to a more accomplished, if not all-round, entertainer. To some extent, this was forced on him. In late 1959, he had made the headlines after an appearance in Dublin was curtailed because his act was too suggestive. A contemporary account described a 'kind of striptease', before Fury started simulating sex with the microphone. This precipitated something of a family crisis, and shortly afterwards, Fury told the press that the humping had to stop: on his father's advice, he was making his act cleaner.

During the first half of 1960, Parnes began to weed out the non-events from his stable. Vince Eager was dropped after a major argument about material, while Dickie Pride was fired after his drug use made him unreliable. Marty Wilde was already fading, and Tommy Steele was up and running in variety. That left just Billy Fury.

In spring 1960, Fury had his biggest hit to date with 'Colette', a brief but bright, self-penned Buddy Holly/Everly Brothers-style confection that was smoothed out by mellifluous backing vocals. Despite the quality of singles like 'Wondrous Place' – one of the best British records of that period – 'Colette' would be his last top tenner until the following year. Something was going wrong with the plan, and some of that was due to the shift in style away from rock 'n' roll – Billy's forte – into something more finessed, if not actively bland.

Parnes began putting together large package tours, like October 1960's 'Rock 'n Trad Spectacular', starring Fury and several others from his stable. As the headliner, Fury was interviewed by *Disc*, under the headline 'Mean, Moody and All Mixed Up'. He showed a canny awareness of the shortfalls in his career to date: 'I think I've got to be more commercial. In the past my records have sold like a bomb for the first week and then they slip to a steady sale. That's why I never get into the charts.'

By early 1961, Fury was the big star who hadn't quite happened. Despite his rampant stage shows, good looks and some fine material, he had not ascended to the home-grown heights of Cliff and Adam Faith. As singles like 'A Thousand Stars' and 'Don't Worry' struggled into the

charts, Jack Good opined, 'Are the Moodies Finished?', positing clean, smart new stars like Jess Conrad as the new role models. 'They all seemed so very happy. And willing to talk. Not at all shy, reticent and moody like Billy Fury. Like man, they have no problems.'

In fact, Fury did have serious problems. He had contracted rheumatic fever as a child, which had left him with a heart defect. He was frequently exhausted and prone to nervous and physical collapses. He self-medicated with the prodigious consumption of marijuana, a habit still so unusual in the UK that no one commented on it at the time. However, as his girlfriend Lee Everett remembered: 'It was common in the Parnes stable; Billy smoked grass from getting up in the morning to going to bed at night.'

In the spring, Parnes and his A&R man at Decca, Dick Rowe, decided on a relaunch. 'Halfway to Paradise' was a ballad tailor-made for the charts, and it worked. As it entered the Top 10, a spaced-out Fury talked to *Disc*. 'I forget meal times,' he told Dick Tatham, 'dates with girls. The names of streets around my home in Liverpool. Where I've left the car. Which town I'm supposed to be playing in.' The article presented him as prone to entering light trances and obsessed with death, seances and the idea of reincarnation: shades of Joe Meek.

This vulnerability and otherness was a major part of Fury's appeal. He appeared to be from another world, apart from the mundane – a very useful attribute for a major star. As John Leyton was finding out at the same time, hints of the occult did not debar success and fame in the UK pop culture of the early 1960s. Death discs were popular and morbidity seemed to be a part of pop stardom, with the sudden and much-mourned deaths of Eddie Cochran and Buddy Holly still exciting comment and record sales.

Coinciding with the discovery of new worlds like the moon, and with the space race in general, this outsider quality also captured the novelty and oddity of a British pop-music industry that was being created on the hoof. Everything was new and strange. Pop then was technological, a quality emphasised in the pop press's description of production techniques like tape loops and electronic sounds, and mirrored in the extravagant clothes worn by many stars – especially Fury,

in his reflective gold lamé suit, which, via Elvis, looked like some pro-jection from the future.

Fury's follow-up to 'Halfway to Paradise' was even more mainstream. Written in the mid-1920s by a Danish violinist called Jacob Gade, 'Jealousy' was a big, blowsy ballad that had already been covered by Vera Lynn, Leslie 'Hutch' Hutchinson and Frankie Laine – stars from previous pop generations. Fury's version was passable, although he does struggle somewhat with the song's melodramatic shifts, and it's not nearly as indi-vidual as some of his previous records.

'Jealousy' was far from exciting, but it was Fury's biggest hit, top-ping out at #2, below the Shadows' prime slice of exotica, 'Kon-Tiki', in early October 1961. However, success brought burnout. The brutal pace of 1960s pop stardom demanded non-stop interviews, TV and radio appearances and seemingly never-ending tours. On 24 October 1961, eight dates into Parnes's 'Star Spangled Nights' tour, Fury collapsed in a taxi in Cambridge city centre and was rushed to hospital with kidney stones.

The pressure was relentless, with dates booked until early December, when the follow-up to 'Jealousy' was released. 'I'd Never Find Another You' was another Goffin/King song, which Fury thought 'syrupy', but it quickly went into the charts, on the way to an eventual destination of #5. Yet his career trajectory – the way he was pushed towards singing ballads as opposed to rock 'n' roll and blues – was indicative of an industry that was becoming subsumed within more traditional ideas of entertainment.

Having initially been a self-starting writer and performer, Fury was no longer in charge of his own destiny. His material was chosen by Dick Rowe and his interviews dictated by Larry Parnes. Jack Good caught this mood in a *Disc* column titled 'The Time Is Ripe for the Big Change': 'Now the current scene is the establishment, and the whole industry is geared to exploit it to the full. Result? Hit records are polished, profes-sional and uninspired, turned out as if from a sausage machine. The big stars in the beat music field have been tamed.'

———

Yet there was another side to this business. Ameliorative and conventional the British pop scene might have been in terms of records, but it was a home-grown industry that was beginning to flex its muscles, particularly in relation to America's dominance. In the UK's top ten best-selling singles of 1961, four were by Americans – two by Elvis Presley, the biggest star of the era – and six by Brits. The latter included 'Johnny Remember Me' at #4, 'You Don't Know' and 'Walking Back to Happiness' at #3 and #5 respectively, and 'Halfway to Paradise' at #9.

Within a still static country, stuck in the mentality of the 1950s, the UK music industry could offer novelty, opportunity and excitement to those who had found the conventional path to success barred to them, because of either their sexuality, ethnicity, temperament or class status. There was no ideology except sex appeal, technological innovation and chart success, and very little attention from the adult world – the serious newspapers, the cultural establishment. But for those of a restless, forward-looking outlook, it was the only game in town.

After pioneering mavericks like Meek, Parnes, Bart and Stigwood had carved out a place for themselves in this dynamic new arena, other marginals were anxious to join in, whether as performers or managers, and they would shape the years to come. One of these was a Liverpool shop owner called Brian Epstein, who had been circling the music industry for a while – predicting the success of 'Johnny Remember Me', meeting Larry Parnes when the Gene Vincent tour he was promoting visited Liverpool in May 1960, or writing to Lionel Bart for advice.

'He was not ostentatious,' Bart told me in 1997. 'He was a fan, I really have to say. There was this young Liverpool person calling me with a posh accent really. He said, "I'm from Liverpool," and he worked in the record section of his father's family department store. He was up on what was going down in the charts, and in those days it was me a lot. I'd just had an immense hit with Cliff Richard doing my song "Living Doll", and it had broken all records in his little shop there.

'So he said he'd love to come down and meet me. We corresponded for a year or two, until eventually he did appear, and he looked the same then as he always did – immaculate. The suit, the very highly polished shoes, the tie, the cufflinks – terribly correct, more British than I think

he needed to be. But he kept this thing up, and it wasn't an image. That was what he presented to the world. He blushed easily. He couldn't take compliments.'

By the early 1960s, Epstein was a man in search of a mission. Despite many humiliations and setbacks, he had reinvented himself as a successful businessman, running the electrical and musical side of the family business at NEMS stores in the centre of Liverpool. Born in September 1934, he was in some ways a product of the pre-war world in his formality and politeness, but in others he was beamed into the future. Seeing the potential of pop music, through his organisational skills he reshaped NEMS into the north-west's go-to record shop.

Epstein was a knot of contradictions: blessed with a strong social conscience, yet in love with the idea of the jet set; a careful and meticulous professional, yet a compulsive risk-taker and seeker of danger. His beautifully cultivated facade concealed a roil of emotions and an extremely volatile temperament: the charm could be replaced by a storm of anger which would just as quickly pass. In autumn 1961, he had just turned twenty-seven. He was successful, but bored. Most of all, he wanted to get out of suburbia as fast as he could.

He became drawn to the vibrant Merseyside music scene when he met Bill Harry, who was seeking funding for his new magazine, *Mersey Beat*. In August 1961, he began writing a record column for Harry called 'Pop's Galore', in which he demonstrated that he was on the ball as far as current trends were concerned, noting the 'good potential' of a forthcoming single by Chubby Checker called 'Let's Twist Again', citing 'Johnny Remember Me' and 'Jealousy' as top local sellers and tipping new singles by Roy Orbison, the Mar-Keys and Timi Yuro.

The sequence of events that brought Epstein to the Beatles in early December 1961 have been well rehearsed: the frequent mentions of the group in *Mersey Beat* throughout the summer and early autumn, and the late-October release of the single that they'd recorded in Germany with Tony Sheridan, 'My Bonnie'. Epstein prided himself on being able to source any record that his customers wanted, and when requests for 'My Bonnie' came in, his interest was piqued. He ordered twenty-five copies, and they sold out within a couple of hours.

As their confidant Bob Wooler told biographer Mark Lewisohn, the Beatles were at a crossroads: 'They were definitely going to collapse as an entity unless something happened for them, and I suggested I write to Jack Good, who was linked with Decca at the time.'

On 9 December, Epstein visited the Cavern, where the group had a residency, in tandem with his assistant, Alistair Taylor. While Taylor thought it 'a dreadful racket', Epstein was intrigued by the fact that they wrote their own songs and was bowled over by their presence: as he later said, 'I never thought that they would be anything less than the greatest stars in the world – and I mean that . . . I sensed something big, if it could be at once harnessed and at the same time left untamed.'

Epstein's decision that he wanted to be involved with the group was instantaneous, yet he proceeded cautiously. He saw them in concert a few more times, just to make sure, and organised a meeting on the 29th of the month, when he declared his interest in managing their careers. The next day, taking copies of 'My Bonnie' with him, he went down to London for the first of innumerable meetings with EMI and Decca, to try to get them interested in this leather-clad group who didn't even sing on the record but merely provided instrumental accompaniment for Tony Sheridan.

A few days later, he had a second meeting with the Beatles, where all agreed that he should be the group's manager. Epstein had no interest in being a Larry Parnes-type Svengali – most probably because he intuited that this would not work with a four-man group, and also because it was not in his nature. He kept his comments about their music to a minimum, concentrating initially on packaging the group with a formal photo session and introducing discipline into their working lives. What Epstein could offer the group was stability, belief and vision. From the very off, he aimed for the top. At one of the initial meetings, he told the band that they would be bigger than Elvis.

In 1961, the music industry was in need of some energy. There was a sense, by the end of the year, that the rock 'n' roll explosion and its subsequent aftershocks were beginning to subside. Apart from Joe Meek, fighting his lonely corner in North London, the former mavericks had become integrated within an industry that had discovered pop only to

turn it into business as usual – even though business as usual is always a contradiction in terms when you're trying to catch the emotional and social zeitgeist.

Epstein was the novice manager of a rough group from a nowhere town, yet, as his ghostwriter Derek Taylor told me: 'Thinking big was what bound Brian and the boys together. They all did think big. Very high notions of themselves, and very high expectations. When he signed them up, when he had them in that office in Whitechapel, he told them, "I think I can help you." He actually believed he could, and he was prepared to sit it out with them, with all their cheek and impudence . . . In a way they had a lot in common, just the vernacular was different.'

Nevertheless, in late 1961, Epstein was going totally against the grain. The mode of the moment was solo artists; groups, as *Disc* informed its readers that December, did not 'stand a chance on disc'. In the last chart of that year, there were no vocal and instrumental groups in the Top 20. The post-Elvis establishment held sway, with solo vocalists and bandleaders dominating. It seemed like a merry-go-round of the same few acts that had been in the charts all year: Elvis, Adam Faith, Cliff Richard, Bobby Vee, Del Shannon, together with longer-lasting singers like Frankie Vaughan, Bobby Darin and Connie Francis. Billy Fury was at #15 with 'I'd Never Find Another You', and John Leyton at #41 with 'Son, This Is She'.

The only groups in the Top 50 were the Shadows, the cod 1920s satirists the Temperance Seven and a new folk-pop act, the Springfields, at #32 with their third single, 'Bambino'. Despite the headway made by British acts, a preponderance of ballads and the lack of Black American music in the charts gave the lie. Jack Good might have been harsh in his assessment that 'pop 1961' was 'affluent, slick, sleek, flabby, unoriginal, superficially smug', but it had more than a grain of truth. The current way of operating was becoming obsolete.

10
Colin MacInnes and Teenage Fashion

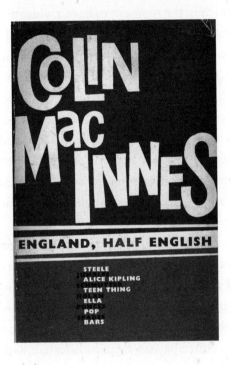

Billy Fury has fair hair, a snub nose, and blue eyes which carry a far-away expression – as if he is forever wondering what this world is all about. When I met him he was wearing a purple jacket, bright red tie, grey trousers and black shoes pointed like the prow of a destroyer.

Dick Tatham, 'Let's Dig a Little Deeper', *Disc*, 29 July 1961

There was little serious journalism in England about the youth movement in music and fashion that was germinating in the early 1960s. For the daily newspapers, the subject was pretty much beneath contempt, while the pop press was simply concerned with reviews of records and the occasional live show and interviews with current hot properties, too much in the moment to have a wider perspective. Pop was outside the mainstream, and the few people who did address the topic were themselves outsiders, debarred by their lifestyle or sexuality.

In September 1961, the writer Colin MacInnes published *England, Half English*, his first collection of journalism. MacInnes was already well known as a successful novelist who specialised in marginal worlds, but the essays on teenage music, fashion and social organisation, spanning from 1957 to 1960, in this new book marked him out as being the most perceptive commenter on this new social cohort. The extraordinary thing was that he was in his forties, old enough to be a father to the teens he so carefully mapped.

A complex character, MacInnes was born in August 1914 to artistic royalty: he was the grandson of the Pre-Raphaelite painter Edward Burne-Jones and the son of the successful novelist Angela Thirkell. He was, however, damaged by his parents' unhappy marriage – his father was a violent alcoholic – and unsettled by a peripatetic adolescence spent shuttling between Australia and Britain. Bisexual, with a preference for men, at a time when homosexuality was illegal, he identified with society's outcasts, principally criminals, teenagers and Afro-Caribbeans.

MacInnes could be charming and generous, but his mood would shift, and he would become a challenging verbal pugilist. Despite his upper-middle-class upbringing, as an adult he lived like a monk, always on the edge of penury, and was happy to proclaim his radical political inclinations. These, however, could be subverted in an instant by a sudden attack of hauteur. He was rarely relaxed in his own skin; he wanted to be free like the outsiders who were his subjects and friends, but in the words of one of them, 'He couldn't give – he was taking all the time.'

What MacInnes did between 1957 and 1961, in his essays and his best-selling novel *Absolute Beginners*, was to record and analyse the growth of British pop and youth culture with a novelist's eye for detail

and narrative and an outcast's sympathy. He was, as Tony Gould titled his biography, the consummate 'inside outsider', half in the establishment, half out, and his ambivalences refused to let him settle, leaving him half formed and restless, like the teenagers he wrote about with such care and attention.

This was a remarkable feat. Many of his articles appeared in literary/political monthlies like *The Twentieth Century* and *Encounter*, a putatively left-wing monthly that was backed by the CIA – this was still the Cold War – and co-edited by the poet Stephen Spender and the neoconservative journalist and thinker Irving Kristol. MacInnes was not writing about teenagers for teenagers – in the language of the pop press – but for informed adults who nevertheless knew almost nothing about this secret world that existed under their noses.

MacInnes was both fan and fascinated, but his articles show a sharp eye for detail, a cool anthropologist's eye and a wider range of references than was usually applied to youth culture. He called Elvis 'a reversion to the Valentino era, with his sleeked, slick locks and sideburns, and his baleful, full-lipped Neronic glare'. He took his reportage seriously: as he wrote, 'It does seem to me that the teenager is a key figure for understanding the 1950s; and that song is, and always has been, a key indication of the culture of a society.'

His first article on the topic, 'Young England, Half English: The Pied Piper from Bermondsey', was stimulated by seeing Tommy Steele live in concert. Published in December 1957, MacInnes's article was acutely prescient: observing the singer's rabid fans, he thought that English teenagers had found 'a troubadour with whom they can identify themselves more fully than they ever could with Elvis or with Johnnie Ray'. Citing Steele's songwriters, Lionel Bart and Michael Pratt, who wrote in an English vernacular, he wondered whether there could be a distinctively English pop culture.

MacInnes was quick to understand that this apparently transient phenomenon indicated a profound social shift: 'Today, youth has money, and teenagers have become a power.' He developed this theme in a February 1958 article titled 'Pop Songs and Teenagers': 'We are in the presence, here, of an entirely new phenomenon in human history: that youth is

rich.' Estimating that there were two million adolescents between the ages of fifteen and twenty-three, and that they each had £3 disposable income a week, he arrived at an annual 'teenage kitty' of £312,000,000.

In asserting the importance of pop and youth culture as topics of serious study, MacInnes was in the vanguard, and he wasn't above a sideswipe at those who didn't get it: 'The hostility of some adults to teen-agers . . . is as sterile as that hatred educated people often seem to have for television: a morbid dislike of these symbols of popular culture which they feel are undermining not so much culture itself, as their hitherto exclusive possession of it.'

MacInnes's article pre-dated the most important youth culture docu-ment of the 1950s, Mark Abrams' 'The Teenage Consumer', published in July 1959 by the London Press Exchange, one of the UK's leading advertising agencies. An East Ender and LSE graduate, Abrams had become the UK's foremost market researcher in the years before the war, inaugurating – among other things – the ABC system of class categori-sation. Using opinion polls and social surveys, he began to focus more on the topic of youth in the 1950s.

The whole purpose of the paper was to alert advertisers, manufacturers and the media to this hitherto ill-defined and poorly understood cohort. 'The Teenage Consumer' proclaimed the appearance of 'a significant new economic group': teenagers. Abrams defined them as being between thir-teen and twenty-five years old – the classic age range as defined by the first explorer of this topic, the American psychologist G. Stanley Hall, in his 1904 book *Adolescence* – and as 'newly enfranchised, in an economic sense'.

Abrams observed the effects of the post-war baby and economic booms. By mid-1958, there were 6,450,000 young people aged between fifteen and twenty-five. In this period, unemployment was low and the young could command good wages: Abrams estimated that they were earning about £1,480,000,000 a year in total, which, after taxes and deductions, ended up at a figure of '£900 millions a year to be spent by teenagers at their own discretion' – which was double their spending power in 1939. This was a huge new market.

In a table of teenagers' expenditure, women's clothing came out on top (£120 million a year) followed by cigarettes, men's clothing and alcohol

(all over £40 million a year). Other products consumed included books, magazines, cosmetics, bicycles, cinema admissions, holidays, chocolate, soft drinks and records, of which nearly half the total sales were down to teenagers. Cinema-going was the most common activity, with attending dances and taking part in clubs and classes also popular.

The volatility of this market was emphasised by Abrams, who advised manufacturers to accept the need for 'frequent change'. He summarised 'the short teenage years between childhood and marriage' as 'a period of intense preoccupation with discovering one's identity, with establishing new relations with one's peers and one's elders and with the other sex. In short, teenagers more than any other section of the community are looking for goods and services which are highly charged emotionally.'

The pamphlet was highly influential. It codified these adolescents as consumers and promoted the teenager as a significant commercial and social force within the UK. This change that Abrams described was already occurring, and indeed had been the focus of media attention in newsreels like Pathé's June 1958 'It's the Age of the Teenager', but he had given it a name, a focus and a price. In doing so, he also ratified the definition of youth that had arisen a decade and a half before, when the word 'teenage' passed into general currency within the US.

MacInnes's third major article on the topic appeared a month after the Abrams pamphlet, and in it he took up the importance of male clothing as a prime item of youth expenditure. 'Sharp Schmutter' began by out-lining in great and accurate detail the 'aggressively elegant silhouette of any sharp English working-class boy today'. No hats were worn, unless 'very small-brimmed', and the hair was 'short, fashioned to lie flat with burned-in parting'. No respectable teen would be seen dead in tweeds, American drapes or any hint of 'the Ted Thing'.

In a very short time, British teenagers had begun to develop a sophisti-cated caste system – running parallel to, if not directly on, class lines – that was expressed in the details of their dress and the type of music that they listened to. The teenage market had expanded so quickly that the possi-bility of, if not the need for, differentiation was already there. There was a fanaticism in the assumption of these cultural signifiers, and a desperate search for identity that often spilled over into gang-like hostility.

By 1959 the Teddy Boy style had long been superseded, and tended to be worn by working-class youngsters, who hated middle-class trad fans and the possibly queer modernists. This loathing was healthily reciprocated by the other two parties, who were also not that keen on each other. The modernists were above all cool, reflecting the music of Miles Davis, Dave Brubeck and the like, and thought the trad fans' galumphing scruffiness ridiculous. In turn, trad fans were mystified by what they considered to be the modernists' politics and lack of affect.

These youth tribes formed the subcultural backdrop to MacInnes's fourth novel, published in August 1959. *Absolute Beginners* climaxed with the Notting Hill race riots that had occurred the previous year, a stark, dramatic sequence of events that marked all of the book's characters. MacInnes had been appalled by the outbreak of violence and had joined together with British jazz musicians like Johnny Dankworth, Cleo Laine and Humphrey Lyttelton to form the Stars Campaign for Interracial Friendship, an anti-racist organisation to promote racial harmony.

The book presents itself as a panoply of modern London, from high to low, from Soho to North Kensington, from the penthouses of Bayswater to the slums of what MacInnes called Napoli – that area to the west of Ladbroke Grove usually called Notting Dale. The cast is a gallimaufry of outcasts and marginals, written as realised characters rather than sensationalised ciphers: a young pimp, a rent boy, a TV celebrity, a successful pop songwriter, a gossip columnist, a young Black man, a junkie and a girl on the game.

In *Absolute Beginners*, character and politics are inferred by youth tribe. The unnamed hero, variously called 'kid', 'teenager' or Blitz Baby, is eighteen, a proto-mod. As a photographer and fully fledged denizen of what MacInnes called 'the un-silent teenage revolution', kid has access to all levels of London bohemia, whether it be coffee bars, jazz clubs, Black shebeens or even the media – the music industry and television. As both hipster and protagonist, his acquaintances span the then current youth types: they include cynical teenage pimp the Wizard, with his drip-dry sky-blue jeans and Continental jacket; Ed, the racist Ted; the Dean, a sharp modern-jazz creation and junkie, with his college-boy smooth-crop hair, neat white Italian round-collared shirt and short Roman jacket, very

tailored (two little vents, three buttons); and the Misery Kid and his 'trad. drag'.

Absolute Beginners also works as a *roman-à-clef*. The songwriter Zesty-Boy Sift is a combination of Tommy Steele and Lionel Bart, and MacInnes uses him to satirise the Parnes stable. There are also gay characters, which was rare in terms of youth-oriented media: the 'cold queer' Henley; the Chelsea denizen the Fabulous Hoplite. At one point, MacInnes speaks through the Hoplite to talk about the legal status of homosexuals:

> 'The world where they make laws and judgements,' he told us all, 'is way up above my poor bleeding baby head. But all I would ask is this, please: is there any other law in England that's broken every night by thousands of lucky individuals throughout the British Isles, without anything being done about it?'

MacInnes's novel is heavily stylised, almost Firbankian. It veers towards the programmatic, but the finale packs a considerable punch as the line is drawn in the sand. It's hard to avoid the thought that the book's narrator, who has such a level of mobility and depth of experience for his years, is a projection of what MacInnes would have liked to have been: thirty years younger and free of hang-ups. His ability to identify with teenagers was profound and stemmed from an analogous sense of incompleteness and alienation within himself.

The book made the best-seller lists on publication and remained popular for years afterwards, most notably in the subsequent Penguin paperback edition, with a cover by the pop artist Peter Blake. Quite apart from anything else, MacInnes's depth of observation and concentration on detail have made it a valuable record of a crucial but under-documented moment in British youth culture: the birth of the modernist style, soon to be known as mod, and its roots in the then homosexual netherworld.

———

MacInnes's location of the style's origin in the Italian look was precisely observed. It had begun at the height of Ted: in April 1956, *Men's Wear* newspaper noted that Italy was 'about to launch a big drive to capture a share of the mass-produced clothing business in Britain and other European countries'. The country was in an economic mess, with high unemployment and war reparations, hence the focus on the clothing industry's ability to export.

In January 1958, the *Daily Sketch* covered this Italian diaspora with a picture story titled 'The '58 Look'. 'The Ted is dead,' ran the copy, 'to be a Toni boy is in. Your suits must have the Italian look if you want to be one of the cool men. That is what those arbiters of teenage fashion, the London jazz-club boys, are saying. They are tired of the Teddy Boy look. Now they want dignity. They're striving for a quiet, respectable effect.'

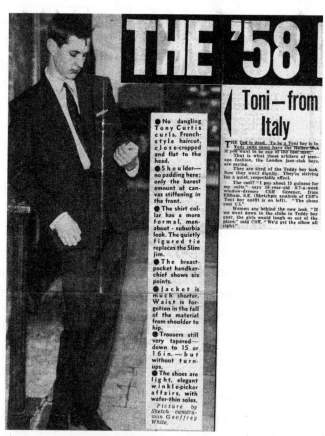

'The '58 Look', *Daily Sketch*, 6 January 1958

This late-1950s emergence of the Italian style into the mainstream only ratified what had been occurring among the cognoscenti since earlier in the decade. The main impetus was to get away from the shapelessness and drabness of English men's fashion, symbolised by high-street outlets such as Dunn & Co., also known as Dung and Co. because of the dull browns of their baggy tweed sports jackets and voluminous trousers.

Brighter colours, tighter body shapes and breaking the bounds of class and caste: that was the drive behind the designers and outlets who were breaking the mould. Almost all were based in Central London. On Shaftesbury Avenue, Austin's specialised in importing American Ivy League styles: button-down shirts, narrow trousers and jackets in reversible houndstooth and herringbone, the kind of look that was being sported by American jazz musicians like Miles Davis and Stan Kenton.

The designer and retailer Cecil Gee had pioneered selling the drape shape in the UK but, around the 1950s, he began to import and promote Continental knitwear: black silk-knit ties and purple and orange mohair sweaters. To attract his chosen clientele of hip young modernists, he hung blown-up pictures of musicians on his shop walls and installed a Gaggia coffee machine. Together with the imported American and Italian clothes, this was the start of shopping as a recreation, as an environment, as what would later be called a lifestyle.

The propensity for male homosexuals – beacons in the gloom of early-1950s austerity – to wear bright colours and American styles had been well observed by Rodney Garland in *The Heart in Exile*. In the year after that book was published, Bill Green opened up Vince Man's Shop in Newburgh Street, close to Carnaby Street, in the warrens of Soho. Holidaying on the Continent, he'd noticed the popularity of black jeans and black shirts, and started to import them into the UK. After a short while, he started designing his own clothes of a more colourful nature. As Green remembered: 'People said the stuff was so outrageous that it would only appeal and sell to the rather sort of eccentric Chelsea sets or theatrical way-out types.' Close to Marshall Street Baths – then very popular as a cruising spot – he was catering to the section of the gay market that valued brightness, outrageousness and a tight cut.

Advertising in *Films and Filming* magazine with live mannequins like Sean Connery, Green quickly expanded his clientele beyond muscle men and theatrical types like Peter Sellers, John Gielgud and Lionel Bart, entering into lucrative deals with department stores like London's Marshall & Snelgrove and Macy's in New York. He widened his tailoring range: popular items included jeans, briefs, swimwear, brightly coloured, patterned leisure shirts, pre-faded denims, trousers made of bed ticking.

By the later 1950s, the shop's clothes had begun to cross over into youth culture with Italian-influenced styles. As Green simply stated: 'I invented a long felt need.' Nik Cohn was explicit in his survey of men's fashion on how it reflected a change in masculinity: Vince 'sold stuff that could once have been worn by no one but queers, and extremely blatant ones at that; now the same things were bought by heteros as well. Behind this, obviously, there was a major shift in male identity . . . in other words, men were coming to terms with the feminine sides of themselves.'

――――――

The true mass-market crossover in Carnaby Street would not happen until a few years later, but the seeds were being sown by a young, ambitious designer and retailer. Born in September 1934, John Stephen left Glasgow for London as a teenager, working double shifts at Moss Bros tailoring and Fortes coffee bar. In 1955, he began working for Bill Green at Vince but quickly realised that there was a gap in the market: the middle ground between Vince's extremes and the expense of Cecil Gee.

After meeting his partner Bill Franks in 1956, Stephen set up in Beak Street, Soho, where he began retailing a range of garments that included, according to his biographer Jeremy Reed, 'hipster trousers in flame-red, lavender, pink and burnt-orange cotton denim, as well as grey and dark blue wool and . . . denim button-down and tab-collar shirts in peacock blue, foggy grey and lipstick pink'. Early adopters like Cliff Richard spread the word through high-profile appearances in the media.

In 1958, Stephen moved into premises at number 5 Carnaby Street, the first of his many shops in that street, selling Aertex T-shirts, matelot

vests, hipsters, bikini briefs, posing pouches, pre-shrunk Levi's imported from America and polo shirts – all very popular with modernists familiar with French *nouvelle vague* films. At this point, he was still half in the gay world, half in the new teenage market, but the latter would soon take over – especially after 1960, when he opened larger premises at 49–51 Carnaby Street, which he called The Man's Shop.

Young gay men were beginning to pick up on the style. Aged fourteen in 1959, Peter Burton was a precocious teen from the East End, not one of the elite but a follower of fashion. 'There was a distinctly Italian look in the late Fifties,' he remembered in his memoir *Parallel Lives*. 'When I was about fourteen, I was kitted-out in an Italian "bum-freezer" jacket, fairly tapered trousers and pointy-toe shoes made from woven leather. I favoured shirts in delicate pastel colours (lilac was a firm preference) and shoes with specially built-up heels.'

In 1961, Stephen opened a third outlet in Regent Street – this time bearing his own name. The shop was opened by pop star Eden Kane, whose 'Well I Ask You' went to #1 in the summer. In September, Stephen got the attention of the tabloids, when the *Daily Sketch* reported on the fact that he used young women to sell men's clothes; the accompanying picture showed two models wearing sweaters, trousers and a denim shirt. 'Even men's ties have a new use as hair ribbons,' sniffed the newspaper as it insinuated the homosexual subtext.

Thanks to the Italian style's popularity with pop stars and their need for striking clothes – as performance, as the transcendence from the mundane befitting modern idols – these tight, bright, colourful, shiny clothes were beginning to be disseminated through the mass media. They fulfilled the early modernist's wish to be cool, to be different from the norm and, indeed, to be outrageous, as the cult began to develop distinct androgynous and narcissistic tendencies.

The social theorists Stuart Hall and Paddy Whannel noticed this 'cool indifference': 'There is something of it, too, in the variations of the "continental" or "Italian" style which become required wear for teenage boys when dressed up (elsewhere, jeans are ubiquitous) with its modern, lazy elegance, its smooth, tapered lines, light materials, pointed shoes or boots, and the flat, rather dead "college" haircut which often accompanies it. A

model of innovation in this field was the drained face and the whole casual ensemble of Adam Faith.'

One early modernist, David May, remembered that 'Mods were always intellectual. There was a large gay element in it. On Saturday afternoons we'd go to get our hair done in the women's hairdressers . . . We didn't fight rockers, we were far more interested in some guy's incredible shoes, or his leather coat. But underneath this, one did read Camus. *The Outsider* explained a lot by way of alienation. A sort of Jean Genet criminal lowlife was also important to our ideals. We empathised with outlaw figures, people who went out and stole and so on.'

This merger of youth style with criminality and homosexuality was explored in a novel published that year. Written by Gillian Freeman under the pseudonym Eliot George – the subject of homosexuality was still controversial, if not taboo – *The Leather Boys* was the story of an anguished same-sex relationship carried on amid the milieu of bikers, modernists and criminal youth gangs. The protagonist, Dick, serves in the merchant navy and is obsessed by his appearance. Freeman cast Dick as unlike the obvious queens he meets in his line of work. He is masculine, he can pass as masculine, part of a youth culture that, if not explicitly homosexual, was homosocial: 'One didn't only dress up for girls . . . The time he spent on [his appearance] was entirely for his own satisfaction. Well, perhaps not entirely. Some was for the other boys, in peacock competition.'

Two other publications that year, both by protégés of Colin MacInnes, explored the modernist youth culture. The hero of Terry Taylor's *Baron's Court, All Change* is a modernist jazz fan, a habitué of the coffee bars and jazz clubs, and, like Billy Fury, an early experimenter with marijuana. He lives in a world of his own, determined to find his own path. On the book's jacket, the author photo – taken by MacInnes's friend Ida Kar – shows a young man with a polo shirt and a college-boy haircut: prime modernist gear.

In turn, Ray Gosling's 'Lady Albemarle's Boys' was the first attempt by the twenty-one-year-old writer to examine his complex feelings about the youth culture that had inspired and shaped him. James Dean was the spark: Gosling later wrote that he had seen *Rebel Without a Cause* three

nights running, because the tale of a brooding young man seeking independence from his parents affected him so much.

His pamphlet, written for youth service professionals, included an ambitious attempt at a cartography of post-Dean, post-Tommy Steele British teen culture. As he observed, taking its name from MacInnes's novel, the new type was 'The Absolute Beginner. The teenager to replace the teddy boy, the *jeune voyou*, the *blousons noir*, the *Halberstarken* [*sic*], this teenage thing, this Great Big Us fighting for no reason at all the Great Big Them.'

Gosling noted the influence of pop culture and its swiftly moving terrain: 'With Larry Parnes solving the *Sturm und Drang* of adolescence, with the world of mass entertainments, the teenage racket had arrived.' Like MacInnes, Gosling was homosexual, although unlike his mentor, he was working-class, a difference he clearly felt MacInnes reinforced, referring to him as a 'high civilised bitch and sometimes bully'. His writings from the early 1960s, however, place him with MacInnes as an important early chronicler of British youth culture, from the point of view of the outsiders it attracted.

In the early days of British youth culture, most adults were unaware of this stratified, incredibly detailed yet barely penetrable world. It fell to gay writers – attuned, for everyday survival, to the minutiae of appearance and attitude – to establish a cartography of this rapidly developing new social force. The fact that gay aesthetics – in pop and fashion and particular – had an influence disproportionate to homosexuals' social status only reinforced the link between a potential mass market and this still subterranean world.

Victim

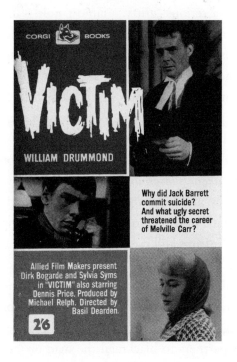

In order to adjust himself to his condition, the homosexual may have to reexamine the social mores that condemn his sexual desires, and rationalise his position in society.

Gordon Westwood, *A Minority*, 1960

I n late summer 1961, a major new film from the Rank Organisation
 opened at the Odeon, Leicester Square – Rank's flagship cinema. This
 was a high-profile release from Britain's largest film company at the
time. *Victim*, however, was not a conventional thriller, a war film or a
light comedy, but a serious, gritty – almost noir – drama about what
was perceived then as a serious social problem: homosexuality. A week
later, Rank announced that, somewhat against expectations, *Victim* had
performed extremely well at the box office.

Although it featured a major star in Dirk Bogarde, a strong support-
ing cast and high production values, *Victim* was a campaigning film. Its
production team had a track record for issue-led movies: director Basil
Dearden and producer Michael Relph had recently completed success-
ful features like *Violent Playground* (1958), which investigated violent
juvenile delinquency, and *Sapphire* (1959), which dived straight into the
Gordian knot of race relations in a country still reeling from the 1958
Nottingham and Notting Hill race riots.

Victim was their seventeenth film in just nine years. Not only did it
tackle homosexuality, but it also highlighted one of the most egregious
injustices in the law as it stood. Because the physical expression of homo-
sexuality was illegal, any evidence that it had occurred could be used
by unscrupulous partners to blackmail the man or men in question. If
the blackmailed then went to the police, they were just as likely to be
arrested for breaking the law as were the blackmailers. This was the situ-
ation facing the film's lead character, Melville Farr.

It was the threat of blackmail and exposure that had undone Oscar
Wilde, whose trial continued to cast a dark shadow over the whole topic
of homosexuality. With the legal and social prejudice it unlocked, it still
threatened to undo lives sixty-five years later. As the pioneering sociolo-
gist Gordon Westwood wrote in his 1960 survey of homosexuals in the
UK, *A Minority*: 'A homosexual with a long and successful career may see
it destroyed in the space of a few minutes by the work of a blackmailer.'

By focusing on the law's most obvious injustice and the dread that it
fostered, the production team on *Victim* were able to deliver a wider state-
ment on the status of homosexuals after the September 1957 publication
of the Wolfenden Report, which argued for partial decriminalisation.

Any attempts to turn this recommendation into law had already been rebuffed by the House of Commons in November 1958, a frustrating state of affairs which gave extra impetus to the formation of the UK's first organised gay rights lobby.

It had begun in March 1958 when, infuriated by the unwilling-ness of lawmakers to discuss, let alone enact, the Wolfenden Report, A. E. Dyson, a lecturer at Bangor University, bombarded the great and the good with letters asking for their support. Backed by figures like the philosophers Isaiah Berlin and Bertrand Russell, the former prime minister Lord Attlee, leading academic and intellectual Noel Annan and writers like J. B. Priestley and Angus Wilson, Dyson placed a signed letter in *The Times* calling for action. The result was the formation of the Homosexual Law Reform Society – HLRS, as it was generally known – with the young barrister Antony Grey as chief executive. Thanks to fund-raising through the Albany Trust, a charity formed in May that year to support the HLRS, and a donation from *Observer* editor David Astor, the pressure group quickly found a permanent office at Shaftesbury Avenue.

Despite their leafleting of MPs prior to the November 1958 vote on the implementation of the Wolfenden Report, the motion was defeated. The debate laid bare some of the lawmakers' attitudes. As Cyril Black, the Tory MP, blustered: 'These unnatural practices, if persisted in, spell death to the souls of those who indulge them. Great nations have fallen and empires been destroyed because corruption became widespread and socially acceptable.' Clearly, the homosexual rights lobby had an uphill task, not just in terms of fund-raising and lobbying politicians, but in public education and raising consciousness.

In May 1960, just as work was beginning in earnest on *Victim*, the HLRS held its first public meeting at Caxton Hall. A moderate turnout was expected, partly because of the fear of exposure, but a thousand men packed the hall. It was a transformational moment: as a young attendee, Bernard Dobson, later remembered: 'You were proclaiming in a blaze of lights that you were one of those homosexual men – they were mostly men – meeting, not in the usual situation, cruising the place, but going there to talk about law reform.'

In the last week of May, two films were released in the UK about Oscar Wilde. The first was a low-budget feature, *Oscar Wilde*, starring Robert Morley and Ralph Richardson. The second was more substantial. *The Trials of Oscar Wilde* starred Peter Finch and James Mason, and was reviewed on its June American release by Bosley Crowther: 'Mr. Wilde himself could not have expected his rare personality or his unfortunate encounters with British justice on a morals charge to have been more sympathetically or affectingly dramatized.'

These films showed that the unmentionable was no longer off-topic. If not totally rehabilitated, the most famous homosexual victim of the law was at least being treated sympathetically in the mass media. Despite the lack of forward movement in the late 1950s, the publication of the Wolfenden Report had given hope to the homosexual men who felt themselves ostracised by society and penalised by the same law that had done for Wilde. It was time for a change, a flash of courage.

The frustration with an antiquated law and a vicious public dialogue on the topic was building. As one of the gay interviewees in Westwood's *A Minority* insisted: 'When I think of the hopeless lives so many homosexuals lead; when I am made aware of the repulsion the ordinary man feels when he comes across a homosexual; and the everlasting shadow of the law – Oh I know there's nothing I can do about it and I don't worry and fret. But sometimes I just get very, very angry.'

In its planning and execution, *Victim* partook in this change of mood. Following Wolfenden, it not only reflected the increasing desire to cast off a series of antiquated statutes, but its production coincided with the incremental steps being made towards political and legal representation for homosexuals. By the time it was being viewed by the public, fifteen months later, it would help to catalyse these demands for equality – such was its power and impact.

With the comparative relaxation in censorship of the topic of homosexuality, the time was right for a serious drama. During May 1960, the Relph/Dearden team sent a draft synopsis and early script of the as-yet-unnamed film to the then secretary of the British Board of Film Censors, John Trevelyan. Fairly new to the job, Trevelyan was more liberal than his predecessors, but even so, *Victim* had to undergo a stringent

process of examination before production was allowed to go ahead. The initial reaction was favourable, but qualified. One of Trevelyan's readers, Audrey Field, reported that the early draft of the script was 'a sympathetic, perceptive, moral and responsible discussion of a problem which can be dealt with on paper as much as the writing fraternity wishes – which will probably be a very great deal, as the world of the arts is full of inverts'. Her main qualification was that she found it oppressive 'to be confronted with a world peopled with practically no one but "queers"'.

Trevelyan agreed, finding the script 'a sympathetic, perceptive and responsible discussion of a real problem. This kind of analysis presents no difficulties in a book but it does produce difficulties when translated to a medium of public entertainment for the masses . . . Public reaction on this subject tends to be strong. For the most part, intelligent people approach it with sympathy and compassion, but to the great majority of cinema-goers homosexuality is outside their direct experience and is something which is shocking, distasteful and disgusting.'

The first stages of the project had begun a couple of years before, when socially conscious scriptwriter Janet Green was struck by the first House of Commons debate on Wolfenden. Encouraged by the loosening of censorship in the theatre – signified by Shelagh Delaney's *A Taste of Honey*, which inter alia included an openly gay youth – she began working on a treatment about homosexuality with her husband, John McCormick. In the meantime, their script for *Sapphire* had been filmed to considerable acclaim.

In May 1960, Green and McCormick were hired to work on the blackmail idea. Influenced by Peter Wildeblood's *Against the Law*, their intention was didactic from the very start. As Green later wrote: 'We feel strongly that this is a matter upon which the public are ill-informed and know only one point of view. In the main, the bigoted one. In this advancing world, we felt that it was time they had placed before them through film, which we consider the most effective medium, this social problem of the homosexual and the small protection the present law allows him.'

On 29 June, the House of Commons voted down MP Kenneth Robinson's motion asking the government to 'take early action' to

implement the Wolfenden Report. The home secretary, Rab Butler, was against it, and the debate was accompanied by the usual pejorative language, so much so that the Labour MP Eirene White was moved to observe in the chamber: 'A number of men, consciously or subconsciously, are moved to vehement condemnation by some feeling that they have to assert their own virility in the process.'

That same day, the BBFC gave the first Green/McCormick script its examiner report. Audrey Field thought there were many possible pitfalls: the nastiness of blackmail and the hints of violence associated with the crime; the sensationalism of the material and the boredom of the public with the subject in general. Certainly, the topic had been opened up by the two Oscar Wilde films, but they were historical. With this script, set in the present day, the film-makers would have 'to proceed with caution'.

The project received a major setback in early autumn, when every major American distributor turned the film down because of its subject matter. Trying to keep the forward momentum, the producers arranged for an article to be published in the UK trade paper *Kinematograph Weekly*, in which the film was mentioned under its original title, *Boy Barrett*. Various stars were considered for the lead role – Jack Hawkins, James Mason, Stewart Granger – but none committed or were thought suitable.

While the film-makers struggled with the censors and the film industry, a book was published that constituted the most comprehensive myth-breaking around the topic thus far. With a foreword by Sir John Wolfenden, *A Minority* aimed to report 'on the life of the male homosexual in Great Britain'. Under the pen name of Gordon Westwood – necessary because the topic was still against the law – Michael Schofield had already published *Society and the Homosexual* in 1952, but this second volume went much further.

Interviewing 127 homosexuals – the first such survey to be done in Britain – Westwood systematically gathered data that exploded many of the myths and assumptions surrounding the issue. In contrast to the idea that all homosexuals were hairdressers or theatricals, he interviewed men from a wide variety of occupations: architect, chef, chemist, civil servant, clerk, company director, doctor, engineer, farmer, fireman, labourer, lorry

driver, musician, porter, shop assistant, schoolmaster, solicitor, stable lad, university lecturer, vicar and many others. They were aged between eighteen and thirty-seven, with the majority living in London because of the anonymity conferred by a capital city. Many were in managerial and skilled manual roles, but there was a surprising number in semi-skilled and unskilled manual jobs. Fifty per cent came from reasonably happy homes, but most had difficulties in adjusting to their homosexuality. Their isolation was key, as revealed in this quote from an interviewee: 'It never entered my head to ask anyone else. It was something I had to sort out for myself.'

Over half of the contacts had made resolutions to stop all homosexual activities. One respondent talked of a very unhappy period in their late teens and early twenties: 'I had a terrific aversion to it and every time I lapsed I hated myself. It seemed evil and very bad to me.' But once some kind of accommodation had been made, their attention often turned outwards, to criticisms of the current legal situation that made any expression of their emotional and sexual orientation punishable by the courts.

Blackmail was indeed one of the key dangers facing gay men. Westwood quoted the statistic that '90% of blackmail cases were cases in which the person blackmailed had engaged in homosexual practices with another adult'. In his sample of gay men, Westwood found that 13 per cent of the 127 had suffered from blackmail and, of those who had, over three-quarters would not involve the police. As one of his respondents said: 'They find it easier to get homosexuals than blackmailers.'

This hinted at the possibility of a strong critique of society from a homosexual viewpoint, and the responses that Westwood received offered a powerful argument for change. As one man told him, 'The law affects one's whole life. I feel like a prisoner.' With testimonies like these, Westwood's conclusions had weight: 'The present social and legal methods of dealing with the problem are irrational and tend to create more social evils than they remedy. This emotional hostility affects many thousands of individuals and reflects upon the community as a whole.'

Shortly after the book's publication, Relph and Dearden had a breakthrough: when the director went round to Dirk Bogarde's house to sell

him the idea, the actor responded very enthusiastically. This was the most commercial casting that the team could have asked for, and shooting could therefore proceed early in the new year. The actor was just about to turn forty, and as he later stated, referring to his role in the 1960 film *The Angel Wore Red*: 'Larking around as a fallen priest with Ava Gardner is all very well when you're still a young man. But when you're turning forty you want to do slightly more serious things.'

Bogarde was desperate to get away from his pin-up image. After his breakthrough role in 1950's *The Blue Lamp*, as a murderous teenage spiv, he had appeared in almost thirty films. Some were serious action roles in wartime dramas, and some were bizarre oddities like *The Spanish Gardener*, but he had made his name as Dr Simon Sparrow in the very popular series that began with *Doctor in the House* in 1954. Despite living with his partner and manager Anthony Forwood, Bogarde had become a teen idol.

The role of Melville Farr, the bisexual married barrister who is at the centre of Green and McCormick's drama, was the perfect eject button. Bogarde never fully explained his decision to take the part, but as well as enabling him to sidestep his pin-up status and aim for more mature roles, it might well have been a moment of unconscious self-revelation on his part. Although he never publicly acknowledged his homosexuality, it was an extremely brave step to take, and without him the film would probably not have happened.

With a bankable star in place, shooting began on the film – now entitled *Victim* – on 7 February 1961. The plot concerns the blackmailing of a young man, Boy Barrett (Peter McEnery), who has been involved with Melville Farr. After Barrett is arrested for stealing money to pay his blackmailers, he commits suicide in his prison cell. The blackmailers then turn their attentions to Farr, who, at the likely cost of his marriage and career, decides to inform the police and face the consequences – to counter the blackmailers and honour his dead friend. In so doing, Farr places himself against the mores of the day. His brother-in-law is disgusted, while his wife struggles hard to understand him. Worst of all, he comes into direct conflict with several other men who are also the object of the blackmailers' attentions: a hairdresser, a car salesman, a tycoon, a writer and a successful actor – the last of whom is played with splendid,

dripping contempt by Dennis Price. All are afraid to expose the black-mailers in case they lose their reputation and their careers. Fear is the key, and it reveals the extortion in all its insidiousness.

The film tracks Farr's progress towards self-realisation. In the climactic confrontation with his wife, beautifully played by Sylvia Syms, he finally responds to her prodding about whether or not he had sex with Barrett: 'All right. You want to know. I shall tell you. You won't be content until you know, will you? Till you've ripped it out of me! I stopped seeing him because I wanted him. Do you understand? Because I wanted him!' As Bogarde later recalled: 'I said there's no half measures. We either make a film about queers or we don't.'

Whether or not it was the film-makers' intention, class is vital to the movie. In the beginning, Farr is completely integrated into the establish-ment, while the working-class builder Barrett is utterly without resources. As the film goes on, Farr becomes alienated from his class and his own homosexual peers. As many men and women in the gay world did as a matter of course, he creates bonds across the classes when he teams up with Barrett's working-class friend, Eddy Stone, and the policemen to nail the blackmailers.

To be exposed as a homosexual in 1961 could mean a vertiginous fall, and by the end of the film Farr is almost a complete outcast, supported by only his faithful assistant, Patterson, and – maybe – his wife. Having been unable to live out his desires – a major source of conflict between him and his homosexual peers – he has been forced to reveal them to all and sundry, and the future is uncertain. Would it not have been easier to be honest in the first place? But a stand has been made, and there is no turning back.

Viewed today, *Victim* can seem programmatic. Much of the dialogue between the two policemen on the case rehearses the Wolfenden argu-ment against the prejudices of the day. Yet the film packs a considerable punch. As Janet Green told the press on the film's release: 'I feel more strongly about the injustice of it all than most men,' and there is a visceral anger at the anti-homosexual attitudes espoused throughout, the misery of the lives blighted by blackmail and the viciousness of the blackmailers themselves.

There are two of them. The shrunken, bird-like Miss Benham is all snapping spite and furious, physical loathing. She is the brains, but Sandy Youth – played by Derren Nesbitt with an oily, insinuating athleticism – is the muscle. It's a memorable portrait of a menacing bully, dressed in what can only be described as early-mod style, with his Vespa and his Italian clothes. There is one hint of his motivation: as he exits his room, the camera lingers on a picture on the wall – a reproduction of Michelangelo's distinctly homoerotic statue of *David*.

After resolving a few final queries with the censor, the film was ready for preview at the end of July. *Victim* was trailed as something groundbreaking and controversial, without explicitly promoting the homosexual angle. The theme of blackmail was prioritised. In press interviews at the time, Bogarde explained that he wanted to break free from the nice, perennially youthful Dr Sparrow character in favour of roles that were more adult, more risqué, more Continental – even at the expense of his career thus far.

The film did good box office during its first week, despite its X certificate, and the reviews came pouring in. Some writers felt that the film was too sentimental and melodramatic; others felt that the whole topic had been whitewashed, if not 'disinfected'. Yet the message got through: as Isabel Quigly wrote in *The Spectator*: 'The film and Bogarde's performance arouse just the feeling and opinion intended – that the law is mad.' *Films and Filming* called it 'a landmark in British cinema'.

The film had a considerable impact in the UK. In Blackpool, 'several members of the public walked out of the cinema complaining'. In London, the house was 'mixed – and quiet, subdued or thoughtful. Comments seemed to be quiet and private.' According to one John Hall, 'He and the homosexuals he knew found the film sympathetic and helpful.' Others wrote of being 'liberated' – 'an overwhelming sense of identification'; 'a watershed in my awareness of gay life'. Dirk Bogarde and Peter McEnery remembered getting letters that simply said, 'Thank you.'

Victim touched a nerve because the blackmail theme connected to life as it was experienced by gay men in the period. Brian Epstein was blackmailed in 1958 after picking up some rough trade by the Pier Head

in Liverpool. Beaten and robbed, he nevertheless went to the police, and the blackmailer was convicted. Luckily, the papers agreed to keep his name out of it; in the headlines he was called 'Mr. X'. However, the episode – which involved him revealing all to his family – was psychologically damaging.

Joe Meek had been living near the edge for a while, but in late 1963, he would be caught cottaging – importuning in a public toilet. The case made the evening paper, not in the headlines but down the page. Soon afterwards, he began to get blackmail demands – for a while, on an almost daily basis. He was vulnerable, having taken advantage of some of the youthful hopefuls that came to 304 Holloway Road, and the less scrupulous – or those with a genuine grievance – saw their opportunity. The resulting pressure only added to his persecution complex.

Apart from reflecting individual cases, much of the film's power was due to the way that it filled the gap between an increasingly assertive homosexual population, which was beginning to conceive of and demand equality, and the lack of any political outlet for those voices. For, despite the clear evidence of widespread dissatisfaction, the HLRS had failed to build on the grassroots enthusiasm displayed at the 12 May 1960 Caxton Hall meeting. Its policy was to target the great and the good: opinion-formers, public intellectuals and sympathetic politicians.

Unlike America, where there was a strong grassroots movement, British gay politics was conducted at an elite level, with the aim of changing the law through influence and lobbying. Nineteen sixty-one was a time of stasis for the lobbyists, as the writer/philosopher Kenneth Walker observed in *The Third Sex*, a collection of essays inspired by Wolfenden and published that year: 'Unfortunately, legal reforms, like the mills of the gods, grind exceedingly slowly, and in spite of the efforts of the society and of many other people, there is no likelihood of an early change being made in the law.'

Alluding to a general sense of frustration, Walker added that the HLRS was trying to draw 'constant attention to the fact that the recommendations of the Wolfenden Report have not yet been implemented. Persons in the United States have had the misfortune to inherit this same antiquated outlook – the attitude that the homosexual is potentially

a very dangerous criminal against whom we all have to be protected. When at long last the HLRS succeeds in its mission, our success will undoubtedly have important repercussions also in the United States and other countries.'

Nevertheless, the wheels were beginning to turn. The voices raised against the manifest unfairness of the law were beginning to accumulate and to have an effect – and in this, *Victim* played an important part. After seeing the film, the Welsh Labour MP Leo Abse – already notorious for his flamboyant dress and his habit of quoting Freudian nostrums in his House of Commons speeches – took note. Having already voted for the Wolfenden Report in 1958, he began to draft a bill to put its recommendations into law.

12

The Rejected

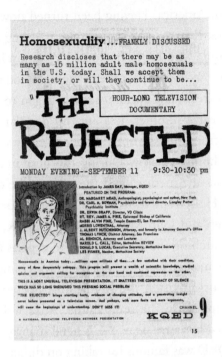

Mon Sept 11 9:30–10:30pm

Homosexuals in America today . . . millions upon millions of them . . . a few satisfied with their condition, many of them desperately unhappy. This program will present a wealth of scientific knowledge, studied opinion and arguments calling for acceptance on the one hand and continued repression on the other.

THIS IS A MOST UNUSUAL TELEVISION PRESENTATION. IT SHATTERS THE CONSPIRACY OF SILENCE WHICH HAS SO LONG SHROUDED THIS PRESSING SOCIAL PROBLEM

Advert in *Mattachine Review* for *The Rejected*, September 1961

While *Victim* was enjoying its first run, a groundbreaking current affairs documentary was shown on American television. Conceived of by the industry professional John W. Reavis, *The Rejected* was a sober and unemotional look at the life and situation of the homosexual in America. Having been turned down by every major network in the US, Reavis and his co-producer Irving Saraf managed to place the programme with KQED, a local TV station in California.

Like *Victim*, *The Rejected* caught the changing mood in society. During 1961, the media's treatment of homosexuals began to shift in America. Published in the early summer, Jess Stearn's popular survey *The Sixth Man* took its title from the assertion that one in every six men in America was 'affected' by homosexuality. During the next month, the Motion Picture Association of America lifted the ban on the overt portrayal of homosexuality in Hollywood films – a small but major step.

Like Janet Green and John McCormick in the UK, Reavis and Saraf spent months researching the topic, talking to experts from the fields of anthropology, law, medicine and religion, and soliciting the involvement of the gay rights organisation the Mattachine Society, three of whose members would appear in the programme. After writing a script, the pair were supported by James Day, the general manager of KQED, who remembered: 'KQED was famous for taking on difficult issues. My philosophy was that we wouldn't get interesting things on the air unless I took the chance.'

Even so, the general feeling in the station was 'On your own heads be it.' The programme was thus hedged with caution: the prevailing social attitudes against homosexuality had to be aired and examined. It begins with a general view of a single, downbeat male figure wandering the streets of San Francisco – the lonely homosexual of popular stereotype. The voice-over by James Day warns the viewer that the subject of this programme is 'controversial, delicate, and to some downright unpleasant'.

The Rejected frames homosexuality as a problem that 'needed to be discussed' and a matter of some social urgency: the narration states that '18 per cent of all American men, for at least three years during their adulthood, have as much, or more, sexual experience with other men as with women'. Much of the discussion is taken up by experts,

with Margaret Mead taking the anthropological approach: namely, that homosexuality has been 'a potential of human beings' throughout different societies and different times.

As they give their testimonies, the experts – a churchman, a psychologist, San Francisco's director of disease control and the area's district attorney – are all shot in a way that accentuates their authority. They wear the suits or uniforms of their profession and are sat behind large desks. Their analysis is, in general, fairly routine and sober. Only one is hostile, but the others talk about the homosexual as the Other – as though he is a visitor from outer space and definitely nothing to do with them personally.

It is a relief, then, to see three gay men sitting informally, even though they look a little beat. These members of the Mattachine Society – Hal Call, Donald Lucas and Les Fisher – are definitely not camp and, at a time when that was the signifier of homosexuality, they could pass for 'normal'. It's a shame that they spend time moaning about the 'queen' stereotype, but that was a very popular trope in gay political agitation then. The *femmes* were seen as letting the side down, in the contemporary wish to appear respectable to the general public and the authorities. Nevertheless, Call speaks a lot of sense. In response to the question, 'Are homosexuals satisfied with the way they are?' he answers that they are not, because they are all aware of the fact that legal and moral sanctions hang over all their lives: 'They have feelings of inferiority because of these sanctions against them.' Call cites the forces stacked against male homosexuals: being seen as a security risk, dishonourable discharges from the armed forces and the pitiful, 'lonely and often dejected situation' of the older homosexual.

Only one interviewee, Morris Lowenthal, a veteran pro-homosexual lawyer, speaks up for a change in the law: 'The code is mere codification of prejudices and superstitions and ancient taboos that no longer exist. The chief argument against these last is that there is a great deal of blackmail, entrapment, coercion of individuals – many people have committed suicide because of being involved in blackmail procedures – and this, in my opinion, is the reason why the law must be removed from the books.'

The main drift from the testimonies is that homosexuality is no longer a moral problem but a medical issue that can be treated. It is clear that the old punitive way isn't working any more. However, the alternative is no picnic. The interview with Dr Karl Bowman is chilling: 'In treatment, we would, of course, like to turn all homosexuals into complete heterosexuals. This is usually not possible. We may be also able to help him live with his problem without too much emotional disturbance, and which will prevent his getting into difficulties with others.'

The Rejected is very much a product of its time. There are no lesbians included. Homosexuals are not to be accepted, but rather to be patronised, pitied, measured and effectively neutered. They are a pest, a virus that needs to be vaccinated against in order to be controlled. Nevertheless, the programme was, for its time, an important and brave statement, offering the first glimmers of understanding on the topic to a wider public, and the first to give any kind of credence to the gay underground and its agitators.

The public and the press agreed. KQED was inundated with letters following the broadcast, many of them requesting transcripts – so many that a partial transcript was published shortly afterwards. Only a tiny minority wrote to complain. According to the *San Francisco Chronicle*, the station 'handled the subject soberly, calmly and in great depth . . . KQED was courageous to tackle what is perhaps the most taboo subject of all – homosexuality, the permanent underground.'

The transmission was big news in the homophile press. All three magazines – *ONE*, the *Mattachine Review* and *The Ladder* – carried ads, features or reviews. '*The Rejected* represents what may be the most outright unwrapping of the subject of homosexuality, a topic so often tabooed from serious and unemotional examination,' declared the *Mattachine Review*, while *ONE* reported that the response to the sponsors from the public 'was favourable and most gratifying'.

All three magazines were going strong in 1961, a year in which, as far as the homophile agenda was concerned, it was a case of two steps forward, one step back. There were positive steps, like the broadcast of *The Rejected*, the loosening of censorship around the topic on film and in the theatre, and the revocation or dilution of anti-sodomy laws in Illinois and Alabama. There was an increasing number of books on the topic

of homosexuality, whether surveys or the dozens of gay- and lesbian-relevant novels reviewed in *ONE* and *The Ladder*.

Perhaps the most important in that year was Jess Stearn's populist *The Sixth Man*. It was the product of several years of research. Stearn had been a crime reporter in New York for many years and had witnessed the application of the law against homosexuals in its raw state. He too wrote about homosexuals as though they were specimens, but the purpose of his book was to expose more of gay life and argue that society's attitude towards homosexuals needed 'a great deal of revision'.

'Homosexuals can be anybody,' Stearn observed, as if surprised that they did not all conform to the effeminate stereotype; 'they consider themselves badly used by society, and of all the injustices, fancied or real, that they fret about, blackmail rankles the most.' He discussed all the gay centres – New York, Los Angeles, London and the beaches of Fire Island: 'business executives, artists, actors, truck drivers, clerks, hairdressers, educators, and sundry other professionals all lose themselves and their inhibitions on the transforming island'.

The book was a by-now familiar canter through the topic: the legal sanctions against homosexuality, the harsh attitudes of the police, and the homophile organisations agitating against the obvious injustices – the New York Mattachine Society in particular. The various ways in which gay men – no mention yet of lesbians – finessed their situation were couched in the usual expressions of alienation and shame, the loathing of *femmes* and the fear of getting old, but there was a new assertiveness contained in the phrase 'sexual equality for all'.

The review in *ONE* castigated Stearn for writing about homosexuals as though they were aliens, but the book was not written for insiders. With perspective, it would have been possible to see books like *The Sixth Man* and *The Third Sex* as educating a wider public on the topic, a necessary step to greater understanding and eventual acceptance. But many gay activists were locked into an increased sense of frustration, as their efforts seemed to be having no effect on lawmakers and politicians. At times, they felt they were shouting into the void.

The news that the homophile magazines reported was relentlessly negative. Although FBI surveillance had dropped considerably since

the mid-1950s, there was an endless litany of legal harassment, suicides and, in Florida and Delaware, group round-ups. In April, a young teacher was beaten to death by three youths in San Francisco; according to the 'Tangents' section in *ONE*, they did so because 'they thought he was "queer"'. This, the police learned in later questioning, was their habit. 'We hate them,' one of the boys told the press, referring to the men they hunted.

There was a concerted legal campaign against the physique magazines, by now the most obvious signifier of the burgeoning gay market. In 1960, following a crusade initiated by the US postmaster general against the distribution and possession of these magazines, several men were arrested and charged in Massachusetts, including the distinguished writer Newton Arvin. The magazines seized included *MANual, Gym, Trim* and *Physique Artistry*. Arvin lost his job and died three years later.

That same year, the US Post Office seized 405 copies of three beefcake magazines published by MANual Enterprises, the company run by printer and publisher Herman Lynn Womack. Although these did not specifically mention homosexuality, *MANual, Trim* and *Grecian Pictorial* had begun to include photos of naked men. The district court ruled that these magazines were without any literary or scientific merit and would appeal to the 'prurient interest' of 'sexual deviates'. In short, they were obscene and therefore 'nonmailable'.

Both Womack and Bob Mizer fought back. During 1961, issues of *Physique Pictorial* carried stories entitled 'What to Do If You Are Arrested'; 'Can the Post Office Dictate Your Reading Matter?'; 'Los Angeles Police Claim You May Not Have a Collection of Nude Photographs in Your Home'. Mizer offered basic advice to men caught in this situation: 'Lawyers tell us that THE POST OFFICE HAS NO LEGAL RIGHT TO QUESTION YOU, AND YOU DO NOT HAVE TO ATTEND ANY HEARING THEY MIGHT PREPARE.'

Mizer was incandescent over what he saw as a bullying attack on basic freedoms. 'The police often engage in this sort of mischief because they have nothing to lose. Few citizens bother to sue for false arrest when harassed in this manner, because attorneys won't take such cases on a contingent basis. This is just one more reason why all police should be

forced to carry at least a $10000 bond – to ensure that they will them-
selves uphold the law they are entrusted to enforce.'

Raids on bars and gay meeting places were also in full swing. In high
summer, it was the turn of the gay beaches on Fire Island, as reported in
ONE's August issue – an account worth quoting for the period flavour:

> Cherry Grove is still the gayest summer spot in captivity. However,
> as usual, a raid on the famous 'meat rack' was staged over the July
> 4th weekend. The whole populace was forewarned of the presence
> of 30 plainclothesmen – many of them deputized truck drivers.
> Those people who went to the dunes anyway must have been men-
> tal masochists.
>
> Be that as it may, charges of police brutality were voiced last
> week at the town hall meeting. The Islanders have engaged a law-
> yer to investigate the situation and go to court if necessary. Ten
> of the defendants pleaded guilty and paid $25.00 fines. One man
> pleaded not guilty and plans to fight the charge . . . The 4th was
> more crowded than ever. Many new faces said that they had read
> about Cherry Grove in Jess Stearn's book *The Sixth Man* and went
> to find out if it was true.

In mid-August, San Francisco police conducted the largest vice raid
in the city's history when eighty-nine men and fourteen women were
arrested at the Tay-Bush Inn, a one-room cafe near Union Square that
catered to the all-night crowd. It was a Friday night, and the place was
packed. At 3.15 a.m. the jukebox went silent, a loudspeaker outside
blared, and the uniformed cops moved in, pushing and shoving as many
of the clientele as they could into the paddy wagons waiting under the
floodlights outside. Nevertheless, a good third of the patrons got away.

The police contacted the press, which ran stories that morning. The
front page of the *San Francisco Examiner* ran with the headline 'A Gay
Cafe Party – 89 Men, 14 Women Held'. The article claimed that the
arrested 'included actors, actresses, professional dancers, a State hospital
psychologist, a bank department manager, an artist, and an Air Force
purchasing agent', and printed their names, ages, addresses and employ-
ers – a punitive measure likely to result in exposure and the loss of status
and employment.

The raid was obviously a test case for the police and city hall – Mayor George Christopher had been elected on a law-and-order platform – but all concerned quickly found that things were not going their way. Six days later, *San Francisco Chronicle* columnist Herb Caen sarcastically referred to the 'courageous raid', following it up a few days later with another piece that pointed out that the police were targeting homosexuals on the basis of their class: 'The only moral, if it's a question of morals: Don't be a poor One. Don't be a poor anything.'

The homophile press picked up on the fact that the arrestees were subjected to harassment in the courtroom. The whole affair was 'handled in some cases as though it were a circus or a Hollywood film production, with TV and newspaper cameramen in the courtroom to photograph the defendants who had not yet been officially arraigned, much less given the opportunity to enter a plea and be tried for a crime'. The intimidation failed. Most of those charged pleaded not guilty and were acquitted. All that effort resulted in just two convictions.

The Tay-Bush raid, as Nan Alamilla Boyd has observed in her history of 1960s gay San Francisco, *Wide-Open Town*, only deepened the resolve of the city's inhabitants to push further for equal rights and demand an end to harassment – a resolve further stiffened by the repeal of San Francisco's laws against vagrancy that September, laws that were frequently used to target and harass homosexual men and lesbians who dared to show their faces in public.

That September, *The Ladder* reported the campaign of a Latino drag artist called José Sarria to get on to San Francisco's board of supervisors (the US equivalent of a city council). Since the early 1950s, he had been the host and featured performer at a famous local bar called the Black Cat, creating a sense of community and solidarity through his banter, careful door policy and insistence that whoever came in, whether it be regulars, out-of-towners or curious straights, this was a gay bar, out and proud. This was unusual for the time. In a 1973 interview in the literary magazine *Gay Sunshine*, Allen Ginsberg remembered the Black Cat as 'the greatest gay bar in America. It was really totally open, bohemian, San Franciscan, Viennese; and everybody went there, heterosexual and homosexual. It was lit up, there was a honky tonk piano; it was enormous. All

the gay screaming queens would come, the heterosexual gray flannel suit types, longshoremen.'

José Sarria was at the centre of the action. In the early 1960s, he released *No Camping*, an album recorded live at the Black Cat which faithfully reproduced his act: lots of in-jokes about the leather crowd revving their Vespas down Market Street, mixed with consciousness-raising. Performing several days a week and climaxing with a full drag opera every Sunday night, Sarria lacerated 'steam bath soirées and the "leather jacket" queens' while exhorting the crowd to unite and be proud: 'United we stand, divided they catch us one by one.'

The Black Cat's popularity attracted a large crowd, but it also drew the attention of the authorities, who were constantly trying to revoke its liquor licence – the favoured way to close down gay bars during that period. Incensed by the recent Tay-Bush raid and the constant threats against the Black Cat, Sarria decided to stand for city governance on a pro-homosexual ticket – the first openly gay candidate for public office in the US. He came ninth out of a field of thirty-four candidates, but the gauntlet had been thrown down.

As far as the homophile press was concerned, these were small victories, hard won against an overwhelming tide of negativity. However, nearly ten years after the Mattachine Society had formed, and five years after the first issue of *The Ladder*, cracks began to appear in the formerly unified movement. A meeting of homophile organisations, held in January 1961 to discuss a bill of rights, had ended in acrimony as no one could even agree that the subject under discussion was a good thing.

The women at *The Ladder* thought that the men at *ONE* were too aggressive and negative. As the editor of *The Ladder*, Dorothy 'Del' Martin, wrote: 'For years the publications of the organizations dealing with the homosexual problem have exploited the subject of injustice to and prejudice against the homosexual . . . Isn't it about time we stopped being cry babies?' Dorr Legg of *ONE* concluded that 'homosexuals, both male and female, still understand neither themselves very well nor the larger society to which they must somehow accommodate themselves'.

Britain seemed to be more advanced in terms of attracting the interest of politicians and lawmakers, but even the modest proposals of

Wolfenden were stalled. In contrast, the homophile activists of America were as far away from any centres of power as they had ever been – hence their frustration. What they failed to notice was that, although political influence was denied to them, homosexuals had a growing amount of soft power – in terms of consumerism, the arts and fashion – which was already having an influence on youth culture.

Jess Stearn had already noticed this in his observations about modern male film stars: the he-man type of a Clark Gable or a Gary Cooper had been replaced by 'some pretty boy with wavy hair' – a male impersonator who simulated masculinity but espoused homosexuality. In fact, the dream model of the time, post-James Dean and Elvis Presley, was moving away from movie stars like Tab Hunter towards the patented pop-star mix of a slightly rough look that accentuated grace rather than power.

This paralleled the shift in the physique magazines, as they oriented themselves ever more exclusively to the homosexual market: away from muscle men and impassive jocks to what the historian Thomas Waugh calls 'slim, sensitive types in moody, introspective poses'. According to Stearn, the homosexual had also popularised blue jeans, leather jackets, broad leather belts and ID bracelets. 'Flamboyantly coloured shirts and open high-cut collars are other homosexual innovations unwittingly adopted by rugged heterosexuals.'

A more detailed account of this process from within the subculture was given in a book self-published in late 1960 by a renegade clergyman immersed in the gay underworld. The Reverend Robert Wood's *Christ and the Homosexual* called for the church to welcome homosexuals, accept gay weddings and ordain gay clergy. As he wrote: 'The Church has done much to keep the homosexual from Christ. Society, often under the influence of the Church, has also thrown roadblocks in the pathway of the homosexual.'

With his insider knowledge, Wood was able to give a detailed account of the insurgent gay influence on men's fashion in general. The most obvious example was western-cut jeans: 'Tight cut, low on the hips, rugged in appearance, different in style, able to be shrunk to form-fit, and the more worn and faded the better, they quickly became the costume of the homosexual who wanted to look trim, to be a bit revealing in the crotch and rump, and to feel "butch".'

Wood knew whereof he spoke. Jeans had begun to percolate through the physique magazines, in particular *Physique Pictorial*, during the mid-1950s, often seen together with an oiled chest, a leather jacket and carefully placed S&M paraphernalia such as ropes, chains, etc. They became a staple: the cover of the March 1961 issue of *MANual* mixed self-improvement – 'How to Improve Your Memory' – with an image of a young man sitting on a phallic log; naked from the waist up, he wears worn jeans and motorcycle boots.

Wood cited these and other items – coloured shirts in particular – as an example of the spread of gay taste: 'Motorcycle clubs and teenage gangs appropriated all . . . these clothing items into a near-regulation uniform that suggested ruggedness, durability, virility and sex. The ever-widening circle of acceptance for this uniform, its standardisation by other groups beyond the homosexual, the influence of the Marlon Brando film "The Wild One", in which this was THE outfit, went on and on.'

Most of all, the homosexual influence on fashion and in the mass media chimed with the self-definition of America as a young country. There was both the classical influence on physique imagery and the rough-trade aspect of icons like Elvis. 'There has been coming to the fore in American thinking the near worship of "youth", "slimness", and "glamor" by both sexes and all economic and intellectual groups. The ideal American male physique is that of the classic Greek, with just a touch of Li'l Abner mixed in to give that American home-spun flavour.'

The ideal American type – promoted by a multimillion-dollar business – was the young, handsome male who wanted to be attractive and retain his youth. Wood thought that this move from rough to 'smooth' masculinity dovetailed exactly with the gay aesthetic and lifestyle: 'Our emphasis on activism calls for virility and stamina. Advertising stresses this kind of model; he is the hero for Madison Avenue, Hollywood and TV; and everyone in the land seems to want to employ or to emulate this man. This is the homosexual personified!'

The problem was that, without unbiased and open access to the mass media, this soft power and its influence, if not benefits, went unnoticed by most Americans. Despite the brave attempts to open out the debate – to let some air into the sealed-off world of social and legal prejudice – most

homosexuals and lesbians were still forced to live lives that were covert, running the risk of being harassed in their homes and in the streets and the clubs by the agents of the state, whether the police or the politicians or the courts or the press.

'Sex deviates' were still seen as murderers, traitors and recruiters of the young. But homosexuals were increasingly willing to fight this tide of misinformation and prejudice. A correspondent to *ONE* late in 1961, Prescott Townsend, explained how he was given fifteen minutes on the Boston station WMEX to counter the insinuations of a trash tabloid, *USA Inside Report*: 'The best thing of all was that [DJ] Jerry Williams let me answer this magazine to two hundred thousand politically and intellectually minded listeners.'

There was a new mood of militancy. It was the early 1960s, yet many laws and attitudes concerning homosexuality dated from the nineteenth century. Art and culture were way ahead of lawyers and politicians and most journalists; the films and the adverts and the literature and the fine art and the pop music of the day were operating as a Trojan Horse, broadcasting more liberal ideas, sounds and images that projected forward into how life could be for gay people and, just as importantly, for men and women in general.

This gap between what was and what could be was at once frustrating yet hopeful. The situation was well described in a lecture given by the psychologist Thane Walker at the Eighth Annual Conference of the Mattachine Society, in September 1961: 'With the dropping of the atomic bomb on Hiroshima,' he began, 'we shut the door on the past. And just as a new mathematics had to be evolved and accepted and old fallacies had to be given up in order to understand matter and its substance, so man must come to a new equation with himself.'

There was an urgency to this need to bring society and its structures and attitudes – as well as personal psychology – into the present. 'With our world on the brink of self-destruction,' Walker continued, 'there is just as much evidence of a bright new hope for the future. Our responsibility is only to overhaul our own social and religious concepts with the same kind of straight thinking which has brought to science the knowledge of the energy of the cosmos and of man as a native of eternity.'

13
Pop/Art

Playing up what things really were was very Pop, very sixties.

Andy Warhol and Pat Hackett,
POPism: The Warhol Sixties, 1980

I n the six hundred or so Time Capsules stored in the Andy Warhol
Museum in Pittsburgh, there are several hundred records. Many of
these are by classical composers or of musical soundtracks, while others
are albums that the artist had some personal involvement with: either
designing the cover or being a friend, acquaintance or colleague of the
musicians concerned. Ranging from the early 1950s to 1987, the year
of the artist's death, they are a partial but illuminating insight into his
aesthetic.

Among them are thirty records mostly dating from between 1960 and
1962. Mainly albums, they are from a crucial period in Warhol's life,
when he sought to change direction and achieve his ambition of being an
acclaimed fine artist. He had already dipped his toe into youth culture –
along with the artists John Minton and Ray Johnson in the late 1950s,
he had pictured the doomed James Dean – but these records represent an
immersion in the popular culture of the day that was dictated not just by
personal taste, but by a necessary repositioning.

Competitive as well as intuitive, Warhol knew that some kind of art
based on everyday commercial iconography was the coming thing in
1961, although its exact form and name was not yet set. He was highly
aware that peers like Roy Lichtenstein and Jasper Johns were already well
ahead in getting this kind of work accepted by galleries and critics, and
he could feel the moment of opportunity slipping away. From the begin-
ning of 1961, the bread-and-butter income from his commercial work
was ebbing, and he needed to move fast.

At the time, Warhol was still best known as a commercial designer.
Having lived within the haute bohemian world of Manhattan since the
late 1940s, he was no naif but a cultured habitué of America's media
powerhouse. As his friend, the art critic David Bourdon, astutely
remembered: 'His metamorphosis into a pop persona was calculated and
deliberate. The foppery was left behind and he gradually evolved from a
sophisticate, into a sort of gum-chewing, seemingly naive teenybopper,
addicted to the lowest forms of popular culture.'

These records chart Warhol's route towards becoming one of America's
best-known artists, offering a crash course in contemporary pop. This
deep dive was not totally calculated; it was research, but filtered through

his personal predilections. He had always loved the mainstream cultural products of his country, beginning with the movie stars of his childhood and early teens. His obsession with Hollywood icons helped him through the difficulties of his youth and shaped the way he saw the world.

In the late 1930s, Warhol had compiled a Hollywood scrapbook, pasting in handouts from Pittsburgh cinemas and autographed pictures he had sent away for. Among the icons included were Henry Fonda, Carmen Miranda, Mae West, Shirley Temple and the then popular trumpeter/ bandleader Harry James. This was a particular cosmology that valorised handsome men and strong, albeit heavily costumed women, one that could almost be described as camp, especially since the compiling of pop culture scrapbooks was not an automatically masculine pursuit.

As is clear from the long-players left in the archives, Warhol's taste during the 1950s was fully within the homosexual culture of the day: musical cast albums, audio recordings of Tennessee Williams plays, modern classics like George Gershwin and Irving Berlin, Lotte Lenya singing *The Threepenny Opera*, torch singers like Tally Brown, the inevitable Judy Garland and rare oddities like Jack Kerouac's *Blues and Haikus*. Apart from a Tab Hunter album – which was perhaps bought for the actor's looks as much as the music – there was almost no pop.

After 1960, however, there was a flood, as Warhol caught up with rock 'n' roll and the teen pop of the day. As well as the Coasters' first album, there is a long-player by the teen bodybuilder Johnny Restivo and a single by the Rays, their big hit 'Silhouettes'. There are two Presley albums, *Elvis Is Back!* and, from the year before, *50,000,000 Elvis Fans Can't Be Wrong*, with its famous repeated cover image of eighteen Elvises, all dressed in the same gold lamé suit – the pop star as iconic object in the age of mass reproduction.

The bulk of the records come from 1960 onwards, slap bang in the middle of that post-rock 'n' roll moment when Elvis-lites were discovered and moulded by manipulative managers and record companies in a seemingly industrial process. The great thing is that Warhol did not differentiate between the sacred and the profane. If it was pop, it was in – never mind if it was hip or not, never mind if it had longevity. Pop was in and of the moment, and his selections enshrine this instantaneity:

(1) Elvis Presley: *Elvis Is Back!* (1960)

(2) Del Shannon: 'Runaway' (1961)

(3) The Twins Jim and John: 'Teenagers Love the Twins' (1958)

(4) Frankie Avalon: *A Whole Lotta Frankie* (1961) – '17 hits!' Six Top 10s

(5) Ben E. King: 'Don't Play That Song' (1962)

(6) The Coasters: *The Coasters* (1957)

(7) Johnny Mathis: *Live It Up!* (1961)

(8) Bobby Vee: 'Rubber Ball' (1961)

(9) Elvis Presley: *50,000,000 Elvis Fans Can't Be Wrong* (1959)

(10) Cliff Richard: *Listen to Cliff!* (1961)

(11) Fabian: *Good Old Summertime* (1960)

(12) Dion: 'Runaround Sue' (1961)

(13) The Cadillacs/Orioles: *The Cadillacs Meet the Orioles* (1962)

(14) Fabian: *Rockin' Hot* (1961)

(15) Everly Brothers: 'Crying in the Rain' picture sleeve 45 (early 1962)

(16) Brian Hyland: 'Let Me Belong to You' (1961)

(17) *The 12 Top Teen Dances* (1961–2)

(18) Frankie Avalon: *A Whole Lotta Frankie* (1961)

(19) Frankie Avalon: *Swingin' on a Rainbow* (1959)

(20) Bo Diddley: *Bo Diddley Is a Lover* (1961)

(21) Johnny Restivo: *Oh Johnny!* (1959)

(22) Neil Sedaka: *Circulate* (1961)

(23) Elvis Presley: *Pot Luck* (1962)

(24) Bobby Vee: *Bobby Vee* (1961)

(25) The Dovells: *Bristol Stomp* (1961)

(26) Joey Dee and the Starliters: *Twist: Live at the Peppermint Lounge* (1961)

(27) Chubby Checker: *Your Twist Party (with the King of Twist)* (1961)

Much of the list is self-explanatory. Almost all the albums contain the artist's big hits of the day: one or two – or more if it's a greatest hits collection – plus a whole lot of filler. There is a smattering of Black American music – Ben E. King, the Coasters and Bo Diddley – and a couple of surprises: the fourth Cliff Richard album and the doo-wop compilation *The Cadillacs Meet the Orioles*. This was probably bought for

its campy cover of three leather-clad models simulating a gang rumble.

The bulk of the records, however, are by young, attractive, solo male singers – no women at all. Some are from the New York area, the Bronx and Brooklyn – Brian Hyland, Dion, Neil Sedaka, Joey Dee – which is hardly surprising, given this was the music industry's main centre in the period. However, even more come from Philadelphia, the hot city of the moment: Frankie Avalon, Fabian, the Dovells, Chubby Checker and the aggregations on *The 12 Top Teen Dances* – the Lavenders, the Dreamlovers, the Applejacks.

Both Frankie Avalon and Fabian were discovered and packaged by the same manager, Bob Marcucci, and they both display a distinctly gay appeal, whether intended or not. Each one could have come out of the pages of *Physique Pictorial*. Avalon was a bit tougher and older, but the teenage Fabian was prime pin-up material. On the *Good Old Summertime* album, released when he was seventeen, the young singer was pictured in a bright pink top, open to the waist, with checked swim shorts that were filled out with a distinct bulge.

Both Avalon and Fabian were under twenty-one in 1960. They were between five and eight years younger than Elvis, who had reached a level of fame that seemed to inoculate him against the usual three-year pop-star cycle. He had three Top 5s in 1959, while he was doing military service in Germany, and three #1s in the year of his re-emergence, 1960. By then, he was a different beast to the wild young man whose overt sexuality had threatened America: sleek, glossy, friends with Sinatra, more conventionally masculine. Which left a gap.

It seems clear that Warhol was getting his pop info from *American Bandstand* and *16* magazine. When, in summer 1961, the gallerist Walter Hopps visited Warhol's town house, he remembered entering a window-less room: 'It was a panelled library, but the bookshelves were empty . . . no pictures on the wall, nothing. What really made an impression was that the floor . . . was covered wall to wall with every sort of pulp movie magazine, fan magazine, and trade sheet, having to do with popular stars from the movies or rock 'n' roll. Warhol wallowed in it.'

In 1961, *American Bandstand* was the biggest thing in American pop. Because of the sheer size of the continent, syndicated TV shows were

vitally important in promoting new records in America, and after it went national in August 1957, *American Bandstand* became the focus of a new wave of pop stars and their manipulators and marketers. If rock 'n' roll had woken up the music industry to the potential of the teenage market, then mediators like Dick Clark showed them how to sell it.

By the early 1960s, the sense of the teenager as a national threat was receding in America. The perception of mass culture and youth culture changed, in the historian James Gilbert's words, 'from negative to positive – or at least to neutral'. Formerly seen as having a disastrous effect on the adolescent psyche, the mass media was now understood as being the selling agent for a massive new market, swelled by the first products of the post-war baby boom. It even started appealing to sophisticates.

Within this process, *American Bandstand* operated – at first accidentally and then deliberately – as a kind of market research poll, as well as an entertainment. Within six months of going national in August 1957, it was attracting twenty million viewers and tens of thousands of fan letters a week. The format was simple but exciting: carefully selected teenagers danced to Top 40 records and judged new releases in the 'Rate-a-Record' segment. These teens became stars in their own right, 'instant celebrities', as one dancer, Ed Kelly, remembered.

There would be three guest stars a week, and this became a highly prized slot for showcasing new records, as it quickly became apparent that *American Bandstand* could break hits nationally; early examples included the Rays' 'Silhouettes' and Philadelphia group Danny & the Juniors' 'At the Hop' – a #1 hit for seven weeks in early 1958. And there was the rub. The competition was so fierce that, if it did not induce corruption, then it did encourage a certain element of sharp business practice. Having realised the show's immense power, host Dick Clark soon presided over a collection of companies, managers and artists that fed *American Bandstand* raw male talent as if on a production line. Musical quality wasn't the point – although that was an occasional by-product – but looks, availability and suitability were: nothing Clark deemed too threatening, nothing too Black. Clark wasn't the only person involved, of course, but he was at the centre of a complex web of interlocking interests.

Danny & the Juniors' 'At the Hop' was released on ABC/Paramount, the record wing of ABC television. Other labels included Cameo, with the Rays and Bobby Rydell, and Swan Records, who had huge hits with Freddy Cannon: 'Tallahassee Lassie' and 'Way Down Yonder in New Orleans'. 'Tallahassee Lassie' was composed by Bob Crewe, who had also written the Rays' 'Silhouettes'. Soon afterwards, he began collaborating with the Four Seasons – macho guys from New Jersey around whom he'd have to hide his homosexuality.

The other main label to ride the *Bandstand* gravy train was Chancellor, a subsidiary of ABC/Paramount. This was co-owned by Bob Marcucci, the Philadelphian who had discovered the two key stars of the *Bandstand* era, Frankie Avalon and Fabian. Both were Italian American teenagers from the noted South Philadelphia High School for boys; other alumni included James Darren and Chubby Checker. 'I worked with them,' Marcucci remembered. 'I picked out their clothes and helped them out in a lot of areas. They were very young. They were 15, 16, 17 and 18.'

Marcucci hit pay dirt with Avalon in early 1958, when 'Venus' went to #1, the first of six Top 10 hits for Avalon that included another #1, 'Why'. With a less powerful voice, Fabian was more difficult to launch, despite a lively first single written by Doc Pomus and Mort Shuman, 'I'm a Man'; eventually, the teenage singer racked up three Top 10 hits, the most successful being 'Tiger', which reached #3. In both cases, appearances on *American Bandstand* were crucial to their success. Clark had an interest in both Swan Records and Marcucci's acts.

Avalon and Fabian were staples of the most successful US teen publication of the time, Gloria Stavers' *16*. Having assumed the editorship in 1958, Stavers turned the publication into what was essentially an *American Bandstand* fanzine. Round and round the same faces went, as though on a carousel: Paul Anka, Rick Nelson, Frankie Avalon, Elvis, Connie Francis, Fabian, Sal Mineo, James Darren, Johnny Restivo and regular *Bandstand* dancers like Arlene Sullivan, Jimmy Peatross and Kenny Rossi. It was very frothy, upbeat and apparently innocent. Yet the difference between Bo Diddley's 'I'm a Man' and the song of the same name recorded by Fabian posed some interesting questions. The whole *Bandstand* aesthetic was tailored to young women, probably a

little younger than the dancers. A certain sexlessness, if not androgyny, was desired, along with a pliable, almost plastic quality that reflected the extent to which some of them – Fabian and Avalon in particular – were moulded and packaged.

Whether there was much gay involvement in this early-1960s pop ecology is uncertain. Bob Crewe was homosexual, even though his condensed biography in *Dig* magazine stated that he 'likes down to earth girls'. With Bob Marcucci, it's harder to say. He was married, with one child, and neither he nor any of his charges have ever spoken in public about the topic in any way. All there is is a hint from the arranger Jack Nitzsche, who, hired by Marcucci to work on an opera production, stated that he thought 'the whole office was gay'.

The question of the gay influence is moot, however, when faced with Andy Warhol's records – a rare cartography of a homosexual pop aesthetic in the early 1960s. What gay men and lesbians were listening to in the early '60s remains barely recorded. For instance, what was on the jukebox of the Tay-Bush Inn when it was raided? It is well established that the gay underground had a strong taste for show tunes, opera, female impersonators and drag queen comedy records, but what about contemporary pop?

There is no reason to assume that gay men did not like rock 'n' roll, but there was something about the subsequent pop styles that drew them in further. Whatever the motivation of Dick Clark, Bob Marcucci and Bob Crewe – which was no doubt to sell as many records as possible – there was a difference between intention and reception. The good looks and plasticity of Frankie Avalon and Fabian appealed to Warhol, and there is other anecdotal evidence that the 'boy' singers of the early 1960s appealed to young men both in the UK and the US.

Indeed, this period saw the establishment of a recognisable gay pop taste, reflected in the choices of teenagers at the time. In the UK, the future writer and archivist James Gardiner was fourteen in 1961; as he told me, he was 'hanging around the Mocha Bar in Watford – the hangout of all the art students and Ban the Bomb CND-ers – smoking Gauloises and drinking black coffee, and in school holidays going up to London on the Bakerloo Line and doing the same kind of thing in Soho coffee bars like Le Macabre and La Bastille, and the Moo-Cow at Notting

Hill Gate'. He remembers records like Del Shannon's 'Runaway' (one of the UK's biggest-selling hits of 1961), 'Halfway to Paradise' by Billy Fury, 'Are You Lonesome Tonight?' by Elvis, 'Rubber Ball' and 'Take Good Care of My Baby' by Bobby Vee, 'Save the Last Dance for Me' by the Drifters, 'Will You Love Me Tomorrow' by the Shirelles, 'The Twist' and 'Let's Twist Again' by Chubby Checker and – a final piece of full-blown melodrama, written by Lionel Bart – 'As Long as He Needs Me' by Shirley Bassey.

The conceptual artist Robert Lambert, who grew up in Baltimore, mentions a wider variety of records in terms of a gay sensibility, reflecting the greater access of American teens to pop music in general. The records he cites from 1961 are almost all by women: 'Just One Look' by Doris Troy, 'I Know (You Don't Love Me No More)' by Barbara George, 'At Last' by Etta James, 'Dedicated to the One I Love' by the Shirelles, 'Saved' by LaVern Baker, 'Hurt' by Timi Yuro, 'Crazy' by Patsy Cline, 'Gee Whiz' by Carla Thomas and Roy Orbison's 'Crying'.

The pretty-boy soloists are present and correct, but these lists reflect two other changes in pop music during the early 1960s: the onset of what was later called the girl-group sound, and the strength of early soul. Groups like the Shirelles were new types of female acts: not the solo singers of yore but streetwise young women, singing about boys in a dramatic, often earthy vernacular. At the same time, Black American music was becoming uptown, more sophisticated, softer in its immediate impact in the hands of higher-voiced R&B acts like the Drifters.*

The soul music maven Dave Godin described this shift, focusing on Maxine Brown's introspective 'All in My Mind', a US Top 20 hit in early 1961: 'It had severed the traditional rural links. It was unmistakably city night club music. It had also moved on to a deeper perception of human psychology, almost as if the initial set of problems with the blues were where's the rent etcetera, survival. Things were still tough, but now we move on to all the problems of interpersonal relationships. The troubled mind thing.

* Rudy Lewis, the Drifters' lead singer during this period – the main voice on 'Please Stay', 'Up on the Roof' and 'On Broadway' – was, according to most sources, a closeted homosexual.

'It's also quite remarkable when you look at the American pop charts then, they were more liberal and cosmopolitan than ours ever were. I think it was tied up with the growing awareness and consciousness of the teenager that was happening. Hollywood was helping in that. There was a focus on being a teenager than hadn't existed before teenage culture was beginning to emerge. Also teenage buying power, and teenagers were starting to be aware of their own power, they could decide what records were going to become hits.'

As it expanded, thanks to the money that was pouring into the youth industries, pop music was opening up to all kinds of social groups who had previously felt excluded or sidelined: young women, Italo-Americans, Blacks and homosexuals. It paralleled the slow shift to emancipation that was being undertaken by Black Americans in the civil rights movement, the still tiny homophile movement and the incipient second wave of feminism – reflected most notably in the book then being prepared by Betty Friedan, *The Feminine Mystique*.

Warhol also felt outside the mainstream, and wanted in. It wasn't just the fact that he was homosexual, but as a Slovenian native of Pittsburgh, he was excluded from WASP society. He was also cut out of the macho – or, at least, closeted – world of fine art, which was just moving out of abstract expressionism. In his own rage at being excluded, Warhol intuited that pop could be as much a vehicle as a weapon: *You think I'm low-class? Well, I am. You think I'm camp? This is what you call low-class and camp, and I'm going to ram it in your face.*

Warhol identified with teenagers and with teenage culture. It was new, it was American and it was happening whether the elites liked it or not. Pop was under the radar of most commentators in the early 1960s. In the art world, the appreciation of pop was a way out of the tortured soul-searching of abstract expressionism and a high seriousness that could strangulate any artist. It sidelined the critics and also appealed to something in Warhol that demanded self-reinvention. He was to become, as one friend called him, 'America's Greatest Teenager'.

In early 1961, Warhol began painting a new series of canvases that would carry him through until the spring. Most of these were images taken direct from newspapers, blown up on a Beseler Vu-Lyte opaque

projector and traced with his paintbrush: two panels from an Ernie Bushmiller *Nancy* strip in February, two *Popeye*s in March and a storm window advertisement that same month. They still had the vestiges of abstract expressionism in the paint drips but, placed out of context, they were impressive and provocative.

Warhol was familiar with the idea of camp, not just as a mode of expression and, indeed, gesture, but as a way of keeping a hostile world at bay. He was also fully aware that it could, subtly and insidiously, get right under the skin; it was hard for straight society to understand and to deal with. These early pictures were prankish, but they were also deadly serious: this was where Warhol had come from – the mass media – and this is where he was going. This was America. And if they were annoying the establishment, so much the better.

In April 1961, he arranged his first major installation. If galleries would not show him, then a shop window would. The luxury department store Bonwit Teller hired Warhol to help promote a season of new, stylish, young women's dresses in bright florals, reds and blues with five of his own paintings. These included blow-ups of ads for Coca-Cola and images from the *Popeye* and *Lois Lane* strips. The display attracted attention in the trade press: 'Cartoons Galore Are Eye-Catchers' ran one headline.

Warhol wasn't the only artist moving in this direction. James Rosenquist was painting montages like *I Love You with My Ford* – a blending of a vintage Ford with a woman's face and tinned spaghetti. Roy Lichtenstein was painting huge blow-ups of comic strips like *Popeye* and *Mickey Mouse*, while Robert Rauschenberg was producing combines like *Black Market*, with its mixture of paint and found objects: street signs and car registration plates.

No American artist, however, tackled pop culture as directly as the young British painter David Hockney. Born in 1937 and raised in Bradford, Yorkshire, Hockney had had to undergo national service before attending the Royal College of Art in 1959. There he fell in with a younger generation of artists that included Allen Jones, Derek Boshier and Ron Kitaj, who were the terror of their older teachers, born in the early years of the century and insistent on the traditional verities of the life class, classical painting and the Old Masters.

All these younger artists were inspired by America. 'Growing up in the 1950s, we dreamed the American dream,' wrote the artist and film-maker Derek Jarman thirty years later. 'England was grey and sober. Over the Atlantic lay the land of Cockaigne; they had fridges and cars, TV and supermarkets. Then as the decade wore on, we were sent Presley and Buddy Holly, and long-playing records of *West Side Story*, and our own *Pygmalion* transformed. The whole daydream was wrapped up in cellu-loid . . . How we yearned for America! And longed to go west.'

Hockney realised he was homosexual at a young age, but once at the RCA, was liberated by his American friend, Adrian Berg. 'I suddenly felt part of a bohemian world, a world about art, poetry and music. I felt a deep part of it rather than any other kind of life. I finally felt I belonged. I met kindred spirits and the first homosexuals who weren't afraid to admit what they were. Adrian Berg lived in a free world, and fuck the rest of it. Once I accepted all this, it gave me a great sense of freedom, and I started to paint homosexual subjects.'

Inspired by physique magazines, graffiti in public toilets and Walt Whitman's coded gay references in *Leaves of Grass*, he began to produce a series of pictures about love in 1960 – 'inspired', he recalls, 'by the fact that the sex life of London had opened up to me, rather than by any one particular lover'. One of Hockney's obsessions at the time was Cliff Richard, then hitting big with 'Living Doll' and his appearance in *Expresso Bongo*. With his greased-back hair, leather jackets and skin-tight trousers, Cliff was, Hockney remembers, 'a sexy little thing'.

Riffing off the ever-present 'Living Doll', Hockney conceived of a new painting called *Doll Boy* (1960–1), in which he rendered Cliff, rather than the putative girl addressed in the lyrics, as the living doll. He worked on several studies and dry runs, but the finished painting shows a central figure against a patterned, highly coloured background. The face is indistinct, but he is wearing a flowing top or dress, on which is scrawled the word 'Queen'. Above his right shoulder is the title, written in lower case: 'doll boy'.

Hockney's ascent was fast. In February 1961, he showed in the annual 'Young Contemporaries' exhibition at the galleries of the Royal Society of British Artists, the group show that announced the arrival of a new spirit in British art. He quickly acquired a gallerist and finished a new

painting, *We Two Boys Together Clinging*, which was inspired by pin-ups of Cliff and a newspaper clipping about a mountaineering accident, with the headline 'Two Boys Cling Together All Night'. His fevered imagination merged the two cliffs into one of his most iconic pictures.

In July, Hockney visited America, where he sold some etchings and immersed himself in New York life. 'I was taken by the sheer energy of the place,' he remembered. 'It was amazingly sexy, and unbelievably easy. People were much more open, and I felt completely free. The city was a total twenty-four-hour city. Greenwich Village was never closed, the bookshops were open all night so you could browse, the gay life was much more organised, and I thought, "This is the place for me."'

To suit this liberation, he transformed himself. Watching TV with a couple of friends, they were struck by an advert for Lady Clairol hair dye, with the catchphrase: 'Is it true blondes have more fun?' Hockney got very excited and decided that he was going to become blond, like the ideal all-American boy. This was a reinvention worthy of Warhol. When he returned to London in early September, 'with a yellow crew-cut, smoking cigars and wearing white shoes', Hockney was a sensation, flaunting his difference and homosexuality for everyone to see.

Later that month, Warhol took an important step towards making his long-desired breakthrough into fine art when he met the gallerist Ivan Karp and invited him to his town house in Lexington Avenue. Karp remembered entering a very elegant living room with fine Victorian furnishings and some surrealistic paintings on the walls – an impression at odds with the rock 'n' roll song that was spinning round and round on endless repeat. Although he was, like Warhol, in his mid-thirties, Karp started dancing, and the ice was broken.

Unusually for the art world, Karp was attuned to contemporary pop. After hearing 'Hey Paula' by Paul & Paula on the radio, he felt it was 'metaphysical music. I couldn't believe the dumbness and beauty of it.' He thought the pop of the day and pop art were part of the same aesthetic: both 'had to do with cleansing away all the traditional, prevailing sensibilities in the arts. The simplicity of the rhythms, the simplicity of the lyrics – that's where rock's confluence with Pop lies. Both are about innocent simplicity, openness to possibilities.'

The key moment in Warhol's move to pop happened when the artist showed his new paintings, all inspired by mass-media iconography. There were differing approaches: some had drip marks; others were completely straightforward, with no 'artistic' intervention whatsoever. Karp told Warhol to drop the drips as they were a hangover from abstract expressionism, while the machine-like reproductions were new and shocking. As he remembered: 'The idea of doing blank, blunt, bleak stark images like this was contrary to the whole prevailing mood of the arts – but it gave me a chill.'

This was the direction Warhol would pursue for the rest of 1961 and into 1962. As his biographer Blake Gopnik writes: 'Warhol's eureka moment – one of the greatest in the history of art – came when he realized he could take the tastes for lowly pop culture that he knew from camp and from elite commerce and transplant them, almost unchanged, into the "rare" realm of fine art.' In immersing himself in pop music as an environment and an idea, Warhol was ahead of almost all of the future pop art pack.

Although he would have loved to have been a teenager rather than in his early thirties, Warhol's relationship to pop music was complex. Karp remembered that he liked it for 'its tremendous force and conviction', but the music wasn't natural to his age group, and he had to learn how to like it, which for him meant working out how to integrate it into his work and image. The blaring pop record would become an integral part of most descriptions of his workplace during the 1960s: an aural approximation of the novelty and attack of his painting.

However, he couldn't help but get further drawn in. It was like a drug; he was in the swing, it was part of his identity, it was a social happening and it was exciting and new. In October 1961, Warhol got involved with the latest thing in pop culture as it was happening. As he later remembered in *POPism*, co-authored by his friend and collaborator Pat Hackett: 'Of course, like everybody else in the fall of '61, we were also running down to the Peppermint Lounge on 45th Street.'

It had taken only one short society column. In the 21 September 1961 edition of *Smart Set*, the gossip columnist Cholly Knickerbocker ran a squib about the fact that a Russian aristocrat, Prince Obolensky, had been seen dancing the Twist at New York's 'chic' Peppermint Lounge.

'The Twist is the new teenage dance craze. But you don't have to be a teenager to do the Twist.' The story was picked up by other columnists, and within weeks it was a feeding frenzy, with Greta Garbo, Noël Coward, Tennessee Williams and the Duke of Bedford all cited as attendees at the club.

The fact that high society was getting involved with pop culture was a sign of the times. Pop and youth were becoming major forces in American society. The idea that the great and the good were taking their cues from teenagers was ludicrous enough, but the Peppermint Lounge was a small, homosexual sleaze pit in one of the worst areas of Manhattan. As Terry Noel, a dancer and waiter in the club, remembered: 'It only held about 140 people. It was a hustler bar; a gay hustler bar on 45th Street, right off Times Square.'

This attention revived a style that had been popular since the late 1950s, first among Black American teenagers and then, with the assistance of *American Bandstand*, in the pop charts. Hank Ballard and the Midnighters had first recorded 'The Twist' in 1958, and the dance became an underground phenomenon that reached the attention of Dick Clark, who nevertheless refused to include it on *American Bandstand* because it was too Black. The song was offered first to Freddie Cannon, who turned it down, before Cameo found Chubby Checker in spring 1960.

Hank Ballard was a music industry veteran, famed for his sharp appearance and risqué tunes. Checker was much more ameliorative: friendly, bouncy, smiling. In mid-September 1960, Checker's version of 'The Twist' went to #1 in the US charts, while Ballard's topped out at #28 the same week. Convinced, as ever, that popularity trounced morality, Clark caved: having thought the dance 'a pretty frightening thing', he featured Checker on *American Bandstand* later that month, and the way that the regulars danced changed from then on.

The Twist helped to relaunch *American Bandstand* after a series of setbacks in 1959, when, as a result of investigations by Congress into corrupt music industry practices, including insider dealing and bribing DJs to play records – 'payola', as it was called – Dick Clark was forced to divest himself of almost all his holdings and business connections with Swan, Bob Marcucci and several others. Unlike Alan Freed, Clark's image

was not harmed by the very public scandal, which was played out in the press and in front of Congressional hearings. After a brief wobble, by summer 1960 he and *American Bandstand* were back.

The Twist was a strange beast, summoned up from the depths of American musical culture. Checker likened the movement 'to extinguishing a cigarette with both feet while drying off one's derriere with a towel'. He claimed, incorrectly, to have originated it, but as Twist historian Jim Dawson writes: 'Such motions can be traced back to pelvic dance moves that were brought to America from the African Congo by slaves, and approximations of Checker's now-familiar moves had appeared in several films since the 1930s.'

The Twist's great novelty was that it could be done solo – which made it a must for gay bars, where men were not allowed to dance with one another. Within the context of the time, this was revolutionary. It encouraged freestyle – improvisation, with no set patterns – and, by keeping footwork to a minimum, put it within reach of everyone. 'There's absolutely nothing in it,' Checker told *Disc* in December 1961. 'People have been doing the same sort of thing for centuries. Especially people who can't dance properly.'

Checker was up and running. By late 1961, his fourth Top 10 hit, 'The Fly', was peaking in the charts when 'The Twist' re-entered the Hot 100 as a result of all the media attention around the Peppermint Lounge. In the chart of 20 November, 'The Fly' was at #10, while 'The Twist' had gone up to #27. That same week, 'Let's Twist Again' re-entered the Hot 100 at #65. Three places below it was a new entry from Joey Dee and the Starliters, the house band from the epicentre of the media storm, with a cash-in tune called 'Peppermint Twist'.

During the week that followed, Andy Warhol had another breakthrough. On 23 November, he invited some friends over to dinner – including Muriel Latow, the owner of a small Manhattan art gallery – during the course of which he bemoaned the fact that his current work, in particular the cartoon paintings, was being trumped by his competitors Claes Oldenburg and Roy Lichtenstein. He begged his guests for ideas, offering $50 (around $430 in today's money) for the one that worked best.

Latow wasn't terribly impressed with Warhol – she thought he was 'one of society's natural aliens' – but she came up with the goods once

the cheque was offered. She told Warhol that he should paint 'something you see every day and something that everybody would recognize. Something like a can of Campbell's Soup.' 'Oh that sounds fabulous,' Warhol replied, and rushed out the next day to the supermarket across the street to buy every single can of Campbell's in the store, an act that would launch him on his way to becoming the most famous artist in America.

14
1962

Movie, baseball and physical culture magazines were strewn about. Bookshelves, barren of books, held cans of beer, fruit juice, cola bottles. Jukebox pop tunes played incessantly so we yelled our first question above 'Many a tear has to fall, but it's all in the game.'

Introduction, 'Pop Art? Is It Art? A Revealing Interview with Andy Warhol', *Art Voices*, December 1962

New Year 1962 was not going well for either John Leyton or Joe Meek. After two huge hits, 'Son, This Is She' was distinctly under-performing. Although *Disc* had the record as entering at #10, the official chart showed it lingering in the 30s, from where it would eventually rise to #15 – a fitting fate for an awkwardly titled record that, in trying to be too different from the formula, was neither one thing nor another. The grand cross-media strategy begun by 'Johnny Remember Me' and continued with *The Johnny Leyton Touch* was faltering.

Even worse, both singer and producer were embroiled in an unseemly controversy, which was being played out in the pages of the UK's weekly music press. The front cover of the 6 January issue of *Melody Maker* displayed a picture of Leyton, heavily made up in an extravagant striped shirt, under the headline 'Pop Singer Denies Gimmick Charges'. As the copy began: 'Will 1962 see the end of the "gimmick brigade" in pop music? Will record companies "ditch" powerhouse echo numbers in favour of more accurate sounds from singers?'

The trigger for the piece was twofold: the entry of 'Son, This Is She' into the official charts, and remarks made by the bandleader and radio personality Jack Payne, who had criticised singers like Leyton for being 'manufactured by studio sounds'. In early 1962, Payne was sixty-two and definitely not a teenage record-buyer. Stung, Leyton replied: 'My critics say all my records are just electronic . . . that I wouldn't succeed without echoes. But no record succeeds through technique alone. Even Frank Sinatra has echo effects. Pop records today must be as exciting as possible.'

The critics had the germ of a point. Leyton would not have had as much success without Meek's studio wizardry, but by 1962 pop was not about the accurate reproduction of a live or studio performance, it was 'an electronic product', aimed, in every which way, at evoking emotions in its teenage audience. Meek understood this, and his riposte to the criticisms was direct: 'Utter rubbish. Certainly I try to inject punch and drive into my productions with John. But he is basically talented. He would have made headway with whoever put him on record.'

The controversy rumbled on over the next few weeks as 'Son, This Is She' dropped out of the charts. In *Record Mirror*, Martin Slavin, who

arranged Helen Shapiro's hits, agreed that it would be impossible for 'John Leyton to sound the same on stage as he does on records unless he sang down a very deep hole'. Meek was furious: 'Who does Slavin think he's kidding?' he replied. 'I would be a fool to listen to an arranger with a bee in his bonnet. I make records to entertain the public, not square connoisseurs who just don't know.'

Meek's paranoia was innate but accurate. The established music industry – the major labels and their musical directors, arrangers and A&R men – were obviously resentful of this bizarre, unpredictable interloper in their midst, messing up their carefully parcelled and patrolled territories. Worse, this boiled over just at a time when Meek's flagship artist was beginning a downhill slide. Meek was forced rely on his wits and the power of the individual hit record, but he also fully understood pop's essential drive: to be as exciting as possible.

Excitement was in short supply during early 1962. The UK Top 10 for the first week of January contained ballads, light pop tunes and trad jazz. Producer Jack Good put his finger on the malaise in one of his intermittent jeremiads: 'That's what the pop scene was last year – a mess. Because there was no common framework, no unity of style, and therefore no excitement. In sum my description of pop 1961 would be . . . frantically searching for something that never happened.'

This was a little unfair on Joe Meek, whose productions he had fulsomely praised, but Good was accurate in the sense that there was a strange interregnum in British pop culture. The 1960s hadn't truly started. The British pop scene was still in thrall to the post-Elvis reconstruction that had occurred in the late 1950s. While there were random novelties and agreeably synthetic treats, there seemed to be no great groundswell, no subculture out of which new forms and ideas would grow. The rest was ballads and bounciness.

Into this vacuum came the democratisation of dance. Following his visit to the UK in late 1961, when he experienced fan mania, Chubby Checker had two records in the UK Top 20: 'The Twist' at #14 and 'Let's Twist Again', which had risen from #11 to #2, where it stalled behind the immovable 'The Young Ones'. 'Let's Twist Again' would remain in the UK Top 20 until mid-May, no doubt assisted by Checker's appearance

in Dick Lester's fast-moving, clever film *It's Trad, Dad!*, in which he performed the Lose-Your-Inhibitions Twist.

While the Twist was at its peak, Billy Fury was interviewed on the set of the first film in which he'd taken a starring role, *Play It Cool*. After three big hits – his latest, 'I'd Never Find Another You', had been in the Top 10 for weeks – he was now a major star. He was not particularly enthused about his success: 'I'm not very good at just turning it on. If I don't feel in the mood then I don't do it right . . . I can't just put on a face and pretend I am feeling great.' This anomie could have been assisted by Fury's continuous marijuana-smoking, which resulted in an early-1962 raid on his flat by the police.

Released that March, *Play It Cool* co-starred Helen Shapiro, Bobby Vee and the veteran gay British character actors Richard Wattis and Dennis Price. Rooted in recognisable locations, like the famed showbiz meeting place the Lotus House in Edgware Road, it nods to the Twist in various club scenes, as Billy and his mates trawl through London club life. It's more realistic and a bit earthier than Cliff Richard's distinctly anodyne *The Young Ones*, but contains the fatal deference to age and class that would soon disappear in British youth culture.

Fury gave an interview to *Disc* that month, in which he came across as 'an intelligent yet modest entertainer' – Larry Parnes had clearly had a word. Fury remarked on the importance of 'Halfway to Paradise' to his career: 'I often wonder what would have happened if I'd not had that hit. I always thought I'd just fade out because I wasn't getting anywhere and life was becoming a drag. Now I never worry about a thing: I've learned to take life as it comes and make the best of it all.'

―――――

Despite the influence of homosexuality on the music industry, it remained a topic understood by insiders but unknown to the public, who, for instance, took Billy Fury at face value as a heterosexual icon rather than one moulded by a gay Svengali. Despite the successes of Joe Meek and Larry Parnes, it was still a closed, albeit coded, world. Indeed, any attempt to open up public discussion about homosexuality in

general – or, for that matter, any relaxation in public and official attitudes – was doomed to failure in the early months of 1962.

In early March 1962, Leo Abse introduced a private member's bill into the Houses of Parliament that attempted to enact some of the Wolfenden recommendations in relation to the policing and sentencing of homosexuals, while at the same time addressing the possibility of blackmail being used against the victim. It was talked out by the sixty-three-year-old Tory MP Cyril Osborne. The *Guardian* observed that 'members who oppose a more human law for homosexuals are at least as determined as they ever were to keep Wolfenden from the Westminster door'.

Abse had been inspired by *Victim*, which was banned in America. After a limited screening at two art cinemas in New York, *Time* magazine weighed in with both feet: 'Nowhere does the film suggest that homosexuality is a serious (but often curable) neurosis that attacks the biological basis of life itself. "I can't help the way I am," says one of the sodomites in this movie. "Nature played me a dirty trick." And the scriptwriters, whose psychiatric information is nearly coeval with the statute they dispute, accept this sick–silly self-delusion as a matter of fact.'

Unable to see the film, *ONE* positively reviewed the film's novelisation by William Drummond as 'a milestone in the homosexual's struggle for fair treatment and equality under the law'. That March, *The Ladder* reported rather tersely on *ONE*'s tenth anniversary. The Daughters of Bilitis felt that *ONE* had, despite its claims of being 'coeducational', failed to represent the female point of view. The magazine quoted the activist Jaye Bell's concerns that 'those in the homophile movement may get caught up in the "cause" and lose sight of the individuals they are fighting for'.

Shortly afterwards, *The Ladder* further expressed its irritation with the predominantly male magazine, as frustration with the slow rate of progress boiled over: '*ONE* has maintained a vigilant, militant attitude – a thorn-in-the-side reminder that homosexuals are here to stay. The public that is most reminded, however, is the public law enforcement agencies. While *Mattachine* has strived for cooperation with law enforcement, *ONE* tends to provoke law enforcement officers to act against them . . . Can "The Big Three" DARE to work together?'

Nevertheless, gay rights got a significant boost in June 1962. The impetus came not from the 'Big Three', but from physique publisher Herman Lynn Womack, who had decided to fight the US Post Office all the way. On final appeal, the Supreme Court ruled that photos of nude men were not inherently more obscene than those of nude women, and that the standards applied to erotic magazines aimed at heterosexual readers also applied to those aimed at homosexuals. The floodgates were opened for a tsunami of gay imagery.

————

During the spring and summer, Joe Meek was reaching the limits of his collaboration with both John Leyton and Robert Stigwood. After the controversy earlier in the year, he had returned to the scene of former triumphs with 'Lone Rider', which sounded like a tired mash-up of Leyton's two big 1961 hits. This did not pass unnoticed: 'The general mood and treatment is harking back to the singer's first hits,' wrote Don Nicholls in *Disc*. 'But . . . I'm growing rather weary of this in-and-out studio sound.' The public agreed, with the single peaking at #40.

Leyton's next release did not involve Meek's studio at Holloway Road. The BBC had complained about the high level of distortion on 'Lone Rider' – Meek had thrown in everything but the kitchen sink in a vain attempt to make the disjointed record work. It was after this debacle that Stigwood decided that Leyton's records had got into a rut. The only solution was for him to produce the singer himself, and, recorded at IBC Studios for a cleaner sound, 'Lonely City' marked the definitive break.

Stigwood also poached Mike Berry, another hit-making act of Meek's, who'd hit the Top 30 in late 1961 with 'A Tribute to Buddy Holly'. Shortly afterwards, Charles Blackwell joined forces with the Australian, and almost immediately had a huge hit with a song he'd written, Mike Sarne's 'Come Outside', a chirpy rendition of heterosexual courting rituals that made #1 in late June. In short order, Meek had lost his main act, another hit-maker and his arranger, the latter a particularly bitter blow as they had worked so well together.

The break also effectively marked the end of Leyton's hit-making career. While 'Come Outside' was still at #1, his new single 'Down the River Nile' was unveiled. Despite a hopeful build-up, the record was a dog, and Leyton prepared his get-out. 'The teenage market is a very important one to me,' he told *Disc* that July, 'because without it, I would be nowhere. I shall always keep an eye on that market, but I hope that when people come to see *The Great Escape* it will be because I am an actor, not a pop singer.'

A couple of days after Leyton's interview, on 9 July 1962, Andy Warhol finally achieved his breakthrough into the art world, when his *Campbell's Soup Cans* show opened at the Ferus Gallery in Los Angeles. Gallerists Irving Blum and Walter Hopps had already shown other pop artists, such as Roy Lichtenstein and Jasper Johns, but this was something different: more minimal, starker, even more pop. For Warhol, it was the culmination of at least eighteen months of preparation and immersion into the pop culture of the day.

After his epiphany with Muriel Latow, Warhol had been producing dozens of *Campbell's Soup Can* paintings in various sizes, ranging from small to big grid, from individual soups to multiple rows. It was the perfect image to announce himself with: the soup can was recognisable, everyday, connected to his poor past and, thus, to the common man, campy – in the guise of the then current fad for antique Coke bottles – and curiously blank. In soon-to-be-classic Warhol style, it didn't mean anything, or rather, it flaunted the idea that it meant nothing.

Naturally, it was more complicated than first appearances would allow. Warhol couldn't shed his aesthete's eye, however much he tried. 'The everyday things we live with are so beautiful and no one realises it,' he told his friend David Bourdon in early March 1962, and the soup can was the perfect example of the mundane that, once carefully observed and conceptualised, could be rendered through an artistic process – i.e. painting – and then put on display in a gallery: in other words, a piece of art.

On 11 May 1962, Warhol had finally got his first piece of major press, in *Time* magazine's round-up of pop painters, entitled 'The Slice-of-Cake School'. Interviewed alongside James Rosenquist and Roy Lichtenstein,

his responses were a perfect piece of positioning and myth creation, accentuating his newly minted blank persona: 'I just paint things I always thought were beautiful, things you see everyday and never think about. I'm working on soups and I've been doing some paintings of money. I just do it because I like it.'

His immersion in pop was deepened through his association with Ivan Karp, who took the artist out to the Brooklyn Fox, where Murray the K was hosting his live shows – action-packed extravaganzas featuring a dozen or more hit-makers of the day performing their hit songs. The 1962 concerts featured the Shirelles, the Four Seasons, the Marvelettes, Fabian, Tommy Roe, Little Eva and the Ronettes. Warhol was transfixed by the high-energy atmosphere in the integrated audience.

On 5 August, the death of Marilyn Monroe was announced. Long obsessed with Hollywood stars, Warhol quickly seized upon her as his next subject: a perfect mix of glamour, fame, sex appeal and death. There was a kind of contiguity as well: in her New York days, Monroe had been a customer at Warhol's favourite meeting place, the gay-owned restaurant-cum-boutique Serendipity. Within weeks, he had produced a series of large canvases in various flavours – mint, grape, cherry, peach – tragic celebrity turned into a comestible product.

———

At the end of August 1962, Meek released his latest attempted blockbuster. After the defection of Stigwood and Blackwell, his output had slowed over the summer, and he had had no records in the charts since 'Lonely City' in the spring. But this was something different, a step up. Recorded with his new house band, the Tornados, 'Telstar' was completely shaped by his fascination with the worlds of technology and outer space – a summation of the themes introduced on *I Hear a New World* a couple of years before.

'Telstar' shared the sense of optimism and expansiveness that had sent the Shadows' 'Wonderful Land' to #1 for eight weeks that spring. On 11 July, Meek had been at home, watching the television, when his imagination was caught by the initial flickering images from the world's

first communications satellite, Telstar 1. This first live transatlantic television broadcast included images of a news conference given by President Kennedy and scenes from San Francisco, Detroit, Niagara Falls, the United Nations and Mount Rushmore.

Meek immediately started fleshing out a melody on tape. His pitch was notoriously wayward, but he built up a demo using a clavioline, a small, battery-operated keyboard, which gave it an otherworldly feel. It was enough for the Tornados to work up, and when they returned to the studio, guitarist Alan Caddy helped Meek to flesh out the melody and arrangement. As drummer Clem Cattini told me: 'Joe wanted a moving rhythm; he sang the beat – like dum-diddy-dum – and imitated the guitar sound and bass. Then we just kicked it about, and he'd direct each individual into the shape he wanted it to go. He knew what he was after, but if someone did something he liked, he'd say, "Keep that. I like it." Then he'd say, "Right, that's it up to there," and it went on like that until it was more or less ready. Then he'd record it and change a couple of things here and there. I played the basic beat with brushes on the cymbals, and it was almost exactly the same as "Johnny Remember Me" and "Wild Wind".'

Over the basic track, Geoff Goddard laid down the top melody on the clavioline, which emitted a piercing sound that would cut through on the radio. Meek ran the whole thing through a series of effects, including a Binson echo unit for the fullness of sound and sense of distance. He then sped the track up. At the beginning and end, he reused machine-like sound effects from the *I Hear a New World* tapes, sped up and used backwards.

Meek had high hopes for the record: in one of his regular seances, he had been informed that it would go to #4 in the UK charts. The *Melody Maker* slammed the track, but the public disagreed, and 'Telstar' quickly leapfrogged John Leyton's latest, non-Meek single in the charts. Meek had his revenge – a concept dear to him – with 'Telstar' jumping into the Top 3 after four weeks.

———

As British pop swelled, so did its latest youth culture. What Colin MacInnes had captured in its underground state finally went overground with the arrival of mod. 'These are the Beau Brummels of the rising generation,' ran the picture caption in *Town* magazine's September 1962 issue. This was from an article about fanatic young stylists from Stamford Hill, North-East London, and it centred around three teenagers, Mark Feld, Peter Sugar and Michael Simmonds, all of whom were more than eager to share their philosophy of clothes and life.

The article was entitled 'The Young Take the Wheel'. Although the word 'mod' was not used in the piece, 'face' was already being used to describe a mod stylist, in the subtitle 'Faces without Shadows'. Writer Peter Barnsley focused on one of the three in particular: 'Mark Feld is 15 years old, and still at school. His family has just moved from Stamford Hill to a pre-fab out in Wimbledon. Of this he does not approve. The queues of Teds outside the cinemas in Wimbledon look just like a contest for the worst haircut, he says.'

Impressed by his arrogance and certainty, Barnsley let the fourteen-year-old – as he was in summer 1962 – talk his hind legs off. '"You got to be different from the other kids," says Feld. "I mean, you got to be two steps ahead. The stuff that half the haddocks you see around are wearing I was wearing years ago. A kid in my class came up to me in his new suit, an Italian box it was. He says, 'Just look at the length of your jacket,' he says. 'You're not with it,' he says. 'I was wearing that style two years ago,' I said. Of course they don't like that."'

These were the arrogant, sharp, clean youths already heralded by MacInnes and Ray Gosling. At the same time, in their disdain, if not hauteur, and precision of style, these young men were the archetype for the new Teen Age – the eternal present of consumerism and pleasure, all the time hurtling towards the brick wall of adulthood. 'Living for the present is a mild way of putting it: for him and all the other sharp faces the present is so short and so intensely satisfying that they cannot give even a minute of their time to considering the future.'

This fanaticism about clothes brought the plot of *The Leather Boys* to life. Feld was inspired by a group of around seven stylists in Stamford Hill,

whose whole life revolved around fashion. 'I used to go home and liter-
ally pray to become a Mod,' he later remembered. 'At this time, clothes
were all that Mod was about. The music and dancing and pills came later.
I'd say that Mod was mentally a very homosexual thing, though not in
any physical sense. I was too hung up on myself to be interested in any-
one else, and, besides, I was still very young.'

On 4 October, 'Telstar' went to #1 in the UK charts. It was at this
moment that a young publicist went up to Holloway to meet Meek, who
was recording a vocal version of 'Telstar' with the fifteen-year-old Kenny
Hollywood. As Andrew Loog Oldham remembered, the producer was
'immaculate but seedy. He had a suit and a tie on and more grease in his
hair than you could imagine. He looked like a real mean-queen Teddy
boy and his eyes were riveting. There were shotguns in his studio, shot-
guns in his head, even then.'

In late 1962, Oldham was only eighteen, a teenager in a hurry, and
already thoroughly versed in showbiz glamour and its pervasive camp. He
was working for Ray Mackender, the former associate of Cliff Richard,
who liked surrounding himself with young men. 'Ray took too much
vicarious pleasure in his youthful friends to pay mind to the taboos of
the day,' Oldham remembered later. 'I realise this now in retrospect; my
own upbringing had been too sheltered for me to understand what Ray
was really about.'

His client of the moment was Mark Wynter, a good-looking young
singer who had racked up a few Top 30 singles over the previous couple
of years, but who was having the biggest hit of his life with 'Venus in
Blue Jeans'. Wynter was then touring with Billy Fury, and Oldham got
to meet the great man and his star. 'Fury was not up to the fantasy: he
was not only stoned, he was bored . . . Billy was not intact. Parnes, on
the other hand, lived up to my true pop Diaghilev image of him – a rare
blend of art, money and sparkle on the job.'

From these encounters, Oldham picked up an appreciation of homo-
sexual style as a weapon. Smartly dressed, slight, with a public-school
assurance and elan that went beyond the call of duty, Oldham was at
once insinuating and unsettling. Although he wasn't gay, 'everybody
thought he was a poof', remembered his friend, the singer Kenny Lynch,

in the vernacular of the time. 'He knew that, he couldn't give a monkey's. Andrew used that to his advantage all the time: when I'm with so and so I'll be a poof, because that's what they want.'

However, Oldham did pick up on the unease between Larry Parnes and his chief client, who was beginning to wilt under the pressures of stardom. After 'Last Night Was Made for Love' and 'Once Upon a Dream' became Top 10 hits in the spring and summer, Fury was struck down by a mystery illness – probably his long-standing kidney complaint – which kept him out of action for over a month. There was a distinct sense, as well, that he was getting frustrated with the light pop and ballads that he was being saddled with.

On 6 October, *Disc* previewed a new 'rock-slanted-vocal-instrumental group' in its 'New to You' section. The brief squib gave the names of the four members and mentioned their stints in Hamburg and association with prominent music industry figures like Larry Parnes and George Martin. In the same issue, Don Nicholls reviewed their first single for Parlophone: 'The Beatles sound rather like the Everlys or the Brooks [Brook Brothers] according to whose side you're on. But in Love Me Do they have got a deceptively simple beater which could grow on you.'

It had been a long, slow grind for Brian Epstein. Having been dismissed by Decca Records after their New Year's Day audition, the Beatles had been turned down by Pye and Columbia shortly afterwards. As a last throw of the dice, Epstein had contrived to get a contract for them with Parlophone after a complex series of negotiations involving EMI publishing subsidiary Ardmore and Beechwood. Completely inexperienced, yet totally insistent, he had succeeded in bending reality to his vision – the first stage in the Beatles becoming bigger than Elvis.

There was no great commitment by Parlophone to the group; only a contract for six sides, all of which had already been recorded by October. The group were untutored in studio work, awkward – they baulked at recording the song that Martin had earmarked for them, the teen potboiler 'How Do You Do It?' – and were in opposition to almost every chart trend of that moment. A lot was riding on the simple, rough tones of 'Love Me Do' but, contrary to expectations, it entered the Top 50 on 13 October.

The previous day, the Beatles had played with Little Richard at the Tower Ballroom in New Brighton, a show promoted by Epstein. The group were thrilled to meet their idol – both John Lennon and Paul McCartney had been fans since 1957 – and he did not disappoint. As the *NME* reported, Little Richard's response was enthusiastic: 'Man, those Beatles are fabulous! If I hadn't seen them I'd never have dreamed they were white. They have a real authentic Negro sound.'

Promoted by Don Arden and publicised by Andrew Loog Oldham – until he got sacked for sending out a press release encouraging fan violence – this was Little Richard's first tour since 1957. Initially, the volatile star – who had temporarily quit his music career to become a preacher – had been reluctant to sing rock 'n' roll, but after a few firm words from Arden he gave the public what they wanted. *Disc* praised 'the fantastic energy and incredible acrobatics of Little Richard . . . this fantastic performer. On Saturday at Woolwich he twisted with a girl from the audience.'

On 13 October, *Disc* reported that Billy Fury's health was still not up to the demands of touring and performing. 'If he doesn't begin taking life easier very shortly, how much longer can he continue? How much longer before his doctors will force him to rest?' It was as though the baton was being passed. The same week, there was an article about the Tornados' success being indicative of a return to groups after the supremacy of solo singers; also mentioned were the Beatles, 'another original sounding group'.

At the end of October, just as the Cuban Missile Crisis reached its height – and the world held its breath – 'Telstar' was still at the top of the UK charts. 'Venus in Blue Jeans' was at #6. Fury's latest record, 'Because of You', had entered the Top 50 at #37, while 'Love Me Do' hovered at #41. In the US, the Crystals were chasing the #1 spot with the Phil Spector-produced 'He's a Rebel' – the girl-group sound as a symphony – while Chubby Checker had two records in the Top 20, 'Popeye the Hitchhiker' and 'Limbo Rock'.

That week, Andy Warhol participated in an important show, the *International Exhibition of the New Realists*, at the Sidney Janis Gallery in New York. He exhibited several pictures, including a *Big Campbell's Soup*

Can and a *Soup Can* multiple. Also exhibiting were Roy Lichtenstein, James Rosenquist, Yves Klein, Claes Oldenburg and many others. In one moment, abstract expressionism was over and, as the *New York Times* wrote shortly afterwards, 'pop' art had arrived.

The pace of life was quickening in the shadow of nuclear holocaust. On 3 November, 'Telstar' entered the American charts; three weeks later, it was in the Top 20. In the 24 November issue of *Disc*, Jack Good – who had moved to America in the summer – reported that 'the current crack among DJ's here is that there are 39 records in the Top 40 and one in orbit – Telstar. The disc is being played with such frequency on Los Angeles radio stations that it is beginning to sound like a Beer Jingle, and Beer Jingles are the things you wake up humming.'

In the same issue, Jean Carol interviewed the Beatles, 'the newest British group to join the ever-growing list of outfits to challenge the Shadows'. With 'Love Me Do' at #23 in the UK charts, they were clearly worthy of coverage. Also that week, Joe Meek was interviewed by Mike Hellicar in the *NME,* who quoted Meek's prediction that 'Telstar' would get to #4 in the British charts and #1 in America: 'I just had a funny feeling about it. I can't explain how I knew – but I did.'

During most of December, the American #1 record was 'Big Girls Don't Cry', one of Bob Crewe's compositions for the Four Seasons, the New Jersey group dominated by Frankie Valli's falsetto. Elvis Presley and Chubby Checker were vying for the top spot but, on 22 December, 'Telstar' leaped from #5 to #1 in the US Top 100 – only the fifth British record ever to reach the top spot. Joe Meek was both out of this world and on the top of the world. This was his zenith.

PART 3
June
1967

15
Dusty Springfield,
Janis Joplin and Janis Ian

We're part of society, part of the world whether we or society like it or not, and we have to learn to live in the world and the world has to live with us and make use of us, not as scapegoats, part of its collective unconscious it'd rather not come to terms with but as who we are, just as in the long run it'll have to do with all the other bits and pieces of humanity that go to make up the whole human picture.

Maureen Duffy, *The Microcosm*, 1966

On 16 June 1967, Dusty Springfield's thirteenth US single was reviewed in *Billboard*. 'Give Me Time' was ranked among the records tipped for the Top 20 of the Hot 100 chart. The review, while short, nevertheless got to the heart of the problem: a big blowsy ballad with a full orchestra, 'Give Me Time' was very much in the shadow of Dusty's huge, cathartic, summer 1966 hit 'You Don't Have to Say You Love Me', which went to #4 in the US and topped the UK charts. Despite the impeccable vocal, the treatment felt formulaic.

In the UK, 'Give Me Time' was already stalling in the mid-20s by the middle of June.* The comparative failure of the single marked a crisis for Britain's premier female artist. After a banner year in 1966 – four Top 20 hits in the UK, including three Top 10s and one #1 – Dusty was struggling to maintain her position in a fast-moving marketplace. Despite being voted Britain's top World Female Singer in the *NME* poll of 1967 and a well-received appearance at the *NME* Poll Winners Concert, her first single of 1967, 'I'll Try Anything', stalled outside the Top 10.

In America, her profile was subject to even more fluctuations. After her breakthrough with three hits in 1964, Dusty had no Top 40 placings during 1965. Following the peak of 'You Don't Have to Say You Love Me' in high summer 1966, 'All I See Is You' had struggled into the Top 20 and 'I'll Try Anything' had just crept into the Top 40. Since the beginning of her solo career, Springfield's inspiration had been American records and productions, and she felt held back by the limitations of the British studios in which she was contractually bound to record.

In 1967, the singer was facing a crossroads. Some of this was structural, in the UK at least, as the post-Beatles pop economy – fuelled, initially, by teenage girls – favoured male artists rather than females. As the Radio Caroline annual for 1965 put it, the charts were dominated by male singers: 'One list I picked up at random had exactly six charmers

* The reviews had been kind – 'a good song of Continental origin and the English lyrics are great. Yes, "great" about sums it up,' said *Record Mirror* – but, scanning through the latest singles in *Disc*, teenage pop star Cat Stevens gave a more accurate assessment: 'I don't think this ballad is quite up to her usual standard, but I must admit it grows on me. It won't be one of her biggest hits – I like her better on faster songs.'

[female singers] among the fifty groups and singers! The widely accepted reason for this state of affairs is that girls are the biggest buyers of records and thus just naturally go for the boys.'

At the same time, the UK charts were polarising. As the first of the new generation of British female singers, Dusty had benefited from the unitary nature of the British pop scene created by the Beatles, a broad church in which it seemed as though all kinds of records and attitudes could coexist in the Top 40. Dusty was a regular on the key weekly pop show *Ready Steady Go!*, where her friend Vicki Wickham was the editor. Springfield acted as a female compère and swapped barbs with the Beatles.

After autumn 1966, however, with the disappearance of the Beatles after their turbulent summer tour, this illusion of unity was no longer possible. The artists behind the British breakthrough of 1963 were all hitting their mid-to-late twenties – dangerously ancient in terms of 1960s pop. Many of the groups who had broken through with the Beatles split up or swapped members, while a new generation of male pop stars like the Troggs, the Walker Brothers and Dave Dee, Dozy, Beaky, Mick & Tich appealed to younger teenagers.

In the first few months of 1967, the UK singles chart was temporarily dominated by what were called 'mums and dads' records: big ballads that – advances in recording quality apart – could have been made any time during the previous twenty to thirty years. In the Top 10 of 1 April, there were four of these: two versions of 'This Is My Song' – a song written by Charlie Chaplin to invoke the 1930s – a slow song from *The Sound of Music*, 'Edelweiss', and Engelbert Humperdinck's blockbuster 'Release Me', which had been written in 1949.

The popularity of these records reaffirmed the spending power of the older generation and a more conservative cohort of teenagers. The absence of the Beatles had coincided with the first beginnings of rock, a more aggressive, initially male form of music that espoused volume and counter-cultural values – which, in this period, meant psychedelics as the gateway to a new consciousness. The February 1967 arrest on drugs charges of the two principal Rolling Stones reaffirmed both this link and the divisive nature of this new form.

Dusty Springfield was caught in the middle. At twenty-eight, she was reaching the upper limit of the age range that, at the time, could automatically sell to teenagers. Since the middle of 1966, she had the accolade of her own BBC TV series – a sure sign of showbiz acceptance. Her 1967 began with a nine-week pantomime run at the Liverpool Empire, during which she enjoyed drag performer Danny La Rue's skit: 'He was dressed up in a long gown with sequins and he sang a couple of my hits. I wasn't offended. I really enjoyed it – it was a good plug!'

The main venues for pop stars who were growing up and out of teen mania – and who were hardly going to play the UFO or other psyche-delic venues – were the cabaret clubs. In April and May 1967, Dusty played several dates at the Talk of the North in Eccles and the Fiesta in Stockton. Between 8 and 27 May, she performed a residency at the Talk of the Town in London, during which she earned £2,500 a week and attracted the attention of a more affluent, mainstream audience.

Dusty's image was changing. Since the first days of her solo career, it had always been heavily constructed, with piled-up beehive wigs and bottles of black eye make-up. 'I overdid a lot of things,' she later recalled. 'It was a good thing to hide behind. Without the face I was a quivering wreck. I was terribly shy. So the more eyes I put on, the less shy I had to feel. And once you put that eye make-up on, it was such a hell getting it off that you would just leave it on. And put more on top of it after it for three weeks at a time. By that time it was really solid.'

From the beginning, Dusty had presented herself as a musician. The November 1963 *Melody Maker* cover that announced the success of 'I Only Want to Be with You' – 'Solo Star Born' – ran a cover photo of Dusty in the studio with a guitar. In another shot from the same time, she is shown tackling a drum kit in a nightclub. This was at a time when female musicians in pop groups were unusual. The Honeycombs would make great play of their drummer, Honey Lantree, almost as if she were a gimmick.

On her records, Dusty worked closely with her producer at Philips, the sympathetic Johnny Franz. He dealt largely with the musicians, while Dusty focused on the vocal arrangements. Her determination and perfectionism raised some hackles. 'It wasn't easy to get those sounds onto four-track,' she told me. 'I was breaking a lot of new ground and asking

musicians to play things they had never heard before, because I had been to the States and they hadn't. So I scowled a lot. I got a reputation as a great scowler.'

Throughout her early solo career, Springfield confounded expectations of what a female performer should be and do. She was extremely candid in her interviews: after a serious collapse in Tulsa during her first major US tour in October 1964, she described the feeling to *Woman's Own*: 'Suddenly it's all too much. The walls start spinning. I can't go on any longer. It's being hungry and stopping in a roadside cafe to eat and having everyone staring at you. "Click" go their eyes to your plate and then back to your mouth.'

In all, Dusty's was a complex, fascinating public persona: a mixture of confidence and shyness, sharp wit and deep immersion in her singing. While her appearance was as solidly constructed as the Supremes' – in some ways, almost like a physical and psychic armour – her presence was constantly mobile, the fluttering of her hands giving away the tensions and the driving ambition beneath the surface. 'I want to sing songs that are real, human, with deep emotional appeal,' she told an American interviewer in 1964, 'this is my hard fight.'

At the core of Dusty's artistry was the sense of intimacy that she projected, and that reached its height on the flip of 'Give Me Time'. Written by Burt Bacharach and Hal David, 'The Look of Love' had originally been recorded by Dusty for the soundtrack of the James Bond film spoof *Casino Royale*, but in April 1967 she re-recorded the song with a bossa nova feel that was as light as a feather. Riding this airy arrangement, her exquisite vocal sounded as though she were talking directly to you, and you alone. It was almost pillow talk.

She described the process to the singer Norma Tanega in terms of there being two currents in a song: the notes and the emotions. Her aim was to match the two. 'She would always know when the emotion would drop off and that's when she'd stop and start again,' Tanega remembered. 'The emotion and the tone had to mesh. People said that she didn't know her own ability, how good she was. She knew her ability all right, that's why it had to be perfect. She knew how to ride that river better than any other raft in the business.'

Dusty's preternatural ability to transmit powerful feelings, like the abjection of 'Give Me Time' and the intimacy of 'The Look of Love', inevitably began to prompt the question of whom she was addressing. This question was exacerbated by the way in which her material appeared to reflect the melodrama of her life: it was as though her nakedly emotional songs involved the listener in her own soap opera – a quality which, along with her love of Black American R&B and soul, helped to boost her popularity among gay men.

After Springfield's ascent to national stardom in 1966, the rumours and innuendos about her gay fans and friends began. To insiders, it was an open secret. As part of the scene that swirled around *Ready Steady Go!*, Springfield was often in the Rediffusion Studios, socialising with Vicki Wickham, Cathy McGowan and gay co-presenter Michael Aldred. She was spotted around town with Peppi Borza, a *Ready Steady Go!* dancer who had had a record produced by Andrew Loog Oldham.

By this stage, Springfield was sharing a flat with the American soul singer Madeline Bell, who had relocated to the UK in 1962. Bell was a direct line to the passionate vocal sound that Dusty had loved so much on her first exposure in late 1962, when she'd visited the US with the Springfields. 'I remember this quite clearly, because you always remember the First Time. I was sitting in the Capitol Motel in Nashville when I heard "Don't Make Me Over" by Dionne Warwick. I actually had to sit down very hard because it was different to anything I had heard before.'

In the following years, Dusty went on to cover songs by the Supremes, Inez and Charlie Foxx, Ray Charles, Arthur Alexander and many more Black American artists. In April 1965, she hosted the *Ready Steady Go!* Motown special, which helped to introduce Tamla Motown to the UK. This groundbreaking episode featured the Temptations, the Supremes, Martha and the Vandellas, the Miracles and Marvin Gaye. Singing a duet with Martha Reeves on 'Wishin' and Hopin'', Dusty could barely contain her glee.

Madeline Bell had sung back-ups on Dusty's second album, *Ev'rything's Coming Up Dusty*, and by 1966 the fact that the two were living together in Kensington had become common knowledge within the small world of London pop, triggering insider innuendos like the one that *Melody*

Maker printed in their review of 'Give Me Time': 'Yes, I can see this is an up-tempo teen-slanted platter that should be a wow on the chart. And also it's a fine record – bound to be a hit all over the world. And I like Madeline Bell too, Dusty.'

In March 1967, *Disc* ran an interview with Bell in which she complained about fan attention and crank calls – 'breathing heavily and sometimes giggling' – which forced her and Dusty to move yet again. 'It gets a bit hectic at times,' Bell complained. 'We get anonymous calls in the middle of the night and strangers ringing the front door bell. We have no privacy. We are continually moving to avoid these callers.'

Dusty's own appearances on the London gay scene included the occasional visit to the Sombrero – a basement gay bar in Kensington High Street – and she went to East End pubs with her friend Lee Everett, who was in the throes of splitting up with her husband Billy Fury. 'Then there'd always be a drama on stage or in the audience,' Everett remembered. 'She was adored by all those queens, you know.' She was fascinated and amused by men in drag, partly because of their very artificiality, which mirrored her own highly constructed appearance.

In the UK, the worlds of gay men and lesbians were usually quite separate. As the co-writer with Vicki Wickham on 'You Don't Have to Say You Love Me', Simon Napier-Bell spent time with Dusty but remembers that 'it wasn't my scene. She couldn't talk about anything I'd want to talk about. She was terribly fragile, and I get nervous around fragile people, cos I'm not fragile. I'll say something to offend them and it will all end in tears. Vicki was my great friend. She would go to the Gateways, which I wasn't allowed into, they were very strict.'

Dusty also made regular visits to the Gateways, which was the principal lesbian club in London in the 1960s. Situated on the King's Road on the corner of Bremerton Street, the club had opened in the 1930s, before becoming popular among lesbians from the 1940s onwards. It remained open to men, bisexuals, homosexuals and the curious until 1967, when owner Gina Cerrito introduced a women-only door policy. It was the one place where Dusty and other lesbians or bisexual women could be open, where they could be themselves. As habitué Ricky remembers in Jill Gardiner's history of the club: 'Dusty Springfield used to go to the

Gateways a lot. She was very friendly. Dusty had short cropped hair and lots of freckles; she wore wigs on stage but not in the Gates. She had very tight-fitting trousers and a blousey shirt that fitted tight into the waist or a jacket. They were usually dark colours, which was unusual. Her friend had gaily coloured skirts. The two of them used to sit in this place called the horse box, where you'd sit to see who was coming down the stairs.'

The soundtrack at the Gateways included most of Dusty's hits. Songs like 'You Don't Have to Say You Love Me' chimed with the clientele, with yearning lyrics about loving against the odds or surviving rejection. Other popular tunes on the jukebox were the Everly Brothers' 'Walk Right Back' and 'Walking Back to Happiness' by Helen Shapiro. As another club-goer remembered: 'The jukebox was always going. All the latest hits and lots of old classics as well. All the Tamla Motown stuff was at its height; the Ronettes and the Supremes were played over and over.'

The writer Maureen Duffy remembered hearing Frank D'Rone's 'Strawberry Blonde (The Band Rocked On)', Adam Faith's 'Someone Else's Baby' and 'lots of Beatles of course, and "Needles and Pins", the Searchers, about the breaking up of relationships'. In her novel *The Microcosm*, Duffy sets a scene in which the child star Eddie Hodges' 1962 US hit gets the crowd going: '[Hodges'] "Girls, girls, girls, were made to love" sings the juke-box and the room answers in chorus, stamping out the rhythm of assent on the patient, dusty floor.'

Duffy's third novel opens with a description of the Gateways, which she called 'the world turned back to front through a glass darkly'. Published in March 1966, *The Microcosm* is a remarkable document, an avant-garde text set in the midst of a still subterranean sexual minority. Using the club as its prime location, the novel blurs gender, time and experience in a dizzying sequence, carried along by different lesbian narrators, who, inter alia, offer serious disquisitions on the nature of tolerance, sexual difference and day-to-day survival.

In one key passage, Duffy offers what sound like hard-won experiential suggestions on how to navigate a still hostile world:

> There are dozens of ways of being queer and you have to find what
> your kind is and then make something of it even if the answer

leaves you a kind of little half-chick, a natural eunuch, the stock figure of fiction. You have a choice. David and the boys don't have a choice because they're outside the law anyway; a negro doesn't have a choice because it's obvious and no hiding the colour of his skin except in very rare cases.

But no one need know as far as you're concerned and yet the only real barrier to their knowing is your pride or fear. The choice is yours whether to side with conformity and pretend that there's only one way of being a human animal or to stick your neck out and say no, there are millions of ways, all elements in the kaleido-scope, shaken together we make the pattern. The pattern is alive like a living cell seen on a slide, changing, vibrating with colour. Civilisations fall. A hand shakes the tube; the pattern crumbles and reforms. Whose hand? Our own.

The Microcosm was born out of Duffy's own experience. After reading Simone de Beauvoir's *The Second Sex*, she realised she was lesbian, but then had to find out how to put this realisation into practice. It wasn't easy in Britain at that time: as she later remembered, 'When I first came out to myself, it was into a completely buttoned-up society where to be gay was stigmatized or at best jeered at. The temptation for many, both women and men, was to hide their terrible or humiliating secret which set us apart from "normal" society and its norms.'

Through a couple of gay male friends, she found the Gateways, and her life changed. Encouraged by the freedom that she felt there, she began to plan a survey of what she felt was an opening-up of social attitudes towards sexuality. Duffy talked to a number of lesbians from varied back-grounds, typed the interviews up and shaped them into a book – only to be told by publishers that 'no one would publish it because I wasn't a sociologist, and was advised to turn the material into a novel'.

Tired of seeing books just about gay men, Duffy decided to turn these notes into a novel, with the possibility of a wider readership than a work of non-fiction. She invented a term for how she wanted to con-struct the book: in 'a mosaic style' that forsook conventional narrative for a Joycean stream-of-consciousness, augmented by an element of what she described as 'myth, saga, romance and fairy tale'. The result

was a novel that matched radicalism of form with its then groundbreaking subject.

Duffy has a sharp eye for class and role. Many women who went to the Gateways dressed in a masculine style. The Butches, as they were called, aped heterosexual male dress, with leather jackets, boots, jeans and padded crotches. Her characters include a Butch called Matt, referred to as 'he' throughout; Cathy, a young woman who has left her working-class home to work on the buses; and an elder called Rae, who remembers the dropping of 'the bomb' in 1945 as making nonsense 'of any talk about human rights or which side was God's or humanity's'.

In many ways, *The Microcosm* builds from that profound sense of nuclear anomie. After the holocaust that has happened, and might well happen again, a hundred times over, old concepts of morality and sexual conduct are completely irrelevant. What matters is the here and now, refracted through prisms of individual consciousness. By 1967, there were at least two successive generations of teenagers who had internalised the nuclear threat into the demand to live for the moment, and now lesbians were demanding to be who they were.

The Microcosm hit home, as it was meant to. It was banned first by the Vatican, then by the Irish government, and finally by the apartheid regime in South Africa. Duffy remembered being 'worried about the publisher's reaction, and whether it would damage sales. But on the other hand it was a form of publicity. Then I began getting letters from women all over the country, thanking me and asking where they could find the gay women's club where the novel is mostly set.'

The novel was also well received by Gateways regulars like Mary McIntosh, who 'just saw *The Microcosm* as life as it is, at last. It really captured a lot of the Gateways for me, the sense that you met a lot of varied people. It was brilliant.' Another interviewee in Jill Gardiner's book remembers how '*The Microcosm* was really important for us, and we were very lucky that it had just been published because for a lot of people that gap had been filled by *The Well of Loneliness*. How sad. We had something very contemporary.'

The Microcosm caught a wave of greater lesbian awareness. As Duffy had noted, gay men were much more visible, a state of affairs that

reflected both male privilege and an uncomprehending climate. In the UK, lesbianism was not illegal but was correspondingly overlooked as a social issue and a solid reality. By the mid-1960s, this began to change. The formation of the Minorities Research Group – and its associated magazine, *Arena Three* – drew national attention to the existence of lesbians as a distinct social and sexual minority.

In January 1965, ITV's *This Week* attempted to answer the questions of 'What is lesbianism? What causes it . . . and can it be cured?' Presenter Bryan Magee found the women he interviewed – including the co-founder of *Arena Three*, Esme Langley – quite unwilling to accept his framing of their lives as a social problem. In March the same year, the BBC ran a programme called 'Lesbianism' in the *This Time of Day* slot, with a similar result: lesbians arguing that their sexuality was not a problem to be cured but something to be recognised as a normal part of human behaviour.

A philosopher turned popular broadcaster, Magee stuck with the topic, writing an article in the *New Statesman* and collating data for the book he published in summer 1966, *One in Twenty: A Study of Homosexuality in Men and Women*. With twenty-one chapters and three parts giving male and female homosexuality equal space, Magee's book became the standard text just as the law to partially decriminalise male homosexuality was going through its tortuous passage in the House of Commons.

Much of the material about male homosexuals was familiar, but Magee's chapters about lesbianism covered fresh ground for a wider readership. Unlike its male counterpart, he noticed that as far as society was concerned, lesbianism did not exist: 'A very large number of people do not realise, even in adult life, that there is such a thing. There is not anything like the same discussion in public places – in fact it is scarcely discussed at all, and seldom mentioned in print.'

Magee considered the importance of gender roles inculcated from childhood onwards. The upbringing of girls was 'oriented far more consistently towards their sexual role than is that of boys. They are encouraged even to organise their fantasy lives round it. From beatlemania and schoolgirl fantasies of knights in armour, contemporary as well as mythical, to the more adult pabulum of women's magazine stories, novels,

films, popular songs, advertisements – every form of pop art – being wooed is the all-pervading theme of the daydream.'

Being a lesbian went directly against this conditioning. Nevertheless, lesbians were women first and homosexual second, he observed. Their financial situation was much less favourable than that of male homosexuals, as men in general were paid more than women. Compared to male homosexuals, a higher proportion of lesbians had children. There was a marginal tendency to go into jobs connected with their homosexuality: butch types went into factory jobs or public transport, occupations that would 'liberate them from many aspects of the female role they find irksome'.

Magee found that, although cloaked in anonymity, 'Lesbians quite often have a fear of exposure in their jobs which broods over them all their lives. They will talk about it in other surroundings; for instance it has several times been said to me in a lesbian club: "my great fear is that one evening somebody I know at work is going to walk in here" . . . It is a striking fact that although lesbianism is perfectly legal, lesbians are every bit as secretive about their condition as male homosexuals who incur the risk of long periods of imprisonment.'

Despite the bigoted language that surrounded the mooted change in the law, the topic of homosexuality was in the news and being discussed openly, in a way that it never had been before. On 14 June 1967, the BBC broadcast two programmes in which lesbianism was featured, one a round-table discussion, the other a focused documentary. In 'Consenting Adults 2: The Women', a number of lesbians were interviewed: an unhappy but candid butch called Steve Rogers, a distraught, anonymous housewife and *Arena Three* contributors Julie Switsur and Cynthia Reid – a happy and well-adjusted couple. The camera crew also shot in the Gateways with a number of regulars, who pointed out how relaxing it was not to be in a world dominated by men. Yet Dusty Springfield was not in a position to benefit from this new assertiveness, locked in as she appeared to be to an old-school light-entertainment career. Nor was she prepared to be assertive: next to no gay man or lesbian was open about their sexuality during this period. She oscillated between candour and withdrawal, between bursts of confidence, crippling shyness and explosive outbursts.

According to her friend and sometime lover Julie Felix, the pressure was intense: 'One time I went to Gateways with her, but I was terrified of being found out. We had to lie. I still feel the scars. I could never really be authentic. As a young girl on TV the first thing I'd be asked was, "Do you have a boyfriend?" I had to skirt around the subject all the time. I'd be doing three or four interviews a day with people asking personal questions. It was such a harsh pressure, like being in a vice. You want to talk about your life, but you can't admit to who you love.'

During the rest of June and July 1967, 'Give Me Time' floundered in both the British and American charts, peaking at #76 in the *Billboard* rundown on 22 July. Three days later, Springfield held a recording session for a song called 'No Stranger Am I', a rapturous, almost spiritual folk song with unusual chord changes that celebrated the start of a love affair: 'No stranger am I / You enter my world / I hear flowers sing / No emptiness now / You enter my world / Hear flowers with me / Sing joyous.'

'No Stranger Am I' was written by her lover Norma Tanega. It had been included on the album that accompanied Tanega's spring 1966 hit 'Walkin' My Cat Named Dog', which had been produced by Bob Crewe in the then fashionable go-go style. While only reaching the 20s in the US and UK, 'Walkin' My Cat Named Dog' attracted a quality of attention that went beyond its chart position. Tanega came from an activist folk background, and her breakthrough song seemed to herald a new kind of femininity: urban, hip, bohemian, unshackled by society's pressures.

When Tanega came over to the UK to promote the record in midsummer 1966, she met Dusty while rehearsing at a taping of *Ready Steady Go!* 'I'm standing there with my guitar, like a dork,' Tanega told Vicki Wickham and Penny Valentine, 'while this woman, I had no idea who she was, stood on some scaffolding and went over and over this song until it was, of course, perfect.' Once they began talking, Tanega was smitten: 'She was witty and flirty, how could you not love her?'

After Tanega returned to New York, the two kept in touch regularly, until the American finally moved in with Dusty in Aubrey Walk, Kensington, where she met Dusty's brother Tom and her parents Gerard and Catherine O'Brien. 'Dusty called me, and we met in New York,' she told me, 'and then I was playing guitar on "No Stranger Am I". I lived

with her right after that. I saw all the recording studios, and I learned everything about recording from Tom and Dusty. I moved everything over, about two tons of stuff, and I expected to be there forever. The O'Brien family was my family.'

With Tanega's folky acoustic guitar and a crystalline, perfectly judged vocal, Dusty's version of 'No Stranger Am I' is a moment of quiet snatched from the demands of everyday life. Springfield soars through the tricky changes with apparently effortless ease. A hymn to intimacy, it's one of the singer's greatest records of the 1960s, and one of the few recordings where she could directly and forcefully express something of a sexual and emotional life that was by necessity hidden.

———

In the middle of June 1967, a new kind of female star erupted in America. It would take her over a year to be fully accepted in the mass market, but Janis Joplin's Saturday-afternoon appearance with Big Brother and the Holding Company at the Monterey Pop Festival – singing hard rock and wracked blues – made an extraordinary impact. So much so that the group were asked to repeat a couple of songs on Sunday the 18th, this time for the film cameras that their soon-to-be ex-manager had banned the day before.

The buzz was intense, and centred on Janis. Although the group were nominally imbued with the all-for-one San Franciscan hippie ethos, it was her appearance and totally committed performance that people applauded and extolled. It was even more remarkable because Joplin did not fit the traditional female mode of the time: she was lightly made up, was not conventionally pretty and did not present as anything other than a tough but vulnerable woman fronting and dominating a fearsomely harsh psychedelic group.

Joplin was twenty-four when her breakthrough happened at Monterey, and it was hardly an overnight success. It had been a long, hard struggle up until that point. Born and raised in the oil town of Port Arthur, Texas, she was the eldest of three children. Her parents had lived through the Depression and thought themselves fortunate to be employed in the oil

industry. A tomboy from an early age, she had a difficult early adolescence. Picked on at school, she found solace in Elvis Presley, Little Richard and the original recording of 'Hound Dog' by Big Mama Thornton.

Obsessed with her unconventional appearance and what she felt were her small breasts and stocky build, Janis became a beatnik, reading Jack Kerouac's *On the Road* and refusing to participate in the area's ingrained racism – a fact that made her even more of a high-school outcast. Moving to Houston at the age of seventeen, Joplin, in her own words, 'took a lot of pills, drank huge quantities of wine, and flipped out'. She returned home briefly to learn key-punching at college, the start of a pattern that would see her oscillate from excess to conventionality.

After a spell at the University of Texas, where she began singing blues and folk songs in public, Joplin moved to San Francisco in early 1963. Having already had relationships with both men and women, she began a relationship with Jae Whitaker, a twenty-five-year-old African American woman, who later remembered: 'She seemed like a lesbian, and she had been with another woman before me, but in some way, she didn't take it seriously. Emotionally, she wanted to please her folks and be the way she was brought up. In her mind, that would make her "whole".'

By 1963, many beatniks had started experimenting with hard drug use, and Joplin was no exception. Her attempts to get her singing career off the ground – she played at the 1963 Monterey Folk Festival and nearly got a deal with RCA Records – coincided with a debilitating speed habit that left her 'emaciated, almost catatonic'. After arriving back in Port Arthur to clean up in spring 1965, she appeared to settle down to a normal lifestyle, contemplating marriage and avoiding any attempt to sing in public – an activity she associated with self-destruction.

Nevertheless, she began to write songs, good ones about loneliness and gender: 'Turtle Blues', 'Women Is Losers'. In March 1966, she performed at an Austin benefit for the blind fiddler Teodar Jackson, the only woman among half a dozen blues and rock acts. These included a new group, the 13th Floor Elevators, featuring a raggedly charismatic young singer, Roky Erickson, whose banshee-like wails and unrestrained vocal approach inspired Janis's approach when she, by a fortunate occurrence, became a rock singer.

Invited to San Francisco by a fellow Texan, the entrepreneur Chet Helms, Joplin joined Big Brother and the Holding Company in June 1966 and quickly learned to adapt to the group's heavy volume and squalling guitars, an experience which she described as 'a real, live drug rush'. In September, she went with members of Big Brother to see Big Mama Thornton at a small jazz club. Entranced by her song of emotional bondage, 'Ball and Chain', she asked the African American pioneer if she could cover it. 'Don't fuck it up,' was the terse reply.

By the winter of 1966/7, Big Brother and Janis Joplin were stars in the still small, not yet nationally known San Franciscan scene. Despite the long hair, beads and flowing clothes that the men wore, the milieu was macho. The foundational myth of the hippie subculture was that of the nineteenth-century pioneer or gold rush prospector: men who would go boldly where no man had gone before – in this case, not further westwards, but further inwards, thanks to the plentiful use of marijuana and LSD, and in Big Brother's case, harder drugs.

The principal women in the Haight-Ashbury orbit were Joplin and Grace Slick, the singer with Jefferson Airplane. Both got on well – and, indeed, were pictured together – as neither accorded with standard femininity. Slick was prettier, with traces of her deb past, but strong-willed and sharp-tongued, with a tone that could cut through the loud guitars, while Joplin, dressed in a hippie cloak of beads and layers, with her wild and strong voice had grown into a unique presence, one that did not rely on conventional attractiveness to be star-worthy.

While her lesbianism was known to the band, it caused them nothing but confusion. When she bumped into Jae Whitaker with drummer David Getz in tow, she told him afterwards: 'That chick, she does something to me. We had a thing together way back, and she really turns me on.' Although a sophisticated city boy – an art student who had grown up in New York – Getz remembered that he was 'really unfamiliar with that whole possibility. I didn't know what to make of it, Janis wasn't doing it to shock me; she was just out there with it.'

During this period, Joplin had affairs with both women and men: James Gurley, the gonzo Big Brother guitarist; the singer Country Joe McDonald; and boutique owner Peggy Caserta, with whom she would

be involved the longest. She always identified as bisexual and, on the face of it, was quite open and blasé about her lesbian activities, but that still did not mean that they were widely known. Just as with male homosexuality – about which there was nary a whiff in the San Franciscan scene – it was not a topic of discussion in the rock world.

Even so, Joplin had a strong sense of where she stood in relation to other female performers. She saw herself as being part of a continuum – 'a sisterhood of song', her biographer Holly George-Warren calls it – that stretched from Ma Rainey and Bessie Smith to Odetta, Nina Simone, Etta James, Billie Holiday and Big Mama Thornton, as well as contemporary artists like Aretha Franklin and Tina Turner. Within this tradition, she sought to lay herself bare when she sang, to deliver an emotional truth about what it was to be a woman.

Indeed, two of the songs that Big Brother played on that June afternoon at Monterey embodied a harsh, unsparing view of the female experience. The Joplin composition 'Down on Me' was a rushing rocker that contained the lyric, 'Looks like everybody in this whole round world / Down on me,' while 'Ball and Chain' moved from passionate attachment to abject pleas and ultimate hopelessness – a whole emotional churn in eight minutes, where love and life were bounded by the feeling of imprisonment.

Between these peaks of hope and troughs of despair, Joplin inhabited every nuance of the material. The tension between her raw vocal and the gear-grinding crunch of the group resulted in an electrifying performance that made her and, to a lesser extent, the band instant stars in the eyes of the media. Rave reviews in the *Village Voice* and *Esquire* resulted in interest from Bob Dylan's manager Albert Grossman and Columbia Records, whose president, Clive Davis, attended Monterey.

In the first full weekend of July 1967, Big Brother played a date at the Circle Star Theater in San Carlos, California. Also on the bill was another female performer who did not fit the conventional mould, a sixteen-year-old folk singer who, that summer, had a controversial sleeper hit. Although first released in September 1966, Janis Ian's first single, 'Society's Child' – a protest song about racial intolerance – had after nine months finally broached the American Top 20; the week after the concert, it would reach its peak of #14.

The two Janises quickly bonded. 'She was seven or eight years older than me, but it didn't matter,' Ian later remembered. 'We both had bad skin. We both felt overweight. We were both outsiders. The only difference is that she'd slept with more people than I had. We went to a party at Peter Tork's house one night, where everyone was wearing bright silk Indian clothing and crashing on a floor filled with pillows and hashish pipes. There were dozens of naked people lolling around; I shrugged it off, trying to look cool.

'Joplin took me to another party and introduced me to Olive Watson, granddaughter of IBM's founder. Olive in turn made us matching suede pants, and at the next party, I watched as a heroin dealer went around the room, giving free shots to all and sundry. When Janis's turn came, she looked up at me and rasped, "Kid, time for you to go home." As I turned at the door to tell her good-bye, the shot was just sliding through her brown suede pants and into her thigh.'

Janis Ian was a child of civil rights campaigners, brought up in the leftist, activist tradition. At a young age, she had experienced the dark side of the American state. Her teacher father had been of interest to the FBI since the McCarthy years, having been placed on the 'watch list' – a designation which resulted in phone tapping and surveillance. This effective harassment was a persistent drag on the family's fortunes, preventing her father from gaining tenure in his work and enforcing frequent changes of job and location.

'Society's Child' had been written a couple of years earlier, when she was fourteen, and emerged from her upbringing. After her parents moved to East Orange, New Jersey, she found herself in a public school in an almost exclusively Black town. As she wrote: 'There were only three white kids in my fifth-grade class, and they were already good friends. I had black hair, brown eyes, and a suspect family. The white kids avoided me like the plague. Fortunately, the Black kids were more welcoming, especially when they found out I could play any song by ear.'

As for many disaffected teens, music provided a safety valve: 'Music filled my world. It saturated my heart.' Like Joplin, Ian's ear was caught by the great blues women: Ma Rainey, Bessie Smith and Billie Holiday. She was also struck by the rising folk star Joan Baez, the popular folk

group the Weavers and the early soul music that she heard coming out of the radio in East Orange – James Brown and early Motown – a sophisticated stew that informed her wish to write and perform her own songs.

It wasn't just her leftist upbringing or appearance that bothered the young Ian. In her autobiography, she revealed that she was molested by her dentist from her early teens onwards: 'I just knew that I was separated from the rest of the world by a thin glass sheet I could never get past.' At the same time, she was dealing with the fact that, despite having had attempts at boyfriends, she was basically attracted to women: 'I was dreaming of saving Joan Baez from drowning, of her eternal gratitude as she kissed me chastely on the lips and adopted me into her life.'

There was no help or guidance available. In the library, she found homosexuality cross-referenced under '"deviant behavior." I picked up *City of Night** and read about male homosexuals; everyone seemed miserably unhappy. I checked out Radclyffe Hall's *The Well of Loneliness*. Throughout the book, Hall spoke about wanting to be a boy, wanting to be a man, wanting to be male. I felt nothing of the kind. I *liked* being a girl. I just also liked other girls. Still, it was good to know I wasn't the only one out there.'

The young teenager started to travel into New York City, in particular Greenwich Village, where she saw gay life in the raw: 'Things that were only whispered about behind closed doors were visible on the street.' In 1964, she sent one of her compositions to the topical song magazine *Broadside*, to which her father subscribed. When the magazine printed it later that year, it attracted the attention of Jac Holzman at Elektra Records, for whom she recorded a few sides. That went nowhere, but her next brush with the music industry was more successful.

Brought by a sympathetic lawyer to see George 'Shadow' Morton – the infamous producer of the Shangri-Las – she auditioned 'Society's Child'. When he refused to acknowledge her presence, reading a newspaper with his feet up on the desk, she brought out a lighter and torched his paper.

* John Rechy's groundbreaking gay novel, first published in 1963, which features material about hustling in New York and Los Angeles, set to the pace of rock 'n' roll. As he told me in 1990: 'I did use a lot of lyrics in *City of Night*, and whilst writing it I saturated myself with a lot of early rock 'n' roll – Elvis Presley, Fats Domino. I wanted to get that rhythm into the prose, that sultry undertow that is at the core of rock.'

That snagged his interest, and he immediately made plans to record the song with a full band. When Atlantic Records passed, feeling it was too controversial, Verve Records picked up on it and released it in September 1966. Ian was fifteen and a half.

'Society's Child' was based on Ian's observation of an interracial couple holding hands on the bus. She began imagining what difficulties they would encounter, in a still racist and segregated world, and how that would eventually break up their partnership. It was a gritty song with a pop production, rooted in pressing issues and with hints of freedom, which reflected Ian's own confusion about her place in the world: a young white woman in a Black school, a radical in a rigidly enforced political climate, a lesbian in a heterosexual society.

The song was a slow burn. Released twice in 1966, it didn't gain any traction until Ian was featured on Leonard Bernstein's *Inside Pop: The Rock Revolution*, a CBS documentary featuring Brian Wilson of the Beach Boys, the Byrds and the Beatles that attempted to present pop music not as commercial fluff, but as *the* contemporary art form. Reissued for a second time shortly after the broadcast in late April, 'Society's Child' began climbing the American charts in early June.

Ian started getting a lot of press, all of which concentrated on her youth and her folkie radicalism – a young woman coming out strongly with her truths. Nowhere was her sexuality mentioned, as would have been expected. Janis herself was highly confused by all the attention, especially when her former associates in the folk world accused her of selling out to commercialism. 'I expected the folk community to support me,' she wrote, 'but only [Dave] Van Ronk and Odetta and a handful of others did. The envy was incredible.'

In October 1967, she granted an interview to *Life* magazine, who typified her, rather patronisingly, as 'a scruffy super-squirt who stands 4'10" in her short suede boots'. The interview focused on her radicalism and her wish to force the discussion of difficult social topics like suicide, loneliness and prostitution. The next month, she appeared on the nationally syndicated *Smothers Brothers Comedy Hour*, where she sang her hit. Although she didn't realise the implications at the time, this would prove to be the temporary end of her career.

It was a moment of affection between her and her long-standing friend Merka that did it. As she later wrote: 'A very well-known television star had spied me asleep in Merka's lap during a break, and he had proceeded to tell several industry people that I was obviously a lesbian, and shouldn't be allowed on national television. I was appalled. Here I hadn't even slept with a boy yet, let alone a girl, and an industry veteran I'd long admired was trying to get me blackballed.' It would take eight years – and more open times – for her to have another hit.*

———

Clearly, the existence of lesbians was not something that the mainstream media or music industry could acknowledge in 1967, either in the UK or the US. The pressure on prominent lesbian and bisexual performers was intense. Obviously different because of their temperament and sexuality, they were forced to come up with elisions and contortions to avoid telling a truth that they seemed to embody in their performances. If they sought and achieved emotional transparency onstage, how did that make them feel when honesty was denied them in their real lives?

Dusty Springfield described that tension in a long September 1967 interview with her friend Penny Valentine of *Disc*, who found the singer 'a complicated girl who doesn't really know where she is going. There's somehow an air of quicksilver about her that makes you think that tomorrow she may go "pouff" and disappear from the scene. Sometime you think she even believes it herself. So here's D. Springfield in the middle of 1967. Over-generous to the people she likes. Surprisingly abrupt to those she doesn't. Easily hurt. Here she is then, at the crossroads.'

As ever, the question of marriage came up, and Dusty's answer was devastating: 'You should love people anyway. But you have to exist with yourself first. I don't believe I can – that's why I can't see myself married. I think marriage, if it happens, is the most desirable state to be in. But there are, to be honest, no men I know that I could live with forever.

* With 'At Seventeen', which reached the US Top 3 in summer 1975.

That's half the trouble with being me. I don't trust people and the boys I like are always so totally aware of who I am. It's lousy.'

The Valentine interview was supposed to preview Springfield's new single, her third of 1967 – an uptempo soul stomper called 'What's It Gonna Be'. Released in late September, it went nowhere in the UK, her first major failure for a good while. While she was on tour in Australia during October, however, something unforeseen happened: 'The Look of Love' started slowly climbing the American charts and, by the end of the month, had breached the Top 30. In the first week of November, it peaked at #22.

That week, 'What's It Gonna Be' was reviewed in *Billboard*. Ranked in 'Pop Spotlight: Top 60', along with new singles by Harpers Bizarre, Burt Bacharach, the Byrds, Clear Light and Country Joe and the Fish, the verdict on 'What's It Gonna Be' was predicated on Dusty's success with 'The Look of Love': 'This pulsating change of pace rocker should catch up to the current hit in short order. She wails her way through this one, loaded with excitement and discotheque appeal.'

Springfield was caught between her desire for freedom and the demands of the more conventional showbiz bag she found herself in: the light-entertainment shows, the hotel rooms, the cabaret spots. During November, she flew to California to tape various television programmes: *The Joey Bishop Show*, *The Red Skelton Hour* and *The Dating Game*. On all three she sang her current hit, 'The Look of Love', and on *The Dating Game* she promoted 'What's It Gonna Be'.

In order to sing this song on prime-time TV, she had to undergo an exquisite humiliation. The format of *The Dating Game* was that the featured female would question three bachelors who were hidden from view; at the end, she would choose one to accompany her on a date, with expenses paid by the show. With her new curly wig and a halter dress, Springfield could barely hide her disinterest and disgust. If the whole rigmarole embodied the bind that trapped her, it was obvious from her face that this charade was not going to continue for much longer.

16
Brian Epstein

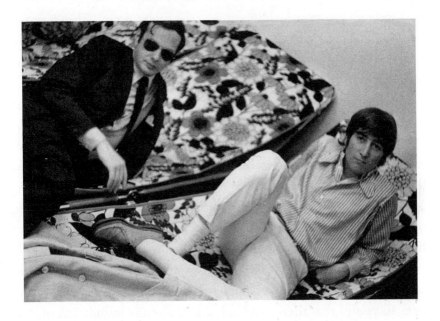

The Beatles are The Boys to Brian Epstein, Cilla is Cilla and the rest are 'my other artists'. He loves them, but, best of all, he loves the Beatles. If there is one thing that makes Brian Epstein an exceptional human being, it is his ability to get on with them. To manage, steer, cajole, persuade, dissuade four of the most cantankerous and self-willed young men during the four and a half years it took them to become world famous is a truly remarkable achievement.

Maureen Cleave, 'The Man Behind the Beatles and How He Lives', *Evening Standard*, 1 April 1966

n mid-June 1967, *Life* magazine published a five-page spread on 'The New Far-Out Beatles'. One of the few interviews that the group gave to publicise their new album, *Sgt. Pepper's Lonely Hearts Club Band*, it was designed to show just how much they had changed since Beatlemania. They were no longer teenyboppers – as the subhead ran, 'They're grown men now and creating extraordinary musical sounds' – and they were no longer eager to please. 'It's all right to dislike us,' said John Lennon, 'just don't deny us.'

The pictures by Henry Grossman told the story. Instead of four grinning young men with identical clothes and haircuts, the reader was presented with a group of disparate individuals, who appeared old before their time in their floral shirts and King's Road militaria. Thomas Thompson's text in the *Life* piece described the in-studio rehearsals for 'Lucy in the Sky with Diamonds': 'We are light years away from anything tonight,' George Martin told the writer. 'They know it is awful now, and they're trying to straighten it out.'

Thompson observed that the Beatles were 'stepping far ahead of their audience, recording music so complex and so unlike the music that made them successful that they could very likely lose the foundation of their support. But that possibility does not bother them in the least.' He asked Paul McCartney if they were worried about this. 'Sure, we're going to lose some fans. But there's no point in standing still. We've reached the point now where there are no barriers. Musically, now, this moment, tonight, this is where we are.'

McCartney was unusually candid, perhaps too much so. Embedded in the article was a time bomb. In Thompson's thumbnail sketches of each Beatle, he quoted Paul proselytising the benefits of LSD: 'After I took it, it opened my eyes . . . we only use one tenth of our brain. Just think what we could accomplish if we could only tap that hidden part! It would mean a whole new world. If the politicians would take LSD, there wouldn't be any more war, poverty or famine.'

The media reaction was almost instantaneous. Drugs had become a very hot issue in 1967, and the Beatles had already attracted negative attention and bans due to the imputed drug references in two tracks on their new album: 'Lucy in the Sky with Diamonds' and 'A Day in the

Life'. Three days later, on the 19th, a follow-up interview McCartney gave to ITN was broadcast nationally. 'Paul, how often have you taken LSD?' the reporter asked. McCartney paused and said, 'About four times.' Cue a media storm.

Brian Epstein quickly rallied behind his charge. 'Let me tell you the background to this,' he told the *Melody Maker*'s Mike Hennessey the following month. 'Paul rang me one Saturday to tell me that he had admitted to the Press that he had taken LSD. At that time I was very worried. I don't think I slept that night and I thought about it all the following day. Then I came up to London on the Monday knowing that I was going to be asked to comment on Paul's admission. I finally decided to admit that I had taken LSD as well.'

Despite this show of support, Epstein's position as the Beatles' manager was not completely secure in summer 1967. His contract with the group was up in September, and the Beatles' increasing desire for independence was a source of great concern. He was beset by health problems, both psychological and physical, and by a series of serious business issues that undermined both his confidence and his authority over the group of four wilful young men who had become adults.

In the *Life* article, Epstein is pictured facing the camera as Lennon, McCartney and George Martin work out a song on the piano. Nobody is paying attention to him. Epstein's visits to the studio were infrequent, and this could have been the day, described by EMI engineer George Emerick, when he rushed into the studio with good news – the contract to provide a song for a TV show that, in order to showcase the potential of satellite communications, would present material from eighteen countries around the world. Met with indifference, he asked Lennon why they weren't more enthusiastic, and got the reply: 'That's what happens when you don't consult us first.'

Nevertheless, the Beatles buckled down to the contracted task. Lennon wrote the song, 'All You Need Is Love', in late May, and by the time the *Life* article appeared and the ensuing LSD furore occurred, the group were closing in on the live recording date of 25 June. On that day, David Magnus took some photos in Abbey Road of Epstein with the group: Lennon is blowing hard into a trumpet, while a smiling

Epstein – resplendent in a braided velvet jacket and still proud of his charges – is making a point to a serious-looking McCartney.

It was the last time that Epstein was ever photographed with the four most famous musicians on the planet.

———

In the four and a half years since the group had signed their management contract, the Beatles had reached heights that only Epstein could have imagined. After 'From Me to You' went to #1 in the UK during spring 1963, their singles stayed at the top for fifteen further weeks that year, while their two albums, *Please Please Me* and *With the Beatles*, took the top spot between May and September. During 1964, their breakthrough year in America, they had a top-grossing film, thirty Top 100 hits, six #1s and, famously in April 1964, all of the Top 5 singles.

During that year, the group earned $25 million in America (almost $188 million today). And the roller coaster didn't stop. Following the lines laid down by Epstein in 1963 and perfected in 1964, the Beatles released three singles in the UK (four in the US), two albums (three in the US) and made another top-grossing film. Their concert at Shea Stadium, which set an attendance record that wasn't broken until 1973, grossed $304,000 and made the Beatles $160,000 (nearly $1.5 million today).

By early 1967, the group had had eleven UK #1 singles and seven #1 albums. In America, they had had nine #1 singles within the same time frame, and their albums had spent seventy-one weeks at the top of the charts. This was a global phenomenon: 'I Want to Hold Your Hand' was #1 in nine countries, as was 'A Hard Day's Night' and 'I Feel Fine'; 'Ticket to Ride', 'Help' and 'Day Tripper'/'We Can Work It Out' were #1 in eight, 'Paperback Writer' #1 in nine, and 'Eleanor Rigby'/'Yellow Submarine' #1 in eleven.

It wasn't just the chart positions. The Beatles had presided over a soft revolution in Britain, as the vestiges of Victorianism were slowly swept away and the country was rebranded as Pop Island – a process marked, just after its apogee, by *Time* magazine's 'Swinging London' issue of

April 1966. With their success in America, the Beatles had opened up British pop music to a vast global market, to a degree that was previously unthinkable. In recognition of the economic benefits this had brought, the group were made Members of the British Empire in 1965.

The Beatles had become bigger than Elvis and, unlike the deposed King – whom they met, under strained circumstances, in summer 1965 – they continued to develop and evolve. Whereas Elvis allowed himself, under the manipulative and controlling Colonel Tom Parker, to waste his time and talent in a series of colourful but meaningless Hollywood films, the Beatles continued to experiment and change, thus appearing to initiate – rather than just synthesise – the rapid changes of that decade.

Some of this was due to the group's own questing nature and ability to respond to unusual times, but Epstein had a big part to play as well. Unlike Colonel Parker, he didn't seek to control his four charges, realising that it was impossible and inappropriate. Although he demanded discipline and, in the early years at least, set them a furious schedule of records, films and tours, he left them alone creatively, deciding early on that this was not his province and that they were in good hands with their producer, George Martin.

Epstein was a new kind of manager, able to devote himself to his charges rather than dominate them. This was a matter of temperament as well as shrewd observation: capable of intense highs and crushing lows, Epstein oscillated between visions of riches beyond belief and a sincere empathy with the outcast and alienated – an empathy that arose from his own emotional state as a homosexual, at a time when any expression of his sexuality was illegal. The five of them worked extremely well together, and the results were beyond comprehension.

'Brian really sailed into uncharted waters,' his friend Nat Weiss told me. 'When Brian came to America, there were no groups that could fill stadiums. There were no groups that could fill Madison Square Garden. We had Elvis, but Brian said they'd be bigger than Elvis back in '61, which I'm sure in some cases was misconstrued. The idea of putting together stadiums and large arenas, all these things were new. He created a lot of these things. Nobody has come near to fashioning a phenomenon like he did, and it's not a learned process.

'I think the image of Brian was that of a very soft, sensitive person, which was not the case. He was a very strong-willed person. I remember when John Lennon refused to do an interview during a tour because the people out here were fascists or something like that, Brian went nose to nose with him. He took his tie and said, "John, you're soft," and stared him down. And you could see it, John backed away. Brian had full control, and they respected his thinking. Brian, in a way, saw them like his children. He understood them.'

By early 1966, however, after three years of success, the strains were starting to show. The Beatles were beginning to assert their own voices. They now talked about politics in interviews, against Epstein's wishes. Late in 1965, they only agreed to play a short UK tour under duress, and they rejected the latest script idea for their third film under their United Artists contract. They had been due to commence shooting in the new year; now, with three months suddenly empty – the longest free time they'd had since the start of their success – they began to ask questions.

In early April, Maureen Cleave published an interview with Epstein in the *Evening Standard*. With her customary incisiveness, she captured a disconcerting man in whom exquisite tailoring coexisted with lightning changes of mood. Like his charges, he was looking for something else: 'At heart he is not a business man at all; the failed actor in anyone dies hard; in him it has been revived in the form of a passionate interest in the legitimate theatre. He would dearly love to write a play. He already writes poems. "Eppie," a Beatle once said, "is sensitive as a bare wire."'

Nevertheless, at the time the bonds were still strong. 'The Beatles admire him because he has always been on their side, carrying their sorrows, fighting the record companies, literally speechless with delight when they topped the American hit parade, hysterical with laughter at their films. "You see," John Lennon said, "he's the only one we take things from. He's one above us. Everybody else packs it in when we start screaming at them because they're frightened. We couldn't be run by anybody but him – not anybody, I tell you."'

The interview was printed at the time when the first cracks in the relationship had started to appear. What Cleave didn't tell her readers was

the fact that Epstein had recently been forced to make a deposition in a New York court, in the long-running and vexatious case concerning the Beatles' US merchandising contracts. These had been signed by Epstein and his lawyer David Jacobs, under the company name of Seltaeb, in 1964. His failure to appear in court to answer counter-charges arising from the case had left him liable for $5 million.

Cleave missed that time bomb but delivered another, when she reported something that Lennon had said during his interview with her, published a few weeks previously in a series that separately showcased each Beatle: "'Christianity will go. It will vanish and shrink. I needn't argue about that; I'm right and I will be proved right. We're more popular than Jesus now. I don't know which will go first, rock 'n' roll or Christianity. Jesus was all right but his disciples were thick and ordinary. It's them twisting it that ruins it for me.'"

Blown up into a controversy by the religious right, this casual remark overshadowed the Beatles' American tour of August 1966 – the final stage in a world tour that had already seen disturbances in Japan and the Philippines. The Beatles were sick of touring anyway – their music and worldview had moved beyond the simple staging and poor sound systems they were forced to play through – and the pressure from adults, regimes and autocrats who disliked their lack of respect and not-so-coded messages of freedom left them sickened and uncomprehending.

This sequence of events undermined Epstein's authority over the group. Already bridling at the yearly schedule that had been instituted three years previously, the Beatles regarded him as culpable for the violence that occurred in Manila, when the group were roughed up by police and nationalists after failing to appear for an event organised by the president's formidable wife, Imelda Marcos. On their return to the UK, they informed Epstein that they would not be touring later in the year and, indeed, that their touring days might well be over.

Despite Epstein's sterling work in steering the Beatles through the religious controversy, he was also berated by the group when they found out about the merchandising mess. The journalist Don Short recalled McCartney laying into Epstein on the American tour: 'We should be making millions out of this. It's your fault that the contracts were not

signed up properly.' Short felt that 'John and Paul especially, and George, who later got into the act, felt that Brian had not been negligent but careless'.

It was all getting too much. As Epstein later said to Short: 'It's so hard to keep the bloody empire going. I am just a manager.' The Beatles' final show at Candlestick Park in August 1966 was a dreadful event for Epstein in two respects. With the Beatles' decision to stop touring, he felt as though a large part of his function had gone. Right from the beginning he had always taken great care over their live shows, enjoying the detailed arrangements, collecting the paper bags full of money and, on occasion, losing himself in the screams of the audience.

Upset at the group's decision, he did not attend the Candlestick Park show, which left him open to something far worse: a reunion with the young man, Dizz Gillespie, with whom he had had an abusive affair in 1965. 'Brian was thrilled to see him,' Nat Weiss told me. 'I warned Brian that nothing changes, but Brian assured me that Dizz had changed. He was there in LA because he loved Brian. I threw cold water on that. I said, "You're dealing with one of the most professional hustlers that I've ever come across and there's no emotion involved, only money."'

When Weiss and Epstein went out to dinner, Dizz broke into their rooms and stole their briefcases. As Epstein's assistant Peter Brown later wrote in his book *The Love You Make*, his boss's attaché case contained pills, love letters, gay Polaroids and '$20,000 in brown paper bag money skimmed from concert funds to be distributed as a bonus. The revelation of any of these items would make John's "Jesus" furor seem like an Easter pageant.' Shortly afterwards, Epstein received a note demanding $10,000 for the return of the briefcase and the items within.

This was the classic gay blackmail scenario. Epstein didn't want to pursue charges because of the sensitivity of the stolen material, but Weiss insisted. Gillespie was arrested and the cases returned. 'But that was the beginning of Brian's loss of self-confidence,' Weiss remembered. 'Brian began to get involved with Seconals. Brian had always taken certain amphetamines which kept him up, and suddenly the seesaw thing began. Down with the Nembutals, up with the amphetamines. Depression began to set in and he found his haven in some of these downers.'

In late September, Epstein was hospitalised in a London clinic. The reason given was that he had gone in for a check-up, but in fact he had overdosed on prescription drugs. Brown had arrived at Epstein's house in Chapel Street, Mayfair, that evening and found his employer heavily unconscious, after what he described as a suicide attempt. There was a note: 'This is all too much,' Epstein had written. 'I can't take it any more.'

His secretary Joanne Peterson noted a downturn in his mood that autumn. 'He was a very sad and lonely person at times, and I felt sorry for him. I thought it was sad that he had so much going for him and yet he felt insecure. Brian was constantly searching, for love, for something to take his loneliness away, and in a way I think he went through a lot of self-punishment.'

'His role was decreasing,' McCartney later recalled, 'and I think that was a sadness to him.'

Epstein regarded himself as a creative person but found himself at the head of a big corporation that he was temperamentally unfit to run. 'He is not a conventional business man,' Maureen Cleave had observed that April in the *Standard*. 'Big contracts sit unsigned for days while he searches for Cilla's new single. "I am not in an agenting mood today," he says. "I don't feel tycoonish today." It drives his staff mad. "I feel rather guilty about it," he said. "But it's always nice to go from a heavy account-ant meeting to a publisher who will play me some nice tunes."'

With the end of the Beatles' public phase, Epstein was forced to confront a variety of serious business problems. He was also forced to confront himself. At the same time as he sought to divest himself of much of the day-to-day running of his company, NEMS Enterprises – which included the management of the Beatles and Cilla Black, as well as agenting groups like the Moody Blues – he was forced to ask himself the question of what might happen after the Beatles. Despite his intelligence and ability, he was unable to come up with an answer.

One solution was to throw himself into the running of the Saville Theatre in London's West End, which he had taken over in 1965. As his friend Larry Parnes astutely noted: 'The more successful he got, the more lonely he became. He bought the Saville for something to do in the even-ings, because not a lot of work, except for a business dinner, takes place

if your artists are not working. And the evenings are the worst time. He was a sensitive person who bottled up his emotions; but all the success and the money could not make up for his loneliness.'

On 13 November, Epstein delivered a coup by hosting the Four Tops at the Saville; the group were currently at #1 in the UK with 'Reach Out I'll Be There'. Earlier that day, however, he had been unsettled by a story in the *Sunday Telegraph* suggesting that the Beatles were contemplating new management and that they had approached 'Mr. Allen Klein, the American impresario, film producer and business manager of the Rolling Stones'. Despite issuing a strong denial, Epstein was rattled, and for good reason.

Neither the Beatles nor Epstein were communicating with each other. While the Beatles were discussing changes among themselves, unbeknownst to the group Epstein was working to lessen his business responsibilities that autumn and winter. His friend and partner in NEMS, Geoffrey Ellis, felt that Epstein was overextended, which, together with the downturn in his mental and physical health, made him seek quick, unsuitable solutions – embodied in the figure of Robert Stigwood.

Five years on from his breakthrough success with John Leyton, Stigwood was still a player in the industry, despite the fact that his company, Robert Stigwood Associates, had been put into liquidation in 1965. Public humiliation was compounded by private indignities. Walking down a London street one afternoon shortly after RSA went under, he saw an *Evening Standard* poster: 'Top Impresario Bust!' Then, having failed to pay the Rolling Stones their fees for an early-1965 tour that he promoted, he received a severe beating from Keith Richards in the Ad Lib Club.

Nevertheless, Stigwood bounced back with a new company, the Robert Stigwood Organisation, and started working as the Who's booking agent. In 1966, he set up the Reaction label through Polydor; by the winter, he had had five hits with its first eleven releases, including three Top 5s by the Who and the breakthrough single by one of the hottest new groups in the country, Cream. He also made contact with the head of Atlantic Records in America, Ahmet Ertegun, who agreed to distribute his groups in the US.

Epstein knew Stigwood socially. Telling the Australian that he wanted to retire from the music industry, he offered him a position as joint manager and director of NEMS, looking after everything except the Beatles. 'It was quite simple,' Stigwood later recalled. 'We'd be joint managing directors together and he would give me an option, I think it was for six months. If I paid him half a million then the controlling shares would be transferred to me and my company. In other words, I would control the company – including the Beatles.'

With the money guaranteed by Polygram, for whom the Who and Cream recorded, Stigwood started to get his feet under the table at NEMS, attending meetings and acquiring his own office. The Beatles were furious. The staff at NEMS were also appalled, and the company was immediately split down the middle. Recalibrating quickly, Epstein issued a statement in late January: 'Although Mr. Stigwood will share with me in the general managing of NEMS's widening interests, I shall continue to be personally responsible for the Beatles and Cilla Black.'

The link-up with Stigwood would rumble on unhappily during spring and summer 1967. Both men were temperamentally unsuited to working together: where Stigwood was cavalier and brash, Epstein was detail-obsessed and finicky. 'Brian tired very quickly of the arrangement,' Joanne Peterson recalled, 'but certainly Robert wasn't given any access to the Beatles in any way, shape or form. Robert was very different from Brian. He had a different way of working, a different persona and certainly a different stature. I think Brian regretted it.'

The Stigwood affair was only one of several questionable judgements Epstein made during the winter months of 1966 and 1967. Above all, the continuing nightmare of the Seltaeb lawsuit continued to haunt him. His method of dealing with it was avoidance. Geoffrey Ellis recalled that he 'retreated to his bed a lot of the time and became more and more difficult to deal with. He started appearing less and less in business and meetings. I have no doubt at all that this merchandising mess was a very important part of his depression.'

The problem had begun in the first flush of Beatlemania, when Epstein had been approached about Beatles merchandising – a potentially massively lucrative market. Inexperienced and under pressure, he handed

the matter over to the gay Beatles lawyer David Jacobs, who bungled the whole thing badly, issuing competing licences to two different, albeit linked, companies, Stramsact UK and Seltaeb US, for royalty rates that were ludicrously low: 10 per cent initially, rising to 46 per cent once the mistake was realised.

By 1965, the matter had gone to litigation, a state of affairs which prevented the granting of new licences and scared off potential manufacturers. The problem was not helped by Epstein's attitude, as Ellis remembered: 'Brian simply refused to go to New York to get involved in the litigation, instead adopting the stance of an ostrich burying its head in the sand.' Even after Epstein went to New York to give a deposition, his eagerness to settle was bedevilled by more acrimonious exchanges and fresh writs for libel.

The Seltaeb case continued to rumble on through the winter months of 1966 and 1967. As if that wasn't enough, Epstein had to renegotiate the Beatles' deal with EMI. After six months of talks, he signed a new worldwide, nine-year contract for the group on 27 January 1967. EMI were terrified of losing their principal asset and offered an unprecedented deal, giving the Beatles 10 per cent of the retail price of their records – double the normal royalty. In return, they were committed to recording seventy individual sides within that nine-year period.

At the same time, Epstein separately negotiated the American deal with the president of Capitol Records, Alan Livingston, who recalled: 'After the peak of the Beatlemania, when the Beatles' contract with EMI expired, Brian Epstein very brightly said to EMI, "I'll negotiate with you for England but I will renegotiate with Capitol for the United States." That's what I had to face. I gave them a $2 million bonus, and a royalty of 9 per cent, which was unheard of at that time; 5 per cent was the maximum.'

The next item on Epstein's agenda was the Beatles' third film. The band were enthusiastic about the power and creative possibilities of the medium, but only on their own terms. After the glossy spoof of *Help!*, they were determined not to be extras in their own vehicle. Instead, the short films that they were involved with in early 1967 were surreal, stylised evocations of mental and emotional states: the promotional clips shot

by Swedish director Peter Goldmann in early February to accompany the upcoming release of the 'Penny Lane'/'Strawberry Fields Forever' single.

By mid-February, negotiations with a new scriptwriter were well advanced. The gay playwright Joe Orton had been contacted by the producer, Walter Shenson. 'I was very impressed by this,' Orton wrote in his diaries, 'but I put on a nonchalant manner.' On 11 January, Orton's play *Loot* had won the *Evening Standard* drama award for Best Play, placing him in the front rank of contemporary dramatists and on the newspaper's front page, as one of the prestigious names 'who stimulate our minds, invigorate our culture and irritate our conscience'.

Flattered and sensing a large pay cheque, Orton agreed to take on the project. After a bit of toing and froing, Orton finally met Paul McCartney at Epstein's Mayfair house on 24 January. As he wrote in his diary: 'He is just as in the photographs. Only he'd grown a moustache. His hair was shorter too. He was playing the latest Beatles record "Penny Lane". I liked it very much. Then he played the other side – Strawberry something. I didn't like this as much. We talked intermittently.

'We went down to dinner . . . "The only thing I get from the theatre," Paul M. said, "is a sore arse." He said *Loot* was the only play he hadn't wanted to leave before the end. "I'd have liked a bit more," he said. We talked of the theatre. I said that compared with the pop-scene the theatre was square. We talked of drugs, of mushrooms which give hallucinations – like LSD. I had a last word with Paul M. "Well," I said, "I'd like to do the film. There's only one thing we've got to fix up." "You mean the bread?" "Yes." We smiled and parted.'

Orton handed in his script to Shenson on 25 January 1967, but Epstein's mind was on other matters. Two days later, he flew to New York, having secured the rights to the Monkees' UK concerts and dates for Cream's first American visit. During the trip, he gave an infamous interview to the DJ Murray the K for WOR-FM radio, in which he sought to announce the merger of his company NEMS with the Robert Stigwood Organisation, and to promote Stigwood's premier acts Cream and the Who, and his new discovery the Bee Gees.

Nat Weiss recalled the drama: 'Before he was to give a radio interview with Murray the K, I came in the room to find Brian slurring his language.

Obviously he had taken several Nembutals. Now, if anyone hears that interview you'll notice that in the first ten minutes are sort of, "Yes," "No," "No." Brian is hardly vocal. As it goes on, he gets more into himself, you have the old Brian Epstein talking about the future of the Beatles, and it becomes very positive when he's out of the influence of the drugs.'

By the end of March, Orton was furious at receiving no acknowledgement of his Beatles film script, titled *Up Against It*. He hadn't been that impressed when he first met Epstein in late January – 'a mousey-haired, slight young man. Washed-out in a way' – and his fury boiled over in his diary: 'An amateur and a fool, he isn't equipped to judge the quality of a script. Probably he will never say "yes", equally hasn't the courage to say "no". A thoroughly weak, flaccid type.'

When the script was returned in early April, there was 'no explanation why. No criticism of the script. And apparently, Brian Epstein has no comment to make either. Fuck them.' Later, McCartney discussed why the project was a non-starter: 'We didn't do it because it was gay. We weren't gay and really that was all there was to it. It was quite simple, really. Brian was gay . . . and so he and the gay crowd could appreciate it. Now, it wasn't that we were anti-gay – just that we, The Beatles, weren't gay.' Nevertheless, Orton blamed the manager.

———

I n spring 1967, the relationships between Epstein and his two principal clients, the Beatles and Cilla Black, were strained. The jury was still out on the Beatles' reinvention as studio-bound adults: their first single for eight months, 'Penny Lane'/'Strawberry Fields Forever', had only gone to #2 in the UK, kept down by Engelbert Humperdinck's blowsy 'Release Me'. This was seen as a comparative failure. With no sign of the album that they'd been labouring on since the previous December, no one knew whether their new phase would work.

Epstein's relationship with Cilla Black had been under strain since the previous winter, when his incapacity had caused him to miss the entire first month of Black's revue *Way Out in Piccadilly*. Backstage at the *NME* Poll Winners Concert on 7 May, Epstein met Tito Burns, Dusty

Springfield's then manager, after coming out of Cilla's dressing room looking 'white'. 'He said he was having a hard time,' Burns remembered. '"I'd do a swap with you," Brian joked, "you give me Dusty and I'll give you Cilla." "Thank you, Brian, but I like the way Dusty sings."'

During that spring, Epstein's mental and physical state worsened. Realising he'd made a mistake with Robert Stigwood, he became irritable and argumentative. Joanne Peterson recalled that 'his depressions got worse. Norman Cowan, his doctor, came to the house often and I'd say, "What's happening with Brian? Why's he like this?" He told me, "Brian is on a collision course with himself. We all have an in-built ability if we're feeling depressed to try and rise above it or waylay it. But Brian heads straight for it and collides with himself."'

In the third week of May, he was admitted to the Priory, the exclusive private clinic in Roehampton. His roller-coaster cycle of uppers and downers had brought him to the brink. Nat Weiss and Stigwood went to visit him one day, which prompted a dreadful row. On the way out, Stigwood turned to Weiss and said, 'You know we can't listen to a word he says.' 'Why not?' 'Because he's not in his right mind, that's why,' said Stigwood. 'I'm going to ignore him completely.'

On 18 May, the contract was signed for the Beatles to represent Britain in a worldwide satellite broadcast, to be shown simultaneously in twenty-five countries on Sunday 25 June. They were to perform a new song especially written for the event. The next day, Epstein discharged himself from the Priory for twenty-four hours and hosted a reception in his Chapel Street house for the Beatles' new album – the first organised press exposure the group had had since the previous September.

The Beatles rallied round Epstein, sending him flowers and socialising more than they had all winter. Back in the Priory on 20 May, Epstein wrote to Weiss: 'I'm really sure this place is doing me a lot of good. For the first time really in six years I'm having some rest and feeling some peace. Of course I've not been completely bound to the place. On Saturday I went to tea and to spend a few hours at Ringo's where John, Cyn, Julian and George all showed up and that was really nice.'

Epstein was discharged from the Priory on 25 May, the day that Apple Music was registered. Brian and his brother Clive were directors of the

company, and the first shares were held by Lennon and McCartney (twenty-four each), and Harrison and Starr (twenty-five each). The move was an indication of the Beatles wanting more control over their business affairs, and was partly stimulated by the Beatle whom he found the most difficult: 'Paul was the one who would get on the phone and create,' Joanne Peterson said. 'Brian had to explain longer with him. On social occasions they were fine together, but whenever there was a worry from the Beatles, it always came from Paul.'

There was absolutely no let-up for Epstein that spring. Hardly cured from his time at the Priory, he threw a lavish house-warming party at Kingsley Hill, his house in East Sussex, on 28 May; he had bought the house during the winter as a retreat. Lennon, Harrison and Starr all came with their wives, along with Lionel Bart, Derek and Joan Taylor, Kenny Everett, Nat Weiss, Mick Jagger, Marianne Faithfull and Robert Stigwood – with McCartney the only no-show.

The house-warming party, also held to celebrate the release of *Sgt. Pepper's Lonely Hearts Club Band* in the UK, was drenched in LSD. If there was any doubt over whether the Beatles' new incarnation would meet resistance, that was dispelled by the rave reviews and instant sales. Within a week, the LP would enter the album charts, rising to #1 on 10 June, where it would remain for the next five months. The same pattern occurred in America: released on 2 June, it went to #1 on 1 July and would stay there for three months.

Reports about Epstein's state of mind that summer are contradictory. There are almost no mentions of emotional partners or sexual encounters, which leads to the belief that, if there were any, they were fleeting and illegal, and not thought worthy of recording. When Lionel Bart met him in the King's Road shop Granny Takes a Trip, Epstein was buying psychedelically patterned shirts. 'I looked like a ragamuffin,' Bart recalled. 'Stoned out of my mind. We did not talk: we both knew were both wrecked and on the road to nowhere.'

Yet, according to his friend and American manager Nat Weiss, the massive success of *Sgt. Pepper's Lonely Hearts Club Band* – a ringing endorsement of the Beatles' risky policy of seclusion – and the forthcoming *Our World* satellite broadcast had lifted Epstein's mood. 'Towards the

end of June he was beginning to emerge from the depression,' Weiss told me. 'He had more positive moments than depressive moments.'

'All You Need Is Love' had been written under intense pressure and close to the deadline for the live TV show. The Beatles began recording the song on 14 June and revised it over a number of sessions in the ten days leading up to the recording date. The plan was that, in the broadcast, the group would play along to an existing backing track, with vocals, bass, guitar solo, drums and orchestra as the only live elements.

The segment went out on air at 9.36 p.m. (UK time) on 25 June. What the estimated four hundred million viewers saw first was two technicians – George Martin and Geoff Emerick – in the studio box, before the camera glided over an orchestral string section to reveal four gilded, garlanded young men. Clad in multicoloured clothes, the Beatles – simultaneously nervous and imperial – floated through the song's undulating motion, while at their feet family and friends swayed and clapped. It was a slice of Haight-Ashbury transported to London NW3.

'All You Need Is Love' was a tricksy, catchy song that showed the joins of its rushed genesis and realisation. Nevertheless, it was a triumph for the Beatles, who effectively became representatives of a whole nation while singing the utopian vision that 'love is all you need'. As Epstein commented at the time: 'This is an inspired song, because they wrote it for a worldwide programme and they really wanted to give the world a message. It could hardly have been a better message. It is a wonderful, beautiful, spine-chilling record.'

It was also a triumph for Epstein, a career peak captured by the David Magnus photographs. 'Brian was always concerned about doing something bigger and better than anyone else had ever done,' Weiss recognised. 'Just as Shea Stadium had been the biggest concert, this was to be the biggest TV show in history, and the Beatles would be seen live across the world. The net result of that live broadcast, the first ever of its kind, was that the Beatles were seen by 400 million people. It's another testament to Brian's creativity. He just saw no limits.'

17
The Gay Managers

Take this business of working class boys growing their hair long in imitation of their favourite pop groups. It upsets people for two reasons or even three. One because they can't tell them from girls and so there's a sexual confusion and an implication of softness and homosexuality among boys, and they might even get deceived themselves and find they've been attracted by a boy by mistake. Then too how can they maintain their own position of superiority if men look like women.

Maureen Duffy, *The Microcosm*, 1966

I t was the high Summer of Love, and in mid-June, the #1 record in the UK was the queasily psychedelic 'A Whiter Shade of Pale' by Procol Harum. At #3 were the Kinks with their first single of the year, 'Waterloo Sunset'. While Dusty Springfield's 'Give Me Time' sank to #27, the Who were at #21 with 'Pictures of Lily'. Also featuring were two more of Robert Stigwood's groups: Cream and the Bee Gees, with their first hit, 'New York Mining Disaster 1941'.

In *Disc and Music Echo* that week, Mike Ledgerwood hosted a 'pop think-in' on the topic of Swinging London, under the headline 'Beautiful Mini-Skirted Birds; Colourful Carnaby Street Fashion; Way-Out Weirdoes; A Discotheque Kingdom Bubbling with Life – And Pop Capital of the World. True or False?' Dusty Springfield was canvassed for her opinion: 'It's a bit of a take-on really, but I quite enjoy it. There's something to be said for and against . . . Really, London is its best publicity agent – and I don't know whether it's benefited or suffered by this fact.'

In summer 1967, the British pop scene was still basking in the afterglow of Swinging London, even though it had, to all intents and purposes, reached its peak well over a year before. The term had become shorthand for a city – and, by implication, a country – that had been transformed by pop music into a youth playground of boutiques, discotheques and pop-star sightings, where extravagant sights and sounds were part of a vibrant culture that had been translated into big business since the Beatles broke America in 1964.

Two factors were central to this appeal. The first was the activities of a group of gay or gay-culture-inspired managers who, in the wake of Brian Epstein, sought to manage their own Beatles. The level of the Beatles' success was unprecedented, and as part of this, Epstein himself gave frequent interviews and became a celebrity. His unusually high profile for a pop manager acted like a beacon, and his example as a homosexual – a fact known to those in the small world of London pop – encouraged other like minds.

The second was the mod fashions propagated by Carnaby Street, which, by 1967, had become internationally known, with guidebooks, maps and magazine spreads informing you of where to shop and where to gaze. Key in this was the figure of John Stephen, whom *Life* had singled

out the previous year as the 'man who led the young clothes revolution in England', running a picture of the young entrepreneur posing in front of his Cadillac in Carnaby Street, super-sharp in a waisted checked jacket.

One of the first of the new breed of managers was Andrew Loog Oldham, who had encountered the Beatles in January 1963. 'I was doing *Thank Your Lucky Stars* with Mark Wynter in Birmingham and the Beatles were doing "Please Please Me". You knew you were in the room with something magic. I did ask John Lennon, and he pointed me towards the man with the paisley scarf, and that was Brian. It was only January to April that I worked for them. Later on he wanted to introduce me to Gerry and the Pacemakers – and their overcoats were like lino you wouldn't put on your floor! With that sort of leatherette binding. But he sat there and said, this is my next number one, and he was right. But you know, sometimes when you get given a run, you get a run.'

In April 1963, Oldham found his own protégés, the Rolling Stones, whom, through a process of trial and error, he manipulated and shaped into the perfect riposte to the Beatles: surly, scruffy, delinquent and highly successful, with six #1s by early 1967. In the early days, they were very much moulded in Oldham's own image: sharp, camp, streetwise. 'Andrew discovered gay life in London and really camped it up,' remembers Simon Napier-Bell. 'Mick loved it, and copied all of Andrew's mannerisms.'

Oldham remembers how the gay world influenced his persona: 'It was a way of life. It enabled me to develop a cloak. I used to walk to school when I was nine, flashing film credits over my head, and as I walked through the gates, deciding who the director was, that would protect me through the day, being obviously different to the people I was mixing with. I got that from the gay people that I knew, and given the environments in which I'd grown up, it's not like I didn't know what it was. They were just the only interesting people, man!'

Along with the Beatles, the Rolling Stones set the style for pop London: long-haired, sharply dressed, sharp-tongued and, as the decade progressed, increasingly androgynous. That didn't affect their heterosexuality, far from it, but it enabled a level of freedom previously denied to young men: the ability to experiment with different ideas about gender

and appearance, even if it didn't exactly alter their more traditional attitudes about the relationships between men and women.*

The gay influence on 1960s British pop has been written about in many memoirs – most notably, Oldham's *Stoned* and Napier-Bell's *You Don't Have to Say You Love Me* – and for good reason. Show business in its widest sense provided a safe haven in a world where the simple physical expression of who you were laid you open to prosecution and even incarceration in prison or a mental hospital. It promised validation and money, not to mention the possibility of alchemising personal sexual attraction into the creation of that often ambiguous figure, the pop star.

The Who's Pete Townshend observed this first hand. As he told me: 'There was also that sense that all of the great managers of the previous era – Larry Parnes, Bunny Lewis [who managed the singer Craig Douglas], Brian Epstein – were all gay or bisexual. There was that sense that it was a given that the only people that could see the true erotic sexuality of a pop performer, and nurture it past the point of the amusement of teenage girls, would be a really good manager who was sexually attracted to his protégé – even if he didn't act on it.'

Back in summer 1964, Townshend was the guitarist in a group called the High Numbers, who were busy orienting themselves within the mod scene, playing covers of soul and Motown songs for chemically enhanced club-goers. 'Dancing was what it was all about. We danced, but unlike the wartime generation we weren't escaping. It was different; a lot of it was plugging into each other. The discovery of men dancing with men being okay was also very important. I thought dancing was about seduction, but actually, it's about affirmation.'

In July 1964, at a Brighton club on the seafront, the group met the man who would become their co-manager, Kit Lambert. 'It happened

* Not that everybody approved. In mid-June, there was a column in *Disc* by *Top of the Pops*' 'disc girl' Samantha Juste called 'Samantha's Scene'. Commenting on men's fashions, she wrote: 'What we can really do without in this country is men wearing make-up. When I was in America, I saw quite a few men wearing powder, foundation and eye make-up and it looked absolutely beastly. I'd hate to go out with a man and get powder all over my collar! And some men – you go out with them and you're not allowed to touch their hair because it's all stiff with lacquer. Ugh – it's horrible!'

in the latter stages of our time at the Aquarium. In the early days, it was Pete Meaden. The actual changeover happened at around that time. I think the nights at the Aquarium were managed by the guy who did the Scene club. Anyway, he went to jail because of the rent boys outside the Scene. He was accused of running a male prostitution racket, but it was absolutely nothing to do with him.

'Two or three of the young mod faces used to rent themselves out. They were gay, they were quite comfortable with it; some of the customers were just older men. And it was money for drugs or it was drugs. It was also seen to be incredibly cool. You had to be brave. I've discussed this with a few other people, like Rod Stewart, who I always used to think was gay and turned out not to be; David Bowie, who never gave a damn which way he swung; Marc Bolan, who I believed was a rent boy for a while. Wouldn't 'fess up, by the way.'

At the time, the High Numbers were managed by Pete Meaden, a mod visionary – he coined the mantra that mod was 'clean living under difficult circumstances' – who was becoming involved with the subculture's principal fuel, amphetamine. Lambert and his partner Chris Stamp were very different: initially, they had been looking to make a film about a pop group – in the mode of *A Hard Day's Night* – but when they saw the High Numbers they realised that they could short-cut the process and become managers themselves.

In this, Lambert was explicitly influenced by Brian Epstein's success; according to his biographer, Andrew Motion, he even believed he resembled him. Lambert himself recognised the similarities within his own character: 'Brian Epstein was middle-class, he was gay, and always having unsuitable crushes on unsuitable rock stars.' Despite this crude comparison, Lambert was motivated not so much by fancying the group, but by finding a vehicle through which he could express his own, often violent iconoclasm, of which sexuality was an important part.

Born in May 1935, Lambert was the son of Britain's foremost modernist composer in the 1920s, Constant Lambert, and his mixed-race wife, Florence. He was brought up in a bohemian household, receiving flickering attention and affection. At an early age, he was an odd mixture of precocious self-possession and crippling self-doubt. After going to public

school at Lancing and spending two years doing national service, he went up to Oxford, where, in a typical Lambert move, he overestimated his ability to finesse his finals and ended up with a fourth.

Lambert discovered that he was homosexual in his late teens and quickly acted on that realisation. He was never entirely reconciled to the state, but was nevertheless enthusiastic. At Oxford, he had a relationship with Jeremy Wolfenden – the son of the Departmental Committee on Homosexual Offences and Prostitution chair John Wolfenden – but, as Motion trenchantly observes, 'for the rest of his life was afflicted by the sense that the sexual pleasures and comforts he most wanted were at best wrong and at worst actually disgusting'.

After studying film at the University of Paris, Lambert drifted for the next five years. In 1961, he travelled to Brazil to help shoot a documentary in an as-yet-unmapped part of the jungle. The expedition unravelled in disarray when its leader, Richard Mason, was killed by a then unknown tribe. Over the next three years, Lambert worked as a director's assistant on films like *From Russia with Love*, *The Guns of Navarone*, Michael Winner's *West 11* and Judy Garland's *I Could Go on Singing*.

It was while working on another film, the kitchen-sink drama *The L-Shaped Room*, that he met Chris Stamp, and the two become fast friends. Chris was the younger brother of Terence Stamp, a young working-class actor then making waves in films like *Billy Budd* and *Term of Trial*. Just twenty-one in 1964, Chris was a sharp East Ender with a handsome, almost wolfish mien. Thoroughly heterosexual, but equally rebellious and iconoclastic, he made a perfect foil for the older Lambert.

The pair had regional pride on their minds when they started looking for a group to film. 'I didn't feel that London boys would allow a lot of northern "oiks" like the Beatles or the Merseybeats to put it across them indefinitely,' Lambert recalled. 'There had to be out there lurking in London the group of the future.' In late July 1964, they found their group in North-West London, when they went to see the High Numbers during their residency at the Railway Hotel in Wealdstone.

Lambert's first impressions of the group were vivid: 'Roger, with his teeth crossed at the front, moving from foot to foot like a zombie. John immobile, looking like a stationary blob. Townshend like a lanky

beanpole. Behind them Keith Moon sitting on a bicycle saddle, with his ridiculous eyes in his round moon face, bashing away for dear life, sending them all up and ogling the audience. They were all quarrelling among themselves between numbers. Yet there was an evil excitement about it all and instantly I knew they could become world superstars.'

The group's immediate competition was the Rolling Stones, with whom they had shared shows on the West London circuit and who, by mid-1964, were just achieving their first #1, with their cover of 'It's All Over Now'. The Rolling Stones also had a bona fide sex symbol in Mick Jagger, while none of Lambert and Stamp's putative charges looked like an obvious candidate for that role. But the observant pair took careful notice of the audience whom the group felt they had been chosen to represent.

'Our audience was a Shepherd's Bush-based bunch of dislocated boys,' Townshend has said. 'Kit studied it, and because he was a homosexual and the audience were ninety per cent boys, he picked up that the link between our audience and the band was a sexual one. He never mentioned it, but he recognised it, and used that piece of secret knowledge to make the band – in dress and manner – more androgynous. We treated our boy audience like thirteen-year-old girls.'

Glamour was the way in which Lambert and Stamp achieved this trick. None of the group was conventionally good-looking, but they dressed crisply in the then current mod style: form-hugging jackets, smart shirts and various forms of op art design, whether in appliqués or badges. What they did do was live wildly beyond their means – smashing guitars, microphones and drum kits – in a theatre of violence and abundance that chimed with the fantasies of their audience. Changed to the Who in late summer, the group's short, sharp name reflected this.

Lambert and Stamp realised, like Andrew Loog Oldham before them, that if their group was to have any longevity, they had to write their own material. Lambert singled out the most obviously artistic of the group, Pete Townshend, and encouraged him to sublimate the experimentation he had experienced at Ealing Art School into the writing of pop songs that went beyond the usual complications of love. In this, he was more than a manager and packager; he became a mentor.

As Townshend remembers: 'Kit Lambert came to get me, took me out of my art school flat and put me in this flat in Belgravia. I went to live with him for six months. So I was bathed in this, older men from the previous generation throwing all these ideas at me. It was fabulous. Kit led me to certain areas of English classical music – Vaughan Williams and Purcell, Walton, some of the lighter ones as well – and Chris guided me to the King's Road scene, the early scene which was in decay at the time, but it was there.'

The Who established themselves in 1965 with three chaotic and abrasive Top 10 singles, all written by Townshend. 'My Generation' in particular was a blast of generational rage with an avant-garde, white-noise finale. The group's aggro wasn't just theatre; they were almost constantly at war with each other, with fist fights and sackings and dramatic exits. They were also at war with the banks – as the smashed instruments piled up – and their first record producer, Shel Talmy, who nearly prevented their move to Robert Stigwood's Reaction label in spring 1966.

Their first release for Stigwood was 'Substitute', a profound song about social and sexual dislocation which made the Top 5. Following this, the Who released a string of Townshend-written singles about outcasts and misfits, all of which were huge hits. In autumn 1966, 'I'm a Boy' told the tale of a young boy whose mother dressed him up in girl's clothes – Joe Meek's pathology in a nutshell. 'My name is Bill and I'm a head case,' Roger Daltrey threatened over Keith Moon's thundering drums, 'they practise making up on my face.'

In the final verse, Townshend writes about self-harm – not that anyone picked up on it at the time: 'I wanna play cricket on the green / Ride my bike across the stream / Cut myself and see my blood / I wanna come home all covered in mud.' This was a new kind of lyric, as the Kinks' Ray Davies approvingly noted that autumn: 'I don't think the rebellion line has been properly covered yet; I'm just very pleased that people are writing things like "I'm a Boy".' As the Who's bassist John Entwistle admitted to *Record Mirror*: '"I'm a Boy" is almost a queer song.'

In early 1967, the Who hit #3 with 'Happy Jack', an even stranger, halting song about a man who was 'not all there' but happy in his seemingly incomplete state. The follow-up was even more explicit. 'Pictures of

Lily' had a storyline that concerned teenage masturbation. A young man finds stimulation in soft-porn postcards from the turn of the century and can't believe it when it's pointed out to him that his favourite erotic object died 'in 1929'. Released in April, it peaked at #4 in late May.

———

'Pictures of Lily' was the second release on Lambert and Stamp's brand-new independent label. They were inspired by Andrew Loog Oldham, who had decided to avoid the majors' stranglehold and launch his own label, Immediate, in August 1965. Immediate's first release, the McCoys' 'Hang on Sloopy', was a Top 10 hit, and further hits followed, most notably Chris Farlowe's #1, 'Out of Time'. On 17 June 1967, the Small Faces' first Immediate release, 'Here Come the Nice', was poised at #26 after one week.

After their problems with Shel Talmy and Decca, Lambert and Stamp were determined to strike out on their own. Track Records was set up with finance from Polydor and assistance from Robert Stigwood. Its existence was predicated on the success of the Jimi Hendrix Experience's first single, 'Hey Joe'. When that made the Top 10 in early 1967, Polydor gave the full go-ahead, and Track's first release was Hendrix's next single, 'Purple Haze', a huge hit that peaked at #3 and was still in the chart on 17 June, after nearly three months.

Track had two Top 5 hits with their first two releases. The third was a different matter altogether: John's Children's 'Desdemona' was a strange affair, with thundering power chords, pounding tom-toms and a highly distinctive singer who appeared only in the chorus, warbling the title as a descant. The song made a big impact in summer 1967, becoming a pirate radio favourite, and was plugged heavily in the June 1967 issue of *Rave*, in which Marc Bolan reviewed his own composition: 'I wrote this one myself, and it took me about twenty-five seconds!'

Bolan had been through many transformations since the October 1962 *Town* article that established him as a 'face' – almost as many as had happened in mod itself. By 1964, he was working as a male model and had fallen under the spell of Bob Dylan. Still known as Mark Feld, Bolan

was trying to crash the music industry, even visiting Joe Meek's studio in Holloway Road. Nothing came of it, and he kept on scratching around in the mod netherworld.

In October 1965, Feld had become Bolan and was launching himself as a solo performer. His hustling bore fruit with a long article in the *Evening Standard* by Maureen Cleave: 'Knit Yourself a Pop Singer – Marc and Mike Will Tell You How'. Talking to Marc and his then manager Mike Pruskin, Cleave detected a rhetoric that entered the world of fantasy: 'Marc will be bigger than the Beatles. "Bigger than Elvis Presley," Mr. Pruskin said, adding by way of explanation that Elvis was bigger than the Beatles.'

Bolan's first single, 'The Wizard', went nowhere, as did his second, 'The Third Degree'. During this period, Bolan fantasised about being a rent boy. Whether he was is moot, but there is no doubt that he was aware of his attraction to homosexual men and that he used this to get on. In early autumn 1966, he telephoned Simon Napier-Bell out of the blue, made an appointment, and shortly afterwards arrived at Napier-Bell's flat with an acoustic guitar and the gift of the gab. The older man quickly hustled the young singer off to a studio.

In October 1966, Napier-Bell was an up-and-coming young managerial figure: confident, shameless, quick to manipulate and self-promote. Having co-written the English lyric of the Italian song 'Io che non vivo (senza te)', the original version Dusty Springfield's huge hit 'You Don't Have to Say You Love Me', he had also become manager of the Yardbirds – a less happy set-up, as the overtired, overworked group were on a downward curve. He had also taken on the management of John's Children, who were just on the point of releasing their first record.

'In 1966 I came into a business that was alive with excitement and optimism,' Napier-Bell later wrote. 'I was one of a group – the young managers, Brian Epstein, Andrew Loog Oldham, Robert Wace, and Kit Lambert – who'd taken over the UK's new pop groups – the Beatles, the Rolling Stones, The Who, the Kinks, the Yardbirds. We young managers were on fire. We weren't in any way associated; we weren't even friends, yet we knew each other from hanging out at the "in" night clubs of the moment.'

Despite the inferences, Napier-Bell told me that 'there was never a gay mafia. There were a lot of people who knew each other, and if you all know each other for a reason, those would be the friends you group with, behind the scenes. If you all liked Arsenal, or you were all gay, you would tend to meet each other, and you wouldn't say there was an Arsenal music business mafia; you would just tend to see some people more often than other people. I never agreed with the idea of a "mafia". That's a straight person's idea of gay people getting together, plotting.

'We were all looking for something we could do, because we had a sense that we could spend the rest of our lives not being out. But we weren't going to spend our lives pretending to ourselves that we weren't gay. So we had to look for occupations, and on that level, where you were going to be out with your workmates, there was hairdressing, the civil service, the theatre, and we wanted another place. I was out to my friends but not to anyone else. But the music business began to present itself as another possibility.

'Robert Stigwood taught me the music business. He wasn't the tough guy people made him out to be. He was crafty and he was also a bit of a drunk: we'd go out and then go back to his office, and two or three in the morning we'd open the last bottle of champagne, he'd fall asleep on the couch, and I'd go through the papers on his desk, learning about how the music business worked. He told me everything. If he came into a room, he could sidle in, and you wouldn't know he was there. But he could exert a presence.'

In October 1966, Napier-Bell recorded fourteen demos with Marc Bolan: songs like 'Hippy Gumbo', 'Mustang Ford' and 'Hot Rod Mama'. It was on these demos that Bolan finally developed his distinctive, unique warble – a vocal sound that cut through every arrangement and leaped out of the radio. He was partly influenced by the Native American performer Buffy Sainte-Marie and adapted her vibrato into an extraordinarily high-pitched timbre. After another unsuccessful single – November's 'Hippy Gumbo' – it was clear that a rethink was needed.

Napier-Bell's solution was to parachute Bolan into John's Children, who had already released two singles that were hormonal bursts of drugged pleas and queer character sketches. Signed to Track Records,

with Lambert's proviso that Bolan was part of the group, they were taken by the Who as support on their brief April 1967 tour of Germany. To cover the group's lack of both material and experience – Bolan had barely touched the electric guitar – Napier-Bell devised a sensational stage show.

A letter in *Melody Maker* described it well: 'The lead singer ran around the aisles, rolled on-stage, had a fight with the bass guitarist, leapt into the audience several times and collapsed crying into the back of the stage. The lead guitarist kicked his equipment, beat the stage with a silver chain and sat in a trance between his speakers.' The Who were severely displeased at being upstaged. As Napier-Bell remembered: 'Kit Lambert told me, "If they do that again, they're off the tour." I thought, "If we don't do it, there's no point being on the tour. So let's do it."'

The whole thing came to a head on 12 April, in the Rhine port of Ludwigshafen. As John's Children ran through their chaotic set, singer Andy Ellison sprinted through the audience, daring them to catch him. When he returned to the stage and started fighting bassist John Hewlett, the audience completely lost control and erupted into violence. In the ensuing mayhem, the group's equipment was completely smashed, and they were forced to make a speedy getaway. John's Children had out-Who'ed the Who, and they were off the tour.

Despite all the publicity, the musicians in John's Children felt they were being over-manipulated. The group also baulked at Napier-Bell meddling with the recordings – a consequence of his time as a film editor. 'After we recorded something, Simon would always take the tapes away and cut them about,' Ellison recalled. 'There are edits all over the John's Children's recordings. It made life very difficult for us. We'd rehearse a number in a certain way, and then find that Simon had chopped the last chorus and put it somewhere else.'

John's Children were the nearly-made-it group of summer 1967. In mid-June, they were preparing for the release of 'Midsummer Night's Scene', a Bolan song which, with a refrain of 'petals and flowers', aimed to catch the Californian zeitgeist. When Bolan heard the final mix, however, he was appalled by the production and quit on the spot.

Bolan's trajectory during this period highlights the gay influence on the mod subculture and the changes that occurred within this central

youth cult between the early and later 1960s. By summer 1967, the smart exactitude of the early decade was transmuting into the flowing robes of early hippie fashions or the retro stylings initiated by new stores like Granny Takes a Trip in summer 1966. At the same time, diehard mod fundamentalists had emerged, a movement that seemed to miss the point of the whole thing.

Pete Townshend considers that 'the mods weren't really over until '65. Jack Lyons maintains that mod was still going strong when the psychedelic era kicked off in 1967, but I don't think that's true. I think Carnaby Street had replaced mod. The romantic part of it was over by the end of 1964. People have said to me, and I think I concur, that what ended mod was the headlines about the riots in Hastings. We looked at that, and thought, "Is that us? Very uncool."'

By 1967, Carnaby Street had become a commercial powerhouse, and John Stephen was at its very centre. According to a publicity leaflet, he owned at least fifteen boutiques there, as well as branches on Regent Street and in Brighton and Loughton. Apart from his shops for men, such as His Clothes, Mod Male, Domino Male, Male W1 and Adam West One, he also owned unisex boutiques called His'n'Hers and His, Hers & Theirs, an outlet for female fashions called Tre Camp and his own tailoring shop.

Stephen had been intimately involved with the early-modernist phase of 1961–2, and as the movement grew into mass mod, his businesses bloomed. Apart from window displays and press ads, much of his PR was done by the pop groups of the day, who wore his clothes on television and on their record sleeves. During 1966, for instance, John Stephen clothes appeared on the covers of the Rolling Stones' *Aftermath*, the self-titled first album by the Small Faces and Cream's *Fresh Cream*.

From mid-1966 onwards, however, the King's Road began to replace Carnaby Street as hipster ground zero. There was a class dimension to this, as young aristos and cutting-edge pop stars began to assume militaria and early-hippie costume. For a while, Carnaby Street remained the domain of mod, appealing more to tourists and the new hard mods, who retained the mod uniform of three-button suits, Fred Perry and Ben Sherman shirts, Sta-Prest trousers and Levi's jeans, and started to mix them with braces and stylised, but very short, haircuts.

Nevertheless, Stephen moved with the times. His business model depended on rapid, eye-catching change. One of his popular innovations – seen on many pop stars – was the introduction of brightly coloured satin shirts, with high, long, pointed collars and puffed sleeves, in deep, rich colours like dark blue, black, bottle green and purple. In menswear, satin was usually used for jacket linings and waistcoat backs, and its appearance on the rest of the upper body fitted the year's colourful, if not hallucinogenic, imperative.

Another high-profile John Stephen design that year was a white, Russian-styled satin shirt with peasant trimming and a round collar buttoned up at the neck. Worn by the Kinks' drummer Mick Avory on *Top of the Pops* while the group were promoting 'Waterloo Sunset' that spring, the shirt was an immediate hit. As Stephen's biographer Jeremy Reed writes: 'The BBC switchboard was jammed literally for hours after the Kinks' performance, with callers anxious to trace the shirt's provenance, before being directed to John Stephen's stores.'

Determined to flow with the times, Stephen pressed further into the mod/hippie crossover, producing clothes that were smart, fitted but highly colourful, in unusual fabrics. His satin shirts and paisley cravats were worn by the summer's emerging hit group, Pink Floyd, whose new record, 'See Emily Play', was reviewed by Penny Valentine in the 17 June issue of *Disc*: 'It's another of those songs which appear childishly innocent on the surface but actually carry a message of doomy evilness.'

Another summer 1967 advert, featuring John Hewlett and Chris Townson of John's Children, caught the crossover between the mods and the hippies. Both are sporting long hair – the highly styled mod haircut beginning to go shaggy – and they are wearing unmistakably hippie clothes: Hewlett a thigh-length Nehru jacket with open, flared sleeves in a paisley pattern, and Townson a striped Nehru jacket with patterns, beads and bells. This soft, androgynous appearance was the hipster look of summer 1967.

———

On 17 June 1967, the Kinks' 'Waterloo Sunset' was at #3 in the UK charts, after six weeks. It was the group's first single for six months: like the Beatles, Ray Davies had decided to step away from the grind of constant touring to focus on songwriting and making records. The song was, on the surface, a celebration of the grot and grime of everyday London, but it masked deep feelings. '"Waterloo Sunset" is really tense, even though it's a ballad,' Davies told me, 'but I've never worked with a song that has been such a total pleasure from beginning to end.'

'Waterloo Sunset' was the Kinks' tenth Top 10 record. Of all their contemporaries, the group was the oddest, the most hermetic and the most attuned to the period's androgyny and camp overtones. Emerging in summer 1964 with 'You Really Got Me', they mixed a foppish, almost archaic appearance with the most brutal, abrasive noise to top the UK charts thus far. Only seventeen at the time, guitarist Dave Davies had such long hair that he was often mistaken for a girl – androgyny in action.

The Kinks blurred the line in several ways, both publicly and privately. Managed by two upper-middle-class young men, Robert Wace and Grenville Collins, they were able to cross class boundaries in a way that might have been unthinkable even in the early 1960s. The clash of working-class North Londoners, debutantes and self-made men provided Ray Davies with material for acerbic songs like 'A Well Respected Man', 'Where Have All the Good Times Gone' and 'Sunny Afternoon'.

Remaining obstinately true to his working-class roots, Davies was able to cast a sharp eye on the period's fancies and follies, while he and the rest of the Kinks enthusiastically participated in the very same. Sixties pop groups might have worn Carnaby Street clothes, but very few sang about it. In early 1966, the Kinks released 'Dedicated Follower of Fashion', the second in their fertile series of social-comment songs. This one mercilessly satirised the mod phenomenon – what Davies called the 'Carnabetian army' – and the song hit #4 that spring. Davies was able to have his cake and eat it, although the balancing act caused him great difficulty. Around this time, burned out from contractual wrangling and constant touring, Davies had a minor breakdown. Nonetheless, 'Dedicated Follower of Fashion' was an apparently jolly romp, an examination of a gay type observed in deadly detail: 'He thinks he is a flower to be looked at / And

when he pulls his frilly nylon panties right up tight / He feels a dedicated follower of fashion.'

Homosexuality, camp and the androgyny of mod was something that Davies felt compelled to explore. In high summer 1965, the group had released their fifth Top 10 hit, 'See My Friend', a droning, circular song of great expressiveness and empathy, and one of the very first recordings to integrate Indian modes into the pop charts. With ambiguous lyrics of loss and the apparent attractions of homosocial behaviour, it was thought at the time to refer to explicit homosexuality – an impression that Davies was not anxious to dispel.

During the promotion of 'See My Friend' in summer 1965, Davies told Maureen Cleave of the *Evening Standard* that 'this song is about homosexuality. I know a person in this business who is quite normal and good-looking, but girls give him such a rotten deal that he becomes a sort of queer. He has always got his friends. It's like a football team and the way they're all kissing each other.' To avoid any such implication, the title was altered to the plural after its release: 'See My Friends'.

The Kinks fit uneasily into the blokeish tenor of mid-1960s pop. Despite their love of the Arsenal, the Davies brothers were not lads: they were too odd, too wayward, too determined to pursue their own course. Davies remembered that Keith Altham, one of the *NME*'s principal journalists, hated that: 'I was talking to him about duality and bisexuality and things like that, and the *NME* wouldn't print that sort of thing. They wanted us to be really normal, go-ahead, all day and all of the night boys – have a pint and . . . piss off. But I wasn't like that.'

'It's being unsure of your sexuality,' Davies told me. 'I was unsure of myself. I still find it hard to relate to guys who are out with the lads.' These serious disquisitions on the nature of masculinity laid bare some of the gender dynamics that lay behind 1960s pop, but they were rarely addressed with such candour and thoughtfulness. Davies's observations, as so often during this period, were partly based on observing the behaviour of his younger brother, who, by the age of eighteen, was cutting a swathe through Swinging London.

Dave Davies remembered that the Kinks' management office was on Boscobel Street, just around the corner from Carnaby Street, where – as

a pop star – he was given heavy discounts on the latest clothes by the proprietors, who expected to see him wearing them in the press or on the television. The more outrageous the gear, the better. His favourites included an Edwardian-style jacket made out of curtain fabric and a purple and pink striped floppy hat found in a ladies' hat shop. As he remembered: 'It was by far the silliest item in the store so I bought it.'

As he recalled in his memoir, *Kink*, Dave 'enjoyed experimenting sexually'. In early 1965, he shared a house with *Ready Steady Go!* presenter Michael Aldred, who fell passionately in love with the teenage guitarist. 'I really liked him,' Davies wrote, 'but tried to avoid having sex with him because I never enjoyed it as much as I liked just sharing a relationship with him.' After a violent outburst of jealousy on Aldred's part, Davies asked him to move out: 'from that incident the most important thing I learned is always to respect another man's feelings'.

The younger Davies's androgynous appearance led to quite a few misunderstandings, and one of them provided the basis for one of his brother's most indelible character portraits. The lead track on their fifth album, released in September, was a screech of class envy, couched within a silky arrangement and a sarcastic, smooth vocal. David Watts is the ideal schoolboy, the captain of the school team, the golden boy. The kicker is that, despite having everything a girl might want – money, status – he remains aloof because 'he is so gay and fancy-free'.

The song had its origin in an incident that occurred in August 1966, when the Kinks played a show in Peterborough that was promoted by a man called David Watts, a smart military type who invited the group back to his Georgian house for an after-show party. As Ray Davies told me: 'We had a few glasses of pink champagne, and all these men kept arriving. Mick [Avory] and Dave homed in on the situation: they were dancing and Mick's trousers fell down, and I said to David Watts, "Don't you fancy that big hunky drummer?" He said, "Get lost, it's your brother I'm after."'

With his customary mischievousness, the older brother suggested that a deal could be done: his brother for the transfer of Watts's Georgian manor house. After being chased by the besotted major, Dave Davies decided it was time to end this farce, telling his suitor that he needed a

few days to think over his offer, before quickly rounding up the group and taking his leave with them. Afterwards, he wondered: 'What signals had he heard in our music? Ray tended to write lyrics that suggested at the very minimum some interest in the exploration of male–male couplings.'

In October 1967, the Kinks released their second single of the year, 'Autumn Almanac', a psychedelic meditation on the change of season and the quiet dignity of unrecognised lives which went to #3 the next month. Promoting the song on *Top of the Pops*, Ray Davies laid the gay influence on very thick: pouting, twirling his fingers, wiggling his bottom and zooming into the camera with his eyes, as though his gaydar had just been activated. It was the most explicit example yet of camping on the programme.

Despite all the camping and androgyny, however, homosexuality was barely spoken about in British pop of the time. What happened offstage didn't get into the press, and the activities of the gay managers didn't matter to the public. No major British star came out as being gay during the 1960s; the influence of homosexuality, while embedded deep within pop culture, was still covert. Liberalisation went only so far, even in the year that a change in the law was grinding through the gears.

The 1967 Sexual Offences Act, which legalised homosexual acts between consenting adults, was not echoed by any outright gay pop statements. There were several taboo-busting records early in the year, including the Smoke's 'My Friend Jack' (LSD) and the Rolling Stones' 'Let's Spend the Night Together' (premarital sex). The most outré statement was Pink Floyd's first single, 'Arnold Layne', a song about a transvestite clothes fetishist. It was seen as shocking for the time, and the group were publicised as being part of a wave of taboo-busters. As *Disc and Music Echo* put it: 'Meet the Pinky Kinkies!'

As if to seal the deal, the record was banned by Radio London. According to Jenny Spires, Syd Barrett's close friend at the time, this provocative aspect was deliberate. As she told me: '"Arnold Layne" was about a knicker snatcher, but it was also a nod to the decriminalisation of homosexuality bill. In a time when it was shocking for men to have long hair even, to cross-dress was seen as almost criminal too – but we

all cross-dressed. Syd and I had several gay friends, and we followed the controversy around the bill.'

Nevertheless, without that groundswell of honesty and openness, the postured camping of pop stars all too often looked like heterosexual privilege to gay men and lesbians. As Maureen Duffy perceptively observed in *The Microcosm*: 'Funnily enough you can reckon that anyone who wears his hair long almost certainly isn't queer. He'd be too vulnerable so I've never seen so many neat heads as among David and his friends. The blow wave and the shampoo and set but not a hair out of place.'

While 'Waterloo Sunset' was near the top of the British charts back in June, the Who were playing the Monterey Pop Festival. Although they included 'Pictures of Lily', their set was marked by a violent climax, when the group smashed their instruments. This was the new condition of rock, which would set in from the end of 1967, replacing the gender blurring of the mid-1960s with a concentration on authenticity and technique. Pop androgyny began to fade, but it would return with full force within half a decade.

18
Legalisation

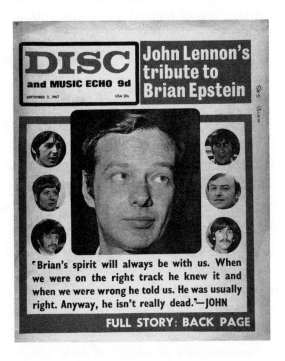

'Do you, then, support the provisions of the new bill which legalises homosexual acts between consenting adults in private?'

'Of course! In fact, the majority of people do, I'm certain.'

Brian Epstein, interviewed by Mike Hennessey,
Melody Maker, 5 August 1967

The high summer of 1967 saw a major change in British law concerning male homosexuality, the culmination of a nearly ten-year campaign that had begun with the publication of the Wolfenden Report in September 1957. It had taken a lot of persistence and, indeed, stubbornness in the face of bigoted and implacable opposition, but finally, with the passage through the parliamentary gears of the Sexual Offences Act, it seemed that the burden of complete illegality was to be lifted from the lives of gay men.

On the evening of 23 June, there was a five-hour debate in the House of Commons about the bill. The proposed Act was at the report stage: an opportunity for the House to discuss and, if necessary, amend the proposed legislation. The bill was quite advanced – it had passed through its first and second readings and the committee stage – but there was still no guarantee that it would be made into law, such was the diehard resistance to its provisions on the decriminalisation of homosexuality.

Infuriated by the success of proposer Leo Abse in getting the bill thus far, the opposition – mainly Conservative MPs, along with some Labour members from northern constituencies – sought to wreck it by tabling a long list of new amendments, for which they made rambling speeches. This attempt at filibustering centred around the status of servicemen and prisoners, and the unpleasant possibility of open advertising in magazines that might allow homosexuals to contact each other.

The debate was not conducted at a high level. Sir Cyril Osborne, one of the most dogged opponents of the bill, proposed a fine of a maximum of £5,000 (£77,000 today) instead of prison for someone convicted of homosexual offences. The various hostile speakers pontificated about 'homos', 'nasty smells', 'utterly degrading and disgusting' practices – the kind of rhetoric that had hardly changed since the gay scandals and pogroms of the 1950s. One Tory MP boomed that it was 'an odious topic'.

It was a brutal process. After a vote at 3.15 p.m., the session concluded, with none of the new, punitive amendments passed. The midsummer debate came near the end of the long and tortuous progress of the bill through the legislative processes of British democracy. The template for the legislation was essentially the partial and flawed recommendations of

the 1957 Wolfenden Report, which for years Parliament had refused to discuss, let alone enact.

The turning point had occurred in 1964, two and a half years after Abse had first introduced his private member's bill into the Houses of Parliament. That summer, the journalist Anne Sharpley wrote a series of five pieces in the London *Evening Standard* about 'London's Hidden Problem'. Her tone was informed and sympathetic: 'The old opprobrious names, "queer", "pansy", "nancy boy", "pouf" were given them. "Gay" is what they prefer to call themselves. A light, unwounding, inconspicuous word that has a useful double meaning.'

Sharpley's articles moved the dialogue forward. The October 1964 election of a Labour government emboldened the Homosexual Law Reform Society, which had already prepared a draft parliamentary bill. The matter was first raised in the House of Lords near the end of May 1965, when the journalist Lord Arran called attention to the recommendations of the Wolfenden Report: 'In accepting the law on homosexual practices as it now stands, we are persecuting a minority and we are being unjust. And these things, I think, are unbecoming to our country.'

The wheels began to turn. As the director of the HLRS, Antony Grey, remembered: 'Immediately after the debate ended I sat with Lord Arran and drafted the substantive clause of what ultimately became the Sexual Offences Act 1967: "Notwithstanding any statutory or common law provision, a homosexual act in private shall not be an offence provided that the parties consent thereto and have attained the age of twenty-one years." Nevertheless, Arran's proposal was shot down by the House of Lords in speeches that offered a ripe display of bigotry.

Immediately afterwards, Abse announced his intention to introduce a bill in the House of Commons. Despite considerable, concerted opposition, the bill had passed the third reading stage in the House of Lords by October 1965 and was being discussed in the Commons, when a general election was called on 10 March 1966. As Parliament had been dissolved, this first attempt failed at the last hurdle.

During this year-long process, public opinion was shown to have shifted in favour of decriminalisation. In an October 1965 national opinion poll, 63 per cent were in favour of decriminalising homosexual

behaviour between consenting adults in private. On 12 February 1966, ahead of the general election, the then middle-market *Daily Mail* gave cautious approval: 'It will end a law that is equally disreputable for being largely unenforceable and cruel when enforced.'

At the end of March, Labour was voted into government with a massive majority of 112 seats. The bill's passing suddenly looked smoother, with the liberal home secretary Roy Jenkins a strong supporter. Reintroduced in the Lords, it passed through all the procedures by the middle of June. It then passed into the Commons, where the various stages were pursued through the winter of 1966 and early 1967. With a shift in public opinion, the opponents of liberalisation were slowly outflanked.

Published in summer 1966, in the middle of this contested legislation, Bryan Magee's report on homosexual men and women, *One in Twenty*, was an important intervention. In the introduction, he declared himself in favour of changing the law so that homosexual acts in private between consenting males were legal. He saw no reason why male homosexuals should be singled out by the law in this way, and added that there was 'universal support for law change among enlightened public opinion'.

One of the devices that Magee used was a concentration on the statistics. Citing surveys stating that between 4 and 6 per cent of people in the UK were homosexual – with the same proportion in men and women – he found that they were evenly distributed through all classes of society, from villages to towns and cities. With two and a half million homosexuals living in Britain, he observed 'the ordinariness of homosexuality, the commonplaceness of it, the fact that every time we walk down a crowded street we pass several homosexuals'.

The everyday nature of homosexuality and the effects of its unwarranted persecution were explored in three groundbreaking BBC programmes that were aired in the first half of June 1967, right at the pressure point of the bill's passage through the House of Commons. Introduced by presenter Jeremy James, the three programmes, called 'Consenting Adults' – which ran as part of the long-running current affairs series *Man Alive* – examined male and female homosexuality on two successive weeks, concluding with a general panel discussion.

The first 'Consenting Adults' was broadcast on 7 June. The programme interviewed five homosexuals: a breezy hairdresser, a bluff Midlands doctor, a tortured gay couple and a provincial clerk, shot in shadow. The episode presented a grim picture of men who had suffered prejudice, violence, ostracism, alienation and the focused attentions of the law. A similar picture was presented by the lesbians in the next week's episode, although a rare moment of optimism was provided by the testimony of Julie Switsur and Cynthia Reid.

On 14 June, at 11.30 p.m. – later than the two preceding programmes – the panel discussion featured an anonymous, forthright female doctor, the novelist Maureen Duffy and the gay social psychologist Michael Schofield, who had published the groundbreaking *A Minority* in 1960 and *Sociological Aspects of Homosexuality* in 1965. In the opponent's role was the Conservative MP for Totnes, Ray Mawby, who was one of the most prominent voices in the campaign against the bill.

The only panel member who seemed to speak freely from within was Duffy; although her status as a lesbian was not stated, it was clear from her sharp, incisive commentary and insider knowledge. Citing Magee's statistic of one in twenty, host Michael Dean asked the panel for their reaction to the two preceding programmes, sure in the knowledge that there would be conflict between Duffy and Mawby, with the doctor and Schofield sympathetic but remaining on the sidelines.

Mawby opened up the conflict by raising the slurs of paedophilia and indoctrination: 'I don't think this type of programme should go out at 8 p.m. in the evening. Many children are still up. There's no need for them to know.' He continued by raising the spectre of blackmail and national security – 'most of the people involved in security cases have been found to be male homosexuals' – which was a bit rich, considering he was later discovered to have been in the pay of the military intelligence service of the Czechoslovak Socialist Republic.

As the panel circled around issues of security, the provisions of the bill, the actions of the police and public attitudes, Duffy showed that she was the only person in the studio who understood the nature of freedom: 'How do you account for the fact that, since it seems likely that the bill will go through, many male homosexuals have said to me that for the

first time they have declared themselves to their friends, workmates, parents, and they felt a tremendous liberation of spirit because of this feeling that at last they are not criminals when they're in bed?'

In a key exchange, she attacked the Judaeo-Christian origin of anti-homosexual prejudice as atavistic: 'It seems to me in a sense we've all assumed automatically that it necessarily is wrong; that in fact we are accepting the tribal beliefs of a very small desert tribe which needed to reproduce fantastically – in 1967, when we certainly don't need to reproduce. We are now going to the moon: one would expect that our moral thinking would be following along at least somewhere behind – not two or three thousand years.'

Mawby was prominent in rallying the opposition during the follow-up debate on the bill in the Houses of Parliament on 3 July. The debate was even more toxic than that of 23 June. The opponents of the bill, including the MPs Cyril Osborne, Gerald Nabarro and Ian Percival, exulted in a delirious, exaggerated sense of outrage, hurling pejorative, bigoted epithets like confetti. Nevertheless, at nearly 6 a.m. the following morning, the bill was passed by a hefty majority.

Over the next couple of weeks, the British newspapers had a field day. Covering the debate, the *Daily Mirror* held that 'after a night of dubious jokes and personal clashes, a social revolution begins'. On 9 July, in an editorial against the 'Homosexual Charter', the *News of the World* thundered: 'This week we take our stand against one of the most pernicious measures ever put before Parliament, the Sexual Offences Bill to legalise homosexual acts between consenting male adults in private.'

On 21 July, the bill went to the Lords for final approval, which was granted. Lord Arran's concluding speech was hardly a charter for gay pride: 'Homosexuals must continue to remember that while there might be nothing bad in being a homosexual, there is certainly nothing good,' he began. 'No amount of legislation will prevent homosexuals from being the subject of dislike and derision and, at best, of pity. We shall always, I fear, resent the odd man out. That is their burden for all time, and they must shoulder it like men – for men they are.'

The bill received royal assent on 27 July, thereby becoming the Sexual Offences Act 1967 – a law which has held sway right through into the

Sexual Offences Act 1967

CHAPTER 60

ARRANGEMENT OF SECTIONS

Section
1. Amendment of law relating to homosexual acts in private.
2. Homosexual acts on merchant ships.
3. Revised punishments for homosexual acts.
4. Procuring others to commit homosexual acts.
5. Living on earnings of male prostitution.
6. Premises resorted to for homosexual practices.
7. Time limit on prosecutions.
8. Restriction on prosecutions.
9. Choice of mode of trial for certain offences.
10. Past offences.
11. Short title, citation, interpretation, saving and extent.

new millennium. It was greeted with a chorus of hostility, but the deed
was done. It was far from ideal: as passed, it tightened up the Wolfenden
recommendations, particularly in regard to the age of consent – which
was held at twenty-one – and the bedevilled question of what was con-
strued as privacy: if there were more than two homosexual men present
when a sex act occurred, it was against the law.

The new Act was a holding measure, designed to be improved upon,
but it didn't address the wider question of why homosexual acts were so
poorly regarded by the public. For understandable reasons, Arran and
Abse had tried too hard to appease its implacable opponents, distancing
themselves from any positive images of homosexuality. It also undercut
the UK's principal gay rights organisation, the HLRS, which, although it
had successfully focused on lobbying the great and the good, had failed
to build any grassroots movement like there was in America.

Although the passing of the SOA 1967 loosened the legal restrictions,
the reception from gay men was muted, dulled by the way they had been

othered in the debate. Without any grassroots discussion, the issue of homosexual rights seemed to be, as the activist and author Roger Baker thought, 'interpreted in entirely heterosexual terms. Through these years of social and sexual upheaval the gay dimension was completely missing. We lacked a model for action, we lacked insight and we most lacked confidence.'

Indeed, one unpleasant result of the public discussion around the bill was that a bright spotlight was suddenly shone on a previously obscure world. As Baker remembered: 'Queer spotting became a great game, as it had been ten years earlier at the time of the Wolfenden Report. This sudden focus of attention, naturally enough, scared most homosexuals to death. This climate created a threat far greater than any relief promised by reform. We kept a low profile.'

Some people thought it was about time that homosexuality was decriminalised, while some older gay men, born well before the Second World War and steeped in the repressive atmosphere of the 1950s, resented the fact that the whole topic had been made public and the supposed cosiness of secrecy removed. The historian Jeffrey Weeks remembered meeting gay men 'in the pubs and the cottages of London and South Wales, who were actively hostile, nervous that the new legality would ruin their cosily secret double lives'.

To some extent, they had a point. With the restrictions on gay men so thoroughly broadcast and so tightly defined, the police – who were essentially hostile to the Act – found it easier to bring prosecutions under the tightly defined privacy and age-of-consent clauses. Convictions for homosexual offences would rise considerably over the next few years: by the 1970s, the numbers of gay men in court under the SOA would triple. Considered as a once-and-for-all solution to the issue of homosexual rights, the Act shut down any further reforms for the foreseeable future.

In a wider sense, partial decriminalisation didn't remove the stigma or the loneliness, nor did it sanction an increase in the number of gay clubs or organisations. That would be the next fight: in the wake of the Act's passing, HLRS chairman Antony Grey decided to press forward with his aim to 'build up new personal and community attitudes, which will

replace the too common cynicism and loneliness of the sexually different with a new sincerity of comradeship and concern for one another'.

This sense of loneliness and shame was amply exemplified by the anonymous, inhibited gay couple – in their forties and fifties – highlighted in the 7 June *Man Alive* 'Consenting Adults' documentary. Late in the awkward, stilted interview, the younger partner suddenly erupts: 'I wish I had been born now because public opinion is different and I would have read more and I would have known more and I wouldn't have started out quite so backward and frightened, shy, not knowing anything when I started out. Life before you meet someone is hell.'

In *One in Twenty*, Bryan Magee observed that 'the central fact about social life for homosexuals is the fact of extreme social disapproval. This is responsible not for everything that characterises their way of life but for more than any other single factor. Because they are doing things, living a way, having emotions, feelings, fantasies and wishes which the majority of people find shocking, they do not express them, they conceal them. And that is the second dominating factor about life for homosexuals – concealment.'

There was the rub. For those born in the 1920s and '30s, the partial freedoms of the Act and its compromised delivery of homosexual rights were far too little, far too late. They had become adolescents and young adults during the war or immediate post-war years, when to be a homosexual was to be of the lowest caste possible. They had received no support in attempting to overcome this social stigma, and the consequent psychological damage bled into every aspect of their lives.

———

For three men, all born between 1929 and 1934, the year of the Act's passing would mark the end, not a beginning. They had contributed massively to popular culture – indeed, they could be regarded as three key creators of the 1960s – and had received considerable validation for their achievements during their lifetimes. They had seen their visions become successful beyond their wildest dreams, but that was not enough. The die was already cast.

On 6 January 1967, North London's the Riot Squad released the Joe Meek production 'Gotta Be a First Time'. It was their seventh single with the producer, a cheerful enough pop song with a brassy arrangement and a muted sparkle of the Meek magic. In common with the producer's other recent releases, it was given short shrift in the music press of the time: 'Frankly there is very little one can say about this very ordinary record without being destructive,' opined the *Melody Maker*; 'at least it is not pretentious, it is not actively offensive.'

Four years on from his moment of triumph with 'Telstar', Meek was rapidly unravelling. The combined British and American success of the Tornados' record had been his peak, as he struggled, with remarkable tenacity and, on occasion, visionary sound creation, to maintain his position as Britain's foremost independent producer – and, by the latter stages, to survive financially. Quite apart from the strain of having to live or die by each successive record, there were two main problems that dogged Meek from 1963 onwards.

The first was an example of that old music industry adage: when you have a big hit, you get a big writ. In May 1963, the French composer Jean Ledrut instructed his publishers to sue Meek for plagiarising, in 'Telstar', his theme tune to the 1960 Abel Gance film *Austerlitz*, 'Le Marche d'Austerlitz'. The ensuing legal battle would remain unresolved for the next few years; while the matter was being decided, all of Meek's royalties from his most successful record were frozen.

The arrival of the Beatles and the Merseybeat groups – with their organic productions that, in general, eschewed echo and reverb – didn't help, making his highly recognisable patch seem quaint and old-fashioned. In response, he worked even harder. That spring, he told the *Gloucester Journal*: 'I'm a dreamer. Very temperamental and very ambitious. But lately people have been telling me I've been working too hard, that I'm ready to crack up. I'll admit I do feel tired sometimes. Sixteen hours a day is some going but I enjoy work. I'm doing what I really want to do.'

Things were not going well with his principal act. Despite having a #1, the Tornados were unable to tour America because of their exist-ing contract with Larry Parnes and Billy Fury. 'We didn't go to America because Larry Parnes said, "If you go, Billy Fury goes too,"' Tornados

drummer Clem Cattini remembered. 'And the Americans said, "Who the hell is Billy Fury?" So that was the end of that, we never went to the States. It was only afterwards that we realised that we were just a vehicle for Heinz's solo career.'

While the three follow-ups to 'Telstar' did successively worse business, Meek concentrated on building up the solo career of his favoured protégé, the Tornados' bassist Heinz. His going solo in spring 1963 precipitated a series of line-up changes that would cripple the group, and, although he secured a triumph with Heinz's first solo record, 'Just Like Eddie' – Top 5 in late summer 1963 – Meek found any further success hard to achieve: Heinz's subsequent singles just scraped into the Top 30.

In November 1963, disaster struck when Meek was caught in a public toilet just off the Holloway Road and charged with 'persistently importuning'. He was fined £15, but he was named and shamed the next day in a short item on the front page of the *Evening News* as 'The Man Who Wrote "Telstar"'. This public humiliation was devastating. As his publisher Bob Kingston remembered: 'He was acutely conscious of his homosexual inclinations and sought to conceal that, even to those who knew him. He never ever once admitted that situation to me.'

The effect was immediate. He was recording that day with a group called the Saints. As a matter of routine, Meek had the habit of bugging the studio to discover what the musicians were saying about him; if there was any adverse mention of his homosexuality, he would immediately terminate the session. He heard them chatting about the item in the *Evening News* – session over. The blackmail threats started: there were phone calls, voices through the intercom on the front door. His paranoia quotient went sky high.

Meek's state of mind was always dependent on the fate of his recordings. He rallied after the flatlining of the Tornados' and Heinz's top-charting careers by pulling off a huge coup with the success of the Honeycombs' 'Have I the Right?' – a fearsomely compressed record with boot-stomp percussion in the choruses, suggested by the Dave Clark Five's 'Glad All Over' and performed by drummer Honey Lantree. Reaching #1 in August 1964, it was also an oblique comment on his own blocked right to sexual and emotional fulfilment.

Meek was nothing if not authorial, and in late November 1964, he released two further productions that hinted at his state of mind. Written by the up-and-coming team of Ken Howard and Alan Blaikley, the Honeycombs' 'Eyes' was a minimal, claustrophobic production that subverted the boy-meets-girl lyric into a slice of itchy unease: 'Eyes I've seen in some crowded places / Staring from lonely faces.' 'Little Baby' by teenage group the Blue Rondos set an aching melody to lyrics of extreme frustration: 'Little baby, if only I had known / Then I might not be alone.'

'Have I the Right?' was his last chart-topper, but Meek continued to adapt. His output barely abated; for every record that held to the old formula, there was another that pointed forward to something new and unique. His production of David John & the Mood's 'Bring It to Jerome' showed him at home with the new R&B medium, which he then transcended with the Syndicats' 'Crawdaddy Simone', a moody record that name-checked the popular Eel Pie Island Hotel club and featured a guitar break so frenzied that it put the Yardbirds' rave-ups to shame.

Nevertheless, he continued to overproduce: in all, he released 141 singles between 1962 and 1965. Constantly searching for novelty, he failed to develop the careers of the Tornados or the Honeycombs, the latter of whom managed one more success, 'Is It Because?', in summer 1965 – one of only two hits Meek placed that year. His life seemed to be dogged by disputes: the 'Telstar' court case and an unpleasant conflict with Geoff Goddard about the songwriting credits for 'Have I the Right?' After losing his case, Goddard never spoke to Meek again.

Meek didn't help himself. He liked to pop amphetamine pills, which accentuated his paranoia. He was obsessed with the possibility that he was being bugged, that people were stealing his ideas through electronic listening devices. He was spooky: obsessed with other worlds, with graveyards, with the occult – reading Dennis Wheatley and Aleister Crowley – and with spiritualism; holding regular seances and claiming to be in regular contact with his hero and musical obsession Buddy Holly through the spirit world.

Fewer hits meant fewer productions placed with record companies, and the pace of his releases began to slow down in 1966. In spring of that year, he achieved his last Top 30 hit with a single by popular

Liverpool group the Cryin' Shames. Written by Burt Bacharach and Bob Hilliard, 'Please Stay' had originally been a hit for the Drifters, reaching #14 in summer 1961. It had featured the group's androgynous lead singer Rudy Lewis, who died in suspicious circumstances in 1964, just before the group were due to record 'Under the Boardwalk'. The Cryin' Shames slowed the song down into a wracked ballad. When the record reached the Top 30, the offers started pouring in for Meek and resulted in him holding conversations with Brian Epstein about the possibility of him managing the group. Epstein offered near-guaranteed stardom, TV appearances and a big advance for new equipment. The group were intransigent, however, and at a meeting in the NEMS office rejected the offer agreed by both men. As bass player George Robinson remembered: 'Meek broke down and cried.'

Very little seemed to go right for Meek at this point. His business affairs and finances were in total chaos. The royalties from 'Telstar' were still frozen because of the Ledrut court case, which had proceeded to a counter-suit in an attempt at an out-of-court settlement. He was not earning from his releases. He had received final notices from the Board of Trade concerning unpaid Tornados' royalties. The band's keyboardist Roger LaVern had been forced to go bankrupt to find out exactly how much was owed to him and the group, and the official receiver was on Meek's back.

There were signs of decline. Songs like April 1966's frantic 'You're Holding Me Down' by the Buzz pushed the Meek production patch into trebly extremes, while Jason Eddie and the Centremen's bizarre cover of 'Singing the Blues', released in June that year, trashed the old chestnut with a repeated burble of reverbed electric squeals, punctuated by bursts of bluesy guitar. They both sounded fragmented, the elements of Meek's previous winning formula accelerating and dissolving into seemingly random static.

Nevertheless, in August 1966, Meek achieved a rare triumph, one that few people noticed but one that gave him great satisfaction. On the flip of the Tornados' 'Is That a Ship I Hear?' – a doomed attempt to ride the pirate radio wave – he placed a flouncy lounge instrumental, 'Do You Come Here Often?', which resolved, after two minutes, into a gay-club

scenario, highlighting an intense, bitchy dialogue between two nitrogly-
cerine queens. This extraordinary slice of gay actuality was released on a
major label – the only such representation in the mid-1960s.

On 2 September, Meek released his fourth-to-last single. Performed by
a reconfigured Paul and Ritchie and the Cryin' Shames, 'September in the
Rain' was a piece of pop fluff, but the flip, 'Come on Back', was his final
masterpiece: a tough rocker – beginning and ending with wicked guitar
reverb, easily the equal of the new, harder American garage sound – that
matched powerful call-and-response vocals with a serpentine electronic
figure and a sinuous rhythm, all tension and release.

Despite these flashes of brilliance, Meek's situation deteriorated fast. As
he wrote to his solicitor, his finances were in a 'helluva mess'. He owed
money to the taxman and his artists; the demands added up to about
£20,000, while there was only £1,300 in the bank. There was the pro-
spect of a lifeline: stung by the departure of George Martin in 1965, EMI
chairman Sir Joseph Lockwood was looking for a replacement in-house
producer and offered Meek a staff job, with an office at Abbey Road studios.

While Meek was still considered a player, his mental state worsened.
The blackmail threats and violence continued: he was beaten up and
found unconscious in his Ford Zodiac, and was also threatened by
gangsters associated with the Kray twins, who wanted to take over the
Tornados' management. In response to these violent events, he kept hold
of Heinz's shotgun in his flat. When he found a bug microphone in his
studio, Meek's extreme paranoia seemed justified.

At the same time, he found no consolation in brief affairs. His prom-
iscuity and mental state precluded the intimacy that he desired, and his
loneliness became all-consuming. As his studio assistant, Patrick Pink,
remembered: 'He used to say, "Nobody loves me. Don't you love me a
little bit? Can't you find some love for me?" He was a temperamental
bastard but a lovable person. He had a very nice side to him, he had a bad
side to him, but don't we all?'

Meek's situation was not helped by his dabbling in other worlds. He
was a subscriber to *Psychic News* and went to see a medium, who informed
him that one of his guides was a Native American chieftain who had com-
mitted suicide; the other was Ramses the Great. There was evidence of

psychic disturbances – poltergeists – in the flat, while drugs and nervous exhaustion caused Meek to have 'trances' – ellipses where he would become mentally vacant – that lasted from a few seconds up to a quarter of an hour.

The first few weeks of 1967 were grim. Behind with his rent, Meek was in constant trouble with his landlady in the shoe shop below, Mrs Violet Shenton. He had already received a notice to quit. As far as his career was concerned, he felt that his time was running out. When the Honeycombs' singer Dennis D'Ell asked him about the downward curve of his success, he replied that if artistic people didn't 'achieve success – because not all artistic people achieve the success they deserve – then they die'.

Brief hope was offered by his acceptance of Sir Joseph Lockwood's EMI job offer, but in late January an event occurred that helped tip him over the edge. In mid-month, the body of Bernard Michael Oliver, a sixteen-year-old warehouse worker from Muswell Hill, North London, was found dismembered in the village of Tattingstone, Suffolk. A shocking, high-profile crime with imputed homosexual associations, it brought fear and uncertainty into London's gay community.

When the police announced that they were going to interview all known homosexuals in the capital, Meek was terrified: his name was on record after his November 1963 conviction. On 31 January, there was a report about the so-called 'suitcase murder', saying that the police had information on where the boy was during the ten days between the last time he was seen and the discovery of the body. As a known homosexual, Meek was terrified that he would be dragged into the case. A couple of days later, two of his latest productions were rejected by EMI on artistic grounds.

On the evening of 2 February, he lost control. When he was visited by Margaret, the wife of guitarist Ritchie Blackmore, she got 'the shock of my life because he was white in his face and it was like the eyes were coming out of his head. Actually he looked like a devil and when I talked to him he didn't answer me. He was like a madman . . . dressed completely in black: black trousers and a very shiny shirt and black shoes.' Meek told the shocked young woman that he was possessed by an evil entity.

After staying up all night on a cocktail of pills, Meek was boiling with anger and paranoia on the morning of the 3rd. He handed Patrick Pink a note that said: 'I'm going now. Goodbye.' During a climactic row with

Mrs Shenton about his rent book, he snapped and shot his landlady in the back. Things then happened very quickly, as Pink remembered: 'Joe was leaning over the landing banister and I thought I was next. He just had a stony-faced cold look.' Meek reloaded the gun and pulled the trigger on himself.

The murder–suicide made the front page of the London *Evening Standard* West End final edition: 'Joe Meek, 36-year-old composer of Telstar and the Kennedy March, promoter of three pop groups, was found shot dead at his Holloway, London recording studio he always called the Bathroom. Beside him was a 12-bore shotgun. On the stairs nearby, dying from shotgun wounds in the back, was Mrs. Violet Shenton, aged about 52. She died on the way to the Royal Northern Hospital. Police believe no one else was involved.'

Why Meek decided to murder Mrs Shenton has never been established. Despite their disputes, they had always had a good relationship. The likelihood was that, by this stage, Meek was beyond any rational behaviour. It is quite possible that, given his fascination with Buddy Holly's death on that date, he had decided to commit suicide on 3 February: when he made his will a couple of weeks earlier, he had hinted that he wouldn't be around for much longer. In a rush of blood to the head, perhaps, he decided to take his landlady with him.

———

Two days after Meek's death, Joe Orton was hard at work on the *Up Against It* script. The Beatles commission was only the latest event in a rapid upward spiral for the thirty-four-year-old playwright. He'd decided to record a diary, beginning in December 1966, that was designed as a document of extreme frankness, only to be published after his death. As Orton wrote in March 1967, 'I'm going up, up, up,' and his response to success was to ramp up his work rate: in eight months, he rewrote two plays, the Beatles script and a new work for the theatre, *What the Butler Saw*.

Success liberated Orton, but it caused his partner, the actor, writer and collagist Kenneth Halliwell, untold anguish. When they met in 1951,

Orton was a teenager and Halliwell was in his mid-twenties. They lived together and worked together, with the older man acting as a mentor. When they were both imprisoned for six months in 1962, for defacing library books by adding photos and text collages that might now be considered high art, both thought that the harsh sentence was given because they were 'queers'.

Halliwell was devastated and never quite recovered, but prison focused Orton's fury. 'Being in the nick brought detachment into my writing,' he said in 1964. Within a year of his release, he received his first commission, when *The Boy Hairdresser* was accepted by the BBC arts and radio network, the Third Programme. In September 1963, he began a play that was designed as a full-blown attack on British society, which he termed that 'old whore'. When *Entertaining Mr Sloane* premiered in May 1964, its perceived violence and perversity caused outrage.

Orton's revenge was served cold, in plots that projected farce into unimagined complexities of misunderstanding, cruelty and polymorphous sexuality, and prose that borrowed from the cadences of camp to express a cold, hard hilarity. Like his friend Kenneth Williams – who from early 1965 took the hidden homosexual code of Polari into the mainstream of British life on the radio show *Round the Horne* – Orton understood that language was not just a tool, but a weapon. His motivation was not integration, but provocation and the subversion of all values.

'Sex is the only way to infuriate them. Much more fucking and they'll be screaming hysterics in next to no time,' Orton wrote in March 1967, and one facet of his diaries is his extreme frankness about his promiscuity: local teenagers in Tangier; orgies in a Holloway Road public toilet that resembled, as he wrote, a 'frenzied homosexual saturnalia'. Unlike the lobbyists of the Homosexual Law Reform Society, Orton wanted absolutely no truck with mainstream society, and his success liberated him to become even more extreme.

In an era when homosexuals were supposed to be furtive and feel guilty, Orton was publicly strident, using any excuse to act out and embarrass the general public. After a 'stuffy' American couple looked down their noses at Orton and his friends in a Tangier cafe, he wrote: 'This is our country, our town, our civilisation. I want nothing to do with

the civilisation they made. Fuck them. They'll sit and listen to buggers'
talk from me and drink their coffee and piss off.' His response to the
self-hatred inculcated in homosexuals was a scalding rage.

In July, he had a discussion with Kenneth Williams about his sex life.
'You must do whatever you like, as long as you enjoy it and don't hurt
anyone else, that's all that matters,' Orton told him. '"I'm basically guilty
about being a homosexual you see," he said. "Then you shouldn't be," I
said. "Get yourself fucked if you want to. Get anything you like. Reject
all the values of society" . . . "I know, I just feel so guilty about it all."
"Fucking Judeo-Christian civilisation!" I said in a furious voice, startling
a passing pedestrian.'

One effect of Orton's rise to fame was that, despite the rejection of the
Up Against It script, he became more involved with pop culture. Born
in January 1933, he had missed the first wave of rock 'n' roll, preferring
classical music and opera. He also liked 1930s stage musicals and torch
singers. As he became drawn into the 1960s cultural milieu, he began
buying Beatles records and mainstream pop: Engelbert Humperdinck's
'Release Me', Whistling Jack Smith's 'I Was Kaiser Bill's Batman' and the
New Vaudeville Band's 'Peek-a-Boo'.

As the summer progressed, Orton found himself drawn to 'A Whiter
Shade of Pale' and Dave Davies's 'Death of a Clown'. In late July, he
borrowed a friend's copy of the Beatles' *Sgt. Pepper's Lonely Hearts Club
Band.* As he wrote: 'It's very good. Some numbers I like more than others.
"With a Little Help from My Friends" and "When I'm Sixty-Four" and
"A Day in the Life". Certainly the most brilliant of the Beatles' records.
They get better all the time. Did very little all day. Went down to the
record shop in Sicilian Arcade and bought a copy of the LP.'

By this time, however, his relationship with Halliwell had become toxic.
Living together in a claustrophobic bedsit in Noel Road, Islington, they
bickered and raged at each other. While Orton was lionised, Halliwell
was all too often ignored and denigrated as a middle-aged nonentity.
As Halliwell become more and more depressed, Orton, flying so high,
was unable to respond. As he wrote in late May 1967: 'I slept all night
soundly and woke up at seven feeling as though the whole of creation
was conspiring to make me happy. I hope no doom strikes.'

During the night of 8 August, Halliwell murdered the sleeping Orton with a hammer to the head and then committed suicide with an overdose of sleeping pills. The bodies were discovered when a chauffeur arrived to take Orton to a meeting with Richard Lester about the projected filming of *Up Against It*. At Orton's funeral on 18 August, the coffin was carried into the chapel and down the aisle to the music of the Beatles' 'A Day in the Life' – his favourite.

————

The next day, the third and final part of a very long Brian Epstein interview was published in the *Melody Maker*. Mike Hennessey asked the question that was on insiders' lips: whether Epstein doubted that the Beatles would re-sign their contract with him. 'No, I don't,' he replied. 'I don't think they mind how long I sign them for. A contract doesn't mean much unless you can work and be happy together. And I am certain that they would not agree to be managed by anyone else.'

Asked whether the Beatles had changed, Epstein replied simply: 'A lot.' As for future plans, he mentioned the possibility of developing ideas for a film in the wake of the runaway success of *Sgt. Pepper's Lonely Hearts Club Band*; he quoted sales figures of half a million in the UK and nearly two million in the US. 'I think they would like to make a sort of *Sgt. Pepper* film,' he told the *Melody Maker*. 'They have proved that they can do the sound part and now they feel they can tackle the visual part as well.'

Epstein was putting a brave face on things. Despite the triumph of the new album and 'All You Need Is Love' – which went to #1 in the UK for three weeks in late July and #1 in the US on 19 August – his general situation was not much improved. The Seltaeb litigation was finally settled on 30 June, when NEMS agreed to pay Seltaeb Inc. a sum of around £100,000. Epstein insisted on paying NEMS's legal costs out of his own pocket, as he felt personally responsible for the mess.

Meanwhile, tensions were increasing with Robert Stigwood, whose lavish spending and cavalier attitude was antithetical to Epstein's costive approach. He also had a major blow-out with Cilla Black, who was furious at his admission that he had taken LSD and had lost patience with his

unreliability; however, after a tense meeting, during which he promised to secure her a TV series – the standard route of career development for female singers in the mid-1960s – she agreed to retain him as her manager.

In the first two parts of his *Melody Maker* interview with Mike Hennessey, published on 5 and 12 August 1967, Epstein had admitted, frankly, that his greatest fear was 'loneliness. I hope I'll never be lonely. Although, actually, one inflicts loneliness on oneself to a certain extent.' Asked about marriage, he equivocated, not yet feeling able to be open about his sexuality: 'I'd like it to happen – if it could happen. Apart from the companionship it represents, I would welcome it because I get very put out trying to run two homes on my own.'

Several witnesses attested to his deterioration that summer. His secretary Vivienne Moynihan considered that 'he'd shown the boys the way to great achievement and success, and thought all his friendships, love and companionship would follow automatically. But these grow slowly. Brian never matured enough to realise that. He also didn't realise that the boys would grow. Suddenly, there he was, poor little rich boy, all the success in the world, everybody accepting him. But he still didn't have any foundation.'

As his friend, the musician Johnny Gustafson, remembered: 'Brian never seemed to have any close friends like we all did. I noticed that any men we saw him with we would never see him with again.' Gustafson thought he had very little protection against the whirlpool of drugs that surrounded pop musicians. To his driver, Bryan Barrett, Epstein confided that the whole Beatles thing had got way out of control, telling him three weeks before his death: 'I feel as though I am a Svengali that has created a monster.'

Yet in counterpoint to these annihilating downs, there were moments of optimism. In tandem with Nat Weiss – whom he had appointed as his personal manager – Epstein was thinking ahead to a life beyond the Beatles, to personal appearances on lecture tours and television, and to managing other artists, like Harry Nilsson. He also planned a trip to America on 2 September to discuss, inter alia, a new Beatles film.

Indeed, Epstein was forced to rally somewhat after his father Harry's death on 17 July. He was very close to his mother Queenie and stayed

with her in Liverpool for the week-long period of mourning – sitting shiva – required by Jewish faith. He then visited her every weekend until mid-August, after which he took her down to London, where he made strenuous attempts to cut down on his drug intake and live within normal hours. She stayed with him in Chapel Street until 24 August, after which he intended to cut loose.

A snapshot of Epstein during his last couple of weeks is provided by Simon Napier-Bell, who met him through Stigwood. 'I didn't know Brian until right at the end of his life,' he told me, 'but when he walked in a room, I couldn't tell you what sort of presence he had, because you created the presence he had. To be a Beatle, or to be the Beatles' manager, was the objective of everybody in the country. Either you wanted to be a star, or you wanted to be a success in another way, meaning you wanted to be Brian Epstein.

'So when he walked into a room, you were completely enamoured, but whether he had an enamouring personality, I have no idea. He had to learn to live with that, so he probably became rather good at endlessly walking onstage. Everything he did was posed or acted, but I think that was forced on him by everyone else's attitude towards him. You can't say someone's posey when you're demanding that they pose, can you?' Nevertheless, Napier-Bell felt that Epstein 'was playing games all the time, with himself as much as anyone else'.

He insists that Epstein invited him down to Kingsley Hill that bank holiday weekend and was upset when he refused. It seems that he was wounded by the Beatles' decision to go to Bangor, North Wales – to sit at the feet of a new father figure, the Maharishi – and anguished at the thought of their partnership ebbing away. It was also clear that he wanted to enjoy himself after several weeks spent looking after his mother and needed bolstering on a long weekend that is often melancholy: the official end of the British summer.

Epstein's state of mind was also observed by the Bee Gees' singer Robin Gibb, who was visiting his future wife, Molly Hullis, at the NEMS offices on the Friday before the bank holiday weekend. He saw Epstein arrive in tears and go straight into Stigwood's office. 'He closed the door and there was a lot of shouting. When he came out, he was still crying. I said,

"What's the matter?" He said, "I can't talk," and he went straight out. Brian had pleaded with Robert to go to Sussex that weekend because he didn't want to be alone.'

On 25 August, Epstein drove down to Kingsley Hill. As well as Peter Brown and Geoffrey Ellis, he was expecting some extra company. As Ellis remembered: 'Brian had also invited a friend of his whom he wanted to get to know better but who was unable to join us, and Brian was rather disappointed.' He decided to drive back to London late on the Friday night, just before a taxi arrived from London with four men, who had presumably been ordered for sexual purposes.

Feeling slightly awkward at being left in Epstein's country house, Ellis and Brown tried to make contact with him the next day, finally getting through at around 5 p.m. Epstein sounded very groggy with pills. After apologising for his non-appearance, he said he would travel back down, but he never arrived. Nor did he call his mother that evening, as was his usual habit.

At around noon on the Sunday, his housekeeper Antonio sounded the alarm: he had tried to wake Epstein but had received no answer. A group of people including his secretary Joanne Peterson, assistant Alistair Taylor, driver Bryan Barrett and Brown's doctor John Galway broke down the door. As Taylor recalled: 'Brian was lying there as if he was asleep. And the doctor just said, "I'm sorry but he's dead." The room was looking so normal. There was a plate of chocolate digestive biscuits on the bed, some correspondence, and a half-empty bottle of bitter lemon.'

The shock was quickly replaced by the need for discretion, as Taylor and Peterson began to clean up. Taylor found 'one joint in a drawer' but no other illegal substances. Peterson remembered that some of those present delayed contacting the police in case there was anything illicit in the house. After going through the whole building and disposing of anything that might be considered compromising, they called the police. As soon as the police were informed, the press were on to it.

There was some haste to inform the Beatles. If the band had been in danger of taking Epstein for granted during the previous year or so, this shocking and sudden event brought them up short. 'We were all horrified and frightened by his death,' Paul McCartney said. 'It was a shock.

We'd gone to Bangor with the Maharishi. This was the start of that phase for us and I think Brian was going to come along at some point. He was going to join us there. I think John got particularly frightened.'

Epstein's death had immediate serious consequences. Despite their frequently expressed criticism, their manager had shielded the Beatles from all business and contractual pressures, leaving them to focus on what they did best: music. Now he was gone, they realised they knew nothing about their extremely complicated affairs. Epstein grounded them, believed in them and negotiated their demands and caprices. Without him as their buffer, they would begin arguing among themselves – the long, slow process of dissolution.

Speculation has long surrounded Epstein's death, triggered by his gay lifestyle and the immediate presence of his lawyer, David Jacobs, who arrived that Sunday afternoon and removed some papers – no doubt incriminating material such as was stolen by Dizz Gillespie the previous autumn: photos, letters, money in brown paper bags. A shadowy figure, Jacobs would be found dead at the end of 1968, hanged in the garage of his Hove home. Rumours abounded that it was a gangland hit authorised by the Kray brothers.

There was no evidence of foul play in Epstein's case. It seems most likely that his death was a simple mistake. As Paul McCartney surmised: 'I think he went back to London looking for a bit of action, I don't know. Then went back to his house after having drunk that evening, and took sleeping pills. My feeling is that he would wake up in the middle of the night – it's so easy to do – and think, "Why am I not sleeping? I haven't had my sleeping pill." Then in a drowsy state he thought he better take some more.'

'The problem with Brian was that he simply would not go to bed,' Jacobs subsequently told his friend and fellow client Godfrey Winn about that final week; 'he was dying on his feet for sleep.' An experienced journalist in the mid-1960s, well known for his columns in the *Daily Mirror* and the *Sunday Express*, Winn had met Epstein through Jacobs. They quickly fell out after a misunderstanding concerning the management of Winn's discovery, the singer Michael Haslam, which Winn was quick to attribute to Epstein's hubris.

Talking to Winn, however, Jacobs was kinder. 'I was very close to him, right from the start. I could advise him over many things, and indeed, tied up his business affairs to good advantage. In a way, I was closer to him than anyone. He really unburdened himself to me. Yet there was something in his nature that neither I nor anyone else could reach and alter. He was not so much a loner as a oncer. What do I mean by that? I mean that he was incapable of any lasting physical relationship with anyone. He was incapable of love.'

Suicide was a possibility, but those close to Epstein felt that he would never have done that to his mother, who was already grieving the death of her husband. There was also the fact that he had recently written to Nat Weiss in glowing terms about his forthcoming trip to New York, where the two of them were planning a yacht trip with 'all manner of lovely pretty mortal persons aboard'. As he concluded: 'love, flowers, bells, be happy and look forward to the future'.

The verdict in the coroner's court was accidental death by Carbrital poisoning, 'unconscious self-overdosage'. Brian Epstein had dedicated his life to the Beatles, and it killed him. As Nat Weiss concluded: 'This was not a part-time, twenty-five percent commission job. It was sacred to him. He was so sensitive that the slightest degree of failure would plunge him into depression. Because he really felt he had such a high responsibility. He may have found other outlets, but nothing equalled that emotional intensity, to give him meaning.'

Murder, suicide, drug addictions, depressions, overdoses, lives without moorings: this was grim stuff. There were individual choices and individual psychologies, but these three cultural icons – Epstein, Orton and Meek – were bound together, through their deaths, to a particular place and time: the moment when homosexuality could slowly begin to emerge from the shadows – a freedom that they had, in their different ways, helped to foster and create, but from which they would not benefit.

———

The generation that had been born in the very late 1920s to mid-'30s had all come of age in the mid-to-late '40s, when homosexuality was being redefined as the enemy within. During those years, and into the late '50s and beyond, homosexuals were demonised as the lowest of the low: traitors, monsters, outcasts, incapable of affection and companionship, doomed to a lonely life. It was hardly surprising that many gay men of that generation internalised this in a way that manifested in psychological volatility, depression and self-hatred.

For a younger generation born in the mid-to-late '40s, however, things were different. They were coming of age at a time of greater openness, if not actual enfranchisement. They had the ability to participate in a mass pop culture of extraordinary immediacy and vibrancy, in a very direct manner: whether as shop workers, as TV presenters or designers, as managers, or even as consumers of a music that spoke to them and their concerns with an unprecedented directness. They felt that they could find a place within this new world; if you could see it, you could be it.

The explosion of the Teen Age and consumerism had another appeal to those younger gay men: it suited their mindset. As Bryan Magee observed in *One in Twenty*: 'Quite a number of male homosexuals develop a sort of "Eat, drink and be merry, for tomorrow we die" attitude, a determination to live now and to the full, packing in all the pleasure they can.' Without any family ties, 'the homosexual can live more in accordance with the impulses of the moment . . . this kind of freedom has enormous attractions for many people'.

During 1966 and 1967, homosexuals and teenagers began to cross over in the West End culture of Carnaby Street and the clubs of Soho. As Peter Burton noted, the 1960s youth revolution 'affected gay youth as much as straight. We – like our straight counterparts – came from a generation that had money to spend and a look and a style that was more consciously fashioned than any that had been since the beginning of World War II. We . . . lived a lifestyle that had no connection with either our parents or with the elder statesmen on the gay scene.'

Born in the East End in spring 1945, Burton quickly found his way into London's gay world. He remembered going to the As You Like It coffee bar in Monmouth Street, where the soundtrack was 'most usually

songs by the legendary movie queens who even then had become a part of history'. Habitués included Quentin Crisp, Lindsay Kemp and Long John Baldry. 'We would all sit at our separate tables with our special cohorts – screaming and chattering like monkeys on speed, or else sedately regal, exchanging sophisticated banter and polished witticisms.'

He remembered also that, like their counterparts in America, his generation were more inclined to be provocative: 'Even when travelling in the singular, we weren't averse to shrieking a quick "Get you, girl" at some menacing naff – and then taking off at the speed of light into the rabbit warren around The Dilly. It's worth mentioning too, that many West End queens could swing a mean handbag and were perfectly capable of fighting back if attacked. We flaunted our homosexuality. We were pleased to be different.'

In 1966 or early 1967 – the date is uncertain – Burton helped to set up a different kind of gay venue. Inspired by a short-lived coffee bar called the Lounge, he teamed up with co-owner Bill Bryant to open a new club. Located in D'Arblay Street, Soho, Le Duce was conceived as a gay version of the premier mod venue, the Scene. When it opened, it was a club for dancing, fuelled by the uppers that kept you going all night. 'They gave you confidence. You felt you could talk to anyone; you could dance all night.

'We shared many things in common with the other youth group who'd sprung up around the same time: the Mods. Economically, those who frequented the Scene and Le Duce both came from the same working-class – South and East London – backgrounds. Both groups paid the same attention to clothes; both groups looked much alike. Not surprising really, as their clothes came from the same shops – initially Vince in Carnaby Street and eventually from the John Stephen shops in the same street. Both groups took the same drug, basically speed.'

Burton later described the club in an article for *Spartacus* magazine as 'pine panelled, with upholstered benches around the walls and a fish tank embedded in the central partition. It's always crowded in the club on Saturday nights, sometimes hellishly so. Steaming hot. Membership is ten shillings a year, admission five shillings on the night.' The titular hero of the piece, Johnnie, is fifteen; in this unlicensed club, he can

spend the next eight hours without having to face 'the cold reality of his life'.

The principal imperative was dancing: 'The club is famous for its juke-box, which houses a massive selection of Motown favourites, soul sounds and a mixture of old and new favourites dating back over the past five years.' In Burton's Le Duce jukebox playlist, Motown predominated: the Elgins, the Marvelettes, Martha and the Vandellas, the Supremes, along with soul – Otis Redding, Bob & Earl – and Dusty Springfield, a perennial gay favourite in the mid-1960s, mainly because of her no-holds-barred performances and melodramatic material.

'I remember going with my friend Rex Lay, who was Bette Bourne's lover at the time,' says James Gardiner, who was twenty in 1967. 'The club was up a side street in Soho, very small and full of cigarette smoke like everywhere else then. A very young crowd, and girls as well as boys. Young West End queens who worked in Carnaby Street and lived in Ilford. God knows how they got home after it closed. Drug of choice was "Blues" or "Blue Bennies" – essentially some Benzedrine-based muck which got you dancing and grinding your teeth for hours on end.

'It was dark, there was a fish tank and minimal décor, and it was not a cruisy atmosphere at all; you went there to dance and parade your mod clothes. I wore Tonik trousers and shirts from Vince, round-neck tight sweaters, often collar and tie (yes, even for clubbing). Surprisingly, a totally home-grown look, given our musical tastes, which were wall-to-wall Tamla: I loved Diana Ross, Martha and the Vandellas, Jimmy Ruffin, Four Tops, Dionne singing Bacharach. Really no rock or English artists at all, apart from Dusty doing smoochy.'

Le Duce didn't last long into 1968: Burton left after a furious dis-agreement with a new owner. But it was a watershed between the more discreet drinking clubs and a different type of venue for a new, assertive generation. Unlike his elders, Burton never remembered feeling that his homosexuality was a problem: 'I never worried about whether my homo-sexuality was "right" or "wrong" because it seemed perfectly natural to me, and by the time I had become aware of society's and the law's atti-tudes, it was too late for me to change mine.'

19

Gay Power

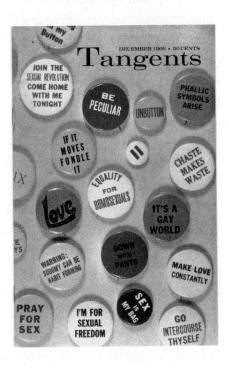

The mature homosexual wants, as much as any person, the freedom and right to develop his personhood in a reasonable and just societal situation. No person should be made to suffer the indignities of being dehumanised by a self-righteous, dictatorial society. We are on the threshold of developing a world where man's life necessities will be fulfilled and there will be leisure time to develop more fully personhood through art and life experience. This social order will demand diverse expression. We must not enter it afraid or repulsed by the different or unusual.

W. E. Beardemphl, 'Drag – Is It Drab, Despicable, Divine?',
Vector, vol. 3, no. 6, May 1967

I n the summer of 1967, the prejudices of the paranoid 1950s still held
sway in America, enforced by the government at the highest level. It was
as though, despite all the agitation and solid groundwork done by gay
and lesbian activists, nothing had changed since the darkest days of the
Cold War. But the timidity of the previous decade had gone. Stimulated
by the greater visibility of homosexuals – and a popular culture that
seemed to support the idea of difference – individuals and groups were
prepared to fight back, to stand up and be counted.

On 22 June, thirty-two-year-old Benning Wentworth, a technical
aide at Bell Telephone Labs in New Jersey, responded to a communica-
tion sent by the Department of Defense revoking his security clearance.
In a thirteen-page document, Wentworth not only denied the imputed
charges of sexual contact with an Air Force veteran, John Gaffney, but
went on to assert that, even if he had had the alleged contact, he was
perfectly comfortable with his sexuality, to the extent of being com-
pletely open.

The fact of blackmail and the threat of coerced espionage had been
behind the US government's purging of gay men from the armed
forces and companies with government contracts since the early 1950s.
Wentworth's next decision blew that wide open: he requested that his
hearing be open to both the public and the press. This exposed the
contradiction in the government's policy. If Wentworth was openly and
publicly homosexual, then he had nothing to fear. If everyone knew, how
could be blackmailed at all, let alone into spying for a hostile regime?

Wentworth was advised by Frank Kameny, an astronomer who, in
1958, had been barred from any future employment by the federal gov-
ernment after a minor homosexual offence. Finding it impossible to
reverse this decision – after fighting it all the way up to the Supreme
Court – he plunged into gay activism, co-founding the Mattachine
Society of Washington DC with Jack Nichols and organising the first-
ever homosexual rights picket of the White House in April 1965.

Nineteen sixty-seven was a very different time to 1955, when the
threat of being considered a security risk was enough to strike terror into
many homosexuals' hearts both within and without government. The
issue had rumbled on throughout the later 1950s and early '60s, without

any definitive resolution. A holdover from the height of the Cold War, it was an obvious and by now anachronistic injustice, the absurdity of which Kameny now hoped to highlight, as well as the obvious invasion of privacy pursued by the Pentagon as official policy.

Sixteen days later, on 8 July, Hal Call arrived in Minneapolis to act as an expert witness in what would prove to be a test case. He was there to support Lloyd Spinar and Conrad Germain, who were facing a twenty-nine-count indictment of producing, distributing and possessing homosexual 'obscenity'. As the leader of the San Francisco branch of the Mattachine Society, and a close personal friend, Call had offered legal and financial assistance to the beleaguered pair: it was time to stand up and be counted in public.

Spinar and Germain were partners who had formed Directory Services Inc. (DSI) in 1963. Their first major success was the directory *Vagabond*, which, first published in 1964, listed a wide range of products that would appeal to gay men. These included greeting cards, jewellery, records, clothing and fashion accessories. They also published a travel guide, *279 Places to Go for a Gay Time*, and offered a pen-pal service for gay men to contact one another in reasonable safety.

In 1965, DSI began to publish hardcore nude magazines – in particular *Butch*, the inaugural issue of which marked a watershed in gay imagery. The old artistic and athletic alibis were there in full force, but the frank acknowledgement of gay insider code in the magazine's title acted as a warning for what was to come. Buried halfway through the issue was the first full display of the male member in a commercially available American physique magazine. It was a sensation: very quickly *Butch* was selling around 50,000 copies an issue.

From there, it was short step to showing a penis on the cover, as occurred the next year, 1966, with *Butch* issue no. 5 and the first issue of another DSI title, *Rugged*. Spinar and Germain had their defence ready; as the publisher's creed in issue 1 read: 'Those concerned with freedom have the responsibility of seeing to it that each individual book or publication, whatever its contents, is given the freedom of expression granted to it by the First Amendment to the Constitution of the United States of America.'

This was the defence that Spinar and Germain were to rely on in court. As the largest gay-owned and gay-oriented business in the world, DSI was a tall poppy that the authorities could not wait to cut down. In the late spring of 1967, DSI's sales warehouse was raided by two assistant US district attorneys, postal inspectors and several US marshals. They had no warrant, but nonetheless seized all of the company's financial records, all its mailing lists and 15,000 magazines, along with promotional flyers, posters, brochures and other advertising items.

The authorities might still have been involved in persecuting gay individuals and gay businesses, but the world had moved on. There was a new generation that was prepared to fight the old battles once and for all, for greater freedoms to come, not just for homosexuals, but for everyone. As the editorial in the second issue of *Butch* observed: 'The only way in which a society can mature sexually, socially and philosophically is by allowing it naturally free and unfettered sexual, social and philosophical growth.'

———

While in the UK the national lawmaking body was on the point of decriminalising homosexual acts, in the US there seemed to be very little advancement. There were victories – the repeal of sodomy laws in Illinois, for instance – but in the main homosexuals were still persecuted by the Post Office and the full force of the law. The general view was still intolerant and the legislation matched that attitude: the penalties for sodomy in all states bar Illinois ranged from one to thirty years, with a sentence of over ten years possible in seventeen of them.

Nevertheless, there was greater media coverage of the topic. In 1966, Capitol Records released an album called *Homosexuality in the American Male* as part of a documentary series on controversial topics, such as the life of shock comedian Lenny Bruce or LSD. Assembled and voiced by the photojournalist Lawrence Schiller, the record began with various quotes from his gay interviewees: 'My need for sex is just second to my need for food'; 'I knew it was wrong, but I knew I wanted it, and I didn't care if it was wrong or not'; 'I felt guilty, ugly, dirty.'

March 1967 saw the first documentary on the topic by a national broadcaster, when CBS showed 'The Homosexuals' in their *CBS Reports* slot. The hour-long show had been three years in the making, and the compromises were obvious in the finished version. Voiced and hosted by Mike Wallace, the tone was titillating and unsympathetic: 'Most Americans are repelled by the mere notion of homosexuality. The CBS News survey shows that two out of three Americans look upon homosexuals with disgust, discomfort or fear. One out of ten says hatred.'

The voiceover repeated all the old saws. There were millions of homosexual men living undetected among the population, a growing and still ill-reckoned menace. They were promiscuous, unstable, neurotic and lived in a way that was completely antithetical to American values. Testimony from actual homosexuals – some self-accepting, if not upbeat, others anguished – was nullified by the punitive opinions of experts like the notoriously anti-homosexual doctors Irving Bieber and Charles W. Socarides.

Clearly, the programme was not designed to show homosexuals in the best light. One particularly dramatic sequence showed a young man being arrested for committing a 'lewd act' in a public toilet: 'This will ruin my life!' he shouted, as the police dragged him away. Nevertheless, the programme did show the fightback: Hal Call advocating a legal solution based on the British model of consenting adults; Frank Kameny leading a May 1965 picket of the White House, with soberly dressed men and women bearing placards like 'Homosexuals Have Human Rights Too'.

'The Homosexuals' received a mixed reception. The subject matter was deemed so controversial that no company would advertise in the breaks. Press reactions ranged from praise to vituperation. The gay press was equally sceptical: *Vector*, the slick new magazine published in San Francisco by the Society for Individual Rights, faulted the programme for failing to portray gay people as 'anything other than sick, wounded animals at best, or dangerous psychotics at worst', while *The Ladder* refused to say anything until 'they will do a report on Lesbians'.

On the surface, it seemed as though not much had changed in the struggle for homosexual rights. Unlike the UK, where the Homosexual Law Reform Society had focused on changing the law through targeted

lobbying of Parliament, gay activists in the US had failed to make connections with lawmakers and politicians, concentrating instead on small, grassroots groups. They were much closer to the people whom they were attempting to represent, but further away from the sources of power.

It had been a long, lonely road for the founders of the 1950s activist groups and, by the mid-'60s, they were all beginning to show signs of weariness. Events came to a head in August 1966, when a conference titled 'Ten Days in August' was hosted in San Francisco by the Daughters of Bilitis. This was, according to *ONE*'s Dorr Legg, the 'most ambitious homophile gathering ever attempted in the United States', with attendees including Frank Kameny, as well as representatives from Mattachine Florida and the Daughters of Bilitis.

So far, so good, but underneath the surface there were tensions between the old and the new guard, between gay men and lesbians, the latter of whom were still under-represented in the sessions and beginning to turn instead to the resurgent women's movement. It was clear by this time that the original 'big three' players – the men who ran *Mattachine Review* and *ONE*, and the Daughters of Bilitis – could no longer work together: the original Mattachine had split into several groups, while *ONE* was reduced to publishing reprints from its late-1950s glory days.

No one embodied the burnout of the first wave more than Hal Call. A Mattachine member since the early 1950s, he had turned away from activism. 'I was tired of holding endless meetings where all you did was talk and nothing happened and there were no resources to even buy postage stamps afterward, and nobody inclined to write it down and make a newsletter out of it. So we pushed the idea of commercialising the gay scene.' In March 1967, he opened the first adult gay outlet in San Francisco: the Adonis Bookstore.

A new generation of activists rushed in to fill the vacuum left by the exhaustion of the 1950s homophiles. The presence of William Beardemphl, of the Society for Individual Rights, and the publisher Clark Polak at the August 1966 conference, as well as the favourable mentions made during the sessions about a new San Franciscan group, Vanguard, offered evidence that there were new approaches to the agitation for

homosexual rights – ones that were more community-based and street-aware, as well as pleasure-oriented.

Outraged by the police policy in gay bars – which strictly prohibited any close physical contact – and aware that gay social life was centred on these venues, Beardemphl set up the Society for Individual Rights (SIR) in San Francisco as an alternative way for men to meet. SIR instituted a social programme that included Friday-night meetings and Sunday brunches, Saturday-night record hops and live bands. It also began to publish the monthly magazine *Vector*, which by 1967 was more in tune with the times than *ONE* or the *Mattachine Review*.

Beginning with meetings in Glide United Methodist Church, a parish in San Francisco's Tenderloin, a district of poor elderly people, hustlers, transsexuals, teenage runaways – the apparent flotsam of the inner city – SIR took on the lease of the second floor of an old Union Hall building near Market Street, in the heart of the district. This 5,500-square-foot complex was the first gay community centre in America. Within weeks, their Saturday-night dances were pulling in hundreds of men.

In July 1966, another group was set up in the Tenderloin by Glide. Realising the depth of the social problem right under its nose, the church consulted the youths of the Tenderloin about their troubles and needs, and set up the Vanguard group in collaboration with hustlers, runaways and street kids. Published in July, the group's first handbill protested against 'the police harassment of youth . . . being called "Queer" and being placed in the position of being outlaws and parasites when we are offered no alternative to this existence in our society'.

It was estimated that there were around a thousand young men and women between the ages of twelve and twenty-five working in the Tenderloin as 'prostitutes, pimps, jack rollers and pill pushers'. Some of these were runaways just trying to survive; others had been hardened by a life of loneliness, danger and constant police harassment. As one of them, Vanguard's president Jean-Paul Marat, told the *Berkeley Barb*: 'When I first got to town I was stopped by the police seventeen times in three days. The last time I got a dislocated jaw. That sort of thing happens all the time.'

Encouraged and sheltered by the ministers at Glide, the members of Vanguard held weekly dances in the church's basement, distributed free

food and clothing to their peers and produced a magazine, also called *Vanguard*. The first issue, published in August 1966, featured an editorial by Marat, who, in his *Berkeley Barb* photo portrait, resembled those mod Chicago youths on the May 1966 *Look* cover that highlighted Carnaby Street fashions, with his Beatles cap, mod jacket with epaulettes and Brian Jones bob.

Vanguard #1 featured poetry, instructions on what to do if arrested and a powerful editorial by Mark Forrester, 'Central City: Profile of Despair', which placed the denizens of the Tenderloin in the context of an all-out critique of American society: 'In the least, all the wino destroys is himself, while the businessman, through the philosophy and methods he employs, taints an entire generation of young people with a slavish mendacity to the lowest denominator of public opinion.'

In the same month this issue of *Vanguard* was published, sometime in August rhetoric turned into direct action. Although the exact date is unknown, the facts of the matter are that, irritated by heavy-handed and intrusive policing inside an establishment that they felt to be a safe haven, Compton's Cafeteria, about fifty or sixty young gay men and drag queens erupted in fury. Triggered when a young transvestite threw coffee over an aggressive cop, they went on the rampage.

Tensions had been building up for a while. According to the historian Susan Stryker, Compton's popularity among young gay men, hustlers and drag queens came from its status as an all-night venue and the fact that, for a long while, the evening manager was 'an older effeminate homosexual' who created a sympathetic atmosphere for the community. When he died, the management introduced a twenty-five-cents cover change and hired Pinkerton security guards to harass the clientele. On 18 July, members of Vanguard picketed the venue in protest.

On that night in August, it exploded. As Guy Strait related in the gay news sheet *Cruise News*: 'Cups, saucers and trays began flying around the place and all directed at the police. They retreated outside until reinforcements arrived, and the Compton's management ordered the doors closed. With that, the Gays began breaking every window in the place, and as they ran outside to escape the breaking glass, the police tried to grab

them and throw them in the paddy wagon. They found this no easy task, for Gays began hitting them "below the belt".'

After the Compton's riot that August, Vanguard organised a 'clean sweep' by hair fairies* in Market Street, with a press release that reinforced the way in which they saw their struggle in terms of current events: 'The VANGUARD demonstration indicates the willingness of society's outcasts to work openly for an improvement in their own social-economic power. WE HAVE HEARD TOO MUCH ABOUT "WHITE POWER" AND "BLACK POWER" SO GET READY TO HEAR ABOUT "STREET POWER".'

The fightback against prejudice and harassment was started by those who had nothing to lose. The Compton's riot did not achieve much on the ground – the cafeteria refused to let drag queens back in, and the police continued to arrest hustlers en masse – but it showed that violence was necessary to make the point to those who would not hear, to make a show of strength and self-worth, when that was exactly what the city, its businesses and its police, was trying to prevent.

It was just one of several actions that occurred spontaneously during 1966 and 1967. The biggest of these occurred in February 1967, when, triggered by a heavy-handed police raid on a Los Angeles gay bar called the Black Cat, hundreds of gay men gathered in protest. As Jim Highland reported in the July 1967 issue of *Tangents*: '400 demonstrators carrying placards protested outside the Black Cat against police brutality. While startled officers looked on, ministers, attorneys and officers of homosexual organizations spoke through loudspeakers.'

The raid had occurred on New Year's Eve, when the bar was full of punters who had just moved over from another venue in the Silverlake area. The New Faces had been holding a costume contest, and fifteen or twenty men in women's clothing had walked the thirty yards up the street to the Black Cat. 'After 11:30 many of the newcomers were in drag,' Highland wrote. 'Impersonating a woman is no longer illegal in Los Angeles. But it is far from safe and cross-dressers know it.'

* Effeminate young men, typified in the mid-1960s by piled-up, teased hair, capri pants, slingbacks and fluffy mohair sweaters.

Just after midnight, plain-clothes police officers, who had been drink-
ing as customers earlier in the evening, re-entered the bar and secured the
premises with force. Among the many incidents of violence, one observer
noted that 'a man in woman's clothes clutched for the front door. The
butt-end of a pool cue felled him, one ear split and bleeding. A bartender
was seized by the shoulders, dragged bodily across the bar amid splinter-
ing glass and hustled outside where uniformed police waited.'

The bar owner was hit by a gun, and 'she fell heavily. A waiter at the
back of the room saw the trouble and ran forward to help his employer.
A small man, five-feet-six, 150 pounds, he didn't get to help. More
officers had arrived. They dragged him out onto the sidewalk and beat
him. Savagely. So savagely that after being booked on a felony charge
of assaulting a police officer, he was taken from the Police Building to
Los Angeles County General Hospital where he underwent surgery to
remove a ruptured spleen.'

For gay men, life in Los Angeles was akin to living in a police state. In
a 1964 *Life* magazine article entitled 'Homosexuality in America', staff
writer Paul Welch had observed that there was a 'running battle between
police and homosexuals'. Because of this heavy-handed policing, 'a
mini-revolt was already occurring on the streets'. The quoted opinion of
an LAPD inspector was unequivocal: 'The pervert is no longer as secret-
ive as he was. He's aggressive, and his aggressiveness is getting worse.'

The raid on the Black Cat resulted in fourteen arrests and a swift back-
lash. The February 1967 protest was organised by a new group called
PRIDE, an acronym for Personal Rights in Defense and Education; this
might well have been the first use of the word in terms of gay politics.
Although six of the men arrested on 1 January were convicted on lesser
charges, it marked a transformative moment for gay people in the city.

———

'A secret world grows open and bolder,' *Life* had proclaimed in
1964, and street activism was just one element in this new assert-
iveness. This was most effectively broadcast through the massive
expansion of gay consumer culture, in particular physique magazines,

which, by mid-decade, were far outselling the homophile movement magazines: in 1965, one title, *Tomorrow's Man*, had a circulation of 100,000 copies – at least twenty times that of *ONE* – while the estimated monthly sales of all physique titles stood at around 750,000.

By default, the physique magazines were a central focus of gay life in the 1950s and early '60s. In his definitive account of the topic, *Hard to Imagine*, Thomas Waugh called them the 'most significant gay cultural achievement during the formative quarter century after World War II'. This freighted them with an unbidden significance, a fact which many publishers chose to ignore, but one that others, like Directory Services Inc., decided to accommodate in their increasingly frank products.

After Herman Womack's victory in the 1962 *MANual* v. *Day* ruling, which effectively curbed the US Post Office's appetite for the censorship of mail-order gay material, the physique magazines got bolder and bolder. The old artistic or bodybuilding justifications for nudity or near-nudity were jettisoned as more identifiably gay models replaced the idealised bodybuilders of yore in magazines like MANual's *Trim* and *Vim* or the Weider brothers' *Adonis*, *Body Beautiful* and *Young Physique*.

By the mid-1960s, there was a feedback loop between the previously hidden gay lifestyle, its subsequent exposure in magazines and/or books and the behaviour and lifestyle then taken up by the gay consumers of these products. By 1965, the physique magazine *Fizeek Art Quarterly* was soliciting contributions from readers and printing them. The drawings sent in displayed a new – white – gay ideal, with Beatles hair, smart mod clothes and a snub nose, as well as collaging gay erotica into their own fantasies.

Underground catalogues displayed an extraordinary range and specificity of erotic and casual wear. In the mid-decade, the Regency Square Christmas catalogue offered a range of styles – hip-huggers, hombre shirts, vaquero cardigans, terry-towel robes and sensational stretch denim – in almost dizzying profusion. The Cloak and Dagger catalogue, from San Francisco, was slanted towards leather, with many G-strings and 'supporters' that enhanced the genital area, along with trousers, jackets and chaps.

The stratification of the erotic object into various formalised types was a sign of confidence and increased visibility, yet of less individuality

Reader's drawing, *Fizeek Art Quarterly*
magazine, number 13, 1965

too. The money that poured into the gay market also found an outlet in
what are now known as gay pulps, which started to explode in number
after 1966. These were cheap paperbacks, usually original novels, but on
occasion reprints or other gay-relevant titles like *Gay Geniuses* ('Famous
Homosexuals: and what made them that way!'), packaged in sensation-
alist covers.

In their history of the genre, Drewey Wayne Gunn and Jaime
Harker estimate that the number of gay pulps published from 1965
onwards jumped tenfold compared to the first half of the decade.
There was a gap in the market: a readily accessible gay readership,
serviced by specialised catalogues, magazines and even bookstores,

that was not being catered to by conventional publishers. The gay pulps rushed in, with material that ranged from camp to erotic and all points in between. They were, nevertheless, highly indicative of the gay zeitgeist in those years.

These paperbacks mixed titillation with a smattering of consciousness-raising. Many were published out of California: PEC from San Diego; Challenge and Viceroy from the same address in North Hollywood. In 1966, you could choose from new titles such as *America's Homosexual Underground* ('An ace reporter covers a world of vice and intrigue') or the hysterical *I, Homosexual* ('The Homosexual Reveals Himself in All of the Stark Nakedness of his Inner Torments, Revelations, and Orgiastic Revelries'). There were porn novels, published with lurid, often crude covers: *The Dungaree Jungle, The Lavender Elves* ('he loved in the never-never world of . . .'), *Gay Three-Way, The Gay Trap, A Chosen World* ('. . . a soul-searching revelation of a youth enslaved into a twilight world of homosexuality from which he couldn't escape'). Some of these approached the status of high art, like Don Holliday's 1966 spy spoof *The Man from C.A.M.P.*, with its Paul O'Grady lookalike cover star and the subtitle 'Yoo Hoo! Lover Boy!'

Holliday's novel began with a serious prologue from Alex Comfort's groundbreaking 1963 book *Sex in Society*: 'Unorthodox sexual behaviour may itself acquire the tone of a general protest against "things as they are".' This was the same mix of principle and exploitation that could be found in the first issue of *Butch*, published in 1965: '*BUTCH* hopes to do its part to bring about a world wherein man will, from the moment of birth, accept himself – not with guilt and shame; but with esteem and serenity – in his totality as God made him.'

This mixture of erotica, information and consciousness-raising was perfected by a new magazine. *Drum*, launched in October 1964 by Clark Polak, quickly became the most popular homophile publication in the country, with a circulation of 10,000 by 1966. By that September, the magazine was offering news, comment, male nudity and classified ads. There was also the first gay comic strip, *Harry Chess: That Man from A.U.N.T.I.E.* The contrast with the staid, text-heavy design of *ONE* and the *Mattachine Review* couldn't have been greater.

Polak was a controversial figure. Inspired by Donald Webster Cory's *The Homosexual in America*, he became involved with homophile politics in the early 1960s. His conception of *Drum* was as a 'gay *Playboy*'. 'I wanted to put the sex back into homosexuality,' he told historian John D'Emilio. 'I always felt it was important to affirm the sexual aspect. Homosexuals have sex! I didn't want to deny this.' But this drew adverse reactions from many activists: it was inconsistent with the accepted idea of the way that the movement should present itself.

The early-1967 issue of *Drum* featured a four-page advert for the Trojan Book Service, which offered a dazzling variety of gay-oriented books and magazines: Magee's *One in Twenty*, *The Boys of Boise*, Gore Vidal's *The City and the Pillar*, Lillian Hellman's *The Children's Hour*, Gillian Freeman's *The Leather Boys* and a whole host of pulp paperbacks, including *The Lavender Elves* and *The Man from C.A.M.P.* Also featured were issues 5, 6 and 7 of *Butch*, 'the most famous of the male nudist magazines featuring big and popular models'.

This fecundity worked both ways. As the secret gay world became bolder, more open, street agitation coincided with the soft power of cultural influence. As Mike Wallace had stated in his voiceover for 'The Homosexuals': 'Homosexuals are discriminated against in almost all fields of employment in all parts of the country. But in the world of the creative arts they receive equal treatment. Indeed, some would say better treatment. There is even talk about a "homosexual mafia" in the arts, dominating various fields: theatre, music, dance, fashion.'*

* The CBS documentary concluded with a bad-tempered dialogue between Albert Goldman and the author Gore Vidal, who was contemptuous of the arguments against homosexuality presented by the weaselly academic. In response to Goldman's charge that there was a homosexual mafia, Vidal replied: 'Well, like most legends, I suppose, there may be some basis for it. I don't know how it would begin. The artist is an artist first, and he's a homosexual or a heterosexual second . . . I have never seen any sign in any of the arts of there being a "homintern", as alarmed editorialists like to write.'

The intellectuals and the mainstream media started to take greater notice. The groundbreaking document in this process was Susan Sontag's essay 'Notes on "Camp"', which, published in 1964, gave a name to an aesthetic that was, if one cared to look, ubiquitous yet completely ignored. Like pop, it was the future. Like pop, as Andy Warhol had observed on his cross-country trip in 1963, it was omnipresent – so much so that it wasn't even an aesthetic any more. It was an environment, a climate, one with profound implications.

In fifty-eight paragraphs, Sontag conducted an intuitive yet rigorous examination of a phenomenon that she defined as 'a badge of identity . . . among small urban cliques'. And yet this 'private code' was worthy of naming and mapping because it constituted a new mode of perception that upended traditional notions of high and low culture, of the elite and the mass. It was 'one way of seeing the world as an aesthetic phenomenon', she wrote, '. . . in terms of the degree of artifice, of stylisation'.

Her early paragraphs outlined the by now clichéd 'so bad it's good' aesthetic; in 1964, that included Aubrey Beardsley's artworks, the 1933 film version of *King Kong*, Tiffany lamps et al. While time-locked, her detailed mapping remains useful in showing how déclassé objects and people have become part of the canon during the half-century since her treatise was published. Sontag predicted this, of course: 'The canon of Camp can change. Time has a great deal to do with it. Time may enhance what seems simply dogged or lacking in fantasy now because we are too close to it.'

She noted the affinity of camp with particular activities and professions: interior decor, clothing, classical ballet, opera, all of which involved a high degree of artifice. In particular, the idea of the epicene and the artificial marked the camp aesthetic; nothing natural, clumsy or butch (although, of course, that became another camp mode). Even more important was the idea of 'Too Much': 'The hallmark of Camp is the spirit of extravagance. Camp is a woman walking around in a dress made of three million feathers.'

Sontag teased out a certain innocence in the midst of camp's mockery

and inversion of meaning, as well as a certain mode of seduction. Camp is not always meant to repel, but to draw in, and it works. Sontag began her piece by being slightly irritated, and ended up having fun: 'Camp taste identifies with what it is enjoying. Camp is a tender feeling.' Despite being published in a small, frankly intellectual magazine, *Partisan Review*, her essay did that rare thing: it had an impact upon the culture by both defining and facilitating a major perceptual shift.

It's easy to forget its age when reading 'Notes on "Camp"', but Sontag's essay can't help but betray its time of writing. The most obvious example is her unwillingness to discuss the way in which camp was, and to some extent remains, a predominantly homosexual code. She delayed this discussion until near the end of the essay, where she admitted that homosexuals 'constitute themselves as aristocrats of taste'; it is they who 'constitute the vanguard – and the most articulate audience – of Camp'.

In 1965, another feminist intellectual, Gloria Steinem, widened the debate with a long, splashy article in *Life* magazine titled 'The Ins and Outs of Popular Culture'. Wide-ranging and heavily illustrated, her piece served to popularise and develop Sontag's idea that popular music and some of the mainstream media had been 'annexed' into the canon of camp. Like Sontag, Steinem observed both the breaking down of boundaries between high and low art and the primacy of camp in the new, democratised pop aesthetic.

'Camp itself – though not technically a source – can be a kind of early warning system for Pop,' she concluded, before adding 'A Vest-Pocket Guide to CAMP': 'A thing is Camp when its form is more important than its content. Old things often become Camp because their form has outlived whatever content there was in the first place. A thing may be Conscious Camp or Unconscious Camp. CC: James Bond movies, Noël Coward. UC: blundering sincerity.'

Steinem observed that 'homosexuals, who always have a vested interest in knocking down bourgeois standards, are in the vanguard of Camp, though no longer its sole custodians. In fact the word Camp was 20s slang for homosexuals both here and in England and was evolved by homosexuals to its current meaning of exaggerated style. It came into common usage via the decorative arts in much the same way

that Negro slang did through jazz, or that Yiddish words did through show business.'

By the mid-1960s, 'camp' was a word very much in currency. In 1909, the *Oxford English Dictionary* had given it an early print citation as meaning 'ostentatious, exaggerated, affected, theatrical. So as a noun, "camp" behaviour, mannerisms, et cetera.; a man exhibiting such behaviour.' The word became common parlance in gay circles during the 1920s: as historian George Chauncey writes, 'Camp was a style of interaction and display that used irony, incongruity, theatricality and humour to highlight the artificiality of social convention.'

The first post-Second World War use of the word in print, marginally mentioned in the Sontag essay, may well be in Christopher Isherwood's 1954 novel *The World in the Evening*, where he comments: 'You can't camp about something you don't take seriously. You're not making fun of it; you're making fun out of it. You're expressing what's basically serious to you in terms of fun and artifice and elegance.' Ten years on, as Sontag and Steinem observed, the term was spreading like wildfire through gay and mainstream culture.

Later in 1964, most likely stimulated by the Sontag article, a label called Camp Records produced ten singles and two albums aimed directly at the gay market. Promoted in homophile publications like *ONE* and the magazines published by DSI, they offered a number of ready-made gay scenarios and stereotypes: the butch and *femme* duality of the single 'I'd Rather Fight Than Swish' – backed with 'I'd Rather Swish Than Fight' – as well as 'Leather Jacket Lovers', 'Rough Trade' and 'Stanley the Manly Transvestite'.

Despite intensive research, the performers and producers remain anonymous.* All ten 45s were released with eye-catching covers – a couple using the same, tightly dressed model. As well as these records, there were publications like *The Man from C.A.M.P.* and *The Gay BC Book, A Camp* by Allen Dennis, which ran through the alphabet as seen through various gay scenarios and types. Its definition of camp was 'something or someone (a) terribly witty or (b) outrageously funny. If you think this book is not camp, you're not, either.'

* See the discography at JD Doyle's Queer Music Heritage: https://queermusicheritage.com/camp.html.

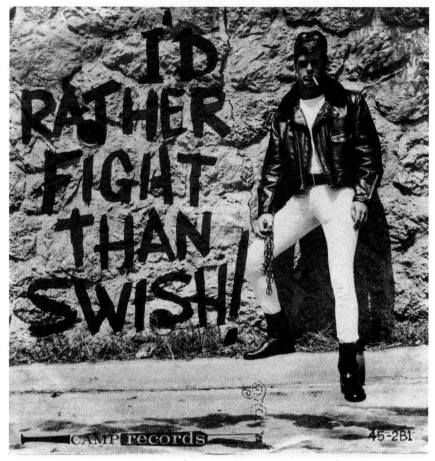

B. Bubba, 'I'd Rather Fight Than Swish', Camp Records,
November 1964

There was a core of steel behind this apparent frothiness. In typifying the camp sensibility as 'disengaged, depoliticized', Sontag failed to comprehend how camp was used by gay men at the time as both protection and as provocation. Camp was political because it made the then despised gay subculture visible, and its inversion of society's values (much like you might read about in Genet or Wilde) was a weapon: in cities all over America, young gay men would go out 'wrecking', flaunting their difference and their femininity in society's face.

In her memoir *Man Enough to Be a Woman*, the Southern boy and future singer Jayne County remembered 1964 as the year that she 'finally

graduated high school . . . and caused a minor sensation at the gradu-
ation ceremony by walking down the aisle of the school hall wearing
Beatle bangs and pale pink Mary Quant lipstick'. Soon after, she 'made
my first contact with queens. I saw these two creatures with long hair and
make-up just walking along the street screaming. And I knew that I had
found what I was looking for.

'I knew there were other people out there like me because I'd read
about them in books . . . I'd got my hands on a copy of John Rechy's
novel *City of Night*, and it changed my whole life. There was a whole gay
subculture in Atlanta, and I dived right into it. Within the year I had
turned into what was known as a Screaming Queen: wearing make-up,
walking down the street screaming at people, screaming at boys, hav-
ing to run from them. That's what screaming queens would do: go out
wrecking people's nerves.'

That there was an edge to a younger generation's behaviour was hardly
surprising. The legal and social status of gay men had hardly changed in
the last twenty years, and there was a sense of impatience and confidence
brought about by access to an inclusive mass popular culture. As County
remembered: 'I'd become a really big fan of the British bands, which was
regarded as a bit way-out, a bit weird. Music brought out my adventur-
ous side, and you have to understand that in the South the Beatles were
regarded as being very, very far out.

'I went to see the Beatles when they played at the Atlanta Football
Stadium. They were like four little specks on a tiny stage with tiny amps
and you could barely hear them because everyone was screaming so loud,
including me. Being a British invasion fan wasn't just about the music. It
was about the way you dressed, the whole attitude. It made kids realise
that you could be different. In the South, it was a big deal especially to
have long hair. Being a Beatles fanatic was an open statement to people,
telling your elders to fuck off, basically.'

By late 1966, pop styles – late pop art and early hippie – were feeding
back into the gay underground. The December 1966 issue of *Tangents*,
a sober news magazine, had a cover that showed a dozen or so badges in
bright colours, with statements like 'Warning: Sodomy Can Be Habit
Forming', 'I'm for Sexual Freedom', 'It's a Gay World', 'Equality for

Homosexuals'. The editorial inside stated that these badges 'sell largely to young people and they sell by the millions. They are one manifestation of rebellion by today's youth against the imperfect world of their parents. The buttons we have pictured indicate a change in attitude toward Western sexual hypocrisy on the part of a whole generation. The old prejudices and laws against homosexuality . . . reveal themselves for what they are – cruel and laughable. And it seems to us that a society formed of men and women who, when they were in high school and college, wore buttons like those on our cover, or insisted upon the right of those who wanted to, to wear them – those men and women are going to make up an America a whole lot less harrowing for homosexuals to live in.'

Jayne County remembered that 'there was a lot of crossover between the gay world and the hippie world, and so I just naturally started to drift over towards the hippies, largely because of the music I was into. A lot of the hippies thought drag queens were cool.' Situated in San Francisco, hippie ground zero in early 1967, *Vanguard* and *Vector* were well placed to observe this crossover. Issue 8 of *Vanguard* ran 'an interview with a transexual' ('I was born this way'), along with a hustler case history, an article about bisexuality and a contributor picture of a young man with a plaid tie, a mod jacket with badge, sunglasses, full Mick Jagger lips and long hair over his ears and collar.

Vector was also covering events on its doorstep. In May, William Beardemphl wrote that 'we are in the middle of a social revolution. One of our liberal politicians, Assemblyman Burton, has called the hippy movement "destructive". I agree. But, "the times they ARE a-changin'" and perhaps what is being destroyed MUST be destroyed – the sex role identification of dress is ridiculous and deserves destruction. The "hippies", in this instance, show maturity and logic in dispensing with this inhibiting social claptrap.'

Nevertheless, in the time lag between institutional logic and events on the ground, the harassment of gay businesses and prominent gay figures continued. In March 1967, Clark Polak was arrested when his home was raided by the police and over 75,000 gay books, photos and magazines were seized. Polak was indicted by a grand jury; however, a judge threw out

the case because one of the warrants was filled out incorrectly. Henceforth, *Drum* would be published intermittently, until its demise in January 1969.

On 26 July, Judge Larson handed down his ruling in *United States v. Spinar and Germain*: he acquitted the defendants on all counts, in a landmark decision that provided a ringing defence of the rights of 'sexual minorities' to have their freedom of speech constitutionally protected. It was the beginning of the end for obscenity charges being used to shut down gay magazines, whether physique or political.

New times needed a new language, and during summer 1967, the team at *Vector* started to develop a powerful slogan. The July issue contained an article by Cindy Claire Lewis, in which she wrote: 'At a recent S.I.R. meeting, the young but very vocal Pat Hallinan suggested that if all fails for us as a minority group, we can always invoke our secret weapon, GAY POWER, upon the economic world.' As the column advised: 'When you visit our friends and advertisers, tell 'em you saw it in *Vector* – that's GAY POWER!'

Hallinan was a gay and civil rights activist who had participated in the summer 1963 voter registration drive in Mississippi. His idea was to adapt Stokely Carmichael's slogan of 'Black Power' in reference to Black economic self-determination by using the formulation 'Gay Power' to achieve homosexual autonomy: in this case, parlaying the consumer power of homosexuals into political and social power by reminding advertisers of the largely untapped market that existed under their noses.

It was the first time the phrase had been formulated, and it was quickly taken up by the new gay magazine, *The Advocate*, formed by PRIDE in Los Angeles that autumn. In a piece headlined 'Gay Power —— $$$', one 'P. Nutz' proclaimed that as 'Black power recently hit the American scene with great impact, filling the TV tube with a refreshing moment-out from The Intercontinental Ballistic Nun and such other thought-provoking programs of the day, I now present a similar concept for your careful cogitation . . . GAY POWER.' Running with Hallinan's idea, the pseudonymous writer observed that it was possible, in a big city like Los Angeles, to lead a totally gay life: living completely within a self-sustaining and self-supporting gay community, choosing

to spend money only in gay-owned businesses. The idea was to use the 'socio-economic force' attained by some urban homosexuals to gain some measure of autonomy and self-respect. 'As more homosexuals move up or down into positions of prestige and authority, the heterosexual is forced to accept him as a real bargaining power.'

Despite the appropriation of Black America's sloganeering, people of colour were rarely visible in the gay media of the time, except in physique or soft-porn magazines. They didn't feature much in the wider media either. There was the occasional sight of a lesbian, like the male impersonator Stormé DeLarverie, who was interviewed in *Jet* magazine in 1961 and pictured in the Black-oriented publication in May 1966, as part of the Jewel Box Revue: 'Actually, the "females" are men,' ran the caption, 'and Stormé is a woman.'

In 1967, the radical film-maker Shirley Clarke filmed a dizzying monologue by a gay African American hustler, Jason Holliday, which, over an hour and a half, left no stone unturned. Holliday turned it on for the camera – doing impressions of Mae West and Katharine Hepburn – but, just like in Warhol's Screen Tests, the focus of the lens forced some reality to emerge. He talked about being a hustler – 'They think you're just a dumb, stupid little colored boy' – and his fundamental unhappiness: 'I guess I never really had any fun at all. Do you know how much that hurts? It only hurts when you think of it. And if you're real, you think of it a long, long time.'

The pace of change was glacial in mid-1960s America. If the world outside and the wider culture weren't going to give gay men and lesbians what they wanted – respect, autonomy, freedom to live life how they wanted – then they would take it for themselves. Schooled not in mid-1950s repression, but in the civil rights movement and '60s pop culture, a younger generation, born during or just after the end of the Second World War, were beginning to flex their muscles. A new age of militancy beckoned.

Their ultimate goal was power: the power to transcend the old definitions of homosexuals as pitied and feared outcasts; the power not to be harassed by the police or the judiciary; the power to be fully accepted as

first-class citizens of the country in which they lived. This was not just economic power but pride: self-acceptance resulting in an affirmation that would transcend the alienation and timidity that had kept homosexuals in the shadows for so long. And so, with difficulty and by degrees, were the old demons banished.

Andy Warhol and the Velvet Underground

It doesn't shatter your eardrums, but that's about all I can say about this far-out group. They're trying to sound like a music box, and it doesn't quite come off. Nico is a gorgeous girl; too bad she hasn't got a voice to match, because the group and the records are a big drag.

Discs a la DEBBI, review of the Velvet Underground's 'Sunday Morning', *Go* magazine, 20 January 1967

I n 1967, Andy Warhol was the most famous homosexual in America. His practice was in flux during this period, as he moved from industrialised art to happenings, pop music and underground films, but, five years into his fame, his celebrity had transcended his art. He didn't make major statements about being gay, but it was encoded deep into his appearance, his media persona and the films that emanated from the Factory. It was implicitly understood by the wider culture, and made him a lightning rod for people's hopes, fears and resentments.

On 22 June, Warhol was supposed to show up in Chicago with cast members Nico and Ingrid Superstar for a screening of his film *Chelsea Girls* at an adults-only cinema called the Town Underground Theater. The film critic Roger Ebert was there, waiting, but Warhol never arrived. The next day, Ebert published 'an interview' with Warhol in which the pop artist and underground film-maker went deliberately vague: 'It's a funny thing. It's like I keep forgetting to come to Chicago.

'I have all of these things to do,' Warhol told Ebert on the phone. 'I'm making this full-length feature called "Since" which is going to be 25 hours long. So you can see there's a lot of work involved in it, and I really wanted to get it finished this weekend.' Warhol was reminded that he also failed to show up in Chicago the previous September for the opening of his Exploding Plastic Inevitable. '"Yeah, I guess I did at that," he said. "We had just come back from California and everything was . . ." His voice drifted off.'

Infuriated by this studied off-handedness, Ebert gave the film a stinging review in the *Chicago Sun-Times* three days later. Giving it one star out of five, he criticised it as '3½ hours of split-screen improvisation poorly photographed, hardly edited at all, employing perversion and sensation like chilli sauce to disguise the aroma of the meal. Warhol has nothing to say and no technique to say it with. He simply wants to make movies, and he does: hours and hours of them.'

It's hard to avoid the thought that Warhol would have been pleased by this hostility. He liked bad reviews because he thought they were perhaps even more honest and interesting than good ones, and because they covered similar amounts of column space. To him, still, all press was good press. He was used to people thinking the worst of him and,

indeed, delighted in turning this negativity back on itself. It was almost as though, to adapt the lyrics of one of his favourite Velvet Underground songs, he acted as a mirror.

At the height of his 1960s fame, he fostered this by working hard to disclaim all meaning. 'If you want to know all about Andy Warhol,' he told interviewer Gretchen Berg in spring 1966, 'just look at the surface of my paintings and films and me, and there I am. There's nothing behind it.' In the *Index (Book)*, published in 1967, there was an uncredited interview, entitled 'Yes and No', in which Warhol proved himself to be a master of nullity:

> 'Do you think Pop art is . . .'
> 'No.'
> 'What?'
> 'No.'
> 'Do you think Pop art is . . .'
> 'No . . . No I don't.'

If, in 1966, Warhol had become the most famous artist in America, in 1967 he became reviled and feared – as a corrupter of youth, a media creation and a hostile provocateur – but also internationally known and respected as a catalyst, an impresario, an artist. Taking his lead from Marcel Duchamp, he was, as his factotum and friend Billy Name remembered, 'master of the art trick, turning the mirror on you'. Deliberately presenting a blank facade, he was the recipient of projections both favourable and hostile.

Name saw the transition in Warhol's life and the gay world that he popularised. Having met Warhol at Serendipity – the artist's favourite hang-out – in 1959, where he was a waiter, he then worked as a lighting designer, with a sideline in 'trimming hair'. Reintroduced by their mutual friend, the artist Ray Johnson, Warhol invited Billy Name – or, as he was until 1966, Billy Linich – to oversee the decoration of his new loft space at East 47th Street, using a silver theme, achieved with a speed freak's aesthetic: tin foil, silver paint and cracked mirrors.

The new loft was the symbol, if not the arena, of Warhol's breakthrough. After becoming the leading painter of pop art in late 1962,

he moved faster than anyone else, transcending any previous definition about the nature of the artist in America. By 1965, the Silver Factory had become a social magnet, and Warhol a producer of images on an industrial scale. With its reflecting surfaces, the Silver Factory was the perfect match of artist and atelier. As Name told me: 'Andy used to say he was transparent – "You can see right through me."'

Nevertheless, behind Warhol's impenetrable facade lurked an outsider's rage. As a working-class gay man from deep in the Rust Belt, he had an incredible drive to assimilate – to crash the glamour world of metropolitan society, inherited wealth and artistic fame. Suffering serial humiliations and setbacks, he played the game until the point in the mid-1960s when he achieved artistic autonomy and some degree of social acceptance; being very publicly associated with the troubled heiress Edie Sedgwick helped to open doors that were previously closed. Then, for a brief period, he rewrote the rules. His underlying fury came out.

From 1965 onwards, the East 47th Street Factory became a mirror image of New York society, and all the more so when Warhol's retinue was asked to smart parties and behaved badly – a tiny ritual of sadomasochism. Warhol's world worked through magical inversion. What society regarded as a deficit became a benefit; no became yes. Drag acts; drug addicts; hustlers; the disturbed, destitute, desperate and degenerate; the obverse, inverse, reverse and perverse – all could become superstars. The enigmatic lyrics – 'I'll be your mirror, reflect what you are' – captures this world turned upside down.

The increased visibility of homosexuality was a large part of this, according to Name. As he told me: 'The gay world in regular culture was a subculture, where people were paranoid about it. It was the old gay world, very camp, gay bars were very specific places, only in the Village or the Upper East Side. They were there for years, and the police would raid and you could all get arrested. It was a cruel life, but because there was a sense of having your own culture that you could participate in, you took the risk. It was so important to make your own life.

'But, in the art world, homosexuality was accepted as a normal part of the world. It wasn't the dominant or the only part, but the art world accepted variations in sexuality. The coming-out from the paranoid gay

culture, into the gay movement – in the art world and at the Factory, it was cool to be gay. Andy and some of the other people were. Not all of them. Paul Morrissey wasn't, a lot of them weren't . . . Almost everyone was Catholic, though, at some point. There was a big Catholic thing.'

Name observed the change first hand. 'When the gay world started to come out as a big part of the underground, there was the S&M thing too. Lou Reed and Mary Woronov had that thing, and the Velvet Underground had the name too.* Andy was fascinated with these people, so when we did the film *Vinyl*, which was based on *Clockwork Orange*, we actually had an S&M consultant; this guy came in from a leather bar. We were like kids pretending to be grown-ups, but because we were the power, we were actually setting these rules.'

Warhol worked out of intuition and instinct. He was a true receptor and reflector at a crucial time in American history. His high-1960s paintings and silk screens reflected the country's dominant values back at America: sex, death, crime, celebrity, media, money, mass production. Just as the mirror works with psychology, the response to these works changed with the individual gaze. Contemporary critics were divided over these artworks, if not actively hostile. Were they a put-on? Were they a critique? Were they a wish fulfilment? Or were they just there?

In 1967, Jean Clay wrote about Warhol in terms of the photographic process. He was 'a sensitive plate' on which America recorded 'its real face'. 'After assimilating all the outward manifestations and mental images of American society, after wallowing in it all, he turns on us and says: "Here, this is YOU. I am just the visible product of this world: my image is YOU." He throws back at us our own brand products, our idols, our habits – but fossilised and isolated so that we see in them a morbidity, a death which we had never expected was there.'

———

* The group was named after the 1963 pulp paperback by Michael Leigh, which examined the 'sexual corruption of our age', covering such topics as group sex, homosexual activities and sadomasochism.

n early 1966, Warhol had announced that he was giving up paint-
ing. His two main projects that year would be a total-environment,
mixed-media discotheque, the Exploding Plastic Inevitable, featuring
the Velvet Underground and Nico, and the long, ambitious film that he
would eventually entitle *Chelsea Girls*. He was moving towards a com-
plete breakdown of the boundaries between life and art, enveloping the
concert-goer in a dazzling barrage of light and sound, stretching the limits
of time in cinema to capture the boredom and mundanity of everyday life.

Such was Warhol's name that the Exploding Plastic Inevitable imme-
diately attracted the mainstream press. The 27 May 1966 *Life* front cover
story, 'New Madness at the Discotheque', led with a picture of the Velvet
Underground during their Los Angeles residency at the Trip. The thrust
of the piece was that the new condition of pop was moving towards an op
art/pop art/happenings environment of lights, music, dancers and films.

Bathed in strobes and using films as a backdrop – principally Warhol's
Screen Tests of Factory superstars and the group themselves – the
Exploding Plastic Inevitable announced itself as a new condition of pop:
'total recreation', *Life* called it. Yet the troupe was unwieldy, and, after the
unsuccessful launch of the first Velvet Underground single, 'I'll Be Your
Mirror', the momentum started to stall over the summer, when both
lead singers – Lou Reed and Nico – were out of action, Nico in Ibiza and
Reed in hospital with hepatitis.

Warhol turned to his long-established fascination with cinema. Begin-
ning in early June, he started visualising a long, ambitious movie that
would be made up of twenty 35-minute reels of film. Shooting in various
locations, including the Chelsea Hotel and the Factory, throughout the
summer, he used superstars like Nico, Brigid Berlin, Gerard Malanga,
Mary Woronov as Hanoi Hannah, Ingrid Superstar, International Velvet
and Eric Emerson to reflect his world in 1966.

At the same time, Warhol's fame was growing. Being publicly associ-
ated with pop art might have worked with the cool and knowing Gloria
Steinem,* but other commentators were not so playful or forgiving.

* He was mentioned in Steinem's *The Ins and Outs of Popular Culture*: 'Are you
confused when you hear statements like "He's in that Warhol bag"?'

Within a society where homosexuality was still illegal, the linking of camp and mainstream pop was enough to engender a backlash. The most extreme example was an April article by the writer and feminist Vivian Gornick in the New York-based liberal weekly the *Village Voice*, which cited Warhol as being part of the homosexual conspiracy to control US culture. 'It is homosexual taste that determines largely style, story, statement in painting, literature, dance, amusements, and acquisitions for a goodly proportion of the intellectual middle class,' she wrote. 'It is the texture, the atmosphere, the ideals, the notions of "camp" (a term, from its beginnings, the private property of American and English homosexuals) which currently determines middle-class taste, directs its signs, and seems to nourish its simple-minded eagerness to grind the idea of "alienation" into yet another hopelessly ironic cliché.'

In summer 1966, Warhol was both channelling and reflecting America's violent spasms. If he was already associated in the public mind with homosexuality, camp and sadomasochism, then the appearance of the *Chelsea Girls* film in September of that year confirmed that impression. Premiering at the Film-Makers' Cinematheque, it featured twelve reels in various configurations that would eventually be put in sequence by Billy Name in November. Each reel played for thirty-three minutes exactly, and they were meant to overlap in the configuration denoted below:

Reel 1: Nico in Kitchen – plays for five minutes with sound, then turned down just audible below Reel 2

Reel 2: Ondine and Ingrid – begins five minutes after Reel 1 and continues with sound until beginning of Reel 3

Reel 3: Bridgit Holds Court – begins with sound

Reel 4: Boys in Bed – no sound – filmed August 1966 at George Plimpton's apartment

Reel 5: Hanoi Hannah – all sound – filmed August 26 1966 at the Chelsea Hotel

Reel 6: More Hanoi Hannah and Guests – no sound until Reel 5 goes off. Sound on until Reel 7 threaded

Reel 7: Mario Sings Two Songs – sound for first ten minutes, then off

Reel 8: Marie Mencken – sound only after Reel 7 turned off – filmed at the Velvet Underground's apartment

Reel 9: Eric Says All – all sound after end of Reel 8 – filmed in July 1966

Reel 10: Colour Lights on Cast – no sound

Reel 11: Pope Ondine – all sound – filmed in the Factory June 16 1966

Reel 12: Nico Crying – sound for last ten minutes under Reel 11. After Reel 11 end, turn lights off on Reel 12 but continue sound – filmed in August/September 1966

This was a dizzying, often exasperating, barrage of sights, sound and emotion. After finishing principal photography, Warhol and co-director Paul Morrissey took the twelve most striking vignettes and then projected them side by side to create a juxtaposition of black-and-white and colour film, of playful sequences against more confrontational, if not disturbing, scenes. Part of the idea was that, with the complicated assembly, the reels would inevitably be run out of sequence. This would not be like watching a film, but an immersion in real life.

The twelve reels contain ambient colour sequences – Nico cutting her hair, Eric Emerson touching himself – but the bulk of the film continues Warhol's fascination with sadism and humiliation: the mocking of drag queen Mario Montez in Reel 7; the screeching of Mary Woronov as Hanoi Hannah as she berates Pepper Davis and Ingrid Superstar in Reel 5; the climactic spasm of violence in Reel 11, when Ondine, out of his mind on methamphetamine, slaps the Jonas Mekas associate Ronna Page – and then, visibly upset, steps out of his frame and his role.

Ondine was gay, of course, flagrantly so, and this sequence was the one that rattled people's cages. It wasn't just the violence, but his acid, threatening tone and the blasphemy in his assuming the role of the Pope. The fact that he shot up on-camera didn't help either. Despite featuring fully in only one reel, homosexuality loomed large in the reactions to the film. As Warhol said later: 'After *Chelsea Girls*, words like degenerate and

disturbing and homosexual and druggy and nude and real started being applied to us regularly.'

The reviews started to come in during October. Archer Winsten wrote that the film contained 'perversion, degradation, seeming influence of narcotics, suggestion of a depraved gathering, frank views of an uncircumcised lad, whips, sadism, masochism'. In the *New York World Herald Tribune*, Richard Goldstein pointed out that 'homosexuals, lesbians, addicts, pushers and debutantes cavort in and around the story line! The horror of our time is in miniature, and this film is a very short peek at a very small hell, in private cubicles.'

The film got a big boost in November, when Jack Kroll gave it a big review in *Newsweek*, calling it 'the *Iliad* of the underground'. *Chelsea Girls* moved to a plusher venue, the Cinema Rendezvous on 57th Street, where it got more mainstream attention – much of it negative. On 11 December, the *New York Times* printed a blistering review by Bosley Crowther, which began: 'It has come time to wag a warning finger at Andy Warhol and his underground friends and tell them, politely but firmly, that they are pushing a reckless thing too far.'

On 22 December, *Chelsea Girls* relocated from Midtown to the Upper West Side: the Regency at Broadway and 67th Street. Two days later, *Cashbox* printed an advertisement for the second Velvet Underground single, 'Sunday Morning' – 'or just what happens when the King of "Pop Art" – goes "Pop Music"'. It had already been reviewed as 'a potential filled deck. The top side, "Sunday Morning", is a haunting, lyrical, emotion-stirring chant. Listen very closely.'

The record went precisely nowhere. This was a highly frustrating time for the Velvet Underground and Nico. With Warhol pressing ahead with his film projects, they were stalled, reduced to playing to small crowds in the Midwest. Any momentum had dissipated. Although the group were heavily featured that winter in the Warhol-edited 'Pop' issue of *Aspen*, the multimedia magazine, that was hardly recompense for their failure to make any headway in the charts or even to operate efficiently in the music industry.

The mention of Warhol in the publicity for 'Sunday Morning' was indicative of their problem. Warhol was an artist, not a mogul, and

he had many other irons in the fire. Paul Morrissey was a film-maker, not a record man. The group's involvement with Warhol was, in fact, a double-edged sword: his generosity had given them a home, money, a record deal and press attention, but in return their unique character and futuristic contributions were, like their appearances in the EPI, left in the shadows.

During 1966, Warhol's fame drew all the light to himself. The Velvet Underground had got a lot of press, but it wasn't in the places that sold records. It was mainstream news outlets or art critics who had written about the group, mostly in dismissive or disparaging terms. The emerging underground press oscillated between confusion, awe and understanding. Even when the band was mentioned, it was always in the context of Andy Warhol. The Velvet Underground had taken a short cut to a pop career, but it was proving to be a dead end.

———

The initial link had been fortuitous. Within the climate of collage and clash that informed the way he worked, Warhol's hook-up with an underground pop group was almost inevitable – although, in the spirit of the time, it was also an inspired shot in the dark. By 1965, pop culture was broad enough to include and exalt the avant-garde. It was also, as Gloria Steinem hinted, voracious: the constant and ever-escalating demands for new sounds, new images and new styles meant that all of contemporary and historical art was there to be plundered.

Since 1963, Warhol had continued his fascination with the teen pop of the day. His memoir of the period, *POPism*, is peppered by references to individual 45s: as a flavour of a memory, an artistic moment or to mark a particular point in time. From 1963, Warhol cites songs like 'Sugar Shack', 'Blue Velvet' or 'Louie Louie' as forming part of the Factory soundtrack, along with Billy Name's opera records. The next year, he remembers Lesley Gore's 'You Don't Own Me' and Dionne Warwick's 'A House Is Not a Home' playing as he worked at the Factory.

In the *Index (Book)*, Ingrid Superstar is described ferreting around in the Factory's record box. She pulls out some 45s. They include old

superpop material like Brian Hyland's 'Ginny Come Lately', but then they move on to Martha and the Vandellas' thundering 'Nowhere to Run' and that chart-topping monolith of negation, '(I Can't Get No) Satisfaction'. Brian Jones in particular was a regular visitor to the Factory, striking up a friendship with Edie Sedgwick and, according to Warhol, appearing in a Screen Test – although it has yet to be found.

The simultaneity of Warhol's pop tunes playing at the same time as Name's high opera formed an aural collage of dissonance and juxtaposition that he sought to foster. Remembering his routine for 1964, Warhol remarked how he would arrive at the 'Factory by early afternoon. As I walked in, the radio and the record player would both be blasting – "Don't Let the Sun Catch You Crying" mixed with *Turandot*, "Where Did Our Love Go?" with Donizetti or Bellini, or the Stones doing "Not Fade Away" while Maria Callas did *Norma*.'

This mix of pop, classical and noise formed his idea of the kind of group he'd like to work with. From mid-1965 on, Warhol attempted to get involved with the contemporary music industry as a participant rather than just a consumer. The Greenwich Village folk singer Eric Andersen appeared in at least one film, *Space*, while two hardcore downtown groups, the Holy Modal Rounders and the Fugs, were filmed and photographed performing in the Factory during July 1965. But for some reason, none gelled.

The Velvet Underground came from the same Lower East Side milieu, but they were younger, better-looking and part of the same film crowd: both they and Warhol were heavily involved with Jonas Mekas's Cinematheque. The group was also featured in a December 1965 CBS news segment entitled 'The Making of an Underground Film', which showed multi-instrumentalist John Cale, singer and guitarist Lou Reed, guitarist Sterling Morrison and new drummer Maureen Tucker improvising a soundtrack to Piero Heliczer's film *Venus in Furs*.

Thanks to the film-maker and cultural catalyst Barbara Rubin, the Velvet Underground were taken under Warhol's wing by the end of the year. It was a good deal for them: management, new guitars and amps, possible shows and record-label involvement, as well as having the freedom of the Factory, where they would become the house band and Reed

could hone his observational skills. It wasn't as though they were inundated with offers elsewhere.

As it happened, the Velvet Underground had developed during 1965 as a perfect mix of pop and noise. Reed was a music obsessive, his tastes ranging from deep soul – songs like Eddie & Ernie's 'Outcast' – to free jazz, Cecil Taylor in particular, and the dreamy romanticism of doo-wop and chart pop. He and Warhol bonded over their love of early-1960s chart music: both cited as a lodestar the Jaynetts' autumn 1963 US hit 'Sally Go 'Round the Roses', an elliptical girl-group hymn that rises and falls in never-ending, cyclical waves of sadness and regret.

Born and raised on Long Island, Reed in particular fitted into the transgressive atmosphere of the Factory. He was inspired by the outcast writers of the 1950s and early '60s: William Burroughs, James Purdy, Hubert Selby and John Rechy, who were describing, often in terse, demotic prose, a recognisable, empirical reality – drug addiction, male prostitution and transvestite and gay life, at a time when all were illegal and completely marginalised and despised. Reed's project was to match these unflinching aesthetics to the pop lyric.

As Billy Name recalls, the gay influence on Reed was profound: 'Me and Lou got on really well, as if we'd grown up together, cos we were both butch guys, and it was so cool to hang out with gay people who weren't fags. Queers were noted for the fag style, and if you were butch you might be embarrassed to be associated with that. We were in our twenties, and people like me and Lou had such strong ideas of our identity, people aren't going to tell us we can't do what we wanted. We just moved it out.'

By 1965, the rules of the game had changed. The serpent of self-consciousness had entered the paradise of superpop. Pop had become more than just teen product. The music industry had usurped Hollywood's place as the modern Olympus. Reed knew that this was the arena for his generation. In 1966, he wrote an essay, 'The View from the Bandstand', which stood as a credo and a statement of intent: 'The only decent poetry of this century was that recorded on rock-and-roll records. Everybody knew that. Who you going to rap with. Little Bobby Lowell or Richard Penniman alias Little Richard, our thrice-retired preacher.'

It wasn't just the Velvet Underground's lyrics and attitude that polarised audiences; it was the way they sounded. Viola player John Cale had had a thorough schooling in the Dream Syndicate, an improv group that comprised La Monte Young, Tony Conrad and Marian Zazeela. 'Motivated by a scientific and mystical fascination with sound,' as Cale later wrote, '[we] spent long hours in rehearsals learning to provide sustained meditative drones and chants.'

Born in South Wales, Cale moved to America to take up a scholarship at Tanglewood, where he worked with Aaron Copland and John Cage. A chance meeting with Lou Reed in 1965 took him down another path: 'I was terrifically excited by the possibility of combining what I had been doing with La Monte with what I was doing with Lou and finding a commercial outlet.' Reed had already released a single in late 1964 with the Primitives. 'The Ostrich' was a spoof dance number, the one-note drone of which sounded very like the Dream Syndicate.

Reed and Cale shared a steely core of determination and a deep confrontational streak. 'Lou and I both had high aims,' Cale mischievously remembered. 'We wanted to be the best band in the world and we thought we could be. We hated everybody and everything. Our aim was to upset people, make them feel uncomfortable, make them vomit.' This chimed both with Warhol's sense of mischief and outsider rage and with the prevailing atmosphere at the Factory, which by mid-1965 had a much sharper edge, as methamphetamine permeated Warhol's entourage.

A key early Velvet Underground song was 'Venus in Furs' – Reed's lyrical synthesis of the famous novel by Leopold von Sacher-Masoch – while their name came from a book about 'aberrant' sexual behaviour that featured S&M paraphernalia on the cover. During 1965, Warhol explored similar territory with 'Vinyl', an adaptation of Anthony Burgess's *A Clockwork Orange*, which featured Gerard Malanga as 'a juvenile delinquent in leather' who is tortured by professional sadists to a soundtrack of singles by the Kinks, the Rolling Stones and Martha and the Vandellas.

In January 1966, the Velvet Underground showed up at the Factory, to be presented with their new singer. Paul Morrissey had serious doubts about Reed's ability as a frontman, and decided to drop in one of his contacts. Warhol always had Girls of the Year: in 1964, it had been 'Baby'

Jane Holzer; in 1965, Edie Sedgwick. With Edie on the way out, Nico was the perfect candidate, with a pop single under her belt that had been released on Andrew Loog Oldham's Immediate label: a sweet but slight folk-rock song called 'I'm Not Sayin''.

The group were not happy – Lou Reed in particular developed a festering resentment at being supplanted – but quickly adapted. Nico broadened their visual appeal. Her background as a model and actress – with a short but impactful appearance in Fellini's *La Dolce Vita* – made her a striking presence. As Cale remembered: 'Nico had a style that she picked up from Elia Kazan, who taught her at the Actors Studio: "Take your time. Create your own time." And she did with a vengeance.'

Warhol's foray into pop music was prompted not only by his recognition of its cultural power, but by the possibility that this could be the key to his next artistic stage. His celebrity had resulted in the offer of a large discotheque space in Long Island, and this could be a good way to fill it. The Velvet Underground were hired not just as an autonomous group, but as part of a wider project to enhance the new condition of the discotheque, which demanded something more than just a DJ and dancers.

The project received an intense flurry of publicity in the first few months of 1966, but by the end of the year, difficulties with the record company, tensions within the group itself and the sheer expense of taking the EPI on the road were helping to make the entire undertaking less attractive to Warhol and Morrissey. With Warhol and Nico getting the bulk of the coverage in the news reports and gossip pages, the group felt ignored, and Reed was not one to remain silent about his displeasure.

The principal source of frustration was the fact that the first Velvet Underground and Nico album was ready to go. Most of it had been recorded in spring 1966, but the complex cover design was creating delays. A special machine had to be built to make the original sleeve, which in Warhol's design featured an offset-printed banana-peel sticker. The many variations in the placement of Warhol's signature and the common displacements of the banana's pink ink reveal what a problematic printing job this was. Basically, Warhol was attempting to apply fine-art standards to the music industry, even if expressed through the mechanics of mass reproduction, and therein lay the problem for Reed and the

other musicians. They saw themselves as a viable pop group, not just fine-art appendages or discotheque adornments or even providers of film soundtracks, and indeed the inexperience of both Warhol and Morrissey made them inattentive and, from the group's point of view, inadequate managers in a highly competitive industry.

When finally released in early March 1967, *The Velvet Underground & Nico* ('Produced by Andy Warhol') was a complete artwork, comprising music, lyrics and visuals in a lavish fold-out sleeve. The cover did not show the name of the group, featuring simply the banana sticker, Warhol's large signature and a small instruction that stated 'Peel slowly and see'. What you got if you did was a typical Warhol tease: a large pink peeled banana that looked uncannily like an erect male member. Or, in other words, *Fuck you*.

The back cover had a blurry picture of the group playing as part of the EPI, with five individual group portraits underneath that, partially obscured by light-show patterns, accentuated the general impression of androgyny – with her short hair and lack of make-up, drummer Moe Tucker could easily have passed for a young man – and even decadence. On the inside were more group shots in black and white by Nat Finkelstein and Billy Name, with one of the producer himself, Warhol, his face perfectly framed by a tambourine.

The Velvet Underground & Nico was queer in the widest sense: different, odd, threatening, destabilising in its references to drugs, its surrealistic flights of fancy and its thorough marination in Warhol's sensibility. Reed's deadpan recitation of existential horrors and street-life scenarios rubbed up against Cale's avant-garde experiments and bone-shaking drones, whether the viola drones of 'Venus in Furs' or the insanely repetitive piano of 'I'm Waiting for the Man', and were bedrocked by Morrison's driving guitar and Tucker's tribal, minimal heartbeats.

Of all the group, Reed was closest to Warhol, whom he regarded as a mentor, inspiration and wayward father, and this closeness resulted in a burst of inspiration. On *The Velvet Underground & Nico*, Reed began as he meant to continue, as a passionate and detailed chronicler of his home town. New York permeates the eleven songs on the album, whether it be drug-deal locations, the sensibility of Warhol's Factory or the means used by New Yorkers to escape the harshness of their environment.

The Velvet Underground & Nico is nothing less than an ambitious manifesto on the part of the group and their producer – here titled in the film-business sense, as the person who put the package and deal together. A mixture of bar-band dynamics, voodoo percussion and avant-garde experimentation, at once crude and sophisticated, the eleven songs sounded dissonant, uneasy, like a shocking rupture. The delivery of the lyrics and the ice-cool, Germanic voice of Nico, alternating with the camp precision of Reed's voice, were something totally new.

The album was quickly, and favourably, reviewed. 'A left-fielder which could click in a big way,' opined *Billboard*, giving it a 'Special Merit Click'. 'Produced by Andy Warhol, the king of the underground set, this album features the haunting voice of Nico and a powerful lyric throughout performed by the Underground. Eleven tracks of sophisticated folk-rock.' *Cashbox* noted that the group was 'one of the leading exponents of psychedelia. The album is produced by Andy Warhol who is a main figure in the far-out frenzy in which the artists deal.'

While remarking that the definition of psychedelia was still up for grabs, *Cashbox* unwittingly put its finger on the problem. The delay in the album's release proved fatal. In the ten months between the bulk of the recording and its release, the centre of American pop had moved from New York – riding high in the spring of 1966 with the Lovin' Spoonful and the Young Rascals – definitively to the West Coast: first Los Angeles, then San Francisco. In the competition between the coasts to be the prime locus of American pop culture, the West had won.

On their May 1966 trip to Los Angeles, the group and their troupe had already intuited the fact that things were not going their way. 'The West Coast was an organised force trying to predominate in the pop scene,' Morrison remembered. 'I remember we were in a rented car going back from the airport and when I turned on the radio the first song that came out was "Monday, Monday". I thought: "I don't know, maybe we're not ready for that sort of thing yet, to be taking these people on, right in their own backyard."'

The local media were far from awestruck. In the *Los Angeles Free Press*, Paul Jay Robbins noted that the group had two settings: 'one is a phlegmatic mode which accompanies lyrics which smack of Baudelaire

speaking through early-morning Dylan; their other style is centred around a bone-scraping electric violin played by a boy who looks like a girl (the drummer is a girl who looks like a boy). The rumbling terror of their delivery is saved only by the viscous movement of their music: if it moves slowly enough, anything lethal becomes tolerable.'

In San Francisco, matters were worse still, as the city was trying even harder to establish itself as a music centre. The local scene's biggest booster was the experienced, benign jazz critic Ralph J. Gleason, but he turned on the scorn for the EPI: 'The girl and the guy with the whips danced on stage in a crude attempt to be sexual. The Velvet Underpants sang a song about whips. It was all very campy and very Greenwich Village sick. But the worst thing was that it was non-creative and hence non-artistic.'

EPI dancer Mary Woronov caught the lack of comprehension between the two cities: 'We spoke two completely different languages. We were on amphetamine and they were on acid. They were so slow to speak with those wide eyes – "oh, wow!" – so into their vibrations: we spoke in rapid machine gun fire about books and paintings and movies. They were into "free" and the American Indian and "going back to the land" and trying to be some kind of "true, authentic" person; we could not care about that. They were homophobic; we were homosexual.'

If *The Velvet Underground & Nico* had been released during 1966, it might well have received a better reception, but by early spring 1967, the pop mood had moved away from that year's harshness to a softer, more upbeat sound, as the idea of psychedelia took hold. On 4 March, the Rolling Stones' 'Ruby Tuesday' was at #1, with psychedelic groups like the Blues Magoos and the Electric Prunes in the Top 40, and West Coast artists predominating: the Monkees, Buffalo Springfield, the Turtles, the Byrds, the Mamas & the Papas.

With Warhol's name prominently displayed in the press reviews, in the advertising and on the record sleeve, the group wondered who was central here. Indeed, Warhol's and Morrissey's managerial qualifications came under further scrutiny when they failed to deal with the rumbling complaints of the young people whom they had so successfully featured – if not exploited – in *Chelsea Girls*, the obvious success of which was raising awkward questions.

Shortly after the album's release, Eric Emerson, the nude acid-tripper in *Chelsea Girls*, brought lawsuits that demanded $250,000 each for the unauthorised use of footage of him in the movie and of his image on the back of the *Velvet Underground & Nico* cover. He ended up settling for all of $1,000, but succeeded in getting a judge to cut the screening of his *Chelsea Girls'* scenes in New York state and in persuading the group's label, Verve Records, to airbrush him off the sleeve, forcing the record off the market for a number of weeks.

Warhol was the star, not the group, as the ad copy for the album made clear: 'What happens when the daddy of Pop Art goes Pop Music? The most underground album of all! It's Andy Warhol's hip new trip to the current subterranean scene. Sorry, no home movies. But the album does feature Andy's Velvet Underground (they play funny instruments). Plus this year's Pop Girl, Nico (she sings, groovy). Plus an actual Warhol banana on the front cover (don't smoke it . . . peel it)!'

An added element of tension was Warhol's homosexuality, although Reed, with his own performative bisexuality, never made any pejorative reference to this fact. The Velvet Underground were trying to make it in the American music industry, which, in 1967, was still very traditional as far as sex roles were concerned. Gay men like the producer and entrepreneur Bob Crewe – then riding high with hits by Mitch Ryder & the Detroit Wheels and the Four Seasons – concealed their sexuality as a matter of course.

Being gay was fine in the art world. In the pop world, it was not, as a review of the EPI show in Ann Arbor that April made clear. As David Freeman wrote: 'Snatching up an arch-light spotlight, one of Warhol's men began to spray intense white light in rhythm to screaming voltmeters. I was sitting in an aisle seat, and he burned my retinas every time he scanned the audience with the spot. Very soon people began walking out; someone yelled "Andy Warhol's queer" and got hit ten times between the eyes with the blinding light. Warhol never smiled once . . . he didn't even seem to enjoy torturing the audience.'

The bottom line for Warhol was always money, and in the first half of 1967, it was clear where the flow was going. He was not painting and the Exploding Plastic Inevitable was eating up resources. The one bright spot

was the success of *Chelsea Girls*, which by that June had moved almost continuously from one New York venue to another, for a total of almost four hundred screenings, earning Warhol $25,000 (around $200,000 today). It was obvious which way he was going to jump.

The EPI's days were numbered. The last full show happened in late May 1967, at Steve Paul's popular rock club the Scene – so much for discovering and creating new venues. The troupe played without the presence of Warhol, who was in the South of France with Nico and Gerard Malanga, promoting *Chelsea Girls* at the Cannes Film Festival. The separation happened soon afterwards. In late May, the Velvet Underground were due to play a show at the Boston Tea Party, a new rock ballroom that would become one of their regular venues. It was arranged by a local businessman called Steve Sesnick, who had ambitions to manage the group. When Nico showed up expecting to sing, Reed refused to let her on stage. That was the end of the experiment as far as he was concerned: the Velvet Underground would henceforth continue as a four-piece, under a new agreement with MGM/Verve.

On 3 June, the group played a benefit party for Merce Cunningham's dance troupe at the modernist Glass House of architect Philip Johnson. In the limousine back to New York, paid for by Johnson, the Velvet Underground decided to sack Warhol as their manager and replace him with Sesnick. Warhol was not pleased when he was told, calling Reed a 'rat', according to the latter.

This was a sudden, ill-tempered break. Reed's feelings can be gauged by an interview published shortly afterwards in an Ohio underground magazine:

> lou: No Andy Warhol questions.
> int: Could I ask you about your relationship to Andy Warhol?
> lou: We've married.
> int: I mean was there any professional relationship outside of the 'Exploding Plastic Inevitable'?
> lou: No.
> int: He just produced your album and . . .
> lou: We produced him!

While more reviews of the album – respectful, if not enthusiastic, in tone – trickled in that late summer and early autumn, the Velvet Underground faced an uncertain future. The severance was not total – Warhol's name continued to be displayed on their billing – but the four-piece found themselves judged by the EPI's absence. As the *Boston Globe* stated that September: 'The audience was strangely cool and the applause was minimal. The reason is quite obvious. The vital element in a total environment lights-with-rock show – participation – was missing.'

————

On 24 September, the *New York Times* published the most thoughtful article on *Chelsea Girls* yet. 'Movies record the collective life of their audiences,' Rosalyn Regelson wrote, stating that 'the sudden popular success of several Underground films indicates a major psychic shift may be in process. *The Chelsea Girls*, which was the first Underground film to surface up to an art house showing and is so far the masterpiece of the "Baudelairean Cinema," sets out the cosmogony within which a good part of the Underground Cinema takes place.

'Andy Warhol's beautiful girls and boys lolling enigmatically and endlessly on unmade beds in tacky rooms have excited a disturbed admiration on the part of many critics . . . More disturbing than the contagious lethargy of the movie is the deeper message: these dreamy swingers, playing their little games, clearly question the most basic assumption of our culture – namely that heterosexual coupling, happy or unhappy, moral or immoral, is a socially significant enterprise worthy of the closest possible scrutiny. Hollywood's tinsel titillation and the art house film's hard bedrock fornication are replaced by a new sexual mythology, a cool, low-keyed playful polymorphism.'

What Regelson was imputing to *Chelsea Girls* – 'a vision of androgyne mysteries, a glimpse of the unio mystica, the blessed union of all striving opposites' – was a complete redrawing of the gender map, a widening beyond traditional heterosexuality to include homosexuality, bisexuality, lesbianism and, indeed, changed models and roles for heterosexual

men and women. This had been an underlying concern of Warhol's for the previous two years, and with this film it reached its perfect first expression.

With its roots going far back into the nature and terms of performance and ritual, the androgynous principle had long been a part of pop culture: the apparent femininity of Elvis, the disturbed bisexuality of James Dean, the wild, camp ecstasy of Little Richard, the long hair of the Beatles, the Rolling Stones and the Kinks, right down to the boy-like appearance of Moe Tucker on the *Velvet Underground & Nico* sleeve. During the next few years, largely as a result of Warhol's influence, it would become a driving principle.

'Andy wasn't gay in the ordinary way,' Billy Name told me. 'Nor am I. Androgyny is a synthesis of divergent sexualities. Andy was gay culturally, and he was attracted to males physically, which technically makes him a real gay, but it was beyond that. When you're a creator, the key word is "generous", because you're generating cultural values. Your nature has to be generous, you have to be giving and accepting and open and listening, but you also have to be playful, and in a sense mud-wrestle sometimes. Andy's gayness was like a cultural generosity.'

By autumn 1967, however, the Velvet Underground were establishing themselves as a separate entity from Warhol. In the underground weekly *Boston After Dark*, David DeTurk observed that the EPI was 'an inadequate showcase for the talents of the Underground itself. In the first place, they were overshadowed by everything else that was going on around them. Secondly, they were constrained to some extent by the Andy Warhol heists of masochism, drugs, homosexuality and a mammoth penchant for putting down America through exposure of her closet skeletons.'

During that month, the Velvet Underground also released their third single, 'White Light/White Heat', a disquisition either on amphetamine or the spiritual practices of Alice Bailey – whichever way Lou Reed told it – that was couched in one of the period's most extreme productions. It came and went without a trace. Although they had already recorded their second album, the group had almost disappeared, with few public appearances.

Just how much the Factory had changed was highlighted by the arrival that month of finished copies of Warhol's second *Gesamtkunstwerk** that year, *Index (Book)*. Compiled earlier in 1967 and edited by Alan Rinzler, *Index* was visual, with minimal snapshot text, plentiful Billy Name photos and an intermedia assemblage that attempted to transcend the two-dimensionality of the book form. The various pop-ups and addenda included a silver balloon, a red accordion and a flexi disc with a photographic portrait of Lou Reed on the label.

'I think that the rest of the world is us,' Nico proclaimed on the flexi disc, but by this time, exactly who was 'us' had changed. The success of *Chelsea Girls*, the dissolution of the EPI and the split with the Velvet Underground had served to throw off many of 1966's superstars. Eric Emerson was already on the way out after his legal shenanigans, and so was Mary Woronov, who, while *Index* was in production, had refused to sign a release form until she got proper recompense, thus incurring Warhol's wrath and resulting in her staying away from the Factory.

Also fading out was Ondine, despite having featured in several Warhol film projects that year, including *The Loves of Ondine*. Nico was still involved; in September, she capitalised on her film fame by releasing her first solo album, entitled *Chelsea Girl*, which featured input from Lou Reed and John Cale. Reviews were favourable, but it didn't sell. She shot several half-hour reels of film with Warhol that year – including sections called *Sausalito* and *High Ashbury* – but she was no longer the It girl of 1966. Nineteen sixty-seven and 1968 demanded new Warhol stars.

There was a distinct sense of the East 47th Street Factory running down as the featured players of 1966 began to disperse. In late September 1967, Warhol received a notice-to-quit letter from the building's managers: the whole structure was to be torn down to make way for a parking lot. In the competition to find a new building for the Factory, Paul Morrissey prevailed and, in late December, the lease was signed on the sixth floor of a Victorian building on the west side of Union Square.

* Total artwork, comprising several media merged into an integrated whole. Warhol produced three in 1966/7: the 'Pop' issue of *Aspen*, *The Velvet Underground & Nico* album and the *Index* book.

This had not been Name's choice, and Morrissey's victory signalled the decline of his influence.

As people began to drop away, the Factory aesthetic started to degrade and turn dangerous. Dark clouds swirled around Warhol in late 1967, the result of his long immersion in sadomasochistic imagery and the explicit association with hard drugs and violence so graphically depicted in the final reel of *Chelsea Girls*, amplified, as if in a feedback loop, by all the press coverage during that year. Warhol was not only America's most famous homosexual, he was also King Sadist.

In November, a friend of Ondine's called Sammy the Italian attempted to rob the Factory with an accomplice. Out of his mind on drugs, waving a gun around, he made everyone who was there line up – including Nico, Morrissey, Name, poet Taylor Mead and Warhol himself – on the famous Factory couch. When Nico asked whether the gun was loaded, he let off a round. The stand-off was curtailed only when Mead, furious at the gunman's disrespect for Warhol, sent the gunman packing with the sheer force of his rage.

Warhol carried blithely on. Towards the end of the year, he was preparing two major new works that would – even more than the eight-hour *Empire* and the three-and-a-half-hour *Chelsea Girls* – seek to dissolve the distinction between art and everyday life – that age-old utopian ideal. The first was a book, eventually titled *a: a novel*, which consisted of the transcripts that were recorded over a twenty-four-hour period in 1965 as Warhol followed a manically speeding Ondine around with a cassette machine. The book was also intended, like *Index*, to break down the barrier of form: as well as being a verbatim transcript of often unintelligible dialogue, the text also included every typing error, every punctuation mistake, every incorrect character identification and every attempt at censorship – one of the typists, Moe Tucker, refused to write any swear words and left them out. Warhol wanted the mistakes left in, finding them interesting and seeking to make the process part of the finished product. The barely readable result was an absurdist production in its own right.

More substantial was the film project that had occupied Warhol for much of the year. *Chelsea Girls* was ambitious enough, but the project

variously called *Sin*, *Vibrations*, *Since*, *24 Hours* and eventually **** was a monumental effort and trial of endurance. It was assembled from eighty half-hour reels, with thirty separate sections, like the feature-length films *Imitation of Christ* (featuring Nico) and *I, a Man*, as well as two dozen shorter sequences featuring Nico, Ondine, Ultra Violet and older material going back to the Edie Sedgwick period.

This time there was no overlap, as the reels ran straight through. The finished film lasted for twenty-five hours – an unimaginable, barely comprehensible compendium best summarised by the American Film Institute in terms of the following keywords: 'Housemaids. Hoboes. Judges. Hitchhikers. Hippies. Children. Sexuality. Male homosexuality. Parenthood. Rape. Death. Travel. Bathing customs. Buddhism. Religion. Motion pictures. LSD. Docks. Beaches. Marijuana. San Francisco. Sausalito. Long Island. "Imitation of Christ".'

The film premiered on 15 December 1967 in the basement cinema of the Wurlitzer Building, off Times Square. Warhol and Morrissey chose the order in which the reels would be shown, selecting the best stuff first and putting on the most boring material in the middle of the night. The aesthetic was questionable, the result mind-numbing. As one viewer remembered: 'I saw thirteen hours of it, and staggered out, exhausted to the point of hallucination: I kept seeing snow covered landscapes all around me, though the weather was in fact clear and mild.'

The reviews were similarly uncomprehending. *Variety* thought that, while *Chelsea Girls* was a 'vision from hell', **** was without any vision at all, simply comprising 'random footage with no narrative or thematic framework whatsoever'. This might well have been Warhol's aim, in theory, but the result was deemed a failure: although various elements of the piece would be shown individually over the next year, **** was never seen again in its entirety. The dream of fusing art and everyday life was coming to an end.

Finally, because of the tremendous influence and power of economics in determining social and cultural attitudes, we must develop GAY POWER in every conceivable way. We as a minority community have untapped wealth and resources that can provide the economic power that can be influential both politically and socially.

Jim Skaggs, 'The President's Corner', *Vector*, vol. 4, no. 4, March 1968

Over Christmas 1967, the Velvet Underground prepared for the release of their second album, *White Light/White Heat*. Although they had officially split from Andy Warhol, their collaboration still permeated the record. The cover image was a tattoo of a skull, printed black on black at Warhol's suggestion. The image itself was taken from a negative film slide by Billy Name of Joe Spencer, who played a gay hustler in Warhol's 1967 film *Bike Boy*. These dark undertones of homosexuality permeated the record.

Released in late January 1968, *White Light/White Heat* contained only six songs: both sides of the previous November's single – the title track and the sibilantly sweet 'Here She Comes Now'; a macabre short story by Lou Reed set to music by John Cale ('The Gift'); a hallucinatory, almost tactile evocation of a botched surgical procedure, with possible transsexual or transvestite overtones ('Lady Godiva's Operation'); and an all-out sonic attack that fragments into the painful sound of madness ('I Hear Her Call My Name').

The album's centrepiece was 'Sister Ray', a live sixteen-minute performance during which all the musicians try to outplay each other – except Moe Tucker, who was charged with keeping everything together. Originally called just 'Searching', it had been premiered the previous spring, when Warhol was still involved with the group. He liked the song and insisted that Reed keep all the dirty words in, particularly the none-too-subtle lines 'Oh, no, man, I haven't got the time, time / Too busy sucking on a ding-dong / She's busy sucking on my ding-dong.'

'Sister Ray' mixed aural chaos with an extreme scenario of hard drugs, violence, homosexuality and transvestism. Reed later described the track as 'built around this story that I wrote about this scene of total debauchery and decay. I like to think of "Sister Ray" as a transvestite smack dealer. The situation is a bunch of drag queens taking some sailors home with them, shooting up on smack and having this orgy when the police appear.'

On 1 February, the album was launched at the Aardvark Cinematheque in Chicago, where two hundred teens watched Andy Warhol movies and saw the Velvet Underground play, each getting a free record. The recollection of an attendee called Bev encapsulated the response: 'The Velvet

Underground is okay, but nothing to go outta your mind over. But it was free so I enjoyed it.'

In that new year, Warhol's time was taken up with two major projects: an office relocation and a major retrospective. Paul Morrissey was sent off to direct the next Factory film, an adaptation of *Romeo and Juliet* with a typically perverse twist: Romona-Romeo was now a Wild West madam and Julian-Juliet, her 'true love', was gay, like all the other cowboys in the film. Indeed, the film's title, *Lonesome Cowboys*, was chosen on the advice of theatre owners, who said that skin flicks with plural names did better box office.

Warhol moved into the new offices on 5 February. He intended this as a clean break; the new office was definitely not a place to hang out. There was now a division between business and pleasure, with all the social activity that surrounded the Factory occurring at Mickey Ruskin's Max's Kansas City, a few blocks away on Park Avenue South. This was a deliberate repositioning. 'We've been building up this camp image for years,' Warhol stated during the move, 'and now that people expect it, we're serious.' His new thing was art as business.

On 9 February, Warhol flew to Sweden for the opening of a giant retrospective of his work at Stockholm's Moderna Museet. The works went right back to the first days of pop art – with the Brillo boxes – and carried through to the mid-1960s, when Warhol defined the obsessions and deep tensions of American life with silkscreens – like those of Marilyn Monroe, Elvis Presley, the dollar bill and the electric chair – that highlighted the confluence of sex, glamour, death and money.

Always ahead of his time, Warhol left the 1960s in early 1968. With the office move and the Stockholm retrospective, there was the sense of an ending. There is a record of this moment. On 8 March, Name shot a group photo in the new Union Square office. What is striking about the image is how few of the old Factory participants are included. Nico is there, to be sure, along with Taylor Mead, Brigid Berlin, a fading Ondine and a dissipated-looking Name in a Bill Blass scarf, but the mood is sombre. It could almost be a memento mori.

———

In early spring 1968, Dusty Springfield was having a crisis over material. After the poor performance of 'What's It Gonna Be', it had been six months since she had released a single, and time was pressing. There were two candidates: 'Magic Garden', the Jimmy Webb song that she promoted on *Sunday Night at the London Palladium* on 10 March; and 'It's Over', a spacious ballad by Jimmie Rodgers, which was eventually chosen. Despite an excellent vocal performance, however, Springfield pulled the record just before its intended release in early April.

Nearly two and a half months later, at the end of June 1968, her final choice was released. Written by Clive Westlake, 'I Close My Eyes and Count to Ten' was an intimate account of an immediate, profound human connection that, with its well-designed emotional troughs and peaks, was tailor-made for Springfield's dramatic approach. Indeed, she later said he had written the song with her in mind.

There was a sense that Dusty was becoming even more uncertain about her career, caught in an *NME* interview on 6 July, as 'I Close My Eyes and Count to Ten' was entering the charts, on the way to its eventual peak of #4. She was unhappy with her record company, her manager and her new ITV series. As the querulous singer trenchantly criticised the television company and the way that they treated her, the writer Keith Altham rather nervously noted that this was not the happy-go-lucky Dusty of old.

Springfield admitted that a lot was riding on her new single. She hadn't had a Top 10 hit since late 1966. 'I certainly have not got to the stage where I can do without hit records. I can exist without them but I would rather not!' She went on to discuss her change of manager, after parting company with Vic Billings, who had guided her career since the end of the Springfields. America was beckoning, despite her equivocations: she talked about performing frequently on US TV and having a new business manager in the US who made sure she didn't 'get conned'.

Her orientation towards America would result in her signing with Atlantic Records in the US later in the year, and the *Dusty in Memphis* album, which, despite the title, was recorded in New York, after some difficulty. When the single 'Son of a Preacher Man' rose into the US and UK Top 10s, Springfield's relaunch seemed set fair but, with the single's

apparently heterosexual orientation, she continued to dodge the questions about her sexuality – as was her right. She would eventually come to a difficult public reckoning over who she really was.

———

On 17 July 1968, the *Wall Street Journal* published a lead front-page article that noted the growing militancy among homosexuals, who were fighting for 'a piece of the action' in America – an intervention that got a positive response in the gay press. 'It is said that the *Wall Street Journal* is six months ahead of society in indicating trends,' observed Craig Rodwell in the *Hymnal*, one of the new breed of gay publications that had sprung up into the gap left by the previous generation of activists.

Born in 1940, Rodwell had become active in gay politics from the mid-1960s, when he worked for the New York branch of the Mattachine Society and participated in various pickets. In the early part of the decade, he'd had a relationship with a statistician called Harvey Milk, which foundered when the older man objected to his activism. In November 1967, he founded the Oscar Wilde Memorial Bookshop, which was intended as a highly visible outreach project.

In February 1968, Rodwell started publishing a newsletter out of the bookstore, calling it *Hymnal* to reflect its campaigning flavour. Its aim was to bring 'Gay Power to New York'. The first issue contained an article titled 'Mafia on the Spot'. As Rodwell wrote: 'The Stone Wall on Christopher St. in Greenwich Village is one of the larger and more financially lucrative of the Mafia's gay bars in Manhattan.' He reported that the bar, which washed its glasses in a filthy tub, had contributed to an outbreak of hepatitis in the homosexual community.

Even though *Vector* had quickly discontinued its 'Gay Power' column, the idea of an assertive gay slogan was in the air. In June, Frank Kameny wrote a long letter to Rodwell's romantic partner Dick Leitsch, another activist who had been involved in the famous April 1966 'sip-in' at Julius Bar in Manhattan, protesting against the licensing laws that penalised openly homosexual behaviour. Taking its lead from the civil rights

movement, and in particular Stokely Carmichael's concept of Black Power, the letter acted as a kind of manifesto for a new era in gay politics.

'One of the points which I have made, with increasing intensity, over the past few years,' Kameny wrote, 'is the pervasively negative attitude toward homosexuality with which the homosexual is surrounded, and with which society is imbued. This is the point: that we must instil in the homosexual community a sense of the worth of the individual homosexual. A sense of high self-esteem. We must counteract the inferiority which ALL of society inculcates into him in regard to his homosexuality.'

Kameny's conclusion was that activists needed to exhort the gay community to stand proudly in solidarity with each other. By August, he was fixed on 'Gay Is Good' as the slogan and, to celebrate its coinage, had thousands of badges printed. He was so convinced of its truth and usefulness in overturning decades of self-harm and self-hatred that he took it to the 12 August homophile conference in Chicago.

The meeting was not an unqualified success. Kameny was concerned, correctly as it turned out, about the conference's proximity in time and place to the upcoming Democratic Convention. Despite the seventy-five or so delegates agreeing a name change to the North American Conference of Homophile Organizations (NACHO), it was difficult to reconcile the various agendas. Determined to pursue a course influenced by the second wave of feminism, the Daughters of Bilitis announced that they were pulling out of NACHO for good.

Nevertheless, on 17 August, the delegates adopted Kameny's resolution: 'BECAUSE homosexuals suffer from diminished self-esteem, doubts and uncertainties as to their personal worth, and BECAUSE homosexuals are in need of psychological sustenance to bolster and to support a positive and affirmative attitude toward themselves and their homosexuality . . . it is hereby adopted as a slogan or motto for the N.A.C.H.O. that: GAY IS GOOD.' This was to 'be given the widest plausible circulation in both the homosexual and heterosexual communities'.

On the opening day of the homophile conference, the second Big Brother album with Janis Joplin was released. The musicians had struggled to adapt to the studio environment, arousing the ire of perfectionist producer John Simon. Taken out of their native San Francisco to record in New York, they were dabbling with hard drugs and dealing with the fact that their singer had become as famous as they were anonymous. Matters were not helped by manager Albert Grossman disparaging the group in his attempt to persuade Joplin to strike out as a solo artist.

Issued with an emblematic cover by Robert Crumb – the most famous artist in the underground press – *Cheap Thrills* was a part-live, part-studio album that, against the odds, captured some of the freewheeling San Franciscan ballroom atmosphere in songs like 'Combination of the Two'. Joplin shined on covers of the evergreen 'Summertime' and Irma Thomas's 'Piece of My Heart'. The last track on the album was another wracked reading of 'Ball and Chain', recorded live at the Fillmore West in March.

Cheap Thrills was both a beginning and an end for Big Brother. It was their first and only hit, reaching #1 in the US during mid-October, in an eight-week run that stretched nearly until Christmas, making it by far the most successful album to have come out of the San Franciscan subculture. By this time, however, Joplin had left, having announced her decision to quit just after the album's release. The group soldiered on through a bad-tempered nationwide tour, before the final show in early December. Neither party would quite recapture the magic.

The week that *Cheap Thrills* was issued, the #1 album in the country was by Robert Stigwood's protégés Cream. *Wheels of Fire* was a sprawling double album, one of the first to reach the top of the US charts since Judy Garland's *Live at Carnegie Hall*. It was a schizophrenic mix of strange art pop and the hyperbolic, heavy, live blues jams that had electrified audiences across the country and that were, unfortunately, encouraging a micro-generation of rock musicians to stretch out on their solos.

Summer 1968 was a triumph for Stigwood, another dazzling high in his customary up-and-down career. In late August 1967, he had hoped that he would seize the main prize – the management of the Beatles – in

the chaos that engulfed NEMS after Brian Epstein's death. Epstein's brother and mother, Clive and Queenie, inherited his shares in NEMS, with the result that they immediately became majority shareholders. Clive assumed the chairmanship, but the Beatles quickly announced – on 31 August 1967, four days after Brian's death – that they had no intention of being managed by Brian's brother and that they would, for the moment, be content with having Peter Brown as their personal manager and Stigwood running NEMS.

NEMS was then consumed by a wild scramble for power, with the Liverpool old guard – road manager and intimate Neil Aspinall, Peter Brown and Geoffrey Ellis – pitted against Stigwood and his partner David Shaw, with Epstein's other partner, Vic Lewis, following his own agenda. Stigwood and Shaw were insisting that Epstein's death didn't void their agreement to buy NEMS, but their problem was that they had to convince the Beatles to stay with them – of which there was no chance.

What Stigwood didn't realise was that the Beatles had already formed an extremely negative view of their aspirant manager. It went way back to October 1962, when the group had come down to London for their first bout of press. One of the magazines they visited was called *Pop Weekly*, which was co-owned by Stigwood. When they arrived at the impresario's offices near Paddington, they were treated with extreme discourtesy by a young, unnamed journalist, who told them that guitar groups were finished. The memory and the association stuck.

Characteristically, Stigwood attempted to force their hands. On 1 September, he convened a meeting at the NEMS office at Hille House, with him and his partner David Shaw in attendance, along with Clive Epstein and Geoffrey Ellis from NEMS and the four Beatles. After Stigwood concluded his pitch, which lasted ten minutes or so, the Beatles simply said no, and that was the end of the meeting. In turn, Stigwood announced that he would not be exercising his option to purchase 51 per cent of NEMS and that he and his staff would leave immediately.

In refocusing his business as the Robert Stigwood Organisation, the Australian had two strong cards: Cream and the Bee Gees, both of whom were rising hit-makers at this point. After extracting a large advance from

Polydor Records, he went back to NEMS and, in November, agreed a settlement with Clive Epstein that allowed him to take Cream and the Bee Gees with him, as well as his office furniture and a £25,000 separation payment. By that time, the Bee Gees' 'Massachusetts' had been at #1 for four weeks.

Over the next few months, both acts became among the biggest in their respective genres. Cream were a smash success in America, with their second album, *Disraeli Gears*, reaching #4 in the charts and staying in the Top 40 for nearly a year, reflecting their popularity as a sensational live draw. Released in June 1968, *Wheels of Fire* went to the top on 10 August, staying there for four weeks, while a single from the previous year, the hard-rock blueprint 'Sunshine of Your Love', slowly rose to a peak of #5.

The Bee Gees had two further Top 10 hits in the UK before the success of their eighth single, the melodic tearjerker 'I've Gotta Get a Message to You'. Still in their teens, the precocious, talented group were successful in America, with five Top 20 hits up to summer 1968. On 4 September of that year, 'I've Gotta Get a Message to You' went to #1 in the UK; it would be their last chart-topper for a while, as both Stigwood's principal acts would split the following year, precipitating another plunge down the roller coaster.

———

On 5 September, Andy Warhol made his first high-profile appearance for three months. The occasion was the wrap party for John Schlesinger's big-studio film about the relationship between a male prostitute and his pimp, *Midnight Cowboy*, based on the 1965 novel by the gay writer Jim Herlihy. This had uncomfortably close Warhol associations: superstars Viva, Ultra Violet and Joe Dallesandro appeared in the film – in a party scene that reproduced a Warhol-style art event – and the artist felt that Hollywood was stealing his aesthetic.

It wasn't the only more mainstream product to tap into the sexual and social underground that summer. In April 1968, the musical *Hair* began its long Broadway run. Featuring drugs, movement politics, astrology

and polysexuality (including homosexuality), the play was a highly suc-
cessful compendium of current counter-cultural themes and obsessions.
Released in May 1968, the original cast recording spawned big hit-single
covers – by Nina Simone and the 5th Dimension – and would reach the
top of the US album charts in spring 1969.

Warhol had been out of action all summer because of a shattering
event that had occurred on 3 June. At around 4 p.m. that afternoon, he
was faced with a loaded gun for the second time in just over six months.
This time, however, it wasn't a drug-addled lunatic but a very disturbed
yet lucid and determined thirty-two-year-old woman. Despite her confu-
sion, Valerie Solanas meant business and, in quick succession, fired three
bullets, the third of which hit Warhol's lungs, liver, spleen, oesophagus
and stomach.

On the day, it was almost a comedy of errors. The new Factory had
been designed to curtail the unstable group scenes that the old East 47th
Street premises had witnessed, but people were still free to come and
go. That day, Solanas was sitting in front of the Union Square Factory.
Having received a few cash handouts from Warhol, she was asking for
more money. Between midday and 4 p.m., she came into the office seven
times, finally coming up in the elevator with Warhol, who had just arrived.

In June 1968, Solanas was homeless and drifting. Claiming she had
been molested by her father, she had been unable to translate her obvi-
ous intelligence into a firm occupation or any kind of stability. By the
later 1960s, she was begging and doing occasional sex work, while living
on the fringes of radical Manhattan and formulating the extreme ideas
that she would later publish as the *SCUM Manifesto* – SCUM being the
acronym for the Society for Cutting Up Men.

Responding to the misogyny that she saw all around her, Solanas
self-published an extreme screed that came decorated with a proudly
erect female middle finger. SCUM was being formed '– To effect a
complete female take-over, to end the production of males. (It's now
technically possible to reproduce without the aid of males and to pro-
duce only females.) – To begin to create a swinging, groovy, out-of-sight
female world. – To end this hard, grim, static, boring male world and
wipe the ugly, leering male face off the map.'

As a lesbian intellectual, Solanas had fitted well into a Warhol scene that was trawling the extremes of underground culture. She started visiting the old Factory in 1967 and had a minor role in the film *I, a Man*; Warhol also paid for a manuscript of her play *Up Your Ass*. She became fixated on the return of this text, which Warhol had apparently lost. She was also planning to target the publisher Maurice Girodias, who had given her an advance on any future writings.

According to Billy Name, Valerie originally meant to shoot Girodias, but when she couldn't find him at the Chelsea Hotel, she ended up at the nearby Factory with her gun, ready to shoot Warhol as a substitute. She felt that, like Girodias, he had stolen her ideas and her soul.

Name was in the darkroom at the back of the space when he heard the bang. He emerged into mayhem, finding Warhol seriously injured and bleeding on the floor of the Factory office, with gallery owner Mario Amaya bleeding from a less serious wound. The result was shattering. Warhol was rushed to hospital, where he would have died – the doctors thought him untreatable – if not for the pleas of the fully conscious Amaya. Nevertheless, Warhol would remain in Columbus–Mother Cabrini Hospital for the next seven weeks with a ruptured stomach, liver, spleen and lungs.

The effects were permanent. Warhol would be forced to wear a corset for the rest of his life to keep the reconstruction of his abdomen in place, and his injuries from that day contributed to his early death in 1987. At the time, his recovery was slow and marked by at least one serious setback: a bad fever in mid-July. He was kept occupied by gossip about his superstars jockeying for top place in the pecking order, as well as editing the raw footage of the film that Paul Morrissey had shot in the winter, *Lonesome Cowboys*.

While Warhol was recovering, Solanas was going through the legal system. Having turned herself in to the police, she was declared mentally unstable and transferred to a prison hospital. On 28 June, she was indicted on charges of attempted murder, assault and illegal possession of a gun: she was declared incompetent in August and sent to an asylum for the criminally insane. Cashing in on her notoriety, Girodias's Olympia Press published the *SCUM Manifesto*; future editions would carry an essay by Vivian Gornick.

During his enforced convalescence, pornography was on Warhol's mind. Stung by the opportunism of Schlesinger's production, he decided to steal a march by making his own film about a male hustler. On his first trip out of his house, he went to Manhattan's sex district, 42nd Street, to watch a porn film and buy the filthiest videos he could find. With Morrissey at the helm, shooting started without delay, and lasted over seven or so weekends in August and early September.

Flesh was a quick turnaround. It opened on 26 September 1968, and was an immediate success, running continuously for the next seven months at the Garrick Cinema in Greenwich Village. With Warhol having almost no input into the actual shooting of the film, it reflected Morrissey's increasing fascination with plot and comprehensibility, with Joe Dallesandro playing the starring role as a bisexual hustler, whose picaresque encounters with men and women provided another travelogue through New York's underbelly.

The cast included a new superstar, the nineteen-year-old Dallesandro, and his clients and lovers: Louis Waldron, who had already appeared in the Warhol films *The Nude Restaurant* and *Lonesome Cowboys*; the nearly seventy-year-old character actor Maurice Braddell; Geri Miller, who worked as a stripper in real life at that point; and Patti D'Arbanville. It also featured two new arrivals on the Factory scene who would have a profound influence over the next few years: Jackie Curtis and Candy Darling.

Warhol had long explored the outer reaches of human sexuality, but this was the first time he had used transgendered performers. He had met Curtis and Darling the previous year in Greenwich Village, where, on the way to pick up some leather trousers from the Leather Man, he noticed a young man walking with a tall, striking, blonde drag queen. Curtis recognised Warhol and asked him to sign his autograph on a paper bag from a clothes shop. When Warhol asked what was inside, Jackie told him it was satin shorts for his new play, *Glamour, Glory and Gold*, and offered to send him an invitation.

Curtis and Darling had been street fixtures for a while. Born in early 1947, Curtis was born John Curtis Holder Jr and was principally raised by his aunt, who ran a Lower East Side bar called Slugger Ann's. Protected by his formidable relative, he began wearing women's dresses

while bartending as a teenager, a look he would alternate with a tough, James Dean-like style. Fluidity was the point.

Curtis began buying 1930s dresses from thrift stores, but was so poor that he'd have to wear them until they fell apart. 'Finally, they were just kind of rags on her legs,' remembered her friend Jayne County. 'They became works of art. Sometimes she would put them together with safety pins, not because she was trying to be cute, but because she was really trying to keep the dress together. It became a style and a fashion, but she was the first person I ever saw to wear that style.'

Candy Darling was born James Slattery in 1944 and was brought up by his mother and alcoholic father on Long Island. Inspired by Hollywood movies and stars like Joan Crawford, he began dressing as a woman during his teens. By 1963–4, she was living with the drag name Hope Slattery and visiting a 5th Avenue doctor for hormone injections. By 1967, she was a close friend of Curtis, who gave her a role in her off-off Broadway play *Glamour, Glory and Gold (The Life & Legend of Nola Noonan, Goddess & Star)*, which opened in September 1967.

The play sold out every night and was revived in August 1968 with a fresh cast, including a young Robert De Niro. This notoriety attracted Warhol, who, even after his near-death experience, was still searching for the new and the unexplored. As he told Pat Hackett in *POPism*: 'As late as '67 drag queens still weren't accepted in the mainstream freak circles. But then, just like drugs had come into the average person's life, sexual blurs did, too, and people began identifying a little more with drag queens, seeing them more as "sexual radicals" than as depressing losers.'

Jayne County had taken a 13th Street flat with the aspiring photographer Leee Black Childers that year and remembered seeing Jackie 'walking along Christopher Street, this bizarre creature with frizzy red hair, a ripped dress, no eyebrows, bee-stung lips. A Puerto Rican queen yelled out, "Girl, I could read you from blocks away!" The other drag queens didn't really understand Jackie. She wasn't trying to be a woman, she had this totally individual freaky style.'

———

Aweek after the premiere of *Flesh*, in early October, the Velvet Underground played their first date without John Cale, at La Cave in Cleveland. In a climactic power struggle, Lou Reed had ousted him from the group early that autumn. His vision was for something more conventional, even softer, that foregrounded his lyrics and dialled down the sonic extremes. Having coerced Sterling Morrison and Maureen Tucker into agreement, he refused to tell Cale himself, sending a simmering Morrison to do his dirty work.

After replacing Cale with the twenty-year-old Doug Yule, a versatile but more conventional rock musician, Reed became the group's leader; from then on, they would be cast in his mould. During November, the group recorded ten songs for their next album, most in a softer and more intimate vein. Among them was 'Candy Says', a song inspired by Candy Darling and sung by Doug Yule that explicitly addressed her gender dysphoria: 'Candy says / I've come to hate my body / And all that it requires in this world.'

That same month, the underground magazine *Open City* printed a long, rambling rap with Reed, in which he explored his conflicted feelings about his former mentor: 'I don't want to get into a conversation about Andy Warhol – but he is simply the Best, that's all there is to it; he is the Finest.' Reed talked about **** ('fantastic') and *a: a novel* ('the most fantastic book you've ever seen)', before concluding with 'All right, that's the end of the Andy rap. We're not connected with Andy anymore.'

Like *Index*, however, *a: a novel* was out of date by the time it appeared in November 1968. With the customary lag between manuscript delivery and the finished book, the publishing house failed to keep up with Warhol's lightning-fast adaptations. Its principal protagonist, Ondine – taped in August 1965 and early 1967 – had decamped, and the moment that the book sought to prolong was already long gone. Not that it mattered much, as it was met with incomprehension and, in the case of the *New York Times*, which called it 'pornography', active hostility.

It didn't matter. Warhol had left that ghost way behind. Frank sex films and transgender superstars would dominate his next phase, into the early 1970s, and it was this Warhol incarnation that would finally travel to the UK, with unforeseen and barely calculable results.

PART 4
January
1973

22
David Bowie

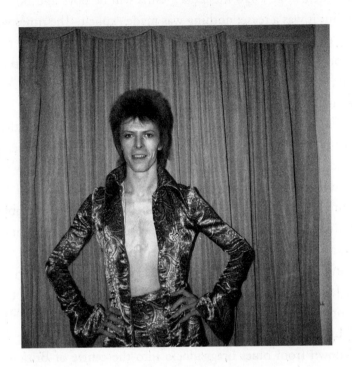

The Bowies occupy the ground floor of a large baronial-looking house in Beckenham called Haddon Hall. The curlicued ceiling of their living room, which used to be a study, is sprayed with gold paint, which he cheerfully admits he bought from Woolworths. On the mantelpiece are framed photographs of Rudolph Valentino, Marilyn Monroe and Greta Garbo, wearing a beret and in an almost identical pose as on the back cover of one of his old albums, *The Man Who Sold the World*. On a side table are stacks of glossy pictures of Jimmy Dean with *16* magazine stamped on the back. 'He was a very passive, gentle person,' Bowie remarks, 'and an experimenter all the time.'

Michael Watts, unpublished profile of David Bowie, summer 1972 (written for the *Sunday Times*)

D avid Bowie blew the whole topic wide open. Sixties stars like the Rolling Stones and the Kinks might have flirted heavily with androgyny – and, indeed, the Kinks put gender confusion at the heart of their huge 1970 hit 'Lola': 'Girls will be boys and boys will be girls' – but it was a tease; nothing was made explicit. The times were not right. It took Bowie's January 1972 admission that he was gay to finally bring some honesty into the discussion of homosexuality in the music industry, and indeed the country in general.

In Britain, during the 1950s and early '60s, homosexuality had been taboo. Under considerable legal and social duress, it had been the love – for over half a century – that rarely dared to speak its name. By the mid- and later '60s, 'queer' and 'homosexual' had become 'gay': a word used to denote a new assertiveness, if not pride, in the face of a continuing stigma. By the early '70s, homosexuality – or its more palatable form, bisexuality – had become fashionable in certain parts of popular culture. Clearly, a sea change had occurred.

In early 1973, the influence of homosexuality permeated British pop. On 20 January, the #2 and #3 records in the UK charts were two variations on the same theme: 'Blockbuster!' by the Sweet and 'The Jean Genie' by David Bowie. Both used the same six-note riff, one that had passed down from blues braggadocio into the centre of Britain's youth culture. 'I'm a man,' the riff's first populariser had declaimed in 1955, but, seventeen or so years later, what kind of men were these?

'The Jean Genie' was Bowie's biggest hit thus far. Released in late November 1972, it climbed up to #2 by mid-January, boosted by an appearance on *Top of the Pops* in which he and his group, the Spiders from Mars, performed the song live, Bowie blowing furiously into his harmonica as though it was 1964 and the Marquee all over again. This was not the customary camera-savvy mime, but an approach that was at once artistic and privileged, befitting the twenty-six-year-old performer who had become the hottest thing in the country.

Enhanced by a solarising effect and the use of a fish-eye lens on the camera, the clip was both exciting and strange. Bowie was dressed in a long, flowing frock coat of many hues, with no shirt underneath, showing a bare chest above light blue, pleated pants, while featured guitarist

Mick Ronson, his hair dyed blond, pumped out the distorted riff in a glittering jumpsuit, cut off at the knees. In the background, a row of selected dancers – men and women of various races – danced with obvious enjoyment and glee.

The performance captured the original spirit of the song's inspiration: the punkish R&B of the Yardbirds and the Rolling Stones' first album, the kind of sound that Bowie had heard and played as a teen in the mid-1960s London clubs. 'The Jean Genie' had originated in late September the previous year, when Bowie and the Spiders were travelling between Cleveland and Memphis on their American tour. Beginning as a jam on John Lee Hooker's 'I'm Going Upstairs', it quickly transmuted, in Bowie's hands, into a version of the 'I'm a Man' riff.*

The biweekly paper *Gay News* suggested at the time that the title was a pun on the author Jean Genet, but this does not seem to have been Bowie's intention, even though the lyrics were allusive and ambiguous. Despite gay hints and a healthy dose of hands on hips in the *Top of the Pops* appearance, the song was partly written to entertain Bowie's new fling, Cyrinda Foxe, who appeared in the video that Mick Rock shot for the song in downtown San Francisco. This was performative bisexuality, at once brutal and subtle, with a healthy dose of elitism.

Leapfrogging over Bowie on the way to #1, 'Blockbuster!' was a pop product, pure and simple. Whereas Bowie wrote and performed 'The Jean Genie', the Sweet's single was produced by Phil Wainman and written by the successful team of Mike Chapman and Nicky Chinn, who had already provided the group with three Top 5 hits. Many of these were basic Europop, with titles like 'Co-Co', 'Wig-Wam Bam' and the schoolboy snigger 'Little Willy', which were performed well by the group, but 'Blockbuster!' was something else.

The Sweet were not a studio aggregation nor a thrown-together boy band, but a skilled pop/rock group who had been making records since the late 1960s. While they enjoyed the attention and the money that the hits brought, they were always seeking to make tougher records. On

* According to his account in May 2023, George Underwood, Bowie's one-time bandmate in the King Bees and a companion on the US tour, started playing the Hooker riff, and Bowie adapted it into the six-note grind.

'Blockbuster!', Chinn and Chapman went with the flow, moving from the novelty of 'Little Willy' and perkiness of 'Wig-Wam Bam' to something much harder. Introduced by the hair-raising sound of an American police siren, 'Blockbuster!' is almost mathematically designed to make the strongest impact. The lyrics impart a feeling of menace, if not actual threat, while the production highlights Andy Scott's reverbed guitar and drummer Mick Tucker's booming timpani.

'Blockbuster!' was released on 2 January 1973, four weeks after 'The Jean Genie' had entered the Top 40. The similarity between the two records was instantly remarked upon – even more so because they were released on the same label, RCA – and initial comparisons did not favour the Sweet, particularly after a disastrous launch at Ronnie Scott's Jazz Club on the 11th. Despite the muttered hints of industrial espionage, it does seem as though ripping off that particular riff was a good idea that occurred to two sharp pop minds at the same time.

As *Top of the Pops* veterans, the Sweet's appearance was pure burlesque, one eye always on the camera's red light. Wearing a huge Iron Cross, Brian Connolly played it as straight as possible, while the two guitarists cavorted to his side. Wearing heavy cat-style make-up, bassist Steve Priest exaggerated his squeaked featured line – 'We haven't got a clue, what to do!' – while waggling his fingers. The effect was both hilarious and reassuring. Despite the song's power, this was show-business camp, albeit amplified.

By the end of the month, the battle was won. Rising to #1 on 27 January, 'Blockbuster!' stayed there for four weeks, while 'The Jean Genie' slowly faded out of the Top 20. Both were electrifying records; the extraordinary thing was that the commercial pop of the moment admitted such blatant exploitation of homosexual mannerisms, and indeed, that those mannerisms were overlaid onto a guitar figure that had begun as an expression of Black American machismo.

As translated by Bowie and the Sweet, the riff had first appeared on Muddy Waters' version of Willie Dixon's 'Hoochie Coochie Man', released in January 1954 – a blues song of male virility. In the hands of Bo Diddley, who released his variant, 'I'm a Man', in April 1955, this braggadocio was streamlined for the rock 'n' roll era: 'All you pretty women / Stand in line / I can make love to you baby / In an hour's time.'

This version was the first to introduce the phrase that rammed the point home: 'I'm a man / A-spelled M-A-N.'

Diddley's song was a founding rock 'n' roll document and, despite other songs with the same name – like Fabian's 'I'm a Man', written by Doc Pomus and Mort Shuman, and aimed at the pre-teen market – it became the standard version. In the mid-1960s, it was covered by British hard mod groups the Who and, in particular, the Yardbirds, in whose hands it became the launch pad for the guitar pyrotechnics of Jeff Beck, as he duelled with the harmonica of singer Keith Relf.

In that decade between Bo Diddley and the Yardbirds, the notion of masculinity as expressed in pop culture had undergone a considerable transformation. As seen on popular American TV shows like *Shindig!*, the Yardbirds were skinny and smart, looking more like art students than beat musicians. As a frontman, Relf offered ambiguous menace, with his long blond hair styled into a perfect bowl cut and his eyes hidden by enormous Continental sunglasses. Here, power was expressed not through physical strength, but through withdrawal and aloofness.*

This revival of 'I'm a Man' fit the new pop mood in 1973. Having split from pop in the later 1960s, rock had become obsessed by authenticity and technique at the decade's turn. While providing some highly enjoyable hit singles – almost by default – these ideas became of zero interest to a younger pop generation, born in the early '60s, who found themselves awakened by the appearances of Marc Bolan on *Top of the Pops*, in particular when he promoted 'Hot Love' in March 1971.

Bolan's glitter look happened almost by accident, when his assistant, Chelita Secunda, decided to style him for that appearance. As Bowie's producer Tony Visconti recalled: 'Chelita saw that Marc was very pretty. It was her idea to take Marc round town and hit the women's shops, getting him the feather boas and the beautifully embroidered jackets he wore. [She] was the first person to really make up Marc. She didn't just put some eye make-up on him, she threw glitter on his cheeks.'

* In August 1965, the Yardbirds performed 'I'm a Man' on *Shindig!*, a performance transformed by Jeff Beck's guitar antics: taking his instrument off and playing the feedback; plucking the top strings and echoing Keith Relf's harmonica in an electrifying duet. This was a huge influence on many US garage bands.

Silver, glitter and highly coloured, feminine clothes became Bolan's calling card as he romped through massive hit singles like 'Get It On', 'Jeepster', 'Telegram Sam' and – his absolute zenith – the spring 1972 #1 'Metal Guru'. They amplified his high, almost feminine vocals and obvious delight in bright, sparkly clothing. The package was fresh, highly sexual yet androgynous, and it began to pull British pop along in its wake. Very quickly, Bolan and T. Rex were seen as standard-bearers for a new pop generation.

———

T he glam arms race had begun. Throughout 1972, acts like Slade, Roxy Music and the Sweet began to pile on the glitter and the ambiguity, vying with each other in outrageously hammy *Top of the Pops* appearances. Whether consciously or not – and much of this was simply a new pop style – these stars were, in their very different ways, playing around with the ideas and possibilities of masculinity: what it was to be a man; how to be a different kind of man.

In doing so, even to the point of appearing to be homosexual – when the reality was, as it sometimes is, more complicated – they were crossing one of British culture's great taboos. Five or so years after the passing of the Sexual Offences Act, this was a new generation, one where boys could be more feminine and, at the same time, if that was what they wanted, remain attractive to girls. Certainly, Bowie had no shortage of female fans, and they started screaming around the time that 'The Jean Genie' became a big hit.

The explicit harnessing of homosexuality to this new pop mood had happened almost exactly a year before, when Bowie gave an interview to Michael Watts and Barrie Wentzell of the *Melody Maker* while promoting his new album, *Hunky Dory*. Bowie was moving very fast during this period: in January 1972, he was already halfway through recording his next album, which was to feature, in part, a harder rock sound inspired by Iggy and the Stooges. Bowie wanted an edge, and he also felt the pressure to be truthful about himself and his friends. So he came out.

'I set the interview up with his management,' Watts remembers. 'I'd listened to *Hunky Dory* and I just thought it was extraordinary. I could sense there was quite a lot to him. I hadn't been prepared, however, for the figure that I found in the offices of Gem Management. Bowie did look great. He was dazzling, that was my impression when I first met him. I've never interviewed anyone at all who was like this. At that point, with the exception of perhaps Bolan, it was a time of London prole rock. Long hair, beards – which I had myself! – and dressing down.

'This was another way that Bowie distinguished himself. He told me: "You'll never, ever see me in jeans. I never wear jeans." He was keen to promote this fashion image of himself. We were knocked out by how Bowie looked, with the red plastic boots and the jumpsuit and the hair-cut – and the sexual frankness. I understand why people think it was a PR stunt, but I can't say that was the predominant motive. I think he understood that what he was saying was going to have an impact, but I think he was being honest about bisexuality.'

As published on 22 January, under the cover headline of 'Oh You Pretty Thing', Watts's piece began by focusing on Bowie's appearance, but quickly slipped into a discussion of his use of Polari – 'David uses words like "varda" and "super" quite a lot' – and his homosexuality: 'David's present image is to come on like a swishy queen, a gorgeously effeminate boy. He's as camp as a row of tents, with his limp hand and trolling vocabulary. "I'm gay," he says, "and always have been, even when I was David Jones."'

Watts observed 'a sly jollity about how he says it, a secret smile at the corners of his mouth. He knows that in these times it's permissible to act like a male tart, and that to shock and outrage, which pop has always striven to do throughout its history, is a balls-breaking process. And if he's not an outrage, he is, at the least, an amusement. The expression of his sexual ambivalence establishes a fascinating game: is he, or isn't he? In a period of conflicting sexual identity he shrewdly exploits the confusion surrounding the male and female roles.'

Bowie's admission of homosexuality, however gleeful and amused, was qualified in the piece by his 'good relationship' with his wife Angie and son Zowie: 'He supposes he's what people call bisexual.' Indeed, despite his long affiliation with gay people in and outside the music industry, he

claimed that he didn't have much time for gay liberation – not wishing to be a figurehead and despising what Watts called 'these tribal qualifications'. Preserving his individuality and independence was of supreme importance.

Wearing dresses, like he did on the cover of *The Man Who Sold the World*, was a part of his outrageousness, his deep desire to be different. But, as the singer observed, society was moving towards him: 'It's just so happened, he remarks, that in the past two years people have loosened up to the fact that there are bisexuals in the world – "and – horrible fact – homosexuals". He smiles, enjoying his piece of addenda. "The important fact is that I don't have to drag up. I want to go on like this for long after the fashion has finished. I'm just a cosmic yob, I suppose."'

Watts knew he had a sensational interview, and to their credit, his editors at the *Melody Maker* ran with it. 'It was a departure for them,' he now says, 'given the nature of the paper and its perhaps rather hetero view of what pop should be. It would be interesting to look back and see how they treated, say, Johnnie Ray. He must have appeared in the paper. Everybody knew about Dusty Springfield, but nobody wrote about it. So, of course, I come along and give them something that is very different.'

Editors Ray Coleman and Richard Williams realised that it was a scoop. When they saw Barrie Wentzell's pictures, that sealed the deal. As Watts remembers: 'Within days, Bowie had gone from being nowhere, really, or even a kind of has-been, even with the release of *Hunky Dory*, to setting the world on fire. I think I did the interview on the Friday, and on the Monday it was on the front. That was the way the *MM* functioned back then, it was very news-orientated. We had power then, the power to make and break.'

Bowie's appearance on the front cover of *Melody Maker* was a rupture, but he wasn't the first to make a statement about bisexuality. In September 1970, the *Evening Standard*'s Ray Connolly had conducted an interview with Dusty Springfield, in which the always impulsive singer blurted: 'I'm going to get into something nasty here. But I've got to say it, because so many other people say I'm bent, and I've heard it so many times that I've almost learned to accept it. I don't go leaping around to all the gay clubs but I can be very flattered.

'Girls run after me a lot and it doesn't upset me. It upsets me when people insinuate things that aren't true. I couldn't stand to be thought of as a big butch lady. But I know that I'm as perfectly capable of being swayed by a girl as by a boy. More and more people feel that way and I don't see why I shouldn't. There was someone on television the other night who admitted that he swings either way. I suppose he could afford to say it, but I, being a pop singer, shouldn't even admit that I might think that way. But if the occasion arose I don't see why I shouldn't.'

Clearly, the pressure of having to conceal who she really was had reached a critical point. In his account, Connolly gave her a chance to retract her admission, but she refused. 'As we lived near each other I drove Dusty home after the interview, during which she mused jokily that what she'd just told me "might put the final seal" on her doom. But she'd made her mind up. She wanted me to write it – although she couldn't quite bring herself to say that she was a lesbian.'

The strange thing was that, unlike Bowie fifteen months or so later, there were very few repercussions from this brave admission. There was a sense that Dusty's career was on the slide, and also, perhaps, an exercise of male privilege in the fact that Bowie got a lot of attention, whereas a woman didn't. But the key thing was timing and attitude: Bowie was gleeful, mischievous, in control – not at all guilty or tormented – which chimed with the emerging gay liberation movement and the relaxations of post-1960s pop culture.

There have been many interpretations of why and how Bowie came out. There was a definite sense that it was opportunistic: as Watts has stated, 'I think he said it very deliberately. He definitely felt it would be good copy. He was certainly aware of the impact it would make.' Talking to Steve Turner a couple of years later, when the fuss had all died down, the writer added: 'I'm sure he did it for publicity. He's a bright boy. I think that he sensed that it was becoming vogueish, that the permissive was becoming permissible.'

However, there was another interpretation, offered by Bowie himself in Watts's unpublished profile for the *Sunday Times* in summer 1972. 'It's just that I'm tired of pretending,' he said, referring to the January interview. 'There are some situations where one would have to pretend to be

totally heterosexual and that bores me because it's not true. So I thought, let's drop this particular sham and just see how honest one can be, and if it does come off it will make things a lot easier for me.

'I could've got away with saying not a thing all the time I was in the pop business, but it would've made things so difficult for me with my life socially. The guys that I know as friends are very positively gay, and I couldn't lead that kind of existence in the papers saying I had Sophia Loren last night and it'll probably be Raquel Welch tonight. You see, because I've been involved with so many theatre people in my career the whole thing about my sexuality is that it's just such a way of life I've neglected to realise how unintelligible it seemed to most rock people.'

'He was just sexually very fluid,' Watts now says. 'As far as I know, he had many more heterosexual relationships than homosexual ones, but I think there's little question that he and Lindsay Kemp were an item, and there were others, particularly early on in his career. Gay sexual activity only became legal in 1967, after Lord Arran and Leo Abse sponsored bills to implement the Wolfenden Report – so he liberated that generation in the 1970s to be open about their sexuality.'

———

It was a question, then, of being faithful to your friends and your milieu. In fact, Bowie had been doing a tour of the gay world from 1964 onwards, around the time he and Marc Bolan met while scuffling around the dustbins of Soho, looking for cast-off clothes. He remembered himself in *Disc* magazine as 'a Wardour Street pill head', a baby mod wearing make-up and ankle swingers. 'But if you were going to wear all the make-up you had to be really swingy, really butch. It was camp with balls, that's what it felt like.'

In 1965, he was managed by Ralph Horton, who introduced him to Kenneth Pitt. Gay was definitely not good back in the mid-1960s, Steve Turner noted in his interview with Pitt, who elaborated: 'It certainly wasn't the chic thing to be. Bowie was self-conscious about his own bisexual tendencies, and didn't want anyone to know. Nobody at that time knew he was gay except for me and Ralph Horton. When I first met

Ralph, he warned me that David was "mixed up". That was all . . . that was his phrase for it. David would have gone to any extreme at that time to avoid it being known.'

In 1966, Bowie was nineteen, already experienced in the music industry: raw enough to be shaped by his older manager, yet determined enough to forge his own path, by however tortuous a route. The first successful result of the partnership was 'The London Boys', a tough song about the dark side of the homosocial, pill-popping mod scene released in late 1966 that came out on Bowie's fourth record label, the newly formed Decca subsidary Deram. That was a mere taster compared to what was to follow.

In the second week of November 1966, Pitt visited the Factory and met Warhol, with the idea that Pitt would promote *The Velvet Underground & Nico* album in the UK. Nothing came of this meeting, but Pitt returned to the UK with an acetate of the album, which he gave to his young charge. Bowie received it as a revelation: 'This music was so savagely indifferent to my feelings. It didn't care if I liked it or not. It could [not] give a fuck.'

In April 1967, Bowie recorded one of the very first Velvet Underground covers, a version of 'I'm Waiting for the Man', with the Riot Squad, whom he had just joined. After the sudden death of Joe Meek, the Riot Squad were casting around for a new direction, and Bowie's use of make-up and focus on mime seemed to fit the bill; for his part, Bowie was interested in working with other musicians. Despite this cover – and the recording of another Velvet Underground-influenced song, 'Little Toy Soldier' – the collaboration didn't gel.

After leaving the Riot Squad, Bowie again tried to cover 'I'm Waiting for the Man' during the sessions for his first album, a strange, vaudevillian, almost childlike affair that accorded to no current trends and sold very few copies. The influence of the Velvet Underground was muted, but there was a hint of dissonance and gender-swapping in tracks like 'She's Got Medals' and the contemporary single 'The Laughing Gnome'. It would take a while for Bowie to fully digest and transcend these influences.

Pitt went on to manage Bowie for around three more years. From an older generation, he was oriented towards more traditional show business – musicals, cabaret, film acting – and for a while Bowie, ever the

chameleon, took on this cloak. His career between spring 1966 and his first hit, 'Space Oddity', in late autumn 1969, showed wild variations of style and medium: from the unique but not totally worked-through fusions of his first album, *David Bowie*, to experiments in film, mime, decadence, folk and straight pop.

The two even lived together, which in Pitt's memory created tensions: 'He derived comfort from leaving off his clothes, sometimes sitting cross-legged on the floor encircled by blaring hi-fi speakers, sometimes just loping around the flat, naked, his long, weighty penis swaying from side to side like the pendulum of a grandfather clock. In this disrobed state he would stand at the sink washing the dishes, much to the joy of the girls whose flat overlooked our kitchen, but I soon spoilt their fun by affixing self-adhesive Decolite to the bottom of the window pane.'

In April 1969, Bowie met Calvin Mark Lee, who was an A&R man for Bowie's new label, Mercury Records, at the Speakeasy. Lee was from San Francisco, a doctor of philosophy, and openly gay. He worked Bowie's first single for Mercury, 'Space Oddity', into a hit, lending Bowie a silver catsuit for his first-ever *Top of the Pops* appearance.

Lee introduced Bowie to Angie Barnett, an American citizen born in Cyprus, who very quickly became his partner in crime. The trio went frequently to Yours and Mine, a very fashionable gay bar in the basement of the Sombrero restaurant in Kensington High Street. This was, as scenester Peter Burton wrote in the gay magazine *Jeremy*, 'the trendy, dolly scene where the impression is that if any of the boys, or girls, have sex it's in front of their bedroom mirror – on their own'.

Immersing Bowie in the gay world, Barnett and Lee took the singer out of Pitt's orbit. As Angie remembered, Pitt was 'very much a man of his generation. He and his contemporaries were queens who knew their place: safe in the closet. They wouldn't dream of challenging the system that dictated that the closet was their only choice, and therefore somebody like David, or me, was dangerous to them. To make no bones about one's deviance from the one true sexual path – to flaunt one's bisexuality or homosexuality in public – was an invitation to disaster.'

On the road to liberation, Bowie gave an interview to *Jeremy* in February 1970. The profile was written by Tim Hughes and Trevor

Richardson, who followed Bowie as he performed three solo acoustic concerts in late 1969 and early 1970 at the Palladium (as part of a Save the Children charity show), the Purcell Room on the South Bank and the Speakeasy. Bowie and Angie had just moved into Haddon Hall – as Hughes and Richardson described it, 'a stunning and monstrous folly of a place in deepest Beckenham'.

His sensitivity and alienation was highlighted: 'David is a refreshing change from so many of the inarticulate and untalented charlatans currently littering the world of pop. He doesn't think they have anything to contribute, though the public are not taken in for long.' Bowie told the pair: 'I am a loner. I don't feel the need for conventional relationships.' Despite the fact that his sexuality was not mentioned, the mere fact that he gave an interview to an avowedly gay magazine was a sign of his willingness to be affiliated to that subculture, a definite marker.

Nineteen seventy was a difficult year for Bowie. After four years as his manager, Pitt was ousted in April, and Bowie transferred his business to a young lawyer, Tony DeFries. Early in the year, he started working with his future key collaborator, guitarist Mick Ronson, who played on Bowie's third album, *The Man Who Sold the World* – a fascinating and frustrating mix of elegant, disturbing ballads about madness and alienation, lumpy rockers and a keynote nine-minute exploration of occult sexuality with gay overtones, 'The Width of a Circle'.

During his first visit to America to promote the album in January 1971, things came into focus. By this stage, Bowie was wearing the famous Mr Fish dress. As Angie Bowie – the pair had married in March 1970 – later explained, she saw the dress in Mr Fish's studio. There were two: 'They were gorgeous: silk velour of the best, softest quality, exquisite Chinese frogging across the front, V-necks, ankle-length hems; amazing work. I showed them to David and he flipped too. He scooped up the robes and headed for the fitting room despite the price Mr Fish had quoted us, a prohibitive £300 apiece. When he came out you could have heard a butterfly swoon. Mr Fish and I both stood there openmouthed, silent, awestruck.'

Bowie wore the salmon pink and blue dress on the cover of the UK edition of *The Man Who Sold the World*. The photographer Keith McMillan

shot him in Haddon Hall, where he reclined on a chaise longue. This blatant androgyny was immediately picked up by the UK music press: in April 1971, *Melody Maker* ran a humorous interview with Chris Welch headlined 'Why Does David Bowie Like Dressing Up in Ladies' Clothes?' 'It's a pretty dress,' Welch quoted Bowie as saying. 'I had to go to Texas, so I thought I'd test the reaction.' Bowie also wore it on the cover of the May 1971 issue of the sex magazine *Curious*, where he was pictured with his new protégé, Freddie Burretti, aka Rudi Valentino.

A song premiered that June set Bowie's gay fascinations to an arrangement that was more powerful than anything he had hitherto recorded. In a mix defined by Mick Ronson's dirty, slicing guitar – an update of his hero Jeff Beck's ability to dominate a track – 'Queen Bitch' had a storyline and approach taken directly from Bowie's long-term obsession, the Velvet Underground. The street-hassle lyric talks about 'cruisers' and 'sweet-talking, night-walking games', while genders slide all over the place.

The scenario pictures a singer transfixed by jealousy of his street-walking boy/girlfriend, who is picking someone up right under his nose. The word 'she' is frequently used, but this could merely be camp badinage: 'but she's a queen and such a queen'. The song climaxes in emptiness after a lyric that doubles as a catty sideswipe at his old friend, and then more successful rival, Marc Bolan: 'She's so swishy in her satin and tat / In her frock coat and bipperty-bopperty hat / Oh God, I could do better than that.'

As a manifesto, 'Queen Bitch' was hard to beat. It remains one of Bowie's finest songs, a masterpiece of demotic gay slang and cutting guitar tone – the first time that he had recorded something that matched the Velvet Underground. Within weeks, Bowie had the opportunity to enter the world of Andy Warhol in person, when the show *Pork* opened at the Roundhouse. Edited by Anthony Ingrassia from 200 hours of Warhol's taped conversations and featuring defecation and homosexual intercourse, *Pork* was as sensational as any thrill-chaser could desire.

Apart from among a few hipsters and art mavens, Warhol hadn't really penetrated the British consciousness until 1971. 'That was Andy's big launch in this country as far as he was concerned,' remembered Leee

Black Childers, who had travelled over with the cast as stage manager, 'but we didn't understand because we were Americans. We didn't know the power of the British tabloid. They were saying horrible things about us. There were pickets out front of the Roundhouse. As the audience was coming in, people were saying, "Immoral" and things.'

As well as Warhol's world, *Pork* brought the fashions of his drag queen milieu to the UK for the first time. 'We wore a lot of sequins,' Childers remembered, 'we wore a lot of glitter, we wore a lot of makeup all the time. Because already from the underground scene, we'd progressed into that. Now we had of course Warhol's magic name behind us. So everybody was looking at us.

'We would get the *NME* and we'd look to see there in the back all the ads of who was playing. There was this little ad that said David Bowie at the Country Club at Hampstead. I said, "Oh, I read about him. He wears dresses," and [Jayne] County said, "Oh, he wears dresses! Let's go. Let's go. Let's go!" We got there: it was a very small place, and not many people in the audience. I couldn't tell you exactly, but like around 30 in the audience. Then he sang "Andy Warhol", and then he introduced us. He said, "Some of Andy Warhol's people are here."

'We told him to come see the show. Then they came and saw *Pork* many times, and we went and hung out with them at the Sombrero, Yours and Mine, a bar. A gay bar on High Street Kensington. We would go there all the time . . . We would dance with Mick Ronson and we'd dance with Angie and Dana and everything. David would just sit there, but we went to that gay bar a lot. We got to really know them well then.'

Two weeks after the final performance of *Pork*, Bowie went to America to sign with RCA Records and – thanks to his new friends – to meet the cream of New York. On 9 September, he was introduced to his touchstones Iggy Pop and Lou Reed, who pronounced himself impressed with 'Queen Bitch'. A few days later, Bowie encountered Andy Warhol. The meeting did not go well – Warhol did not like Bowie's tuneful tribute song or his attempts at mime – and only took off when the artist remarked on Bowie's gold and yellow shoes.

Bowie was unfazed. On his return to the UK in October, he played a benefit for the Gay Liberation Front at London's Seymour Hall, before

beginning rehearsals for his next album. The new material was more uptempo, rockier and raunchier – songs like 'Hang On to Yourself', 'Sweet Head' and 'Velvet Goldmine'. At the same time, Bowie was carefully repositioning himself in contrast to the pop culture of the day; as a fan of the communications theorist Marshall McLuhan, he understood the media all too well.

'I feel we're all in a fucking dead industry,' he told the UK's *Cream* magazine that November. 'Rock should tart itself up a bit more, you know. People are scared of prostitution. There should be some real unabashed prostitution in this business.'

Hunky Dory was released in December 1971, two weeks before Christmas. A melodic and lyrical tour de force, it captured Bowie in the transition between being a singer-songwriter, a songwriter for hire, an occultist and philosopher, and the hard-rocker to come. But despite its quality and Bowie's successful repositioning in the eyes of the press, the album was not an immediate success; nor was its accompanying single, 'Changes', flying out of the shops in the first month of 1972. Bowie was already planning his next move, however. Shortly after Stanley Kubrick's film of *A Clockwork Orange* opened in mid-January, Bowie went to see the film with Mick Ronson and freely adapted some ideas and the visuals.

By then, he had most of his next album in the can, but seeing *Clockwork Orange* enabled him to stiffen up the concept. Bowie was moving at warp speed, trying anything and everything to cut through a moribund pop culture and launch himself again into stardom – this time, on a surer footing. Clearly, something sensational was needed, and the opportunity came with *Melody Maker* and Michael Watts. But it wasn't out of the blue: his coming out was merely the culmination of an idea and a series of associations that had been bubbling away for nearly three years. Nevertheless, the impact was immediate and intense.

'When he announced his bisexuality to me,' Watts remembers, 'there was complete uproar. DeFries backed Bowie all the way, but even he was surprised that he'd made that announcement. They had an interesting relationship, I think . . . The creative ideas came from David, but without DeFries, I don't think he would have been as big a star as he became.'

Over the next few weeks, Bowie finalised the track listing for what he hoped would be his breakthrough statement, *The Rise and Fall of Ziggy Stardust and the Spiders from Mars*, and recorded three more key songs – 'Suffragette City', 'Rock 'n' Roll Suicide' and, in early February, his next single, 'Starman'. On 7 February, he and the Spiders unveiled their new *Clockwork Orange*-inspired outfits on the BBC's *Old Grey Whistle Test*, where he played 'Queen Bitch', despite the apprehensions of producer Michael Appleton.

'Starman' was released on 28 April, and to promote the record Bowie gave an interview to Rosalind Russell of *Disc*, who wrote that 'he delights in the unexpected, the shocking – an accomplishment itself these days. His audiences now are at first wary of the cultured effeminacy, but Bowie is a past master of theatrical effect and there is always the doubt, the feeling that it's all a display – but you just can't be sure. Bowie is glamorous, a peacock among the pigeons in the music world.'

The piece was headlined by the phrase 'Bent on Success', a pejorative wording which showed the attitudes of some men – particularly editors and subs – in the music press. This in turn got a hostile reaction from the Gay Liberation Front: as the British newspaper *Gay News* reported: 'The Sub-Editor excused himself out of this by claiming that these were standard phrases used in the paper. GLF's argument is "Every week in your paper [*Disc*] we read something which takes our cause in vain. It's hard enough as it is, without you being snide and making fun."'

An attractive single with a melody highly reminiscent of 'Over the Rainbow', 'Starman' hit the spot with a science-fiction lyric of extra-terrestrial benevolence that expressed a warm inclusiveness. But, despite a series of sell-out shows and a building momentum, it took nearly two months to appear in the UK Top 50, which it did in late June, by which time *The Rise and Fall of Ziggy Stardust* had been released – to excellent reviews – and was entering the charts.

Bowie needed to pull out all the stops. Just over a week later, he played a show in Oxford, where, in the finale, 'Suffragette City', he simulated fellatio on Mick Ronson's guitar. He made sure that his friend Mick Rock got the shot, which shows an audience at once surprised and delighted. Two weeks later, with 'Starman' at #41, he played *Top of the Pops*, a

performance that resonated with a sub-generation of British teenagers and finally catapulted him not just into stardom, but into a position of central cultural importance.

Skinny and heavily styled, Bowie was relaxed and having a good time. When the lyric came to the phrase 'picked on you-ooh-ooo', he twirled his finger and pointed directly at the camera. The moment that truly resonated occurred when he started to sing the first chorus. As Ronson approached the microphone, a grinning Bowie suddenly swept his arm over Ronson's shoulder and pulled him to the mike. It wasn't just the hint of homosexuality that made it so powerful, but the sense of tender comradeship that went beyond sexuality.

While 'Starman' and *The Rise and Fall of Ziggy Stardust* continued to climb the charts in midsummer, Bowie busied himself with promoting his new protégés and inspirations Lou Reed, Iggy Pop and Mott the Hoople. On 14 and 15 July, Reed and Iggy and the Stooges played their first concerts in the UK; the latter's shows, in particular, were a ferocious display of razor-sharp, guitar-driven rock, with a level of audience confrontation never before seen in the UK.

Also key to this was Bowie's decision to exploit and amplify the generation gap that was in the air, highlighted by the song that he gave to Mott the Hoople, a dynamic hard-rock band that had fallen on hard times. With its dismissive lyric about the Beatles and the Rolling Stones – 'We never got it off with all that revolution stuff' – 'All the Young Dudes' posited an explicit break with the 1960s and helped to make that happen when it became an era-defining Top 3 hit in the summer.

The process worked both ways. Bowie was hot enough to underwrite the relaunch of the stalled careers of charismatic performers. They got hits; he got glamour by association. By exercising his patronage, he showcased the artists who epitomised the way he thought pop and rock music should go and, with his productions, enabled them to have the impact that he felt they warranted. In this way, he was not only a performer, writer and singer, he was an impresario, someone whose importance went beyond simply becoming a pop star.

In his unpublished *Sunday Times* profile, Michael Watts affirmed Bowie's generational importance, stating that the music industry cognoscenti

were expecting him to revitalise 'a business that is looking hungrily for new superstars to replace the Hendrixes and the Janis Joplins. After a long hiatus . . . a glamour and mystique of Hollywood proportions is suffusing the rock scene in the compulsive shape of Mr. Bowie.'

Watts singled out Bowie's professed bisexuality as the single factor that made him special. It spoke of a new honesty around the topic of homosexuality and chimed with the sexual freedoms of the early 1970s. While the younger females in his fanbase didn't quite understand what was going on, the slightly older males seemed to identify very heavily with the singer, to the point of obsessiveness. Indeed, he had just received his first dirty letter from a male fan: 'Bowie's reaction is one of slight shock and amusement. He's aware that there will be repercussions.'

In *Beat Instrumental* that August, Steve Turner confirmed Bowie's importance in changing sex and gender attitudes, quoting the singer as saying: 'I'm a practising bi-sexual although I've never tried to put it over or make a meal of it. Now it happens to be trendy to be gay.' Turner also noted that 'despite his openness on the subject he's not a leading light in Gay Lib, although he may be something of a hero to the members of this organisation. "I know a few people that are in Gay Lib and they're people that obviously need it."'

Turner wondered 'whether Bowie felt there was a trend towards the bi-sexual star rather than the all out masculine or feminine image. I remarked on the number of glitter-eyed young boys who are seen at T. Rex concerts dancing with each other in the aisles. Bowie didn't see this as a new phenomenon. "What about Elvis Presley?" he asked. "If his image wasn't bi-sexual then I don't know what. I think Jagger's image was also very bi-sexual. People talk about 'fag-rock' but that's an unwieldy title at the best of times. I think it's all rock 'n roll."'

Bowie was correct in pointing out that he was, despite the sensation his comments had caused, part of a long continuum in pop performance. Androgyny was not new, but the real change was that, in 1972, twenty years after Johnnie Ray's first hit, Bowie had become hugely successful – in the UK at least – after an open and very public admission of homosexuality. In previous times, this would have been a career killer, but Bowie

not only flourished, but pulled along a whole section of British popular culture with him.

———

I n September 1972, Bowie released his next single, which was, as he described it, 'my attempt to do a bisexual anthem'. 'John, I'm Only Dancing' posited another scenario of jealousy, this time between a man seemingly in a gay relationship flirting with a woman and trying to make excuses for his attraction. The song was diffuse and the lyric slippery, but the kicker came in the chorus, with the repeated address to a man, John. As if to emphasise the confusion, the track ended with a stuttering, distorted guitar solo reminiscent of Pete Townshend's freak-outs for the Who.

The song was promoted with a video, directed by Mick Rock, that interspersed a dimly lit performance with footage of writhing male and female dancers. Bowie has a sharp orange haircut, with an anchor tattoo on his cheek. The whole clip is like something out of Jean Genet. It was banned by *Top of the Pops*. *Gay News* responded to director Hugh Attwooll's statement that it was a matter of taste: 'No-one who'd seen the last few weeks' *Top of the Pops* programmes would seriously think of the BBC as an arbiter of taste.'

During the week that 'John, I'm Only Dancing' entered the charts, on its way to its eventual peak of #12, Bowie began his first US tour, accompanied by the Spiders and a massive entourage that included Cherry Vanilla, Leee Black Childers and his old friend George Underwood. This was under the umbrella of the new company that Tony DeFries had formed in June 1972, Mainman.

A section of the American press and public were prepared for this visitation. In an article for the gay magazine *After Dark*, Henry Edwards recorded Bowie backtracking from his *Melody Maker* interview. '"That was hilarious," he gasps. "I didn't have a reaction. It was quite a good article. We drew bigger audiences than we had ever drawn!" David laughs again and then suddenly turns serious. "I get floored when people ask if I'm straight or gay or whatever. I don't want to recognise those categories. I refuse to. I will not be tied down by those sorts of things."'

The tour was a partial success. Bowie had a strong following in the major cities and on the coasts, but the whole top-heavy affair lost money. The gay subculture certainly responded, as *Melody Maker*'s Roy Hollingworth observed at Bowie's Carnegie Hall concert: 'There was much glitter, and several men dressed as ladies. As somebody quite rightly said, "The '60s are over, well and truly over."'

––––––

I n late January 1973, Bowie set off on a world tour that would encompass one hundred dates in a little over six months. Behind the scenes, there were squabbles about money, but on the surface it was business as usual, if not better: when the flashy, America-saturated *Aladdin Sane* album was released in April, it immediately went gold, with advance orders of well over 100,000 – the first album to do so since *Abbey Road*. It went straight to #1, making a youth-culture icon of the red and blue lightning flash made up by Pierre Laroche on Bowie's face.

In May, Bowie returned to the UK for a forty-one-date tour. His latest single, 'Drive-In Saturday', was at #3 in the pop charts. Hollingworth was on hand to record his arrival at Charing Cross Station: 'And when he arrived they screamed and they cried, and they rushed, and gushed forth and beat their feverish feminine fists into the backs of the indeed brave coppers who shielded HIM. For he is indeed HIM. One girl, her face bloated, and most ugly with tears and ruddy emotion, fell halfway twixt train and rail. A young copper dragged her to safety.'

By spring 1973, Bowie had trounced his one-time friend and rival, Marc Bolan. Bowie was hipper and weirder, while T. Rex were, after three years, on the way out. Bowie spoke to a new teen generation. Talking to Hollingworth, Bowie reflected on how he had 'created a somewhat strange audience – but it's also full of little Noddy Holders, and little Iggy Pops. I know we used to attract a lot of "queens" at one stage but then other factions of people crept in. Now you can't tell. They're all there for some reason.'

On 12 May, Bowie and the Spiders from Mars played at Earls Court, a cavernous art deco building, and the UK monthly *Cream* sent along

a writer and a photographer to record the event. Mick Gold's photos caught the teens with their bipperty-bopperty hats, but there were also well-dressed, foppish young men in jackets, bow ties and white gloves, as well as a perfectly dressed rocker wearing sprayed-on, studded jeans, a sleeveless T-shirt, a studded wristband and long, quiffed hair reaching his shoulders.

Another couple essayed the French existentialist look, with belted white coats and an intense air. This was not just an audience, but a culture. The early 1970s were a retro time, when fashions from the 1920s, '30s and '40s were easily available in charity shops and market stalls and plundered for contemporary looks. Bowie's constant reinvention – the idea that the world is a constantly revolving stage – and his powerful aura empowered his audience to attempt the same on the streets of cities around the UK.

To mark the Earls Court event, Bowie gave a long interview to London's *Evening News*. When asked if telling the world about his unorthodox sexual habits had hampered or, in some strange way, helped his thrust to fame, Bowie dismissed the idea and reiterated his lack of regret over the admission of his bisexuality.

On 2 and 3 July, Bowie and the Spiders from Mars played at the Hammersmith Odeon. It was already scheduled as a major event, with Dylan documentarian D. A. Pennebaker on hand to film proceedings. Jeff Beck was there to join in on three songs. Just before the final number, 'Rock 'n' Roll Suicide', Bowie stepped up to the microphone and announced: 'Not only is this the last show of the tour but it's the last show we'll ever do.' And with that, he finessed the first of his many great escapes.

Ziggy was gone, and his creator had already moved on to other things. While Bowie changed musicians and began work on his next project – covers of high-1960s mod classics by the Yardbirds, the Pretty Things and the Who, among others – his records continued to sell. Three weeks after the Hammersmith Odeon, all five of his RCA albums were in the UK Top 40, with three in the Top 20: *The Rise and Fall of Ziggy Stardust* at #15, *Hunky Dory* at #11 and *Aladdin Sane* at #5.

The decision to retire Ziggy seems to have been part considered, part impromptu. For over a year, the pressure on Bowie had been intense. It's

exhausting to be right in the centre of things, and the alienation between David Jones and his Bowie and Ziggy personae was severe. What many fans didn't fully realise was that *Ziggy* was a theatrical construction, the projection of a fantasy, with, on the second side in particular, a definite script. The character – a plastic rocker – was almost unimportant in the face of the narrative's trajectory. In the script of *Ziggy*, Bowie had described the rise, to be sure, but also the fall: the moment when he got attacked by his group and deserted by his fans, with the only option a melodramatic rock 'n' roll suicide. It was all there; he had done what he said he was going to do.

Being at the forefront of changing sexual attitudes was also punishing. There was the danger that it would all become a pop fad. His gay statement had widened into more general discussions about 'decadence' – especially after the success of *Cabaret*, the defiantly bisexual film adaptation of Christopher Isherwood's *Goodbye to Berlin* – as well as polysexuality, genderfuck, glam and glitter. This was a heavy weight to carry on top of pop/rock superstardom, and it's hardly surprising that Bowie, having made himself the focus, began to withdraw.

Writing in *Gay News* that September, Denis Lemon caught this shift away from simple discussions of homosexuality, which thanks to Bowie had already become a media, if not pop, cliché: 'The word everyone is pouncing on, especially to describe the apparently semi-retired David Bowie, is "decadent". But to twist an old adage, "one man's decadence is another man's liberation".' That was the key. Bowie wasn't a politician; he was a musician and pop star. And he was a major liberator.

Bowie had lived in and around the gay world since he was a teenager and was well versed in all its codes and undercurrents. He took from its highly charged, coded, underworld creativity and, in turn, gave something back: visibility and affirmation, in a package that was transmissible to, and enthusiastically accepted by, the mass pop market in the UK. He understood that a new decade demanded a new openness and frankness about those facets of human life that had been hidden, even taboo, and in this was part of a wider cultural and political movement.

Indeed, the biggest inspiration for Bowie's coming out was not the dry, unsatisfactory Sexual Offences Act, but the rhetoric of gay liberation

that had originated in America and arrived in the UK at the turn of the decade. He knew all about this from his friends, the journalists at *Jeremy* and the Gay Liberation Front benefit he played in October 1971. This was a new, confident assertiveness on the part of gay men and lesbians, one that insisted on openness and pride. The key concept was the slogan 'out of the closets and into the streets', and this is what Bowie courageously lived out.

23
Stonewall and Its Aftermath

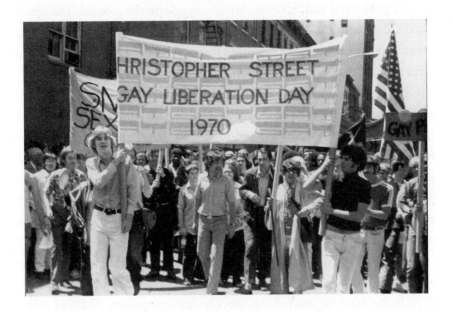

Rock, used not as the purists define it but to cover the whole gamut of contemporary youth music, seems to me one of the major influences upon social attitudes toward sexuality and sex roles.

Dennis Altman, *Homosexual: Oppression and Liberation*, 1971

I n America as in England, music was the key medium through which homosexuality was discussed – and even enacted – in the wider culture. The gay themes and images that emerged in music and, occasionally, the mass media seemed to come out of nowhere, but they were the product of a prolonged and, at times, bitter struggle on the ground. The whole discussion might have been kept firmly within the bounds of entertainment, but the politics kept bleeding through in the early 1970s – as was fitting for a marginal group fighting hard to establish itself.

One of the more visible symptoms of these changes was the appearance on the news-stands of glossy monthlies like *After Dark* and *Vector*. Long gone were the pleading editorials of *ONE* and the *Mattachine Review*; with their frank nudes and mainstream ambitions, these substantial, thick magazines were evidence of a new confidence on the part of a previously apologetic, outcast subculture. In particular, the breadth and fecundity of specifically targeted adverts showed the diversity and purchasing power of a newly confident, assertive gay demographic.

In January 1973, the current issue of *After Dark* featured a cover shoot with Bette Midler, who was hailed as 'a new superstar'; her first album, *The Divine Miss M*, entered the US Top 40 that month. She had established her core audience from within the gay subculture. Starting in summer 1970, she had begun singing every Friday and Saturday night – in the words of *GAY* magazine, 'facing an audience of five or six hundred men, all naked except for towels around the loins' – as the featured entertainment at Steve Ostrow's Continental Baths, in the basement of New York's Ansonia Hotel.

In her October 1970 interview with *GAY*, Midler described her feelings about the audience, who were there primarily for sex rather than entertainment: 'Gay men are spectacular, they're very warm, very responsive. They are the most marvellous audience I've ever had because they're not afraid to show how they feel about you. They applaud like hell, they scream and carry on, stamp their feet and laugh. I love it. It's going to be very hard for me when I get back before a straight audience.'

Performing a mixture of show tunes, blues and girl-group classics, Midler's earthy humour chimed well with the locale. *The Divine Miss M* was a winning mixture of campy 1960s hits – 'Leader of the Pack',

'Chapel of Love' – gospel-rock songs by Leon Russell and John Prine, a classic late-1950s dance number ('Do You Want to Dance?') and a 1941 jump-blues song, 'Boogie Woogie Bugle Boy', which went to #8 when released as a single. Her inclusion in *After Dark* was perfectly timed, and in sync with the magazine's policy of featuring coverage of suitable contemporary pop stars.

The January 1973 issue also contained a long interview with Alice Cooper, hot off the Top 10 success of the 'School's Out' single and album. Writer Henry Edwards joined Cooper's barnstorming tour in Jersey City, where the 22,000-strong audience 'passes the time by indulging in every conceivable kind of drug. Twelve-year-old kids openly hawk pills. Every other person seems to be nodding out under the influence of some narcotic. When Alice appears on stage, however, the crowd goes wild.

'Down front, though, a small group of young men work hard at tormenting the star. "We hate you, Alice," they jeer. "You're a faggot!" Alice responds by letting his hand rest casually on the outline of his genitals. Since Alice is wearing a one-legged pair of trousers and yellow bikini underwear, the audience can obviously get the message. Suddenly, Alice thrusts his groin forward and he gropes himself vigorously, suggesting to his tormentors that, grotesque though he is, he is as much of a man, if not more so, than they are. The audience cheers his put-down.'

First published in 1968, the New York-based *After Dark* had its roots in classic performance – theatre, ballet, cinema and the like. Without specifying it, by 1972 its principal readership was assumed to be gay, with articles about John Vaccaro's latest off-Broadway play, *Sissy*, and art deco, along with plentiful adverts for kaftans by long-standing gay fashion house Ah Men, super-briefs, uncensored 35mm colour slides of nudes, and anti-ageing and hair-care products, as well as listings for clearly gay venues, restaurants and bars.

The January 1973 issue of *Vector* took a different approach. The magazine's gay orientation was upfront, with a cover picture of an African American dancer, Bill McWhorter, wearing only a leather posing pouch. Inside, McWhorter was asked for his opinions about the gay world: 'Some gay people I've met are very sad, because of their one track mind. What they live for is to get up in the morning and go to a bar, and cruise

and have a drink. To me that's sad. There's a bunch of things out there in that world that you can do. You can be a man and gay too.'

The titillating cover was to some extent misleading. *Vector* had been formed in 1964 by the leading San Francisco gay rights group SIR, and retained its campaigning flavour, with articles about San Francisco bars, news items about police raids and even manifestos, like this one from a Columbus activist: 'I've faced the fact that gay people are oppressed, and until they decide to do something about it, they will sit in those stinking gay bars, baths, parks, johns, truck stops and closets, and keep taking the shit society deals out to them.'

Nevertheless, adverts for good mental health and self-help – the San Francisco Gay Counselling Service, for instance – vied with graphic gay bathhouse promotions: 'Come on out to the Baths on 21st St.: "We never close."' There were other picture adverts for florists, barbers and clubs, plus listings for bars and baths in the Bay Area and dozens of classified ads for saunas and masseurs, along with personals. Even the *Vector* calendar for 1973 was promoted with a half-erect penis.

This was nothing like the apologetic approach of the 1950s and even mid-'60s homophile press. Clearly, something major had happened in the intervening years, and a long article by Suzannah Lessard in *Vector*'s January 1973 issue explained exactly what that was. In the piece, reprinted from the *Washington Monthly*, Lessard, the granddaughter of the notorious architect Stanford White, was not specific about her sexuality, but the title – 'Gay Is Good for Us All' – showed a deep involvement in, and understanding of, the gay world.

Firstly, the terminology had definitively changed: homosexuality in politics and life was no longer called 'homophile' but 'gay'. Frank Kameny's formation, 'Gay Is Good', had prevailed. Indeed, Lessard began with a gay liberation movement march in New York: 'The marchers were confident. They had taken the trick out of the trick mirror; the invisible homosexual was now massively visible. With what seemed hardly more than a flick of the wrist they had upturned a whole new complex of bigotry and exclusion into broad sunlight.'

Lessard traced the change to one night in late June 1969, when the police raided the Stonewall Inn, a gay bar on Christopher Street. A

common enough occurrence, but this time 'the sissies fought back'. As word of the struggle spread, it developed into several days of serious disturbances, after which, as Lessard noted, 'The image of the homosexual in the eyes of the world, and, more important, in his own eyes as well, was irrevocably altered.' With Stonewall, gay liberation had its foundation myth.

Dancing had always been central to the homosexual subculture. A gay journalist who did a survey of New York's gay bars in 1969 noted the soundtrack was mainly chart hits. In the Stonewall bar on Christopher Street, the most popular tunes on the jukebox were 'No Matter What Sign You Are' by Diana Ross and the Supremes, 'Stand!' by Sly and the Family Stone, 'Aquarius/Let the Sunshine In' by the 5th Dimension, 'I Turned You On' by the Isley Brothers, Barbra Streisand's 'Before the Parade Passes By', the Temptations' 'Don't Let the Joneses Get You Down' and a reissue of Chris Montez's 1966 hit 'The More I See You'. In the continuing lack of any easily definable gay taste, particular songs were taken up by the clientele because of their apposite lyrics, like 'Stand!' – 'There's a midget standing tall / And the giant beside him about to fall!' – and the Flirtations' 'Nothing but a Heartache': 'Loving a bad guy is such a sin.' Of particular relevance to the events that were about to occur was Diana Ross and the Supremes' 'The Young Folks', with its warning to the older generation: 'They're marching with signs / They're standing in lines / Protesting your right to turn out the light / In their eyes!'

On 27 June, it was business as usual on a Friday night. The Stonewall was a Mafia-run bar with extremely basic facilities; there was no running water and no fire exits. Like many other bars, it served alcohol but did not have a licence; its continued operation relied on bribing the police with what was called 'gayola'. The great attraction was that it was one of the few places in Manhattan where men could dance freely together. It was extremely popular with a clientele that also included drag queens, hustlers, young street kids and a few lesbians.

Raids on gay bars were frequent: in the previous two weeks, three other bars in Greenwich Village – the Snake Pit, the Checkerboard and the Sewer – had been targeted by the police. When the cops arrived at the Stonewall at 1.30 a.m., Stevie Wonder was on the jukebox. They locked the doors, started dismantling the bar's furniture and lined the two hundred or so punters up to check their IDs – a process that could result in exposure and worse. As one terror-stricken man moaned: 'I'll lose my job. What will happen to me? My family! Oh no, no, no!'

So far, it was the usual routine. But this was not the early or even mid-1960s any more. The previous year, young protestors had been involved in a pitched battle with police at the Democratic Convention in Chicago, and there was a new mood of militancy in the air. Club-goers started giving the cops lip by saying things such as 'We're not taking this', while 'transvestites' in the back room began actively struggling. When questioned, some lesbian customers began challenging the police, which resulted in some aggressive frisking.

The Stonewall had been raided three days previously, and everyone had had enough. As the cops started dragging people to the paddy wagons outside, there were shouts of 'Gay power'. Nevertheless, according to one eyewitness, everything was going to plan, 'until a dyke lost her mind in the streets of the West Village – kicking, cursing, screaming, and fighting'. When the lesbian – often claimed to be Stormé DeLarverie – was finally bundled inside a police car, the crowd slashed its tyres, and the riot began.

The police, under the command of Inspector Pine, were trapped inside the club. The crowd outside numbered at least two hundred, and was growing all the time. Christopher Street was a well-populated area in the heart of the club district, and even late at night there were people around. More joined the throng as the violence exploded. They threw bottles and garbage cans and ripped up cobblestones, targeting the police. Predominant among the active fighters were the street kids: the homeless, effeminate ones, 'flame queens' who had nothing to lose.

The dam had erupted. 'We all had a collective feeling like we'd had enough of this kind of shit,' remembered a participant. 'It wasn't anything tangible anybody said to anyone else, it was just kind of like everything over the years had come to a head on that one particular night in the one

particular place, and it was not an organized demonstration. It was spon-
taneous. That was the part that was wonderful. Everyone in the crowd
felt that we were never going to go back. It was like the last straw.'

Events settled into a running battle between the protestors and riot
police, until things calmed down at around 4 a.m. The next night – the
hottest 28 June in New York's history – the crowd returned in force. By
10 p.m. there were a couple of thousand in Christopher Park, the small
triangle of land outside the Stonewall, and the running battles continued
around Christopher Street, Grove Street and Sheridan Square. After a
few quiet nights, there was another flare-up the next Wednesday. It was
vicious but brief.

The riots had an immediate impact. Flyers handed out in the area even
during the disturbances made it clear that a Rubicon had been crossed:
the riots had shown 'that gay people are reaching the end of their patience.
At the bottom of the calls for GAY POWER and HOMOSEXUAL
EQUALITY is a realization that we can influence our existence – if we
can only come together.' Another leaflet exhorted: 'Many of us in the
community have been heartened by the appearance of a new spirit . . .
Now is the time to take a stand on our own behalf.'

Activists were quick to build on the energy that the riots had unloosed.
At a meeting on 9 July to protest police harassment, Gay Liberation
Front was suggested as a name for the steering committee. A month after
the riots, there was another public meeting, attended by five hundred
gay men and lesbians, who listened to activist Martha Shelley declaim:
'Brothers and sisters, welcome to this city's first gay-power vigil. We're
tired of being harassed and persecuted. If a straight couple can hold
hands in Washington Square, why can't we?'

During August, the Gay Liberation Front (GLF) announced itself
with a manifesto: 'We are a revolutionary homosexual group of men and
women formed with the realization that complete sexual liberation for
all people cannot come about unless existing social institutions are abol-
ished. We reject society's attempt to impose sexual roles and definitions
of our nature. We are stepping outside these roles and simplistic myths.
We are going to be who we are . . . Babylon has forced us to commit
ourselves to one thing . . . revolution.'

Energy transformed itself into consciousness, which was transmuted into three new magazines. Formed in September 1969, *Gay Power* declared itself 'New York's First Homosexual Newspaper'. A biweekly edited by John Heys, it was very much an arts magazine, with a heavy dose of movement politics: its second issue included an editorial, 'Get the Mafia and the Cops Out of Gay Bars', protesting against 'the Mafia (or syndicate) control of this city's Gay bars in collusion with certain elements in the Police Dept. of the City of New York'.

Mid-November saw the first issue of *Come Out!*, the newspaper produced by the New York GLF, which contained the ringing capitalised phrases 'COME OUT FOR FREEDOM! COME OUT NOW! POWER TO THE PEOPLE! COME OUT OF THE CLOSET BEFORE THE DOOR IS NAILED SHUT! WE ARE COMING OUT IN COMMUNITY, A COMMUNITY THAT NUMBERS IN THE MILLIONS.'

At the start of December, *GAY* magazine also produced its first issue. Edited by former activist Jack Nichols and his lover Lige Clarke, the publication was funded by Al Goldstein and Jim Buckley, publishers of the radical pornographic tabloid *Screw*. Beginning the previous year, the pair had written a column for *Screw* called 'The Homosexual Citizen' – the first in any magazine outside the gay ghetto. *GAY* had links to the previous generation of activists and a toe in popular culture: the second issue's cover featured a still of Mick Jagger in *Performance*.

The near-simultaneous appearance of these three publications was seen, at the time, as a direct evolution of the Stonewall riots. Indeed, young gay writers attested to their transformative effect. As Lily Hansen wrote in *GAY*: 'Homosexuals, encouraged by the successes of the Negro rights movement, feel more confident in labelling their cause one of civil rights. They step forward with poise and openly claim these rights. They're no longer scared of myths.'

Even more direct was a poem by 'Heather' in *Come Out!*:

> I am new
> Born again;
> All the old roles
> (Butch, fem, straight)

Died and fell away
And I stand naked
With fresh skin,
New,
Not yet quite sure
How to think of myself:
Only knowing
That my skin
Is very tender
To the touch.

The mainstream media was quick to pick up on this new mood. In late October, *Time* magazine ran a cover story entitled 'The Homosexual in America'. With its conservative editorial policy, the news magazine was no friend to homosexuals, and indeed, much of the piece made it clear exactly what gay people were up against, with terms like 'deviates', testimony from hostile 'experts' like Dr Edmund Bergler and a conclusion that stated: 'The life of a homosexual is a pathetic little second-rate substitute for reality, a pitiable flight from life.'

Several old tropes were wheeled out, including the idea of a homosexual conspiracy to dominate the arts and the media. A recent poll was cited, stating that 63 per cent of the nation considered homosexuals 'harmful to American life'. Even so, the article recognised that something had changed: 'Male and female inverts have been organizing to claim civil rights for themselves as an aggrieved minority. Their new militancy makes other citizens edgy, and it can be shrill.'

The light had been let into the long-shuttered room of the gay subculture, and long-held misconceptions were tumbling in the face of greater openness and assertiveness. Tom Burke's 'The New Homosexuality', published in *Esquire* that December, began by positing a time lag between the public image of the homosexual and the reality on the ground, setting up a mid-1930s neuter queen who 'mourns Judy' and 'gets mugged by midnight cowboys' as an archetype that was disappearing just as Middle America was catching up.

The generational change had been set in motion by the Beatles. Writing in *Come Out!*, the twenty-three-year-old Perry Brass remembered that

'The first time I saw the Beatles was in 1964. I watching television at the homes of some "friends". We had just had a discussion about "integration". One of the boys present, who was in the Air Force and was dating a girl from a good Jewish family, saw them and said they looked like the queers on Market Street in San Francisco. I decided to go to San Francisco as soon as I could.'

Despite the macho orientation of the early San Franciscan music scene, the softer style of the hippies – the long hair, flowing clothes and, on the surface at least, looser attitudes – as they spread through America and beyond was a turn away from the old masculine certainties. The blurring of perception and consciousness was a major facet of psychedelic drugs, and that, mixed with the androgyny of many British and American groups, was attractive to young gay men and women.

Indeed, the psychedelic lifestyle was giving the new homosexuality form. The more common use of drugs from 1967 onwards meant that gay and straight youth alike were experiencing the same things, and this had resulted in a definite shift in gay and generational consciousness. The result was a yawning gap between the older, self-hating generation and the new young radicals, between the old aunties and the 'red-blooded, all-American, with-it faggots' that the writer was presenting.

'That's what has died,' Burke wrote: 'this homosexual feeling of being isolated from the straight world by guilt.' The article ended with a description of a public meeting in mid-July 1969. Dick Leitsch, a Mattachine veteran, was calling for gradual change, but was interrupted by a 'tense boy with leonine hair: "We don't want acceptance, goddamn it! We want respect! Demand it! We're through hiding in dark bars behind Mafia doormen. We're going to go where straights go and do anything with each other they do and if they don't like it, well, fuck them!"'

The meeting ended with a dozen impassioned boys 'on their feet, cheering. They are the new radicals who will rally in Washington Square, and lead a mass march down 6th Avenue, halting astonished traffic, carrying the lavender "Gay Power" banner, chanting "Gay Power to Gay People", singing "We Shall Overcome" solemnly in Sheridan Square. Again and again, Dick Leitsch tugs frantically at his clean white tie, shouting for the floor, screaming for order. He is firmly ignored.'

Apart from this generation gap, there were other tensions in this new gay landscape that reflected the tensions in the wider late-1960s youth culture, in particular between the revolutionaries and assimilationists, the hedonists and the politicos, the commercially oriented and the hard-line Marxists. There were tensions between the three publications – *GAY*, *Gay Power* and *Come Out!* – and arguments within the GLF itself, between gay men and lesbians and the new radicals who insisted on ideological purity.

In the May 1970 issue of *GAY*, the three magazines summarised their positions:

> *Gay Power* – we feel the name *GAY POWER* should and could doubly express the multitudes of gaydom and the powerhouse of diversity in gaydom. We feel strongly that there is a tremendous axe to grind.

> *GAY* – We hope to make the most literate, informative and entertaining publication we possibly can, and we want to reflect the best thinking by America's finest homosexual writers. We'd like to see the words 'homosexual' and 'heterosexual' fade away.

> *Come Out* – We operate as a collective. We have a definite view that the society is what's fucking us up. That a male-dominated, capitalistic, heterosexual society is the root of all our problems. We think competition and living and producing to earn money is the root of a lot of our problems. So we are trying to create a newspaper in a collective cooperative spirit where making money and making sales and selling ads is not our modus operandi.

To the GLF members who put together *Come Out!*, *GAY* and *Gay Power* were tied into the very capitalistic structure that they were seeking to overthrow: 'Because "queer sells" (meaning we are a market), they jump on the gravy train proclaiming themselves sexual revolutionaries. Bullshit! The more papers, the merrier, but let them be put out for and by our community.' *Gay Power* retorted with an editorial which cited the 'shrill demands' of the 'less responsible persons beginning to infiltrate the homophile cause'.

Nevertheless, all three were infused with the post-Stonewall spirit. *GAY* was determined to be newsy as well as entertaining, but *Come Out!* was the paper that sought to prolong the messianic energy of that moment.

Despite the infighting, backbiting and theoretical contortions, its eight or so issues represented a sincere, honest attempt to create something new, indeed something utopian: the wish, amid all the auto-critiques, to break through the old definitions and forge a new sexuality, not just for gay men and lesbians, but for all.

Observing this new mood, the writer Dennis Altman wrote that 'gay liberation advances beyond the civil rights liberalism of the early groups; it is in some ways what Black Power is to the Civil Rights Movement'. This radical impetus was strengthened by the February 1970 formation of a new group, the Gay Activists Alliance (GAA), formed by former GLF member Jim Owles, who had dropped out because he 'couldn't stand to see GLF torn apart by theological arguments'.

Indeed, the GAA was quick to establish its differences from the twin poles of revolution and reaction: 'What it is not is the GLF, although liberation for the homosexual is our ultimate goal. What it's not is Mattachine, although the civil rights aspect of that organisation is something that we're deep into, too.' While the GLF was revolutionary, the GAA was hip, highly structured and well versed in street politics. Among its armoury was the zap: the public harassment, if not humiliation, of public figures who pursued anti-gay policies.

There was plenty to be active about, as the harassment of homosexuals had not diminished in the months following Stonewall. In January and February 1970, GAY published stories about the continuing refusal to give security clearance to homosexuals and the regular police raids on the Continental Baths. These involved 'denizens of the law . . . enticing, entrapping, and allegedly in some cases, brutalising Continental customers'. In response, the GAA picketed City Hall.

Two days after the GAA picket, the vice squad – under the command, again, of Inspector Pine – conducted an early-morning raid on Greenwich Village bar the Snake Pit. During the confusion, a young Argentinian immigrant, Diego Viñales, panicked by the possibility of deportation as his visa had expired, jumped out of a second-floor window and impaled himself on an iron fence below. As GAY reported: 'Six fourteen-inch iron prongs had pierced his body and leg, thigh and pelvis . . . Surgeons had laboured for hours that morning to save his life.'

While the twenty-three-year-old Viñales lay in hospital in a critical condition, the GAA arranged a public demonstration. Walking through Greenwich Village, they handed out leaflets that stated: 'SNAKEPIT RAIDED, 167 ARRESTED, ONE BOY NEAR DEATH AT S. VINCENTS. One boy either fell or jumped out precinct windows, landed and was impaled on a metal fence. Anyway you look at it, the boy was PUSHED! We are all pushed.' After a political furore that made the pages of the *New York Times*, Pine was relegated to a beat in Brooklyn.

A year after the Stonewall riots, there was a march to celebrate the anniversary. Organised by long-term activists Craig Rodwell, Linda Rhodes and Ellen Broidy – two members of the radical lesbian group Lavender Menace – the plan was to walk up 6th Avenue to Central Park. 'It was touch and go down to the wire,' remembered Suzannah Lessard. 'No one knew until the last minute whether more than a handful would actually show up, and few thought the march would reach its destination without a violent confrontation with bystanders or the police.

'But thousands and thousands turned out for the first big holiday from the closet. The festive mood was intoxicating. People in their Sunday best, their hippie best, lots of workshirt and jeans types, a few fantastic costumes – they looked more like a peace march . . . than homosexuals. They just didn't look queer, and that fact registered everything from horror to discomfort to plain surprise on the faces of people on the sidelines. As one marcher put it, "So much has been accomplished in terms of who we are. We are people."'

Recognised today as the first Gay Pride march, the Stonewall anniversary event publicly affirmed the new gay confidence. Throughout the summer and autumn, the GLF, the GAA, the Radicalesbians and other groups continued to protest against the harassment of homosexuals. In the summer, New York's authorities conducted a clean-up campaign in Times Square, targeting hustlers and their clients, while the police raided a gay bar in Sheridan Square, just around the corner from the Stonewall. Activists picketed police stations, while Mayor Lindsay and his wife were zapped.

There was pushback. In September 1970, *Harper's* magazine ran a major piece by the writer Joseph Epstein, 'Homo/hetero: The Struggle for

Sexual Identity', in which he called homosexuals 'cursed' and expressed his wish to eradicate 'homosexuality off the face of this earth'. The response was immediate and furious. In *The New Yorker*, editor Merle Miller wrote: 'I am sick and tired of reading and hearing such goddamn demeaning, degrading bullshit about me and my friends.' Jim Owles of the GAA retorted simply that 'I dislike being despised.'

First published a couple of months afterwards, Suzannah Lessard's long article, 'Gay Is Good for Us All', detailed the prejudice that the new gay movement hoped to vanquish. Firstly, she tackled the thorny question of gay self-image, twisted and bent out of shape by social attitudes: 'Most people view the homosexual as a criminal and a pervert, an attitude deeply imbedded in the culture; and it would take rare assurance for a homosexual not to let this attitude pervade his own image of himself and further deter his drive to challenge it.'

Lessard itemised how, at the same time as the legal penalties for active homosexuality remained entrenched in federal law, homophobia permeated popular culture. Whether it was the word 'faggot' being used as a universal term of derision or the appearance of homosexuals in movies as 'ridiculous or desperate or disgusting', degrading images of homosexuality were rife and unquestioned, serving to shore up heterosexual superiority. Yet it was this unquestioned superiority – 'the masculinity curse' – that Lessard wished to unpick.

She detected a crisis of sexual identity in the late 1960s, and thought that it favoured gay men and lesbians: 'Gay Liberation has played a crucial role in dissipating the deeply rooted reverence for the image of the king-male. Many gay women had long rejected that image; and so they provided straight women with living examples of independence from that candy bar. Gay men were in an equally unique position, for not only had they been victimized by those who play the male role, but they had also suffered because they had been made to play it themselves.'

N ew forms of political organisation – including mixed group-ings of men and women, and street actions like vocal protests and zaps that targeted the gay-hostile – were only part of the post-Stonewall diaspora. Communal pleasure was an important part of the new gay world, and it was best expressed in dancing – as the unplugged jukebox at the Stonewall continued to reverberate through New York City. Right from the beginning, the GLF had expressed a desire for 'space to be together' and began looking for an old building where they could hold gatherings and dances.

The necessity for gay-run venues was summed up by the activist Bob Kohler: 'For the first time – hallelujah! – gay dances would be non-Mafia-run. It would be the first time that it would be gay dances by gay people for gay people, with the money that was handed in at the door going to gay issues and gay causes. This was a fabulous first. I get chills when I think about it. I mean, what had we had up till that point? Our entire existence revolved around oppressive, Mafia-run gay establishments where they hated faggots, where you risked your life.'

By early 1970, the GLF were holding dances at the Alternate University, an 'inexpensive evening school' for all sorts of radical topics unavail-able elsewhere, including Marxist political theory, men's consciousness, yoga and astrology. Charging an entrance fee of only $1.50 and a mere twenty-five cents for beer or soda, the events quickly became popular. A snapshot from a February dance had the crowd moving to Sly and the Family Stone's 'Everyday People': 'The dancing was of the usual superla-tive quality. Them queers can sure break a leg.'

Nevertheless, the GLF struggled to gain financial support for their own gay community centre and, indeed, to hold together their own disparate and volatile coalition of 'drag queens, bull dykes, the blacks and browns'. The GLF had, from the beginning, aimed for a fusion of gay men, les-bians and people of colour, but after nearly two years, many women were heading towards the women's movement – especially after the move-ment's historic prejudice was reversed by the climactic intervention of the Radicalesbians at the May 1970 Second Congress to Unite Women.

In the penultimate issue of *Come Out!*, dated spring/summer 1971, the GLF was pronounced 'fragmented but not dead. So many people who

have identified with GLF have gone into their own little radical closets, finding it easier to stay in there with old friends and radical acquaintances than to come out and deal with the world . . . Although all of these people still maintain a Gay identity, they are still not struggling around issues that are Gay issues. Going back into left straight organisations as an open Gay person is like naming your own oppression.'

The dust was settling. The revolutionary period of the gay movement was nearing its end. In March 1971, the *GAY* magazine columnist Sorel David wrote: 'Nothing's going on anymore. The Gay Community Centre is probably going to close, or has closed by now, and there hasn't been a women's dance for about four weeks. The Radicalesbians are all dead – tied their construction boots up too tight and strangulated, one by one, and nobody seems to be occupying buildings too much these days. Too bad, I sort of miss the old revolution in a way.'

Radical gay life was beginning to split into clear factions: radicalism versus gradualism; politics versus pleasure and culture. Nevertheless, the political campaigns continued. In September 1971, Frank Kameny was involved in the victory over the government's long-standing persecution of homosexuals, when US district judge John H. Pratt ruled that 'government security evaluators cannot subject homosexuals to "probing personal questions" about their sex lives or withhold security clearances when such persons refuse to answer such questions'.

It was a very different time from the McCarthy era, and the first brave but cautious attempts of the *Mattachine Review* and *ONE* to counter the revulsion and persecution that homosexuals faced in the early 1950s. The most obvious and far-reaching change was stimulated by popular music and the wider youth culture, as the pleasure principle became all-important. It might well have disappointed the Marxists of the GLF, but it was still an expression of confidence that helped to build a community.

In May 1971, the GAA started sponsoring Saturday-night dances in an abandoned firehouse at 99 Wooster Street in SoHo. Principally aimed at gay men, and featuring experienced DJs, the events superseded the GLF dances and were a huge financial success. As disco historian Alice Echols notes: 'Their deejayed disco dances became wildly popular, drawing on average 1,500 people. "These were great jubilant shindigs," recalls

one participant, and they brought together "hippies and macho men, outrageous glitter queens and intense politicos".'

As in the mid-1960s, pleasure beat politics as an organising principle for the gay world – and damn the ethics. One result of the late-'60s relaxation in the obscenity laws was a huge explosion in homosexual male pornography, the gay mass market of the age. In 'The New Homosexual', *Time* had reported that 'San Francisco's Adonis bookstore has some 360 different magazines on display that carry everything from lascivious photos of nude men to reports on the homophile movement and love-lorn advice by "Madame Soto-Voce".'

In contrast to the old, principally black-and-white, A5-size magazines featuring half-erect members, the new publications were in butcher-shop colour and completely explicit. Titles like *A Night in the Hayloft, Gang Bang, The Hitch-Hiker, Marine Studs* and *Cock-Crazy Cowboy* – all from 1969 and 1970 – left absolutely nothing to the imagination. In a softer form, both *GAY* and *Gay Power* carried ads from porn publishers like Times Sq. Studio and Colt Studios, while advertising the groundbreaking erotic films by Pat Rocco.

GAY and *Gay Power* tapped into the sexual underground that the activists sought to ignore. Another facet of this, throughout 1970 and 1971, was their coverage of pop culture, in which they focused on its androgynous content. In March 1970, *GAY* picked up on the biopic of Christine Jorgensen: 'Although Christine was one of the first (and is one of the most famous sex-changes) she is no longer a minority by any means. Many less-publicised operations have taken place in Scandinavia, and much of the "freakish" attitudes surrounding them have decreased.'

In an early issue of *Gay Power*, the contributor Pat Maxwell noticed the liberating effect of pop culture and how it worked outside Marxist theology: 'The Beatles must have made a fortune – those capitalistic bastards. Considering the social and personal liberation they brought to post-puritan mortem, I imagine they deserve our donations. By example they demonstrated domination over their own bodies, suggested freedom from political and social oppression, and radicalised their fans to define his or her own sexuality.'

Gay Power also ran stories on the Warhol/Vaccaro scene; editor John Heys had previously worked as an actor in Charles Ludlam's Ridiculous Theatrical Company. Its first picture cover, in November 1969, featured Jackie Curtis in a photograph by Leee Black Childers. It was also one of the first outlets to showcase the work of Robert Mapplethorpe. In the March 1970 issue, there was a long discussion between Curtis and Warhol scenester Ritta Redd about seeing Iggy and the Stooges at Ungano's, which picked up on the performer's androgynous quality:

> J: What did you think when Iggy started dry humping his guitar player (another male)?
> R: It wasn't two males up there, it was just SEX. A love making movement, simple pure and beautiful, without gender or hostility.
> J: Do you feel Iggy's hostile at all?
> R: No. He has tremendous keen eyes that are adorable and his half man, half boy's anatomy makes him very loveable.
> J: But I get the feeling that Iggy was both masculine and feminine. You know, Ying [*sic*] and Yang.
> R: Therefore you get your new life styles and will incorporate that style, the masculine–feminine person. A conflict of opposite has always been extremely appealing, especially contained in one heaving body. I just hope Iggy isn't pushed into a kind of category because his type of individual with all that mystique and power should be allowed to go a step further and that would be something to see.

Within six months of Stonewall, this radical androgyny was seen as inimical, if not antithetical, to the hardcore politicos of the GLF and the left. A long article about Jackie Curtis in a later issue of *Gay Power* quoted Rosalyn Regelson in the *New York Times*: 'Gender male, "not a boy, not a girl, not a faggot, not a drag queen, not a transsexual – just me, Jackie," grooving down St. Mark's Place in miniskirt, ripped black tights, clunky heels, chestnut curls, no falsies, Isadora scarf gallantly breezing behind her.

'Walking down St. Mark's Place at midnight with Jackie offers a revelation about the long-haired political activists who regard themselves as street guerrillas of the new people's revolution. They jeer at and threaten

Jackie with the backlash zeal of a bunch of uptight goons. But Jackie sails through the machismo of the Che–Mao country unperturbed, with the confidence of one who knows that she is riding the wave of the future. History is on her side, her head is held high and her chiffon scarf waves behind her like a banner of freedom.'

———

GAY and *Gay Power* might have been outliers, but they accurately foresaw the way in which cultural power could be as effective as political protest in changing the circumstances of gay people. If there had been an opening up of masculine possibilities, then that was the message – that there were many ways to be a man – that gay men had got from the previous decade of pop culture. If that translated into a crisis of gender, then in the post-liberation politics of the late 1960s and early '70s, so much the better. That was the cutting edge, and it had the best chance of greater visibility, if not even mass exposure.

This radical androgyny was even picked up by *Life* magazine, in another homosexual exposé, this time from December 1971. It photographed 'three bearded, outlandishly dressed homosexuals . . . who claim they are trying to cultivate a life-style which will free men and women from the dictates of sharply defined "sex roles." They argue that the liberation of homosexuals will also free heterosexuals to adopt aspects of the less restrictive homosexual life-style. This includes the freedom to dress as one pleases, either as a man or a woman or both.'

In his thorough survey of the post-Stonewall gay world published that November, *Homosexual: Oppression and Liberation*, Dennis Altman also noticed that 'there is the whole cult of transvestism and exaggerated sexual role-playing that is intimately connected with the gay world, yet has had, via Andy Warhol and his large group of camp followers, a major effect on our social and artistic mores. The transvestite more than anyone else in our society knows the way in which we are trapped by the conventional blue/pink dichotomies of men and women.'

Altman concluded that 'there is a new style of campdom that is being mobilised against social pressures: the old style transvestite who painfully

hid his genitals and plucked out all body hair is being replaced by boys in beards and dresses who send up the whole social concept of masculine/feminine. This style of gender confusion was made famous by the Cockettes, a group that originated in San Francisco and for a time became fashionable among the avant-garde. "Don't call us drag queens," one of them is reported as saying, "call us freaks."'

That same month, the Cockettes made their debut in New York, travelling to appear in their play *Tinsel Tarts in a Hot Coma* at the Anderson Theatre in the Lower East Side. It was seen as a big event: they had hired former Warhol acolyte Danny Fields, who had worked with the Velvet Underground and the Stooges, to handle the press, and the results were beyond expectations. They were, Fields said, the easiest act he had ever promoted. Carnival had come to town and, for a while at least, it was a sensation.

This promised something fresh in a jaded city, a hippie drag-queen troupe boosted by no greater cultural icons than veteran columnist Rex Reed and best-selling author Truman Capote. As part of the pre-hype, Maureen Orth from the *Village Voice* was sent to travel with the troupe as they flew over the continent from San Francisco. It was 'pure insanity all the way . . . pandemonium reigned from the moment the Cockettes stepped off their chartered bus, along with three tons of luggage that was heavy on the cardboard and tinsel'.

It was Reed's September rave, syndicated in around 150 papers, that had broken the Cockettes above ground and persuaded entrepreneurs Harry Zerler and Dennis Lopez to fork out the $40,000 necessary to transport the troupe, hire the hall and set the stage for what promised to be a memorable opening. With articles in the *Village Voice* and *Rolling Stone*, the Cockettes were the city's new favourite weirdos. As Orth commented: 'Not since Andy and Edie had New York made a group of society's freaks its very own darlings in one short week.'

There were problems. The New York transgender clique – Holly Woodlawn, Jackie Curtis and Candy Darling – regarded the Cockettes rather sniffily. In Woodlawn's eyes, only the New Yorkers were serious: they had to look real to survive on the streets, whereas the Cockettes were mostly men messing around. The two came from different coasts and

traditions: the absurd against the cosmic; the gender-simulating against the gender-shattering. As troupe member Dusty Dawn remembered: 'It was all a play. We didn't realise that their play was different to our play.'

The Cockettes were too busying partying and taking drugs to take care of business. The troupe had completely failed to rehearse, and made things more difficult for themselves by rejecting the existing stage set. A completely new cardboard replacement had to be erected a couple of days before opening. The sound system wasn't installed until the last minute, and when the Cockettes finally knuckled down to a dress rehearsal, their theatrical ineptitude became painfully apparent. Even so, they failed to understand their situation.

Opening night was an event that went beyond all expectations. Rex Reed called it 'the craziest, wildest in New York's history'. Present and correct were celebrities of the order of Gore Vidal, Allen Ginsberg, John Lennon, Ahmet Ertegun, Angela Lansbury, Robert Rauschenberg, Diana Vreeland, Tony Perkins and Cyrinda Foxe, and Warhol superstars like Ultra Violet, Candy Darling, Holly Woodlawn and Jackie Curtis. Truman Capote sent an encouraging telegram – 'keep it gay, light and campy' – and the delighted Cockettes dedicated the show to him.

It was a disaster, as Maureen Orth reported from the front line: 'The audience came to get wrecked and thrilled by a fantastic new set of freaks. But as soon as the curtain went up it was all downhill. The audience was dying to be surprised, outraged, anything. They loved Sylvester, even after 45 minutes, but the Cockettes were hopeless. The sound system was terrible, the show was too slow to crawl, and the Tinsel Tarts were even too tired to be themselves. They forgot lines and bumped into each other, all this for the media heavies and literati.'

The reviews were brutal. 'Having no talent is not enough,' declared Gore Vidal, while *Women's Wear Daily* pronounced it 'Dreadful'. The *New York Times* asked: 'For This They Had to Come from Frisco?' Captured on film, the vox pops were even worse: 'It's three years old, no, five years old'; 'It was totally inept'; 'It's no good just being a drag any more. Anybody could do it.' In the face of this humiliation, the Cockettes managed to knuckle down and played to good houses for the rest of the run.

This spectacular failure to cross over into the mainstream marked the beginning of the end for the troupe, some of whom had not wanted to make the trip in the first place. Even the idea of entering the commercial, conventional world was anathema to some members, who believed in ideas of spontaneity and free exchange, with no money or expectations. Just to be in the moment was enough. This had already precipitated a serious split, the Cockettes travelling without their inspirational leader, Hibiscus.

Without Hibiscus's transforming, shamanic energy, the Cockettes were – apart from the featured singer, Sylvester – rendered naked and exposed on that November opening night, nearly two years after they had begun in that post-Stonewall ferment. Unlike their New York counterparts, they were products of gay liberation, the commune movement and the San Franciscan Haight-Ashbury subculture. They were nothing if not utopian, but like the GLF, their fantastic ideas were on a collision course with the wall of reality.

The Cockettes began as total hippies, forming out of several communes in the summer of 1969. Their undoubted leader was Hibiscus, a nineteen-year-old veteran of the counter-culture and radical theatre. Born George Harris III in September 1949, Hibiscus had first come to prominence when he was photographed by Bernie Boston at the October 1967 March on the Pentagon: wearing a thick turtleneck sweater and with a blond bowl cut, the youth faced the serried ranks of military police, carefully placing a flower in the barrel of a raised gun.

Later in 1967, Harris travelled to San Francisco with Allen Ginsberg, where he joined Irving Rosenthal's Kaliflower commune, began taking LSD and transformed into Hibiscus, under which identity he began attending meetings of the San Franciscan gay liberation group the Campaign for Homosexual Freedom. Finding Rosenthal's rigid communalistic ethos too stifling, he ran away and created the Circus – a group of people determined to cast off 'the oppressing shackles of Society's rigid and unrealistic concept of masculine and feminine'.

Together with Fayette Hauser, Scrumbly – the musician of the group – and other early core members like Miss Harlow and Goldie Glitters, Hibiscus formed the Cockettes as a 'gender-fuck theatre group' in high

summer 1969. The group were informed by four separate strands: the dislocations of the Theatre of the Absurd, as practised by John Vaccaro, Jack Smith and Ronald Tavel; the confrontational, in-the-moment performances of the Living Theatre; radical gay politics; and the alternate reality presented by the frequent use of LSD.

'Our group consciousness,' recalled Hauser, 'was the Cosmic one. We considered ourselves Freaks. Hibiscus was the Master Freak, our Shaman, our Firecracker, and we all lit the fuse. He galvanised us into a group consciousness that was open and inclusive, positive and life-affirming, shameless, sacrilegious, and daring in our personal vision. Our metier was High Drag. We were what we wore, and we wore it a lot. We brought all that we were becoming and creating at the time and put it on stage. Our lives and the stage became one.'

Gender confusion was the whole point. The Cockettes' first performance was held at the Pagoda Palace Theatre, an old 1900s cinema in North Beach that ran Chinese films by day and porn at night. It had recently been taken over by Sebastian (aka Milton Miron), who showed incredibly strange movies, billed under the title of the Nocturnal Dream Shows. On New Year's Eve 1969, Hibiscus brought out an old Victrola and played a 78 of the cancan, and the troupe began dancing wildly. The Cockettes' name 'spread around town like wildfire'.

During 1970, the troupe developed more shows: *Paste on Paste* was 'an ode to Glitter and to Jayne Mansfield', while *Alice in Wonderland* was 'through the looking glass with the Cockettes on stage'. The summer saw their first sell-out show, *Hollywood Babylon*, based on Kenneth Anger's sensational exposé, and the emergence of a cameo feature: the song 'Stormy Monday', by the young African American singer Sylvester. In November that year, the Cockettes produced their first show with a typed script, *Pearls Over Shanghai*. Things were getting more organised.

Hibiscus rebelled. A snapshot of the Cockettes taken in January 1971 by writer Barbara Falconer made it clear that he was totally unwilling to make the compromises necessary for fame and attention: he walked out of the interview without a word. March's *Tinsel Tarts in a Hot Coma* was the last Cockettes show before Hibiscus split, after a violent confrontation. While Hibiscus formed his new group, the Angels of Light,

providing 'free entertainment for poor people . . . Poor gays – oppressed people', the Cockettes went from strength to strength.

September 1971's show, *Pearls Over Shanghai*, was loosely based on the 1941 film noir by Josef von Sternberg and was, as Hauser noted, 'the culmination of everything'. This was the show that Rex Reed raved about on 18 September, calling the troupe 'the most unbelievable American phenomenon since Martha Mitchell. They are the current sensations of the powerful underground press, a landmark in the history of new, liberated theatre, and if you've never heard of them, some circles would say you just aren't alive.'

It was on the back of this review that the Cockettes came to New York and met their fate. Within months, they fell apart. Like the dissolution of the GLF, which had occurred the previous year, the utopian dreams that had propelled them dispersed in a combination of drugs, clashing egos and irresolvable ideological differences. The only alternative was to try and join the system, and by 1972, integration into the existing capitalistic structure seemed increasingly possible as, attracted by the visibility of a previously poorly served market, businesses began to be more receptive.

One arena in which that began to seem possible was pop culture. Dennis Altman had already observed the ability of music to suggest, even enact, the future: 'As Plato put it, forms and rhythms in music are never changed without producing changes in the most important political forms and ways . . . the new style quietly insinuates itself into manner and customs and from there it . . . goes on to attack until it ends by overthrowing everything, both in public and in private.'

In the revised edition of *Homosexual: Oppression and Liberation*, Altman cited *Hair*, *Performance* and the British drag tradition as leading to the current state of affairs: 'The breakdown of sex roles and sexual norms that had been hinted at in the sixties was manifest in the mainstream of rock (if not yet in the bubble-gum radio stations). Two names stand out – the American group Alice Cooper and the Englishman David Bowie. Bowie in particular suggests both androgyny and gender-confusion: he claims to be bi-sexual and his songs reflect this.'

He ended with a challenge: 'Ultimately one must conclude that the music of the counter-culture has reflected both the new sensuality and

the breakdown of blue/pink sex role dichotomies, and the uptightness about homosexuality that remains. Yet is there not something a little strange, perhaps sad, that gays in the rock world remain closeted while they are coming out in the much more traditional, Consciousness II and literate worlds of theatre and literature?'

At the end of 1972, Henry Edwards wrote a summary of current and future trends in *After Dark*, titled 'The Year of the Peacock': 'Rock has never gone away and now it even has a brand new look. The teeny-bopper magazines call it "glam-rock"; the slicks call it "freak rock"; the undergrounds call it "glitter rock". Call it what you will, everyone is now dressing up in new and darling ways. This year has indeed been the year of the Peacock . . . and most insiders are saying that we ain't seen nothin' yet! I, for one, can hardly wait.'

Having found himself a rock band and record contract in the year or so since his appearance at the Anderson Theatre, Sylvester was also making waves. In late October 1972, he and his Hot Band supported David Bowie in San Francisco, and in April 1973, he released his first album, which, containing covers of Ray Charles, Neil Young, Leiber/Stoller and James Taylor, was oriented in terms of sound and marketing towards the mainstream rock market. It was neither an artistic nor a critical success, but it did get Sylvester a good deal of publicity.

As Richard Cromelin wrote after seeing Sylvester and the Hot Band at the Whisky A Go Go, 'At a time of rampant bandwagon-jumping, Sylvester is one of the few who can handle costumes and glitter comfortably, with a sense of what it's really about. He's a master of transformation, and a look at more than one set is advised in order to grasp the totality of his befuddling androgyny.'

In the April 1973 issue of *After Dark*, Henry Edwards reviewed another openly gay performer. Working completely by himself, Chris Robison had released an openly gay-themed record called *Chris Robison and His Many Hand Band*. Edwards noted that he was 'honest about his sexuality. It's all over the album. Yet, he is neither trying to shock nor exploit homosexuality as just another of today's pop gimmicks. He has let his audience know a major detail of his life, and then he buckles down to his real concern, which happens to be music.'

404 The Secret Public

In April, the gay Canadian poet Ian Young used this album review to examine the history and current state of gay rock. Citing Little Richard's 'screaming queen act', the Velvet Underground and the record cover of the Rolling Stones' 'Have You Seen Your Mother, Baby, Standing in the Shadow?' – 'with all five Stones decked out in 1940s drag' – he stated that, in the 1960s, 'record company managers and promotion men were still telling performers to conceal their gayness and, of course, still decided what songs they could record'.

Even in the supposedly more liberal 1970s, little had changed: 'Even with the current commercial fad for "glitter rock", very few rock lyrics do more than hint at gay relationships or gay sex, and when they do, it's usually to present them as something bizarre and perverse to titillate straight listeners. The lack of really gay music has been due not so much to puritanism (much less to any lack of gay artists) as to fear, on the part of the record moguls, of falling sales.

'It is assumed that for most record buyers, "Gay is not good." Thus, with a few exceptions, records and liner notes have tended to give the impression that all rock artists are resolutely and conventionally hetero and that queers don't exist save as oddities good only for an occasional gimmick song like the Kinks' "Lola". This, together with large doses of musical machismo and fear of government's radio licensing power, has tended to keep gay sounds out of range for most rock audiences.'

Robison's album didn't sell, but the conventional idea of masculinity was shifting in youth culture. As Young wrote: 'It is the androgynous, sexually ambivalent ideal, rather than the specifically gay, that is now coming into its own in the rock world.' It was too early for singers to be completely out of the closet in America, but the explosion of Stonewall and the energy that followed in its wake had an impact on the mainstream and brought the open, successful expression of homosexuality much closer.

On 24 June, the third annual Gay Pride march through New York pulled in a massive crowd estimated at between 9,000 and 13,000. The rally blocked off half of 5th Avenue on its way down from Central Park to Greenwich Village's Washington Square. In the park, three and a half hours of speeches and entertainment were presented from an elaborate

stage, with a sound system that could be heard two blocks away. There were wrangles – particularly about the participation of 'transvestites' – but the whole event was, to one onlooker, 'mind-boggling'.

That same night, a fire ripped through the UpStairs Lounge gay club in New Orleans, killing thirty men. The reaction in the city was not all sympathetic. As one report noted: 'Comments like "I hope they burnt their dresses off" and "It was only faggots – why worry?" caused numerous fights and confrontations within the Quarter.' After investigation, it was found that the fire had been started by a disgruntled punter who had been ejected earlier, but its effects had been worsened by inadequate safety procedures within the club.

For all the positive activity in the major cities, gay life was still precarious in America. Stonewall had unlocked a reservoir of energy that, by 1973, was resolving into a determination to make life better for all gay people. The fights about security clearance, representation and rights would continue, soundtracked by a lively pop culture that, while heavily biased towards males, took its images and codes from the newly visible gay world. Although complex and vexed, the relationship between gay pop and politics was intimate and symbiotic.

24
Gay News

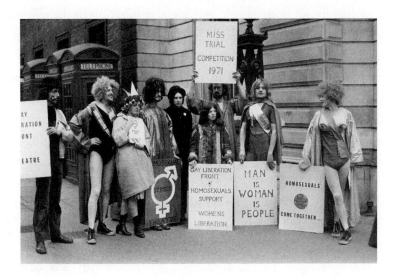

Stephen MacLean: Do you know much about the British gay scene?

Allen Ginsberg: Nothing at all, I know nothing at all about it. I keep wondering, is Mick Jagger the head of it or anything?

SM: If only he were . . .

Denis Lemon: David Bowie. Not by choice.

Denis Lemon and Stephen MacLean, interview with Allen Ginsberg, *Gay News* #27, 12–25 July 1973

The 1972 version of David Bowie didn't spring from nowhere. As was clear from his associations in the late 1960s and early '70s, he hadn't developed his sensibility in isolation. Although he refused to affiliate himself explicitly with gay liberation – which was his prerogative – he had found both artistic and social inspiration in the gay world, in particular the renewed sense of freedom and possibility that rippled through the British gay subculture in the early 1970s.

Gay liberation it was called in the UK, in direct acknowledgement of its American inspiration, but the British GLF and its offshoots were working in a different context: a smaller country, a more centralised media, and with pop having a more direct influence in changing social attitudes. As Peter Burton wrote in an early issue of *Jeremy*, one of the new British gay magazines: 'Pop is the great God to the whole Youth Revolution; it is from pop that all life stems; it is from pop that much of the finance stems; it is from pop that inspiration and ideas come. It is pop which leads.'

By the very early 1970s, a distinct generation gap was emerging between those born well before the war – formed in their adolescence by the illegality and scapegoating of the 1950s – and those young enough to be emboldened by the newly omnipresent youth culture. The new condition of homosexuality demanded openness and pride: as *Oz* editor Jim Anderson wrote in April 1970, it was 'time to get out of the guilt ridden ghettos of the gay world. Until we do it in the road and get our fucks just like everybody else, we are all closet queens.

'Kiss goodbye to all those old classifications and fetishes. So long Bette, and Judy, and Marilyn, and Barbra. Girls are girls not mother symbols. So long Boys in the Band, you're stranded in the sixties. So long dinge queens, toe queens, leather queens, size queens, cottage queens, hair faeries, fag hags and chubby chasers. There is no need any longer to shriek and camp about like hysterical birds of prey, no need for that bitchy defiance. You can relax. The bum trip is over. Join the GLF.'

In early 1973, the British gay world still took many of its cues from America. The 24 January issue of *Gay News* contained a review of Bette Midler's *Divine Miss M* that mentioned her stint at the Continental Baths – a large and openly sexual venue then unthinkable in the UK – and

a lengthy discussion of Dennis Altman's *Homosexual: Oppression and Liberation*. As Roger Baker wrote: 'For him the homosexual needs no justification, no excuse and of course, no special pleading – that besetting sin of most British writers, straight and gay, on the subject.'

The foundation myth of Stonewall dominated the energetic, scrappy mood of British gay politics, even if its impact had been delayed. As the future GLF leader Aubrey Walter later observed: 'During the first year of GLF in the United States, most gay men and lesbians in Britain were unaware of what was happening on the other side of the Atlantic. There were very occasional reports in the press, such as in spring 1970 when gay liberationists disrupted a psychiatric conference in San Francisco.'

During a visit to America in summer 1970, when he was exposed to the first full flush of the American gay liberation movement, Walter met the nineteen-year-old Bob Mellors, and they decided to try to start a similar group in the UK. Mellors was a student at the London School of Economics (LSE), and it was there, in a basement classroom, that they held the first open meeting of the British Gay Liberation Front in mid-November 1970. It was attended by eighteen men and one woman.

Within weeks, word of mouth ensured that the weekly meeting was attracting up to two hundred people. Stuart Feather remembered entering 'a classroom filling up with lesbians and the kind of gay men I'd never seen before. By their clothes I could see they didn't go to any gay bar or club that I knew. Some of the men were our age, late twenties to early thirties, but most were ten years younger; students mainly, poorly dressed beauties with long hair, and some with beards. Others were hippies wearing afghan coats, beads, bracelets and even longer hair.

'Among the twenty or so gay women were a few teenagers, others in their early twenties, but the majority were in their thirties, most with shorter hair styles and smarter trousers. There must have been fifty of us altogether, and the great thing was that everyone was warm and open, there was none of that uptight judgemental feeling you found in bars and clubs.'

Jeffrey Weeks recalled his first meeting as 'intoxicating. For the first time in my life I was in a room filled with scores of openly gay men and women of all ages, hippy and conventional, flamboyant and sober, *femme*

and butch, white and (some) Black, all apparently completely upfront
and proud about their sexualities and gender diversities, and freely link-
ing the fight for homosexual liberation to other radical political struggles,
especially women's liberation and Black liberation.'

Unlike the Gay Liberation Front in the US, the British GLF wasn't
born out of a spontaneous event – a long-simmering reaction against
oppression that boiled over into street violence – but was a conscious
attempt to import a movement that had begun its own ideology, and to
translate that ideology to the UK. There was no strong tradition of gay
grassroots action in the UK, and that was what the GLF sought to change.
Above all, it was, like post-Stonewall politics in the US, utopian in nature.

For those who attended meetings in those first few weeks and
months, the initial impact came in the form of a surge of energy that
sought to transform the way gay people thought about themselves, and
then to transform the way that the world thought about gay people. As
Walter remembered: 'At the heart of GLF philosophy was the process
of "coming out", which required every gay man and lesbian to root
out from their own minds the idea that their sexuality was bad, sick or
immoral and develop in its place "gay pride".'

For Weeks, 'A key idea for me . . . was "the closet", a concept that
instantly evoked an image of being confined, trapped, locked away, hid-
den from and by history. Gay liberation offered a new visibility – "out
of the closets and into the streets" – with coming out, publicly affirm-
ing and celebrating our sexuality, a central strategy. Coming out was a
mark of pride and self-confidence. The movement provided a support-
ive context in which being open about our gayness was now possible: it
empowered us to act in the world.'

This was quickly translated into action. On 27 November 1970, the
GLF held the UK's first public demonstration by lesbians and gay men
at Highbury Fields, Islington, protesting against police entrapment in
general and the arrest of Young Liberals chair Louis Eakes for cruising in
a public toilet. Walter remembered this as 'a very exhilarating moment
for homosexuals in Britain, to actually be banded together in public for
the first time, holding hands and shouting our "Give us a G" slogan. We
all felt so tremendously high.'

On 4 December, the GLF held its first disco at the LSE. Walter and the group 'had recognised that if we were to attract people from the gay community we had to create an alternative social scene to the existing gay pubs and clubs'. Indeed, the existing gay world was often hostile: when a couple of GLF members tried to hand out leaflets to their fellow lesbians at Gateways, they got into a big argument with the proprietors, who told them: 'You want to change everything – the whole of society – but you won't because things are all right the way they are.'

Like gay men discarding the old world of Judy Garland and *The Boys in the Band*, the lesbian GLF activists thought the owners' 'negative attitude and distorted self-image' was the result of 'the rigidly sex-defined roles she and her girlfriend feel compelled to play – "butch" and "*femme*", as among the most traditionalist heterosexual couples. This is not a personal attack, but it is another indication of the unliberated state of this as of very many other lesbian couples in which one partner plays the submissive "feminine" role.'

Another result of this utopian energy was the institution of a media workshop and the production of a small, A5 magazine, *Come Together*, in early December. The second issue contained a British GLF mission statement that explicitly yoked the group to other oppressed groupings: namely, the women's movement, the Black struggle, the working class and 'young people, who are rejecting the bourgeois family and the roles and lifestyles offered them by this society, and attempting to create a non-exploitative counterculture'.

There were four basic concepts: coming out, coming together – collective endeavour – and a full examination of sexism, as well as 'exploring the means to extirpate it'. Jeffrey Weeks thought that, in the spirit of the age, the GLF defined itself as 'a revolutionary organisation', with the stress on homosexuality as a political issue, 'the taboo against homosexuality so deeply embedded in Western civilisation that only revolutionary overthrow of its structures could truly liberate the homosexual'.

The GLF's relationship to pop and youth culture was complex. Most early members were under thirty and had been exposed to the generational currents that had swirled around them since the early 1960s. As Weeks noted: 'The GLF in its early days drew its support from those

GLF events, *Come Together*, issue 4, February 1970

who had already been touched by the New Left or the counter-culture. It
had a high proportion of artists, drop-outs, social-security claimants and
the young (the typical age range was twenty-five to thirty-five) – that is,
those who had least to lose by being defiantly open.'

There was a psychedelic tinge as well, as the hippie style took hold
among GLF members and, indeed, encouraged the apparent feminin-
ity and flamboyance that they wished to express. 'Throughout 1971 the
GLF dances became freakier, the clothes more way out, the atmosphere
increasingly counter-cultural,' Weeks wrote, and one event saw 'hun-
dreds of freaks, gay, straight and just plain weird, cavorting merrily to
the music of the Pink Fairies and Hawkwind in an atmosphere generally
reminiscent of decadent Rome'.

In that respect, all was 'good vibes', but the prime influence on the
British GLF, as it was in New York, was the revolutionary rhetoric of
1968, with its uneasy mixture of strict Marxist analysis and the sense
that anything was possible. Weeks remembered that 'there was, I believe,

a general belief among the people who made up the gay movement that we were at the beginning of an historic wave; we were on the crest and it was about to surge forward'.

The relationship to the existing gay world was initially more problematic. The GLF didn't help itself by its militant rejection of other gay publications: an editorial in the first issue of *Come Together* called 'all the so-called gay mags, such as *Jeremy* . . . a load of absolute bullshit and an outright insult to gay people'. In January 1971, the *Observer* noted that 'the homosexual population in general remains aloof [to the

Cover, *Come Together*, issue 4, February 1970

GLF] – "I enjoy my double life," said a delicate youth wearing a gold chain belt in a Chelsea pub, "I don't want to come out."'

The GLF very quickly attracted the attention of the mainstream media, and as a result helped to influence the public perception of gay people. As Jill Tweedie wrote in the *Guardian* that April: 'These young homosexuals, by their very acceptance of the normality of homosexuality, challenge the status quo . . . and they are beautiful to see. It is lovely to be with men and women who are not ashamed to express their affections openly, in the normal heterosexual ways, the hand in hand, the arm in arm, the occasional cuddle, the quick kiss. Suddenly, watching them, the whole evil, squalid image of homosexuality crumbles.'

One major strand to emerge within the GLF was the concept of radical drag. Just as the drag queens and street people had initiated the fightback at Stonewall, so they started to claim their place at the forefront of the new movement. Writing in the fourth issue of *Come Together*, Neon Edsel said: 'We were always out. We were the contorted public face of all of you and you were our good quiet uncle tom brothers. In being queens, unmistakably, we have always been the everyday confrontation with outside the gender role.'

'The metamorphosis of gay men into drag queens in 1971 was a mainly though not exclusively working class phenomenon,' Stuart Feather later wrote, 'that can be seen as responding to and challenging the structured and orthodox beliefs of the bourgeois Marxist ideologists. This oppositional tendency also appeared in the Women's group at this time, between the Marxist socialist women who were mainly middle class and some of the younger working class sisters starting to explore Radical Feminism.'

There were tensions, but the summer and early autumn of 1971 were the GLF's most vibrant period in the UK. In August, a few hundred members marched through the West End in, as Jeffrey Weeks has written, 'the first effort at a major gay march, protesting at the discriminatory age of consent, beginning with a gay day in Hyde Park'. Attempts by a few marchers to convert bar-goers in Earls Court were less successful: 'At the beginning of the movement even the "gay ghetto" seemed part of the enemy camp.'

Quite apart from the less than great enthusiasm shown by many involved in the commercial gay world, there were many hostile forces

arraigned against the open provocation of the GLF. In August 1971, around thirty GLF members protested in Fleet Street, marching into the offices of every newspaper, chanting and waving placards, before congregating outside the *News of the World*'s headquarters. The attitude of the tabloids to gay people was summed up by the accompanying leaflet:

GAY LIBERATION FRONT IS ALIVE AND WELL, AND WE WISH WE COULD THANK YOU FOR IT, BUT WE CAN'T. BECAUSE THE PAPER YOU WORK FOR DOES ITS BEST TO PUT US DOWN. Here are a few recent examples: What pansies want is a lecture on self discipline . . . these creatures who children should be warned against (*News of The World*). It is editorial policy never to write about GLF (*Sun*) nor to accept any advertisement containing the word Gay (*IPC*). No letter mentioning homosexuality may be discussed on the advice page (*Sun*).

In September, there was a large combined demonstration at the Methodist Central Hall, Westminster – involving the GLF, women's liberation groups and individuals from the underground papers *IT* and *Oz* – at the London launch of the church-based pressure group the Festival of Light, which had been set up to agitate for stricter morality in public and private. As the organisers – including 'the more famous moral leaders of the nation, Lord Longford, Malcolm Muggeridge, Mary Whitehouse, and Cliff Richards [*sic*] the pop-star' – walked out, the protest began.

While the GLF youth group at the front of the balcony unfurled a banner which stated, in big red letters, 'Cliff for Queen', members of the street theatre group removed their coats to display Ku Klux Klan uniforms, after which they started shouting, 'Burn them like faggots! Hanging's too good for them! Bring back the birch! Jail them for life! Crucify them!' The final act occurred when some radicals, disguised as workmen, 'threw a number of switches and plunged half the hall into darkness. As the *Guardian* headline next day put it: "Darkness in Our Light".'

The GLF knew very well that they were operating in a repressive climate. During 1970 and 1971, there was the constant backdrop of major industrial unrest, a worsening economic situation, bombings by the

Angry Brigade and a general climate of reaction and retrenchment in the areas of culture and sexuality. Their action made it clear to the moralists – and the press – that they were not going to have it all their own way, at the same time as the press attention brought this new kind of militant, even fashionable homosexuality into prominence.

It also got them into more trouble with the law. After a move to Notting Hill Gate in summer 1971, the GLF collided with the local police, who tried to pressurise publicans in the area to ban GLF supporters from their premises. Several pubs were told that the renewal of their licence would be threatened if they served GLF customers. After an appearance on television protesting this matter, members were emboldened to conduct an early-October occupation of a local pub. The police backed off, but relations between the two parties remained hostile.

During that October, the GLF produced its first concrete manifesto, which, according to Aubrey Walter, 'was a considerable advance on the earlier Principles. It represented a major attempt to integrate a theory of homosexual oppression into the general theory of society, and located the root cause of our oppression in the gender system.' As it stated: 'The long-term goal . . . is to rid society of the gender role system which is at the root of our oppression. This can only be achieved by the abolition of the family unit in which children are brought up.'

This was amplified by Jill Tweedie in the *Guardian* that December: 'Because homosexual men do not play out the normal "masculine" role they are forced to question the results that come of heterosexual males playing heterosexual male roles and they see, more clearly than most, the shortcomings, the disadvantages, the downright tragedies brought about by social ideals of "masculinity". They develop an understanding of how women are oppressed by such males, they have recognized the same tendencies in themselves and have become concerned to root them out.'

As it turned out, this was in part wishful thinking. A year after its formation, the GLF was already riven with irreconcilable tensions. Quite apart from its fractious relationship with the mainstream gay world as such, it had settled into three distinct groups, each with their own vision: the hard-line Marxists; the assimilationists, who were more sympathetic towards the commercial culture; and the extreme genderfuck of the street

theatre group, the radical queens, who were determined to put the commune ideal into practice.

Even more damaging, there was a major split between gay men and lesbians. Right at the beginning of the British GLF, tensions had emerged. There were many more gay men than lesbians in the group, which Aubrey Walter thought to be 'a reflection of the gay scene in general'. Male privilege translated into increased visibility and an increased focus on gay male issues like cottaging. As the GLF's lesbians became more influenced by, and involved with, the women's movement, they started to criticise the male-centric nature of meetings and policy.

These criticisms had been aired in the 'Women's Issue' of *Come Together* that summer: 'We share the experiences of our gay brothers but as women we have endured them differently. Whereas the men in GLF partake of the privileges of the male – you have been allowed to organise, talk and dominate – we have been taught not to believe in ourselves, in our judgement, but to act dumb and wait for a man to make the decisions. As lesbians, "women without men", we have always been the lowest of the low.'

After a fractious meeting in February 1972, the women in the GLF decided to 'overcome our own passivity and your male chauvinism' and announced their split from the movement. However, as Walter remembered: 'The bitterness . . . was most extreme between feminists and anti-feminists in the men's GLF,' and it was this split – between the radical queen communards of street theatre and the 'straight' gays – that eventually caused the suspension of the weekly meetings in April 1972 and the splitting of the national organisation into local groups.

In July, just as it was disintegrating, the GLF pulled off a major coup with the first official Gay Pride march in the UK. The culmination of the group's ideal of an open and confident, indeed non-commercial, gay scene, it had been planned for a while. It began in London on Friday 23 June with a dance at Fulham Town Hall and culminated on International Gay Pride Day, Saturday 1 July, with a carnival parade from Trafalgar Square to Speakers' Corner, followed by a Gay Day in Hyde Park.

As Jeffrey Weeks remembered: 'About seven hundred of us paraded from Trafalgar Square to Hyde Park in glorious confusion. Chanting Gay

Pride slogans – "Gay is good", "Lesbians ignite", "Avenge Oscar Wilde", "Out of the closets into the streets" – popping balloons, handing out leaflets, holding hands and blowing kisses, it was a joyous and exhilarating celebration. We held an informal party in Hyde Park and danced later to the sexually ambivalent songs of David Bowie's *The Rise and Fall of Ziggy Stardust and the Spiders from Mars*, the soundtrack of that summer.'

———

Just at the point when the GLF was dissolving into a mess of sectarian groups, *Gay News* published its first issue, on 23 June 1972. Its first editorial was hopeful: '*Gay News*, as you will doubtless tire of hearing and reading after the first few issues, is not our paper, but yours: it belongs to the whole of the gay community. It's for gay women as well as gay men, for transsexuals and transvestites, for anyone with a sexual label but who we like to call "gays of all sexes".'

Stressing its collective nature, the paper led with stories about queer bashing, police entrapment and an announcement of Gay Pride week. Unlike *Come Together*, it was printed in broadsheet format and included arts reviews, in particular critiques of the film *Cabaret* and Dusty Springfield's latest single. The last page included information about other magazines – *Come Together*, *Sappho* and *Arena Three* – as well as national GLF groups, of which there were twenty-nine in total, with twelve in London.

The British GLF was short-lived but had considerable influence. Within the general climate of hostility, ignorance and prejudice that swirled around homosexuality, it was a brave and successful intervention. Apart from the general relaxation of gender roles it fostered, it helped to change the perception of homosexuality and, in its featuring of radical drag, had a considerable influence on pop culture – most notably in the person of David Bowie, who was rising to national prominence that summer. *Gay News* was another positive result of this utopian moment.

The prime mover was Andrew Lumsden, a journalist at *The Times*, who had been frustrated in his attempts to get newspapers like the *Daily Mirror* and the music press to print anything about the GLF. As he

remembered: 'I was so angry that the principal Labour Party-supporting paper and the principal top paper both refused in the space of a fortnight to carry a description of what the GLF was in the simplest terms, it seemed to me that there was only one thing to do and that was to have a newspaper of our own.'

When Lumsden put his idea to a GLF meeting in autumn 1971, there was only one enthusiastic supporter: the future editor, Denis Lemon. During the winter, a small group planned the direction of the new paper: it aimed to go beyond the sectarianism of earlier publications and appeal 'to the whole of the gay community'. The proposed publication had no burning ambition to transform gay consciousness, but sought to tap into the consciousness that existed – an approach that was broadly populist. In many ways, it aimed to make gay culture mainstream.

As it began to appear regularly, *Gay News* established itself as a bridge between the radical approach of the GLF – being frankly, and determinedly, 'out' – and more traditional, entertainment/music-orientated American magazines like *After Dark*. It aimed for a middle ground between the specialised gay liberation papers like *Come Together* and the soft porn/consumerist thrust of magazines like *Quorum*, *Man to Man* and *Q International*. There was nudity in the new paper but it was kept fairly discreet.

Gay News didn't come out of nowhere: it built on what future contributor Peter Burton called 'the valid contribution made to British gay publishing by capitalist entrepreneurs such as John D. Stamford (*Spartacus*, launched from Brighton in 1968); Peter L. Marriott (*Jeremy*, 1969); Alex McKenna (the imitative *Jeffrey*, 1970) or Don Rusby (*Follow-Up*, 1972). Each of these publications had features in common – notably a reliance on entertainment features and photographs of alluring young men.

'When Stamford founded *Spartacus* there was no gay press and though there were plenty of gay journalists, there was NO gay journalism. Those of us who were involved from the very beginning – and that's only two people, Roger Baker and myself – had to find our material and learn to write about it in a style our readers would not have previously encountered. Neither Roger nor I – nor anyone else, for that matter – had any experience of writing for an exclusively gay readership.

'There were few things we could be sure about. There were a few things that seemed safe: short stories, poetry, book reviews, profiles or gossip items about the famous, horoscopes, such news items as could be gleaned from national or local newspapers. We tried, we experimented. Possibly a ten-year difference in our ages meant that Roger and I adopted slightly different points of view. He know more about the Campaign for Homosexual Equality than me; I simply found it boring even then, and said so.'

After seeing an advert in *International Times* for a new gay magazine, *Jeremy*, Burton sent off for an issue. Although he failed to receive a copy of the dummy magazine, he began writing a theatre column in the first full issue. This was, as he remembered, 'the first attempt at mass-marketing a gay publication. It was also the first publication of its kind to attract advertising – a limited amount, but advertising all the same. One or two people now realised they had an advertising medium directed at a specific market.'

Sent out to potential investors in spring 1969, the dummy issue of *Jeremy* set out its stall: 'For "Permissive Society" perhaps it would be better to read "Positive Society". For that is surely what the revolution has been all about? Getting our sense of values straight. Accepting – and happily – that people are no less people and no less worthy and capable of loving because they feel and act differently. The battle for honesty is far from won, but perhaps some of us, at least, now begin to see less through a glass darkly and more face to face.'

In August, publisher Peter Marriott revealed his editorial policy to the *Daily Mirror*: '*Jeremy* will be designed to appeal to gay people and bisexuals. It will not be at all crude, but very sophisticated and camp, and its motto will be: "Who cares about sex?"' Nevertheless, the gay orientation was pretty obvious: early issues had pretty specific listings – gay pubs, clubs and drag venues – as well as a long article by the Albany Trust delineating the various laws and penalties facing homosexuals after the Sexual Offences Act.

In issue 3, Burton wrote a rather jaded piece about London gay-club life. Critiquing Yours and Mine – around the time that David Bowie first went to the club – for its clientele of self-regarding models and 'small-time pop star' celebrities, he observed that 'the London gay scene

is extraordinary in its dullness, boorishness, witlessness, and total cliqu-
ishness. The number of gay clubs in London is diminishing as public
recognition of homosexuality grows and the state of the few remaining
clubs goes, in general, from bad to worse.'

In 1970, *Jeremy* started to up its pop quotient. No stars were openly
quoted as being gay, but they were selected in part because of their visual
appeal. In January, there was the long profile of David Bowie, followed
by front covers of Thunderclap Newman's Jimmy McCulloch and the
British pop group Edison Lighthouse, recently at the top of the charts
with 'Love Grows'. There was a definite attempt to integrate the maga-
zine with the existing youth culture: issue 8 featured a pop column and a
photo article about skinheads.

This was deliberate. For the first time, pop and youth culture were
impacting on the gay scene as it happened; the two worlds were no longer
as separate as they had been in the mid-1960s. In his reports for *Jeremy*
on London's gay clubland, Burton observed that a generation gap had
opened up, created by the spread of pop culture into the gay world from
the later 1960s onwards. Many venues had adapted or, in staying the
same, become frozen in amber, like many of their clientele. To younger
people in their twenties, this was brutally evident.

In an interview for *Jeremy*, Burton talked to Le Duce regular Iris and
recorded her observations: 'There's the older ones who've been around
for six to ten years. Some of them are a bit piss elegant, cos they think
nobody can know what it's like until they've been around as long as they
have. A lot of these older boys don't like the girls . . . they think they
interfere. I like some of the young people who go to Le Duce . . . I don't
like Yours and Mine because it's full of grotesque trying-to-look-young
pretentious beings. Whenever I go there I feel out of place.'

Burton observed that, a decade previously, women had not been
welcome in gay bars and clubs. 'These days the situation is completely
reversed, though there are still a few last strongholds of homophile
masculine society. A lot of this change must be put down to the Youth
Revolution, which has affected sex, homo and hetero, strongly vigorously
and healthily.' He thought Le Duce 'a stronghold of the new toleration
and bisexuality'.

By this stage, Burton was the editor of the magazine – a brief tenure, as *Jeremy* soon went under. 'Most of those entrepreneurial figures who launched gay magazines had good ideas,' he later wrote; 'unfortunately, to a man, they lacked the requisite financing. Not only did all those early magazines founder on a sea of debts, they almost all went down without paying their contributors. But they did exist and those who wrote for them did so for little or no money and out of the belief that something of this ilk should exist.'

Gay News saw this dream come to its first fruition. It emerged in a propitious climate for new magazines: April 1972 had seen the first issue of the lesbian magazine *Sappho*, while the second-wave feminist monthly, *Spare Rib*, began publication the week after *Gay News*'s first issue came out. Its first few months were rocky. It had no professional distributor – WH Smith refused to stock it – which meant that it had to rely on subscriptions and street sellers, and there was an atmosphere of perpetual financial crisis.

Despite its collective status and its avowed aim to reflect the gay movement's myriad contradictions, *Gay News* was targeted by both the Campaign for Homosexual Equality and the radical queens of the Notting Hill Gate GLF, who thought that the collective had used 'the socialist finance of GLF to float their own enterprise'. Nevertheless, the paper stabilised into a regular bimonthly pattern – itself a first in gay publishing in the UK – and soon began to take on its own particular flavour. The front section had a strong political slant. A repeated theme that emerged out of the GLF and lived experience was the inadequacy of the 1967 Sexual Offences Act, which was described as 'this absurd law'. Comment pieces slammed the obvious and glaring anomalies: the age of consent at twenty-one (eighteen for heterosexuals); the definition of 'privacy', which was more restrictive than Wolfenden; the exclusion of Scotland and Northern Ireland from legalisation; and the excessive severity of the maximum penalties for the many offences.

The fact that gay people felt empowered to criticise the law and the government was a sign of new confidence. Instead of accepting their second-class status, gay men and lesbians were prepared to stand up and criticise the very foundation of that prejudice: the social stigma that still

resulted in job dismissal, blackmail, violence and even murder, and that created a toxic brew of self-hatred, shame and guilt in too many men and women's lives.

In August 1972, *Gay News* recorded a typical press article: a hostile editorial in the *Sunday Telegraph* which opined: 'The Act was intended to protect an unfortunate minority from persecution, but not to empower them to spread their deviant ideas in society at large.' Enforcing this continuing tide of hostile commentary from moralists in the press were the police, who routinely harassed, entrapped and arrested gay men in particular, although lesbians were not immune. *Gay News* covered both groups' travails.

Closer to home, leading collective member Denis Lemon was arrested by the police outside the Coleherne, a very popular gay pub in Earls Court, when he tried to take photographs of their harassment. The police's comments included: 'Soon all you homosexuals will be driven out of sight again'; 'The public has had enough of hearing about your sort'; 'Papers like yours and the underground press will soon be stopped.' At the station, the staff sergeant informed Lemon that he was 'a "pervert", "a queer" and "an abnormality that had to be stamped out"'.

A year or so later, the pioneering American psychologist Dr George Weinberg reinforced the message, commonly expressed by the GLF in the US and the UK, that the issue was not with gay people themselves, but with society's attitudes towards them: 'The real problems are none of those which the so-called experts invent, or spend their time at trying to solve. The real problem is an illness, which we call "homophobia". The word "homophobia" has become very popular in the US. It refers to the morbid and irrational fear of homosexuals, and the hatred of them.'

In early 1973, *Gay News* was beginning to make waves in the national press. It approvingly commented on the support of Alan Brien in the *Sunday Times*, who, in an article about freedom of expression, noted that many mainstream papers refused, 'even when paid for each line, to mention underground or dissenting publications. *Gay News*, the homosexual fortnightly, and *Lunch*, the Campaign For Homosexual Equality monthly, both find their ads refused. Are editors who pride themselves on the freedom of the Press aware of this?'

Welcoming this support from the Sunday paper of record, *Gay News*
reprinted the article word for word: 'We do this for a number of reasons.
Firstly, to demonstrate that we are not alone in our struggle for social and
legal equality. Secondly, to show any heterosexual reader that it isn't just
gays who shout about discrimination etc. Thirdly, because we believe that
it will give hope and encouragement to many gays who think that those
demanding equality are fighting a losing battle.'

The main failure of *Gay News* in its first few months was its compara-
tive lack of lesbian coverage. This was addressed in late 1972, when the
paper featured an interview with *Sappho* editors Jackie Forster and Babs
Todd, which stated that 'if a woman is a lesbian, she's doubly oppressed.
First as a woman and then as a homosexual.' Although they were firm
supporters of Women's Lib, they found it 'a sad reflection on the state of
women's organisations that they weren't liberated enough to be able to
welcome their gay sisters wholeheartedly.'

Lesbians were better represented on the cultural side, with regular
reviews of Dusty Springfield records, including the 1973 album *Cameo* –
'a beautifully tender and bluesy collection of emotional love songs by
a right-on sister' – and news stories like the outing of Joan Baez in the
tabloid press during early 1973. In an earlier interview, Baez had stated
that 'one of the nicest whatever you want to call it – loves of my life – was
a woman. It was something that happened when I was 21, and not since
then. I'm more male orientated now.'

The paper applauded her frankness: '*GN*'s reaction to these disclosures
and opinions is "Right on, Joan" for "coming out". It certainly isn't wrong
to talk about it. Perhaps her example will encourage others, especially
those likely to receive the media's attention, to follow suit. Unfortunately
we do not have a good enough photograph at present to do Joan justice,
otherwise she would have been the first individual to receive the notable
honour of being our inaugural Gay of the Month.'

During that summer, the paper announced that Polly Perkins, who
had an album called *Liberated Woman* released at the end of June and a
book, *Songs for the Liberated Woman*, published in July, would be start-
ing a regular monthly column very soon. 'In the past, Polly has written
for "Stage", "Listen Easy", "London's Pubs" and "Gay Scene", and her

regular feature will be an excitingly different addition to *Gay News*.' The promised column remained elusive, but in the meantime, the album was sensational.

Perkins was a show-business veteran who had started recording in 1963. As part of the Dusty Springfield set in the mid-1960s, she had compèred *Ready Steady Go!* and released a few pop singles. Previewed by a stomping single, 'Coochi-Coo' – 'a female version of camp rock' – *Liberated Woman* was an extremely strong statement for the time. As Perkins wrote in the sleeve notes: 'Liberation for women means society crumbling, marriage ruined, children left to get on with their own scenes, men losing their hold on the purse strings, women fancying other women.'

The accompanying book, *Songs for the Liberated Woman*, was a small volume containing dozens of songs about women – some going back hundreds of years – that Perkins had sung, written or rewritten. They were grouped into headings: 'Travelling Women', 'Women's Laments', 'Teasers', 'The Wife', 'The Mother', 'The Daughter', 'Avenging Women', 'Women in Drag', 'Dream Women', etc. The idea was 'to completely reflect the views of a female chauvinist' and 'a liberated woman'. It was an extraordinary document.

————

Building up to *Gay News*'s first anniversary in June 1973, several articles addressed the state of play concerning gay rights and gay life. The GLF's Philip Conn observed that 'not one of the minimal demands of the GLF Manifesto has yet been realised. It is obvious that where we do not simply take them, as when we ignore the antiquated age of consent, then a lot of work has got to go on persuading those who make the laws and determine the policies that derive from them, to take gay people seriously into account. This needs to go on at all levels of society.'

The editorial in the paper's first-anniversary issue tackled this situation head-on: 'It is fairly obvious from reading through the pages of the current issue of *GN* that the position of gay people in society hasn't changed a great deal over the last year. Homosexuals are still discriminated against,

harassed, murdered, slandered, terrorised and generally abused by all and sundry. Agent provocateur methods are "allegedly" widely used by the police throughout Great Britain and magistrates "allegedly" allow their personal prejudices to interfere with their judgements.

'Gays of all sexes are still isolated and lonely, they are driven to despair and suicide, and gay women still have twice as much hostility to face as any male homosexual. Sex education, and not just about gayness, is primitive and unimaginative, and people continuously use religion to oppress those not of like mind. And what's *Gay News* done about it? Not very much. But we have told a lot of people they are not alone in their struggle for equality and there are encouraging signs that significant changes are likely to happen in this decade.'

In his survey, Roger Baker felt that *Gay News* offered 'a very good documentation of one gay year', which had a cumulative effect, 'indicating the breadth of the gayworld, underscoring the truth that homosexuals cannot be stereotyped but are essentially heterogeneous. And this, of course, is why *Gay News* cannot hope to appeal to every gay person. But it is good to see it hanging outside the newsagent, flanked by *Melody Maker* on one side and *Amateur Gardening* on the other. This is integration.'

Baker shrewdly observed the split between 'the radical principles of gay liberation in editorial outlook, comment and treatment of news stories' and 'the survival need to incorporate certain compromises which makes the paper seem, often, a reflection of the straight-gay scene'. There was one other thing, 'and that is a really creepy pre-occupation with a pop singer called David Bowie. Rarely an issue is allowed to escape without a picture of this young man. I think the David Bowie organisation ought to support the next twelve months of *Gay News*, so there.'

The week that *Gay News* was first published, 'Starman' had made its initial entry into the Top 50. Whatever the readers thought, the collective putting the paper together realised that the singer's admission of homosexuality – which enacted the founding GLF principle of coming out – was a watershed moment in gay life. As 'Starman' and its parent album turned into big hits, being gay became fashionable and newsworthy. Seen from *Gay News*'s perspective, Bowie's success was a portal to a future of greater visibility, tolerance and even equality.

In August 1972, *Gay News's* Peter Holmes stated that this was 'going to be the year of gay rock: this year Alice Cooper is getting friendly with snakes, the Kinks are living up to their name, the grounds of Elton John's Honky Chateau have turned into a camp-site. And Elton and Rod Stewart camped around with John Baldry on *Top of the Pops*. Most important, Bowie is back in the top twenty singles for the first time since "Space Oddity" (1969) and he's well up in the album charts.'

In December 1972, Lemon made Bowie 'Artist of the Year'. 'For too long groups and solo artists have had trite, lacklustre stage acts. But after a David Bowie concert, audiences will be reluctant to accept the mediocre, slipshod stage presentations of the past. Bowie's theatrical, uninhibited professionalism when giving a "live" performance has broken through many social barriers and taboos. And everywhere audiences have reacted enthusiastically to his assaults on accepted convention and narrow minded morality.'

In early May 1973, *Gay News* put Bowie on the front cover, sporting the leather jacket that he wore in the 'John, I'm Only Dancing' video, under the headline 'Bowie Extravaganza to Rock Gay Ghetto'. A few issues later, the editors explicitly pegged Bowie's success to the greater visibility of *Gay News* and gay people in general: 'As you will realise by reading the David Bowie article in this issue, *GN* was given some flattering publicity in London's *Evening News* a couple of weeks ago.

'Apart from being pleased with all the publicity, there is a serious and constructive side to the amount of media exposure we have received of late. First – many more people now know of our existence. Secondly – a section of the media accepts that *GN* has achieved its aim of establishing itself as an independent newspaper and, for the first time, there is a publication able to accurately inform gays about what other homosexual men and women are accomplishing and experiencing throughout the UK, as well as in other parts of the world.'

As well as propagating gay ideas and images into the mainstream of pop culture, Bowie was in turn recognised by the gay press as being the prime agent of this change. In that early May, Denis Lemon wrote that 'the effect of Bowie's forthright and intelligent attitudes towards his sexuality will have far-ranging repercussions on all those involved in the

sexual revolution or engaged in gaining equality and an end to discrim-
ination for those who do not wish to, or can't, conform to society's rigid
and outdated standards'.

The gay sensibility was percolating through to the mainstream. In
October, *Gay News* commented on a 'refreshing' piece by Ray Connolly
in the *Evening Standard*, where he stated: 'None of the previous gener-
ations of rock singers were feminine in their appearance but Bowie seems
to have started a trend towards sexual ambivalence . . . since the new
attitudes towards sex have meant a more understanding attitude towards
homosexuals, it is likely, however, that there will now always be a propor-
tionate place for the bisexual in pop.'

There was also an early recognition in the UK of the pink pound:
the idea that economic power could be translated into political pressure.
'The homosexual consumer is a force to be reckoned with,' wrote Iain
T. Finlayson in *Gay News* that August. 'He is likely to have no family to
support and his income/spending power is likely to be the greater as a
result in comparison with many heterosexual consumers but there are no
advertisements outside the gay press which cater unambiguously for the
homosexual.'

This was an echo of the Gay Power argument conducted in the US
during the late 1960s. As Finlayson continued: 'The heterosexual market
is assiduously exploited and if it should ever transpire that advertisers get
around to exploiting the gay market as well, I for one will be delighted –
not because I particularly like the idea of being exploited but because it
will mean that the bastions are falling and it will be a demonstration of
further social acceptance of the homosexual as an integral member of the
society in which he or she exists.'

David Bowie had been influenced by gay culture and had given some-
thing back: a pop stardom that served to lift up *Gay News* in particular,
and the gay community at large. It offered a transformation that would
take years to be fully enacted, but, in the short term, gay life was informed
by the greater openness in the charts. This was a fragile progress, however,
based as it was on the fickle nature of pop fandom and media fashion-
ability. What would happen when the fad switched to something else,
perhaps even its polar opposite?

25
Warhol's World

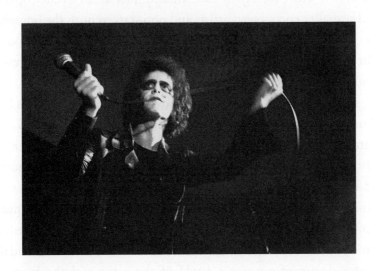

Clearing the television documentary on Andy Warhol which he and two other appeal Court judges had barred from being shown on ITV, Judge Denning tried to give the programme his seal of disapproval by saying it shows 'the perverts and homosexuals who surround Mr Warhol'.

'Perverts and Homosexuals Show',
Gay News, issue #17, 21 February 1973

Glam might have propelled a definite fascination with camp and bisexuality into the British pop charts, but hardcore gay culture – as refracted through the lens of Andy Warhol – was a little too much for wider society to take. Indeed, just as the greater openness around sexuality encouraged artists and pop stars to push the boundaries further, so the reaction against such perceived extremes – and homosexuality in general – began to gather pace. Increased gay confidence resulted in a right-wing backlash, and it was not slow to come.

On 15 January 1973, an injunction to stop a TV broadcast was issued by Ross McWhirter, the editor of *The Guinness Book of Records* and a prominent right-wing campaigner with strong ties to Mary Whitehouse's morality group, the Festival of Light. McWhirter had seen reports of David Bailey's upcoming documentary about Warhol, which was scheduled for transmission on the 16th by one of Britain's prime commercial TV companies, ATV. After the writ's dismissal, McWhirter immediately took his case to the Court of Appeal – and started a national scandal.

Bailey's documentary was a study of the artist and the Factory in transition, between the chaos of the 1960s, the extreme gender warp of the early '70s and the businesslike approach to come. Featuring interviews with New York art-world mavens Leo Castelli and Henry Geldzahler, and superstars past and present like Jane Holzer and Candy Darling, there was nothing much to get that upset about; even a bed-bound discussion between Bailey and Warhol about drag queens was unremarkable.

McWhirter hadn't actually seen the film but had read tabloid reports about bad language and a scene in which Factory perennial Brigid Berlin was filmed making 'tit prints': painting with her breasts on pieces of paper. Outraged and disgusted, he saw an opportunity to further the right's agenda of curtailing what was then called 'the permissive society' – a formulation of the period that lumped together horror films, pornography and the expression of gay and lesbian rights as decadent, actively harmful phenomena that were polluting Britain's public life.

Warhol had already aroused the attention of the censors with the banned films *Flesh* and *Trash*. After ATV previewed the film to the press, there was a tabloid furore, and McWhirter struck: his claim was that the

film contravened the Vagrancy Act of 1838, which made illegal the 'wilfully exposing to view, in any Street or Public Place, any obscene Print, Picture, or other indecent Exhibition'.

The Lords in the Court of Appeal agreed, and voted to uphold the injunction. Right at the last minute, the film was pulled from the schedules, with no date announced for any future broadcast. It was, effectively, banned. If McWhirter thought that was the end of the matter, then he was quickly disabused as, within days, the affair became a national cause célèbre. It was immediately seen as a test case on censorship, the freedom of expression and gay rights in general, with Andy Warhol – who in 1973 was still not quite a household name in Britain – right at its centre.

An early salvo came from Alan Brien, in his influential *Sunday Times* Diary: 'I thought Andy Warhol's *Trash* was one of the best films I saw last year,' he wrote; 'it is partly because of ambiguity in his achievement, the poppy-Cocteau effect of the charlatan genius, that I looked forward to seeing David Bailey's portrait of him last night.' What disturbed him most was the naked, anti-homosexual prejudice of self-proclaimed moralists like McWhirter and the Christian campaigner Lord Longford.

Gay News quickly joined the fray, inveighing against 'Britain's self-appointed arbiters of morals, the Festival of Light'. It criticised McWhirter for not having seen the documentary before seeking to ban it, and noted that the switchboards of the Independent Broadcasting Authority – the regulatory body for ITV was appealing against the ban – and Thames TV, the London weekday television station, were jammed with telephone calls complaining that the documentary had been shelved.

Gay News concluded its report with a number of quotes from those involved:

> Andy Warhol (in New York): 'How quaint. How old-fashioned. Maybe they should see my movies.'

> The National Council for Civil Liberties: 'While a minority has a right to persuade, it does not have the right to impose its views with the blunt weapon of censorship. The NCCL urges the IBA to show this film at the earliest opportunity and let the viewing public decide on its merits or deficiencies.'

Peter Thompson, secretary of the Festival of Light: 'Thank God for men like Mr McWhirter.'

David Bailey: 'I am amazed that the judges can make the order stopping the Film without having seen it. Hitler used to burn books he hadn't read.'

While the legal wrangling about the Bailey documentary continued, Warhol's *Trash* was finally screened on 8 February 1973. It had taken nearly two years for this Paul Morrissey film to pass the British censor. The certificate had been granted the previous November, but Warhol's European agent, Jimmy Vaughan, had delayed the opening for three months to capitalise on the publicity surrounding the Bailey documentary. In fact, the film dropped right into the ongoing scandal.

In the *Observer*, George Melly thought *Trash* 'a carefully considered, totally responsible film'. The censors thought otherwise. It had been a long, hard road to get *Trash* shown in Britain at all. The scene where Holly Woodlawn simulates masturbation with a beer bottle was at the centre of the problem, but the depiction of drag queens, transsexuals and heroin addiction was also an issue. The time delay between the US and UK release only highlighted just how repressive the cultural climate was in Britain, despite the effusions of glam rock.

Trash had premiered in America during autumn 1970. The campaign to get the film shown in the UK had started in May 1971, when Warhol – visiting the UK during his major retrospective exhibition at the Tate Gallery – showed a print to the outgoing head of the British Board of Film Censors, John Trevelyan, who promptly passed the buck to his successor, Stephen Murphy. After viewing the film in June, Murphy advised that 'the film would require cuts at best and at worst may be denied a certificate altogether'.

In late 1971, the BBFC conducted a survey to discover people's reactions to the film. The students and housewives agreed by a majority that the film should be shown, but 62 per cent were offended by the open use of heroin and 19 per cent by the beer-bottle masturbation scene. Nevertheless, the film was not passed. When Jimmy Vaughan asked the BBFC to reconsider in June 1972, they offered a compromise which

involved cutting the prime offending content, as well as the 'opening fellatio scene'.

In October, *Gay News* reported on the current state of gay films in Britain: 'With the exception of some commercially financed and marketed "gay" movies, no gay movie has been given a reasonable circuit showing (ie nationwide) – with the possible exception of *The Killing of Sister George* – which was a cop-out in every way.' It gave the ICA – the Institute of Contemporary Arts in Central London – praise for regularly showing Warhol's 1960s films like *Lonesome Cowboys*, *My Hustler* and *Chelsea Girls*, along with Kenneth Anger's *Scorpio Rising*.

Despite the fact that *Flesh* had been shown in April 1971, *Trash* was still banned, receiving only a limited showing at the London Film Festival. The film would finally be granted a more general release in November 1972, when, after protracted wrangling, it was given an X certificate (only for viewers aged eighteen and over). The way was paved for the David Bailey documentary, which, as *Gay News* announced, would be broadcast on 27 March 1973 – despite the efforts of a 'handful of narrow minded bigots to dictate what you can watch on your TV set'.

The ITV companies had appealed against the moralists, and the injunction had been reversed, with McWhirter forced to pay half the costs, plus damages. When eventually broadcast, the film was a ratings hit, as the censorship campaign backfired. Around 14 million tuned in to what was hardly as sensational a documentary as had been billed, showing that – beyond the controversy – there was an appetite, however vicarious, for the representation of the sexual margins of society.

After such a build-up, however, the result was a damp squib. Viewers might have thought they would get some insight into this enigmatic artist, but, by 1973, Warhol was a decade into his public persona of the Man Who Gave Nothing Away. As he admitted at the time: 'I'd prefer to remain a mystery; I never like to give my background. It's not just that it's part of my image not to tell everything, it's just that I forget what I said the day before and I have to make it up all over again. I don't think I have an image, favourable or unfavourable.'

Activists might have bemoaned the documentary's apparent inability to engage with the censorship controversy – as *Gay News* opined, 'It

didn't really expound with great anti-establishment issues which seemed to be one of the key causes behind its temporary shelving' – but that was not what it had set out to do. With its thorough immersion in Warhol's world, it gave the best mass-market introduction thus far to the man who was currently having an enormous, if occluded, impact on British pop culture – if only through his influence on David Bowie.

———

D avid Bailey's film was the first time the UK mainstream had fully heard about Andy Warhol, despite his high reputation in the art world and music scene. And the British public heard about him not as an artist, but as a shocking, polyperverse impresario, at the very time when glam rock was at its height. Indeed, Warhol's past and present rehearsed and showcased almost all of the period's pansexual strands, whether in the films, the pop interviews in Warhol's *Interview* magazine or the most famous song to be written about him and his world.

Early 1973 was the moment when Britain caught up with the last five to ten years of Warhol. Most people watching the Bailey documentary would not have seen any of the mid-1960s Factory-era films shown in the clips, nor would they – despite the efforts of the band's UK record company – have heard the Velvet Underground. Indeed, the films at immediate issue – *Flesh* and *Trash* – had been filmed and premiered in 1968 and 1970 respectively. What Britain was receiving as new was already receding into Warhol's past.

The undoubted star of *Trash*, Holly Woodlawn had arrived on the Warhol scene in 1969, a year or two after Jackie Curtis and Candy Darling. She was already known to them, having been invited by Leee Black Childers to live at the 13th Street apartment that they shared with Jayne County (then known as Wayne), who remembered: 'There was me, Leee, Jackie Curtis, Ritta Redd and Holly Woodlawn all living in this tiny coldwater flat in the East Village. For a while there it was becoming the Leee Childers House for Wayward Drag Queens.

'When we'd first seen Holly, she was still trying to look real. She had short, short dresses and long, long falls down to her waist. Loads of lashes.

Very show-go-go-girl. Then she started to get into the Trashy Holly look that she made famous. I think she got that look because she got skint; it developed out of necessity, and then she realised that it was going to work for her. But before that she was trying to pass, which was a lot easier in the 60s. I mean, she still looked like a drag queen, but the women in the 60s looked like drag queens as well.'

In autumn 1969, Woodlawn was appearing in Curtis's play *Heaven Grand in Amber Orbit*, which secured her an interview in *Gay Power*. She had already intersected with the Warhol world by trying to charge a camera to Warhol's account. As Paul Morrissey remembered: 'This brazen lie must have appealed to my comic sense. I simply had a hunch that here was some kind of "character" or personality. Although Andy pointed out that Holly was someone who had tried to rob him, the combination of lying and larceny only increased my curiosity.'

With Curtis and Darling, Woodlawn completed the trilogy of transgender performers who lit up Warhol's social scene at the turn of the 1970s. The action was not held within the new Factory now – out of bounds after the Solanas shooting – but in Max's Kansas City, Mickey Ruskin's bar, just around the corner from Union Square on Park Avenue South. This was the place where all the downtown worlds collided: artists and theatre people, druggies, rock stars and the gay world.

At the centre of this trans trio was Jackie Curtis. As County remembered: 'She was super-freaky to look at, she was a weird drag queen, which was very hip, but she was also very smart and creative and could write, act and sing. Jackie Curtis, Candy Darling and Holly Woodlawn were the queen bees – but Jackie was the smart one, the most intellectual, the most temperamental. She'd developed a great stage look with her ripped clothes covered in glitter, in her hair, on her face – she was the first of the glitter queens.'

The relationship between the three was competitive and difficult, exacerbated by lifestyle, drugs and Warhol's own passive-aggressive power plays. All offered their own preferred versions of genderfuck: while glitter queen Curtis was the leader, Darling was ice blonde, inspired – like Warhol was – by 1950s Hollywood glamour queens. Woodlawn was frankly trashy but was the new girl on the scene, especially after

Curtis, who was taking far too much amphetamine, was banned from the Factory in late 1971.

By that stage, the drag queen period was pretty much over, as *Interview* editor Bob Colacello remembered: 'Jackie [Curtis] was persona non grata at the Factory; Holly had stopped coming by for handouts because she had a manager in Dallas who got her a paying part in an almost-aboveground movie called *Is There Sex After Death?*; and Candy had a big solo finale, the most closeups, and top billing in Andy Warhol's *Women in Revolt.*' But this was the highly androgynous Warhol phase that was getting the most exposure in Britain during early 1973.

Warhol's use of drag queens was in part informed by his deep sympathy for the underdog, and by his own wish to press buttons and push gender boundaries, which would always be a sub-theme in his work. As the theatre critic Stefan Brecht observed, in the American twentieth century, a new type of homosexual had emerged, who was 'queer (freakish)'. It was the special characteristic of these types 'to adore women – helplessly, to the point of imitation . . . The essential point is that they are exposing and by their mockery opposing a perverse culture.'

There was another side to this fascination. Throughout the Factory films of the mid-1960s and further into the '70s, Warhol and Paul Morrissey were obsessed by the thought that they could create an alternative Hollywood – hence Holly Woodlawn. Warhol knew that their freakish sensibility and tough milieu debarred them from any kind of engagement with the mainstream film industry, and so – as in the 1960s with Edie Sedgwick and Ingrid Superstar – he created an alternative glamour world, this time not with women, but with men as women.

The idea of glamour was fundamental to Warhol's life and art. As Henry Geldzahler perceptively observed in the Bailey documentary: 'Andy, like too much of his generation which grew up in the '30s and '40s, was terribly Hollywood star-oriented and he'll never get out of the glamour and glory of not only producing these stars, but actually being one also, and it's not something one gets tired of. Just as no matter how much money comes in he'll always have been a Depression baby.'

Something had fundamentally changed in Warhol after the Solanas shooting, and it manifested in his public appearance. He began to move

away from his high-1960s haute bohemian/sadist combo to a more preppy look: at his major Whitney retrospective in May 1971, he wore a gingham shirt, a V-neck sweater and an Ivy League corduroy jacket. This was part of a process that over the next year would see him, in real time, shed the more difficult Factory habitués. His channelling of the dark side was dialled down.

However, Warhol hadn't entirely abandoned his desire to shock. April 1971 saw the release of *Sticky Fingers*, the first Rolling Stones studio album for nearly two years. As ever, it was a tease: the elaborate cover showed a man's midriff, his large penis heavily accented, but if you undid the working zip, all you got was a pair of underpants. Warhol would never say who the model was, but the image was a Polaroid taken by Warhol of Factory associate Corey Tippin that had been pulled out of a selection of rejected photos.

In May 1971, *Pork* opened in New York. This was a marriage of Warhol's world with the Theatre of the Ridiculous. Writer and director Tony Ingrassia had worked with Charles Ludlum and acted with Jackie Curtis in *Heaven Grand in Amber Orbit*. 'Andy Warhol contacted Tony Ingrassia,' remembered Jayne County, 'and told him he wanted to do a play from all the tapes he'd been making of his private telephone conversations with the Factory crowd, people like Brigid Polk [aka Berlin] and Viva.'

Much of the eventual script was a vicious skit on recent Factory denizens, much to Warhol's amusement. After a brief run in New York, the play transferred to London in July, with the cast arriving to a wave of publicity. Sequestered in an Earls Court flat with Geri Miller, Leee Black Childers and Cherry Vanilla, County initially found London boring and staid. 'The gay bars were very quaint and old-fashioned; England hadn't loosened up that much. Of course, being in Earls Court, Leee and I managed to find plenty of trashy bars with drag shows and rent boys.'

The reviews of *Pork*'s run at the Roundhouse were universally appalling, but it was the UK's first full exposure to the world of Warhol in the flesh. Its lessons were well learned by a few insiders, including David Bowie, but the shock tactics belonged to an era that was passing. With its deliberate cruelty and personal provocation, *Pork* effectively acted as

a kiss-off to the most recent generation of Warhol acolytes and stars, some of whom disappeared from the scene, while others – like County – decided to move into a different sphere: rock music.

Autumn 1971 saw Warhol's past come back to haunt him. Valerie Solanas had been released from prison earlier in the year – after serving two years of a three-year sentence – and she continued to threaten Warhol and others. In November, she was put back in prison after harassing her one-time publisher Maurice Girodias, Howard Hughes and RCA chairman Robert Sarnoff with threatening letters and telephone calls. That November also saw high-1960s superstar Edie Sedgwick die from a barbiturate overdose in California.

It was during this transitional period that Warhol bought an estate on the furthest tip of Long Island: a main lodge and four cottages, set in twenty acres of land near the village of Montauk. Despite its remoteness – it was 120 miles and three hours away from New York – it was very upscale, and it marked the beginning of his climb into high society. As part of this campaign, he resumed doing commissioned portraits that year, charging $25,000 for idealised and retouched paintings that were more like plastic surgery than accurate images.

By 1971/2, Warhol had been at the cutting edge for nearly eight years. It was an exhausting and dangerous place to be, as he'd learned to his cost. His injuries from the shooting were continuing to have an adverse effect on his health, and even worse was his terror of the random and the druggy. Baby Jane Holzer remembered that 'if anyone even dared to come in that Factory and light up a joint they would get thrown out. I have been with Andy in a taxi cab, someone lit up and he just falls apart. It really upsets him.'

In autumn 1972, Warhol was, as he wrote in his diary, 'trying to clean up and straighten out, wear ties'. At September's Venice Film Festival, *Vogue* described his entourage as 'really very establishment, these days . . . dressed very Classic', with Fred Hughes, dressed in 1920s whites, like a character from *The Great Gatsby*. Talking to David Bailey, Brigid Berlin marked Hughes as the prime agent of the change from 'Andy when he wore blue jeans and his leather jacket' to the businessman that she now believed him to be.

Bob Colacello was indicative of, and instrumental in, this shift. He had been brought into the Factory fold in late 1970, when his favourable review of *Trash* in the *Village Voice* – 'a social document' – brought him to the attention of Morrissey and Warhol. With the previous editor, Søren Agenoux, having been fired, Colacello was installed as the editor of *Andy Warhol's Interview*, the magazine that would become Warhol's prime shop window during the early-to-mid-1970s.

Having begun as a film publication, *Inter/VIEW* (as it was known before the title change) continued in that orientation until a major injection of cash in the summer of 1972, when a new company was formed on Union Square just to publish the magazine. Warhol would get a half-share, while funders paper magnate Peter Brant and art dealer Bruno Bischofberger shared the other half. The magazine shed its filmic subtitle and instead became part of Warhol's world, with the new title *Andy Warhol's Interview* and the artist's name written in his own handwriting on the masthead.

Interview issues from mid-1972 onwards continued its original focus, with articles about films like *Performance*, writers like Anita Loos, directors like Otto Preminger and stars like Ryan O'Neal and Jack Nicholson. Peppered throughout were full-page, beautiful black-and-white pictures of Hollywood stars from the 1930s through to the 1950s; the subscription page in the June 1972 issue, for instance, featured a press photo of Greta Garbo looking into the middle distance.

By the beginning of 1973, however, pop and youth culture were beginning to regularly feature alongside reports about and interviews with high-society figures like Bianca Jagger and Princess Lee Radziwill. There were interviews with major Black music figures like Diana Ross and Curtis Mayfield, as well as British pop stars such as Ray Davies and teenage Max's scenesters like Cyrinda Foxe, recently notorious for her dalliance with David Bowie.

From January 1973 onwards, *Andy Warhol's Interview* was distributed in the UK. Costing twenty-five pence, it represented cheap glamour and became the go-to magazine for a sub-generation of Bowie fans and glam rockers, with its mixture of cutting-edge, androgynous pop stars, Hollywood glamour and gossipy interviews. Imbued with camp, *Interview* showed that a magazine devoted to this aesthetic could be both

successful and influential. It was almost mainstream, a strange place for Warhol to find himself, but it was where he wanted to be.

———

The March 1973 issue of *Andy Warhol's Interview* featured a glamorous photo of Yves Saint Laurent associate and jewellery designer Loulou de la Falaise. Inside were interviews with designer Karl Lagerfeld, comics genius Stan Lee, most elegant gay movie writer Parker Tyler and David Bowie, who managed to say nothing about his sexuality, preferring instead apocalyptic fantasies: 'This is a mad planet, it's doomed to madness. We might have freaked the world so much, twisted it off its axis, its practical and mental axis so much.'

There was also a major interview with Lou Reed by Glenn O'Brien, who caught up with him just after a five-week tour of the UK: 'We got the guys and the girls. They both interested in what's goin' down. The glitter people know where I'm at. The gay people know where I'm at. Straight people may not know where I'm at, but they find it kind of interesting when they show up . . . I dig the gay people and the glitter people. I make songs up for 'em. So I have to. It's just that I was doing that in '66, except people were a lot more uptight then. They weren't into it.'

Reed's popularity and his bisexual image created a safe space where freaks could congregate, flourish and find themselves, even in hardcore Middle America. In Milwaukee, for instance, he encountered a radical gay drag troupe called Les Petites Bon-Bons. 'The gay kids were goin' crazy. All the glitter queens were out. A typical audience that I would pull. Later on I did some investigating. It turns out that there are clubs, almost nobody knows about 'em, but they exist and they showed up for the show.'

———

In early 1973, Reed was nearing the height of his first fame as a solo artist. As the big spread in *Interview* attested, he was back in the good graces of Andy Warhol; he also had a high-profile album just entering the US Top 40 and a hot single in the shops. His current philosophy was,

as he told O'Brien, to 'hit 'em on the highest and the basest level. And it's just like a big party. A big party. Now when I go into the dressing room I see people in gold lamé with pink hair and I dig it. It's as simple as that.'

It had been a long climb back since Reed left the Velvet Underground in August 1970, before the release of the *Loaded* album, exhausted by the effort of seemingly getting nowhere. He told Geoffrey Cannon a few months later that he'd lost his enthusiasm for continuing with the group. 'His decision to split was influenced by Brian Jones' death, and perhaps confirmed by the deaths of Jimi Hendrix and Janis Joplin. Many rock musicians have been hurt, or paralyzed, by having their persons sucked up and consumed by the vortex of their personae.'

Nevertheless, the cult of the Velvet Underground began within months of Reed leaving the group, prompted by the release of their fourth album, *Loaded*. While their former principal songwriter and singer languished in Long Island, working for his father's firm and writing an excellent disquisition on rock death and the afterlife entitled *Fallen Knight and Fallen Ladies*, the music world began to realise exactly what it had missed. As Cannon declared: 'I expect [*Loaded*] to be the most impressive album released by any band in the world in 1971.'

In autumn 1971, the Velvet Underground's UK distributor, Polydor, began a comprehensive overhaul of their catalogue that included reissues of their first three albums – *The Velvet Underground & Nico*, *White Light/ White Heat* and *The Velvet Underground*, all of which had sold poorly on original issue – and the first UK release of Nico's first solo album, *Chelsea Girl*. The critics lined up with their superlatives, reflecting a sense that the public and the culture were ready for the Velvet Underground in a way they had not been in 1967.

Sometime during that period, Reed returned to the studio and recorded seventeen acoustic demos. He had new supporters, Richard and Lisa Robinson, a husband-and-wife team who were movers and shakers in the New York rock scene. Richard had just produced one of the year's best albums, the Flamin' Groovies' *Teenage Head*, while Lisa was an influential columnist for the *NME* and *Creem*. Richard had just become an A&R man at RCA Records, and one of his first acts was to offer Reed a deal.

In the winter of 1971, Reed went to London to record with Robinson and the pick of British musicians, including two members of Yes, Rick Wakeman and Steve Howe. The first product of this new alignment was his first solo album, released in May 1972. *Lou Reed* was a tentative mixture of the new and the old, a hostage to fortune thanks to the inclusion of several Velvet Underground-era songs. The production was strangely flat, highlighting the proficient but often sterile musicianship and rendering Reed's voice low in the mix. It was a bust.

Salvation came from an unexpected source. Talking to Geoffrey Cannon in July 1972, Reed remembered his first encounter with David Bowie: 'I was up at RCA and they played the album and I said, "My God, he's right there, right there," and that is all there was to it. Then I heard the second album. I sit around and listen to his albums for hours because they are what I'm like. He's the only person I know doing something that I can really listen to outside the Kinks . . . David is right there on centre. I've never seen a better lyric than "The Bewlay Brothers".'

Reed and Bowie's mutual admiration society would be short-lived, but it was at its zenith by summer 1972. The two had met during Bowie's New York visit the previous September, when Reed had expressed his appreciation of Bowie's Velvet Underground tribute 'Queen Bitch'. Realising that the *Lou Reed* album was an artistic and commercial failure, Bowie offered to produce Reed's next album with his team, which would include Mick Ronson, ace bassist Herbie Flowers, Klaus Voormann and the Spiders' Trevor Bolder.

The link-up went public on 8 July, when Reed joined Bowie onstage at the Royal Festival Hall in London. Backed by the Spiders from Mars, Reed and Bowie performed 'I'm Waiting for the Man', 'White Light/White Heat' and 'Sweet Jane' before a crowd of around 3,000. On the 14th, Reed played his first UK show at the King's Cross Cinema in London, and two days later he attended a big press conference held by Bowie to announce his autumn tour and introduce his new protégés.

In publicly allying himself with Reed and Iggy Pop, whom he was also producing that summer, Bowie was toughening up his image. There was calculation in this, as always, but Bowie was also a huge Velvet Underground fan, one of the very first people in the country to have heard

their records. They were a touchstone and an inspiration: in the run-up to the release of the *Ziggy Stardust* album, he and the Spiders regularly played 'White Light/White Heat' and 'I'm Waiting for the Man'.

The Velvet Underground might well have helped to unlock Bowie's inner rocker, but for Reed the equation was a little more complicated. Indeed, most things were complicated with Reed: that was his nature. He was naturally suspicious, often self-sabotaging, but he knew that he needed a career boost and that Bowie was hot. He also saw a means of not fighting his past: this way, he could capitalise on his time with Warhol and the Velvet Underground and integrate it with the current androgynous glam generation.

Transformer – a clever pun which hinted at a new phase and sexual divergence at the same time – was released in November 1972. The gold and black front cover featured a Mick Rock photo of Reed in full make-up and eyeliner, while the back showed, in Reed's words, 'this very well-hung stud looking into a mirror and looking back at him is this beautiful girl'. The man wears a Muir cap and engineer boots, while the 'girl' could easily be trans: two sides, for those in the know, of the still hidden gay world.

The album was directly aimed at both the pop audience that was energised and fascinated by Bowie's bisexuality and the gay constituency who had felt empowered by his coming out. This balancing act between mainstream and insider code was deliberate, as Reed explained: 'There's a lot of sexual ambiguity in the album and two outright gay songs – from me to them, but they're carefully worded so the straights can miss out on the implications and enjoy them without being offended. I suppose though the album is going to offend some people.'

Thanks to Mick Ronson, who produced as well as arranging and playing guitar, *Transformer* was a major step up from the previous album. The sound is fuller, with Reed's voice properly integrated and arrangements that are sympathetic rather than overpowering. Several songs are downtempo, but rock excitement is conveyed by Ronson's guitar, which slices right through songs like the opening 'Vicious', rendering in sound the feeling and meaning of the lyrics: 'Hey, why don't you swallow razor blades?'

Several songs hinted at the gay experience: 'Vicious', with its lyric 'Do you think I'm some kinda gay blade?'; 'I'm So Free', with its references to Times Square; and, even more directly, 'Make Up', with its GLF slogan lyrics – 'Now, we're coming out / Out of our closets / Out on the streets / Yeah, we're coming out.' *Gay News*'s reviewer called the latter 'the best Gay Lib song I have heard'. As ever, New York in general was Reed's subject, but the surprise was just how much *Transformer* was haunted by the influence of Andy Warhol.

In an interview conducted earlier in the year, Reed had talked appreciatively about Warhol. 'We worked with him rather closely, but he didn't do anything to the music too much. He has a real flair for publicity. But I really like him – a lot. He could get us work. There would be all these art shows where Andy was supposed to present something and there would be movies and lights and us. We played these strange places – Chrysler Museum, Contemporary Arts Centre, Ann Arbor, Michigan, Contemporary Culture Centre. No-one had seen anything like it before.'

Five years after they had parted acrimoniously, the two were on good terms again, and Reed felt comfortable enough not just to acknowledge, but to reaffirm the influence. 'Vicious' had been suggested as a song title by Warhol during the Velvet Underground period – he had even given Reed the opening line, 'I hit you with a flower' – while 'Andy's Chest' referred to his near-fatal shooting by Valerie Solanas, an incident that had, along with her light sentence, infuriated the singer.

The album's outstanding track was 'Walk on the Wild Side', a slow shuffle dominated by Herbie Flowers' bass lick and augmented by Ronson's sympathetic string arrangement and Ronnie Ross's baritone saxophone, as well as by backing vocals from David Bowie and Thunderthighs, a female trio that comprised Karen Friedman, Dari Lalou and Casey Synge. Reed's vocal is relaxed and foregrounded; unlike on some of his uptempo songs, his voice doesn't sound forced but is relaxed and intimate, highlighting the narrative.

The five verses work as capsule biographies of five Warhol superstars: Candy Darling, Sugar Plum Fairy (Joe Campbell), Little Joe (Dallesandro), Jackie Curtis and Holly Woodlawn. These were the characters who were in the news, in the cinemas and, eventually, on national

television in the UK. With plentiful references to drugs ('just speeding away'), hustling and transgender life ('shaved her legs and then he was a she'), 'Walk on the Wild Side' was the perfect introduction to the world of Warhol and a bohemian anthem.

A loose concept album about the Factory and Warhol, *Transformer* got mixed reviews but made the Top 20 in both the UK and the US, where Reed's androgyny attracted adverse comment: as far as one rock journalist was concerned, Reed looked like 'a full-fledged social degenerate now, and I really don't see how he could get any lower'. Meanwhile, Reed went out on tour in the US with his new backing group, a teenage aggregation called the Tots, hired to supply the requisite rock muscle.

In late January 1973, he played the Lincoln Center in New York. The first show went badly, according to his friend Ed McCormack, who wrote about the show in *Rolling Stone*. Warhol was there and stepped in. 'Andy heard the news from the vultures in the lobby as soon as he walked in: the first show had gone badly; Lou's timing was off; he seemed listless through the entire set, perhaps even slightly drunk.' After his encouragement, Reed dramatically improved.

As the generally acknowledged stand-out track on *Transformer*, 'Walk on the Wild Side' was released as a single on both sides of the Atlantic during winter 1972/3. It became a hit in the US first, entering the Hot 100 in mid-February and peaking at #16 in late April. In the UK, it was much slower to catch fire, only going into the Top 50 in May, on the way to its eventual zenith at #10 as it competed with Suzi Quatro's 'Can the Can', Sweet's 'Hell Raiser' and Bowie's 'Drive-In Saturday'.

Reed had become a bona fide glam pop star, but even before his chart peak, he was violently reacting against the Bowie association. In a drunken interview with the *NME*'s Nick Kent and *Creem*'s Lester Bangs that April, he was determined to prick the bisexual bubble: 'The makeup thing is just a style thing now, like platform shoes. If people have homosexuality in them, it won't necessarily involve makeup in the first place. You can't fake being gay, because being gay means you're going to have to suck cock, or get fucked.

'I could say something like if in any way my album helps people decide who or what they are, then I will feel I have accomplished something in

my life. But I don't feel that way at all. I don't think an album's gonna do anything. You can't listen to a record and say, "Oh that really turned me onto gay life, I'm gonna be gay." A lot of people will have one or two experiences, and that'll be it. Things may not change one iota.'

At his moment of greatest triumph, Reed backed away. This was no doubt necessary for his self-determination – and was a canny anticipation of the glam backlash – but it led him to some typically caustic rejoinders: during the Kent/Bangs interview he talked about writing a song for his next album called 'Get Back in the Closet You Fuckin' Queers'. But, like Warhol, he could not and would not fully abandon the sex and gender underworld. His own fascinations and ambivalences were too deeply built in.

———

Just as the most famous song about the Factory was rising up the charts, Warhol fell very ill. The previous few months had been hugely challenging. His Mao paintings, while masterpieces, had not been reviewed in the major newspapers and had not sold. His stock in the art world had plummeted: he was seen as a 1960s person. In late November, his mother, to whom he was extremely close, had died of a stroke. Characteristically, Warhol never talked about it; his reaction was 'cold'.

Everything caught up with him in April 1973, when he collapsed at a dinner party attended by his friend Diana Vreeland, who remembered that he 'was writhing with pain'. The cause was the symptom that would dog him for the rest of his life: agonising pain from gallstones. He was taken to hospital, but his existing injuries prevented any surgery on his gall bladder. After his near death in June 1968, Warhol was terrified of hospitals anyway, and discharged himself as soon as he could.

By 1973, the momentum of Warhol's 1960s had finally ebbed away. After the dreadful shock of his shooting, he had sustained himself with major retrospectives, a revival of his portrait work, the release of some new films by proxy and a fresh, boundary-crossing generation of superstars. However, just at the moment when he'd made an impact in the

UK – and was associated with the gender-bending pop culture that he had so influenced – he was temporarily out of action, in abeyance.

In pop culture terms, his most visible presence came in the form of the monthly editions of *Andy Warhol's Interview*, which, during the rest of 1973, continued to cover its established mix of high society, New York life, movie stars past and present and the cutting edge of pop culture, which, over the course of that year, still highlighted the flamboyant genderfuck of post-Bowie glitter rock: articles about Andrew Logan's Alternative Miss World, the New York Dolls, Rodney's English Disco and the first heavily promoted out gay performer, Jobriath.

The magazine's interests went beyond current trends to include anything that challenged gender norms. An October 1973 interview with the young poetess Patti Smith included her thoughts on June Christy, Chris Connor and Billie Holiday: 'I'd like to sing like them. Look at those chicks in the fifties, they all look like platinum bull-dykes.' As she continued: 'I was always a tom-boy, I hated being a girl. I was always Flash Gordon, not his old lady. I never identified with any female at all.'

The previous month's issue had included an interview with Peggy Caserta, author of *Going Down with Janis*, a 'real scorcher' of a memoir that documented her relationship with Janis Joplin. 'Every word of my book is true,' Caserta told John Calendo. 'Some people say I'm aching on Janis' fame, but most people seem to think that I would know better than anybody how Janis would feel about it. I started writing this book two years before she died, and Janis acted real flattered that I was going to do it.'

Nevertheless, despite the graphic detail, Caserta felt the need to deny that she and Janis were lesbians: 'We had no preferences whether it would be a guy or a girl that stumbled in. We just dug whoever we dug. Janis liked guys to rough her up. They had to convince her that they were righteously that pissed about her. It's easy to understand. It came from her rejection fear. She felt that if somebody could work their emotions up to hit her, then, in one way or another, they cared for her.'

That month, Lou Reed released his first record since *Transformer*, a depressing song cycle about two doomed lovers in Berlin. In an interview with *Rolling Stone*, he declared his intention to 'totally destroy' the

'glitterglam crowd that he had courted so fervently'. 'This one will show them I'm not kidding. You know, I got a lot of abuse, different periodicals have been ripping me to shreds, so I think that this will show them once and for all just exactly where I could go. It's very real, very very real. It's kinda unpleasant to listen to but it's safe.'

By then, Warhol's own relationship to pop was also detached. With the films and the magazine up and running, he did not need to be present; his name was enough. He had become a brand whose reach extended to the gay world, the art world, pop culture and high society, and which was used to sell. As a full-page *Interview* ad for Pioneer stated: 'Music is an important part of Andy Warhol's lifestyle. It's a vital source of inspiration for his many-sided activities. Small wonder he sets aside hours each day to listen to his vast and varied collection of records.'

This wasn't just hype. In the Andy Warhol Museum, some of his records from the early 1970s are preserved. They include vinyl by those with whom he had worked – the Rolling Stones, John Cale – as well as the latest albums by Bette Midler, the Bee Gees and the German psychedelic group Amon Düül II. And yet Warhol was already attuned to the next pop culture shift: among his records was the debut album by First Choice, the spring 1974 hit-makers who presaged the new underground gay style. Glitter would come and go, but the dance would go on for ever.

26
The New York Dolls

And it's not for one person to say that they're heterosexual or homosexual or a bisexual, because none of those things are real, none of those things have anything except media and cheapness. 'Cause people are just sexual and people feel things that no-one can say are any one of those things, because they're not. No-one is any of these things because everyone is all of those things. It's all just a media creation.

David Johansen, interview with Ted Castle used in the press release for the *New York Dolls* album, excerpted in *Gay News*, issue 31, 6–19 September 1973

On 8 January 1973, the New York Dolls played the fifth show of their new year's residency at Max's Kansas City. Having suffered recent turbulence and tragedy, they were on a temporary downswing, as they struggled to regain their equilibrium. The theatre critic Stefan Brecht went to see them that night. The son of famed playwright Bertholt Brecht, he knew something about avant-garde performance, and what he saw intrigued him enough to take them on their own terms and go deeper.

Brecht thought that the New York Dolls were the cousins of 'megalomaniac magician kings of sex' like Mick Jagger. They were, in his phrase, 'queer histrions', working class, 'by and large nice boys' who, 'thrilled by oral sex', threw light on what he called 'Queer Theatre'. 'That their oppositionist and even rebellious stances take the form of a put-on, and has only a temporary and primarily stylistic effect on their peer audience, is not against them, for their shows are not phony, and what are the effects of art anyway?'

The day after the show was David Johansen's twenty-third birthday. The Dolls had formed in December 1971, just over a year before, when the members were all at the turn of their twenties: bassist Arthur Kane was the oldest – at twenty-two – while the youngest was Johnny Thunders, still nineteen. They had begun, as Brecht shrewdly observed, as 'friendly, clean youngsters', but they were also charged, or had charged themselves, with reflecting their time, place and milieu – and that meant that the world would claim them soon enough, with their genderfuck and pop decadence.

The five New York Dolls came from Queens, Brooklyn and Staten Island. They had the wonder that kids from the suburban boroughs had for the high-density island on their doorstep. As David Johansen explained that year: 'As far as my own situation in New York City here and now: Rimbaud used to write about the monstrous city and the effects it would have on the species. And here it is 1973 and everything is very fast and moving and I try to understand how people feel about it, how they relate to the environment. That's what a lot of my songs are about.'

During 1972, the Dolls emerged at the apex of a series of connections that included Warhol's world, the Theatre of the Ridiculous, Max's

Kansas City, the Angels of Light and David Bowie. This was the cultural moment of glitterglam, of open transvestism, of bisexuality and a flirtation with homosexuality, and the five musicians were right on point. Darlings of their adopted Manhattan, they would conduct an experiment in how to fit these ideas, images and values within the mainstream American music industry of the time.

———

The New York Dolls began in the long-standing friendship of Queens teenagers Syl Sylvain, Billy Murcia and Johnny Genzale, with Johansen coming in at the end of 1971. 'David [Johansen] was a New York theatre guy, the Theatre of the Ridiculous,' Sylvain told me. 'I guess Warhol was at the head of it all. He was in that clique but he had his bands on Staten Island. He was more like an activist. David was that kind of a person, a believer. He would stand up and try to make things happen.'

Johansen was brought up on Staten Island. As he remembers: 'The area I come from is called the North Shore, it's close to the ferry, the skyline is there across the bay, so it's a bit more cosmopolitan, more Democrat; you could be in Manhattan in twenty-five minutes. We used to go to the Murray the K shows, and the person who got me was Mitch Ryder. They gave the bands five minutes, and Mitch Ryder would come on and in five minutes he'd do three or four monster songs. At the end of it, he'd have no shirt on, he was soaking, sweat was flying everywhere.

'I was awestruck by him, I think that cemented that I'm really gonna do this. I liked all of those bands. The Kinks, the Zombies, whatever came out, all the bands from England. But also tempered with American R'n'B. I had a band in high school. The band that we had then, we could do things like "Mustang Sally", but also the Four Seasons, crazy singers like Lou Christie. Something about the camp value of rock'n'roll appealed to me.

'Before I met any of the other guys in the Dolls, I had been living in Manhattan for a while. I'd been through, for want of a better word, this hippy metamorphosis, the psychedelic scene, going to the Fillmore: they used to put on these great, eclectic kind of shows, you could see Miles

Davis and the Who, there was a lot happening there. I used to work for this guy in St Mark's, Warr Wilson, who had a store on St Mark's Place. He had a basement where he had a workshop, a Dickensian place with stone walls and moss dripping down.

'I used to notice these racks of costumes – he had these big, lush boas and wild costumes with sequins, there was this giant sequinned phallus – and I wondered what he was doing with this stuff. "Oh, this is a costume that I'm making for Charles Ludlum's Ridiculous Theater" – and I've gotta check this out. I went to . . . rehearsals, and these were like the greatest people I'd ever met. They were so much fun, and so brilliant. I'd met individuals like that, but I'd never met a mob of them!

'And I just started to make myself useful. I would string the guitars. When they did a musical, I would back them up, do sound effects, shaking the tin so it's thunder, all that kind of business. I just liked being with them, they were such great characters. They definitely influenced me. Making a spectacle that's not shoe-gazing. I got a lot from them, and from Little Richard. I went to this party he had at the Waldorf, before I was in the Dolls. He was carrying on, really funny, making all these pronouncements. He was a great character.'

Like the other group members, Johansen was hustling a living on the fringes of the Manhattan rag trade. As he recalls: 'We noticed each other because of the way we would dress on the street. The East Village in those days was very creative. There were huge thrift stores back then. Somebody would take over an old TV studio on 4th Street and turn it into this gigantic used-clothing emporium. You could find really great stuff, it was unbelievable the stuff you could get. And really cheap. I used to go for more a Dietrich kind of look.'

Named by Sylvain Sylvain – 'I discovered the name, the Dolls. I didn't know it meant pills, I just thought it sounded good' – the New York Dolls began in flamboyant style. Sylvain: 'I was sick and tired of wearing bell-bottoms, it was a rebellion against that. If you wore a little make-up, were influenced in any way by the best of the late '60s – the Doors and the Rolling Stones – you had to have sex appeal. Before we started, me and Billy used to put on make-up just to go down to the supermarket, shopping. Getting dressed up to go shopping, it was fun to do that.'

After playing a few rent parties, the group played their first date in early May 1972 at the Mercer Arts Center, supporting former Warhol acolyte Eric Emerson's the Magic Tramps. The Mercer was a large arts space that had been converted out of an old welfare hotel, the Broadway Central Hotel on Mercer Street, into thirteen spaces: five theatres, including the Brecht Theater and the Oscar Wilde Room, as well as a video studio and performance space, a nightclub, two acting schools/studios, a boutique and a rehearsal hall.

Johansen later told *Circus* magazine that 'it all came together at the Mercer Arts Center. We were opening for The Magic Tramps, but we were so good that they booed The Tramps off stage, so we opened and closed the concert.' The Mercer quickly booked the group for another show in the Oscar Wilde Room, a larger space with several floor-to-ceiling mirrors that reflected the band from all angles and an audience capacity of 200: the perfect name and environment for what was about to occur.

The group had brushes with the hardcore gay world, playing a couple of shows with Warhol superstar Jackie Curtis at a gay bathhouse (most likely the Continental Baths; as Arthur Kane remembered: 'They didn't seem to appreciate the *femme* look') and appearing at events hosted by Hibiscus and the Angels of Light, who had moved to New York from San Francisco. 'We'd play in these lofts,' Sylvain remembered. 'The Angels of Light was one of them. Art, rock, theatre, drag queens, very flamboyant.'

'I knew the Cockettes and the Angels of Light,' says Johansen. 'I met them before I was in the Dolls, though. They did these shows at a Chinese movie theatre in North Beach in San Francisco, and the time I was in the Bay Area, about '69, I used to go to their show every Saturday night, I think it was. They would show some kind of cult movie, like *Freaks* or something, and then do a performance. When they came to New York, they got slimed because they were so ill-prepared, but that was kind of the point of them.'

After *Pork*'s run had finished in the UK, Jayne County had returned to New York and was developing her own group, Queen Elizabeth. 'I was determined to take all of my experience in the Ridiculous shows,' she remembered, 'and present them in a rock & roll format. Someone told

me that there was a group playing at the Mercer Arts Center every week called the New York Dolls who wore make-up and women's clothes. I couldn't believe it. I thought we were going to be the first, but the Dolls beat us by a few months.

'David Johansen, the lead singer, had been in Charles Ludlam's play *Whores of Babylon*, he'd been around Max's a lot, and he knew that all that stuff was in the air. Being gay and bisexual had always been a big taboo in rock, but it got pushed through from the underground scene into the rock world, and suddenly it was very hip. Bowie announced his bisexuality after seeing *Pork*, and then everyone was playing with the idea. Soon it became cool to paint up and wear glitter and outrageous clothes.'

The Oscar Wilde Room was the perfect environment to develop an audience, as early fan Alan Betrock recalled: 'One, it was bigger and allowed more people to get in comfortably. Secondly, it was out of view of the "straighter" visitors to the Mercer's more commercial presentation – thereby keeping the Dolls' nouveau–freakish–bisexual audience out of sight. The audience, after all, helped the Dolls get much of their early publicity. Guys in "dresses" and high-heeled shoes playing to an ecstatic audience of people whose sex was in doubt?????'

The Dolls became fashionable, drawing in taste-makers and celebs like John Cale, Alice Cooper, Todd Rundgren, Bette Midler and Lou Reed. Alert commentators quickly realised that this was a new pop moment, and that it was marked by a group which manifested as transvestite: to Ed McCormack of *Rolling Stone*, David Johansen looked like 'Mick Jagger's skinny kid sister', while 'the big tall skinny goldylocked blond bassist is looking a little shy in his lipstick and pink pantyhose'.

Lou Reed's producer Richard Robinson remembered how these shows at the Oscar Wilde Room felt in relation to the rock culture of the day: 'The Dolls were the point of transition. The heralding of a new kind of rock and roll. Spaced-out San Francisco rock had grown into the smooth commercial downer music of Los Angeles. The image of the music was a girl playing a piano and humming about how groovy her lost love was. The Dolls were like getting thrown through a plate-glass window. That's what the Dolls sound like.'

It was during the Mercer Street residency that the New York Dolls met their future manager, Marty Thau, an industry veteran who had worked at Cameo-Parkway Records and had just resigned as the head of A&R at Paramount Records. On seeing a show at the Oscar Wilde Room, Thau liked their spirit – 'I was impressed with their clarity as to how they were going to become a big rock'n'roll group. They were very confident, very funny and very intelligent' – and, with backing from booking agents Steve Leber and David Krebs, signed them up.

In July 1972, Leee Black Childers was brought in to photograph the group for a major story in Britain's *Melody Maker*.* As he remembered, this was 'attributable to Roy Hollingworth, one of the first rock journalist stars. A good writer and a good man. He was posted to New York and I had come back to New York from doing *Pork* and had gone to work at *16* magazine, taken under the wing of Lisa Robinson. He called Lisa and said, "I have to find a photographer to work with for *Melody Maker*," and I met with Roy and we got on straight away.

'It was he who said there was this group who are "supposed to be really weird. Let's go. I'll interview them, you photograph them." We went down to this loft on the Bowery, and it was the very beginning of the New York Dolls. I put them in their closet. Their clothes were like all of our clothes, clothes that they'd found in garbage cans and stuff and thrift stores and Salvation Army's. They just put on make-up like we all put on make-up, and wore women's clothes because it was the most polka-dotty stuff that they could find in the garbage.

'They were totally irreverent, totally crazy. To my mind, they were much more interested in being irreverent than Iggy was; Iggy was physically irreverent, they were mentally irreverent. They did it with their clothes and make-up and attitudes. You couldn't get much more street

* The article was published in the 22 July 1972 edition of *Melody Maker*, their first piece of British press. Under the headline 'You Wanna Play House with the Dolls?', Hollingworth wrote: 'They might just be the best rock'n'roll band in the world. And whether you believe that or not, you're going to have to take notice of them . . . in them lies the rebellion needed to crush the languid cloud of nothingness that rolls out from the rock establishment.' He also noted that they were not yet signed to a record company.

kid than Iggy. David Johansen was more cerebral, he could speak your language. Iggy would go from one to the other, Gentleman Jim or the Dead End Kid. David J was both at once, and to my mind in a more creative way.'

By September, the New York Dolls had attracted the attention of the mainstream media in New York. For a moment, it seemed possible to inject ideas of gender variance and possibilities into the highly patrolled masculinity of American rock. In the *Sunday News*, Lillian Roxon wrote that '*Variety* loves the Dolls. *Melody Maker*, the world's biggest music paper, loves the Dolls. Everyone and his mother loves the Dolls. Only the uptight record company people hate them.'

On the 26th of that month, during his first major US tour, David Bowie went to see the group at the Mercer Arts Center. He had come with an enormous entourage that included several of his friends from *Pork*, who now had official positions with Mainman: Tony Zanetta was president, Cherry Vanilla chief press person and Leee Black Childers was executive vice president, which meant travelling with Bowie and assisting with other acts in the Mainman stable – Iggy and the Stooges, Mott the Hoople and Jayne County.

Ever the consummate assimilator, Bowie quickly took on elements of the New York Dolls' style – heavier make-up, custom-made, high, back-less mules – and entered into a fast relationship with David Johansen's friend, the actress and former assistant to Greta Garbo, Cyrinda Foxe. Bowie later remembered that he had written 'The Jean Genie' 'for her amusement in her apartment', and he spirited her off to San Francisco to appear in the song's video as a 'consort of the Marilyn brand'.

As part of this international dialogue of androgynous rock brats, the New York Dolls travelled to the UK in October 1972 to play some dates, the biggest and most prestigious of which was at Wembley Pool, support-ing Rod Stewart and the Faces at a benefit gig for the Stars Organisation for Spastics. Fronted by Johansen in a lurid polka-dot jacket, they did not go down well: as the *Melody Maker* reviewer noted, 'Their glamour bit brought wolf whistles and shouts to go before a note had been played.'

The visit was bedevilled from the start. The group were supposed to support Lou Reed on his dates with the Tots, but at the last minute he

axed them from the tour, and they were forced to play pick-up shows. On 6 November, tragedy struck when drummer Billy Murcia died after overdosing on the depressant Mandrax at a party. The partygoers didn't have the sense to let him sleep it off and instead panicked, putting him in a bath and force-feeding him coffee, which caused asphyxiation and death.

On their demoralised return to the US, the Dolls quickly found a new drummer, Jerry Nolan, who had been playing in Queen Elizabeth with Jayne County. A more dapper, handsome version of Leo Gorcey, Nolan was, at twenty-six, older than the rest of the group but cleaved to their obsession with clothes: as one member of his previous band recalled, 'He looked like a clone of Johnny Thunders. He had the high-heeled shoes and the Kamali pants and teased-up hair.'

On 19 December, Nolan played his first show with the New York Dolls, a record company showcase. 'We just went right into this show just to get ourselves back into it,' Johansen told *Creem* magazine. 'But someone had invited down Ahmet Ertegun, Clive Davis and these other crazy people. Out of an audience of 500, there were maybe 20 real kids who were there to rock. The rest of 'em were record company people, and if you mess up . . . well, goodbye, and the trap door opens and you fall into the snake pit.'

Coming so soon after the death of Murcia, this was a low point in the New York Dolls' history. Despite their rabid fanbase and a strong selection of catchy songs, their androgynous appearance and often sloppy performances went directly against what the US music industry thought palatable and commercial: well-crafted, adult-oriented and definitely heterosexual rock. Their importance may well lie in how much they disrupted the expectations of the music industry and the media, but at the time it was hard going rather than heroic.

It was at this point that Stefan Brecht saw the group at Max's Kansas City. He caught nothing of their recent travails, preferring to see them as 'real dolls: nothing more, nothing else'. He grasped one fact that many commentators, blinded by their transgender shock value, missed: that the New York Dolls were a classic teen pop group, with songs that captured the contemporary teen experience, and they were influenced not

just by underground theatre and the Rolling Stones, but by 1960s garage and the girl groups.

Brecht caught them at a pivotal moment. At the end of January 1973, the group began a twelve-day residency at Kenny's Castaways, on 84th Street in the Upper East Side. At the repeated urging of Paul Nelson, the A&R man at Mercury Records, Mike Gormley, the label's head of publicity, flew in from Chicago to see the group. Bowled over by them and their press coverage, he immediately recommended that they be signed to Mercury, and the deal quickly followed.

In February, the underground writer Miles wrote a piece that placed the Dolls at the centre of a Manhattan renaissance. Reviewing their Valentine's Day show at the Mercer Arts Center, with Suicide, the Magic Tramps and Jayne County supporting, he called them 'representative of a new wave of New York groups who have picked up on Marc Bolan, Slade, Elton John, David Bowie in a big way and combined them with such historical figures as The Fugs, the early Mothers and the very much present day Lou Reed.

'This together with such groups as The Angels of Light and the Cocquettes [sic] who represent the west coast branch of all this. This being post-Rolling Stones New York faggot-rock. OK here come the NY Dolls. A hard rock, camp prissy 100% homosexual group in black tights posturing and imitating all of Mick's stage gestures and leaps. Its [sic] terrific! So Faggot-rock emerges from out the closet and nothing could get it back in again by the look of it.'

During that month, a new rock magazine hit the stands, a self-styled 'grafting of *Rolling Stone*, *Hit Parader*, *Popular Mechanics*, and *Women's Wear Daily*'. Dated March 1973, the first issue of the New York-based *Rock Scene* – edited by Richard and Lisa Robinson – featured writers and photographers Henry Edwards, Lenny Kaye, Loraine Alterman, Leee Black Childers and Lillian Roxon, with articles on Marc Bolan, Ray Davies, Slade, David Bowie, Lou Reed, Alice Cooper and Sylvester, who confided: 'If I make it big, I'll be so crazed.'

At a moment when many British chart regulars were failing to make any headway in the US, *Rock Scene* was obviously Anglophile and tied in to the early-1970s activist/critic project for proper, teen-oriented, exciting '70s rock. In the first issue, the picture stories on the New York

Dolls and the famous meeting in London of Bowie, Reed and Iggy Pop vied with a big feature on *Nuggets*, Lenny Kaye's 1972 compilation that convincingly revived the excitement of 1960s garage bands, whom he termed 'punk rock' and recast for a new, receptive generation.

The New York Dolls had the teenage approach and raw noise of the 1960s rockers, but this was the early '70s, a pop generation further on. They were, in Brecht's formulation, part of the New York world of 'queer theatre', an approach that included gender provocation and, indeed, the upending of most established norms. The Dolls' adoption of women's clothing might have come from their daily lives as rambunctious teens in the heart of the New York fashion industry, but it soon took on another meaning.

Wearing selected items like slingbacks, 1940s women's jackets or polka-dot blouses – while slathering themselves with make-up – did not make the New York Dolls transvestites or transsexuals in the manner of Candy Darling or Jayne County. They still wore enough men's items to be recognisably male. They were not trying to pass as women, nor were they proclaiming themselves as gay, although, in the newly liberated climate of their time and milieu, it would have been easy to make that assumption. In fact, the Dolls were all basically heterosexual, although David Johansen did proclaim at one point that he was 'trisexual'. 'Everybody used to say that in those days,' he remembers. 'It's not something that I came up with. It's a way of saying, "Get off my back, don't talk to me about this stuff, I don't even know how to respond to whatever it is you're saying." It was great fun then, just letting go. There was something about those days, they were just carefree. It was a time in our lives when we didn't have to do anything in our lives that we didn't care to do.'

The word 'trisexual' was picked up on in several articles about the group. It worked both as a kiss-off and an elegant formulation that, by implying the user could try anything, allowed for experimentation and play. As Sylvain Sylvain told me: 'We tried it with as many people as we could, but we weren't gay. We used it.' Their whole approach was not about being tied to a specific gender or sexuality, but about extending the possibilities and definitions of what it was to be a young man in and outside the world of pop culture.

Gender play was great fun for the Dolls. Their friends did it, their audience did it, and they reflected both. But there was another side, allowed by a wider definition of 'queer theatre': here, 'queer' can mean odd, unsettling, not quite right, and there was a sense, as they gained traction, of the group becoming aware that their blurring of gender, however male-oriented, was being perceived as outré and threatening, showing up as it did the painfully constructed machismo of American rock culture.

The way the group looked opened up a generational and perceptual divide. As *Creem*'s Ben Edmonds wrote: 'One of the first things that made record executives uneasy about the New York Dolls was simply the way they looked, which consequently must make it very important. As with the first time you ever saw the Rolling Stones, the way the Dolls look establishes an instant identification. Perhaps the main reason that the Dolls have been so misunderstood is that they don't play to any existing audience; it's an audience that has yet to reveal itself.'

As had occurred with the Stones nearly a decade previously, the New York Dolls' image was seen by the press as shocking and unpalatable. As the New York *Sunday News* wrote in May: 'Sneering, sporting women's clothes, shoes, makeup and hairdos, contending they add pizazz to their music, the recently emergent New York Dolls are classically offensive. Their raw, screaming music supports the obvious hostility of their stage image.'

This image was placed right up front on the cover of their first album, released in late July. Emblazoned with the title written in pink lipstick, the otherwise black-and-white cover presents the group in full feminine flow. Sylvain Sylvain looks like a living doll, while Thunders and Nolan stare out of their make-up with a direct, street-punk gaze. On the left, Arthur Kane, in an off-the-shoulder T-shirt, slumps in dissipation. In the centre, David Johansen looks at his reflection in a pocket mirror.

'We showed up with the clothes,' Johansen recalls. 'Syl had arranged with Betsy Bunky Nini* [*sic*] for them to do the shoot. Syl had been in the rag trade – he and Billy had a sweater company. Toshi was the photographer.

* A designer clothing store founded by Betsey Johnson, Anita Latour and Linda Mitchell.

We came in and it was all set up. There was a make-up person there. We went for it. We availed ourselves of the hairdressers and the make-up, and the Betsey Johnson people were so into it, it was kind of infectious.'

The music inside the sleeve was another matter. The eleven songs – ten originals plus a cover of Bo Diddley's 'Pills' – loosely form a suite of meditations on being young and hungry in New York, that monstrous city. From the Shangri-Las reference on 'Looking for a Kiss' to the noisy guitars that updated the blues of the Rolling Stones with the screech of an IRT subway train, the album was saturated in the atmosphere of Manhattan: the decibel levels, the insistent voices, the existential angst ('Personality Crisis'), its snatched pleasures and freakish mutations.

Two songs in particular embodied the group's trisexuality. Among the catchiest, they were released as singles in the US and the UK. 'Jet Boy' offered a scenario of jealousy couched in space-age terms: 'Jet Boy stole my baby / Flyin' around New York City so high / Like he was my baby.' Offset with high, girl-group harmonies, 'Trash' quoted a line from Mickey & Sylvia's 'Love Is Strange': 'How do you call your lover boy?' Spoken a cappella by Johansen, it was delightedly and deliberately ambiguous.

They were writing about their audience and their associates in New York. 'I would imagine they were amalgams of people,' Johansen now says. '"Jet Boy" is like an ideal. "Trash" could be about a million people. It's hard to remember. I don't know where it comes from – it's in the air. When you write for a band, it's like being a speech-writer for a political party or something, you want to make it representative. If you start writing personal songs in a band like that, it's like iffy, to say the least.'

The album got rave reviews right across the board.* Among their own audience and within their own bubble, the New York Dolls were huge. But it was quite different when they ventured out of Manhattan.

* The New York Dolls had become, as Ron Ross observed, 'the ultimate rock critics' band, because, along with David Bowie, Lou Reed, Alice Cooper, and Todd Rundgren, and in a less self-conscious way, Stories, Raspberries, Blue Ash, Badfinger, Slade, and Iggy, the Dolls are the best critics of rock and roll pop music has ever produced'. Citing influences like Eddie Cochran, the Shangri-Las, the Ronettes and the Angels, Ross concluded that the album was 'pretty much a microcosm of life itself'.

The androgynous cover made it almost impossible for the album to get the airplay it needed. As their A&R man, Paul Nelson, remembered: 'I didn't expect leading radio stations to be shocked by it, it didn't seem that shocking to me. It created something that remained at the forefront of a lot of people's opinions, and they never got beyond the cover.'

Johansen is more philosophical: 'When you're a kid, and naive about business, you think that if you get a contract, your worries are over. But then there's a whole new kettle of fish. The powers that be have an interest in taming your rebelliousness, and that becomes a headache. Trying to satisfy everybody and remain true to yourself. Whether they could cope with it or not didn't matter to me. The East Village social scene was evolving rapidly. Things that were becoming normal there were so far from the rest of the country that they couldn't really make that leap.

'Since the '50s with the beatniks, the East Village had been incrementally moving along, and wound up at this spot, in 1972, and the rest of the country was still in the '50s. So it was kind of shocking to them, but the important thing is that they needed to be shocked. People worry about so many things that they don't need to. You could boil it down to the capitalist system, having to get up and face work every day. But it's silly. People get so worked up about things that are hardly even there.'

Nevertheless, the New York Dolls found an audience when they went on tour. Johansen remembers Detroit, San Francisco, Toronto and Miami as being great, but 'there were places where the vibe wasn't right. Now and then we'd get someone yelling from car windows. I think people thought twice about trying to menace us, because there was something about us that made them think we could be dangerous if you fucked with us. We wouldn't be afraid to fight you, as opposed to just being your victim.'

————

In late August 1973, the New York Dolls travelled to Los Angeles for a five-night residency at the Whisky a Go Go, where they intersected with the subculture that revolved around Rodney's English Disco on Sunset Strip. A magnet for visiting British rock groups and teenagers

from the suburbs, it was a mixture of innocence and extreme sleaze, all soundtracked by the latest records from Slade, the Sweet, Suzi Quatro and, presiding over it all, David Bowie. It was designed, as its presiding spirit Rodney Bingenheimer stated, 'as Los Angeles' first stark-raving discotheque'.

Richard Cromelin precisely observed the club's dynamic in *Interview*: 'Once inside, everyone's a star. The social rules are simple but rigid: All you want to hear is how fabulous you look, so you tell them how fabulous they look. You talk about how bored you are, coming here every night, but there's no place else to go. If you're not jaded, there's something wrong. It's good to come in very messed up on some kind of pills every once in a while, and weekend nights usually see at least one elaborate, tearful fight or breakdown. If you're 18, you're over the hill.'

This was a new teen world that rejected the hippie aesthetic in every possible way. Instead of jeans and natural fabrics, there was lurex, sequins and rhinestones. Nineteen forties and '50s kitsch shaded into every possible mutation, as Cromelin observed: 'There are some extreme cases, which of course are the most charming and interesting. Sable Starr in an outfit from Frederick's of Hollywood children's department, straight out of the *Story of O* . . . Les Petites Bons Bons wandered in one night, hair cropped short in the shape of stars, stripes and hearts.'

The sexual dynamic was as fluid and confusing as the New York Dolls were, perhaps even more so. The most obvious mode at Rodney's was extreme narcissism, but, in Cromelin's insider account, 'You'll find boys looking for someone to take care of them, and other boys looking for boys, though gay men out for a trick are driven to the cliff by the situation there, by beautiful young things who are compelled by fashion to look and act gay but are ill-prepared to step any further along the path of decadence.'

A snapshot of this outrageous culture was included in *Rock Scene*'s September 1973 issue, which, underneath a shot of Rodney's superstar Sable Starr, included Richard Creamer's shot of 'writer Richard Cromelin, with Jerri and Bobbi of Les Petits Bon Bons [*sic*] – L.A.'s latest dragrock sensation in [a] serious moment'. It was a startling image, taken at the party that they had helped to organise, with Leee Black Childers, for Iggy

Pop; Bobby Bon-Bon is wearing full make-up, a turban, a necklace and what looks like a 1940s patterned dress.

It was Robert Lambert's second day in Hollywood. A couple of years before, he had formed Les Petites Bon-Bons with Jerry Dreva as a conceptual art project concerned with fandom and celebrity. Like the Cockettes, they came out of post-Stonewall gay radicalism, as Dreva related: 'We began to feel that a new synthesis of art, politics and sex was needed. We attempted to integrate our radical gay politics with a visionary tradition (going back to William Blake) that called for living the unrepressed life, integrating art and life and cultivating androgyny.'

Lambert remembered the reasoning behind their approach: 'You can't change laws until you change minds, and you don't do that by boring people to death. The problem with manifestos is that few read them that didn't write them. And as gay people, we had so many better tools at our disposal – creativity, humor, irony, sarcasm, wit, foolishness, and the ability to put on a great show. That started with costumes. Thrift shop hippie glamour meets classic drag on an acid trip, and take it from there.'

A major part of their work was to send handmade packages to anyone of importance. 'Andy Warhol, of course,' Lambert itemises. 'William Burroughs. Norman O. Brown. John Cage. Columnists we followed, Jill Johnson [sic] at the *Village Voice*, gay writers like Arthur Bell, or Christopher Isherwood; hell, Rona Barrett, and why not? Even when we didn't get replies, it didn't diminish the secret thrill that we had reached them. It wasn't until later we learned that others were sending art through the mail, and that it had a name, Correspondence Art.'

Originally based in Milwaukee, the Bon-Bons began to relocate to Los Angeles during 1972. Jerry Dreva moved there in June; staying with Cromelin, he immediately plugged into the pop subculture, hanging out with members of the Cockettes, gay blues singer Long John Baldry and David Bowie. In August, Dreva was there with Rod Stewart and Ron Wood to see Sylvester and the Hot Band: 'He's a magnificent huge Black Gay who sings like Aretha Janis combination. JUST FABULOUS!!!!'

When Bowie arrived in LA that October, Dreva was one of the first people he got in touch with: 'Thursday afternoon – David Bowie arrived here on Tuesday and called 4 hours later – The Ultimate Response to

a Bonbon package so far! I almost Died. And Richard and I spent 3 hours with him that same nite at a friend's private club – he is Perfect. Heaven. Not one ounce of bullshit. Zero pretension & posing. Brilliant, Beautiful, Sensitive – Homo Superior. A Fabulous Queen!'

The rock culture of the day was facilitating and amplifying the arena within which the Bon-Bons could play, and for a brief while they were at its centre. 'On my first visit to Rodney's we were called out in front of the club for photographs,' Lambert remembered. 'Every aspiring photographer in L.A. knew if he wanted the most interesting subjects in town, he could find no more willing volunteers than the crowd at Rodney's. Two weeks after I arrived our photo appeared in *Rock* magazine with the caption, "this is Los Angeles".'

In June, Les Petites Bon-Bons were approached by the publicity department of Columbia Records to throw a party for Iggy Pop and his band the Stooges to celebrate their return to the Whisky. 'Iggy had become a fan of ours and the feeling was definitely mutual,' Lambert recalled. 'His shirtless drug-crazed wallowing-in-broken-glass onstage antics were closer to performance art than anyone else in rock at the time, and we adored him. The job seemed a perfect match for our sensibilities.

'We rented the ballroom atop the Continental Hyatt House on Sunset Blvd., a hotel favored by rock stars and their groupies, and close to the Whisky. The list ran up to 200. We taped up gay porn in the bathrooms. First task was to get as many Cockettes as possible – Wally Cockette, since become an Angel of Light, Pristine Condition, Goldie Glitters, and of course Divine. The infamy of *Pink Flamingos* was growing, and to cap the occasion she flew her makeup man Van Smith in from San Francisco just to turn her out in full Divine glory.'

It wasn't all roses. Away from the new world of glitter and gender play, the Bon-Bons and their entourage ran into the violent machismo, if not homophobia, of the established rock scene. At a party for the Eagles, various Bon-Bons and Cockettes were, in Lisa Rococo's (aka Richard Cromelin's) report, chased by 'awful macho Laurel Canyon creatures' down the deserted Pacific Coast Highway, 'after jovially telling the assailants, in answer to the latter's request, that no, they didn't have any cocaine to offer them'.

That summer saw the peak of the Bon-Bons' notoriety. When the New York Dolls came to town, Lisa Robinson observed that 'the Whisky is packed with glitzy glitter fans, and of course the Bon Bons. In addition to the original Bobby and Jerry Bon Bon, there are now more of them, and they are wearing – get this – shaved heads for a start. Then, they've got on these long white robes . . . the effect is sort of effete Hare Krishna. But topping it all off are these enormous curly five-and-dime eyelashes that go all the way up to the eyebrows and button earrings! Cute?'

The Whisky a Go Go was home from home for the Bon-Bons. As Lambert remembered: 'We didn't have to pay. Just nod and say "Hi Mario!" to the doorman. We had no problem getting into the Dolls' dressing room to deliver the customary BonBon package. I'd made a whole set of paper doll cutouts, each with the head of one of the band members, with several changes of costume. They opened their gifts immediately, and David and the boys were very sweet and genuinely, unabashedly charmed and pleased, guileless in their gratitude.

'We caught both shows on Wednesday, the 29th of August, then again on Sunday September second. In between there was a photo session with famed celebrity photographer Julian Wasser at Rodney's for all the Bon Bons. These are the photos that became icons of the glitter period, would appear in *Interview* magazine and, some six months later, a double page spread in the sixth issue of a brand new magazine called *People* – original fodder for the new cult of celebrity. We were to be among the first to become famous simply for being famous.'

The ease with which the Bon-Bons moved with acts like Bowie, Iggy Pop and Mott the Hoople in the Los Angeles rock world and, indeed, how they were seen to be emblematic of its culture showed just how much things had opened up for openly gay men in the post-Bowie youth culture. It was, as Lambert recalled, 'a vast cultural sea change . . . only two years before gays were universally denigrated in the macho world of rock, which openly railed against fags and pansies. We had questioned their attitudes, challenged their opinions, and changed their minds.'

The Bon-Bons caught the culture of glitter at its gay and transgender zenith. Ever alert to the changing of the weather, in October, Lambert pronounced the drag-rock era of the Bon-Bons over: as he wrote, it was

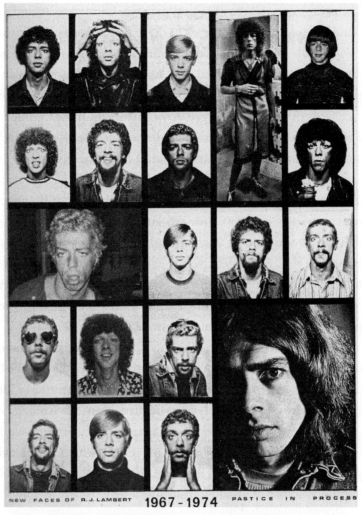

A cartography of gay style 1967–1974, Robert Lambert,
Egozine, issue 1, 1975

'dead of natural causes and there is nothing that can restore its inspirational effect on my creativity. I wear nothing but butch levi & leather drag now, to the teeth, rings are gone, high heels are gone, curls are gone, just button-fly levis, black or white T-shirts, short hair. Lots of weight-lifting, too. My transformation took all of 2 weeks.'

T he post-Stonewall era of radical drag was coming to an end, but no one had told the latest entrant in the gay-rock stakes. While the New York Dolls toured to mixed reactions in middle America, *Interview* magazine announced the arrival of a new star. "'I'm a true fairy," said blond, short-haired Jobriath, who had just signed a $500,000 recording contract with the recently merged Asylum/Elektra record group. Pearly white nail polish glowed from his bony fingers, as he shyly expounded on his musical feelings. "Music is an extremely feminine thing.'"

Born Bruce Wayne Campbell in late 1946, Jobriath was an army brat who had been drafted in the mid-1960s. After going AWOL, he scuffled around the fringes of show business, landing the part of Woof in the Los Angeles production of *Hair*, before being fired because 'I started upstaging everybody and there wasn't enough room for me, I was going forward, I wasn't a hippy anymore. They didn't understand it.' After a brief period in a rock group called Pidgeon, he was arrested by the military police and put in a psychiatric hospital.

It was there he began writing the songs that he later recorded onto a demo tape, which he sent to Columbia Records' president Clive Davis. It was in Columbia's offices that he was discovered by Jerry Brandt, a long-term music industry player who had been the Rolling Stones' mid-1960s tour agent and had also managed Carly Simon. As Brandt remembered: 'I asked the guy in the office just what Clive Davis was going to do with this artist. The guy said, well, Clive thinks Jobriath is mad and unstructured and musically destructive to melody. I said, "Oh yeah?"'

There seems little doubt that Brandt was personally involved. During a conversation with Bob Weiner in *Interview*, Jobriath stated they had met in a New York gay bar. Brandt was cruising him, and in the vernacular of the time, they 'got it on'. The impresario took the singer out to the West Coast, where, in his own words, he 'fell in love'. In turn, Jobriath quit alcohol, started working on his songs and perfected some of his PR patter, stating that 'schizophrenia isn't all that bad. It may be the lifestyle of the 70's.'

By his own account, Brandt was fired up: 'To me, Jobriath's songs were a revelation. I had discovered the "True Fairy". I thought he could

be America's David Bowie. The images the tape were evoking in my imagination were mystical. I saw money in Jobriath, and the monetary possibilities of launching the first openly homosexual glam rocker in the early 1970s after the success of David Bowie and Marc Bolan. Jobriath was as different from Bowie as a Lamborghini is to a Model A Ford. They're both cars, but it's a matter of taste, style, elegance.'

The *Interview* piece set the style for the hype to come:

> Jobriath: I become a true fairy onstage.
> Weiner: What do you mean? Like Puck in a *Midsummer Night's Dream*?
> Jobriath: No, like Tinkerbell.
> Weiner: Tinkerbell is only a light in *Peter Pan*. It's imaginary.
> Brandt: Jobriath is your imagination. He is a true fairy.'

By October 1973, Jobriath's first album was ready for release. Eleven songs had been recorded in Electric Lady Studios with former Hendrix engineer Eddie Kramer. Performed by a group of four musicians – Billy Schwartz, Steve Love, John Syomis and Andy Muson – the songs on *Jobriath* were an ambitious but ill-assorted mix of rock, glam and show tunes; gay love songs were interspersed with space fantasies and an homage to the golden age of rock 'n' roll, 'Rock of Ages': 'A Little Richard goes a long long way.'

The key song was 'I'm a Man', not the Bo Diddley or Spencer Davis tune, but Jobriath's own statement of masculinity. This was not your standard rock machismo, nor even Bowie's bisexuality, but songs written by a man and sung to a man: 'You know I could love you / But if I should love you / Then I would love you / The way a man loves a woman / And live my life like been livin' it.'

After getting a deal from Elektra Records, Brandt went overboard, declaring that 'the energy force of 1973 came from homosexuals and Puerto Ricans' and describing his new find as the superstar of the 1970s. 'It's Sinatra, Elvis, The Beatles and now Jobriath,' he announced. 'Jobriath is a combination of Dietrich, Marceau, Nureyev, Tchaikovsky, Wagner, Nijinsky, Bernhardt, an astronaut, the best of Jagger, Bowie, Dylan, with the glamor of Garbo. He is a singer, dancer, woman, man.'

This uber-gay theme was exemplified by the album's gatefold cover, which presented a made-up and plucked Jobriath, who resembled 'an ancient Roman statue creeping with his legs smashed'. The image stopped short, just underneath Jobriath's buttocks, highlighting their shape. This was the photo that, as Brandt remembered, 'we plastered over every bus in New York City. We erected a fifty-foot-square billboard in Times Square that said, "Jerry Brandt Presents Jobriath".'

The hype didn't stop. 'All this time we were talking up a stage production that was going to cost $200K. I told the press Jobriath would make his live debut at the Paris Opera House and in London at Royal Albert Hall. Jobriath informed the press that the show would feature him dressed as "King Kong being projected upwards on a mini Empire State building. This will turn into a giant spurting penis and I will have transformed into Marlene Dietrich." Didn't matter if it happened. It was the impression that mattered.'

The reception for the *Jobriath* album was mixed. *Cash Box* declared it 'one of the most interesting debut albums of the year', while *Rolling Stone* said that Jobriath had 'talent to burn'. *Record World* described him as 'a true Renaissance man who will gain a tremendous following'. But the massive hype was not borne out by the quality of the music, which was patchy at best. As Bowie had discovered, it was fine to be gay – or bisexual – if you had the songs and the talent, but Jobriath did not, and the backlash was swift and brutal.

Writing in the *New York Times*, the usually sympathetic Henry Edwards, in a piece entitled 'How to Make a Pop Parody', described Jobriath as a reflection of the 'trendish group that haunts New York's rock joints. These self-conscious few have not only adapted David Bowie's look but have also transformed it into a brazen parody that celebrates outrageousness for the sake of outrageousness and heralds transvestism and pseudo homosexuality as one's most cherished idiosyncrasies . . . The results can only be described as dismal.'

While Jobriath was attempting to claim New York, the New York Dolls were preparing for their second visit to the UK. This time, they would come with the wind behind them. Their album was released in the UK in mid-October to considerable interest and rave previews. While

the American music industry and mainstream rock audience were united in their indifference, if not hostility, to the group, the greater spread of gender variance, whether it be glam or fashionable bisexuality, in the UK gave them a second lease of life.

They were seen as a significant group by rock critics and gay commentators in the UK. As Denis Lemon wrote in *Gay News*: 'Audiences are at long last reacting against rock musicians who have as much stage presence as a handful of ageing prunes, and it comes as no surprise that people love and gayly welcome the outrageousness (decadence) of the emergent "glamour/glitter/gay" bands. If "outrageousness" means that members of rock groups openly display their rejections of stereotyped sexuality, all the better.

'As a result, gayness, bisexuality, drag or whatever are very much part of the newly found liberation to be found in contemporary music . . . you can see for yourself what the Dolls look like. No doubt shocking for some. I find their drag/make-up/transexual image stimulating and adventurous, particularly as they avoid the tackiness and predictability so many male feminists (substitute your own label if that one offends you) settle for. The Dolls really are just a natural progression of the liberating trend started by Bowie.'

In early October, *Melody Maker* promoted a survey of New York rock with a cover photo of Jayne County at her most outrageous, gurning in a huge, teased, blond wig, full make-up, pearls and destroyed fishnet tights, as she trailed what would be her brief link-up with Mainman. Then, in the last week of November, the paper put the New York Dolls on the cover. 'Rock and roll is sex,' Roy Hollingworth proclaimed. 'And the Dolls played on. And they played sex.'

That week, the group played several dates at universities around the country, before a big showcase at the Rainbow Room in Biba, Barbara Hulanicki's art deco paradise in Kensington High Street. The next day, they recorded a couple of songs – 'Jet Boy' and 'Looking for a Kiss' – on the BBC's *Old Grey Whistle Test*: a brilliant performance by the group at their knock-kneed, chaotic zenith, marred only by the acid commentary of host Bob Harris, who called them, with obvious distaste, 'mock rock'.

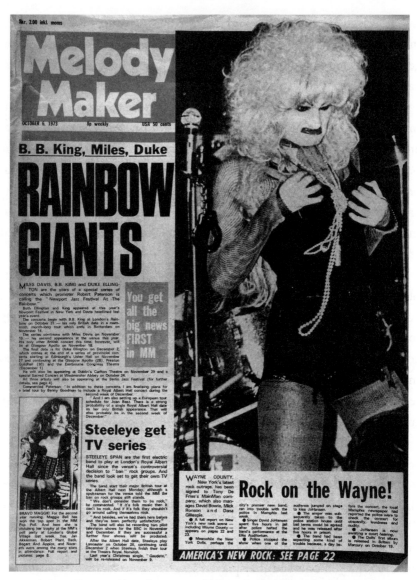

Jayne County (then known as Wayne), 'Rock on the Wayne',
Melody Maker, 6 October 1973

On 28 November, the New York Dolls travelled to the Continent for what would be a particularly fractious trip. They got ferociously drunk and were late for a TV show, infuriating their record company's European office. Then their managers, Marty Thau and Steve Leber, returned to New York, leaving them without any money. At a show in Amsterdam,

they were heckled by homophobic protestors. And, for the first time, there were signs that Jerry Nolan and Johnny Thunders were getting deeper into hard drugs. The band's moment was slipping away.

The portents were there for all those involved to see. In December's edition of *Rock Scene*, the perennially on-point Lisa Robinson tolled the death knell for glitter rock: 'It's admittedly pretty hard to stand out in a crowd these days but a few still manage. But where can it go from here? Platform boots and bared midriffs are already a cliché, and it hasn't been fashionable to wear see-thru (unless, perhaps, if you're male) for about a year now. Will David Bowie's spacesuits look silly this time around?'

In perhaps the unkindest cut of his *Jobriath* review, *Interview*'s Michael A. Meltzer had observed that 'being a "fairy" these days isn't enough'. In the 1970s, the pop cycle moved fast and, nearly two years after it had first appeared, the trisexual wave was ebbing – and with it the possibility that the New York Dolls would be a major success. Indeed, their momentum was stalling: the album made it only to #116. They were failing to carry the mainstream rock audience with them, and into this vacuum came the demons of self-doubt and self-sabotage.

The infiltration of gay-derived ideas of bisexuality and polysexuality into the machismo of American rock had been a fascinating experiment, a liberating force for many of those involved, including, for the first time, many openly gay men. It had exposed the American media and teen audience to numerous previously forbidden or occluded images, which had created a resistance – if not a backlash – that ensured that they went so far and no further. In turn, the gay subculture turned away from glitter to find another route to visibility and acceptance.

The Loft and the Gallery

Rather than reinforcing stereotypical homosexual behaviour, as do most places in the gay world, gay liberation offers an alternative, as, for example, in its dances. Giving a dance has become one of the most common of gay liberation activities and, despite frequent complaints that these merely duplicate (if less expensively) the dance bars, they play an important part in defining a new sense of community.

Dennis Altman, 'The Movement: Confrontation and Community', *Homosexual: Oppression and Liberation*, 1972

I t begins with a fast, sinuous guitar and cowbell figure. Cymbal taps announce an African voice, stuttering the title – '*Mama ko mama sa maka makossa*'. This is repeated four times, before horns extend the sound picture, drawing the listener in. Out of their drone emerges a spirited saxophone solo, embodying high life and high times, before the muted backing vocals – '*Hey soul makossa*' – reintroduce the voice, half singing, half speaking in an African dialect.

Adding a horn flourish that punctuates the highly rhythmic verses, which revolve around the sound of the title phrase, the track evolves over four and a half minutes, driven by the then ubiquitous *Shaft*-style wah-wah guitar and a regular three-note pulse from the bass. Manu Dibango's delivery of the lyrics is sometimes welcoming, sometimes urgent, sometimes hardly there. The words themselves are highly percussive and, despite any language barrier, suggestive of their meaning.

Sung in the Duala dialect, which originates in Douala, Cameroon's largest city and Central Africa's largest port, 'Soul Makossa' was written in summer 1972 by the Cameroonian musician and songwriter Manu Dibango. 'The Duala word *makossa* is often glossed as "(I) dance",' linguistic expert Ben Zimmer writes, observing that the word itself is 'derivative of *kosa* (to peel or remove the skin of a fruit or vegetable); the name refers to the twisting and shaking movements of the dancer'.

Dibango, an experienced bandleader who had begun his career in Paris and Belgium during the 1950s, was nearly forty when he cut 'Soul Makossa'. It was, in the eyes of its composer, just a groove, a jam, a joke almost. The song was placed on the flip side of 'Mouvement Ewondo', a theme song for the Cameroonian football team on the occasion of the eighth African Cup of Nations, which, involving eight different countries, was held in Cameroon during February and March 1972.

As Dibango remembered: 'On one side of the 45 I recorded the hymn; on the other I recorded "Soul Makossa," written using a traditional *makossa* rhythm with a little soul thrown in. In my Douala neighborhood, at my parents' house, I rehearsed this second piece. The house had no air-conditioning, and the windows were wide open. All the kids flocked around. Hearing me rehearse, they fell over laughing. Unbelievable – how on earth had I concocted that mishmash? Poor *makossa* really took a blow.'

'Mouvement Ewondo' was issued in France as 'Hymne de la 8e Coupe d'Afrique des Nations' in early 1972. And there it lay, until a New York disc jockey called David Mancuso found it in an import store, African Markets and Imports of Brooklyn, and began playing it at his private parties in mid-Manhattan. The African lyric didn't matter: verbal comprehension was not important to the reception of 'Soul Makossa'. It was the feel, the groove, the looseness, its homeopathic injection of warmth and abandon into the puritan land of America.

By January 1973, the record had become an underground hit in New York, regularly played not only by Mancuso, who distributed several copies to his friends, but by the influential DJ Frankie Crocker, on the city's most popular Black radio station, WBLS. The record was so popular that some enterprising souls in Brooklyn began pressing and selling bootleg copies. By February and March, it was filling the floor at two of New York's premier gay dance clubs: the Loft on Broadway and the brand-new Gallery in SoHo.

———

Along with records like Eddie Kendricks' nearly eight-minute 'Girl You Need a Change of Mind', released that January, 'Soul Makossa' was creating a new kind of club sound – rhythmic but loose, spacey but funky, with Latin, world and jazz inflections – that would, within a year, make a major impact on the charts and herald the gay world's ability to influence mainstream music taste. Originating on a different continent, and from a different world, 'Soul Makossa' announced the sound of the long-hidden gay underground coming into the light.

The New York Dolls might have played around with shades of homosexuality – and Jobriath might have made it explicit – but that was within a mainstream rock arena. The gap between that subculture and the hardcore gay world could not have been wider. By the early 1970s, most gay men – despite the radical drag outliers – did not want to present as camp or drag any more. For them, that was an outdated affect and style. The mood was turning towards hyper-masculinity, and the dance floor replaced the bar or theatre as the vital social arena.

The Stonewall Inn might have been among the few venues, if not the only one, where men could openly dance with each other in 1969, but its music policy was determined, as it was in New York's other gay bars, by the jukebox: three minutes, almost always current hits, with a few gay-relevant classics (usually divas and weepies). The idea of having someone come in and programme a mood over an evening – let alone set up consistent beats per minute for dancing – did not yet exist in the gay world.

In the aftermath of the Stonewall riots, the revolutionary politics that they sparked were comparatively ill understood. The activists of the GLF operated within a small but noisy bubble, and it would take a while for their rhetoric to percolate. For gay dancers like the writer Vince Aletti, Stonewall was 'more mythological than real. The sense that we were entering a new era had been building up for a while. It was inevitable that gay activity would move into something a little bigger and a little more celebratory, and it didn't surprise me that discos followed.'

As the utopian politics of the immediate post-Stonewall moment fizzled out, more gay men – rather than lesbians, who were finding their own place within the wider women's movement – decided to focus on pleasure rather than dialectic. The conflict between politics and pleasure had long bedevilled activists, but the post-Mattachine history of gay rights had shown that political pressure, whether lobbying or street demos, was enhanced, if not dwarfed, by the cultural impact of music, art and the development of the gay market.

The GAA-run Firehouse dances in SoHo became the main focus during 1971. The DJ there was Barry Lederer, who played 'heady, drug-oriented music' with tough, political undertones. His playlists, as he recalled, included 'some commercial stuff like "Brown Sugar" by the Rolling Stones, and "Nathan Jones" by the Supremes, but also "Harlem" by Bill Withers, "Life And Death In G & A" by Abaco Dream, or "Feel The Need In Me" by the Detroit Emeralds. Let's not forget "Black Skin Blue Eyed Boys" by the Equals, or "Rain" by Dorothy Morrison.' This was the sound that, mixed together by pioneering DJs, would begin to percolate through the other gay clubs that opened and flourished in the early decade. As in the Firehouse, these largely became oriented towards gay white men, although there was some Black and Latino, if not lesbian,

crossover. These clubs were commercially run rather than community-oriented, which tended to encourage audience fragmentation, but the music contained the trace element of that liberation moment, even if it definitely stayed within its own separate world.

Prime among these venues was the Sanctuary, located in a less than salubrious part of Hell's Kitchen on West 43rd Street, between 9th and 10th Avenue. Taking over from the famed mid-1960s discotheque Arthur, which had closed in summer 1969, the Sanctuary was based in an old church, with the altar converted into a DJ booth. Beginning as a straight club, it had reopened as a gay-friendly venue in February 1970, with Francis Grasso on the decks, making it perhaps the first gay-oriented club or bar to dispose of the jukebox.

Grasso remembered that the opening night was attended by around 500 dancers. '60 percent were white, 25 percent were Spanish, 15 percent were black. The opening night was a bang. I'd never seen a crowd party like that before. I said to myself, "This is going to be fun!"' The soundtrack, as dance historian Peter Shapiro has observed, 'mixed "head music" with tribal percussion (feet and groin), while the pattern of drug use moved away from psychedelics to poppers and Quaaludes'.

Indeed, Grasso's playlists from 1970 comprised an eclectic mix of rock, funk and African rhythms, making for a seamless aesthetic: as well as Abaco Dream's 'Life and Death in G & A' and several James Brown tunes, there were funk-rock workouts like 'Machine Gun' by Jimi Hendrix's Band of Gypsys and 'I'm a Man' by Chicago; Olatunji's 'Jin-Go-Lo-Ba (Drums of Passion)'; cuts from the first album by Osibisa; soul classics by the Temptations, Mitch Ryder and Sam & Dave; and contemporary rock tunes by Led Zeppelin and King Crimson.

Around the same time that the Sanctuary reopened, a young Italian American decided to launch his own dance space, to fulfil his own social and spiritual mission. Beginning on Valentine's Day 1970, with the apt title Love Will Save the Day, David Mancuso turned his loft space at 647 Broadway – north of Houston, in the same block as the Mercer Arts Center at 673 – into a non-commercial, inclusive environment. This was not so much a discotheque as a rent party, but it would have a huge effect on the sound of gay dance music.

Mancuso's parties were strictly by invite only. As he told dance historian Bill Brewster: 'I wanted it to be private. And the loft was also where I slept, where I dreamt, everything.' After a while, they became more regular, occurring every two weeks and attracting a hardcore crowd who wanted something different. 'Everybody. Gay, straight, bi, black, Asian. There were a lot of different people and they were my friends. And I keep my friends; so they brought their friends. You would have really the whole spectrum and there was never a problem with fighting or anything.'

In these early days, Mancuso played similar records to Grasso: Motown, Stax, James Brown's 'Sex Machine', Olatunji's 'Jin-Go-Lo-Ba (Drums of Passion)' and Little Sister's 'You're the One'. But his prime interest was in creating a lushness of sound – indeed, a whole environment. As Vince Aletti recalled: 'In the centre, in a small enclosed booth filled with records and equipment, was David Mancuso at double turntables, blending records end-to-end (Rule #1: Never let the music stop) and playing the lights until the crowd screamed and swooned and begged for more.'

Mancuso was famous for blending sound effects into his six- or seven-hour sets. 'I spent a lot of time in the country,' he told Aletti, 'listening to birds, lying next to a spring and listening to water going across the rocks. And suddenly one day, I realised: What perfect music. Like with the sunrise and sunset, how things would build up into midday. There were times when it would be intense and times it would be very soft and at sunset, it would get quiet and then the crickets would come in. I took this sense of rhythm, this sense of feeling . . .'

Aletti added: 'It was all a matter of tuning into what Mancuso calls "That natural rhythm, that three-billion-year-old dance – I just applied it through these artificial means, which were amplifiers and records." Though this style of structuring the evening around a natural ebb and flow of energy was arrived at independently by a number of other disco DJs and has become a standard approach for the new wave of discotheques, Mancuso was one of the first to perfect it and make it work for him.'

Born in October 1944 in Upstate New York, Mancuso arrived in New York in 1962 – 'during the Cuban Missile Crisis' – with $2.15 in his pocket. 'I did a lot of waiting. I worked in a publishing company. Then I worked in a health food store, then I became a personnel manager for a

restaurant chain. That was my last nine-to-five. There wasn't much differ-
ence between collecting unemployment and being a disc jockey. So that
would be up until about 1967. I traveled a lot.'

An avid record collector and audiophile, he started giving parties in his
Broadway loft after giving up full-time employment. Mancuso had been
in contact with Timothy Leary, and his parties had an explicit psychedelic
feel. As he told Brewster: 'I used to love to go out. Also I went through the
sixties, with the whole psychedelic movement as far as the music goes, the
civil rights thing. I met a lot of people. And they all interacted with each
other. Anyway, I knew a lot of different people; a lot of different names.

'I had this space. Now what I used to do were these rent parties: 50¢.
And, if you use that money to pay your rent in New York, it's legal. So
you could have a party in your apartment so long as you don't break the
law or anything. You can actually charge admission. And they had the 45
records on the stack. So I was in a commercial loft. There were sprinklers
and everything. So I decided to do rent parties. I sent out 36 invitations.
But it took about six months to get going.'

Once up and running, Mancuso's loft opened up every week for a
Saturday all-nighter. 'When you came in, everything was included in the
contribution. It was an invitation. You were not a member. It was not
a club. I didn't want to be in that category. It meant different things to
me. I wanted to keep it as close to a party as possible. It was like $2.50
and for that you'd get your coat checked, food, and the music. We used
to squeeze fresh orange juice and organic nuts and raisins. We did it up.
Everything was quality.'

Mancuso did not serve alcohol. Instead, he attempted to recreate the
psychedelic experience – with or without drugs. Dubbing sound effects
onto reel-to-reel, he included these to create a seamless flow. 'I wanted
the music to be continuous, with no blank spots, but I also wanted to
play the records as the musician intended. I got into mixing for a while
and then I stopped. I just said to myself, what am I doing? It's like having
a painting on the wall. I shouldn't change the colours; I should leave it as
it was intended, let it stand on its own.'

By 1972, Mancuso's dance space had become known as the Loft, the
name under which it would remain popular for years. At 647 Broadway,

time stopped. As Aletti remembered: 'Dancing at the Loft was like riding waves of music, being carried along as one song after another built relentlessly to a brilliant crest and broke, bring almost involuntary shouts of approval from the crowd, then smoothed out, softened, and slowly began welling up to another peak.'

Three years after Stonewall, the New York gay world was moving on from the Firehouse dances, with new commercial venues targeting a broader clientele, one that included African Americans and which, for a while, welcomed women. First among these was the Continental Baths, which had been running a gay disco alongside live entertainment since 1970. In February 1972, *Women's Wear Daily* called it 'the steamiest spot in town. Nicknamed the Tubs by the regulars, the Continental Bath & Health Club is making a big splash.'

The DJ was the charismatic Jorge La Torre, who remembered that 'the article made people aware that the Continental Baths was a fashionable place to go. We hit full stride at that point. It became terribly chic to go to the Baths – to this steam box. All sorts of celebrities came along.' The club's focal point – gay men in various states of undress having sex – made the atmosphere even steamier, as La Torre recalled: 'At the Baths you could just walk out of your room and go straight onto the dance floor. The environment allowed people that extra freedom.'

A new venue opened in summer 1972, this time specifically aimed at the Black crowd. Situated on 49th Street, between 8th and 9th Avenue, Better Days launched with a female DJ, Bert Lockett. 'I had gay men try to touch me,' she remembered, 'because they thought I was a cute guy.' After a row with the owner, Lockett was replaced by Toraino 'Tee' Scott, who had played at the Continental Baths. Influenced by Mancuso's set-up at the Loft, he installed a new sound system that accentuated both the treble and the bass.

There was also a busy scene out in the predominantly white gay resort of Fire Island, with the Ice Palace and the Botel in the Pines, where Barry Lederer moved after the Firehouse. In 1971, the model and sound obsessive Tom Moulton had created one of the first continuous mixes for the Botel. His non-stop forty-five minutes of music captured a future where dancers wouldn't have to adjust tempo after a mere three minutes – the

length of a single – but could keep going in a heightened state for as long as the tape and DJ allowed.

On Fire Island, a new kind of sound started to take shape that, in Peter Shapiro's description, helped 'to create disco's intensity'. 'The bodies, the heat, the sweat, the sunrises and the throb of the music all conspired to create a heated sense of nowness, a sense that nothing existed outside that room. No past, no future, no regrets, just right now.' At the same time, a new, very white style coalesced around the imperatives of dancing and sex. Gay men were starting to dress alike to attract alike, to turn themselves into almost robotic desire machines.

At the end of 1972, another new venue opened in Manhattan, this time explicitly influenced by David Mancuso's parties. Set up by a trio of Fire Island regulars called David Bruie, Jim Jessup and David Sokoloff, the Tenth Floor opened on Wednesday 6 December 1972. Situated at 151 West 25th Street, by 5th Avenue, it was a small loft, with minimal decor, that could hold a hundred people on the dance floor. Entry was by invite only, with Barry Lederer imported from the Botel in the Pines.

The Tenth Floor might have used the Loft as a template for how to create and build a sound and audience, but it did not enshrine Mancuso's utopian integration. 'I went to the Tenth Floor and I went to the Loft,' remembers one celebrant, Alan Harris. 'There was no attitude at the Loft. David was a really nice man, he played the type of music I liked, and he had a very crossover crowd. The Loft was, "Let's embrace everybody who can get in." The Tenth Floor, on the other hand, was much more attitudinal. It was about who's in and who's out.

'At David's, the group was too diverse for that,' Harris added. 'You would dance with a three-hundred-pound black lady and have the most fabulous time. That wouldn't happen at the Tenth Floor – they would screen that person out at the door. The Loft was warm and loving, whereas the Tenth Floor was sensual and sexual. There was definitely a feeling of, "Let's go out and get laid," and the Tenth Floor met that demand. It was certainly needed at the time.'

It was at the Tenth Floor that the recognisable gay look of the 1970s began to take shape. Later known as the 'clone', it was the hyper-masculine combination, designed for instant recognition and total sexual

appeal, that Andrew Holleran described in his *roman-à-clef* about the Tenth Floor, *Dancer from the Dance*: 'We had our web belts and painter's jeans, our dyed tank tops and haircuts, the plaid shirts, bomber jackets, jungle fatigues, the all-important shoes.'

This soon coalesced into a uniform of 'Levi's jeans, construction boots, a hooded zippered sweatshirt, and a waist-length flight jacket – the MA1 – that was silver on the outside and orange on the inside, with the hood of the sweatshirt invariably flipped outside the jacket.' Wearing this uniform immediately made it clear that you were one of the elite – the 500 regular invitees at the club. For the Tenth Floor was nothing if not exclusive – an explicit inversion of the gay dance world's initially inclusive, utopian appeal.

Exclusivity was an integral part of the club's attraction. 'They all knew each other without ever having been introduced,' Holleran wrote. 'The composition of our band of dancers changed, but it usually included one doctor, one hustler, one designer, one discaire, one dealer, and the assorted souls who had no idea what they were doing on earth and moved from disguise to disguise (decorator, haircutter, bank teller, magazine salesman, stockbroker) with a crazy look in their eyes because their real happiness was only in music and sex.'

New venues opened up in the wake of the Loft. In February 1973, the Gallery opened in Manhattan, this time at 32 West 22nd Street, a few blocks away from the Tenth Floor. It was set up by Nicky Siano and his partner Robin Lord with a loan from a veteran who had just received compensation for his injuries in Vietnam. While still teenagers, Siano and Lord had been regulars on the nascent gay-club scene, attending the Firehouse – 'your basic hangout' – and then, in 1972, the Loft, an experience that transformed Siano's life. 'There were these white lights, these six-hundred-watt floods, and these floods were so bright and they would flash,' he told Tim Lawrence. 'Your pupils would dilate, and then – boom! – the next second David would throw you into total darkness so you would go totally blind for a moment. He understood what people were going through on the dance floor psychologically, and he would send out different stimuli to make the dance floor react. He created an environment for each record. He was so much more than a DJ.'

Ejected from the Loft by David Mancuso for selling downers, Siano decided to open his own venue. The Gallery began as a club aimed at heterosexuals, before orienting itself towards the gay audience. Instrumental in this were two Black teenagers, Larry Levan and Frankie Knuckles, veterans of the scene at the Continental Baths. They followed the Loft template by decorating the smallish room with balloons and streamers, and encouraged an atmosphere that was flamboyant, wild, ecstatic.

Like the Tenth Floor, Siano was playing the predominant R&B sound of the moment: the records being released by the Philadelphia International label. As he remembered: 'I loved the Philly sound, but then everyone did. They made great records.' The label had been set up in 1971 by the veteran writers and producers Kenny Gamble and Leon Huff, who, stimulated by Norman Whitfield's complex productions for Motown, were seeking to update that famous label's style for a new decade.

A spring 1972 Harvard Business School report titled 'A Study of the Soul Music Environment Prepared for Columbia Records Group' identified the behemoth's institutional failure to tap into the burgeoning Black market and the Black influence on the mainstream pop charts; as they wrote: '30 percent of the top 40 is composed of records which have "crossed over" from soul stations.' The report recommended that the company enter 'custom label agreements with outside product resources' – which is what president Clive Davis did with Gamble and Huff.

With Columbia's promotional muscle thrown behind Philadelphia International, the label started having huge hits. In March 1973, the #1 record was the O'Jays' 'Love Train'; at the end of the previous year, the group had hit #3 with the social-comment classic 'Backstabbers', while Harold Melvin & the Blue Notes' 'If You Don't Know Me by Now' made #3 also. In mid-December, Billy Paul's frankly romantic 'Me and Mrs Jones' went to #1 for three weeks over the holiday period. This was a lush, sophisticated yet street-smart sound that sweetened the rawness of early-1970s dance records with creamy orchestration and smooth vocal harmonies. It was, in many ways, the sound of the American mainstream music industry discovering and actively promoting Black music – a classic

case of the market providing social visibility and commercial validation. The same dynamic would soon begin to work in the long-suppressed gay world, as the message of confidence and liberation in these records crossed over into unexpected realms.

By spring 1973, a definite gay discotheque sound was developing. David Mancuso and Nicky Siano began playing the same records in their respective clubs. Mancuso might have been more psychedelic and Siano more dance-oriented, but both highlighted the spacey, almost ambient jazz groove of War's thirteen-and-a-half-minute 'City, Country, City' – from the #1 album *The World Is a Ghetto* – and Eddie Kendricks' 'Girl You Need a Change of Mind', a gospel-influenced, relaxed tour de force that ebbed and flowed over seven and a half minutes.

Both tracks contained plenty of breaks: pauses in the song where all or almost all of the instruments dropped out, leaving just the drums and percussion. Both Mancuso and Siano picked up on these percussive elements and sought to highlight them. In Siano's case, this involved locating the break and then playing that part over and over again, using two copies of the same record; as Peter Shapiro notes, this 'created a dark whorl of sound, a vortex of tribal drums and propulsive bass murmurs that was at once exhilarating and menacing'.

———

The new condition of gay dance music favoured the loose, the percussive and the atmospheric, and 'Soul Makossa' was perfect for this aesthetic. By the spring, original copies of the Manu Dibango single had long disappeared from the import shops and badly pressed bootlegs were proliferating, so much so that – as *Billboard* reported that May – the district attorney authorised a raid on Town Hall Records of Brooklyn, where they seized '1,500 allegedly counterfeited copies of "Soul Makossa"'.

The difficulty of locating the copyright holders had prevented a legitimate US release thus far. As *Billboard* noted: 'The unprecedented popularity of the record has triggered something of a stampede by several record companies to get their own version out, and working with Raven

Music/Cooper Music (BMI), which claim to have U.S. publishing rights to the song, such firms as Avco Records, Buddah, Mainstream and Town Hall Records, which claims to have started a label under which it will release the tune, are already rushing to market.'

While Atlantic Records were preparing to reissue the original that May, a slew of cover versions began to appear from quickly assembled troupes like the Mighty Tom Cats, the Nairobi Afro Band, Afrique and All Dyrections, with versions upcoming by Michael Olatunji, the Simon Kenyatta Troupe, the Gaytones and Jablonski. Most of these were direct, inferior copies, with only Olatunji and Afrique – with a prominent and hypnotic bassline – adding anything at all to the original.

With this competition, Atlantic Records placed a full-page ad in the 2 June issue of *Billboard*, with the headline 'THE ORIGINAL FIESTA RECORDING IS NOW ON ATLANTIC! SOUL MAKOSSA/ MANU DIBANGO', a picture of Dibango, plus text from radio guide *The Gavin Report*: 'African styled original is a big European hit, but U.S. companies so far have been unable to negotiate purchase of the master.' The magazine placed the release in their 'Recommended' section: 'the original master which started the race going'.

It was the Afrique version – on Mainstream Records – that broke first, entering the Top 100 on 9 June. Dibango's original entered two weeks later, and by the first week of July, the two records were playing tag in the Top 50. 'Sales of "Soul Makossa" are being hampered because there are too many cover versions,' *Billboard* commented, quoting one DJ: 'It doesn't matter which version is best (I think it's Afrique) because we won't play any of them now. They confused the listeners and killed themselves off.'

Nevertheless, Manu Dibango emerged as the clear winner in early August, topping out at #35. The sales of 'Soul Makossa' might have been blighted by the spring's feeding frenzy, but it was the first chart record to show the power of the gay clubs. 'It was hard to say disc jockeys had power when a record like "Papa Was a Rolling Stone" was a hit,' Vince Aletti recalled. 'All those records were really big club records, but they were also big radio records, and it was difficult to tell which happened first. "Soul Makossa", though, definitely took off in the clubs.'

It was 'Soul Makossa' that Aletti led with in his groundbreaking piece about the new music for *Rolling Stone* that September. 'Paar-ty! Paar-ty!' he began. 'You hear the chant at concerts, rising like a tribal rallying cry on a shrill wave of whistles and hard-beaten tambourines. It's at once a call to get down and party, a statement that there's a party going on and an indication that discotheques, where the chant originated, are back in force after their virtual disappearance with the flashbulb pop of the Sixties.'

In Aletti's account, discotheques hadn't gone away, they'd just gone underground, 'where the hard-core dance crowd – blacks, Latinos, gays – was. But in the last year, they've returned not only as a rapidly spreading social phenomenon (via juice bars, after-hours clubs, private lofts open on weekends to members only, floating groups of party-givers who take over the ballrooms of old hotels from midnight to dawn) but as a strong influence on the music people listen to and buy.'

Clubs were at the cutting edge of popular taste: 'The best discotheque DJs are underground stars, discovering previously underground albums, foreign imports, album cuts and obscure singles with the power to make the crowd scream and playing them overlapped, non-stop so you dance until you drop. Because these DJs are much closer to the minute-to-minute changes in people's listening/dancing taste, they are the first to reflect these changes in the music they play, months ahead of trade magazine charts and all but a few radio station playlists.'

With his on-the-ground knowledge, Aletti defined the music played in these new discotheques as 'Afro-Latin in sound and instrumentation, heavy on the drums, with minimal lyrics, sometimes in a foreign language, and a repetitive, chant-like chorus. The most popular cuts are usually the longest and most instrumental, performed by black groups who are, frequently, not American. One of the most spectacular discotheque records in recent months in a perfect example of the genre: Manu Dibango's "Soul Makossa".'

It was the first major article about what the headline referred to as 'Discotheque Rock' in any mainstream publication. As well as giving a potted recent history of the genre and its distinctive sonic characteristics, Aletti suggested some further listening for his primarily rock readership:

'a sort of basic discotheque library supplemental to the selected works of War, Eddie Kendricks, the O'Jays, Earth, Wind & Fire, the Temptations, James Brown, Stevie Wonder et al, but vital to any house party for the moment at least'.

Top of the list was Manu Dibango's *Soul Makossa* album, as well as records such as the J.B.'s' 'Doing It to Death', Everyday People's 'I Like What I Like', 'Woyaya' by Osibisa, Willie Hutch's 'Theme of the Mack' and a Spanish long-player by Barrabas, which 'on the basis of two tracks, "Wild Safari" and "Woman", broke in discotheques when it was still an import record'. This last had been discovered by David Mancuso and spread like wildfire through the gay clubs that summer, just as they were really taking off.

In the vacuum caused by the temporary closure of the Loft in the spring, both the Gallery and the Tenth Floor flourished. As the Gallery's sound man, Bob Casey, remembered, the club 'was smoky, it was mobbed, it was great! Nicky's Gallery was the first place I saw dancers jump up and spin the mirror ball. There was a real party atmosphere. The energy was so up and so happy that I thought to myself, "This is the way it should be!" The Gallery became my benchmark club.'

The fevered early-morning atmosphere in the Tenth Floor was captured by Andrew Holleran, who zeroed in on the moment when the exhausted dancers 'pushed onto the floor and united in the cries of animal joy because Patti Jo had begun to sing in her metallic, unreal voice those signal words: "Make me believe in you, show me that love can be true." (Or because the discaire had gone from Barrabas' "Woman" to Zulema's "Giving Up," or the Temptations' "Law of the Land." Any memory of those days is nothing but a string of songs.)'

The Loft successfully reopened in the autumn, just as the music industry was responding to the big *Rolling Stone* feature. In the first week of October, *Billboard* ran an article entitled 'Discotheques Break Singles', in which it cited 'the reemergence of discotheques as an important medium for product exposure'. Going mainstream was no problem for the new breed of DJs, as Aletti remembered: 'I didn't get the feeling that I was violating the underground. People didn't want to remain underground. They were ready to be recognized.'

A perfect illustration of this interlinked trend – for discos to break singles and for gay DJs to get mainstream exposure – was provided by Eddie Kendricks' follow-up to 'Girl You Need a Change of Mind'. Released at the end of July, 'Keep on Truckin'' quickly made the lead review in *Billboard*'s 'Recommended Soul' section: 'A churning, Stevie Wonderish synthesizer keyboard track rivets attention to this lyrically vague riff song. Kendricks exhorts listeners to keep on trucking several dozen times as the locomotive rhythm section drives ahead.'

'Keep on Truckin'' was nothing if not a ferocious groove, modulating over its full seven minutes with shifts in its instrumentation, from horns to wah-wah guitar, vibes and a synthesiser figure, with Kendricks just another element in the mix. The lyric is functional at best, a series of exhortations and basic locomotive metaphors: 'I'm the red ball express of lovin' / Diesel-powered straight to you.' Two minutes in, there's a huge cymbal crash that turns the track upside down; out of it comes the break, simple but delicious in texture, only for the track to build up again.

After the impact of 'Girl You Need a Change of Mind' earlier in the year, 'Keep on Truckin'' was heavily played in the gay clubs, in particular the Gallery. Unlike the previous single, however, 'Keep on Truckin'' crossed over in a major way. Entering the Top 100 in late August 1973, it hit the Top 10 in the first week of October, on the way to its eventual early-November peak at #1, where it stayed for two weeks. By the time it dropped out in late December, it had been in the chart for four months.

Kendricks' monster hit set the stage for the next phase of dance music, one in which the individual tastes of cutting-edge DJs – in this case, in the gay clubs that had until only recently been underground – would lead to a recognised mainstream style with its own, abbreviated name: not 'discotheque' but 'disco'. As such, it would sweep the board in the mid-to-late 1970s, carrying with it the gay subculture that had created the exotic, ecstatic conditions within which it could develop and flourish.

1974

Glitter rock and glam rock and all the trends won't last because
the same dance gets boring. But it was the sound of '72–73,
there's no denying.

Simon Frith, 'Will It Go Round in Circles', *Let It Rock*, July 1974

In the first *Billboard* chart of 1974, there were three Beatles in the Top 30 – all except George Harrison. It seemed as though the 1960s had never gone away, but they had, for the chart was full of the new soul and dance music coming out of Black America. Stevie Wonder and Barry White were in the Top 10, while just one place below Ringo Starr's 'You're Sixteen' – and rising fast – was the first hit by the backing group White had assembled for his girl-group project, Love Unlimited: the Love Unlimited Orchestra.

This lush, dramatic instrumental unfurled like a film theme, with sweeping strings announcing a solid bed of horns and chicken-pluck guitar. The depth of sound was due to the twenty-four or twenty-five musicians playing on the record – a veritable orchestra, including flutes, French horns, violins, violas, harp, cellos and the usual rhythm section. Although it wasn't from Philadelphia – both White and the Orchestra were based in Los Angeles, and the record was released on a subsidiary of 20th Century Fox – 'Love's Theme' fit right into the new, sophisticated dance sound.

It nearly wasn't a single at all. Visiting 20th Century Records' promotional manager, Billy Smith, Nicky Siano and his colleague David Rodriguez 'went down into the basement and saw the Love Unlimited album on the shelf,' as Siano remembered. 'Billy said, "These are dead albums waiting to be trashed," and David replied, "They've got black people on the cover – give them to us!" David and I started playing "Love's Theme" and it took off from there.'

Released as a single in early November 1973, 'Love's Theme' entered the charts a month later, before an eleven-week climb up to its #1 peak on 9 February 1974. Along with Eddie Kendricks' 'Keep on Truckin'', this was a hit that had been broken, not by the still resistant radio DJs, but by the still subterranean New York gay clubs. '"Love's Theme" was in the top twenty before it even got any airplay,' Siano recalled. 'The power we had was phenomenal!'

In the first couple of months of 1974, the Gallery had a new anthem – another discovery by Siano and Rodriguez. Just before Christmas 1973, the two heard a new Philadelphia International single while visiting Columbia Records. 'David Rodriguez and I heard it in Laverne Perry's

office,' Siano told Tim Lawrence. 'Everybody was after Gamble and Huff productions at this point and "TSOP" was really smooth, really exciting. She had two copies. She gave us one, and David stole the other. We were the only ones with copies that holiday, and we played "TSOP" to death.'

'TSOP (The Sound of Philadelphia)' was the second single by the label's house band, MFSB – a pool of more than thirty musicians based at the label's favourite studio, Sigma Sound. Standing for Mother Father Sister Brother, MFSB released their first album in 1972, which featured covers of the O'Jays' 'Backstabbers' and songs by Curtis Mayfield and Sly Stone. 'TSOP' was written the next year, in response to a request by host Don Cornelius for a new title theme for *Soul Train* – the most popular Black TV dance show of the period.

More disco than 'Love's Theme', with accentuated hi-hat hisses and percussive congas, the track was augmented by Philadelphia International group the Three Degrees, who added percussive scat vocals and phrases – like 'Let's get it on, it's time to get down' and 'People all over the world' – to the track's driving forward motion. Entering the Top 100 on 2 March, while 'Love's Theme' was still in the Top 10, 'TSOP' eventually went to #1 on 20 April, where it remained for two weeks, until the beginning of May – another record broken by the gay discos.

———

I n mid-February 1974, David Bowie released a new single, his first for several months. 'Rebel Rebel' was a chunky, Rolling Stones-style rocker – Bowie was obsessed with Mick Jagger at this point – which read like a rousing farewell to the glam era that he had helped to inaugurate. The lyric took great pleasure in toying with sex and gender ambiguity, with the aside 'you tacky thing' and the teasing lyric 'You've got your mother in a whirl / She's not sure if you're a boy or a girl.'

'Rebel Rebel' was Bowie's first release of new, self-penned material since 'Drive-In Saturday' in April 1973. In the intervening ten months he had killed off his alter ego, Ziggy Stardust; lodged five LPs in the UK Top 30 at one point in August 1973; released *Pin Ups*, a covers album of the records he had loved as a wannabe mod pop star in the mid-1960s; and begun

work on two separate long-form projects, one with female Black American group the Astronettes, the other a new, ambitious concept piece.

Despite temporarily giving up live shows, Bowie didn't have to worry about his continued relevance. In mid-February 1974, Lulu's version of 'The Man Who Sold the World' peaked at #3 in the UK, while Bowie himself had four albums in the Top 30. In the singles chart of 23 February, 'Rebel Rebel' entered at #6, the highest new entry. That week, Bowie swept the board in the 1974 *NME* Readers' Poll, winning Best British Male Singer, Best Producer and World Male Singer. Business as usual, one might have thought, but this was not a continuation; it was, rather, an ending.

On 28 February, *Rolling Stone* published a four-page interview involving Bowie and William Burroughs. It was moderated by writer Craig Copetas, who observed that 'Bowie's house is decorated in a science fiction mode'. Over a Jamaican fish lunch 'served by two interstellar Bowieites', the sixty-year-old novelist and twenty-seven-year-old rock star talked about astral projection and science fiction – the apocalyptic nature of the Ziggy Stardust character and the Robert Heinlein novel *Stranger in a Strange Land*.

Dystopias were on Bowie's mind. At the time the interview was recorded, in late November 1973, Bowie was working on a possible musical based around the character of Ziggy Stardust, using the cut-up approach developed by Burroughs. He was also working on a possible TV adaptation of *1984*: as he told Burroughs, 'That's a political thesis and an impression of the way in another country. Something of that nature will have more impact on television. People having to go out to the cinema is really archaic. I'd much rather sit at home.'

Burroughs didn't have much time for pop music – as he told Bowie, 'The content of most pop lyrics is practically zero, like "Power to the people"' – but the two conversed as equals. The younger man was content to inform Burroughs of current sociological trends, in particular the generation gap between 'people who are into groups like Alice Cooper, The New York Dolls, and Iggy Pop, who are denying totally and irrevocably the existence of people who are into The Stones and The Beatles. The gap has decreased from twenty years to ten years.'

Sex was hardly spoken of at all, except when Copetas asked Bowie where he thought sexuality was going. 'I don't see it going anywhere,' Bowie replied. 'It is with me, and that's it. It's not coming out as a new advertising campaign next year. It's just there. Everything you can think about sexuality is just there. Maybe there are different kinds of sexuality, maybe they'll be brought into play more. Like one time it was impossible to be homosexual as far as the public were concerned. Now it is accepted.'

The interview was also notable for Bowie's disavowal of his former mentor and inspiration, Andy Warhol. 'I adore what he was doing,' he told Burroughs, accentuating the past tense. 'I think his importance was very heavy, it's become a big thing to like him now. But Warhol wanted to be a cliché, he wanted to be available in Woolworths, and be talked about in that glib kind of manner.' When Burroughs commented on Warhol's alien appearance, Bowie replied, 'This man is the wrong colour to be a human being.'

This was a little unkind, but the interview's whole purpose was for Bowie to reposition himself for the next stage in his career. In allying himself so publicly with Burroughs, Bowie was closing down his glam phase. Instead of name-checking the apparently flippant and frivolous Warhol, he was allying himself with a serious, well-respected and rather forbidding literary figure who had turned his alienation into a coherent and compelling worldview that represented a usable influence for Bowie. Nevertheless, it reaffirmed his fascination with the gay world.

Since his frank declaration of his homosexuality just over two years previously, Bowie had become the most totemic pop star of his generation. In his case, being open about the complexities of sexuality and gender had not precluded success. Between June 1972 and the end of 1973, he had six Top 10 singles and six Top 30 LPs, including two #1 albums. More to the point, he was subculturally significant, shaping the aesthetic of a new teen and post-teen pop audience, one that was more tolerant and sexually fluid.

Bowie spoke to the weirdos, the outsiders and those teens and post-teens up for a bit of excitement. In May 1973, at the height of Ziggy's success, he reflected on how he had 'created a somewhat strange

audience – but it's also full of little Noddy Holders, and little Iggy Pops. I know we used to attract a lot of "queens" at one stage but then other factions of people crept in. Now you can't tell. They're all there for some reason. And we get young people. Those lovely young people. And they have to be considered very seriously.'

Bowie's openness and sense of play unlocked something in his fans. He certainly had a healthy appreciation of their devotion: as he stated in the Burroughs interview, 'Trying to tart the rock business up is getting nearer to what the kids themselves are like. Because what I find, if you want to talk in the terms of rock, a lot depends on sensationalism, and the kids themselves are more sensational than the stars themselves. The rock business is a pale shadow of what the kids' lives are usually like.'

During the second half of 1972 and throughout 1973, the dominant style in British pop had been glam: fast, teenage-oriented pop rock, with flamboyant clothing and a highly performative androgyny. There was a parade of hits by the Sweet (two #2s with the era-defining 'Ballroom Blitz' and 'Teenage Rampage'), new Chinn/Chapman protégés Mud (one #4 and one #1), Slade (a #2 and a #1) and the one woman to crack the glass ceiling, the leather-clad Suzi Quatro (a #4 and a #1).

Bowie didn't start the trend, but he gave it its gay twist, and it was he who had the most influence, as the writer Steve Turner observed in 1974: 'There are as many Bowie imitators in the stands at Millwall on a Saturday afternoon as there are in the canteen of the Royal College of Art on a weekday. One group would see him in terms of rebellion and glamour while the other see him as the man most responsible for making the world a safer place for closet queens and maybe they also appreciate his lyrical references to Nietzsche, Genet, Warhol and Crowley.'

The US release of 'Rebel Rebel' in May, with its psychedelic remix, gave little hint of the album that it trailed. When *Diamond Dogs* arrived later that month, Bowie's full immersion in dystopian literature was revealed. 'The theme of the album is the aftermath of a nuclear holocaust,' wrote Chris Charlesworth in *Melody Maker*. 'It's pretty heavy stuff about corpses rotting in slimy thoroughfares, fleas the size of rats, rats the size of cats and "peoploids" clinging to safety atop high skyscrapers.' It was a departure in more ways than one.

In his review of the record, Michael Gross gave a requiem for the androgynous excess of glitter – 'An era when any man in hot pants and mascara could rise to the top of the record charts just by shaking his dyed pink hair at the glitter hungry fans. But when the sequins settled, when the clouds of smoke and special effects were cleared away, only one glitter rock star stood half a chance of making it past the fad into permanent stardom. His name was David Bowie and his chances were better than all the rest because he had a secret. He had talent.'

Gross and Ron Ross were two of the writers proclaiming the end of the glitter fad during the first half of 1974. In a brutal piece for the *NME*, 'Farewell Androgyny', Nick Kent asked: 'Is it time to shut the closet door?' In *Let It Rock*, Simon Frith wrote about the year between September 1972 and September 1973. Describing the singles chart, he observed the dominance of 'the English stomp': 'crude and brash music for crude and brash dancing' that encompassed 'football rock' (Slade), 'sexy monoto-rock (T. Rex) and glamour (Bowie)'.

Frith wrote about the genre as though it was in the long distant past. Overkill would be a big problem for most of the artists mentioned, whose UK hits would begin to taper off by the end of the year. In the US, the style had been less teen-oriented and more influenced by post-Stonewall gay politics and aesthetics – radical drag in particular. More confrontational than its UK version, it never really got the backing of the mainstream music industry – radio particularly – and its leading practitioners would find the going very tough.

In mid-June 1974, while 'Rebel Rebel' was climbing, rather effort-fully, into the Top 100, Jobriath released his second album, *Creatures of the Night* – principally comprised of sessions for the previous album. The record was not without merit – 'Scumbag' was an attractive, folky character assassination – but the same problems remained: an affected singing voice and a songwriting approach taken from musicals, which did not translate well into the rock market. At the same time, his openly gay approach did encounter prejudice.

Jobriath's high-profile March 1974 appearance on *The Midnight Special* was, as Jerry Brandt remembered, 'a struggle. At the audition, producer Stan Harris was mortified after every one of Jobriath's songs simulated sex

onstage. He said: "We can't do this on TV!" We wrangled about [*sic*] four
hours. All Jobriath had on was a body suit. He did "I'm a Man" and "Take
Me I'm Yours". He was going to do "Rock of Ages", but they objected to
the S&M overtures in the lyrics.' Guitarist Billy Cross remembered the
experience as 'horrible: they hated us and that wasn't fun'.

Creatures of the Night went nowhere, and Jobriath was sent out on
some dates that were met with a dwindling response. In a later inter-
view, the self-confessed 'schizophrenic' singer and composer gave a terse
account of his failure: 'Mr. P. T. Barnum Brandt was so busy getting his
name on posters and buses, he neglected to get me on tour or get my
album played. They used a mannequin's ass for the poster and it wasn't as
round as Jobriath's. That is probably why Jobriath didn't make it.'

On 15 June, the New York Dolls crossed the Canadian border to play
a show in Toronto, supported by another Leber and Krebs act, Kiss. An
unenthusiastic review the next day called them 'the epitome of bad taste':
'The first and last time the Dolls performed in Toronto, they were part of
the wave of rock bands whose ambivalent sexuality was considered to be of
more interest than their music. Since then, the Dolls have started believ-
ing their own publicity, which has called them the new Rolling Stones.'

This was the nub. The New York Dolls were seen, whatever their actual
sexuality, as a gay or bisexual group, and that, in the world of American
rock, was anathema. The group themselves didn't seem that bothered –
the first few months of the year were spent recording a new album and
playing dates with as much enthusiasm as before – but, as 1974 wore
on, it would increasingly become a problem. If they weren't associated
with bisexuality and decadence, then they were just another rock group
among many, losing fire.

On 22 June, 'Rebel Rebel' reached its US peak of #64 – not a spec-
tacular success. On the same day, *Diamond Dogs* entered the US Top
40 album chart. The record was boosted by the first stage of Bowie's
Diamond Dogs tour, which ran from 14 June until near the end of July.
This was the most complex theatrical staging of any rock event thus far,
with sets that included the post-nuclear-holocaust Hunger City – made
out of 20,000 individual parts – a movable catwalk and the use of a
cherry picker that allowed Bowie to soar high above the stage.

Reviewers thought that Bowie had gone beyond rock into a futuristic, dark kind of musical theatre. The set was inspired by the German artist and satirist George Grosz, who had been forced into exile by the Nazi regime. In Bowie's fevered brain, decadence, of which bisexuality was a part, operated as a precursor of fascism, a harbinger of social breakdown that led to much more terrible things than a man fellating a guitar or wearing women's dresses – the phase that Bowie had convincingly left behind.

———

While Bowie was working on the first leg of the *Diamond Dogs* tour, George McCrae's 'Rock Your Baby' peaked at the top of the American charts. One of the earliest big hits to use a drum machine as an integral part of the sound, this was a light, sinuous groove – with plenty of space in the sound – featuring a soulful, at times falsetto vocal. Stretched out over six and a half minutes in its full version, 'Rock Your Baby' was a sparse, sexy dream that had been popular in the discotheques before its final ascent to #1, three months after its release.

It followed another dance record, 'Rock the Boat' by the Hues Corporation, which had a more conventional sound, with horns, guitar and a strong bassline. This had been played in the discotheques for eight months before radio finally picked it up – another example of the DJ's new selling power. As Nicky Siano remembered about that period: 'We were dealing with the same crowds every week, and we programmed them. We heavily rotated records, just like radio, and the next week that record would be a hit.'

These disco hits weren't coming just from New York, Philadelphia or even Cameroon. 'Rock Your Baby' came out of Miami, while the Hues Corporation were based in Los Angeles. The new dance music was spreading across the country, out of the gay discotheques and into the mainstream, and musicians and producers were taking notice. While the records still sounded disparate, a definite style was developing, and the leader in this – with hits by MFSB, Harold Melvin & the Blue Notes, and the O'Jays – was still Philadelphia International Records.

This new music coming out of the gay clubs was what Bowie heard in New York during the spring that 'TSOP' was at #1. When his tour brought him to Philadelphia for a five-day residency in early-to-mid-July, he took time out to visit Sigma Sound Studios, where his backing singer and part-time partner Ava Cherry was recording. He was so struck by the studio and the sound it created that he made a plan to come back in a few weeks, during a gap in the tour, to begin recording a new album.

It was in Philadelphia as well that Bowie began playing his first dance-music cover in his set, a version of Eddie Floyd's evergreen 'Knock on Wood' – a pirate radio favourite in 1967 and a Top 20 UK hit. The whole residency in Upper Derby, Philadelphia, was recorded for a live album that would be released in the autumn, of which this busy yet faithful cover would be the lead single – and the first example of Bowie's new direction. For, right in the middle of a tour that was supposed to promote his latest album, *Diamond Dogs*, Bowie radically changed his whole approach.

After recording seven songs in early August – with backing singers Ava Cherry, Robin Clark, Diane Sumler, Luther Vandross and Warren Peace augmenting complex, intricate, Philly-style arrangements – Bowie began integrating them into his set list on the second leg of the tour, which began in Universal City on 2 September 1974. Alongside the *Diamond Dogs* material and a few old hits were new, Black-inflected tunes like 'It's Gonna Be Me', 'Young Americans' and a radical, sax-led reworking of 'John, I'm Only Dancing'.

Bowie struggled to integrate the warmth of Philly with his chilly persona. Lester Bangs went to see him during his Detroit residency in mid-October and had a vision: 'I peered and peered, trying to catch the ultimate vibe . . . Johnny Ray [*sic*]. Johnny Ray on cocaine singing about *1984*. Bowie is as cold as ever, and if you get off on his particular brand of lunar antibody you may well be disappointed in his latest incarnation, because he's doubling back on himself.' This was the remote performer captured in Alan Yentob's fly-on-the-wall BBC film *Cracked Actor*.

———

While Bowie continued his 'Philly' *Dogs* tour, as it became known, in November, Nicky Siano reopened the Gallery after an enforced closure. After the collapse of the Mercer Arts Center building in August 1973, New York's regulatory bodies – in particular the buildings department – had begun to take a closer look at the unregulated nature of the gay clubs. In May 1974, David Mancuso made the front page of the *New York Times*, accused by a neighbour of knocking down a wall in the Loft and damaging the fabric of the building with the stomping of '500 frenzied dancers'.

The Loft was shut down a couple of weeks later. The last record that Mancuso played was the Temptations' angry, stoical 'Law of the Land'. A couple of months later, the fire department entered the Gallery and, with no prior warning, announced its immediate closure on the grounds of inadequate safety. When the Gallery reopened a couple of months later at Mercer and Houston, the new version was 'high tech and innovative', in contrast to the 'homey, underground feel' of most gay venues at the time.

The opening night attracted a crowd of over 1,500, who all went mad to Siano's song of the moment, taken from LaBelle's recently released *Nightbirds* album. 'That was the first time that I turned off the sound in the middle of a record,' he remembered. '"What Can I Do For You?" was the big song, and they sang the entire thing.' The event was recorded in the DJ magazine *Melting Pot*: 'The atmosphere started out warm and congenial and went up hill from there. Nicky Siano was in his prime and the crowd – well, the crowd was the epitome of the word "TOGETHER".'

Disco had become big news. On 2 November, *Billboard* ran a story on its front page headlined 'Labels Mix Records for Club Scene'. As it reported: 'Specially mixed versions of commercial singles are being offered to discotheques here by a number of labels looking to capitalize on the clubs' growing reputation as record "breakout" points . . . executives say that the clubs are a definite influence in breaking records and that they consider it well worth the time and effort to reach the disco audience.'

In the same issue, the DJ and mixer Tom Moulton began two new columns. One, titled 'Disco Action', included a top ten based on club responses and another on the best-sellers at two New York record shops,

Colony Records and Downstairs Records. Among the listings were singles by Barry White, Disco-Tex and the Sex-O-Lettes, the Hues Corporation, the Trammps and Harold Melvin and the Blue Notes, but topping them all was a record by Gloria Gaynor, a cover of a Jackson 5 tune called 'Never Can Say Goodbye'.

'Never Can Say Goodbye' received a very enthusiastic response in the clubs, but a clueless MGM baulked at promoting the record to the radio stations. Moulton made this a cause célèbre in his other column, 'Discotheque Club Dialog': 'With large numbers of discos reportedly opening around the country, four questions most asked of discos by their customers are: (1) The name of the record being played and the artist. (2) Is it new? (3) Where can it be purchased? (4) If Gloria Gaynor is so popular at discos, why isn't she being played on radio?'

Within a month, Gaynor's record would enter the Top 40, eventually peaking in the Top 10 – another example of the way that discotheques and gay-club life were dragging the major labels, kicking and scream-ing, towards recognising this new market for dance music. This was an example of a style that, far from being imposed from above, was coming up from below, as it were, from among the more marginalised groups in American society – gays, Blacks and Latinos – and taking its place in the mainstream.

In the week that Moulton wrote his first column, he was having his first chart success with a remix of 'Do It ('Til You're Satisfied)' by the Brooklyn group B. T. Express – #14 and rising in the Hot 100. After making his name providing tape mixes for the Fire Island clubs, he had come to the attention of a sharp A&R man at Scepter Records, Mel Cheren. Moulton was frustrated by the short length of many dance sin-gles and began to seek instrumental tracks that he could mix longer, to keep the vibe going and make his job as DJ easier.

When Cheren passed him a tape of 'Do It ('Til You're Satisfied)', Moulton extended the three-minute track to over five and a half; both versions were released on the 45. 'The band absolutely hated it,' he remembered. 'We had a station here called WBLS and they played the long version, not the short version. And it became a no. 1 record and they were on *Soul Train*. And Don Cornelius interviewed the band and

asked them about the length: "Oh yeah, that's the way we recorded it." I was so fucking mad.'

On 16 November, 'Do It ('Til You're Satisfied)' peaked at #2 in the pop charts. That week, Vince Aletti began 'a regular report on the state of the dance floor' for the trade magazine *Record World*. 'I'd been writing about music for five or six years before arriving at *Record World*,' he wrote later, 'but I'd never written for one of the music trades and had always taken a skeptical, if not adversarial view of the music business. Suddenly, I was not just writing from within that business, I was an integral part of a booming scene.'

Completely oriented towards cutting-edge dance music, while codifying the new abbreviated term for the genre, Aletti's 'Disco File' column allowed him to write about club news and hot new cuts – including an album of the month – and featured four playlists from selected club DJs around the country. Full of detail and records both familiar and obscure, it reads like a week-to-week, month-to-month diary of a culture that was proliferating under his very eyes.

'The year that "Rock the Boat" and "Rock Your Baby" became big hits was the year that the business at last realised that there was this underground of dance clubs that was making records happen,' he remembers. 'These were records that had been huge club hits for six months before they became number-one, pop chart records. When they did, the business realised that there was something going on, that there was this underground that had a lot of power, that they better start dealing with.

'Disco came out of a sound that was already there, and it only needed to be labelled. The people who were playing in clubs initially put together records and saw a connection between all kinds of music internationally and discovered a sound that became put down on vinyl in a different way. People started seeing these connections and started making records to fit into this mould. The public that consumed the music had no idea, really, where it came from and that most of the clubs that were making these records happen were gay or had a very bisexual audience – that the underground that started all this stuff was gay.'

In his first column, published on 16 November 1974, Aletti praised the B. T. Express album *Do It ('Til You're Satisfied),* remarking that 'their

504 The Secret Public

steamy "Express", running just over five minutes on the album, is the cut – and for nearly everyone polled, the immediate answer to the question, "What's the hottest record in your club right now?"' He also noted the popularity of First Choice's 'The Player' (on Philly Groove), and that '"Lady Marmalade" (just out as a 45) and "What Can I Do for You?" are the top choices from LaBelle's soaring *Nightbirds*'.

In the DJs' playlists, which included input from Toraino 'Tee' Scott, as well as other DJs from New York and Los Angeles, the most popular records were Gloria Gaynor's 'Never Can Say Goodbye', 'Express' by B. T. Express, 'Get Dancin'' by Disco-Tex and the Sex-O-Lettes, and LaBelle's 'What Can I Do for You?' The last two were by long-standing acts – with strong connections to the gay scene – who had seen an opportunity for a revamp within this emerging genre. Both would become huge hits as 1974 turned to 1975.

'Get Dancin'' was a charming, street-smart novelty written and produced by the 1960s veteran Bob Crewe, an old-style party record with crowd noises, whistles and an anonymous female chorus chanting cut-up lyrical references to recent hit tunes like 'Radar Love' and 'Rock the Boat'. The main hook was the exultant performance of Sir Monti Rock III, who, acting as an MC and DJ, preened, camped and rapped in a mixture of accents, including his native Puerto Rican. As he exclaimed with delight: 'I'm turning myself on.'

During the extended vamp at the song's end, Rock adds the aside: 'Nobody can tell you how to wear your hair, darling, just keep doing it.' This is something that he had experience of, having started out as a fashionable hairdresser in New York during the early 1960s. During a long and varied career, this self-described 'Puerto Rican faggot' had worked in Las Vegas and was an outrageously flamboyant television regular – as 'hairdresser to the stars' – on programmes like *The Merv Griffin Show* and Johnny Carson's *Tonight Show*.

Disco-Tex and the Sex-O-Lettes were deliberately constructed as a disco group – hence the first name of Monti Rock III's alter ego. Unlike most other disco hits, which were dance records adopted by the gay crowd, 'Get Dancin'' was targeted at the newly coalescing genre, at the same time as it was deliberately, and joyfully, constructed to make

the most out of Rock's gay appeal, and thus the gay disco audience. In this, Rock's TV appearances, in which he came off like a hip, exuberant Liberace, were tailor-made.

That November also saw the second single released from LaBelle's fourth album, *Nightbirds*. Featuring Patti LaBelle, Nona Hendryx and Sarah Dash, the vocal group had been around in various formations since the early 1960s, producing classic sides like 'I Sold My Heart to the Junkman' and 'Take Me for a Little While'. When the girl-group era faded, they were renamed LaBelle and, under the managerial eye of Vicki Wickham, reinvented themselves for the new rock era, covering 'Wild Horses', 'You've Got a Friend' and 'Moon Shadow'.

It wasn't a success. As Wickham told Peter Shapiro: 'The thing that I really did wrong at the beginning was to put them into jeans and t-shirts because I thought we can't do the same old dresses and wigs. It really was dismal. I mean they looked pretty bad . . . Thank god for someone called Larry LeGaspi, who came to a show and said, "You are doing it all wrong. I make costumes." I said, "We've got no money." He said, "Don't worry. I'd be delighted. I have friends, I can do it. If you let me dress them, you don't have to pay at the beginning."

'And he came up with this whole concept – the silver, the feathers, everything – and it was wonderful. And that was what was missing . . . He was right, that these three women were larger than life. When you put the three of them together, the moment they opened their mouths everyone would just go, "Oh my God." It was just enormous, their presence on stage . . . He saw this much more than I did: if we put them in wonderful clothes, they can carry it and that's what's needed. And indeed it was.'

Relaunched as a space-age disco act in flyaway silver uniforms, LaBelle – an 'all-girl band' – were orientated towards the gay underground, which, in Wickham's words, 'endorsed them as a potentially interesting diva group', especially when they played the Continental Baths. Picked up by Epic Records in 1973, they underwent another revamp, going to New Orleans to work with writer and producer Allen Toussaint. The result was both funkier and, with songs like 'Space Children' and 'What Can I Do for You?', tailored for the disco audience.

Most of the album was written by Nona Hendryx, but it was the opening track that made the biggest impression. Beginning with a pounding bass, piano and cowbell figure, 'Lady Marmalade' was a sassy, street-jive song with several irresistible hooks, climaxing in the chant: '*Voulez-vous coucher avec moi ce soir?*' The fact that Bob Crewe had written an erotic hymn to New Orleans sex workers only added to the song's sense of outsider daring, a code that worked for the underground audience and, very quickly, a mainstream one that was unaware of it.

While David Bowie was making a very strange appearance as a coked-out soul man on *The Dick Cavett Show* – where he played 'Young Americans' and the old Flares number 'Foot Stompin'' – Gloria Gaynor, LaBelle and Disco-Tex and the Sex-O-Lettes were topping the charts in Vince Aletti's 'Disco File'. In the *Billboard* Hot 100 chart for 7 December, dance records clustered in the top ten: Carl Douglas's 'Kung Fu Fighting' was at #1, with the Three Degrees' Philly classic 'When Will I See You Again' at #3, B. T. Express at #4 and Barry White at #10.

Disco was unstoppable that winter. The style that had originated in unregulated New York gay clubs was now attracting week-by-week updates from Tom Moulton and Vince Aletti and was spreading throughout the country. 'Discos Demand Five-Minute Singles', stated *Billboard* on its 14 December front page, while in his 'Disco Action' column Moulton remarked on the developing scene in Miami: 'There is a feeling that the disco club scene here is starting to get established,' he stated. 'Not as a fad but as a legitimate entertainment outlet.'

A couple of weeks later, Aletti reported on the opening of a brand-new, specially designed gay club: 'Flamingo, a huge, superbly-designed new private discotheque (for members and their guests only) opened in New York last week and even with the rugs rolled and stacked at one end and a ladder still standing at the other, it looked like the best space in town.' The pace on opening night was 'hectic'; popular records included 'Get Dancin'', 'Never Gonna Say Goodbye' and 'What Can I Do for You?'

A forerunner of the exclusive and elitist discos to come, the Flamingo opened on 14 December 1974, near the site of the original Loft on Houston and Broadway. Based on the success of the Gallery and, in particular, the Tenth Floor, it operated a male-only membership policy.

Members paid up to $600 a year, which kept out many poorer dancers. The Flamingo fostered the spread of the look that had begun on Fire Island and at the Tenth Floor: the macho uniform of jeans, boots, leather, flannel shirts, moustaches and toned bodies.

On 29 December, the *New York Times* ran a long piece at the front of its Arts section called 'Disco Dancers Are Back and the Kung Fu Has Got Them', in which Henry Edwards observed that 'the new urban clubs attract a clientele led by a polyglot coalition of young white, black and Latino gays and straights. What this group has shared in common for the past two years is the notion that an evening out can best be spent in a non-stop, dusk-to-dawn onslaught of thumping rhythmic activity.

'With radio stations popularizing the fad, the public at large suddenly appeared to be as eager for a rhythm fix as the most flamboyant urban trendy,' Edwards continued. 'The second coming of disco dancing' was providing a boost to a sluggish music business: 'The industry has marshaled its production and merchandising apparatus and given full-scale support to disco-soul not only because it wants to sell records, but also because a new trend always gives the illusion of renewed vitality.'

The disturbances at Stonewall, coupled with the continued cultural influence of Andy Warhol, had resulted in two separate strands of gay life being propelled into the mainstream: the radical drags and the disco dancers. In the UK, glitter had prevailed in rock/pop, while, in the US, it was the club-goers who were propelling male gay culture into the mass market. Disco was yet to be recognised as an overtly gay phenomenon, but the increasing spread and popularity of the music, combined with the on-the-ground politics, would soon force that to change.

PART 5
January
1978

Robert Stigwood and
Saturday Night Fever

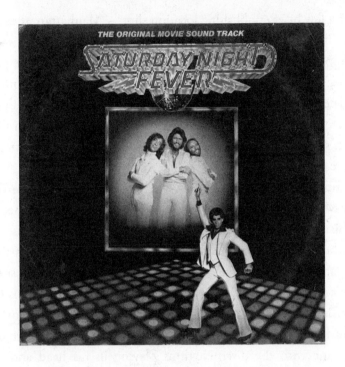

'The kind of escapism in the disco sound and disco environment satisfies the needs of oppressed peoples,' says sound engineer Alex Rosner. 'The pioneering done in the disco field has been done by gays, with the blacks and Puerto Ricans following. The common denominator there is oppression.'

Maureen Orth, 'The Disco Whirl', *Newsweek*,
8 November 1976

I t is one of the most famous title sequences in film history: just under three and a half minutes of music and moving images that announced a new kind of masculinity and heralded an entertainment industry sensation that would dominate American social and cultural life for eighteen months.

After a few brief establishing location shots – Manhattan, the suburbs of Brooklyn, an elevated suburban subway line – the camera moves to a shoe-shop window and looks downwards, as if to reinforce the primacy of the legs, knees and feet that will be highlighted in the sequence to come. There is a cut to a pair of feet, encased in maroon, ribbed shoes and partially obscured by flapping black flares. They are walking in rhythm, so much so that they are almost dancing, to the fast and urgent – if not desperate – disco song by the Bee Gees, 'Stayin' Alive'.

The camera pans upwards to show the young man in full: John Travolta as Tony Manero, an Italian American. He is wearing a black leather jacket, a red shirt open to the chest, with a prominent gold chain. His eyes are alive and roving, taking in the possibilities of the street scene, particularly with regard to any attractive young women. At one point, he stands in front of one, invading her space until she brushes him away. His heterosexuality is, at this point, unreconstructed, if not positively obnoxious.

Nevertheless, this is a new kind of man, loose, relaxed, stylish, in perfect sync with the disco rhythms playing in his head and on the soundtrack. Carrying a tin of paint, as if to reinforce his everyday origins, he epitomises the mid-1960s UK mod ethic of grace under pressure, of transcending his mundane life through clothes and movement. Almost sashaying down the street, he is, in his own way, the Dancer from the Dance.

Despite Manero's quickly established heterosexuality, this was not how the majority of young American males comported themselves at the time. *Saturday Night Fever* was a commercial product aimed at capitalising on the three-year-old disco craze. While its gay origins were disavowed for the mass market, they bled into the film and Travolta's character in many subtle ways, informing a storyline that took in Manero's trajectory from traditional masculinity into something quite different, something more open and sophisticated.

This was part of producer Robert Stigwood's intention. As his friend and colleague Freddie Gershon remembered, Stigwood had seen disco spread internationally during 1975 and 1976, 'in England, France, Germany. It was going down the social strata. Five years earlier it would have been deemed effete for men to even be on a dance floor. Now men were becoming peacocks. It was Robert's instinct that a Tony Manero existed in every community in the world.'

Saturday Night Fever remains a textbook example of how a minority subculture gets taken up by the entertainment industry mainstream. In the delicate ecology encompassing visibility, validation and erasure, disco's original Black, Latino and gay adherents rightfully felt short-changed by the whitening and heterosexualising of their music. There were some benefits to the music's exposure, however: more money for many of the Black artists who had originated the genre, and greater social status for the gay men who had helped to create a sensibility.

At the time, however, *Saturday Night Fever* was a sensation. Nothing like it had been seen since the Beatles' arrival in America fourteen years earlier. In the week of 21 January 1978, the double-album soundtrack went to number one in the *Billboard* charts; the film was at number one in the weekend box office, where it had been for the previous two weeks, taking in nearly $4 million; while in the weekly box office, it ran second, behind *Close Encounters of the Third Kind*. In the *Billboard* Top 10 singles chart that week were two songs from the *Saturday Night Fever* soundtrack: the Bee Gees' 'Stayin' Alive', rising fast at #10, and 'How Deep Is Your Love' at #2, down from the top, replaced by RSO* act Player at #1. Also rising fast was the youngest Gibb brother, Andy, with '(Love Is) Thicker Than Water' at #14. The next week, there would be four RSO records in the US Top 10. On 4 February, 'Stayin' Alive' went to #1, where it would stay for four weeks.

The weekend might have started there, but it lasted longer than any-one expected. In March, 'Stayin' Alive' was usurped at #1 by Andy Gibb, and in turn '(Love Is) Thicker Than Water' was replaced by another song from the *Saturday Night Fever* soundtrack, 'Night Fever', which remained

* Robert Stigwood's record label, the Robert Stigwood Organisation.

at the top for eight weeks. Between the third week of December 1977 and mid-May, Robert Stigwood's acts racked up twenty consecutive weeks at the top of the American charts. Meanwhile, the *Saturday Night Fever* soundtrack album would remain at the summit until July.

This almost unprecedented success was a total triumph for Stigwood, who, a decade after his humiliation by the Beatles, had become the most important impresario in the US. It was also a tribute to the resilience of the Bee Gees, who had risen, fallen and risen again in a spectacular manner. Well versed in the ups and downs of the music business, Stigwood had, in his own mercurial, piratical way, long planned a heist that integrated the film, music and television industries. This one had been at least three years in the making.

———

T he pivot point was the release, in May 1975, of the Bee Gees' single 'Jive Talkin''. This marked their transition from a melodic but floundering pop group into one attuned to the new genres within Black music. As Barry Gibb said at the time: 'The main vein at the moment is soul – R&B – disco, so we moved into that area. There's so much of this kind of music going on around us and we want to do it.' After quickly entering the charts, 'Jive Talkin'' rose to the top in August, where it stayed for two weeks.

It had been an up-and-down few years for Robert Stigwood and his signature act. After the disaster at NEMS, he had seen the Bee Gees split temporarily in 1969, before reviving with a couple of big American hits in 1971: 'Lonely Days' and 'How Can You Mend a Broken Heart'. After a couple of expensive theatrical failures, he had decided to concentrate on film and television. As he told his PA, James Daley, in the mid-1970s, his aim was integration: 'The movie sells the TV show, the TV show sells the record, the record sells the movie.'

It was Stigwood who suggested that the Bee Gees record at Criteria Studios in Miami. Their fellow RSO act Eric Clapton had already recorded there with considerable success: the #1 album *461 Ocean Boulevard*, the studio's address. After the failure of their two previous albums, *Life in a*

Tin Can and *Mr. Natural*, Stigwood insisted the Bee Gees reorient themselves to the current disco sound, and to that end brought in experienced R&B producer Arif Mardin, whose credits included Aretha Franklin, Diana Ross and Dusty Springfield, among many others.

Choosing Miami was no accident. The city was a major player in the new disco sound, with TK Records releasing huge hits like George McCrae's 1974 'Rock Your Baby', which was written by KC and the Sunshine Band, who themselves would have three #1s between summer 1975 and summer 1976: 'Get Down Tonight', 'That's the Way (I Like It)' and '(Shake, Shake, Shake) Shake Your Booty'. 'Here was a new culture to absorb, to base our music on,' Barry Gibb remembered. 'People wanted to dance.'

'Jive Talkin'' was quickly recognised as a potential hit. Based on the rhythm that the Bee Gees' car made as it crossed the causeway that connected Biscayne Bay to Miami, it was propulsive and mechanistic, and once Mardin had encouraged Barry Gibb to push his falsetto range, it made for an arresting new sound that fit right in with the Black American tradition of falsetto then popular in disco songs by the Stylistics, George McCrae and Disco-Tex and the Sex-O-Lettes.

Sent out on unmarked white-label cassettes and vinyl singles to avoid any immediate association with a group marked by recent failure, the song quickly gained traction on its release. Many DJs thought the group were Black, but once they found out it was the Bee Gees, they played it anyway. Stigwood's marketing savvy paid off: as the rock magazine *Creem* pointed out, 'The next thing we knew, "Jive Talking" was heard in the chichi-est of discos, and it looked like the Bee Gees were passing right through the color line, like a K-Tel's *Greatest Hits of the Ghetto*.'

'Jive Talkin'' caught the disco wave. As it was climbing into the American Top 10 in late July, Van McCoy's 'The Hustle' went to #1, a high-profile disco hit that triggered mainstream media interest in this still developing music and subculture. 'The Hustle' was an irresistible, feather-light confection featuring a lush, smooth orchestral sound, with a prominent woodwind part, swaying strings and a strong sense of uplift. Mainly instrumental, with vocals interjecting the title phrase and instructions to 'do it', 'The Hustle' rose quickly up the charts.

Aged thirty-five in summer 1975, McCoy was a music industry veteran who had cut his teeth in doo-wop before joining Scepter Records, where he worked on hit singles by Ruby & the Romantics, Erma Franklin, Jackie Wilson and Betty Everett, for whom he wrote the 1960s dance-floor filler 'Getting Mighty Crowded'. After releasing solo records for well over a decade, he rebranded himself as Van McCoy and the Soul City Symphony and, inspired by Barry White, started making records with the new, lush disco sound.

On its release in April 1975, 'The Hustle' was called 'essential' by Vince Aletti in the most important record of disco's progress during this period, his *Record World* column 'Disco File'. Beginning in November 1974, Aletti's 'Disco File' was right at the heart of the culture as it developed week by week. As he remembers, it relied on constant research and consultation: 'I wasn't out all the time, but I was getting all the records. I was going to the stores that stocked the records to find the things that hadn't been sent to me. I was calling the DJs all the time, to find out what I was missing. Mostly I was playing these things at home, but I wasn't dependent on my own taste, for the most part. It was important to see how a record worked at a club. If there was something I wasn't that sure about, sometimes I would take it to a DJ at the beginning of the evening and see what he thought. Mostly I had to go on my own instincts about what I was going to write about, but I did constantly test it by going out to clubs, hearing things that I hadn't heard.'

Aletti's columns for the first six months of 1975 captured disco's rapid growth: major-label investment by Atlantic, Warner Brothers and Motown; the launch of the twelve-inch single by Mel Cheren at Scepter Records – a new format, specially aimed at disco DJs, that had room for extended mixes and improved sound quality; and the institution of the Record Pool, a self-help network of insiders like Aletti and David Mancuso, which, acknowledging the difficulty of getting new records from record companies, acted as a clearing house for new releases from up to a dozen labels.

Taken together with recent big hits like 'Lady Marmalade', 'Never Can Say Goodbye' and Harold Melvin and the Blue Notes' 'Bad Luck', disco was looking like a persistent, fertile trend. Welded to a glamorous

partner-dance style called the Hustle, this was a perfect lifestyle mix that attracted the attention of journalists in the upscale New York press, who were glad to have an eye-catching news story under their noses.

In August 1975, the DJ Richie Kaczor took the *New York Daily News* writer Sheila Weller to Nicky Siano's Gallery. 'The wildness is exquisitely wholesome,' she wrote. 'The floor is a drum to the dancers – many of them gay, most of them black – whose upsprung fists and tambourines lob the balloons and streamers above at what seem to be collectively-chosen intervals. "Get ready for a rush!" Richie whispers, and the song smoothly melts into "Love Is the Message" over which deejay Nicky Siano – one of the city's best – blares jet-plane sound effects.'

The commercial growth of disco continued during the second half of the year, with *Billboard* #1s by KC and the Sunshine Band ('Get Down Tonight' and 'That's the Way (I Like It)') and Silver Convention's 'Fly, Robin, Fly' – a track that marked the start of the Eurodisco connection that, boosted by the smash success of Donna Summer's 'Love to Love You Baby' (#2 in February 1976), would refresh the sound of dance music over the next couple of years.

By the end of the year, there were at least 500 discos in New York and 10,000 nationwide. In late October, David Mancuso reopened the Loft to a more muted crowd. The next month, the Flamingo restarted, followed by the launch of the upscale Infinity on Broadway, a huge space that on opening night featured a six-foot pink neon penis by the entrance. It was becoming clear that, as *Forbes* magazine put it, disco was not just about music; linked as it was to nightclubs, it was also becoming crucial to people's 'social lives'.

Aletti had another go at summing up the state of play in his end-of-year round-up: 'If the concept of "Disco music" was born for the masses in 1974, it grew up with astonishing precocity and took over in 1975 if only because it was the only trend in sight. The music business stopped regarding Disco as some sort of freakish, tainted offspring of r&b and pop and took Disco out of the underground to see what sort of tricks it could turn at the top of the charts.'

Disco's fresh importance to the music industry was highlighted in the First Annual International Disco Forum, held by *Billboard* at New York's

Roosevelt Hotel in late January 1976. Beginning with a speech by publisher/editor Lee Zhito – 'The time is right for disco' – the Forum advised the industry to move with the times: 'Disco is rapidly becoming the universal pop music, and the industry now has another viable tool to tap additional consumer dollars.'

Covering the Forum, the *New York Times*' John Rockwell called it 'the most tangible sign yet of the packaging and dissemination of a disco craze that can legitimately count New York as its center. The current disco boom comes about from the unique mix of blacks, Latins, whites, homosexuals, heterosexuals, cafe society, drugs and media that New York combines more volatilely than anywhere else. The Roosevelt convention shows us the way the American entertainment industry moved in to market it all to the masses.'

Gay people – almost exclusively men at this stage – were beginning to gain traction in the industry. As Vince Aletti remembers: 'The roots of disco were more and more obvious because of the attention it was being given and because of gay lib and all kinds of lib at that point. It was fairly blatant what was going on in clubs, part of which made the scene incredibly exciting and vigorous, but from the music business point of view – and I guess from the pop music point of view – it was a little out of control.

'Most of the promotion people who were initially hired were gay because the mainstream promotion people did not want to deal with the clubs. They were not going to go out after midnight to hit seven gay clubs around Manhattan. So the men and some women who were hired by record companies to do this were people who were already on the scene, who already went to clubs on their own, who knew the DJs, who were part of what's going on, and who understood the records. A lot of people on the scene called it "homo promo".'

One of the new breed was Ray Caviano, a native New Yorker who, having worked 'primarily in rock 'n' roll' realised in 1975 that 'something was happening in the gay clubs. So being a record man and being gay, I went back to the drawing board, and said, "Well, there's something to be done here with the music and more importantly the promotion of these records." So I created the first network of promotion to club DJs around the country, bearing in mind that a lot of these DJs were gay.

'In 1975 and 1976, we were promoting a lot of big records that were not only big in the gay clubs but crossed over to the radio – records like the Ritchie Family and the Savannah Band, Vicki Sue Robinson. And in turn I went to work for a company called TK Records, and they were involved in some really big records that crossed over. KC and the Sunshine Band in particular. And the Eurodisco scene came along, so this network became very influential in the promotion of dance records in the early stages.

'The gay disco scene started with a lot of black records: Van McCoy, 'The Hustle'; the Hues Corporation, 'Rock the Boat'; Gloria Gaynor and 'Honey Bee'. The gay clubs were very open to black music and played a pivotal role in having black music expand in this country and reach white people. So, in fact, disco was very involved in catapulting black music into the white market and consequently getting on the radio. I used the base of breaking records in the gay clubs, crossing them over into mainstream black clubs and white clubs, and then onto radio.'

During the first few months of 1976, the mainstreaming of disco continued apace. After 'Love to Love You Baby' reached #2 in February, the Miracles hit the top with 'Love Machine (Part 1)', the lead track from a loose concept album, *City of Angels*, which also contained a nod to their gay audience, 'Ain't Nobody Straight in L.A.' This was followed by Johnnie Taylor's 'Disco Lady' in April and the Sylvers' infectious 'Boogie Fever' in May. At the end of that month, Diana Ross went to #1 with her two-part disco suite, 'Love Hangover'.

While 'Love Hangover' was topping the charts, *New York* magazine published a piece by Irish English writer Nik Cohn, who wrote a slice-of-life story featuring an Italian American character from Brooklyn, 'Tribal Rites of the New Saturday Night'. Observing the rituals of the new teen generation in various discos around the greater New York area, Cohn distilled his impressions into the story of one club and one group of close friends, led by Vincent, who seeks escape from his life as a 'teen menial' in his alter ego as a dandy and 'the very best dancer in Bay Ridge – the ultimate Face'.

Contrasting the 1970s teens with those he had written about in the high 1960s, Cohn noted that there was less money around, and this

shortage resulted in greater attrition and continual pressure. The climate around the Brooklyn teens seemed more like a return to the 1950s: they took less risks than the previous youth generation, tending instead to graduate from high school, go straight into a job and save for the future, if they could. Within this life of endurance, Saturday night was their 'one great moment of release'.

Cohn later admitted that much of the story was based on his experience with British mods in the 1960s, but it translated well. In his hands, disco was converted from an exclusively Black and gay scene to a suburban, mass teen cultural event. And, like the mods and punks that both preceded and followed this teen subculture, Vincent and his gang were, underneath it all, riding Saturday night into the wall. Asked about the future by the observer who crops up throughout the story, Vincent nihilistically answers: 'What future?'

Later that June, the Bee Gees released their second full-on disco single. With its driving, uptempo beat, flavoured with some ingenious, if not hypnotic, falsetto vocal hooks, 'You Should Be Dancing' was an instant hit, entering the *Billboard* Hot 100 the week after its release. Vince Aletti thought it 'should be even more of a success on the disco level than "Jive Talkin'" . . . Irresistible.' By early September, it had risen to #1.

Disco delirium continued throughout the autumn. 'You Should Be Dancing' was replaced at #1 by '(Shake, Shake, Shake) Shake Your Booty', the second of five US disco chart-toppers in a row, which were completed by 'Play That Funky Music' by Wild Cherry, 'A Fifth of Beethoven' by Walter Murphy and the Big Apple Band, and the novelty 'Disco Duck' by Rick Dees and His Cast of Idiots. This last was released on RSO Records, and when the Bee Gees' next single – the ballad 'Love So Right' – hit the Top 10 in the first week of November, Robert Stigwood had two records in the US Top 5.

That week, Maureen Orth wrote a major cover story for *Newsweek*, 'The Disco Whirl'. Observing that, in the week before publication, five of *Billboard*'s top ten singles were disco hits, Orth noted the tensions that disco was creating. It aroused hostility in the rock world, while disco DJs posed a threat to traditional radio. 'Disco smashes can sell 200,000 singles and get on the pop charts before ever being heard on the radio. With

this power, the disco deejay has mounted the first successful challenge to radio airplay in the making of a hit record.'

Most of all, she recognised disco's crossover potential: 'The group most responsible for keeping discos alive was the homosexual community. Gays wanted places where they could lose themselves dancing – and at the same time make the scene. Private parties became private clubs and then public ones. When the recession hit and rock-concert prices began to soar, young straight people began to look for a cheaper form of entertainment. For a $5 minimum, the straights could go to a loft frequented by gays, hear good music, see good dancing, and join in.'

———

I t was time for Robert Stigwood to make his next move. Over the last couple of years, his fortunes – always see-sawing between triumph and disaster – had, on balance, enjoyed a substantial upswing. Added to the Bee Gees' recent chart-toppers was a successful movie: the film dramatisation of Pete Townshend's rock opera *Tommy*, which had grossed $34.3 million. The TV series *Beacon Hill* had launched well in the second half of 1975, while RSO's two films of 1976, *Bugsy Malone* and *Survive!*, had also been successful.

Stigwood's ability to cross-promote these projects between the worlds of music, film and TV did not go unnoticed. In a *Rolling Stone* profile, RSO was described as a 'family company', with Stigwood as the charismatic father. 'Everywhere you look an unusual camaraderie is evident. The people who work here share an enthusiasm that is less than a cause but more than just a well-paying job. It seems to be a cult of personality attached to Robert Stigwood himself.'

His position was strengthened by the major business restructuring that was completed in June 1976. In a deal engineered by show-business lawyer and future RSO CEO Freddie Gershon, there was a reverse takeover of Stigwood's UK-listed public company by a new US business, the Robert Stigwood Organisation Inc. Despite the successes of 1975, the UK RSO was burdened by debt and the share price didn't reflect the true value of the company, so the answer was to take it into private hands.

The deal to distribute the records and films produced by the Robert Stigwood Organisation Inc. became a battle between Warners and Polygram, with Stigwood eventually deciding that he didn't want his movies tied to Warner Brothers. The deal was funded by Stigwood's sale of 50 per cent of RSO Records to Polygram, almost guaranteed by a new contract that signed up the Bee Gees for five years and eight albums. Stigwood joined Polygram's board, while Polygram became RSO's US distributor, replacing Atlantic – much to label head Ahmet Ertegun's disappointment. One result of this was that the Bee Gees lost their current producer, Arif Mardin.

This complex manoeuvre ensured that Stigwood retained as much control as possible over his record company and what he began to regard as his most valuable assets, royalties and future movie rights. After the deal, he basically left England for good, taking up residency in the tax haven of Bermuda and spending an increasing amount of time in Los Angeles. This was to facilitate his central project: to make hit movies that, if they were not exactly musicals, would have a very strong musical content.

He was still very much tied to his core artists, the Bee Gees, who remained, in the short term, his principal cash cow; in turn, they had made millions out of the RSO restructuring. Apart from their continuing singles successes, September had seen the frenzied launch of the group's *Children of the World* album at their new pop-up shop on 57th Street. When the band arrived by crashing through a replica of their new album cover, they were surrounded by hundreds of teenage girls.

The Bee Gees were now established as major stars in America, and on the back of their pop success, Stigwood was preparing his incursion into the film world. In January 1977, he had the group record their contributions to the film adaptation of the off-Broadway production *Sgt. Pepper's Lonely Hearts Club Band*, which revolved around a loose plot about an innocent rock singer taking on the trials of the music industry. The Bee Gees would record several Beatles' songs with the cast, including 'Oh! Darling', 'She's Leaving Home' and 'A Day in the Life'.

This project was very personal to Stigwood, representing an idealised reversal of his humiliation at the hands of the Beatles in summer

1967. Nevertheless, it was only one of four film projects that he proposed in 1977. Early that year, *Rolling Stone* itemised the others: *Grease*, the second in Travolta's three-picture deal with Stigwood (budgeted at $4 million); *Saturday Night Fever* ($3 million); and the as-yet-unbudgeted *The Geller Effect*, an autobiographical film starring the twenty-year-old psychic Uri Geller.

The last would never happen, but Stigwood had his hands full with the other three; this was an ambitious, high-risk plan. His modus operandi was an adaptation of what he had done in the music industry in the mid-1960s: keep control of the project and the content for as long as possible, before involving any backers. That way the project – whether a record or feature film – would not be diluted or taken out of his hands, and more importantly, he would reap the financial benefits if it was a success.

For the three films, Stigwood funded the initial stages – development, script, actors, director – out of his own money, right up to the point of preparing a shooting schedule and selecting the production team. Then, for the actual production, he sought the backing of the distributors, who would receive a percentage of the gross. That way he minimised the financial risk to himself, kept ownership of the rights and got a greater percentage of the profits than he would have done if the studio had entered the process earlier on.

The second film in the trilogy was brought to Stigwood by the Hollywood agent Allan Carr, whom Stigwood had hired to do the promotion and marketing for the dramatised Who vehicle *Tommy*. Carr had bought the rights to another Broadway show, *Grease*, which repackaged on-trend 1960s nostalgia – George Lucas's *American Graffiti*, the popular TV show *Happy Days* – into a bright and attractive stage musical with an existing score of twenty or so rock 'n' roll pastiches, including the huge future hit 'Summer Nights'.

Saturday Night Fever was directly inspired by Nik Cohn's 'Tribal Rites of the New Saturday Night'. Working on gut instinct, Stigwood and his producer Freddie Gershon did the deal with Cohn: $10,000 against a final rights fee of $90,000 on commencement of principal photography, with first refusal on writing the screenplay. Cohn did not admit at the time that much of the article was fictionalised, but it didn't matter:

Stigwood was making an entertainment, not a documentary, and he was convinced at the time that 'disco would sweep the world'.

The next step was to put the team together. After Cohn's script proved unsuitable, Stigwood hired Norman Wexler, an Academy Award-nominated scriptwriter whose recent credits including the New York cop drama *Serpico*. For the lead role, Stigwood selected the twenty-two-year-old actor and singer John Travolta, who had already made his name in the TV series *Welcome Back, Kotter* and Brian De Palma's *Carrie*. In summer 1976, he'd had a Top 10 hit with the ballad 'Let Her In'. As an added bonus, he had played a minor part in the touring version of *Grease*.

On 26 September 1976, Stigwood held a lavish press conference at LA's Beverly Hills Hotel to announce that RSO had signed Travolta to a three-picture deal, for a fee of $1.5 million (around $7.5 million today). This was a huge amount for a still untested film actor, which nevertheless reflected Stigwood's ambition and confidence. Travolta was immediately assigned to the dance-film project, with work on *Grease* to follow. After some initial hesitation, he threw himself into the character and the task of mastering the dance routines.

The final piece in the jigsaw was studio involvement. Stigwood had met with Barry Diller, the head of Paramount Pictures, while working on *Tommy*, and the friendship was cemented after the Australian's success with the Mexican disaster movie *Survive!* in early autumn 1976. Fresh in the job, Diller was on the lookout for quick hits, and Stigwood's idea of combining music and film fit the bill. A new three-year, three-picture distribution agreement was signed between RSO Productions and Paramount Pictures by the end of the year.

Nineteen seventy-seven began with the pressure on. Stigwood's first task was the soundtrack for the *Saturday Night* film, and in particular nailing the theme song. The Bee Gees were recording a new album at the Château d'Hérouville, outside Paris, when their manager arrived to tell them that the plans had changed. They recorded four songs and quickly finished a fifth, 'Night Fever', which was written as the title theme. When Stigwood rejected it as 'too pornographic, too hot', the group returned to a demo that Barry Gibb had recorded and adapted it to the brief.

Built around drum loops, as drummer Dennis Bryon was temporarily unavailable, 'Stayin' Alive' is a pulsing, gritty masterpiece, its slightly robotic feel chiming with the Eurodisco productions of Giorgio Moroder and the city grind of the lyric, which perfectly matched Stigwood's brief: 'I've been kicked around / Since I was born.' The group's trademark falsettos reach an edge of hysteria, matching the desperation of lines like 'Life goin' nowhere, somebody help me.'

During the production of *Saturday Night Fever* and *Sgt. Pepper's Lonely Hearts Club Band*, the Bee Gees released a live double album, *Here at Last . . . Bee Gees . . . Live*, which went to #8 in the charts and stayed in the Top 40 for over seven months. This occasioned a front-cover interview with the rock magazine of record, *Rolling Stone*, which featured a cover shot by Andy Warhol's *Interview* regular Francesco Scavullo that set the group in stone: white suits, long bouffant hair, medallions and bracelets, shirts undone – a look that would shortly take over the world.

As if to reinforce the importance of their manager, Frank Rose's accompanying article, 'How Can You Mend a Broken Group? The Bee Gees Did It with Disco', also included quotes from Stigwood. Rose previewed 'Stayin' Alive' – 'It has real jive precision, like a sleek black Mercedes with an ashtray full of coke' – and quoted the group as maintaining no illusions: '"We're fully aware that our music is almost totally commercial," says Barry. "We write for the present."

'The sun rarely sets on Stigwood,' Rose continued. 'He is a constant traveler, a bachelor with homes in Los Angeles, New York and Bermuda, a peripatetic power broker with a penchant for style and a fondness for life in the grand manner. Like Brian Epstein before him, he lives in the Noël Coward tradition – but where Brian pioneered in translating the Coward style to the purposes of the businessman, Stigwood adds a crucial refinement: it is not sufficient just to be a businessman; one must also be a good businessman.'

Two weeks after the piece was published, Andy Gibb's first single, 'I Just Want to Be Your Everything', went to #1 in the US, where it stayed for four weeks. Only nineteen when he hit, the youngest Gibb was promoted as a clean-cut teen idol from 'a slightly cool Osmond family'. While the record was still in the Top 10, the first salvo in the *Saturday*

Night Fever campaign was struck, with the release of the Bee Gees' signature ballad from the soundtrack, 'How Deep Is Your Love'.

Taking most of the summer, the *Saturday Night Fever* shoot was troubled. John Travolta was distracted by the serious – and eventually fatal – illness of his partner, Diana Hyland. Director John Avildsen argued with Stigwood about the inclusion of Bee Gees songs and was summarily fired, replaced by John Badham. The location shoots in Brooklyn were disturbed by an attempted protection-money shakedown. And there were serious arguments between Stigwood and Barry Diller about the bad language in the film, which would affect its rating.

Released in late September, the Bee Gees' 'How Deep Is Your Love' was promoted on billboards and by a TV ad that promoted the forthcoming film and its soundtrack album – the beginning of a $7 million campaign. It slowly rose up the charts during October and November, peaking at #1 during December, the month of the film's release. By then, the film's title theme – 'Stayin' Alive', released in December – had entered the Top 40, on its way to the top of the charts. The timing was perfect.

Disco was ripe for mass exposure. In October 1977, *Billboard* declared that the magazine's third Disco Forum, held in New York that September, showed that 'clubland was on the verge of becoming America's most financially lucrative sector within the field of entertainment. "More revenue goes through the disco scene than the record business and the motion picture industry," Larry Harris, vice president of Casablanca Records, told the 900 registrants. "In fact, disco's $4 billion annually is second only to organized sports in the field of entertainment."'

Released in mid-November, just ahead of 'Stayin' Alive' and the film premiere, the soundtrack album for *Saturday Night Fever* was a mixture of old and new, with Black pioneers – and genuine underground records like 'Disco Inferno' – rubbing up against orchestral sequences by David Shire and six Bee Gees songs, which reached back to their 1975 and 1976 #1s 'Jive Talkin'' and 'You Should Be Dancing'. Two other songs were written by the brothers: 'If I Can't Have You', performed by Yvonne Elliman; and 'More Than a Woman', by funk act Tavares.

Compiler Bill Oakes front-loaded most of the Bee Gees songs on side one, which began with their new single and their current hit. Two other

songs – by Kool & the Gang and KC and the Sunshine Band – came from TK Records, highlighting the Miami connection. Label politics also ensured the inclusion of an RSO release, Walter Murphy's 'A Fifth of Beethoven'. While the album was not exactly cutting edge – there was no European electronic disco, the new sound of the moment – it was a canny mixture that summed up disco's past, present and immediate future.

Saturday Night Fever shipped half a million copies and entered the *Billboard* Top 40 on 10 December 1977, six days before the film's premiere in Los Angeles, held at Mann's Chinese Theatre. The event was covered on nationwide TV, showing the crowd scenes as celebrities such as Peter Frampton and Andy Gibb arrived. After the film was over, Stigwood hosted a bash costing $150,000 that doubled as a wrap party for *Sgt. Pepper's Lonely Hearts Club Band*, which had finished filming that day.

When *Saturday Night Fever* opened in New York, Stigwood held another party, this time at Studio 54, which was already established as the elite club in the city. Bianca Jagger presided over an event that featured a horse on the dance floor and the release of dozens of doves, which were summarily fried by the club's lights and had to be swept away. This was a new kind of luxe PR: imperious, imperial events designed to give the impression that the film was a certain hit before it was even in the cinemas.

Nevertheless, success was not assured. Even with an expertly conceived, cross-media promotional campaign, you still can't sell a turkey – as Stigwood would later find out. But *Saturday Night Fever* was a brilliantly executed mash-up of various Hollywood genres – the musical and the juvenile-delinquency flick, mixed in with inner-city social realism – that, together with a charismatic lead and a strong disco soundtrack, captured the sweat and pulse of a great city and its hardscrabbling youth.

———

From the iconic opening onwards, *Saturday Night Fever* doesn't let up. The plot centres around Tony Manero, a young Italian American who works in a paint store and dreams of another life. Despite living in a huge city, he and his gang reflect a small-town mentality, preoccupied

with turf and traditional values. Their one area of escape is the Odyssey, the local club, where Tony excels on the dance floor. There, the gang behave like princelings, throwing their weight around and dismissing women who do not come up to their standards. Their only time is tonight.

However, Tony's world is shaken by two events. His older brother quits the priesthood, sending the family into turmoil. At the Odyssey, he meets Stephanie – another consummate dancer and, to him, a worthy partner – who has her eyes set on bigger things. Although she comes from Bay Ridge, she is in the process of moving to Manhattan and mocks his parochialism. 'You probably live with your family, hang out with your buddies,' she tells him, 'and Saturday nights you blow it all. You're a cliché. You're nowhere, on your way to no place.'

Despite winning the dance contest at the Odyssey – in theory, a triumph and a vindication – Tony finds his life choices challenged by two further events. He tries to force himself on Stephanie, who manages to push him off, thus placing this new, precious friendship in jeopardy. Then one of his gang, the troubled and vulnerable Bobby, who adoringly looks up to Tony, walks the high wire on Brooklyn Bridge and falls to his death. It's not entirely certain whether this is an accident or suicide.

This precipitates a crisis. Tony leaves the gang and rides the subway all night until dawn. The ending of the film is strangely ambiguous. Against her better judgement, Stephanie allows Tony into her Manhattan flat, where for the first time he opens up and talks about his future. While there is no chance of any romance, they decide to be friends – a decision that establishes trust and, for Tony, if viewed kindly, a way out of his previously macho attitudes. For the first time, he treats a woman as an equal, rather than a sex object or an appendage.

Quite apart from the quality of the performances and the music – fused together in the central, iconic dance sequence – *Saturday Night Fever* remains a fascinating, if time-locked, document because there are so many slippages. At the film's end, Tony makes a decision to stop dancing at the Odyssey, which vitiates much of the film's previous two hours. As Alice Echols writes: 'Curiously for a movie marketed as a celebration of disco, *Saturday Night Fever* suggests that getting ahead (as opposed to "stayin' alive") requires abandoning disco.'

For an entertainment, it makes many subtle points about the nature of masculinity and class, at the same time as it entertains. The working-class neighbourhood and family that Tony comes from is depicted – in a slightly clichéd manner – as hidebound, static and, for him, unbearable. His gang come from the same milieu and, as young men, have extremely traditional, rigid attitudes about women and the neighbourhood. This continuum is unending, unless someone has the courage to break out of the circle. This is Tony's quest.

The principal task performed by *Saturday Night Fever* is putting what originated as a Black, gay and Latino style into a prejudiced, white, sub-urban context. This involves the explicit disavowal of homosexuality in particular, seen in the scene – around twenty-five minutes in – where the gang bully and jostle two swishy (and thus, for the viewers of the time, obviously gay) men whom the gang call 'fags'. One gang member pulls out his T-shirt in an imitation of a woman's breasts. The hurt and surprise in the gay pair's faces as they escape is still shocking.

Despite the fact that, in another instance of overt disavowal, David Bowie is called 'a faggot' at one point in the script, homosexuality bleeds into *Saturday Night Fever* around the edges. Travolta's choreographer, with whom he developed a very good professional relationship, was a gay Black man, Lester Wilson. The Odyssey DJ was played by Sir Monti Rock III, the star of Disco-Tex and the Sex-O-Lettes, who was one of the more flamboyant queens on the disco scene; there is no sense, as Tony chats to him, that this an issue.

Most of all, Tony himself is depicted ambiguously, most notably in a scene where he prepares himself for a night out. The camera rises up from his crotch, covered simply with black bikini briefs, before lingering lov-ingly over his chest and nipples. As director John Badham remembered: 'We got all kinds of hassle. We were letting some man walk around in his underwear, showing his body off.' So as to remove any immediate homoerotic implications, the film's production designer deliberately put a Farrah Fawcett pin-up poster in shot.

These slippages add to the film's impact. Tony's change from sexist stereotype to a more aware, if not actually feminised, male is directly attributed to Stephanie, but it is also informed by the homosexuality that

was intimately involved with disco in the first place and which, despite the efforts of the film crew and scriptwriter, still infuses the film. If it's to be liberation, then it must be liberation for all. One of pop culture's great achievements is to free up heterosexuals from the macho paradigm, and Tony Manero is iconic proof of that.

The reviews were mixed. *Variety* called the film 'the worst in teenage exploitation rehash', while in *The New Yorker*, Pauline Kael raved: 'The way *Saturday Night Fever* has been directed and shot, we feel the languorous pull of the discotheque, and the gaudiness is transformed. These are among the most hypnotically beautiful pop dance scenes ever filmed.' The Bee Gees' musical contribution also came in for praise. For *Rolling Stone*, 'Stayin' Alive' communicated 'the spirit of the film'.

By the end of December, it was clear that both the film and its associated album and singles were smash successes. Within the first eleven days of its release, *Saturday Night Fever* grossed more than $11 million. By the last week of February, the film was #1 in the weekday and weekend box-office charts – after being held off by the sci-fi blockbuster *Close Encounters of the Third Kind* – and three Bee Gees songs were in the Top 10: 'How Deep Is Your Love' at #10, 'Night Fever' at #8 and 'Stayin' Alive' at #1.

From 18 March to 15 April, the Bee Gees held the top two places in the US Top 100 with 'Night Fever' and 'Stayin' Alive'. This was a domination of the chart paralleled only by the Beatles in March and April 1964, particularly since on 22 April there were two Andy Gibb singles in the Top 30 and the new #2 was Yvonne Elliman's version of a Bee Gees song from the film soundtrack, 'If I Can't Have You'. As Maurice Gibb said later: 'We weren't on the charts. We *were* the charts.'

This level of success attracted more heavyweight press. In April, *Time* magazine ran a cover story on the *Saturday Night Fever* star: 'High Steppin' to Stardom: John Travolta Owns the Street, and His Fever Seems Contagious'. Discomania, it reported, had become a national craze. The text zeroed in on the masculinity angle, quoting *Saturday Night Live* producer Lorne Michaels: 'John is the perfect star for the '70s. He has this strange androgynous quality, this all-pervasive sexuality. Men don't find him terribly threatening. And women, well . . .'

Saturday Night Fever had an immediate impact on the music indus-
try. In mid-May 1978, Casablanca Records released its own disco film,
Thank God It's Friday, with an accompanying soundtrack album that
Vince Aletti praised as 'much more representative of disco music right
this minute than the *SNF* collection of oldies'. Focusing on a single night
in the life of a fictional Los Angeles disco, the movie eventually grossed
over $20 million, but this was seen as disappointing after the extraor-
dinary performance of its predecessor, which had inflated expectations.

In June 1978, *Billboard* held its fourth Disco Forum at the New York
Hilton. In his opening speech, the then mayor of New York, Edward
Koch, proclaimed that 'the disco and its lifestyle has helped to contribute
to a more harmonious fellowship toward all creeds and races, and it has
brought the industry unprecedented sales and unprecedented prosper-
ity'. Shortly afterwards, *Record World* announced that 'last year, 1977,
was the best year ever in records, setting new highs in sales and revenues.
And 1978, only six months old, has already surpassed the first six months
of last year.' This was all due to disco and *Saturday Night Fever*.

In August, *Billboard* reported on the ultimate mainstream accolade,
'Ad Agencies Go Disco to Sell Product'. 'Madison Avenue has discovered
disco music,' Joe Radcliffe reported, 'and the discovery is not only help-
ing boost the sales of just about everything from stereo equipment to
hamburgers . . . Disco music is being used in such popular brand name
products as Prell shampoo, Breck, Trident chewing gum, Hall candy
products, Burger King, Colt 45 and Sanyo audio and video products.'

At the same time, television started to feature disco more heavily, such
as on the Merv Griffin and Dinah Shore chat shows, and on established
music programmes like *American Bandstand*, *The Midnight Special* and
Soul Train. Radio was still a holdout – clinging to rock in the face of the
onslaught – but in August, a soft-rock station in New York, WKTU,
changed to an all-disco format. It quickly became the number-one sta-
tion in the area, and within months nearly two hundred radio stations
had converted from rock to disco.

Nineteen seventy-eight was the year of disco's triumph in America.
There were new super-discos like Xenon and New York, New York – just
two out of an estimated 20,000 discotheques in the country. There were

disco-dancing schools, disco pizzas, disco haircuts and the like. There were an estimated 37 million Americans taking to the dance floor: as *Newsweek* reported, 'Thousands of shaggy-haired, blue-jean-clad youngsters are suddenly putting on suits and vests, combing their hair and learning to dance with partners.'

The Bee Gees and John Travolta became disco, and disco went from being an underground – Black, Latino, gay – phenomenon to being *the* dominant form of entertainment in America. It was seen to sum up an era, a decade and a generation. As the gay commentator Andrew Kopkind wrote in the *Village Voice*: 'Disco is the revolt against the "natural" Sixties, the seriousness, the confessions, the struggles, the sincerity, pretensions and pain of the previous generation. Disco is the affirmation of the "unreal" Seventies, the fantasies, fashions, gossip, frivolity and fun. The Sixties were braless, lumpy, heavy; disco is stylish, chic, sleek, light. Disco emphasises surfaces over substance, mood over meaning. The Sixties were a mind trip (marijuana, acid); disco is a body trip (Quaaludes, cocaine). The Sixties were cheap; disco is expensive.'

This was an astonishing feat for a minority culture, but in the transition, many insiders felt that something had been lost. Despite the continuation of the gay disco underground in predominantly Black and Latino gay clubs like Paradise Garage – opened in January 1978 and presided over, with astonishing grace, by Continental Baths veteran Larry Levan – it was impossible to stem the white suburban tide and its takeover of what had been an inner-urban, integrated, creative scene.

For some DJs like Frankie Knuckles, who had played with Levan in the Continental Baths early in the decade, it was all too much: 'When people like Frank Sinatra and Tony Bennett and some of the most unheard-of people started making disco records, then I knew something had to change, that it was going to stop. It had to turn itself round because it'd just gotten to be too much. All that polyester, I couldn't stand it.'

In the December issue of *Christopher Street*, the gay literary magazine, Andrew Holleran, whose *Dancer from the Dance* had just been published to great acclaim, lamented founding clubs like the Tenth Floor: 'The old dark disco, which did not know it was disco, which was simply a song played in a room where we gathered to dance . . . songs you could dance

to for a long time, because they concentrated energy rather than evaporated it; songs that went inside you, rather than lodging in your feet and joints the way light disco does.'

Others felt a sense of betrayal. 'One of my problems with *Saturday Night Fever* is how straight that club was,' says Vince Aletti. 'That skewed it into something quite different from what I understood. The straight clubs were half the scene already, but it did make it seem like this was the big deal. That was dismaying. Also, you know . . . the Bee Gees? That was not right. I can't argue with the music that came out of *Saturday Night Fever*, but having a group of white boys represent this music, which was not white basically, just seemed wrong.

'I've said often that that was the beginning of the end. It was too much, and when something becomes that big, everyone is then looking for the next big thing. No other record could compete with that, but that was never a realistic goal, and nobody in club life really cared, as long as the music kept happening, and it did. But there was always this reactionary factor, waiting to pounce.'

Meanwhile, Robert Stigwood had racked up another huge success. On 10 June, John Travolta and Olivia Newton-John's 'You're the One That I Want' – released on RSO Records – hit the top spot (to be quickly replaced the next week by Andy Gibb's third #1, 'Shadow Dancing', which stayed at the top for seven weeks). This was the lead single from the second in Stigwood's film trilogy, *Grease*, the double-album soundtrack of which had been released in late May and was shooting up the charts.

Incredibly, Stigwood repeated the heist he had pulled off with *Fever*. On its release on 16 June, *Grease* got mixed reviews but was an immediate hit: on its opening weekend, the film grossed nearly $9 million in 862 theatres in the US and Canada, ranking at #2 (behind *Jaws 2*) at the box office for the weekend. After two months, it had grossed $100 million to become Paramount's second-highest-grossing film behind *The Godfather*. At the end of July, the soundtrack album went to #1, where it remained on and off for twelve weeks.

So far, so good – two smashes out of three. Stigwood came badly unstuck, though, with his third film in the trilogy, the first one that he had begun preparing back in early 1976, and the one dearest to his

heart. Written by the sharp rock critic Henry Edwards and starring Peter Frampton – the star of 1976 with the multimillion-selling *Frampton Comes Alive!* – while also featuring songs by Aerosmith, Earth, Wind & Fire and others, *Sgt. Pepper's Lonely Hearts Club Band* was set to be a huge blockbuster. However, beset by production problems and, perhaps, a complete misunderstanding of what made the original album tick – which was in part its restraint – *Sgt. Pepper's Lonely Hearts Club Band* was a huge flop on its 21 July release. The reviews were appalling – 'a film with a dangerous resemblance to wallpaper' – and its box office failed to meet either budget or expectations. The soundtrack album performed reasonably, reaching #5, but many more copies were shipped than sold.

The unkindest cut came from one of the four men who had shunned Stigwood back in 1967. None of the Beatles commented publicly, except for George Harrison, who said: 'I feel sorry for Robert Stigwood, the Bee Gees, and Peter Frampton, because they had established themselves as decent artists, and suddenly it's the classic thing of greed. The more you make the more you want to make, until you become so greedy that ultimately you put a foot wrong. It's damaged their images, their careers, and they didn't need to do it.'

If Stigwood felt humiliated, he had plenty to console himself with. In 1978, RSO and Stigwood-associated acts had spent twenty-eight weeks in total at #1 in the Top 100, more than half the year, a feat reminiscent of the thirty weeks that George Martin's productions for the Beatles, Gerry and the Pacemakers and Billy J. Kramer had spent at the top of the UK charts in 1963. His soundtrack albums for *Saturday Night Fever* and *Grease* had spent thirty-six weeks at the top of the US album charts – getting on for nine months.

But it was all too much for the forty-four-year-old. Accounts from the time have him dissolving in hedonism – heavy drinking and 'male orgies' – while he began to disassociate himself from the running of RSO: an echo of Brian Epstein at NEMS in 1966. Sometimes the fulfilment of dreams is hard. Snowed under by his unprecedented success, Stigwood sought nothing other than to retreat. As his PA, Kevin McCormick, remembered: 'After *Saturday Night Fever* you could never get him interested in anything again. He really had no serious desire.'

His legacy in terms of gay life and politics was ambiguous. Born in 1934 – the same year as Epstein – Stigwood was old school. Unlike Epstein, he did not promote himself alongside his clients, nor did he give many interviews. Like his one-time friend, colleague and rival, he remained silent about his sexuality. In his dealings with his clients – even his closest, the Bee Gees – he was focused on business and commerce, at the same time as his gut instinct on what would work with the public and the times was often preternaturally acute.

Lacking Epstein's vulnerability and business naivety, Stigwood was able to parlay the considerable media-industry experience that he had accrued since the early 1960s into the successful domination of late-1970s pop culture. But he also lacked Epstein's idealism, which showed in his lack of public support for the gay audience that had created and nurtured the form out of which he and RSO had made millions. Disco had been a gay form, but any active engagement with gay politics and culture would be left to other managers and artists.

The juggernaut that he had set in motion continued despite his partial withdrawal. In the last weeks of December 1978, *Grease* and *Saturday Night Fever* were still high in the *Billboard* album charts. The Bee Gees' latest single, 'Too Much Heaven' – a feather-light downtempo love song – was shooting up the charts, reaching #2 after seven weeks. Andy Gibb was at #8 with '(Our Love) Don't Throw It All Away'. Disco tunes were dominating the US Top 10: Village People, Alicia Bridges, Chic at #1 with 'Le Freak'. What could possibly go wrong?

Harvey Milk and San Francisco

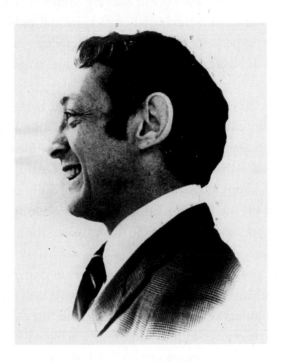

Clubs are insulators, providing a closed but therefore supportive environment. The crowd on the floor can feel as though it is attending a private party. Indeed, much of the special appeal of discos to gay people is that they are celebrations. They reflect a change in the mood of gay people, a change in self-image. Feelings are warm and positive, and people are learning to loosen up, to relate and express themselves with their bodies and feel good about it. The disco scene creates a tribal feeling among gay men, a feeling of strength and unity and belonging.

Barry Laine, 'Disco Dancing: Too Hot for Love',
Christopher Street, June 1978

During the mid-1970s, the rise of disco and the maturation of the possibilities thrown up by the post-Stonewall movement led to a new phase in gay politics. Zaps, Marxism and generational hostility were on the way out; dancing and working within the system were the new buzzwords and, with the fusion of pleasure and politics – boosted by the wealth of experience held by some gay activists – there were great strides forward. It wasn't the fearful 1950s any more; tangible change was within grasp.

At this time, an experiment in urban living was being conducted in several American cities. As the decade progressed, the most advanced example was occurring in San Francisco, where gay men – and it was mainly gay men – had their own district, the Castro, with its own enclosed world: shops, discos, bars and cafes, and easily available sex, all tied together with the new macho look that, originating in New York in the early 1970s, had spread to the West Coast. The area offered the complete package.

The Castro also had its own representative on San Francisco's city board. On 8 January 1978, Harvey Milk was sworn in as city supervisor. This was the culmination of a five-year struggle for the forty-seven-year-old, who, after many vicissitudes, had finally achieved his ambition of being the first openly gay man to attain political office in California and, indeed, the US. His position gave him the opportunity to vote on laws and ordinances that would affect the everyday lives of the city's residents, including the large gay community.

For a couple of years, Milk had been in the habit of calling himself 'the mayor of Castro'. The soubriquet was earned, and it stuck. Living there and running an open office right on the main drag, he understood the needs of the thousands of gay people who had moved to San Francisco – traditionally a safe haven for gay men and lesbians – from all over the country. By 1978, the Castro had become a beacon for gay men in particular and an international symbol of gay pleasure and pride.

Abrasive and media-savvy, Milk was totally aware of the symbolic and practical implications of his position. He aimed at nothing less than to be the figurehead of American gay politics. On the day that he was sworn in, he walked from his shop in the Castro along the fifteen blocks to City

Hall with his partner, Jack Lira. Surrounded by 150 supporters, he told reporters: 'This is a walk of reconciliation with a nation of people. This is a walk that will give to many people hope.'

A populist and a community politician, Milk was always aware of the optics. Staying outside in the rain while the main event went on indoors would make him seem different from the elite sequestered inside. As he told the reporters and the crowd: 'Anita Bryant said gay people brought the drought to California. Looks to me like it's finally started raining. This is not my swearing-in, this is your swearing-in. You can stand around and throw bricks at City Hall or you can take it over. Well, here we are.'

The reference to the anti-gay campaigner Anita Bryant was no accident. Milk's ascension was played out against a background of increasing pushback. The success of gay men and lesbians in becoming part of the mainstream of American life, both political and social, was accompanied by an organised backlash that said, *Thus far and no further*. Indeed, Bryant's success in repealing a gay rights ordinance in Dade County, Florida, the previous year marked a concerted campaign to check gay equality and send gay men and lesbians back to the 1950s.

In January 1978, the gay press – monthlies like *After Dark* and *Vector*, and the bimonthly *Advocate* – was preoccupied with *Saturday Night Fever*, disco, vintage Hollywood and the state of gay rights in the US. That month, the new gay literary magazine *Christopher Street* ran an editorial about a series of polls on the topic of homosexuality taken by Gallup, Harris and *Time* magazine late the previous year: 'American public opinion is about half way towards full acceptance of homosexuality.'

The figures were contradictory, however. Gallup found that 56 per cent of Americans favoured equal job rights for lesbians and gay men in principle, but over half objected to gay clergy and gay elementary-school teachers. Nearly half of Americans in the Gallup and the *Time* polls thought that homosexual relations between consenting adults should be illegal. Nevertheless, the Harris Survey found that 'a majority (55%) considers gays "the most discriminated against" group in American life today'.

Christopher Street noted that there were plenty of reasons for despair, including Anita Bryant being seen as 'the most admired woman in America', revelations about the targeted harassment of homosexuals in

Houston and 'opinion writers bemoaning "homosexual pacifism" in our foreign affairs'. However, it also noted that 'a couple of decades ago the positive figures in those surveys wouldn't have been close to, or above, 50%; they'd have been closer to 10%. Getting to the 50% area is a phenomenal improvement in our level of acceptance.'

Indeed, Gallup had found that 66 per cent of Americans thought homosexuality was 'more prevalent' in 1978 than it was twenty-five years previously. Clearly, the level of awareness about the existence of homosexuals and gay rights was much higher than it had been in the late 1960s or early '70s, before the long tail of Stonewall. 'It's clear that the gay activism spawned in the sixties is paying off,' *Christopher Street* concluded, and this was reflected in the increased mass-media coverage in the intervening years.

In September 1975, *Time* magazine ran a cover story entitled 'I Am a Homosexual: A Gay Drive for Acceptance', which highlighted the public admission of his homosexuality by US Air Force Sgt Leonard Matlovich. As ever, the article began – typical of many such pieces – by uncovering a secret world of gay gatherings and wild parties beneath the surface of American life. It continued with the usual trawl through gay bars, hustlers, leather men and 'furtive' public sex. These supposed revelations were counterpointed by a sober assessment of the legal restrictions still facing gay people in the US, where homosexuals faced penalties that were more severe than in any other Western nation. It noted that sodomy between consenting adults was still illegal in thirty-eight states, with possible prison sentences of up to life. At the same time, despite the reversal of the ruling that gays were unfit for public service, government and industry were still not giving security clearances to gays 'because of fear of blackmail'.

In that respect, the Lavender Scare still held sway. However, the report noted the gains made by homosexual activists and politicians: the reversal of anti-sodomy laws in twelve state legislatures; the ending of the listing of homosexuality as a psychiatric disorder by the American Psychiatric Association; and more liberal corporate policies about hiring 'openly avowed gays'. Nonetheless, these gains, *Time* concluded, came with a price: 'Many other Americans have become alarmed, especially parents. Some are viscerally hostile.'

In the summer of 1976, *Vector* published a cover story entitled 'Is Gay Lib Dead?', with an arresting graphic of the pink triangle that homosexual prisoners had worn in the Nazi concentration camps. As expected from a politically oriented, grassroots magazine, the answers were firmly in the negative. As Frank Kameny responded: 'Certainly not; it never has been dead. I don't know why anybody should think it is.' He talked about his new motivation: the imposition of federal anti-discrimination laws.

'We've just begun to fight,' teacher Doug Dean replied to the question about gay liberation. 'In politics and public life, more and more people of stature are coming out of the closet. I myself came out last fall to express my sexual preference publicly, and I've been greatly impressed by all the positive reactions I've received.' A carpenter called Tony Randall agreed: 'It's happening in more and better ways; we're exercising our views through our votes and our representatives.' He was credited as a full-time volunteer at Harvey Milk's campaign headquarters.

By that summer, Milk's campaign for city supervisor was already up and running. An attempt the previous year had fallen short, but Milk was nothing if not persistent. It had been a long and tortuous journey, from conservatism to radical politics, from secure jobs within the establishment to living hand-to-mouth. Theatrical, scatty yet stubborn, Milk had seen both sides of American life, and in the Castro he found the means to integrate the separate parts of himself.

———

Born in late May 1930, Harvey Milk was raised on Long Island, in a middle-class family; his grandfather owned a department store. A headstrong child who liked attracting attention, he had an active homosexual life as a teenager, which brought him into contact with the law when he was arrested, in 1947, for cruising in Central Park. This incident did not hinder his progress through high school or his time at Albany State, where he was the *State College News*'s sports editor.

Milk was of the generation that reached their twenties in the post-war era, right at the time of the Lavender Scare. The mood was conservative,

almost blank. 'The class of '51 didn't have any unusual characteristics,' a classmate remembered. 'We didn't have anything that stood out. We fell into a rut that had no character at all. Harvey and I were just like that – we were ordinary.' On graduation, Milk joined the Navy, and although he found it extremely arduous, he stuck out the nearly four-year period of service.

While working as a teacher in a Long Island high school, he met his first lover, Joe Campbell – later, the 'Sugar Plum Fairy' of Lou Reed's 'Walk on the Wild Side'. The restless pair moved to Dallas and then back to New York, where Milk got a good job as a statistician at an insurance firm. Neither the job nor the relationship stuck. By 1962, he'd met Craig Rodwell, a fiery twenty-two-year-old who was incensed by society's treatment of homosexuals. Ironically, in the light of future events, their relationship would founder on Rodwell's radicalism and open defiance.

In 1964, Milk supported Barry Goldwater's bid for the Republican presidential nomination. After his insurance job, he got a position deep in the heart of Wall Street, working as a researcher in the information centre of Bache & Company, a major investment firm. As his biographer, Randy Shilts, notes: 'The job allowed him to use his sharp memory, his knack for math, and, most significantly, his uncanny intuitions about social and business trends that could influence investment futures. He rose rapidly. Within a year he was the information center supervisor.'

In his mid-thirties, Milk was torn between Wall Street respectability and the desire for freedom. Through his lover at the time, Jack McKinley, he got involved with the radical gay underground, acting in experimental plays, circling around the Warhol scene thanks to Joe Campbell, who acted in *My Hustler*. After a few years of this double life, he quit Wall Street and started living an alternative lifestyle, moving to San Francisco, where he saw the radical drag troupe the Cockettes and worked as the stage director for the San Francisco production of *Hair*.

He began to drift. After spending a year driving through California with his current partner, Joseph Scott Smith – where he was, according to his friend Jim Bruton, happier than at any time in his entire life – Milk found that his money was running out. Alighting in the Castro at

the end of 1972 with no job and no prospects, he and Smith decided to put down roots and opened a camera store called, simply enough, Castro Camera. He had no particular aptitude for photography, but he had found his stage.

Milk and Smith were early adopters in a city that was rapidly transforming itself into a gay mecca. San Francisco was shifting from its origins as a thriving port to a service economy, with gay people finding jobs in corporate headquarters and in the tourist industry. Seeking low rents close to the city centre, the gay migrants alighted on an old seamen's district called the Castro and began to move in among the working-class residents of mixed origin – Irish, Italian and Scandinavian – and continued to replace them when they began to move out to the suburbs.

In the early 1970s, San Francisco was not welcoming to gay people, despite the continued existence of a defiant subculture. Mayor Joseph Alioto pursued a discriminatory policy towards homosexuals: during 1971, police arrested nearly 3,000 men on public sex charges, many of which were cases of entrapment. At the same time, there was a vigorous gay political caucus, building on the decade-long efforts of pioneers like José Sarria and the originators of the Society for Individual Rights (SIR).

The city's gay power brokers were all allied with SIR. Jim Foster, David Goodstein and Rick Stokes had all suffered for their sexuality – being fired from their jobs and driven out of their occupations, being subjected to electric shock therapy – yet were determined to work within the system to bring about true homosexual equality. They scored a major coup during the 1972 George McGovern campaign for the Democratic presidential nomination, when they whipped up gay support for the candidate, in terms of both donations and votes.

Considering Milk an abrasive upstart, they rallied against him when he decided to go into politics that spring. His decision was triggered by several factors: a demand for a state tax that he felt discriminated against small businesses; the realisation that local schools were underfunded; and fury at the Watergate hearings, which exposed the corrupt Republican regime. He announced that he was going to run for supervisor: he believed that was the only way a better world would be possible for gay men like him and his lover.

Although he failed in his 1973 bid, Milk campaigned again in March 1975. Having supported the unions in their protest against the anti-union practices of the beer distributor Coors – including organising a Castro boycott – Milk got the support of the teamsters, firemen and construction workers. This time he came seventh, but more importantly, he had built a strong working relationship with the city's new mayor, George Moscone, which would soon bear fruit.

By 1975, the Castro had transformed from a run-down inner-urban district into a thriving gay enclave. The wave was unstoppable as the old Victorian houses were snapped up by the incomers. In 1974, Milk had organised both the Castro Village Association for local business and the first Castro Street Fair, which had attracted a crowd of 5,000; the next year, the figure jumped to 25,000, making it the best-attended fair in the city.

As the old seamen's bars turned into gay bars like the Pendulum and corner stores into outlets selling Levi's, jockstraps and other accoutrements, a definite Castro style began to emerge. The counter-culture was fading, along with its androgyny. 'I moved to Florida in the winter of '74–'75,' remembered former Cockette Kreema Ritz, 'and when I returned, the second half of the decade had begun – grocery stores had turned into bars and bathhouses. Then I noticed all these men with mustaches, and I thought, where are all these people coming from?'

The new style was utilitarian and proletarian, a definite rejection of both camp and androgyny. It was summed up by Andrew Holleran as 'a male homosexual in his twenties or thirties who travelled in packs with other clones, had short dark hair, a short dark moustache, and wore levis, work shoes, plaid shirt, and bomber jacket over a hooded sweatshirt. The jeans were faded and sometimes frayed in strategic places. Dark glasses were aviator-style and occasionally mirrored.'

It might have derived from workwear, but no macho man would have worn this costume – which is what it was, originating not from the demands of occupation, but the desire for group recognition and group sex. The devil was in the detail: jeans rubbed at the crotch to emphasise the penis and rucked up tight at the back to highlight the bottom. At the same time, the attitude was defiant: clones did not mince or camp but

strode down Castro Street as though they owned the place, which they soon did.

This hyper-masculinity had been percolating through the gay world for a while, beginning in the need to overcome the camp, closet-identified style of the 1950s and early '60s. As a contributor to the New York Gay Liberation Front magazine *Come Out!* had written in the first flush of gay lib: 'The straight world has told us that if we are not masculine we are homosexual, that to be homosexual means not to be masculine . . . one of the things we must do is redefine ourselves as homosexuals.'

Well suited to disco dancing and urban living, the clone was well established by the mid-1970s. In 1975, *The Advocate* published a cover story on the changing gay image, in which it noted the near disappearance of long-haired gay men. It was, as the gay journalist Randy Shilts observed, the end of the 'Judy Garland style'. If you wanted sex, you had to be a clone, and as sex was all-important to many gay men, that was the deciding factor.

Adopting this parodic masculinity was a definitive statement that the old ways were dead. By subverting workwear, gay men were demanding an equal place in American society; stating that they were not victims but men like any others; building themselves into a highly visible social bloc, with their own districts, their own businesses, their own culture and their own political organisation. People might have mourned the uniformity and, perhaps, the laziness of the look, but as much as anything else, the clone style was an assertion of collective power.

By 1976, disco was a major part of this lifestyle, which was characterised by historian Martin P. Levine as 'the 4 D's': disco, drugs, dish and dick, a combination that he defined with a description of a typical bacchanalia. 'As the night passes and gets crazier, alcohol and drugs take command and the odor of poppers permeates the air . . . It's where San Francisco's gay "night people" bid farewell to the new day as they swagger home from over-nights at the baths and the late, late dance clubs.'

In his diaries from the period, Castro resident Mark Abramson remembered going walking down Market Street and following 'the sound of the bass beat to the nearest disco, the Mind Shaft. It wasn't crowded. The doorman waved me in, too late to have to pay a cover. In back, the raised

dance floor was full of half-dressed men and a couple of women. Five athletic, young black men with beautiful bodies moved in complicated rhythms. The dancers escaped into their own world with the music the key into their fantasies.'

There were tens of thousands more Mark Abramsons, coming from all over America to be free, to be who they thought they wanted to be. Even if it was a new kind of conformity, it was their conformity. It wasn't all ideal: there were tensions between the new arrivals and the old working-class residents who were being pushed out by gentrification. San Francisco's economy was not booming, and many gay men in their twenties – rootless and far away from home – were forced to duck and dive or go on unemployment benefit to survive.

In the tsunami of clones, neither women nor Black Americans were particularly well represented; sometimes they were not welcome in what one Black gay resident, Brian Freeman, called a 'vanilla gay neighbourhood'. Queens and drags were even more virulently scorned. As Edmund White later wrote: 'Our old fears about our sissiness, still with us though masked by the new macho fascism, are now located, isolated, quarantined through our persecution of the transvestite.'

———

In August 1976, the Castro Street Fair pulled in 100,000 people – a massive show of strength from this experimental gay community. Harvey Milk was in the thick of it at Castro Camera, and the popularity of the district further fuelled his political ambitions. Despite having been appointed a city commissioner by Mayor George Moscone, he ran for the California State Assembly – in the 16th Assembly District located in San Francisco's East Bay – an act that caused Moscone to fire him as commissioner.

Despite a chaotic campaign, Milk lost by only 3,600 of the 36,000 votes cast. Nevertheless, it was a crushing blow, coming as it did after the death of his father and the end of his long-standing relationship with Joseph Scott Smith. Worst of all, he received his first serious death threat during the campaign. Milk had long felt that he would die early. 'You

know I will probably be killed one of these days,' he said at the time, and there was a sense of urgency to his political campaigning.

Milk persisted, casting himself as the classic underdog, kept down not just by the San Franciscan political machine, but by the city's gay establishment. He might have been dramatic, but he was shrewd enough and paranoid enough to recognise the existence of a powerful anti-gay backlash; after all, as a locally prominent gay person he had begun to experience it. This exploded with force in June 1977, and his vocal opposition would propel him into nationwide prominence.

In early June, the singer and conservative Southern Baptist Anita Bryant led a successful campaign to repeal a gay rights ordinance in Dade County, Florida, that banned discrimination against gay people in terms of employment, housing and public accommodations – the first time any southern city had passed such a law. Adopted in early 1977, it was in force for only a few months before being repealed.

The Dade County law was just one part of a nationwide push for gay rights: forty other cities had guaranteed them, including Detroit, Minneapolis and Seattle. Wyoming had decriminalised gay sex acts that February, making it the nineteenth state to legalise sex between men; five other states were considering reform at the same time. The momentum was behind the campaign for a national bill of gay rights. It seemed as though, finally, the civil structure of America was ready to admit those who had long been vilified and excluded.

Bryant's campaign reversed that momentum. A former Miss America contestant and a pop singer with two Top 10 records to her name, Bryant was both religious and media-savvy – she was employed as spokesperson for the Florida Citrus Commission, promoting the state's main export, orange juice. An attractive woman, she appeared in commercials for Coca-Cola and Holiday Inn, among many others. In 1973, she had sung 'The Battle Hymn of the Republic' at the funeral of President Lyndon B. Johnson.

Bryant's seemingly lightweight media profile led to her being underestimated by gay activists, who initially sneered at her rhetoric, but she was a populist, adept at coming up with sound bites that advanced her agenda while playing on the public's fears and prejudices. Her campaign's

title, Save Our Children, raised the age-old conflation of gay men with paedophiles. It was easy for her to present herself as all-American, committed to the traditional family values that gay men were – to her mind – bent on subverting.

Her attempts to push back against change were long-standing. In March 1969, Bryant made national news when she gave a speech at a Rally for Decency in Miami, which was sparked by the Doors' appearance at the Dinner Key Auditorium – the concert at which it was alleged that Jim Morrison exposed himself. The rally attracted 35,000 teenagers, who heard Bryant state: 'I just know that this decency movement is going to succeed. Too many people in the entertainment industry are alarmed at the direction in which the industry is headed.'

Bryant's anti-homosexual campaign was full of emotive and bigoted appeals that dehumanised and totally misrepresented gay people and the drive for gay rights. 'What these people really want, hidden behind obscure legal phrases,' she stated, 'is the legal right to propose to our children that theirs is an acceptable alternate way of life . . . I will lead such a crusade to stop it as this country has not seen before.' According to several sources, she also referred to gay people as 'human garbage'.

This was part of a wider trend in American society. In the later 1970s, the reaction against '60s radicalism and '70s hedonism was well under way. The country was in visible decline, with the humiliating end to the war in Vietnam, the collapse of the motor industry under the volume of cheap Japanese imports, the hollowing-out of the inner cities, and poor economic indicators – the dollar hitting new lows, inflation rising fast. These all contributed to a sense of national impotence.

In this climate, the gains won over the last decade by Black Americans, women and gay people were seen by neoconservatives as contributing to this loss of national power. As ever, the slice-of-cake argument held that rather than increasing the size of the cake, these groups were taking large chunks from heterosexual white Americans. By 1977, a powerful caucus was actively working to mobilise the silent majority against a variety of issues: affirmative action, sex education, abortion rights, gay rights.

As *Newsweek* asked in a front-cover story that year, 'Is America Turning Right?' The religious element in this backlash added to the virulence

directed at gay people, who, apart from anything else, had come to public prominence with a style of music that was directly opposed to the comforting machismo of American rock. As disco historian Peter Shapiro wrote: 'With its mincing campness, airbrushed superficiality, limp rhythms, flaccid guitars, fey strings and overproduced sterility, disco seemed emblematic of America's dwindling power.'

Beneath her saccharine facade, the born-again Bryant was campaigning for nothing less than the erasure of not just twenty years of progress, but of gay people from public life. It was the opening salvo in what would become a long war, and was treated as such by many gay men and lesbians, who suddenly realised the seriousness of what was going on. In the Castro, there was a spontaneous vigil to protest against the repeal, growing from around fifty people to a crowd of 3,000 within an hour as hundreds of men piled out of the nearby bars.

The July issue of *Christopher Street* published a letter by the writer Frank Hoffman that described the scene: 'The chants went up: "2, 4, 6, 8, gay is just as good as straight"; "2, 4, 6, 9, lesbians are mighty fine!"; "Fight back now". Someone sang "Reach Out and Touch" by the Supremes. Some lesbians started jumping on cars. The crowd, now 5,000-strong, moved to City Hall. In Union Square, they were spontaneously addressed by several speakers, including Harvey Milk. 'This is the power of the gay community,' he rabble-roused through his megaphone. 'Anita's going to create a national gay force.'

Despite this show of resilience in the face of such overt discrimination, Bryant's success emboldened anti-gay attitudes across the country. Fundamentalist Christians agitated to repeal gay rights ordinances in Saint Paul, Wichita and Seattle. The rhetoric became even more extreme. Randy Shilts quoted anti-gay activists in Seattle who called for 'Christian patriots' across the US to rise and quash gay rights: 'This would be a step forward in preservation of Aryan culture and western civilization.'

On 13 June, State Senator John Briggs held a press call at San Francisco City Hall, where he announced his campaign to remove all gay school-teachers from Californian classrooms. Briggs was in his late forties, a Republican placeman who had decided to run for the governorship of California in 1978. His adoption of anti-gay policies was not determined

by religious conviction but by sheer opportunism. Encouraged by Bryant's success, he saw a hot populist issue.

Bryant's rhetoric had immediate and deadly effects. In late June, a thirty-three-year-old gardener, Robert Hillsborough, and his friend, Jerry Taylor, were jumped in the Mission district by a gang of young thugs. Taylor managed to escape with a beating, but Hillsborough was beaten viciously and then stabbed fifteen times by a Latino teenager. As John Cordova put the knife in, he yelled, 'Faggot! Faggot! Faggot!' and 'This one's for Anita.' Hillsborough died forty-five minutes later in hospital.

The murder made the front pages in San Francisco. Interviewed shortly afterwards, Helen Hillsborough, Robert's mother, said: 'I didn't think much about Anita Bryant's campaign at first. Now that my son's murder has happened, I think about the Bryant campaign a lot. Anyone who wants to carry on this kind of thing must be sick. My son's blood is on her hands.'

On 26 June 1977, San Francisco held a Gay Day Parade that was attended by over 200,000 people. Eyewitness Maria Stecenko, reporting in *Christopher Street*, observed 'young republicans rubbing shoulders with Maoist faggots and feminist dykes; teachers; kids, prostitutes, "Straights for Gays", ministers, lawyers, the Butterfly Brigade, Latinos, Chicanos, Gay American Indians, the Third World Gay Caucus, gaudy bar floats, disabled people in wheelchairs, welfare recipients, uniformed softball teams, City Administrators'.

This was not only a community expression of pride and political strength, but an increased recognition of the forces arrayed against gay men and lesbians. One group of picketers blocked the street, carrying portraits of Adolf Hitler, Joseph Stalin, Idi Amin, a burning cross – and the smiling face of Anita Bryant. In return, four days later, a series of small explosions blew in the storefronts of three gay businesses in the Castro – in particular, Mainline Gifts and Castro Camera, both 'conspicuous focal points in the gay community's efforts to mobilise'.

Castro Camera was deliberately targeted for its window display, which highlighted the worst of the Bryant campaign's anti-gay media blitz. As he surveyed the shattered glass of his shopfront, Harvey Milk was quoted as saying: 'I think we're in for a protracted civil rights struggle in which

many glass windows will be broken. This incident was a premeditated act of violence. They had to bring those explosives down there and tape them to the windows. It was a major risk, and it was planned.'

Milk had already found his place; now he found his cause. Despite the vitriol directed their way, he thought that the Florida vote offered a political opportunity for gay people. As he wrote in his column in the *Bay Area Reporter*: 'The word homosexual has now appeared in every household in the country. More good and bad was probably written about it in the last few months than during the entire history of the world. Anita Bryant herself pushed the gay movement ahead and the subject can never be pushed back into darkness.'

The opportunity to ride this wave came quickly. Milk announced his candidature for city supervisor, this time for the city's District 5, as San Francisco had voted for the first time to hold elections by district rather than city-wide. This encompassed Haight-Ashbury and part of downtown, abutting the Castro and Mission districts. He was standing against his old SIR rival Rick Stokes, and it was a clear choice between the gay establishment and the upstart. In the new, polarising mood, Milk beat six other candidates, winning 30 per cent of the vote.

His rise to national prominence was symbolic of the rising visibility of gays in American life. Despite the backlash, there had been many gains. During 1977, the National Gay and Lesbian Taskforce had established itself as a prime lobbying organisation. 'The group's vigilance over the media has had a major impact on how gay people are depicted on television and the news,' stated *The Advocate*. 'Such effective public relations have made the group the highest profile homophiles ever in the United States – if not the world.'

In February 1977, NGLT co-director Jean O'Leary had become an advisor to Midge Costanza, President Carter's assistant for public liaison. Early in the administration, Costanza, a lifelong champion of gay rights, held an advisory meeting at the White House with seven gay men and seven lesbians to discuss their grievances about discriminatory federal practices. Carter was not present, but a dialogue had been established, and the incorporation of gay rights into the policies of the Democratic Party had begun.

In November, delegates at the National Women's Conference voted overwhelmingly for a resolution calling for an end to discrimination against lesbians and gay men in the US. It asked specifically for federal, state and local legislation barring 'discrimination on the basis of sexual or affectional preference in areas including . . . employment, housing, public accommodations, credit, public facilities, government funding and the military', and state legislation to repeal 'laws that restrict private sexual behaviour between consenting adults'.

O'Leary was the architect of the resolution. Interviewed afterwards, she recognised that 'now, more than ever, lesbians are an integral part of the women's movement and lesbian rights is unquestionably a feminist issue. I hope that gay men recognise this, that we have support here, and also feel that they should support other feminist issues. There's good reason for them to do so, since we're all in this together, especially these days with the rise of the so-called new conservatism. The right wingers are building coalitions and we have to build our own in defence.'

The NGLT media watch was having an effect on American television, which previously had a poor record on gay representation. Writing in summer 1977, gay journalist Philip Gerson noted that 'last season saw more gay exposure on network television than ever before. The exposure was both good and bad, sensitive and insensitive, but at least the word "gay" and the concept behind it were being discussed. Some reference to it has been made in nearly all of the shows on network television.'

These incremental gains went hand in hand with the creation of very noticeable, well-populated gay districts in cities around America, particularly New York and San Francisco. Greenwich Village had led the way ever since the turn of the century, but – coincidental with Milk's appointment – the Castro had become the most famous and most politicised gay ghetto in the country. The thousands of clones that thronged its streets became the embodiments of the gay lifestyle that America was just discovering, to its confusion, curiosity and, on occasion, distaste.

———

Returning from Italy in 1977, the writer Edmund White made some pertinent observations on how gay life had changed in America during the ten years he'd been away. Printed in *Christopher Street*, White's article – 'Fantasia in the Seventies' – helped him on his way to becoming one of the best known, more astute observers of the new gay culture in the US. It focused on what to him was the biggest change: the ubiquity of plentiful and flamboyant sex.

'For the longest time everyone kept saying the seventies hadn't started yet,' he began. 'There was no distinctive style for the decade, no flair, no slogans. The mistake we made was that we were all looking for something as startling as the Beatles, acid, Pop Art, hippies and radical politics. What actually set in was a painful and unexpected working out of the terms the sixties had so blithely tossed off. Sexual permissiveness became a form of numbers, as rigidly codified as the old morality.'

Later that year, White published *The Joy of Gay Sex*, an illustrated guide to gay sexual positions and possibilities, which was published in tandem with Bertha Harris's *The Joy of Lesbian Sex*. Interviewed together in *Christopher Street*, White admitted that 'most things I've read about gay sex are either apologetic or political or clinical. I thought it would be a liberating act for me, and possibly for the reader, to write in a sort of worldly, urbane, funny tone as though it was perfectly acceptable to be gay. I thought it might help to make it acceptable'.

Harris told the magazine that 'Ed and I have many points of reference in common. Neither of us, in any way, could be considered bestsellers. We write fiction that is "arcane", that while it does not receive critical acclaim receives critical attention.' She felt that 'lesbians by and large are still on a day-to-day survival level, continually threatened, continually in a position to lose their jobs. And if they have children, lose their children and so forth. They can be attacked by their neighbours – especially at this time when the right wing is increasing its fervour.'

White did identify one novel fact about gay male life at that point: namely that, freed from the demands of heterosexuality, child rearing and, in many cases, the bourgeois life, gay men were free to act like teenagers, a cohort in themselves. 'In the United States, and especially among gay men, this period of adolescence is being extended for the first time in

history into the forties, fifties, even sixties. It has become a way of life.'
He called this 'a brand new invention of our times, the cultural neoteny
of gay life'.

Suspended between worlds and between ages, gay men were free to
indulge in the desires that most heterosexual teenagers would have given
their eye teeth to act out. The most controversial of these, in a still devoutly
Christian country, was unrestricted sex. Mark Abramson's Castro diaries
of 1977 and 1978 capture a world of polydrug use – cocaine, Quaaludes,
Percodan, Valium, LSD and marijuana – and rampant sex, which he ini-
tially thought 'the main purpose of all gay men in the city'.

The Castro look was all about sex signifiers. As White wrote: 'A
V-shaped torso by metonymy from the open V of the half-unbuttoned
shirt above the sweaty chest; rounded buttocks squeezed in jeans, swelling
out from the cinched-in waist, further emphasized by the charged erotic
insignia of colored handkerchiefs and keys; a crotch instantly accessible
through the buttons (bottom one already undone) and enlarged by being
pressed, along with the scrotum, to one side . . . Gay pride has come to
mean the worship of machismo.'

During that year, the pioneering gay novelist John Rechy published
his sixth book, *The Sexual Outlaw*, which he plotted as the equivalent
of a film documentary, with an authorial commentary that took in gay
politics and the way in which gay oppression fed into gay lifestyles.
Developing the dark theme of his 1967 novel, *Numbers* – a book that
fused sex with a mathematical death drive – *The Sexual Outlaw* depicted
sex not as liberation, but as a furious, if not revolutionary, response to a
repressive society.

Sex as revolution, as identity, as habit, as avoidance of intimacy:
this highly visible, all-consuming stage in the development of the gay
community did not go without commentary at the time. If White was
celebratory, with reservations, and Rechy able to construct a plausible
political rationale, the gay writer and editor Seymour Kleinberg was
much more critical, finding the clone style 'in its own way as reactionary
as the hysteria that Anita Bryant's campaign consolidated'.

Kleinberg was in his mid-forties when he went to the New York
S&M bar the Anvil and got talking to a young man called Daniel,

who typified himself as a slave and slept with other men only with
the permission of his master. Operating under a blizzard of drugs, this
twenty-two-year-old was old before his time in terms of sexual experi-
ence: 'When he discusses his life, it appears to be an endless dirty movie,
but the anecdotes tend to leave his listeners in a moral vacuum . . . one
feels adrift, puzzled, perhaps bemused. Most of all, this nice boy seems
very remote.'

The new urban gay identity might have baffled the older Kleinberg,
but for those twenty- and thirty-year-olds on the scene, drugs and clubs
were simply part of life. Writing in *Christopher Street*, Michael Musto
identified a gay *Saturday Night Fever*. For his gay version of Tony Manero,
going to the disco 'was a fun, ego-building escape from his working life
as a nobody. Take all of that and multiply it by seven on the fanaticism
scale – or better yet, imagine a week in which every night is Saturday –
and you've got an idea of what every night fever is all about.'

For the gay activist and arts promoter Barry Laine, disco dancing was
the expression of something more profound. In an article for *Christopher
Street* titled 'Disco Dancing: Too Hot for Love', he observed that 'dan-
cing is more free-form, less partnered and less step-oriented. Men often
dance in the company of another man or men, but rarely with him or
them. What partnering exists is often explicitly sexual, the old "bump
and grind" and pelvic–ass contact that simulates anal intercourse.'

It was this feeling of unity and pleasure that the Castro embodied
and that Harvey Milk turned into practical city politics. In the Castro,
lifestyle and activism fused into a kind of gay nirvana – what Randy
Shilts called 'a sense of gay manifest destiny'. Not that this brought Milk
an easy life. He was never more than one degree away from chaos. As
the highest-profile gay politician in the country, Milk regularly received
hate mail and death threats: 'shoot fruit, not pool', ran one threatening
letter. He also had persistent money problems. Nevertheless, he began
gearing up for the fight against the Briggs Initiative. In April 1978, the
Republican senator John Briggs filed the petitions that assured that
Proposition 6, his anti-gay-teacher drive, would be an initiative put to
a referendum on the California state ballot in the 7 November election.
With more repeals of gay rights ordinances in Saint Paul and Wichita,

it looked like California would be next in enacting anti-gay legislation, and urgent action was necessary. Realising the level of threat, gay conservatives, moderates and radicals began to act together for once, to construct a broad, united front.

In June, Edmund White went to a couple of anti-Proposition 6 fund-raising events in California. At the Santa Monica Civic Auditorium, he watched poet and singer Rod McKuen 'quite heroically take a stand against Anita Bryant. I say "heroically" because he has undoubtedly lost many of his fans – a big move for an orphan brought up in extreme poverty who then learned to make suffering pay: he and Chairman Mao are, after all, the best-selling poets of our century.' That year, McKuen released an anti-Bryant single, 'Don't Drink the Orange Juice'.

On 7 June 1978, Santa Monica also showcased a concert called 'A Night for the Preservation of Human Rights' – what White termed 'a benefit for the New Alliance for Gay Equality in its fight against the Briggs initiative' – which featured Peter Yarrow of Peter, Paul and Mary, and popular singers Harry Chapin and Joan Baez. The mood was gloomy, but White was pleased to note 'the politeness that lesbians and gay men showed one another' at the benefit.

Baez was a high-profile catch. The disclosure of her lesbian affair had instigated a brief media furore in 1973. 'I felt a little hypocritical – after all, they made such a stink about that – because it was, for all intents and purposes, a one-shot thing,' she told *Christopher Street*. 'I was bouncing off a four-year affair with the first love of my life – possibly the only one. I hated men. I didn't want to see anything walking around with that particular attachment on his body.'

By the late 1970s, Baez was defining herself as basically heterosexual, but still enjoyed dancing in gay bars and was a strong supporter of gay rights. 'I am at ease dancing my ass off in a gay dance hall,' she admitted. Indeed, her song 'Altar Boy and the Thief' – from her 1977 album *Blowin' Away* – was composed after going with friends to the Pink Elephant Saloon, a gay bar in Santa Monica. Some of the lines sympathetically observed 'a transient star of gay bar fame'.

In his response to the Briggs Initiative, Milk formed his own group, San Franciscans Against Proposition 6, and got to work doing what he

did best: rabble-rousing in his constituency. On 25 June, he addressed the crowd at the San Francisco Gay Freedom Day Parade – a huge event with a record-breaking crowd estimated at 375,000, encompassing at least a hundred separate gay groups – with an explicit attack on the imputed Nazi politics of Anita Bryant, John Briggs and Proposition 6.

Despite his successes, Milk was wearing himself out. With his work as a city supervisor, his campaigning against Proposition 6 and his pastoral work in the Castro, he had little time for his business or his partner. When, in August 1978, Jack Lira committed suicide, Milk had no time to mourn. Meanwhile, the Proposition 6 fight was getting dirtier, with Briggs circulating campaign leaflets bearing newspaper headlines like 'Teacher Accused of Sex Acts with Boy Students' and 'Why a 13-Year-Old Is Selling His Body'.

Briggs was going for broke with his rhetoric, in one speech equating homosexuals with 'adulterers, burglars, communists, murderers, rapists, child pornographers, and effeminate courtiers who had undermined the Greek and Roman civilizations'. In September, the polls showed that support for the measure was winning by 61 to 31 per cent. Yet over the next couple of months, two high-profile interventions – by Ronald Reagan and, late in the day, President Carter – helped to turn the tide.

On the day, 7 November 1978, Proposition 6 lost by 75 to 25 per cent – nearly a million votes. Addressing a rally in the Castro that evening, Harvey Milk was triumphant: 'This is only the first step. The next step, the more important one, is for all those gays who did not come out, for whatever reasons, to do so now. To come out to all your family, to come out to all your relatives, to come out to all your friends – the coming out of a nation will smash the myths once and for all.' He had under twenty days to live.

With Mayor Moscone firmly in support of gay men, there was little antipathy to Milk and the Castro in City Hall. The one holdout was another newly appointed supervisor, Dan White, who had turned hostile to Milk after his follow councillor delivered the casting vote against him when he tried to prevent a psychiatric centre being built in his district. As 1978 progressed, White became more and more entrenched in his opposition to Milk and his project of advancing gay rights.

White was thirty-two in late 1978, old for his years. An Irish American from a working-class background, he had served in the Vietnam War and worked as a cop before entering politics. He was rigid, authoritarian and hated to lose. Once Milk had opposed him, he tried to counter his policies at every turn, voting against gay rights and opposing the announcement of Gay Freedom Day. On the actual day, he watched the parade sourly, and was quoted as saying: 'The vast majority of people in this city don't want public displays of sexuality.'

In November, White got himself into a serious muddle. Increasingly alienated and jealous at Harvey Milk's rapidly rising star, he resigned as supervisor early in the month, citing the difficulty of earning a living as one reason. Four days later, he reversed his decision, but Mayor Moscone, irritated at this obdurate local politician and urged on by his colleagues, including Milk, refused to reappoint him. When White held an angry press conference to protest against this state of affairs, he was supported by only one supervisor.

For his part, Milk had long felt that White was dangerous and represented malign forces in the city: police officers, real estate developers and downtown business interests. The difference between those reactionary groups and his progressive, community-based approach could not have been greater. Yet he failed, as did all concerned, to recognise the homicidal hostility brewing under the stolid surface.

On 27 November, White exploded into violence. Entering City Hall at around 10.30 a.m., he stomped through the building until he found his quarry. He shot Mayor Moscone four times: one bullet into the arm, one into the lung and two into the head. He then sought out Harvey Milk in his office and, reloading his Smith & Wesson with dumdum bullets for maximum impact, shot five times: one into the wrist, two into the chest and the fourth and fifth into the head. By 11 a.m., both Moscone and Milk were dead.

This wasn't a random shooting or an impulsive act, but a carefully planned execution. Milk had long foreseen his death, but for this to happen at his moment of triumph was bitterly cruel. The initial reaction from the community was surprise, shock and deep grief. That evening, a crowd of 40,000 gay men and lesbians marched from the Castro to City

Hall in total silence, holding lit candles aloft, accompanied by a lone drummer and the sound of a distant trumpet playing 'Blowin' in the Wind'. The anger would come later.

The impact on San Francisco was immediate. The mood among the community that Milk had so effectively organised was incredulous and fearful. For Mark Abramson, who appreciated all that Milk and Moscone had done for the Castro, 'It was always good to know there were people like them running things in this city. Those of us who are bystanders in this drama are left with a feeling of, "Now, what? What does the future hold? What could happen next?" I expect an earthquake to hit and wipe out the rest of us.'

Nine days before his execution, Milk had left a cassette tape that foreshadowed his legacy. 'This is to be played only in the event of my death by assassination,' he began. 'Should there be an assassination . . . I would like to see every gay doctor come out, every gay lawyer, every gay architect come out, stand up and let the world know. That would do more to end prejudice overnight than anybody could imagine. I urge them to do that, urge them to come out. Only that way will we start to achieve our rights.'

Milk's appointment as San Francisco city supervisor was a high-water mark in late-1970s gay politics and life. Yet although the campaign against Proposition 6 had been successful, it was essentially reactive, an attempt to stop the backlash whipped up by neoconservatives and fundamental Christians, of whom Anita Bryant and John Briggs were mere figureheads. More impressive, perhaps, were the coalitions between different groups that Milk had established in the process of embedding gay men and lesbians in the fabric of San Franciscan life.

His assassination marked the end of this particular wave. It reinforced the fact that, in American life as elsewhere, any gains on the part of gay people and lesbians were hard won and vulnerable to hate campaigns whipped up by religious authoritarians and cynical politicians. As soon as gay people put their heads above the parapet and demanded the rights that they deserved, they got pushback and backlash. Sex and disco were ample substitutes, but often that's all they were.

31
The Tom Robinson Band

Robinson knows he won't lessen the violence against gays to any major degree unless he inspires gay people to defend themselves. Their apathy in England sickens him . . . His song, Sing If You're Glad to Be Gay, which has real hit potential here, is done in a mock pub sing-along style that is full of irony. 'That song is meant to be like a fist in the face for gay men. It says, "Come on, Wake up!"'

Kevin Meadows, 'Tom Robinson Band', *Christopher Street*,
April 1978

At the beginning of 1978, *Gay News* was involved in a struggle for its very existence. On the front page of the issue dated 12–25 January was a headline blazoned large, 'Blasphemy Appeal', announcing the fact that the Court of Appeal would hear *Gay News*'s suit against its conviction for blasphemy the next month, on 13 February: 'Four days have been set aside for the hearing at the Law Courts at the Strand. *Gay News*, and Denis Lemon the paper's editor, are appealing against both conviction and sentence.'

The report summarised the paper's current position. In July 1977, Judge King-Hamilton had found *Gay News* guilty of blasphemy, fined it £1,000 and ordered the company to pay four-fifths of Mary Whitehouse's legal costs. As the editor, Denis Lemon had also been fined £500, given a nine-month suspended prison sentence and ordered to pay the remaining one-fifth of Whitehouse's costs. As grounds for appeal, *Gay News*'s lawyers contended that King-Hamilton had misdirected the jury in his summing-up and that his sentencing was excessive.

The paper's front page also reproduced the signatures of many high-profile liberals from the arts world – Joan Bakewell, Melvyn Bragg, Margaret Drabble, Maureen Duffy, Ian McKellen and Harold Pinter – who protested that the conviction was a threat to freedom of expression. At the same time, Lemon gave notice of a 'mass demonstration for Saturday February the 11th – the weekend before the appeal opens. We want to take the demonstration from somewhere on the Embankment through the West End to Speaker's Corner.'

By 1978, *Gay News* was at the centre of British gay life and, basic format aside, was barely recognisable from its early issues in 1972 and 1973. It had become, as Jeffrey Weeks wrote, 'a major bulwark of the gay community. With a circulation of over 20,000, it reflected admirably the way the gay scene had changed over the decade. It was no longer completely furtive and underground. It was open, variegated, multi-dimensional, pleasure orientated. Access need no longer be restricted to those with arcane knowledge.'

The paper's first issue of 1978 reflected a more confident and varied gay world. There were pages of advertisements for films, books, cosmetics, services and clubs – like Fooberts, just off Carnaby Street, or Bang

Disco at the Sundown, on London's Charing Cross Road. There was an interview with gay poet Thom Gunn, reviews by Lemon's partner Jean-Claude Thevenin of new albums by Brian Eno and Donna Summer, and a long interview with 'The New Improved Sylvester'.

As well as helping to create a market, *Gay News* included reports on the issues affecting gay people. One of the lead stories in January 1978 was about the $5 million lawsuit that the mother of San Franciscan murder victim Robert Hillsborough had brought against Anita Bryant, her husband Bob Green and the Florida-based Save Our Children Inc. The paper reviewed the circumstances of the murder and quoted Helen Hillsborough, who blamed Bryant and the 'hate campaign against gays' that she had started.

Gay News also covered issues closer to home: the fight of openly lesbian Labour MP Maureen Colquhoun to avoid deselection, press attacks on lesbians having children, and the arrest of two gay men in London for walking arm in arm. There was a story about the fact that Tommy Wylie – the young man at the centre of the notorious documentary *Johnny Go Home*, about older men predating on runaways – had sued Yorkshire Television, the makers of the film, for unauthorised use of copyright material.

There was also arts news coverage of an upcoming *Gay Times* Festival, which featured performances by Gay Sweatshop, a showing of the film *The Blue Angel*, starring Marlene Dietrich, and screenings of documentaries by Thames TV on women and gays. A small news item announced the release 'of the Tom Robinson number, "(Sing If You're) Glad to be Gay", on a four track EP due out later this month or early in February. The announcement ends speculation in the music press that the song might be too much for EMI to swallow after last year's Sex Pistols debacle.'

Coinciding with the attack on gay life spearheaded by Mary Whitehouse was a contradictory phenomenon: the rise to national prominence of Britain's first gay and unequivocally political pop star. Tom Robinson came out of the space and momentum that the British Gay Liberation Front and *Gay News* had helped to create and, at every point, acknowledged this fact. His chart success with his first single, '2–4–6–8 Motorway', and his song 'Glad to Be Gay' placed the gay agenda right in the mainstream of British music and youth culture, to great effect.

From small beginnings, the British gay scene was developing its own momentum, lifestyle and culture. Although it was nothing like on the scale of America, this visibility brought its own backlash: in this case, spearheaded by a figurehead who, like Anita Bryant, was fuelled by her religious beliefs in her determination to protect the sanctity of the Christian religion and reverse any hard-won gay rights – indeed, to put gay men and lesbians back in the closet.

————

The situation for *Gay News* in early 1978 was very serious, with the magazine on the losing side in a prolonged and expensive legal battle. The appeal was nothing but a rearguard action against a well-supported opponent who had the momentum behind her and the law on her side. At the time, Mary Whitehouse's case was seen as a direct attack on gay people in general. As Jeffrey Weeks recalled in his history of gay liberation, *Coming Out: Homosexual Politics in Britain*: '*Gay News* was an important symbol of the changes that had taken place. Its defence was an essential part of homosexual politics.'

The whole affair had begun in early June 1976, when *Gay News* published a poem by the university lecturer and poet James Kirkup. Titled 'The Love That Dares to Speak Its Name', it was a deliberate inversion of the famous phrase in Alfred Douglas's poem 'Two Loves' that was publicised during the Oscar Wilde trial. Kirkup's poem was written from the viewpoint of a Roman centurion, and graphically described him having sex with Jesus after his crucifixion. It also claimed that Jesus had had sex with his disciples, guards and even Pontius Pilate.

Denis Lemon, *Gay News*'s editor, initially hesitated, but after consultation with his typesetter and research editor Rictor Norton, he decided to publish. 'I read it and gave my report: the poem appeared to be sincere and serious rather than deliberately provocative,' Norton later wrote. 'It had genuine poetic qualities; and it was written by an internationally recognised poet. I reassured Denis that, although the poem was in many ways shocking, it clearly was not pornographic because it was not obscene simply for the sake of obscenity.'

There was, nevertheless, an element of provocation. Both the editor and some of the staff were happy to print material that would annoy Christians, in particular gay Christians: they felt that 'it was impossible for someone to be a good Christian and a good homosexual simultaneously'. They also felt that the Christian Church was inextricably hostile to gay liberation because the strictures of that religion were 'the major single cause of gay oppression'.

The poem caused immediate offence, as evidenced by angry letters to the paper, but the real problems did not begin until Mary Whitehouse received a copy in the post around early November. She reeled in shock, describing the poem in her autobiography *A Most Dangerous Woman?* as 'a kind of re-crucifixion, only this time with twentieth-century weapons'. In her view, the sacred body of Jesus Christ was 'utterly defiled and at the mercy of those who hate the sound of his voice'.

By 1976, Whitehouse was in her mid-sixties and was the country's best-known moral and religious campaigner, having spent a decade and a half agitating against what she saw as a decline in moral standards, which covered everything from pornography to pacifism, promiscuity and bad language on television – with particular reference to the BBC. Her pressure group, the National Viewers' and Listeners' Association, gave her a platform from which to broadcast her usually restrictive views and solicit political support.

Whitehouse was self-appointed but strikingly successful. Her everywoman appearance, sharp mind and unwavering certainty made her both a dogged, difficult opponent and a prominent national figure, with frequent appearances in the mass media. By 1976, she was concerned with the topic of blasphemy, having been alerted to the topic by an item in the BBC television satire *Beneath the News* that she felt to be sacrilegious. When she obtained legal advice, she was advised by her QC to wait for something more 'grossly offensive'.

Kirkup's poem was not the only work of art to mention sex and Jesus Christ. When, in summer 1976, the Danish performance artist Jens Jørgen Thorsen proposed to come to Britain to make a film about Christ's sex life, the NVALA got involved and, after whipping up the press, successfully solicited the opinion of the Queen on the matter, who stated

her opposition to this 'obnoxious' film proposal. When Thorsen finally arrived in Britain in early 1977, he was immediately deported.

After failing to get the backing of church leaders in her campaign against *Gay News*, Whitehouse announced her decision to launch a private prosecution at the end of November 1976. Leave was granted on 9 December for her to proceed against Gay News Ltd and Denis Lemon for publishing, and Moore Harness Ltd for distributing, 'a blasphemous libel concerning the Christian religion, namely an obscene poem and illustration vilifying Christ in his life and in his crucifixion'. The charge against the distributor was subsequently dropped.

Blasphemy was an archaic concept in British jurisprudence by the late 1970s, but the concept went to the heart of Whitehouse's religious beliefs. Despite the fact that a successful prosecution for blasphemy had not been brought in the British courts since 1922, she wrote, in a letter to *The Times* early that December, that 'although broadcasting is exempt from the Obscene Publications Act, we are advised that broadcast blasphemy is a common law offence and that, though dormant, the relevant law is still operative'.

The question of Whitehouse's motivation remains. Clearly, she felt that her beloved Christian religion was under attack from an increasingly secular society, and she sought to counter this at every point. As she explained in a letter to the frustratingly non-supportive Archbishops of Canterbury and York: 'If I did not do something to end this sacrilege, then I would carry the shame of this abdication for the rest of my life.' That might be understandable, but what undermined her claim to principle was her prejudice against homosexuality.

Coming from an evangelical background, Whitehouse's thinking on the topic was black and white. In 1954, she called homosexuality 'an excrescence', and from that time on she explicitly targeted what she called 'the homosexual/intellectual/humanist lobby'. While she claimed at the time that her dislike of homosexuals was not behind the prosecution, her views and those of her supporters made it clear that homophobia was high on the agenda.

Whitehouse's masterstroke in the prosecution was not to target the writer of the poem, James Kirkup, but the publisher, *Gay News*, and its

editor, Denis Lemon. This immediately skewed the legal argument away from the issue of free speech – whether or not the poem should have been written in the first place – and towards the question of whether Lemon was right to have published it. This was a shrewd move: Kirkup was not prepared to fight the charge, while *Gay News*, realising that the game was on, had to prepare for battle.

The seriousness of the matter was evidenced by the fact that the case opened at the Central Criminal Court, the Old Bailey, on 4 July 1977. From the off, the bias was clear: Judge Alan King-Hamilton QC systematically rejected the defence's witnesses, refused any literary experts and did not allow Lemon to speak. Whitehouse's QC was allowed to smear gays in general with the charge of paedophilia without objection. Guided by what he called 'some superhuman inspiration', King-Hamilton summed up heavily against the defendants.

Four days later, the jury finally found – by a majority of ten to two – both the defendants guilty. King-Hamilton fined Gay News Ltd £1,000 (around £6,600 today) and ordered the paper to pay four-fifths of Mary Whitehouse's costs, which totalled nearly £8,000 (some £53,000 today). He fined Lemon £500 and sentenced him to nine months' imprisonment, suspended for eighteen months, stating that it had been 'touch and go' as to whether the editor should be sent to jail.

The impact on *Gay News* was considerable. Much time that would otherwise have been spent on producing the paper was taken up with legal meetings, fund-raising and meetings with other, alarmed gay organisations, who saw the verdict as an attack on the whole community. The paper's continued existence became its prime focus. Most insidious of all was an atmosphere of self-censorship, as the legal judgement forced editors and contributors to question every story.

Nevertheless, the publicity surrounding the trial raised the paper's profile and turned the case into a liberal and humanist cause célèbre. A month after the verdict, a *Gay News* Defence Committee was formed, with representatives from lesbian and women's groups and gay liberation groups, while the poem at issue was republished in the *Anarchist Worker, Socialist Challenge, Peace News* and the anarchist monthly *Freedom*.

Writing shortly afterwards in the new gay socialist magazine *Gay Left*, the art historian Simon Watney thought the poem 'silly', 'at times amusing' and 'extremely "literary"'. He accepted that Whitehouse's case was principally motivated by her 'love for the Lord' rather than open homophobia, but believed that her successful prosecution spearheaded a wave of negative reaction from the right and far right: organisations ranging from the Festival of Light, the National Association for Freedom and the Conservative Party to the explicitly fascist National Front.

Watney thought that this was the result of a threatened Middle England railing against a rapidly changing country, although by the mid-1970s, attitudes to gay men and lesbians had improved somewhat: a survey commissioned by *Gay News* in 1975 revealed that respondents were satisfied with the status of the 1967 Act. Some 40 per cent of the random sample of 1,930 adults felt that homosexuals should be able to live together openly, but 53 per cent were opposed to gay marriage. By the later 1970s, the original wave of gay liberation and its commercial counterparts were fusing into a larger, more diverse homosexual culture, which in turn was integrating further with the mainstream. *Gay News* was, as Watney observed, the perfect target for anyone seeking to reverse this process, because it was 'a visible and accessible gay publication. In that sense, whatever one thinks of its editorial policies and explicit sexual politics, it is the most "out" example of gay pride in Britain.'

In his history of the period, Jeffrey Weeks noted the push-me, pull-you dialectic of increased gay visibility and its backlash. Life in that wider society was still not easy for gay men and lesbians, with press harassment, media stereotyping, police harassment and poor self-esteem still standard features of everyday experience. Despite a general climate of ambivalence, 'It was in the literary and show-business world that homosexuality became most tolerated,' Weeks wrote, and it was in a pop culture freshly stirred by punk that the next breakthrough occurred.

––––––

While *Gay News* was gathering support for its appeal, the Tom Robinson Band issued their second seven-inch, an EP of four songs. 'Don't Take No for An Answer' was the lead-off track, but it was the second, '(Sing If You're) Glad to Be Gay' – an already established live favourite – that attracted the most attention. Not only was it a sardonic, if not bitter, call-to-arms intended to rouse the gay community, it was the first song on a major UK label to address the reality of gay life in direct, politicised terms.

'Glad to Be Gay' was high profile, not just because it contained the word 'gay' – in a defiant and unapologetic context – but because the Tom Robinson Band were, at the time, one of the hottest new rock groups in the country. Since their signing by EMI the previous year, they had attracted several features in the weekly music press – read by hundreds of thousands of teens – in which Robinson's sexuality was taken as a matter of simple fact. The group's first single, '2–4–6–8 Motorway', had reached the Top 5 late the previous year.

Recorded live in London, 'Glad to Be Gay' opens with a spoken address about homosexuality being classed as an illness, before the slow, music-hall beat begins. Two sarcastic verses about how 'the British police are the best in the world' lead into lines about *Gay News* and pointed rants against the mainstream media: 'Read how disgusting we are in the press / The *Telegraph*, *People* and *Sunday Express* / Molesters of children, corruptors of youth / It's there in the paper, it must be the truth.'

'Glad to Be Gay' is nothing if not comprehensive. Interspersed with the sardonic chorus are further verses about queer-bashing, police round-ups and, perhaps worst of all, gay self-hatred: 'Lie to your workmates, lie to your folks / Put down the queens and tell anti-queer jokes / Gay lib's ridiculous, join their laughter / "The buggers are legal now, what more are they after."' As the song progresses over five minutes, Robinson leads the band and the crowd through the repeated refrain, his tone more acid each time around.

It's an impressive piece of rhetoric that, by highlighting a simple and rousing chorus, sweetens what for many listeners might have been a difficult pill to swallow. The rock audience was not used to encountering the realities of gay life: David Bowie might have said he was gay, but he

was an androgynous spaceman; Rod Stewart might have sung about his gay friend in 'The Killing of Georgie', but he still presented as a (rather camp) lad; Elton John had admitted his bisexuality in 1976, but did not mention his long-standing affair with his manager, John Reid.

'Glad to Be Gay' fit right into the polarised climate that the gay community encountered in early 1978. This was no accident. Born in 1950, Robinson was heavily influenced by the first wave of gay liberation in Britain and sought to incorporate those ideas and ideals into his practice as a working musician – most notably the insistence on coming out of the closet and being open, if not proud, about his sexuality. It had taken just under five years, but in early 1978 he had found his audience and his time.

Brought up by his middle-class parents in County Durham, Robinson realised that he was attracted to the same sex at an early age. 'It was in secondary school that a word for what I felt emerged,' he says, 'so then "homo" was on the agenda. As an insult. And that realisation – "Oh my god, that's me." Also, vague warnings from my parents about "kidnappers", as they put it. I wanted to know what the kidnappers would do with me. We didn't have any money; they couldn't ransom me. My mother said, "They might play with your willy," and I thought, "That sounds great!"'

All the messages were 'negative, because until 1967, being openly gay risked a prison sentence. It was as simple as that. I was an avid consumer of pop culture. It was all boy-meets-girl, girl-meets-boy. All the emotions described in pop culture, magazines, films, TV, books . . . everything related to an emotion that I almost felt. I sort of felt like that, but not about a girl. You just felt such an outsider. The closest anything came was the Beatles' "You've Got to Hide Your Love Away" – that thing of being a reject and having to hide your love.'

When Robinson was sixteen, he had a nervous breakdown and was sent to Finchden Manor, a home for disturbed boys. Inspired by John Peel's *The Perfumed Garden* radio show and a visit to the school by veteran bluesman and catalyst Alexis Korner, he began to think that his future lay in music and began 'singing in the folk clubs. I started wearing a GLF badge. I was still keen to be visible and out there, reaching out to anyone who saw it and recognised it and knew what it was about.'

In early 1972, Robinson encountered David Bowie for the first time. 'I got picked up by a guy, a British Rail guard, who took me back to his house. I woke up the next morning, went downstairs, and there was this record I hadn't heard before playing on the stereo – "Wake up, you sleepy head, put on some clothes, shake up your bed . . ." – and there was a log fire in the grate! Of course, it was his party trick, he must have done that for everyone he picked up, but I didn't know that. But here, for the first time ever, is music that soundtracks my life.'

In 1973, Robinson moved down to London. 'I got digs in Clapham and looked in the back of *Time Out*, and in among the agitprop and the rest was a section – "Gay". That was a total mind-blow, that in a publicly available magazine there were gay listings. It just showed the Earls Court clubs and pubs, the Salisbury – not very much. But just going to those places and seeing these handsome, fit young men walking into a gay pub who knew or thought they were gay. That was mind-blowing.

'Once inside, you found they were mostly full of rent boys and it wasn't as nice as it originally looked, but the *Gay News* seller came around, and I bought a copy, and that was the total opening of the door. *Gay News* was so central to the emergence of a consciousness, for our whole generation, in the UK. Just to know where things were, where you stood with the law, where to find a gay doctor or a gay solicitor, if you were arrested. All that kind of information was in *Gay News*.

'GLF had already imploded by the time I arrived in 1973, but there was Gay Switchboard, there was *Gay News* itself, there was the South London Gay Community Centre in Railton Road. There was a north London GLF disco in King's Cross, at the Prince Albert. There was the Gay Sweatshop Theatre Company and Lesbian Line. All of these things were happening as a result of that initial energy. The GLF was the like-able part of it. It had the wildness and the anarchy and the mixing-up of genders and fun. I was emotionally drawn to the spirit of the GLF.'

At a GLF dance in Stockwell, Robinson 'suddenly realised it was all about sex'. It was there that he picked up a pamphlet called *With Downcast Gays: Aspects of Homosexual Oppression*, which had a big impact on his developing politics. Written by Andrew Hodges and David Hutter, who had previously worked with the GLF's counter-psychiatry group, the

pamphlet sought to explain and counter gay self-hatred. 'Before going on to describe how homosexuals oppress themselves,' they began, 'we should first explain why they do so.'

The authors held that because gay men and lesbians never heard anything good about gay life as children, they went on to develop negative attitudes to their own sexuality as they grew up: 'We have been taught to hate ourselves, and how thoroughly we have learnt the lesson.' They cited examples of gay self-hatred: not wanting to teach in case they were a corrupting influence; avoiding the company of gay people because they cannot bear to see a reflection of their own homosexuality. 'Our self-oppression', they concluded, was 'automatic'.

That year, Robinson formed Café Society with Hereward Kaye and Raphael 'Ray' Doyle, a group featuring acoustic guitars and close vocal harmonies. 'We've been friends for five or six years,' Robinson told *Gay News* in 1975, 'and so they knew me as a person and they knew I was gay, possibly before I did. Certainly there was no problem there.' Nevertheless, Robinson found himself in the position of having to integrate his assertive gay politics within a group where the other members were heterosexual.

Soon after their formation, they became one of the first signings to Ray Davies's boutique label, Konk West. No stranger to the topics of homosexuality and androgyny, Davies quickly focused on Robinson's sexuality, 'because I was doing my best to draw attention to it. He told me: "It's best to tease, don't be so fucking explicit." Much better to be teasy and ambiguous, and to keep the whole thing fluid. That's the way to make the connection, not by thumping the tub, you know.'

In May 1975, Robinson gave a long interview to Denis Lemon and Jeff Grace of *Gay News*, in which he publicly affirmed his homosexuality for the first time in print. The initial exchange went:

> GN: You must be one of the only members of a pop group in Britain who hasn't tried to hide his gayness. Why did you decide that it wouldn't harm your career to be what you are?
> TR: Well, it just seemed a natural extension of coming out. One is more or less oneself on stage, anyway, and since in the last 18 months I'd come out, it didn't seem any different to come out on stage.

Robinson talked about Café Society and his relation to gay politics. Asked what his responsibility to the gay movement was, he replied: 'Just to be openly that I think. If every gay in Britain was to come out overnight, an awful lot of the prejudice and ignorance that abounds among hets would disappear. This is a thing that so many people don't realise about coming out. They imagine that if they come out people will think they're a "nasty queer", whereas in fact when one comes out with one's friends they change their idea of what a "nasty queer" is.'

In summer 1975, Robinson released an early version of 'Glad to Be Gay' on a single in aid of Bradford GLF. 'It was a first attempt,' he says. 'It was for the CHE [Campaign for Homosexual Equality] conference in 1975. It was supposed to be a sort of rousing-the-troops, "Isn't it great that we're gay and we're normalising it?" That was the impulse, a propaganda singalong, we-shall-overcome, without the doom and gloom.'

After a long delay, Konk West eventually released the Café Society album in summer 1976, but, as Robinson says: 'It sold about 600 copies. With the group we could go out and play live, even though we had a nonsense record deal. So we were playing the Scarborough Penthouse to about forty people, and the DJ came on and said: "That were Café Society. Next week, we've got a band coming up from London, and I don't know anything about them, except they're supposed to be the worst band in England and they're called the Sex Pistols."

'And something about it made me think, "It's going to be rammed next week. That's got to be a must-see ticket." Then we started seeing stuff about them in the *NME*, just small snippets. So I went to see them at the 100 Club, and it was another seminal moment. Two things were really important then: seeing the Pistols and realising that whatever the next big thing was, it wasn't a vocal-harmony trio; and then seeing the police descending on Earls Court and applying the sus laws to the gays, as well as the people in Notting Hill and Brixton.

'It was a very hot summer, and there was unrest, and the police started beating up the people outside the Coleherne. Denis Lemon tried to take a picture of them doing it, and one of them came up to him and said: "Have you got a receipt for that camera?" "Not on me, no." "Right, you're nicked, on suspicion of it being a stolen camera." Got him in the

van and beat him up. The realisation that we were all in it together, as per GLF theology, was brought home very actively by what the police were doing to the queer community.

'At the same time, the theatre troupe Hot Peaches had come over from New York. They were doing a season at the Oval House and needed to rent a local musician or two to back them on their songs, and I got roped in. It was brilliantly wonderful. They were so angry and so funny, and so righteous in their anger. They were driving home that it was the drag queens that fought the cops at Stonewall. Not the besuited CHE types. The drag queens put in the grunt work and built a platform from which the others condemned them. That was really important.'

Robinson wrote 'Glad to Be Gay' that summer. 'It was for Pride '76. I don't know how many were there; fewer than a thousand for sure. I remember we were outnumbered by the police, and I was quite nervous, singing that line about "the British police are the best in the world". I was so relieved to have got through it and not be carted off in a Black Maria at the end of it. It was meant to be an attack on the apathy in our own community, fuelled by what I'd learned from Hot Peaches and the Sex Pistols.'

After leaving Café Society in October 1976, Robinson played the London clubs with a pick-up band – 'The lesson of punk was, "Do it your-fucking-self"' – before forming the Tom Robinson Band, first bringing in his old friend Danny Kustow on guitar, then Brian 'Dolphin' Taylor on drums and Mark Ambler on the organ. After attracting some interest in the weekly music press, the next thing was to get a record deal, but the supposedly liberal music industry was not supportive.

'Colin Bell was managing us at the time,' Robinson says. 'He went around to Stiff Records to invite them to a gig, and Jake Riviera said: "I don't want to come to a gig and stand with a load of queers." During punk, people would go: "Oh, why did you sign to EMI rather than an independent like Stiff?" And the answer was simply that EMI didn't give a fuck, they just wanted to make money, whereas Stiff brought their ideology to bear, and it wasn't very pleasant.'

Signing to EMI for a reported £150,000 in summer 1977, the Tom Robinson Band found things happening very quickly. In a major *Sounds* feature early that autumn, Pete Silverton itemised the following points:

4. The Tom Robinson Band play some of the gutsiest rock 'n' roll and sing some of the bravest lyrics I've ever been lucky enough to hear.

5. The Tom Robinson Band have recently signed a recording contract with EMI, the label's first signing since the Pistols' debacle.

6. Tom is gay – He's neither ashamed nor boastful about it. He just informs you of the fact and if you don't like it, you know where you can put it, don't you, John.

7. The rest of the band aren't gay.

This was the general attitude of the mostly heterosexual music-press writers, who responded positively to the group's energetic, albeit traditional, rock sound, their radical lyrics and the good feeling they engendered at their concerts. 'It was undoubtedly one of the best gigs I have seen this or any other year,' wrote *Melody Maker*'s Harry Doherty that December about a double-header at the Lyceum – the show where they recorded the live version of '(Sing If You're) Glad to Be Gay'.

'How to record "Glad to Be Gay" was always a problem,' Robinson says. 'We recorded a studio version with TRB, but it just sounded limp. The problem was, we'd just had a big hit, internationally, and had no album in the can, and no time in the schedule to do it. So we recorded three of the gigs at the end of the tour, and Chris Thomas mixed them. The idea was to release it as a thank-you to the fanbase – there was such a loyal following. We had a thing where if they wrote to us with an SAE, we would always reply.

'We deliberately put four of the strongest songs from the live set onto this EP, which we called *Rising Free*. Radio 1 put a sticker on theirs saying that track two was not to be played under any circumstances without reference to the controller's office. They could play "Don't Take No for an Answer". Capital Radio, on the other hand, played "(Sing If You're) Glad to Be Gay" as the lead track, and it was #1 on the Capital Hit Line for six weeks. So it wasn't that people didn't want to hear it; Radio 1 didn't want to play it.'

On the day of the song's release, as if to underscore its urgency, the National Front went berserk in one of London's best-known gay pubs.

According to the *Gay News* report: 'Between 16 and 20 men wearing National Front badges "went berserk" in the Royal Vauxhall Tavern. One customer suffered fractures to his face after being hit with a heavy water bottle by one of the men and a member of the staff, who went to his aid, had his ribs cracked.' Throwing beer glasses and smashing the furniture, the men caused some £1,000 worth of damage.

Two weeks later, on 11 February, Robinson was the highest-profile performer at the National *Gay News* Defence Committee rally, held in Trafalgar Square. 'It was really, really important,' he says. 'We couldn't believe that blasphemous libel was still a thing. It's times like that where the gloves come off, and you see the British establishment for what it really is. They're cunts, and they just brazen it out, every time. Blasphemous libel hadn't been used for fifty years, and they brought it back and succeeded.'

———

Tom Robinson's appearance at the Defence Committee rally was trailed in the *Gay News* issue of 9 February 1978, which also included two separate, rather gloomy disquisitions on gay politics after the blasphemy trial. 'There is little comfort to be drawn from events of the past fortnight,' ran Denis Lemon's editorial. 'The first chilly breezes of the much-discussed "backlash" seem all set to blow themselves up into a gale. In the West it seems to be the politicians of the right who blow cold against our claims to be treated as people not animals.'

Elsewhere in the issue, a 'non-gay Anglican Priest', the Reverend Neil Richardson, discussed what to him was the 'disturbing' nature of the recent Whitehouse trial. He saw the whole event as indicative of an 'impressive and well organised growth of opposition to gay liberation' that mirrored the backlash that was then occurring in America. 'The National Festival of Light and the Trial of *Gay News* are two examples of this opposition's activities and of their influence in high places. To these people, this is a holy war, a jehad [*sic*].'

While the *Rising Free* EP see-sawed around the lower teens and mid-twenties in the UK chart, the Court of Appeal quashed Lemon's

suspended prison sentence, but otherwise unanimously rejected all the grounds of appeal. The *Gay News* blasphemy convictions and fines stood. In its 23 March issue, the paper laid out what would follow: 'The next big decision to be taken is whether or not *Gay News* should appeal to the House of Lords. That is the decision we are leaving to you, the readers.'

The front-page story described the scene: 'Outside the court, a tired Denis Lemon was jostled by crowds of reporters who wanted to know whether Mary Whitehouse had indeed succeeded now in closing *Gay News* down. "No," answered Denis. "Ever since Mrs Whitehouse announced her plans to prosecute us the letters of support have been flooding in – with cash and cheques to help us. We are confident that our Fighting Fund contains enough now to pay for all the costs up to date. The paper will continue to publish as usual."'

After 'Glad to Be Gay' dropped out of the charts, the Tom Robinson Band found themselves busy recording their first album amid personnel difficulties. Organist Mark Ambler had been sacked early in the year. 'Shedding Mark was awful,' Robinson says. 'Such a mistake. Basically, our producer, Chris Thomas, couldn't bear working with him. Dolphin Taylor couldn't work with him. It should have been four lads against the world, that's what beat groups were supposed to be. Once members can be hired and fired, it's not the same thing any more.'

The demands of the music industry allowed no let-up. A quick promotional trip to America in February resulted in a near riot when the group's limousine was torched by protestors. 'Our own internal contradictions didn't help either,' Robinson remembers. 'The fact that Danny and I had met in a place where fucked-up adolescents went to be saved meant that the band contained the seeds of its own destruction. Both mad as hatters, and there was built-in tension there, right from the beginning.'

At the same time, Robinson was finding it difficult to adapt his radical politics to a closeted music industry. 'At least fifty per cent of the club owners, the managers, the agents, and the company execs are gay, probably more,' he told *Christopher Street* that spring. 'They are a little nervous about me because they don't want the boat rocked. They can fuck or get fucked by the lead guitarist of any aspiring group if they want to make it at all. It is so predatory and fucking exploitative that it makes me riled.

'They run a lot of the business in Britain. They would rather we weren't too successful. Or that we shut up and sat down. And on the other hand I get the straights in the business who say, "I don't know what he's complaining about, this fucking gay oppression business. If there's one industry where you're not oppressed if you're gay it's the music industry, the entertainment business." The problem that they're both missing is that if you're gay out in the sticks in Britain, you have no life at all.'

The Tom Robinson Band were also involved in the 30 April Carnival Against the Nazis, an event organised by the Anti-Nazi League and Rock Against Racism that began with a march from Trafalgar Square to Hackney's Victoria Park, where there was a stage and performers such as X-Ray Spex, Sham 69, Steel Pulse and the Clash. It was a resounding response to the inroads that the far right was attempting to make into the pop culture of the day, encouraged in part by punk's stupid, irresponsible adoption of the swastika.

Robinson would be one of the event's public faces, and his group were the headliners on the day. 'It was the cheapest possible PA,' he remembers. 'The sound was just terrible. All the faders were pushed to maximum and the cones were jumping out of the speakers to try to get the volume up to a listenable level. It was the being there, really. Billy Bragg talks about hearing "Glad to Be Gay" there and realising for the first time that gay people were a thing. He suddenly looked around and found he was in the middle of a gay contingent.'

This was the biggest pop culture event of the year, and Tom Robinson was at the heart of it. Within a month, the group released their first album, *Power in the Darkness*, to mainly positive reviews. Containing ten songs, it was a political primer, with rousing rock tracks like 'Ain't Gonna Take It', 'Up Against the Wall' and 'Grey Cortina' rubbing up against more downtempo songs such as 'Too Good to Be True' and 'Better Decide Which Side You're On'. Peppered with agitprop lyrics and Danny Kustow's strutting guitar, it offered solidarity for a society in crisis.

Entering the charts in early June, *Power in the Darkness* reached #4, staying in the UK Top 40 for three months. The Tom Robinson Band were now a major rock act with committed fans who responded to their

openness and willingness to engage, with the group releasing regular information bulletins. Yet there were no songs on the album that specifically addressed the gay experience. Pushed and pulled by his new rock stardom, Robinson was becoming adrift from his core beliefs. The necessity to write and sing about class politics and rising fascism had taken over from singing about his sexuality. His laudable desire to be open and accessible to his fans rebounded against him, and when the Tom Robinson Band got together to begin their second album, they found the cupboard nearly bare. 'I should have been writing more fucking songs,' he says now. 'I'd lost sight of what it was we were doing, and why it mattered. If I'd spent more time writing songs and less time answering fan mail, things might have turned out differently.'

Meeting the singer after a major TRB show at the Hammersmith Odeon that October, two writers for *Gay Left*, Derek Cohen and Hans Klabbers, attempted a summation of Robinson's impact on the gay world: 'Perhaps the most outstanding effect has been the way he has become a focus for young emerging lesbians and gay men, not just in this country but as far away as Japan and the USA. He has become a focus for young people who are coming out, a positive image to identify with that resonates with their own sexuality.'

Robinson's pioneering openness and engagement helped to persuade other stars to be more candid. In late October, Elton John gave a major interview to the leading music weekly, the *NME*, in which he talked frankly about his sexuality. 'I was very naive', he told Roy Carr. 'I think I was a virgin until I was 22 and that was only because I was living with this girl at the time. I didn't accept the fact that I was gay and didn't come out of my shell until I was about 24. But that wasn't only sexually, that was all round. I was so naive it was pitiful.'

John's revelations were partly prompted by the UK pick-up of an interview he'd given to *Rolling Stone* in October 1976. Stung by David Bowie's comment in *Playboy* the previous month that he was 'the Liberace, the token queen of rock', he addressed the question of his sexuality with gay writer Cliff Jahr: 'There's nothing wrong with going to bed with somebody of your own sex. I think everybody's bisexual to a certain degree. I don't think it's just me. It's not a bad thing to be.'

In the *NME*, John told Carr that 'the only reason I made that statement about being gay was nobody had actually asked me before. But I don't think it was some startling revelation – a lot of people already know. I felt that I'd rather be totally honest about it than to try to cover it up.' He accepted that his openness was, in part, a result of privilege: 'It's much harder for someone in a normal walk of life than for people in a theatrical profession. If you are continually surrounded by straight people it must make things that much more difficult.'

He criticised the gay stereotypes propagated by the mass media: 'You've got to act like Larry Grayson or John Inman before the general public think of you as being homosexual. And I think that . . . *Gay News* should attack the Graysons and Inmans of this world, because they always deny being homosexuals yet make their living out of persistently portraying homosexuals. What people don't realise is that most homosexuals aren't like Larry Grayson or John Inman, they're very frightened people who desperately need associations like CHE.'

Answering a question about rock's machismo, John replied that 'the only artists who have openly ever said anything concrete about being either gay or bisexual have been David Bowie, Marc Bolan, Tom Robinson and myself – and Robinson has been the only one who has come out and admitted to being 100 per cent homosexual, which is a very brave step. But then he's got nothing to lose. To be honest, I don't believe that I'm 100 per cent gay, because I'm attracted to older women and therefore I can't dismiss that side of my character.'

'I met Elton at the *Guinness Book of Pop Records* cover shoot,' says Robinson. 'It's an extraordinary photo. They'd got together a selection of people who had had hit records in the last thirty years. There's Elton, there's me, there's also the Drifters, Dame Vera Lynn, Jonathan King, Dave Dee, Errol Brown from Hot Chocolate, Cliff Richard, Billy Idol, Paul Jones from Manfred Mann, whom I had idolised. And Elton. We both thought we were going to hate each other, from what our public personas were, but we got on really well.

'He'd come out as bi in 1976. Already that was more than most people were doing. It was definitely nailing some kind of colours to the mast. And it turned out he actually is bisexual. I didn't believe in bisexuality

until it happened to me. I really didn't. I thought it was just people who hadn't come out properly. But everyone's bisexual when it comes down to it. Nobody is 100 per cent one way or the other. Labelling yourself as bisexual is a cop-out because you don't want to be despised for being "queer" – that's what I thought. But he really was bisexual.'

During 1977 and 1978, Robinson had shown great courage in being openly homosexual in a very heterosexually oriented arena: rock music. His intervention had a huge impact: the veil of silence around the topic was removed, and many would follow his lead in the years to come. In the short term, however, he would find himself coming adrift as a rock star, at the same that the repression he warned about as a gay activist continued apace.

In mid-November 1978, *Gay News* previewed its upcoming appeal in the House of Lords. The paper's readers had voted by a majority of twenty to one that Denis Lemon should proceed to the highest court in the country. Unlike the victory against Proposition 6 in California, however, the appeal was not successful: meeting for five days from 20 November, the five judges held that the appellants' argument that intention was a necessary ingredient in the crime of blasphemy was not relevant. The convictions were upheld.

The judgement was not published until February 1979, but a line had been drawn under the matter. Despite Mary Whitehouse's successful campaign, there would be no more high-profile prosecutions under the blasphemy law. If she had wanted to close down *Gay News*, her efforts had misfired: staff estimated the value of the free publicity resulting from the trial at £1.5 million, and for the next few years the paper boomed. Her attempt to curtail open gay life in Britain had failed.

Jubilee and *Nighthawks*

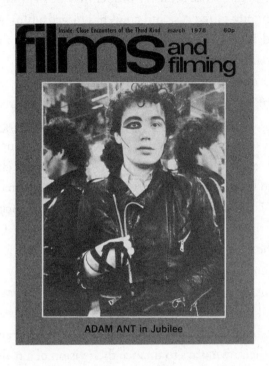

Inside: Close Encounters of the Third Kind march 1978 60p

films and **filming**

ADAM ANT in Jubilee

While discos play 'Don't Leave Me This Way' and 'What's Your Name, What's Your Number?', [Jayne] County and the Electric Chairs bawl out 'If You Don't Wanna Fuck Me, Fuck Off' and 'You Make Me Cream My Jeans'. Disco music celebrates broken hearts and two hearts beating as one; the new music – Punk, New Wave, Medium Wave or whatever – dispenses fistfuls of electronic chords with 'Love Comes In Spurts' (from Richard Hell and the Void Oids), 'Piss Factory' (Patti Smith) and 'Looking After Number 1' (the Boomtown Rats).

Keith Howes and Alan Wall, 'Punk: Wot's in It for Us?', *Gay News*, 9–22 February 1978

In late January 1978, a critic from *Variety* magazine went to a preview of Derek Jarman's second feature film. It's fair to say he loved it: '*Jubilee* is one of the most original, bold, and exciting features to have come out of Britain this decade. The industry proper may be napping, but Jarman, along with a highly-gifted cast and crew, has forged a film which through its brutal and lyrical vision of contemporary England, should help to restore native and international faith in British cinema.'

Jubilee was one of two independent British films to tackle the gay experience that year. While Jarman's allegory took freely from the punk scene in its cast, designers, performers and ideology, Ron Peck's *Nighthawks* was in the tradition of social realism, tracing the life of a schoolteacher chasing every-night fever in London's gay clubs. Wanting to escape from his mundane everyday life, Jim seeks affirmation and connection in disco, whereas in Jarman's film, punk is the rocket fuel for an all-out attack on Merrie England in the year of the Silver Jubilee.

Between the poles of punk and disco, both films offer a picture of the British gay scene's relationship to music in 1978. Disco was the thing in the burgeoning gay clubs and the glue that held the commercial scene together; punk was more outré. Nevertheless, there was a crossover between both films. Peck and Jarman were good friends and colleagues, struggling in their own ways to finance their vision of a truly gay cinema; indeed, Jarman appears in several disco scenes in *Nighthawks* and is credited with assistance.

Certainly, as far as the mainstream charts were concerned, disco was the sound of the day. In the Top 20 for the week of the *Jubilee* screening, there were four disco hits (including two by Donna Summer), one song from the *Saturday Night Fever* soundtrack ('How Deep Is Your Love'), two big reggae hits and the usual UK mix of the time: ballads, novelties and rock 'n' roll revivals. Not a punk or even new wave song in sight: despite having enormous coverage in the music press and national media, neither sold that well as a matter of course.

Although disco fell short of the dominance that it exerted in America, its presence was heightened in the gay world. January's *Gay News* issues contained large adverts for the popular Bang Disco in Tottenham Court Road – playing only American imports – as well as for other

clubs, such as Fooberts and Glades at the Global Village. Its music coverage featured a mixture of show tunes, classical, early electronics (Brian Eno's *Before and After Science*) and disco. There was no punk, and the only rock act to get a mention was the Tom Robinson Band – in a news story.

Punk's relationship to the gay scene was complex and contradictory. Many of those involved in 1976 and early 1977 were outsiders, and sexuality was a part of that: at least two important early venues were gay clubs, while the clothes designed by Malcolm McLaren and Vivienne Westwood used gay imagery. But as punk became integrated within the increasingly niched music industry during 1977, it became harder to be open: gay people were supposed to like disco, while punk all too often oscillated between outright hostility and the denial of its gay beginnings.

The two worlds couldn't have seemed more separate. With punk's seeming determination to throw off the gay associations that were intimately linked to its origin, it's hardly surprising that many gay people in the UK looked on with bemusement. Dancing was the social glue for most gay men and lesbians on the scene, and who wanted to dance the pogo with spit flying all around you? Not sexy. With the wealth of disco coming through from America, punk seemed like an irrelevance.

Nevertheless, *Gay News* detected an 'increasingly visible punk/gay connection' in early 1978, occasioned by Tom Robinson's breakthrough and the new single by Elton Motello, 'Jet Boy, Jet Girl', which contained the seemingly explicit homoerotic lyric 'When I'm with him it's just a dream / He gives me he-e-ead . . .' In the issue dated 9–22 February, the paper decided to take the bull by the horns, with an extremely long feature by Keith Howes and Alan Wall entitled 'Punk: Wot's in It for Us?'

The two writers interviewed several luminaries from the punk scene: Jordan from Seditionaries, Gene October of Chelsea, Pete Shelley of Buzzcocks, Faebhean Kwest of Raped and BoBo Phoenix of Dead Fingers Talk. They found a series of responses that ranged from the disdainful to the bitchy – Kwest: 'Tom Robinson shoves being gay up people's nostrils but then Tom and I have known each other for ages and we fucking hate

each other' – and the elusive: only BoBo Phoenix was unequivocal about being gay rather than bisexual.

Jordan was particularly bilious about the gay scene: 'It's horrible! . . . Prissy. The gay clubs used to be better music-wise but now I'd rather not go out at all than go to listen to disco music. I used to be into women but I've gone off them now. I don't like the gay girls' clubs . . . I can't give a shit about CHE and I hate everything about *Gay News*; in fact, one of my flatmates and I were discussing doing this interview and we decided that if you brought up gayness, I'd ask you to leave.'

Chelsea's Gene October talked about his time at the Sombrero and other gay clubs, while Pete Shelley of Buzzcocks was described as 'diffi-dent and docile'. He 'often wears a gay badge during performance and his guitar strap boasts the legend "I Like Boys". Like most people in Punk, Pete is vague about his sexuality, simply saying "I have girlfriends, I have boyfriends." He finds the concepts of homosexuality and heterosexuality "frightening" because it cuts off "half the world".'

Howes and Wall observed that 'for many gays the Punk scene would appear to offer some kind of safe harbour'. They hoped that 'the energy and excitement Punk has generated will remain: the removal of a lot of restrictions in dress – girls can wear leather, boys can dye their hair; the genderless songs; the pogoing; the humour and the unity as embodied in the words of Poly Styrene in her song "Oh Bondage, Up Yours" – a high decibel celebration of people, "not boys or girls . . . not black or white . . . we're people, so unite."'

Featuring two performers from *Jubilee* – Jordan and Gene October – the *Gay News* piece was partly stimulated by the imminent release of the film, which premiered on 23 February 1978. Jarman's film was saturated in punk, with performances from Adam and the Ants, Siouxsie and the Banshees and Chelsea, and short cameos by Jayne County and the Slits. It was made by a gay director and featured a gay couple, one of whom was played by future *Chariots of Fire* star Ian Charleson. Yet it managed to alienate gay critics as much as it did the punks and the music press. 'Politically naïve' and 'ambivalent', thundered Jack Babuscio in *Gay News*. With both punks and gay people involved in their own political struggles and 'correct' group thought, a film that crossed the boundaries

of time, played with contemporary ideas of gender, blurred documentary and fantasy and ignored voguish ideas of social realism was hardly going to play well.

———

The beginnings of *Jubilee* coincided with the first stirrings of punk in the UK, as Derek Jarman remembered: 'I first saw Jordan outside Victoria station in '74 or '75. I didn't know who she was, she was just a very startling image, more than anything I'd ever seen. She was wearing white patent high heels and a very short miniskirt with a plastic, almost see-through front, and a t-shirt, and a bee-hivish hairstyle. Very blonde. I think it was Egyptian makeup at the time, and she looked stunning. I wasn't in any way aware of punk at that stage.

'As far as I was concerned, Jordan was the original. Everyone else in the fashion side follows on from Jordan, even Vivienne Westwood and the Sex shop, because without Jordan the shop wouldn't have worked. Everyone else came in and saw Jordan dressed up, and the attitude, and it took off from there. She was the Godmother if you like. She was the purest example of all. Her approach was very different, blatant sexuality. She was the original Sex Pistol.'

Born Pamela Rooke and raised in Seaford, on the south coast, Jordan changed her name at the age of fourteen. A huge David Bowie fan and a ballet student, she began experimenting with her look while still at school: 'I saw an interview with Keith at Smile, and I took all my pocket money and went and got a mohican hairstyle. Short but not shaved, and long and bright pink here, with two red tails coming down the back. I must have been very naive cos I went to school thinking it would be alright, but it wasn't. I was sixteen, so that would have been '71.'

From an early age, Jordan carried herself fearlessly: 'I think because I did ballet for many years, it gives you a sense of physical confidence when you've done a tight discipline like that. Apart from that, I liked to treat myself like a painting. I didn't consider that people would be offended or outraged by it. It really never crossed my mind. It's got to do with the way you carry yourself and the way you walk. If you slouch and look like

that, people think you're a tramp. But if you carry yourself right, that's style, the way you carry yourself.'

In 1974, she began to gravitate towards London, getting a job at Harrods and making a splash on the gay scene. 'When I came up to London I went to the Masquerade Club in Earls Court, a gay club, very outrageous even by today's standards. It was difficult for a woman to get into those clubs, the male gay scene was very insular. They were very worried about women coming into their clubs, and the only way you got in was by how you looked. If you looked crazy and outrageous you were alright, you weren't a straight girl going down there for a laugh.'

A basement beneath a launderette, the Masquerade – which opened around 1972 – 'was a two-room dive, really', remembers early habitué Alan Jones. 'You paid to get in, and the price included a meal, and about halfway through the evening a plate appeared before you with some ham and a roll and a bit of lettuce. They had to serve you a meal, otherwise they couldn't stay open. One room: everyone was sitting around, looking very camp. It was Carnaby Street. Back then, everyone was dancing to Top 40 hits, Black Sabbath, things like that.'

By the time Jordan got there, a couple of years later, the club's musical policy had shifted to the early disco era – 'things like "Rock Your Baby" and "Rock the Boat"' – and the crowd were wearing 'the wedge haircut, high-waisted Oxford bags'. This was also the scene at the Sombrero, which, as young fashionables, both Jordan and Jones patronised. 'To be honest, I didn't really like it that much,' Jones says. 'It was mainly rent-boy city. But it was the first disco with a flashing floor. It was tiny, but there was a lit floor.'

By 1975, both Jordan and Jones were working together at the latest incarnation of Malcolm McLaren and Vivienne Westwood's shop at 430 King's Road, now called Sex, with Michael Collins as front of house. Jones began as a customer. 'I used to go to Let It Rock when it first opened, and I got talking to Malcolm in passing. Once you're used to buying things from a certain store, you go back. It fitted the image I liked at that time. It wasn't trendy at that time, but it was the image that I liked, being on the gay circuit. You wore tight jeans, it worked.

'At that time, we're still talking glam rock, and it was all long hair and sweaters tied around the necks. The stamping grounds then were in Earls Court, that's where I would be parading around. Just around the corner, of course, was the Coleherne, and then I found out that just around the corner from the Coleherne was the Catacombs, which was my all-time favourite club. They couldn't serve alcohol, but it was the best place, and the DJ, Chris Lucas, was the best I've ever come across. The music he played set the seal on my whole life, really.

'When that closed about one o'clock, you were cruising around Wharfedale Street, non-stop, which was why the neighbours got really upset. They'd call the police, and we'd all run away, and when they'd gone, we'd all go back. If I'd have lived in Wharfedale Street in the '70s, I'd have gone fucking bananas. All night, you know, people outside your house, cruising. The Catacombs was a great place. Tiny, divey, people having sex in the corners because it was so dimly lit.

'I worked at the shop for nine months. I was on the dole, living with a prostitute in Clanricarde Gardens, Notting Hill. The deal was, she'd come down from Leicester, I let her have my apartment, and she would give me 20 per cent of her money. So I was on the dole, making money from her, and I was moonlighting with Vivienne. There was me, Jordan, Debbie Juvenile and Michael Collins, and we would do on and offs. Tracie O'Keefe was there, too. That was just as it had turned into Sex; we hadn't gone over to that new interior then, those rail things.'

With a slogan taken from gay liberation ideology – 'Out of the bedroom and into the streets!' – Westwood and McLaren were intent on confronting British society with its darkest spectres in their new designs for the renamed shop, Sex. As well as the 1950s Teddy Boy-inspired designs that they had made for Let It Rock, the new incarnation featured rubber and leather fetish wear that they sold to rubber enthusiasts – to be worn in private, before the disaffected young began wearing it outside for all to see.

As well as the fetish wear, McLaren and Westwood started to produce a line of explicit T-shirt designs that took from heterosexual pornography – erotic stories written by the junkie novelist Alexander Trocchi in the 1960s to make money – as well as hardcore gay porn. In one case,

they produced a design – the 'Nude Boy' T-shirt – that sourced commercially available paedophile imagery; along with the under-the-counter Nazi memorabilia on sale in the shop, this item of clothing pushed the boundaries of sense and tolerance to the limit.

The motivation was to provoke and disturb a moribund pop and youth culture. According to Alan Jones, 'It didn't matter to Vivienne, it could be hardcore porn, Nazi imagery or paedophilia, she didn't care, did she? She just stuck it on, just to be as in-your-face as possible. We all went along with it. I loved that run of shirts. God knows how I managed to get away with wearing them in the street. But I think it was just done to shock, that was the brand at the time.'

By summer 1975, Jones was a walking outrage, decked out in the shop's latest designs. 'I had three major things – no, four. There was the porno story, I had the one with "Sex" written diagonally across it, I had the very first nude little boy T-shirt, which was a purple T-shirt rollneck, and the "Perv" T-shirt. Leather trousers and the accoutrements, the spurs, the dog collar I wore at one stage. I had earrings then, but I stopped wearing them when everyone else did.'

It was McLaren and Westwood's latest design, best known as the 'Cowboys' T-shirt, that caused all the trouble. Lifted directly from a magazine, *Colt*, featuring Jim French's gay porn illustrations, the image, *Longhorn's Dance*, showed two cowboys – kitted out in cowboy hats, boots, one wearing a denim jacket and the other a leather waistcoat – facing each other with knowing looks and pendulous, nearly touching penises. The dialogue goes:

> 'Ello Joe. Been anywhere lately.
> Nah, it's all played aht Bill. Gettin to straight.

Cowboys with cockney accents talking about the politics of boredom: a perfect McLaren/Westwood mix and one that would be worn by the group that, in late July 1975, they were trying to assemble. And, as provocateurs, they got an almost instant reaction. As Jones remembers, he paid a visit to the shop with a friend on 26 July and bought the two latest designs: 'I bought the "Cambridge Rapist" shirt and the "Cowboys" shirt. It was a hot day. I decided to put the "Cowboys" shirt on. We walked

along the King's Road, up Sloane Street, along Piccadilly. At Piccadilly Circus, that's when the police pounced on me and said: "What's that you're wearing? Disgusting, disgusting," and they arrested me for it. When they went through my bag, of course, they found the "Cambridge Rapist" shirt, so that was more grist to the mill. I was dragged to Vine Street, booked, and had to attend Vine Street court. The documentary *Johnny Go Home* was on the telly a few nights before, about rent boys in Piccadilly, and they thought I was a rent boy. Actually, I was only ever a rent boy once, and I hated it.'

Jones was charged and convicted under the 1824 Vagrancy Act for 'showing an obscene print in a public place'. As he remembers: 'It ended up costing me thirty quid. And there was me in the dock, going, "Yes, I am homosexual" – it wasn't quite *The Naked Civil Servant*, but I did come across quite disdainfully. They got me purely on the gay imagery, the cruising, the documentary, thinking I was a rent boy. They had no conception of fashion.' The whole affair made the front page of the *Guardian* a few days later.

The 'Cowboys' T-shirt was a dry run for the career of the Sex Pistols. From the off, the group was designed to be a walking advertisement for the Sex shop's clothes, which meant that the Pistols regularly wore many of the more outré designs, including those with gay imagery – the footballer, the cowboys. As they began to pick up steam in spring and summer 1976, they were frequently photographed in these items, which, together with other disturbing imagery like the 'Nude Boy' T-shirt and the use of swastikas, announced a group designed to create division.

In their early days, the Sex Pistols operated on the margins, playing in art schools and colleges, picking up stray oddities as fans. In February 1976, they played in Andrew Logan's loft, in front of the sets recovered from the filming of Derek Jarman's explicitly gay parable *Sebastiane*. Jarman was there and shot a brief Super 8 reel, which was the first-ever movie footage of the group. As he recalled: 'I remember Jordan coming to ask me to bring my camera up, cos the band was playing. I didn't know who they were at that stage, I don't think any of us did.

'Obviously I can't remember what they were singing because it was all completely new, and it was a high energy racket. There were about ten

or fifteen people there, and Jordan and Vivienne in the front row were egging them on and gobbing at them and pretending to have battles with them, and Johnny turning his back and singing mostly to the wall, rather than to us. I remember having to be careful with the camera even with that small number of people there, cos it was all over the place. Jordan was rushing around wrestling with people.'

The Pistols started to pick up disaffected former glam-rock fans, suburban misfits like Siouxsie Sioux and her younger friend, Berlin. 'I hated suburbia,' she told me. 'I thought it was small and narrow-minded. There was this trendy wine bar called Pips or something, and I got Berlin to wear this dog collar, and I walked in with Berlin following me, and people's jaws just hit the tables. But I walked in and ordered a bowl of water for him. It was hilarious, I got the bowl of water for my dog as well! People were scared!

'My sister was a go-go dancer, that's another one of my routes for getting out. I used to go with my sister on her dates, to the Gilded Cage, the Trafalgar, and I loved it, bright lights, total unreality. I used to go with her, and occasionally some of the pubs would be half-gay, half-straight elements to them. I think I went on a blind date once, and he took me to a lot of these gay places – Masquerade, Chaguaramas. It was Disco Tex and the Sex-O-Lettes, Bowie and Roxy, Barry White was huge.'

Because of the way they looked, gay clubs were safe havens for these early punks. 'There was this heavy transvestite place called Chaguaramas,' remembered Berlin. 'A dingy dive where the worst transvestites in the world went, and all these businessmen. There was Chaguaramas, Sombrero's, and then Louise's. Those were the ones that most people went to. There was Masquerade that became the Showcase, in Westbourne Grove. There was Rob's I went to once or twice, that was Bryan Ferry's hangout, very chic.'

In the autumn, the Bromley Contingent – as this group of fans was known – began going with McLaren and the Sex Pistols to Louise's, a discreet lesbian club in Poland Street. According to Berlin, 'Siouxsie introduced everybody to Louise's. Six of us went out one night to this very exclusive, very heavy lesbian club in Poland Street. We pressed on the doorbell looking like god knows what, a cartoon probably. Madame

Louise at the door: Hello, darlinks, okay? And her faggy American boyfriend going, hi!

'Three quid to get in. We went in, and it was very quiet. Red tablecloths, mirrors everywhere. They played soul and Doris Day and campy stuff. Lush disco. And of course, Diana Ross's "Love Hangover" was a very pertinent song, we used to practise that campy dance in Siouxsie's place. So there was us six weirdos and four or five heavy dykes being very, very resentful, middle-aged, middle-class dykes. Me and Siouxsie looking so bizarre on this empty dance floor.'

During 1976, British punk coexisted with gay people in gay spaces. It was a true outsider movement and, in the late 1970s, to be gay was still to invite a marginal existence. Siouxsie summed up this period as 'a club for misfits, almost. Anyone that didn't conform to any mass Mecca to belong to, it was waifs, there was male gays, female gays, bisexuals, non-sexuals, everything. No-one was criticised for their sexual preferences. The only thing that was looked down on was being plain boring. That reminded them of suburbia.'

It was the same in Manchester, where the fledgling punk subculture – based around Buzzcocks – found a home in a tiny bar beneath the theatre run by Foo Foo Lammar, the north's answer to Danny La Rue. 'The Ranch was a gay bar really,' Pete Shelley recalled, 'and gay bars were the places you could go and be outlandish with your dress, and not get beaten up. You could almost get into cross-dressing, without it being a big hassle. People were bohemian, while everybody was trying to conform. Your sexuality wasn't an issue.'

There was a problem in this, of course. As it developed during 1976, British punk was defined as reactive, in opposition to everything else. 'I hate shit,' Rotten said in his first major music press interview. 'I hate hippies and what they stand for. I hate long hair. I hate pub bands. I want to change it so there are rock bands like us.' Hippies had long hair and flared trousers, and they smoked dope; punks had short, brutally cropped hair and straight legs, and if they took drugs at all, they took amphetamines. That was the new party line. But that also meant that punk had to distance itself from pop generations past and present. McLaren and Westwood, in particular, fostered this division. Like most

of their cohort, the Sex Pistols had come through the androgyny of glam
rock, but that was now passé. Punk began to express a kind of puritan-
ism, partly derived from the charismatic character of Johnny Rotten,
whom Jordan described as not 'sexually mature': a disgust with love and
sex, which Rotten later memorably described as '2 minutes and 52 sec-
onds of squelching noises'.

Even more urgent was the need to distance themselves from the New
York punk scene, which was more accepting of androgyny – as in Robert
Mapplethorpe's iconic cover for the first Patti Smith album, *Horses*. The
Ramones' first album featured a disturbing song about a hustler, '53rd
and 3rd', while Jayne County redefined herself as the semi-drag front
person of a hard-rock band, the Backstreet Boys. The crowd at Max's
and CBGB's were older, more bohemian, post-Warholian, less inclined
to make dramatic statements about who they were and who they weren't.

In particular, the Sex Pistols had to distance themselves from one of
their immediate forebears. Most of the group had been transfixed by the
New York Dolls' appearances in the UK, and McLaren had lobbied hard
to get Syl Sylvain to come over and join the group, eventually gifting
Steve Jones Sylvain's iconic Les Paul guitar. Johnny Rotten put paid to
any anxieties about the Dolls' influence by appearing to refer to an indi-
vidual in the group, probably lead singer David Johansen, as a 'bored
little faggot'.

After the Sex Pistols got a contract with EMI, punk began to perco-
late through the music industry, which had its own opinions on how to
market this new phenomenon. It wasn't disco, which was already being
targeted at gay people; rather, it was rock, which was considered a prin-
cipally heterosexual phenomenon, despite the by-now-fading impact of
Bowie's sexuality. When the Sex Pistols swore at presenter Bill Grundy on
teatime television in early December, it became about the tabloid media,
which added simplicity, stupidity and a much wider audience.

The impact of this instant notoriety on a group of four young men,
just into their twenties, was considerable. On their subsequent tour of
the UK, organised to promote the band's first single, 'Anarchy in the
UK', things began to quickly unravel. According to Jordan, 'John had
become the centre of attention and he couldn't focus on anybody. It

all happened at once: the Grundy thing exposed it, opened it out and
ruined it. Because it became pedestrian, mainstream, everybody knew
about it. It wasn't a club, a shop, a group of fans. It went mass.'

Alan Jones observed the punk scene's strange relationship to the gay
world: 'The Bromley Contingent were mainly gay, so there was that. I
could leave punk behind and go to the Coleherne, but nobody else really
did that. All the guys who were in the Bromley Contingent, they literally
kept themselves to the punk ghetto, they kept themselves very much to
themselves. I'm sure when they went to Chaguarama's and all that, they
were getting off with each other, but I kept those two worlds separate. It's
only later on that it became more straight.'

The Sex Pistols reached the peak of their power in June 1977, when
their single 'God Save the Queen' represented the principal protest at the
Queen's Silver Jubilee – an event which for many young people seemed
to highlight the state of a country that was dreaming, if not living, a nos-
talgic nightmare. On the bank holiday of the celebration, the Sex Pistols
took to the River Thames on a boat called the *Queen Elizabeth* and blasted
out a short set that included their new single and 'Anarchy in the UK',
which was timed to erupt as the boat went past the Houses of Parliament.

For punk insiders like Jordan and Jones, this was a turning point. 'I
just thought there was doom coming, after the boat trip,' Jordan remem-
bered. 'John was being really obnoxious to everybody. It was the star
trip, and him thinking that everything had got too commercial. I don't
think he could handle it. Nobody believes how difficult it is to carry on
something like that. Anyone can sing, but to sing with conviction those
powerful words every night, words that were black and white . . . I think
he'd lost the need to do it.'

'The day of the boat party was the day I said, enough is enough,' Jones
recalled. 'As soon as we got surrounded by the police, and the ensuing
hysteria when we docked, and everyone was being filed off and being hit,
and running off in all directions, and filed into the vans, and I stepped
back and looked and I thought, this is it. I don't want to know any more.
It was getting really violent. I'd had enough of the shop by that time, too.
Punk was getting less interesting. Disco was more me, and I just moved
straight into that.'

It was at this point that Derek Jarman began shooting his second feature. As he told me: 'The genesis of *Jubilee* was originally a Super 8 film with Jordan. It wasn't anything to do with punk in that sense. It grew in the course of early '77, while we were writing it, and it was Jordan who brought in Adam Ant and the punk element, because we wanted musicians involved. I had started collecting fanzines and things, people had started selling them down at the corner of the King's Road in the market there, and that excited me, and it got amalgamated with writing the script.'

Aged thirty-five in 1977, Jarman was a generation older than most punks, potentially a prime target for their Oedipal hostility. 'What could be seen as a rift between two generations didn't occur with Jordan,' he recalled. 'I don't think she felt it. There was a continuity. You couldn't actually like someone like Andrew Logan, so Johnny would be very rude to me when I went out. It was differentiation in the marketplace. The new element was Jordan's interest in bondage gear and fetishism.

'My connection with it all was very peripheral, but once *Jubilee* started it became less so, because it created a focus for about four or five weeks. Jordan actually helped and collaborated a lot with it, not just with bringing people along. I'd seen Adam on the street, and I mentioned I'd seen this lad with "FUCK" written on his back, which I thought was written on with eyeliner, but Jordan told me she'd actually carved it in with a razorblade. So he came along, and gradually one person introduced another.

'Siouxsie and the Banshees came along, and we filmed the Slits, the Banshees, Adam and the Ants, Chelsea and [Jayne] County. I knew Gene [October] already, cos he'd been around the gay clubs for years, and he transformed. He'd always wanted to do something, and he felt he could fit in here. I don't think the others would think of him as an originator; they thought of him as a bandwagon-jumper.'

Like the fanzines that flourished in the first few months of 1977, *Jubilee* is a highly collaged allegory that merges the two Queen Elizabeths: the sixteenth-century version is seen in a series of hieratic, lush settings – alongside John Dee, the alchemist, and his assistant, played by original Sex Pistols friend and colleague Helen Wellington-Lloyd – while Elizabeth II

is brutally murdered in a hellish, derelict landscape. This is the shadow of their time, embodied in Ariel, whom Dee summons up as a daemon to display the nightmare visions of a violent and degraded country.

Jubilee is saturated in punk: not just in terms of the musicians, but in the clothing and set design. The characters wear either T-shirts and bondage trousers from Vivienne Westwood's shop or boiler suits emblazoned with painted slogans, like the early Clash, while Sex Pistols imagery – posters and news reports – is seen throughout. The whole cut-up feel and acceleration of punk is counterposed with scenes of urban dereliction – mainly filmed in London's Docklands, which has its own description, 'Postmodern', graffitied on a brick wall.

The film features a gay couple, Sphinx and Angel, who are murdered by the police for resisting arrest. A nightclub scene, shot in the Catacombs, evolves into a gay orgy as disco music plays. Jarman was too involved in the gay world not to represent his tribe, even if punk was cooling towards overt homosexuality that summer. Indeed, the storyline and its participants exhibit the upending of gender roles that early punk had helped to bring about in pop performance.

The principal characters are a five-strong girl gang – including Jordan as Amyl Nitrate and Toyah Wilcox as Mad – which projects outwards from a key punk manifestation: the rise of powerful women like Siouxsie of the Banshees, the Slits and Jordan herself. Contrasted against them are the men: the policemen whom they kill, and in particular Gene October as Happy Days and Jayne County as Lounge Lizard – a sex object and 'a demented transvestite rock star', fit to be disposed of by the gang.

Jarman had picked up on something that, by summer 1977, was in danger of being swept away by the music industry's wholesale adoption of punk as rock. Thanks to its gay and lesbian influences, punk had offered new templates for performers which included the strong, assertive personae adopted by the Slits or Siouxsie and the Banshees, the matter-of-fact use of female musicians by groups like the Adverts or the visionary preaching of X-Ray Spex's Poly Styrene. No woman had sounded or looked like this in pop music before.

The corollary was that, despite an outbreak of machismo as groups became subsumed into the demands of rock, men were allowed to be

non-macho, to exhibit weakness, even to be queer. It was a delicate balance: Gene October, who was known to be gay, was vilified and underestimated, while Pete Shelley and Jayne County managed to navigate this minefield with a couple of terrific singles that autumn – the witty, ecstatic, pansexual anthem 'Orgasm Addict' and the extremely direct '(If You Don't Want to Fuck Me, Baby) Fuck Off'.

Jubilee ends on a cautionary note. Despite the gang's extreme postures and casual, homicidal violence, they are taken up by a Rupert Murdoch-like media impresario, Borgia Ginz – played with tremendous, lip-smacking relish by the former associate of Lindsay Kemp, Jack Birkett – who whisks them off to a Dorset mansion. The county is protected by barbed wire and customs officers – Blacks, homosexuals and Jews are banned in Dorset – not that that bothers the girl gang, now recast as Ginz's latest pop group, the Daughters of God, one whit.

Jarman was sceptical about punk's claim to represent the nation. 'The use of the Union Jack was worrying in that sense, because Dada leads to Weimar, and that sort of anarchy, which leads to the repression – and I put this into *Jubilee*, because in its own funny way, it did end in repression with Margaret Thatcher's England. *Jubilee* told that parable, and at the time it was complete fantasy, based on supposition, and in time it came true. Indeed, everyone had signed up, particularly the next generation, like Adam [Ant], who became an old-fashioned pop star.'

Jubilee was both accurate and ambivalent. A complex, contradictory film, it was hardly designed to appeal to the punk audience that it simultaneously parodied and celebrated. Almost to a man – and it was mainly men back in early 1978 – the weekly music press hated it when it premiered. The *NME* opened proceedings with an agenda-setting pre-emptive strike: 'disturbingly irresponsible', 'indefensible', 'grim', 'potentially dangerous when one considers that this is to be punk's great statement – its first and possibly only big film'.

The older newspaper critics were less partisan. In the *Evening Standard*, Alexander Walker felt that it was 'the movie that tells us more about 1970s youth than any film so far'. The unkindest cut came from Vivienne Westwood, who printed her incandescent missive on a T-shirt: 'I had been to see it once and thought it the most boring and therefore disgusting

film I had ever seen,' she began, before delivering an ad hominem, homo-phobic attack on Jarman himself, judging that the film represented 'a gay boy's love of dressing up'.

In hindsight, Jarman felt that 'there was homophobia running through the whole thing really. Vivienne's T-shirt about me, which was pretty extraordinary, it was the only thing that upset me.' Part of the problem was caused by the fact that McLaren was in the middle of trying to set up his own Sex Pistols film, and *Jubilee* was competition. At the same time, Westwood was furious about the involvement of Jordan – her former model and assistant – which she saw as treachery. Such was the vexatious state of punk in early 1978.

————

While *Jubilee* was opening in the cinemas, Ron Peck was finally shooting his feature film. It had taken nearly three years for him to get to this point, during which, as *Gay Left* reported, he had 'been largely concerned with two tasks – working around the film in the gay community, and raising money. He has spo-ken to hundreds of gay men who have shown interest in the film either because their experience was relevant to it or because they wanted to appear in it.'

Whereas *Jubilee* was an auteur's vision that involved members of the punk elite, *Nighthawks* was fully intended from the beginning to be an accurate reflection of London gay life. Indeed, an early draft was called 'All You Need to Know About Gay Oppression and How to Fight It in London in the 1970s'. Financing was a problem – both the British Film Institute and the National Film Finance Corporation were slow to find funds – and the money was only raised at the end of 1977.

The storyline of *Nighthawks* was suggested by the 1975 case of John Warburton, a gay teacher who was seen by his pupils at a gay rights demo. When he truthfully answered their questions about his sexuality, he was sacked. Jim, the film's chief character, is in a similar situation: not out at work, while enthusiastically sampling the delight of London's gay nightlife. The climax of the film, where he talks openly about his

sexuality with his pupils, is a direct echo of the Warburton case – except, in this fictional situation, Jim keeps his job.

Nighthawks is a social-realist independent film that, to today's eyes, moves at a glacial pace: the cuts are slow, the character development is minimal and the action, while counterpointed between work and play, seems at points to be going round in circles. All of which reinforces the principal point of the exercise: namely, the constant round of sex and club-going that, having become an integral part of the gay lifestyle during the 1970s, has become an obsession, almost an addiction.

Apart from the lead actor, Ken Robertson, *Nighthawks* was made with non-professional actors from gay acting workshops and the gay scene who improvised throughout. The film is full of ellipses: gaps in communication, missed phone calls, lovers who have moved on without leaving a forwarding address. Few of the men are open and communicative about what they really want, and the dialogue often trails off into silence. They are friendly enough, but somehow dissociated, as if a life outside sex is not truly worth bothering with.

As Jim does the rounds of the clubs – and scores: he doesn't have any problem there – there's almost a sense of the clientele swimming underwater in slow motion, bathed in the dim red light. He is seeking connection, but his contradictions and compulsions make that hard to achieve. When he does find a potential partner, John, with whom he can relax and unburden himself, he still persists in going out to the clubs. 'Do you want to dance?' he asks John, and the last we see of Jim is when he disappears into the anonymous crowd.

Trailed as the most ambitious project yet from within the gay world, *Nighthawks* attracted some confected controversy. The *Sun* ran a story claiming that 'twelve-year-old children have appeared as actors in a shock film about a homosexual school teacher. They are shown in scenes where the "gay" teacher instructs his class in homosexuality.' *Gay News* rebutted these insinuations with a statement clarifying that the children were not involved in any sex scenes and appeared with their parents' permission.

Jubilee and *Nighthawks* were two very different but complementary cinematic renderings of London gay life in the late 1970s, and as such,

were both seen as controversial. While one was unapologetically dramatic and allegorical, the other was rooted in the daily grind: grotty flats, grey streets seen through rain-flecked car windscreens, threadbare art galleries, decrepit classrooms, packed gay clubs. Yet both were made by determinedly independent gay directors who saw themselves as colleagues and allies.

In its transition between small basements and larger, less claustrophobic spaces, *Nighthawks* captured two separate eras of London gay club life: the era of dives like the Catacombs and the Masquerade, and that of the new type of gay club that began to replicate what was going on in America. In the London of the mid-decade, many of the DJs in the larger venues were entrenched in funk, and much of the disco scene was stuck in the late 1960s in terms of atmosphere and scope.

The big change was the 1976 opening of Bang, at the Sundown theatre in Charing Cross Road every Monday night. With a capacity of around a thousand people, Bang was inspired by the gay clubs in New York, San Francisco and Los Angeles – large, unafraid, above ground and exciting. It was started by Jack Barrie, who had run the Marquee, and the star DJ was Gary London – real name Jerry Collins – who had been to America and was fired up by the club scene he'd witnessed there.

'The minute it came on the scene, it was a huge success,' remembered early adoptee DJ Tallulah. 'The queues! It went right round past the 100 Club. It was the most packed it had ever been. He couldn't have picked a better venue to bring that sort of thing to Britain. Mainly because of the way the club was designed, the bars on each end, the hamburger joint, you could look down on the dancefloor. He had three DJs on. It had lighting FX. It had fog machines. It had balloon drops.

'Music-wise, these were all import records. By then, you'd know what was going on in America, even though you couldn't get there, so we knew what the records were. The trendy ones who were in demand at Bang were the air stewards, because they'd be travelling all over the world, but particularly to New York and LA. Then they'd have four- or five-day stopovers, so they'd be going to the clubs, so they'd know which records to bring back, whatever the hit record was.'

Bang quickly established itself as the key London venue. 'Gary London's Bang Disco Top 10', printed in *Gay News* during July 1978,

gives a good snapshot of the club's music policy at its height: it includes the Chic production, Karen Young's 'Hot Shot'; Jacques Morali's production for Patrick Juvet, 'I Love America'; Grace Jones's 'Do or Die'; 'Mission to Venus' by Silver Convention; the Top 3 crossover hit 'Boogie Oogie Oogie' by A Taste of Honey; and Barry Manilow's percussive swayer, 'Copacabana'. Eight out of the ten were American imports.

Two more clubs opened in 1976. In Earls Court, there was the Copacabana, based on an American club of the same name in Fort Lauderdale and featuring as the house DJ Chris Lucas from the Catacombs. Earls Court was rapidly becoming a gay district, with major traffic in nearby gay pubs the Coleherne and Brompton's, leading to demands for a large nightclub. The Copa, as it was soon called, quickly became a major hub for the developing clone scene in the UK.

The other game-changer was Glades, held on Wednesdays in Charing Cross. 'That was one of my favourite clubs,' remembers Alan Jones. 'It was upstairs in what used to be the Global Village. Downstairs is where Heaven proper is now. The first couple of times we went, they had a drag queen show, but they soon realised that none of us wanted to watch drag. Those were the days when people went to discos and there had to be other entertainment as well. When it moved to non-stop dancing, that's when it all stopped.'

Reconstructed playlists from the club reveal an eclectic mix – the rigid BPM of disco in some American clubs hadn't arrived yet in the UK – that ranged from spacey funk tunes, like War's 'Galaxy', and earlier disco favourites, like Manu Dibango's 'Big Blow' and Cloud One's 'Atmosphere Strut', to contemporary floor-fillers, like Evelyn 'Champagne' King's 'Shame', chart fodder, like the Michael Zager Band's 'Let's All Chant', and electronica, like Space's 'Prison' and Sylvester's 'You Make Me Feel (Mighty Real)'.

By 1978, a whole new club lifestyle had become available to gay men in London. 'I was travelling between London and the US very frequently,' remembers the author James Gardiner, then working as an antiques dealer. 'In London, I liked Glades, a once-weekly, Wednesday-night event in what was then a straight club called Global Village. I used

to drive down from my flat in Caledonian Road. Mondays, of course, was Bang. Saturdays was Copacabana in Earls Court.

'I remember I used to wear all the clone and cowboy gear bought in NYC out in London, and used to get a lot of attention as a consequence. Or so I thought. I guess it was mainly the drugs. We used to stay up thanks to chewing "blue bennies", which I used to get from a friend in Camden Market, where I sometimes had a stall, alongside various Blitz exhibitionists. By now I was thirty, so they all seemed a bit young and loud and very queenie. I much preferred the American butch style, and this extended to my taste in music.'

In April 1978, the ante was upped in London club life by the opening of the city's nearest equivalent to Studio 54, the Embassy. 'It was a fantastic place,' DJ Tallulah remembered. 'They brought a DJ, Greg James . . . he was a great DJ. He mixed. The Embassy was a breath of fresh air. It was London's antidote to Studio 54. We knew that the boys were all going to be in shorts. Lots of stars – big stars – rooms off to the side, everyone knows the boiler room was the coke room. The gay night, Sunday night, it was the nearest to a chic club that London ever got.'

London gay nightlife was taking off in a big way, and this is what *Nighthawks* captured. The final scene was filmed in Glades, and it shows dozens of men dancing, dressed in denim, checked shirts and, in one case, punk gear. The music is specially composed electronic disco – the original recordings were too expensive to license – but the feeling is accurate: this is the soundtrack to gay club life. The dancers and the onlookers in the balcony combine to give a picture of both solidarity and alienation. It looks like great fun, but there is a restless undertow.

In some ways, punk and disco were two sides of the same coin: a shared wish for community and the desire to simultaneously transcend and celebrate alienation. Punk flaunted it into anger, while disco aestheticised it into dancing and sex. In terms of the gay world, however, there could be only one winner, and that was disco. The music came from America – the leader in gay styles in 1978 – and it was both associated with and useful to gay men, in particular, as they began to flex their muscles and make themselves more visible in the UK.

Punk, by contrast, was a short-lived phenomenon whose labyrinthine contortions and rebarbative qualities rendered it inexplicable and impenetrable to many gay men. The music itself failed the first test: it was useless for dancing. The question is, why did so many gay men and lesbians get involved? One answer could be that it was a reflection of an even deeper outsider wish for individuation, not just from the ordinary straight world, but also the new, straighter world of the mainstream gay scene, now that it was becoming more established.

Andy Warhol and Studio 54

Then it was time to dress Bianca for Studio 54. Then over to
Studio 54 and it was full of pretty people.

Andy Warhol and Pat Hackett, *The Andy Warhol Diaries*,
entry for 4 January 1978

On 3 January 1978, Andy Warhol finally got to see *Saturday Night Fever*. He had tried to see it the previous day, but gave up after taking taxis to various sold-out theatres. He thought the movie was 'just great'. The diary entry for that day also includes gossip about his close friends Halston, Bianca Jagger and Liza Minnelli, who had turned up on Halston's doorstep the night before, demanding 'every drug you've got'. Another item includes Warhol's thoughts about the Sex Pistols' arrival in the US for their delayed tour: 'Punk is going to be so big.'

The diary had begun in autumn 1976, when Warhol agreed with Pat Hackett – who had already kept what she called a 'very sketchy' log of Factory events and appointments for several years – that they should talk every weekday morning. The ostensible purpose was to log his business expenses for tax purposes, but it quickly became something different: a record of Warhol's doings that particular day, whether they be social or business, which, as Hackett wrote, 'came to have the larger function of letting Andy examine life'.

Like his long-term habit of keeping Time Capsules, into which he poured every single item on his desk, for as long as it took to fill up the archive box, Warhol was turning the minutiae of his everyday life into his art. The fusion of art and everyday life had long been a preoccupation of his, but by the late 1970s, the life that this process was recording was very different from the radicalism and sense of possibility that had marked the mid-'60s. Valerie Solanas's bullets and changing fashions had put paid to that.

Beginning at the end of 1976, *The Andy Warhol Diaries* plunge the reader straight into his new phase. There are prestigious art openings, society weddings, dinners at the Iranian embassy. A drag queen called Gigi makes an appearance – Warhol would never quite shake off gender-fuck – but his prime social group is revealed on 6 December, when he attends an opening at the Metropolitan Museum with Halston, Victor Hugo and Bianca Jagger. Bianca gives Warhol her panties, which he pretends to sniff. No doubt they are in a Time Capsule somewhere.

The records in his boxes from 1974 to 1978 reflect the change in his lifestyle. Some are by friends or are commissions: Lou Reed's *Coney Island Baby*, David Johansen's first solo album and the Rolling Stones'

Love You Live. Elsewhere, they range right across the board, from the teen pop of the Bay City Rollers and David Cassidy to Deaf School, the Sex Pistols and *The Muppet Show*, but the most popular genre is disco: Gloria Gaynor, the soundtrack to *Saturday Night Fever* and Grace Jones's Studio 54 favourite, 'I Need a Man'.

As January 1978 progresses, the references to Studio 54 increase in frequency. On 4 January, he goes there with Bianca Jagger: it is full of beautiful people. On the 21st, he goes in a blizzard, and the place is still heaving. On the 22nd, he attends a party at which Victor Hugo gives him a present: 'a used jockstrap – it was great'. Then it's on to Studio 54 again: Warhol left at 2 a.m., just as Halston and Bianca were arriving. 'They were both in elephant masks, but the photographers didn't care, they're tired of Bianca. She better get out of town for a while.'

The diaries for the years 1977–9 give a detailed record of Warhol's new phase as an artist and businessman. During that period, he was both a cultural Zelig and a social arbiter, giving his imprimatur to every event that he attended – and he attended almost everything that he could. Despite his carefully plotted move up the social scale, he kept in touch with the outrageous queens of the demi-monde. These were the twin poles of his life. As one fed the other, so both fed his art.

Studio 54 was the most elite disco of the period, and Warhol one of its prime habitués: Halston–Liza–Bianca–Andy, the magic quartet. Anticipating the cultural shifts to come in the 1980s, Warhol's work – as exemplified by his portraits and Richard Bernstein's glossy covers for *Interview* – had become about celebrity: his celebrity and his relationship to even more famous celebrities. This was the completely logical conse-quence of the direction his life and work had taken from the mid-1970s onwards.

———

In the summer of 1974, Warhol had moved both his home and his office: the latter to a more spacious building on Union Square, the for-mer to a large house on East 66th Street, in the heart of the Upper East Side. This had been the home of a banker, but Warhol added $70,000

worth of renovations to the purchase price of $310,000 to involve his new partner, the interior designer Jed Johnson, who had suggested the move as the Lexington Avenue house was full to bursting. Warhol hoped that the joint project would bind them closer together.

Warhol's upscale move reflected a shift in *Interview*'s content. The waning of glam meant that the magazine concentrated more on the movie stars, jet-setters and showbiz royalty that had always been part of its staple diet: cover stars in 1974 and 1975 included Anthony Perkins, Lorna Luft, Bette Midler, Raquel Welch, Lee Radziwill, Bianca Jagger and Liza Minnelli – all glossed by the designer and artist Richard Bernstein. It was the magazine for the new Beautiful People.

There was also a subtle move to the right. With income from his films and original art drying up, Warhol was forced to rely on portrait commissions during this period, and the kind of people who could afford his prices were not struggling downtowners. 'We're trying to reach high-spending people,' *Interview*'s editor Bob Colacello said about the magazine's editorial policy. A strong Republican, Colacello facilitated this orientation towards the rich and the conservative, even if it wasn't always an easy fit for Warhol's core Democratic politics.

One of Warhol's new friends in particular embodied this move uptown. By the early 1970s, Roy Halston Frowick, better known as Halston, had become one of America's best-known designers, renowned for his minimal, glamorous, comfortable clothes for women, which were worn by superstar clients like Greta Garbo, Lauren Bacall, Elizabeth Taylor, Bianca Jagger and Liza Minnelli. Between 1968 and 1973, his designs were estimated to have earned him $30 million.

Halston was rich, gay and had impeccable social connections. Having met in the early 1970s, when Halston designed an evening dress using a fabric printed with Warhol's *Flowers*, the couturier and the artist became close friends. This was mutually supportive: Warhol put Halston in *Interview*, while the designer remembered that he had 'really opened up a whole facet of society to Andy that he hadn't been in before. I mean, he was more of a downtown boy and I was an uptown boy and I introduced him to so many uptown people. That really did help.'

Warhol's portraits during the mid-1970s included Halston, gallery owner Leo Castelli, Belgian fashion designer Diane von Furstenberg, actress and memoirist Brooke Hayward, David Hockney, Mick Jagger, Roy and Dorothy Lichtenstein, Golda Meir, Yves Saint Laurent, Frederick Weisman, a millionaire art collector, and Doda Voridis, the sister of a very wealthy Greek ship owner. Working from photographs and silk screens, Warhol overlaid swatches of paint, turning the faces and upper bodies into washes of abstract colour. Many portraits were of well-known artists and musicians, wealthy patrons, art dealers and high-society denizens, but Warhol really came unstuck when, prompted by his own greed and Colacello's urging, he started to court the rulers of oppressive regimes. In December 1976, he attracted adverse comment when he was photographed with Imelda Marcos at the opening of 'The Glory of Russian Costume' exhibition at the Metropolitan Museum of Art, but the real problem occurred when he targeted the Shah and the Empress of Iran as potential clients.

Warhol and Colacello associated with the autocratic ruler and his family over a couple of years, at a time when the Shah was presiding over a police state notorious for its human rights violations. Warhol succeeded in selling the Empress a dozen portraits of herself, for a fee of about $200,000, and completed studies of other family members and the Shah himself, but at a considerable cost to his reputation: in late 1977, the *Village Voice* called him 'fascist chic's recording angel . . . with his Polaroid and his tape recorder'.

At the same time, Warhol – as he had done with the *Ladies and Gentlemen* series a couple of years previously – was plunging deep into the gay underworld. It's as though his social climbing had to be balanced with something earthier, more of the street. Even while cosying up to the Shah, Warhol was preternaturally alert to the changes on the gay scene, which still remained subterranean in the eyes of the mass media, and by picking the right guide, he could keep in touch with the underground and present it to the light. In the mid-1960s, it had been brilliant amphetamine queens like Billy Name and Ondine; in the late '60s and early '70s, drags and trans people like Candy Darling and Jackie Curtis. Warhol now chose someone who was immersed in

the hedonism of the mid-to-late '70s. His guide was Victor Hugo, a well-endowed Venezuelan who had worked as a hustler before becoming Halston's lover in 1972. A designer and artist, Hugo regarded it as his job to stir things up, and as such, he introduced the requisite element of wildness into Warhol's social life.

Although he shied away from the direct effects, Warhol liked nothing better than to watch, to be a voyeur of outrageous people and their behaviour; even Valerie Solanas hadn't entirely cured him of that particular itch. Hugo totally fit the bill. 'Perhaps you would describe me as jaded, darling,' he told *Interview* in April 1975, 'but I prefer to say that in living there is absolutely nothing that is bad. I can only say that I live fully 24 hours a day – and I regret nothing.'

From the beginning of the *Warhol Diaries*, Hugo appears as a wild and disruptive presence, much to Warhol's initial delight. In mid-June 1977, he goes round to visit Hugo at his new loft, which has just 'a bed in the middle with big jars of different types of Vaseline around it – he's so much like Ondine'. A couple of days later, Warhol accompanies him to Greenwich Village, ostensibly to look for ideas, but as Warhol told Hackett: 'I was his prop to go cruising, the boys would come over to talk to me and Victor would get them.'

The declared purpose of these wanderings was to collect cast members for a new sequence of pictures that Warhol was planning. In March 1977, he told Hackett that he was asking young men to pose nude for this series, to be called *Landscapes*. The posing soon became active. Hugo's task was model recruitment, and he was very good at his job. The men came into the Factory's back room, where they were encouraged by Warhol and Hugo to indulge in every kind of sex act.

Eventually totalling ninety-four silkscreened canvases, forty drawings, over 1,500 Polaroids and forty-seven rolls of film, this series would represent the height of Warhol's activities as a voyeur: several times he watched the models having oral and anal sex. The sessions got so heavy that Warhol's major-domo, Fred Hughes, banned them from the Factory office. Yet these were works that, in the climate of the time, were impossible to sell – except the tamer ones, which Warhol called *Torsos*. This was a project that went beyond artistic expression. 'It was something that

Andy needed to do,' remembered his assistant, Ronnie Cutrone. 'I think *Sex Parts* was a final announcement or affirmation of his homosexuality.' Another series that Warhol undertook at this time, in tandem with Hugo and Cutrone, was what he called the *Piss Paintings* – canvases individualised by streams of urine. In June 1977, he talked about having a joint, self-explanatory exhibition with Hugo of *Piss and Come Paintings*.

It was during that month that Warhol's diary first mentions a visit to Studio 54, for the party for the Broadway musical revue show *Beatlemania* – attended, as he noted, by Aerosmith and Cyrinda Foxe. Whether or not it was his first visit is not recorded. The club had opened six weeks before, on 26 April 1977. It was a 1920s former opera house, theatre and CBS television studio – hence the name – situated in midtown, on 54th Street: a perfect spot.

When CBS started marketing the building in 1976, several club owners and prospective night-world entrepreneurs showed interest, but it was the team of Ian Schrager and Steve Rubell who bought the building and spent $400,000 on converting the big space into the most lavish nightclub yet seen in Manhattan, an island that thought it had seen it all. Promoting the opening, Studio 54's host and PR Carmen D'Alessio sold the glamour and luxury: 'I would say the opening night will be more like going to a premiere than going to a discotheque.'

Rubell and Schrager – along with backer Jack Dushey – had spared no expense in creating a dazzling, hypnotic environment of sound, vision, motion and sheer scale. They had hired two well-known lighting designers, Jules Fisher and Paul Marantz, to construct a constantly changing sensual environment of movable sets and complex lighting, while set designer Ron Doud had built a backdrop that simulated a volcano and hung from the ceiling various props, including a man-in-the-moon figure with a huge cocaine spoon under his nose.

Rubell and Schrager had form. Both came from Brooklyn; both went to Syracuse University; one was gay and extrovert, the other neither. Inspired by Maurice Brahms's club Le Jardin, where the music policy was cutting-edge and the crowd socially mixed to a degree unseen at other gay clubs, they opened a disco of their own in Queens, the Enchanted Garden. Despite innovative features like themed rooms – an idea later

taken up by the 1980s hot spot Area – none of the A-list were going to come to Queens. Manhattan it had to be, and so it was.

The opening-night press release stated that the club combined 'theater, disco, café, nightclub and every other entertainment divertissement known (and some unknown) to 20th Century Man'. Studio 54 was deliberately constructed as a holistic environment of pleasure, an aggressive sensurround of dance, sex and drugs – a fitting embodiment of the momentum that had been building up in New York's gay club scene since the early 1970s and which, turbocharged by the wider culture's fascination with celebrity, was taking over the mainstream media.

The music policy was widescreen, up-to-date mainstream disco. The very first song played was the dramatic Tom Moulton mix of 'Devil's Gun' by C.J. and Co. In the early days, Richie Kaczor played the weekends and Nicky Siano the weekdays, before he got ousted. 'My style of playing was not straightforward,' he recalled. 'Richie played very straightforward. Everything matched. He was a great DJ for Studio. I mean it was very very seamless, because that's what they wanted.'

To some extent, Studio 54 was the logical extension of the previous decade of gay underground clubbing – its reliance on disco, its atmosphere of wild hedonism – streamlined for mass-media and mass-market exposure. Both Rubell and Schrager wanted a fashion-oriented, sophisticated nightclub, but they also knew that in order to achieve that, they had to rely on a core constituency of gay white clubbers. 'It's like casting a play,' Rubell told Bob Colacello. 'If anything gets too strong it gets too straight or it gets too gay.'

Apart from the sheer lavishness of the spectacle, the principal difference between Studio 54 and the earlier generation of gay nightclubs – however smart – was its door policy, which Rubell, in particular, turned into its calling card. If you weren't a member, you had to wait outside the club by a velvet rope, begging to be let in on the whim of doorman Marc Benecke. If you weren't wearing the right clothes – or, in some cases, were not the right colour – you would be excluded, forced to stand aside as the elite passed by you into the club.

The scenes were often desperate and very unbecoming. They all added to an atmosphere of licence and decadence inside and disappointment

outside. This was the theatre of exclusion: a drama of who's in and who's out, tailor-made for the celebrity sheets, that reinforced the elite status of those who were let inside and introduced a new divisiveness into clubland.

As Vince Aletti recalled: 'I didn't like the whole velvet rope thing, I found it offensive, but even as I say that, almost all the key clubs were membership. You couldn't just walk in. Including the Loft and the Garage. If you were black, it wasn't too likely you were going to become a member. There was a lot of exclusionary nonsense going on. So the ideal of the wide open club was not exactly true. Once you got inside, it felt completely wide open, gay/straight, men/women, black/white, especially at the Loft, and that was the ideal. But first you had to get in.'

Studio 54 took off quickly. When Halston arranged a birthday party for Bianca Jagger in early May, several photographers were there to record her arrival onstage on a white horse, led by a Black couple, whose nakedness was concealed by gold paint. She dismounted and was presented with a birthday cake. The pictures went around the world. 'Bianca's party was the catalyst,' Benecke recalled. 'It just snowballed from there. Studio opened on a Tuesday. The next couple of nights weren't as busy. But that picture started the ball rolling.'

The club became famous, not for its music policy or the quality of its dancers, but for catering, in spectacular fashion, to celebrities. It was a stage for the rich and famous, the gay and beautiful, the eccentric and the fashionable. It set the new standard for New York discos. In mid-May, a new club called New York, New York opened on West 52nd Street: with a mainly heterosexual, interracial crowd, it quickly became the place patronised by the people who couldn't get into Studio 54.

Despite temporarily closing in mid-May for the lack of various licences, including one for liquor – a precursor of legal troubles to come – Studio 54 went from strength to strength over the next few months, even as a juice bar. From that June, Warhol's diaries record his regular attendance at the club, a near constant round of parties and evenings with Halston, Victor Hugo and Liza Minnelli. By the end of September, he complains that 'the nightlife is running me down. I can't even drag myself up on the pillow.'

Warhol quickly became one of the A-listers, let in free even when accompanied by a large group of people, given free drugs – although he claimed in his diary to rarely take them – and access to the VIP area in the basement, where people took cocaine and relished their insider fabulousness. He became very tight with Steve Rubell: a diary entry for 25 September 1977 mentions an evening spent together at heavy-duty gay clubs like the Cock Ring, 12 West and the Anvil.

The core group was Warhol, Minnelli, Bianca Jagger, Halston and Truman Capote, who had found his re-entry into Manhattan high society after the ostracism that followed the publication of 'Le Côte Basque', his planned *roman-à-clef*. The tabloid fame that the five gained through their exposure at the club gave a rocket boost to all their careers: they were, as Steve Rubell's brother Don remembered, 'a sort of version of Frank Sinatra's Rat Pack. Steve was involved with that tremendously. They loved each other's company.'

The club became a Petri dish that mixed increased gay visibility with a number of eccentrics and what the veteran journalist Anthony Haden-Guest called 'Flamboyances' – like Rollerena, a thirty-year-old gay man from Kentucky who dressed as a 1950s lady, twirling around the dance floor on roller skates. Celebrities were encouraged to exhibit outrageous behaviour: Grace Jones, who needed no encouragement, came in naked a few times, as a relief from her usual extravagant costume.

In November 1977, two articles examined this new phenomenon. Dan Dorfman profiled Steve Rubell in *The New Yorker*'s money column as 'The Eccentric Whiz Behind Studio 54'. Although the article was favourable, Rubell swerved speculation about his sexuality and gave the journalist some quotes that would prove extremely unwise. 'Profits are astronomical,' he said. 'Only the mafia does better.' Even worse, he told Dorfman: 'It's a cash business and you have to worry about the IRS. I don't want them to know everything.'

Four days later, Anna Quindlen wrote a state-of-the-club-nation story, 'What's New in Discotheques'. She began with Studio 54 – 'the old Fortune Opera House that became CBS studios has now become the Oz of discos – that is, Oz after Dorothy's house lands and everything turns strange and technicolor. Whether because of the phenomenal

publicity that has surrounded its every gyration . . . or because of a kind of uninhibited upbeat ambience . . . the club . . . is the hottest of the discos at the moment.'

The party was in full swing for Rubell's birthday celebrations in early December, and at the New Year's Eve bash as 1977 turned into 1978, when planner Robert Isabell arranged for the dance floor to be covered with 4,000 kilograms of glitter. As Ian Schrager later remembered, it felt like 'you were standing on stardust. People got the glitter in their hair, in their socks. You would see it in people's homes six months later, and you knew they'd been at Studio 54 on New Year's.'

Bianca Jagger, Liza Minnelli and Diana Ross were there, watching the main attraction, Grace Jones – resplendent in a see-through dark body suit, decorated with gold leggings and gold gloves from wrist to elbow. On top of the suit she wore a pair of very short gold pants, attached by two halters to her upper body and neck. The whole ensemble highlighted her crotch area, while her short hair, stylised make-up and warrior posture made it clear that, in the late 1970s, we weren't in Kansas any more.

––––––

In the second half of 1977, Grace Jones was the rising star of gay disco. The gay audience had long loved divas – Liza Minnelli's mother Judy Garland comes to mind – but in the pop era this had come to encompass many Black female performers. 'From Gloria Gaynor on, there were so many strong black voices,' remembers Vince Aletti. 'Women dominated. I'm not even going to try to figure out those reasons, except that it was compelling: Loleatta Holloway, Donna Summer, Diana Ross.'

With her tall posture, fearsome mien and Amazonian attitude, Jones stood for a new kind of assertive female role model. As far as the gay audience was concerned, she couldn't have been further away from Garland. She was strong, fearless and, with Tom Moulton, made a series of records that tore up the gay discos: 'I Need a Man', 'La Vie en Rose', 'That's the Trouble'. She had recently released her first LP, *Portfolio*, which Aletti described as 'a superbly crafted album that should bring one of the biggest disco sensations of the year to an even larger audience'.

In September that year, Jones had been voted the 'most promising new Disco artist' at the third *Billboard* Disco Convention in New York. She did not begin her performing life as a singer, and it had been a long and unconventional path to a diva-hood that, in late 1977, was only just beginning. 'She didn't have a great voice,' says Aletti, 'but she had a great image, and knew how to keep things changing. People respected her for that. Her performances from the beginning were very theatrical.'

Born in Jamaica on 19 May 1948, the young Grace Jones had her world turned upside down when her parents emigrated to America, leaving her in the charge of her maternal grandmother and her husband, Peart. Mas P, as Jones called him, was 'a real sadist'. Raised in the Pentecostal faith, she experienced it as nothing but harshness, and physical abuse was frequent, which she found humiliating. In one quote from her autobiography, she called her upbringing 'a classic horror movie landscape'.

Growing up with several brothers, she became a tomboy, excelling at sports like running, but at the same time was very concerned with her looks. At the age of fifteen, she moved to America to join her parents and siblings in Syracuse, Upstate New York, and there she began to see the possibility of freedom. While still in high school, she began going out to gay clubs with her older brother, Chris. 'This was when gay life existed deep in the margins of the margins of the mainstream,' she wrote, 'a system of rumors, innuendo, and scandal.'

At college in Syracuse during the later 1960s, Jones started experimenting with her style. She'd picked up on the Supremes' fashion sense and mixed it with Afro hair, which was then becoming fashionable. Transformation became her goal – 'My instincts were to become someone else, to be unbound, to be born once more. I was born, I will be born, but as fast as I wanted to go,' she wrote – and her ambitions were encouraged by a bohemian theatre professor at Onondaga Community College, who got her involved in a summer stock tour that taught her about performance and staging.

Jones started her wanderings. In Philadelphia, she got involved with a commune and started taking LSD; she lived naked for a month, worked as a go-go dancer – anything that was not conventional, anything that allowed her to slip through the bonds of gender, race and class. She began

modelling in the early 1970s for a magazine aimed at African American women, in which she was photographed with the psychedelic soul group the Chambers Brothers. She auditioned as a singer for the producers Gamble and Huff but blew the session, hating the stress of tests.

She began working for the upscale agency Wilhelmina Models, and it was at this point that Grace Jones began to fully emerge. Deciding to accentuate her unusualness, she cut her hair to the bone. 'It made me look hard, in a soft world,' she wrote. 'It made me look more like a thing than a person, but that was how I had felt I was treated growing up – as a thing, without feeling, an object, not even human. My shaved head . . . was also a way of moving across those things, belonging while at the same time not belonging.'

It was around this time, while working as a model in New York, that Jones sampled the gay-club underground with her friend Pola, starting off at Better Days. Another favourite spot was Le Jardin, which hosted celebrities like Bianca Jagger, Andy Warhol, Truman Capote, Jackie Onassis and Lou Reed, as well as hardcore drag queens. All of New York nightlife seemed to be there, soundtracked by funk and early disco, and Jones observed Steve Rubell, then working as a doorman at Le Jardin, taking notes.

In 1975, Jones went to Paris for a job with *GQ* magazine and stayed, working with Helmut Newton and Issey Miyake. Again, she hit the clubs, including one called Le Sept, which was patronised by gay people. 'They were coming into the light. They were coming into the world. This was very much a time when you could sense the role music and culture were playing in the evolution of homosexuality . . . now they had more and more places to go, where they were the pioneers, the ones in control, explicitly setting the trends. I belonged in these places.'

After being asked to record a demo of the Three Degrees' 'Dirty Ol' Man', Jones began to conceive of herself as a singer. Called back into the studio, she recorded her first two singles, 'I Need a Man' and 'That's the Trouble', in France and England respectively. When 'That's the Trouble' got attention in the disco press – 'sensational', Vince Aletti called it – she was brought over to New York to make some promotional appearances, including one at the Gallery, Nicky Siano's club, on New Year's Eve 1976.

It was around this time that Aletti met her for a feature in Warhol's *Interview*. 'It was just as she was starting out,' he says. 'She was great, very easy. So we knew each other in a way that made it very comfortable for her to talk. Her performances were very androgynous. She played it up. She knew how. She'd come out of modelling, and what better preparation do you have for that kind of attention?'

Published in January 1977, the *Interview* piece sealed Jones's entry into the world of Andy Warhol. The introduction happened through her friend and record-sleeve designer Richard Bernstein, who had been masterminding the covers of *Interview* for nearly five years, establishing the stripped but heightened, if not airbrushed, glamour look that would mark out the magazine in the marketplace. Jones was a perfect subject for him. 'Because of Andy, he moved from face to face,' she remembered, 'and I became one of those faces.'

As well as helping Jones to get covered in *Interview*, Richard Bernstein designed the twelve-inch sleeve for her second single, 'I Need a Man!': a striking magenta-and-dark-flesh-coloured image that zeroed in on her eyes and glossy mouth, at once glamorous, artistic, but confrontational. A more assured production thanks to Tom Moulton's involvement, the single was an odd blend of European romanticism and New York get-down.

Jones got the seal of approval from the man himself: as she remembered, Bernstein's 'high-ceilinged studio was on the ground floor of the Chelsea Hotel, a short walk around the corner from Andy's studio. I would go to the Factory a lot. Once we met, he would invite me all the time. It wasn't the easiest place to get into, so it helped to be asked by Andy himself. You had to have the right qualities, and I must have passed the test. That's the kind of test I like. You don't even know what the questions are, but all your answers are correct.'

In short order, she signed to Island Records, who released the album *Portfolio* and its lead-off single, a cover of the Edith Piaf warhorse 'La Vie en Rose', in the last few months of 1977. All this attention set Jones on her way to the next stage: her collaboration with designer Jean-Paul Goude, who styled and shot the famous photo of her: nearly naked and oiled, holding a microphone at arm's length and with one leg stretched out in the air, she resembles nothing else than a heroic art deco bronze.

With her ambiguous and outrageous, if not threatening, image, Jones was the perfect choice to play at Studio 54's first New Year's Eve party. She was a regular: 'At the time, Studio 54 seemed like the place I had been heading for since I had left Jamaica – not the promised land, but some sort of grand playground where I could really forget about those whips and prayers. It would become a new place with rules and rituals to break free from, but for now, I was speaking in very different tongues.'

———

'La Vie en Rose' was released in America during January 1978. While it climbed up into the Top 10 of the US dance charts, the Studio 54 party went on with an ever more crazed momentum. In March 1978, there was a birthday party for Elizabeth Taylor, at which Bob Colacello recalled dancing with the seventy-four-year-old doyenne of the New York fashion world, Diana Vreeland: "'It really becomes more like pagan Rome every day," I told her. "I should hope so Bob!" declared the Empress of fashion, shaking her booty to the throbbing disco beat.'

On 26 April, the club held its first-anniversary party, an event notable for the self-indulgence of its inner circle. The club was getting wilder and wilder. It wasn't just the drugs and the nudity, but a general feeling of entitlement and removal from the everyday world and everyday constraints. As the activist and club maven Jim Fouratt remembered: 'Studio gave license. That was what the door policy was about more than anything else. It was to make you feel that if you got in, you were in a world that was completely safe for you to do whatever you wanted.'

A year in, Studio 54 was infamous for its glaring fusion of drugs, sex, celebrity and conspicuous consumption, all set to a disco beat within an exotic, hothouse environment – with its scale and larger-than-life staging – that set celebrities against buff, nearly naked gay white boys. This was the American dream for 1978, one that was a logical extension of Warhol's high-1960s silkscreens and paintings, enshrining as they did the core American fascinations of sex, death, celebrity, money and crime.

By this time, Warhol was completely synonymous with Studio 54, as its momentum built. The wildness began to slip into the day-to-day

running of the Factory office, which was besieged by calls from people wanting Warhol to get them into the club. The increasingly bizarre antics of Victor Hugo, who was always in the office and on the phone, were wearing thin. In April, he exploded at Colacello and started threatening violence to Halston and Warhol – an unpleasant echo of Valerie Solanas.

In June, Robert Stigwood held the launch party for *Grease* at Studio 54. A week later, Warhol was in London for the presentation of his *Athletes* series of paintings at the ICA, where he was pictured with Jordan and Diana Vreeland. *Gay News* covered the event and declared that there wasn't much to see. The paper's Keith Howes managed to commit the solecism of asking Warhol about his magazine's almost wilful policy of not asking its homosexual subjects about their sexuality. 'I've never even thought about it,' the artist replied.

If there was one thing that Warhol was not interested in during the summer of 1978, it was overt engagement with politics, particularly gay politics. He was deep into his new role as a celebrity. Finally he had become a figure on the level of the famous people whom he had once depicted at a remove: Marilyn Monroe, Liz Taylor, and so on. Going to Studio 54 was fun – it satisfied his need for gossip, sociability and voyeurism – and it loosened him up. 'Andy had changed,' said the Italian journalist Daniela Morera. 'He was not afraid anymore.'

Studio 54 was at its very zenith, ready for a fall. Two articles that June – one in the *Village Voice* and one in *Esquire* – lifted the lid off the club's glamorous surface, to reveal a murky world of memberships that didn't guarantee entry, rampant drug-taking and possible Mafia involvement. Steve Rubell and Ian Schrager managed to finesse the membership issue with the Department of Consumer Affairs, but Henry Post's claim in *Esquire* that members were roughed up and abused, while being refused entry, ensured that some of the 'sour notes', as he called them, lingered.

The impending scandal exploded on 14 December. At 9.30 a.m., the IRS raided the club and found around a million dollars in cash stashed around the place – in the walls, behind the pipes, up in the roof. 'The *Daily News* had just called wanting a quote from me,' Warhol told his diarist. 'They said that fifty agents had gone in and raided Studio 54

for income tax and that they'd busted Ian Schrager for two ounces of coke.' Rubell's quote about the IRS the previous year had come back to haunt him.

The inspectors opened the safe and found the real books, which told the true story of how much the pair had earned and concealed from the taxman. While the raid was in progress, Schrager arrived in his Mercedes. The agents searched the car and found a further $100,000 in the boot. When they searched him, they found cocaine and arrested Schrager on a charge of possession with intent to distribute, before he was released on bail.

The IRS had been alerted by a disgruntled employee, Donald Moon, who had been summarily fired by Rubell. Taking his revenge, he had told the IRS where the money was hidden and where the real books were. In all, Schrager and Rubell were skimming off around $2.5 million a year, 80 per cent of the takings. It was alleged that they were paying off one of the Mob's loan sharks. When they were asked to turn him in, they threatened to make public alleged narcotics use by a White House chief of staff, which made the authorities even more determined to take them down.

———

On the day of the Studio 54 raid, 'Le Freak' by Chic was at #1 on the *Billboard* chart, having leaped from fourth place the previous week. It was the group's second major hit and a peerless example of their clean style, with all the disparate elements – female vocals, selectively used strings, funky yet mathematical, percussive guitar and pumping bass – locked together in perfect gliding motion. 'Just come on down to the 54 / Find your spot out on the floor,' they sang in an apparent exhortation, but it hadn't been quite that simple.

Reviewing the song for 'Disco File', Vince Aletti called it 'a brittle, brilliantly crafted, super-glossy pop tune that manages to be quite charming and quite heartless at the same time. There is nothing the least bit freaky about "Le Freak", but its very safeness has been the key to its success.' A success it most certainly was – at the time, Atlantic's biggest-selling single, and one that would see-saw on and off the #1 spot until well into

the new year. Yet such was the craft that went into the record that it was easy to miss a dark undertow.

The inspiration for 'Le Freak' had come nearly a year before, when Grace Jones invited Nile Rodgers and Bernard Edwards to attend her New Year's Eve show at Studio 54. The idea was that the pair would catch her performance and talk through some production ideas. Chic were hot, with a big dance-floor hit in the charts: on 30 December, their first single, 'Dance, Dance, Dance (Yowsah, Yowsah, Yowsah)', was in the Top 30 after ten weeks in the *Billboard* Hot 100, on its way to an eventual peak of #6 in late February.

As their name suggested, Chic were concerned with ideas of sophistication and branding. When Edwards and Rodgers were working out how to orient themselves in the world of music, they were inspired by the facelessness of Kiss, whose individual personalities were subsumed within a strong visual identity, and the gloss of Roxy Music, whom they thought 'slick and suave', with 'sexy cover girl imagery'. As Rodgers remembered: 'Slick and suave. Check! We could do that. Their art direction was as important as their music. Check! We could do that.'

Chic weren't initially completely convinced by disco – particularly novelties like Walter Murphy's 'A Fifth of Beethoven' – but it provided a grid onto which they could pour their own musical interests: as Rodgers summarises, 'a fusion of jazz, soul, and funk grooves with melodies and lyrics that were more European influenced'. Signed by Atlantic Records, who were falling behind in the highly competitive dance market, the group quickly hit pay dirt with 'Dance, Dance, Dance (Yowsah, Yowsah, Yowsah)' and its accompanying album, simply called *Chic*.

Rodgers vividly remembered that New Year's Eve and the humiliation they suffered. It was snowing outside, and both he and Edwards were dressed up to the nines in Cerruti and Armani dinner jackets, Afros and wing-collar shirts – living up to their brand name. When they got to the door, their names were not on the guest list. When they asked doorman Marc Benecke to check through the list again, they were told to 'fuck off'. Smarting at the rejection, they walked through the snow to a friend's nearby apartment and began jamming on a riff and shouting out Benecke's words. Edwards heard something in the riff and the chorus,

even though it would have been impossible in its then current form to get it on the radio. The pair changed the phrase 'fuck off' to 'freak off' – the name of a popular underground dance that would surface the next year in records like 'Freak with Me' by the Universal Robot Band – and eventually changed 'freak off' to 'freak out'. With the reference to a new dance satisfying the pair's 'flair for Deep Hidden Meaning', and a French phrase – '*c'est chic*' – to add the requisite European flavour, the song was ready to go.

Featuring Luther Vandross alongside the group's patented double female lead vocal, provided by Alfa Anderson and Robin Clark, 'Le Freak' was released on 21 September 1978. Entering the Top 100 a month later, it was in the Top 10 by the end of November, after an amazing jump from #37 to #6. By 9 December, it was at #1, where it would stay for five weeks. 'We got our first seven-figure check for the label's only triple-platinum single (six million in those days),' Rodgers recalled. 'The Zen of it was, by not getting what we wanted, we got more than we imagined.'

The biggest song of the season was a successful curse. 'Le Freak' had begun as a howl of rage about Studio 54 and its exclusive, cruel door policy; by the time it was at number one, the club was in deep trouble. Andy Warhol's diaries from the Christmas period reflect a growing disenchantment with Rubell and the club. After the bust, he stopped calling the owner 'Stevie'; from then on, it would be just 'Steve'. The revelations of financial malpractice at Studio 54 had pricked the bubble, and the distancing process had already begun.

During the later 1970s, Warhol – together with his friends and colleagues Halston and Truman Capote – became subsumed within the world of the old rich, the new rich, the famous and, in one notorious case, the authoritarian. In his life, shock tactics, artistic practice and any hint of gay liberation were downplayed in order to be acceptable, to function as a service economy to the very wealthy and the American establishment. In this, he continued to accurately reflect one aspect of his time.

Unlike Capote, Warhol never laboured under the illusion that these people were his intimate friends, but his involvement with Studio 54 was part of the same process. With a gay owner, a gay DJ and gay functionaries

– barmen, busboys, dancers – Studio 54 marked some kind of acceptance of homosexuality within the new mass culture of celebrity. However, the club downplayed any gay involvement. It might have traded on the fertility of gay club life to attract celebrities, but in this fantasy world, gay people were at best facilitators, at worst courtiers.

34
The Village People and Sylvester

SYLVESTER

Sex disco music will be fabulous. I want to have someone fuck on the record and record it, the sounds. Not moaning or groaning, but the sounds of sex, the sounds of touching, the actual sounds of penetration. Nice music and close miking. It's not gonna be a record for sex, it's a record for dancing, with sex.

Davitt Sigerson, 'This Man Was Singing About It Years Before Tom Robinson', interview with Sylvester, *Sounds*, 26 August 1978

The ubiquity of disco in 1977 and early 1978, and its acknowledged roots in gay life and club culture, gave rise to the possibility that gay people – in particular, gay men – might have hits and be recognised for who they were. As in the early stages of any boom, the field was, for a brief time, open to previously marginalised producers and performers who, in this case, were emboldened to make more explicit statements than ever before. In 1978, two gay-identifying musical acts, the Village People and Sylvester, had big hits, and in so doing, injected some reality into the mass market.

The two were very different, although each reflected identifiable styles. The Village People took the clone look – the hard hat, the Native American, the leather man, the military man, etc. – and turned it into easily identifiable stereotypes. Sylvester was harder to pin down: on the surface, he presented as *femme* – a relic of his time with the Cockettes – but his style was far subtler, coalescing in what could be called cosmic androgyny, where male and female fuse into one another.

Both were making waves in early 1978. In mid-January, *Gay News* published a long interview with Sylvester, who was more than happy to affirm his sexuality: as Jean-Claude Thevenin wrote, 'His press release also mentions that it was his grandmother, a Blues singer during the '30s, who helped Sylvester accept his gayness. "It's true. She'd met quite a few gay men and so she saw the signs in me early in my life. When I was in my teens she told me to live the way I wanted to, not to pretend. So I took her advice and did exactly that."'

In late February, while Sylvester was beginning to record his next album, the Village People released the titular single from their second album, *Macho Man*. With single entendre lyrics like 'I've got to be a macho (Dig the hair on my chest?) / Macho, macho man (say dig my big thick moustache),' it was hardly subtle or even serious. Campy in its own way, it nevertheless reflected the increased machismo of the gay clone style, from which subculture the group's imagery was taken and, eventually, turned into living dolls.

The gay-themed *Macho Man* album was released at the same time. Vince Aletti found 'the glorification of macho dubious at best (oppressive at worst especially in a gay context, which this certainly is) but its

treatment by the Village People is comic enough not to be taken seriously and driving enough to be irresistible dance material. Following this shamelessly narcissistic number, "I Am What I Am" extends the same sound to a rousing song, part plea, part demand for tolerance, taking "I Was Born This Way" the necessary one step further.'

From late 1977 through to the end of 1978, the Village People and Sylvester found the timings in their favour. While Sylvester's 'Over and Over' was a hit on the *Billboard* dance chart in early 1978, his follow-up, 'Dance (Disco Heat)', would crack the Top 20. The Village People, meanwhile, would have two Top 30 hits by the end of the year: 'Macho Man' and 'Y.M.C.A.'. At the same time, both artists' second albums – *Macho Man* and *Step II* – were Top 30 successes.

These achievements were, in the short term, a triumph for the ability of disco to bring varying aspects of gay life into the mainstream, but it was not without its tensions. It was definitely strange that disco – a very popular music form shaped and consumed by gay people, one that had helped them develop a highly noticeable lifestyle – should have virtually no records made by the people that it represented. Partly that was due to the hostility of the American music industry; partly it was down to not finding the right approach or presentation.

Only Sir Monti Rock III had broken through the glass ceiling, with his two hits as part of Disco-Tex and the Sex-O-Lettes, but he was an MC, almost a carnival barker. Born in 1942, he was more of an outrageous 1960s queen of the previous generation. Disco-Tex's hits were short-lived and, although his performance in *Saturday Night Fever* brought him to a wider audience, he was not representative of current gay life. Yet he introduced the idea that gay men could ride the disco wave on the way to some kind of visibility, even credibility.

In early 1978, the incredible success of *Saturday Night Fever* and the Bee Gees was taking all the available air from not just any other pop act, but from disco's gay, Black and Latino origins. The late-January opening of a brand-new New York club, Paradise Garage, would keep the spirit of the original Loft mix going, but the venue would take a while to find its feet. Meanwhile, the momentum was building for more gay performers to sing gay songs for a gay audience, and if possible, to have hits.

———

I t had been a long time coming, and not without a couple of honourable attempts. The underground gay taste for Black American female vocalists was already well established – early Loft/Tenth Floor favourites included Lyn Collins's 'Think (About It)' and Patti Jo's transcendent 'Make Me Believe in You' – and indeed, with records like Gloria Gaynor's 'Never Can Say Goodbye' and LaBelle's 'Lady Marmalade', it started to determine the pop charts in late 1974 and 1975. These were records adopted by the subculture.

As disco boomed, it pulled in other records that could be adapted to give meaning to circumstances. A perfect example was offered by Frankie Knuckles, talking about the Trammps' late-1975 release 'That's Where the Happy People Go': 'The Trammps I think actually made one of the first disco songs that really catered to gay people. I don't think they were actually saying that's where gay people go, but of course people latched onto that and it was almost like a theme song for a long time.'

The first overt gay liberation disco record emerged in February 1975, and was quickly noted by Vince Aletti in his 'Disco File' column: 'Bunny Jones' Gaiee Records, designed as an outlet for openly gay performers – an idea whose time has certainly come – has been picked up for distribution by Motown. Gaiee already has something of an underground hit on its hands in Valentino's "I Was Born This Way".' With lyrics like 'I'm happy, I'm carefree, and I'm gay', this was no victim anthem.

The record was an idea whose moment had arrived, and the upbeat approach of both sides – the flip was titled 'Liberation' – denoted a new confidence. 'Valentino – christened Charles Valentino Harris when he was born on May 4, 1952 in Selma, Alabama – is gay and proud to be that way,' wrote John Abbey in July that year, when he interviewed the singer in the British Black music magazine *Blues & Soul*. '"And I'm happy to be that way," he smilingly stressed. "I'm proud to be gay."'

The whole package, from writing the song to its release, was put together by a Black American woman in her mid-to-late forties, Bunny Jones. A trailblazing entrepreneur, she had built up a chain of beauty

salons in the 1950s and '60s and become a strong presence in Harlem. She met many gay people in her line of work and had many gay friends. Appalled at how they were treated by society – feeling 'that gays are more suppressed than blacks, Chicanos, or other minorities' – she wrote the song as an upbeat anthem in 1971.

It took a while to find the right singer, but in 1974, she hired twenty-two-year-old Charles Valentino Harris – who had performed in *Hair* as a dancer – to make the lyric a reality. 'I loved it right from the beginning,' he said at the time. Working with Valentino and composer Chris Spierer, she recorded the song in an *echt*-Motown style and released it on her own label. As she told *The Advocate*: 'I named the label Gaiee because I wanted to give gay people a label they can call home.'

'I Was Born This Way' was seen as controversial at the time, dealing as it did, in John Abbey's words, 'with the situation by which the artist is gay. It has a lyric which pulls no punches and is refreshingly open about a subject that remains a mystery to many of us'. It got good press in *Gay*

Promotion for 'I Was Born This Way' in *Gay News*, no. 73,
19 June–2 July 1975

News, where Denis Lemon noted that it was popular in New York disco-theques and called it 'one of the finest gay recordings ever produced'. He did, however, predict the record's fate in the UK: 'It is likely the radio station controllers and programmers will demonstrate their prejudices by denying I Was Born This Way airtime.' In the US, it sold around 15,000 copies and created a bit of a buzz in the dance clubs, but when Motown bought the rights and the name of the label in an attempt to promote gay records in general, the single and the idea of a gay catalogue fizzled out. Valentino would not record again.

Motown did, however, nurture the career of another early entrant in this field, the Dynamic Superiors, whose lead singer, Tony Washington, was openly gay. In 1975, the label released the group's second album, *Pure Pleasure*, which featured a front-cover photo of definitely male, hairy legs, topped by a pair of hands wearing red nail polish. On the lead single, 'Nobody's Gonna Change Me', Washington spoke covertly yet with confidence of his gay pride: 'It ain't so easy getting along / But every day I'm feeling strong / Don't give me no contradictions / I got my own convictions.'

While the Dynamic Superiors toiled in comparative obscurity, Motown revived 'I Was Born This Way', this time with Carl Bean, an openly gay man and devout Christian. In February 1978, Vince Aletti previewed it as 'a superb, driving Philly production by Norman Harris, Ron Kersey and T. G. Conway (executive producer is the song's composer and prime champion, Bunny Jones). The message is a relevant one for the disco community, though many of us are ready for something considerably more militant and aggressive.'

'Macho Man' overlapped with Carl Bean's record on its release, but there would be only one winner. For, despite the fact that the group epitomised gay stereotypes – to the point of almost being Castro carica-tures – the Village People were curiously non-threatening. Like Valentino, they were put together as a package by a producer/entrepreneur, but they were even more disassociated from the process: the six types pictured on the album sleeve had been quickly cast and assembled after the original studio-bound concept was shown to have legs.

The Village People were originally put together in 1977 by Jacques Morali, a French Eurodisco producer, and his Moroccan lyricist, Henri

Belolo. After getting hooked on the Philadelphia sound, the pair moved to America in 1973 and, after recruiting three singers, created a disco act called the Ritchie Family, who had two Top 20 hits in 1975 and 1976 with 'Brazil' and 'The Best Disco in Town'. Their four albums, including the Top 30 hit *Arabian Nights*, were lush disco concepts and travelogues.

Morali got the idea for the Village People in early 1977, when he and Belolo saw a young man called Felipe Rose walk through the West Village, dressed from head to toe in the Native American costume that was his heritage. They followed him into the Anvil, where he worked as a table dancer. When they saw a man wearing cowboy drag watching him intently, they got the idea for a group that would represent gay American males. As Morali later stated, it was fantastic 'to see the cowboy, the Indian, the construction worker with other men around'.

Morali and Belolo took the idea of a gay-identified group to Neil Bogart at Casablanca Records – flush with money after his huge success with Donna Summer – and the first album quickly followed. Released in July 1977, *Village People* featured recognisable gay types on its cover – Rose and singer Victor Willis surrounded by stand-in models wearing checked shirts, bandannas, hard hats and tough expressions – and featured four songs that hooked into a concept based around gay hot spots on both coasts: 'San Francisco (You've Got Me)', 'In Hollywood (Everybody Is a Star)', 'Fire Island' and 'Village People' (about Greenwich Village).

With a grainy, almost sweaty, black-and-white sleeve photo that made the models look intimidating, and lyrics that mentioned leather, open-air cruising and Fire Island venues like the Sandpiper and the Ice Palace, there was no doubt at whom the record was marketed. Indeed, the title song, 'Village People', was a call for gay solidarity, if not liberation: 'To be free / We must be / All for one.'

With its mix of Philly International and Eurodisco, the music was right on point, and crossed over. But the unexpected success of *Village People* – it made #54 in the *Billboard* album charts and sold 100,000 copies – left Morali and Belolo with a problem. Initially, the group was just a studio concoction: only Rose and Willis were actively involved. As the demands for live performances and personal appearances increased,

Morali revisited the West Village to find a more permanent set-up. After two hundred auditions, he eventually found his People.

Cowboy Randy Jones was one of the first, meeting Morali while he was dancing on stage with Grace Jones at the 1977 *Billboard* Disco Forum. The other members were recruited after a marathon series of auditions: Glenn Hughes, a worker on the Brooklyn/Battery tunnel, became the leather-clad biker with the huge moustache and hairy chest; David Hodo, formerly a Broadway chorus boy, became the construction worker in hard hat and checked shirt; while Alex Briley, who had sung on the first album, made up the numbers as a Black American stud. With Willis as the frontman, this was a racially mixed boy band of adult men, not necessarily all gay, fashioned to simulate the types that Morali and Belolo saw in Greenwich Village. After the *Macho Man* album was released in late February, the freshly assembled Village People were thrust into a round of interviews and PAs. Their new image was not threatening or even particularly sexy, but highly etched and precisely detailed in the bright, primary colours of the *Macho Man* album sleeve. This was not documentary but show business.

While the first album's cover deposited the viewer right into the gay subculture – the bar gatherings that occurred in the Village and the Castro – the one for *Macho Man* saw the Village People disassociated from their gay roots. They were a pop product, with six separate images on the back that included their names, their functions and their star signs. In another group shot, Morali was pictured sitting in the central position: dressed all in white, he is holding his left hand to his chin in a pensive mode. He is determinedly non-macho.

Even in April 1978, the Village People saw their future in traditional terms. They told writer Mark Bego 'about how they saw their stage act evolving into a spectacle of a Broadway show scale'. Clearly, these were not politicos or gay liberationists. They were there to sell records and did what they were told to do by Morali and Belolo. As both the single and the album gained momentum, the group began to backtrack from the obvious gay implications of their image.

While acknowledging their roots in Greenwich Village – described by *Blues & Soul*'s David Nathan as 'a cosmopolitan area which is noted in

particular for attracting many folks with alternative lifestyles, attitudes' – they told the magazine that 'we want to present a particular concept of masculinity because we feel that with the advent of women's liberation, men have had a hard time having any real images to look to. Especially young people.'

As they began to morph into show-business caricatures that summer, their supposed core audience became less enthusiastic. 'I'm gay and I wanted to make a top star gay group,' Morali had told *The Advocate* that April, but 'Macho Man' reportedly got a tepid response in gay bars as it crossed over into the mainstream. In response to this new audience, the six members of the group did not talk about their sexuality in interviews and refused all labels of race, sexuality or musical genre.

'Macho Man' entered the *Billboard* Hot 100 on 24 June 1978, the beginning of a long, slow climb that would see it peak at #25 in early September. The previous week, Vince Aletti had previewed Sylvester's new record: '"You Make Me Feel (Mighty Real)" is classic Sylvester and a stunner – set to a driving yet comfortable synthesiser pace, jumping with electronic effects but always emphasising Sylvester's androgynous lead which builds to a nice gospel-tinged climax.' Aletti expected the record to hit big, and his prediction was correct.

Within weeks, both David Mancuso and Larry Levan were including 'You Make Me Feel (Mighty Real)' in their 'Disco File' Top 10s – high praise from the DJ dons. The single would project Sylvester into the stardom that he had always desired, but it had been a long and, at times, bitter haul. He was thirty when the record was released, and it had taken many false starts and many lost opportunities, until, his voice surfing and soaring above the synthesisers, Sylvester found a song and a sound that matched his life and his essence.

B orn in September 1947, in South Central Los Angeles, Sylvester was raised by his teenage mother Letha and his aunt Juju – 'fierce women', as he remembered them. Abused at the age of eight by a choir leader at the local Pentecostal church, he refused to blame himself

for his sexuality or see himself as a victim. He was open about his sexuality and gender fluidity, wearing women's clothes from his early teens on.

Sylvester refused to compromise. After receiving validation from his grandmother – who, as he remembered, 'was the first person to tell me I was gay. She knew some queens in the thirties and they were her running buddies' – he drifted in and out of his mother's home. In his mid-teens, he fell in with a group of queens who called themselves the Disquotays, after the affected pronunciation of the title word in Chubby Checker's 1965 single 'At the Discotheque'. The gang's name was a pre-echo of his eventual success.

The Disquotays were all street kids, around fifteen to twenty of them, too effeminate to be employable in that era. Several of them took hormones and were in a pre-transitioning state. Despite the fact that it was illegal to dress in women's clothes – 'masquerading' was a crime that could result in prison – they hit the gay bars and the Sunset Strip in various manifestations of drag, taking their cues from models like Veruschka and Twiggy and magazines such as *Vogue* and *Harper's Bazaar*. Their ideology was simple and rigidly adhered to: 'Be Fabulous, Be the Party, Look Good.'

By early 1970, that particular party was over. Sylvester enjoyed expressing his feminine side but never wanted to become a woman. Even at that early stage, he was interested in gender-blurring, while having an active gay side. Los Angeles suddenly seemed played out; the only identities that seemed possible for feminine men there were drag queen, transsexual or standard gay guy. When he was invited to San Francisco by a member of the Cockettes, Goldie Glitters, he jumped at the opportunity.

Initially crashing with the future Screamers singer Tomata du Plenty, Sylvester soon met the other Cockettes. His introduction involved him doing Billie Holiday impressions, wearing a floral shirt tied up at the waist and a black do-rag. The troupe needed a singer for an upcoming show, but they were all white and had no gospel experience. Although initially reluctant – 'I was really really scared. It was nothing I wanted to be part of' – he joined in time for the August 1970 show, *Tropical Heatwave*, where he sang 'Stormy Weather'.

Moving into the principal Cockette commune, Sylvester enthusiastically embraced some elements of the lifestyle: the thrift shopping for

vintage and women's clothes; the use of psychedelic drugs; the lack of everyday constraints. But he always held himself back from the deepest craziness. Although he appeared as part of the troupe in shows like *Pearls Over Shanghai*, he was already making solo appearances by January and February 1971, performing songs by Ethel Waters, Leonard Cohen, Judy Garland and Bessie Smith.

Sylvester's Blackness, insistence on glamour and his focus meant that he always stood apart. 'I was in the lifestyle for a penny and for a pound,' Fayette Hauser remembered, 'and for me the Cockettes came out of my lifestyle. But for him, it was the other way around. He had other things to do. Sylvester was never a hippie like we were. He didn't want to toss it all away. He wanted to sing in drag and that's what he did with the Cockettes. He was interested in being an artist.'

As his performances with the group evolved, Sylvester began to identify with the 1920s jazz icon Josephine Baker. 'I was always the glamorous thing, on and off stage,' he remembered. 'I really believed for a certain time that I was Josephine Baker. In my attitude, in my everything, I WAS Josephine Baker. I'd go out with a headdress and a sort of silly costume, and men would open and close doors for me, light my cigarettes. I wouldn't get out of a car until someone opened the door for me.'

Encouraged by the air of fantasy that permeated the Cockettes, Sylvester started to go deep into his grandmother's world. In 1971, he told *Rolling Stone* that he wanted to sing the same songs as she did: tracks by Billie Holiday, Bessie Smith or Victoria Spivey. He wanted to recreate what Black audiences in the 1920s had seen in Harlem or Chicago's South Side, and his dream was to have his own splendiferous tent show, with art deco sets and Busby Berkeley-style extravagant staging.

By the time of the Cockettes' New York debut in November 1971, however, Sylvester was thoroughly fed up with the whole circus. While the others partied, he rehearsed every day for the show. Coming out half-naked in pants and boots, with a white guitarist and bassist, a trio of Black women backing singers and a repertoire drawn from Nina Simone and the Rolling Stones, he was the hit of the show, according to the *New York Daily News*, while the *New York Times* held that he 'wailed and shouted rock and soul like an Aretha touched with Sumac'.

It was time for him to make his move. On the second night, Sylvester apologised from the stage for being involved with the Cockettes, whom he called a travesty. On the fourth, he refused to sing, while telling the audience that they could see the performance for which they had paid hundreds of dollars for a pittance in San Francisco. When the audience got rambunctious, Sylvester told them they were suckers and walked off. It was a bitter end to his association with the troupe.

Returning to San Francisco, Sylvester played a few solo dates, before putting together his Hot Band. The idea was that he would be as flamboyant as possible, while the rock-oriented group would provide musical legitimacy. With the heterosexual band members pressed, rather awkwardly, into sequins, beads and lamé, Sylvester sang contemporary standards like the Beatles' 'Blackbird', Wilson Pickett's hit version of 'Stag-O-Lee' and Neil Young's 'Southern Man'.

By October 1972, they were well known enough to support David Bowie at San Francisco's Winterland. An early supporter was the writer Richard Cromelin, who caught several Hot Band performances in the Los Angeles area and, in April 1973, singled out Sylvester's persona as worthy of note: 'He's gay, but his image encompasses an extensive portion of the sexual spectrum, transcending rigid categories and obliterating arbitrary distinctions. The old blacks and whites are melted and blended into a finer shade of grey.'

Sylvester was one of the very first artists in rock-era America to be honest about his sexuality. This was radical stuff, even for 1973. While Bowie and the New York Dolls played around with ideas of gender and the possibilities of masculinity from a heterosexual or bisexual perspective, Sylvester came straight out with the truth. The only other person to do so at the time was Jobriath. While he did not benefit from the same amount of hype, Sylvester was a much more substantial artist.

Despite the Hot Band's promise, neither *Sylvester and the Hot Band* nor the album's follow-up, *Bazaar*, came near the charts or close to unlocking the singer's potential. The problem was that their record company, Blue Thumb, was trying to fit Sylvester into a rock bag, with virtuoso musicians and wildly disparate material that ranged from 'A Whiter Shade of Pale', 'God Bless the Child' and 'Nobody's Fault but Mine' to the early national anthem, 'My Country, 'Tis of Thee'.

Nineteen seventy-four was a lost year for Sylvester. After the Hot Band broke up, he lost his record deal and split up with his partner, Michael Lyons. Expelled from France after causing a fracas – in July, *Rolling Stone* mentioned that in Paris, people had followed him from store to store, calling him 'an ugly American' – he travelled to England. When that didn't work out, he returned to San Francisco in dire penury and began playing in the Castro with a small band made up of a pianist, drummer and keyboardist.

Becoming a Castro feature over the next year or so, playing the clubs and the annual Street Fair, Sylvester's career began to pick up momentum. In 1976, he acquired a new manager, Brent Thomson, who persuaded him to get rid of his drag queen appearance in favour of short hair and a smart suit. He also, crucially, got three new musical partners: the guitarist and arranger Tip Wirrick and former gospel singers Martha Wash and Izora Rhodes, who became the Two Tons o' Fun. The three made for an impressive front line.

In August, Sylvester began a season at the Palms Cafe on Polk Street, where he played songs by Aretha Franklin and Leon Russell, and, most importantly, an Ashford & Simpson song he had seen the pair perform on *Soul Train*, 'Over and Over'. Through Martha Wash, he attracted the attention of industry veteran Harvey Fuqua, whose credits went right back to early doo-wop through to Motown and who was looking to find and develop talent in association with local label Fantasy Records. Fuqua saw Sylvester perform in the Castro and was blown away.

In February 1977, Sylvester went to Fantasy Studios in Berkeley to begin recording his first album. He nailed 'Over and Over' in one take. On the nine-minute dance-club version, the song begins in Philly International style, with sweetening strings and horns, before Sylvester comes in with his extraordinary voice, as high as a woman's yet identifiably masculine. At around four minutes, the track breaks down into clapping and crowd noises, before picking up speed into a full disco rush.

However, Fantasy were hedging their bets. Although there was another strong club cut – the Sylvester composition 'Down, Down, Down' – the album suffered from the singer's perennial identity crisis on vinyl: uptempo bangers were followed by testifying ballads or mid-paced call-and-response

numbers like 'I Been Down'. There was too much midtempo funk for the emerging disco style, which was simple and streamlined and fast, and which rarely featured guitar solos.

Fantasy's hesitancy extended to the marketing and the album sleeve. In the early publicity material for the record, much was made of Sylvester's past with the outrageously gay Cockettes. However, the label began to backtrack once reviewers commented on the startlingly androgynous back cover, which showed Sylvester resplendent in full drag, with sequins and earrings. Although the singer was pictured in short hair and male attire on the front, he was wearing lipstick and rouge.

Fantasy quickly pulled the cover, replacing it with an image of Sylvester in a white jacket, white shirt and short hair, holding a rose. The reverse was blank, except for a patterned background and the song information. While the cover and the press release were quickly amended to elide Sylvester's homosexuality, the singer wasn't having it. 'All my songs are associated with being gay,' he told *San Francisco Gay Life* that summer. 'I've never been straight. When I sing a song, I sing the lyrics as they were written. I don't change the pronouns.'

Marketing Sylvester was also a huge problem for his label. Black radio did not pick up on the album, and there is some evidence from a local Berkeley DJ, Leslie Stoval, that 'he was informally blacklisted because he was gay. Black radio is very macho, and they weren't ready to give this gay man his place. They didn't want to deal with it.' Nevertheless, 'Over and Over' went to #18 in the US dance charts, and the money that came in gave Sylvester some stability. Realising where his future lay, he got an apartment right above the Castro, in the Twin Peaks district.

For most Sundays that year, Sylvester played in a club called the Elephant Walk, in the Castro, with a repertoire taken from Diana Ross, James Taylor, the Doobie Brothers and LaBelle. There, he could be who he really was and, despite the Castro's antipathy to Blacks and *femmes*, he was well loved. As the poet Aaron Shurin remembered: 'Everybody adored him. He was somebody who annihilated the schism between the clones and the faeries. Everybody felt like they owned him. Everybody felt like he was speaking for them.'

Nevertheless, 1977 ended on a low: a disastrous tour of Mexico was followed by the loss of his band – Sylvester was never very good at keeping musicians together. In early 1978, he travelled to the UK, where 'Over and Over' had received a good reception. 'I believe in individuality and that is the purpose behind the album sleeve,' he told John Abbey of *Blues & Soul*. 'You see, I understand both sides of me and I don't believe that being soft and loving makes me any less of a man, as such.'

'Over and Over' brought Sylvester greater visibility. In the spring, he began preparing his second Fantasy album, road-testing the material several days a week at San Francisco venues like the City Disco. He'd previewed the album to Abbey as a timepiece from the 1920s and '30s, but he quickly realised that it wasn't happening: it was too much like the hodge-podge of material found on *Sylvester*. He'd been ploughing that furrow for nigh on five years, without any major success. It was time to move on.

The momentum of his most disco-fied track to date was too strong to ignore. Sylvester needed futurism, not retro, and the answer came from within the gay subculture that he represented. With the album under way, he continued to play the City Disco, and that's where, in late May 1978, he met the lighting designer Patrick Cowley, who had a strong calling card: the previous year, he had constructed a massive, sixteen-minute mix of Donna Summer's 'I Feel Love' that enhanced its disco pulses and mechanical peaks and pushed them into the stratosphere.

When he met Sylvester, Cowley was in his late twenties. Born in Upstate New York, he was a musical child who found his métier when he enrolled on an electronic music course at San Francisco's City College. Learning quickly on a reel-to-reel tape recorder and an English VCS3 synthesiser – the same model that Brian Eno used with Roxy Music – Cowley formed an electronic jingle company with two friends, while involving himself in the city's gay subculture, living with ex-Cockette Scrumbly and providing the music for a post-Cockettes revue.

Cowley started recording his own music in 1975, beginning with Herbie Hancock-style funk – with heavy synth overtones – and progressing to electronic covers of 'Papa Was a Rollin' Stone', Herbie Hancock's

'Chameleon', 'Do It Any Way You Wanna' by People's Choice and 'I Feel Love' by Donna Summer. Like so many others, when Cowley heard the latter, he saw the future laid out before him. It was a short step from his early ten-minute cover to the explosive remix that he completed in September 1977.

He was right on trend. 'Perhaps the most significant development in disco this year is the success of totally synthesised music,' Vince Aletti wrote that August, citing Kraftwerk's 'Trans-Europe Express', Donna Summer's 'I Feel Love', 'Magic Fly' by Space and Giorgio Moroder's 'From Here to Eternity'. That autumn, Cowley produced his first commercially released mix, an exploration of Michele's 'Disco Dance' that exploded into phased, time-lapsed deep-space and deep-sex sounds for the second half of its fourteen minutes.

Cowley's immersion in disco, funk and synthesisers went hand in hand with his explorations of the San Franciscan sexual underworld: as he wrote that September, 'Romance is on the rise. Tonites [*sic*] menu a burger & a fuck. The blond man bent over the table in the woodshed reminds me of fucking a tight woman . . . a great grip.' Beginning in 1974, his diary covers every encounter and every permutation, in venues like the Club Baths, the Folsom Street Barracks and the 'Til Dawn Glory Holes at 1808 Market Street.

His remix of 'I Feel Love' was homosexual sex in sound, unfettered and unashamed, insistent and hallucinatory; a gay bathhouse in music, a masterpiece of synaesthesia. When Cowley sent a copy to Donna Summer's record company, Casablanca, hoping for a release, they rejected it,* but he knew he'd fashioned a breakthrough, and Sylvester's 'You Make Me Feel (Mighty Real)' was the perfect next step. The singer was bored with his existing sound and ready for the something new that Cowley could provide.

Sylvester had already recorded a midtempo version of 'You Make Me Feel (Mighty Real)', but, given a free hand, Cowley drastically upped the pace, stripped away the underpinnings, streamlined the arrangement, added percussion (bongos and handclaps) and drenched the track with

* It was eventually released on Casablanca in 1982.

Moroder-style pulses, synthesiser melodies and counter-melodies that simulated the effect of drugs like marijuana and poppers, turning the twelve-inch mix into a constantly repeating, six-and-a-half-minute symphony of sex, longing and intimacy.

Beginning with a galloping, mechanical bassline – which would soon become a staple of Hi-NRG – the twelve-inch mix of 'You Make Me Feel (Mighty Real)' begins the melody with a synthesiser whoosh. Sylvester's lyric describes an encounter that starts in the first verse and moves quickly to a bedroom scene in the second. After two minutes, the mix becomes a jam, with Sylvester vamping on the 'feel real' lyrics and the synth melodies exploring various spirals of increasing intensity. Punctuated by regular whoops, Sylvester's voice is helium-high, matching the tone and melody of the synthesisers. As the track churns away over its final minute, there are wordless sex noises.

'You Make Me Feel (Mighty Real)' was a major gay liberation statement. Not only did it come out of the deepest recesses of the gay world – the bathhouses, the back rooms, the drag scene – but its lyrics went right to the heart of one of gay liberation's prime tenets: the ability to shrug off self-hatred and be proud. 'I feel real when you touch me' speaks of the excitement of guilt-free sex, while 'I feel real when you want me' goes further, into the realm of mutual desire – the revelation of two people discovering that they are free to be who they are.

Gay men had not been allowed to 'feel real' for as long as they had known they were gay, from adolescence and beyond. Most had grown up without any positive role models or people in the wider culture with whom they could identify. There were doors opened, possibilities invited, but not consistently enough to counter the relentless heterosexual propaganda that not only excluded gay men, lesbians and the non-gender-compliant, but also young heterosexual men who were not satisfied with the restrictive definitions of manhood.

This had huge implications in the Castro and beyond. 'You Make Me Feel (Mighty Real)' could hardly have come from anywhere else but San Francisco, a city transformed by Harvey Milk's ability to turn the gay cohort into a visible political power. Gay people, particularly male homosexuals, were on the up, and it was time for them to be fully represented

in a pop culture that had long offered them shelter, hope and even some kind of affirmation. Taken as it was from Black American culture, 'realness' was the perfect metaphor.

Sylvester had finally found the sound to match his voice and his presence. In mid-June, he went to the third *Billboard* Disco Forum in New York. Barely heralded, he spent his time trying to work out what made disco such an industry sensation, and put his research into his next album, *Step II*. The first side was a brilliant mix of 'You Make Me Feel (Mighty Real)', 'Dance (Disco Heat)' and a reprise of the former.

Sylvester didn't have to wait long for the fame that had eluded him for so long, as his new twelve-inch hit the charts on both sides of the Atlantic. In the US, 'Dance (Disco Heat)' was sold as the top side. The seven-inch had another song on the flip, 'Was It Something That I Said', while the twelve-inch retained 'You Make Me Feel (Mighty Real)'. For its UK release in July, the seven-inch was flipped; 'Dance (Disco Heat)' would not appear until that October, as the follow-up.

This slight confusion didn't hinder the record's success: by August, the twelve-inch was at #1 in the *Billboard* dance/disco charts, where it stayed for six weeks. 'Dance (Disco Heat)' peaked at #19 in the Hot 100 that autumn, while 'You Make Me Feel (Mighty Real)' made it all the way into the UK Top 10, rising to #8. Released in early July, its parent album, *Step II*, also did extremely well, reaching a peak of #28 in the US, on its way to getting a gold album award for 500,000 units sold.

In August, Sylvester made a triumphant return to the UK, which he had left in poverty four years before. When he played clubs like the Sundown and the Global Village, he was met by mobs; at the Lyceum, he played his latest single to a crowd of 2,500. He did the rounds of radio, music press and *Top of the Pops*: after he performed on the programme twice in early-to-mid-September, 'You Make Me Feel (Mighty Real)' entered the UK Top 20.

Sylvester had become a star. The UK PR for Fantasy Records, Sharon Davis, found him 'a warm, considerate, introvert man who cringed at authority, bullies and heat' and who, despite having sought stardom for so long, wasn't quite ready for the reality. As he told her: 'I've always lived out my fantasies of being whatever I wanted to be – I did all the things

that I thought stars do. When I actually became one it sort of freaked me out.'

———

In early September, 'Macho Man' peaked at #25 on the *Billboard* Hot 100, while 'You Make Me Feel (Mighty Real)' reached the top position in Vince Aletti's 'Disco File' Top 20. The Village People record was a high-profile hit, which, as Aletti observed in his column, already had its clones in two versions of the old Spencer Davis Group hit 'I'm a Man', one by Macho, the other by Star City. *After Dark* termed the impact of the Village People 'Macho mania', while remarking on the group's similarity to comic-book superheroes and the masked rock stars of Kiss.

The notion of what a man was and could be had been through many permutations since Bo Diddley had adapted Muddy Waters' 'Hoochie Coochie Man' for his original 1955 recording. From that founding Black braggadocio through the Yardbirds hyperactive white-boy rave-ups to Bowie's bisexuality, the idea had taken many twists and turns. Jobriath might have made the homosexual possibilities explicit with his song 'I'm a Man' but had gained no traction. He was an oddity too far even for the gay subculture.

In 1978, with clones all around, masculinity had again been redefined. Yet the clone was a mixture of emulation, the 'real man' – the often desired and all too usually unavailable sex object – and parody. Despite the adoption of work clothes, they were worn too tight and were too pristine to pass for the real thing. And yet the clone turned on its head the whole idea of what a real man was. Real men certainly weren't gay, but here were gay men, wearing their clothing. How could a layperson tell the difference?

'"Macho Man" did not happen in gay clubs but in straight ones,' wrote the gay activist Andrew Kopkind. 'The Village People is the first gay-to-straight "crossover" group, a group with an originally gay image and following that's made it in straight discos. The funny thing is that straights don't really believe the group is gay. They love 'em in Vegas and . . . in Midwestern shopping centers. Did straights ever catch on with

Paul Lynde?* With Liberace? People will protect their identity at all costs; they'll pretend to the last possible minute that it's all an act.

'Gay activists have protested that Casablanca is deliberately closeting The Village People to make the act "safe" for straights. A Casablanca PR functionary says that producer Jacques Morali (who reportedly picked all the members except possibly the accomplished lead singer because of their tough good looks rather than their musical talent) became visibly upset when a *Newsweek* interviewer began probing into the gay issue. But the group is coming out, as it were, with ever more outrageous lyrics and postures.'

Kopkind cited the Village People's new single, 'Y.M.C.A.', as a textbook example of an ambiguous record that could appeal to the mass market and the gay subculture at once. Indeed, with its relentless Eurodisco pulse and gruff, shouted lyrics and emphases, 'Y.M.C.A.' was an unbearably catchy, if not simplistic, piece of music and arrangement that quickly made it into the charts after its October release. Entering the Top 40 in mid-November, it was the perfect trailer for the group's third album.

With its title taken from the gay sex hunt, *Cruisin'* took the gay ambiguities as far as they could go. The cover shot showed the group, still in their costumes, posing on various items of hardware – a digger, a police motorcycle, an army jeep – while disporting themselves like sex icons, particularly Randy Jones, stretching his groin in the sun. Here, the usual mix of camp and gay hints – 'Hot Cop', 'I'm a Cruiser' – were given a melodramatic finale by the pill-popper confession 'Ups and Downs'.

Despite being soaked in gay imagery and gay slang like its predecessor, *Cruisin'* was not popular in the gay discotheques of New York. Despite, or maybe because of, that appeal, the album swiftly entered the charts.

In the last week of November 1978, 'Dance (Disco Heat)' peaked at #19, which is where it stood on the day that Harvey Milk was assassinated. A couple of weeks later, Sylvester appeared on the mainstream network TV show *American Bandstand*. As usual, host Dick Clark

* Born in 1926, Lynde was an American actor, comedian and very popular game-show panellist who regularly appeared on programmes such as *Bewitched* and *Hollywood Squares*.

conducted an interview that, despite the whoops from the audience, was a little uncomfortable. 'It's getting a little strange in here,' he began, while Sylvester, resplendent in a long, curly wig, spoke in a soft, lisping voice. There is no doubt about who he is, and here he is, obviously gay.

Unlike the Village People, whose success he would not emulate, Sylvester was loved by the gay audience. A review of his December concert at the Roxy in Los Angeles noted that 'his hard-core constituency is gay and proud – the short-haired, T-shirted guys at ringside Thursday appeared to be greeting a messiah – but in inspirational songs like Patti LaBelle's "You Are My Friend" and in his charming, unaffected conversation, Sylvester adds a universal message of pride and determination to the celebratory entertainment of his lighter pieces.'

'He was wonderful,' says Vince Aletti. 'I saw the Cockettes on their first New York appearance and he was really the only legitimate performer. I liked him mainly because he made great records. He could carry off that double personality, being a guy and being a diva; he was actually out, and actually gay, it was important. The message of his music, and the fact of him – it's shocking, in a way, that there wasn't more of that in club life. There were occasional examples, but nothing else had that impact.'

In the final chart of the year, *Cruisin'* by the Village People stood at #15 in the album charts, beneath Donna Summer and Aerosmith, but above Rod Stewart. 'Y.M.C.A.' was at #8 for the second week, while 'Dance (Disco Heat)' was nowhere to be seen. It would be Sylvester's only US Top 20 hit. For a while, however, they had stood side by side in the Top 20, an eruption of the gay code and lifestyle into the American mainstream. In the short term, the prize would go to the showbiz clones, but in the long run, it would be Sylvester's realness that made history.

35
1979

There is a big cultural difference between rock and disco, and it's gayness. Some people don't like to talk about it, but it's true. Disco began in gay clubs. At first, it was just a case of speeding up the gap between records on the jukebox. But that's how the concept of continuous music began. The disco club was the first entertainment institution of gay life, and it started in New York, as you would expect.

Kenn Friedman of Casablanca Records, quoted in Andrew Kopkind, 'What We Do Now Is Disco: Gay Music Co-Opted by Straights', *San Diego Reader*, 16 August 1979

Nineteen seventy-nine would see disco's complete, albeit brief, conquest as a pop style and, as a direct consequence, a peak of gay visibility and acceptance. It might seem strange that such a functional, upbeat form should bear such freight, but for the previous fifteen years – ever since the true beginnings of post-war teen culture – pop music had been the one place in American and British societies where the then marginalised, in particular Blacks, women, gay men and lesbians, could have a voice and a face.

Together with the ubiquity of disco early in the year, this newly heightened visibility would help to engender a vicious backlash against both the music and the gay lifestyle with which it was largely associated. However, the practitioners of disco, especially Black American and gay artists, weren't going to fade into obscurity if they could help it – they merely changed tack – and in the same way, gay men and lesbians were not going to surrender their hard-won gains without a fight.

At the beginning of the year, disco acts ruled. On the chart of 6 January, the Bee Gees were at #1, Chic were at #2 and the Village People were at #7. As *Billboard* noted that week: '"Too Much Heaven" moves up to number one this week, becoming the trio's seventh top-slotted single, more than any other act has achieved in this decade. Elton John and Paul McCartney and Wings are second with six number ones . . . The move also makes the Gibbs the first act to string together four consecutive number ones since 1970, when the Jackson Five had four in a row.'

The mass media was falling in line. *Billboard* took stock of disco's domination, reporting that both AM and FM radio stations were succumbing to all-disco formats. This was big news, as radio DJs, who saw themselves as being in direct competition with their club counterparts, had for a long time been hostile to dance music. At the same time, a rush of TV stations began to feature disco: NBC's principal music programme, *The Midnight Special*, was about to showcase a series of appearances by the Village People, Sylvester and Chic.

The Bee Gees were still at the height of their superstardom, which, a year after *Saturday Night Fever*, showed no signs of abating. In January, they played a televised charity concert in New York's United Nations building to raise money for UNICEF, the United Nations International Children's

Emergency Fund. The brainchild of Robert Stigwood, it featured three of his acts – the Bee Gees, Andy Gibb and Olivia Newton-John – as well as Donna Summer and Rod Stewart. It was watched by 900 million people.

A month later, the Bee Gees released their first post-*Saturday Night Fever* album, *Spirits Having Flown*. A mixture of styles, it was trailed by the most overtly disco track, 'Tragedy', a song that refined their falsetto, emotive approach and took it into the realms of pure, ecstatic melodrama. The single and album were given the usual RSO hard sell, including a starring appearance by the group at the Grammy Awards, and despite the critics calling it characterless and boring, *Spirits Having Flown* was propelled to number one by the beginning of March.

In the *Billboard* chart of 10 March, there were two RSO acts – the Bee Gees and Olivia Newton-John – and five disco records in the Top 10: 'Y.M.C.A.', Donna Summer's 'Heaven Knows' and, in the Top 3, 'Tragedy', Rod Stewart's major disco move, 'Do Ya Think I'm Sexy?', and, at #1, Gloria Gaynor's 'I Will Survive', a showbizzy gay disco staple rescued from B-side obscurity by Studio 54 DJ Richie Kaczor, who played it non-stop and helped to turn it into a huge hit.

The Village People were on the crest of the disco wave. Promoted by an early pop video that made the most of its New York locations and the group's signature, by now finely tuned look, 'Y.M.C.A.' went all the way up to #2 in the US, where it stayed for three weeks, and topped the UK charts for the same amount of time that January, selling over a million copies in both territories. By early March, the *Cruisin'* LP was topping out at #3 in the American album charts, after a four-week run.

That month, Casablanca Records released the group's fourth single, 'In the Navy'. The record was completely formulaic, but that didn't stop it from entering the charts almost immediately, enhanced as it was by an exquisitely camp video that showed the group performing, with the cooperation of the US Navy, on the frigate USS *Reasoner*, accompanied by a couple of hundred seamen. By mid-April, it stood just outside the Top 20, on its way to a peak of #3. The group were now superstars and were granted the accolade of a *Rolling Stone* cover story in April.

Gay ghetto imagery, however sanitised, had gone totally mass market, and it surprised no one more than the group's producer and packager, as

Vince Aletti remembers: 'I was really friendly with Jacques Morali. He was funny and charming. I knew Jacques before Village People. I remember thinking it was hilarious and silly. He didn't take it terribly seriously either. The fact that it got over in the way that it did, I still can't believe it. "Y.M.C.A." is kind of a wedding reception song for the straightest couples in the world. Do they get it? I don't know.'

In January, Sylvester filmed a promotional film for 'You Make Me Feel (Mighty Real)' among the disco balls at the Embassy Club in London, during which he managed to change identity several times. Beginning in a black leather jacket and trousers, with a tunic and long, curly hair, he then shifts into short hair, a white suit open at the neck, with sunglasses hanging from the pocket, and white fan. The next change is into a loose jacket covered with sequins, then black leather trousers with a shiny gold vest, before he exits the clip in a multicoloured, sparkling tunic vest. This was the dizzying gender collage of the Cockettes, adapted for the disco age by a testifying performer. Sylvester knew where his roots lay and kept in with the gay disco crowd, attending the Paradise Garage when in New York. He had entered the gay subconscious.

On 11 March, Sylvester premiered his new, all-disco album *Stars* at the San Francisco War Memorial Opera House. *Le tout* San Francisco turned up: men in fancy dress and formal wear, others in leather chaps, a master and slave in matching leather tuxedos. The set list was tailored to Sylvester's multiphrenic personality. Beginning with a quick overture of his two major disco hits, the set settled into covers of the Beatles' 'Blackbird', Leon Russell's 'A Song for You', Allen Toussaint's 'Happiness', LaBelle's 'You Are My Friend' and the standard 'Lover Man', via Billie Holiday. Midway through the concert, while Sylvester stood on stage fanning himself, Harry Britt – on the order of new mayor Dianne Feinstein – presented him with the keys to the city. Then it was disco time. As the band began 'Dance (Disco Heat)', there was a big roar, and the audience and the performers went up together. The finale was 'You Make Me Feel (Mighty Real)'. Sylvester began the song with a bit of call-and-response: 'Y'all know what I meant when I say you make me feel real? I mean real. You must have had someone in your life that made you feel real.' Each section of the Opera House sang the

refrain, before the band and Sylvester came in. 'We had service,' he later remembered.

Released in April 1979, *Stars* is his most consistent disco statement. The title track is a helium rush – all pumping bass and meteoric synth sounds – taken at an incredibly fast pace (138 rpm): an adaptation of the theme of Sly and the Family Stone's 1969 #1 'Everybody Is a Star' for the gay disco age. The nearly twelve-minute 'I (Who Have Nothing)' is a falsetto vocal tour de force, but it is 'I Need Somebody to Love Tonight' that is the winner: a swampy, seductive song that is the perfect embodiment of Sylvester's desire for sex music.

That month, *Newsweek* led with a cover story about the entertainment phenomenon of the moment. The 'Disco Takes Over' article centred on Donna Summer, who was on the point of releasing 'Hot Stuff' – an epic disco stomper that would provide her with a second number one. In the piece, Summer was strangely keen to disassociate herself from the genre that had made her name. She told the magazine that her big hope was that she wouldn't 'die with disco. I'd like to have as much validity as Streisand and Aretha Franklin.'

———

On 23 April 1979, as 'Hot Stuff' entered the Top 100 and 'I (Who Have Nothing)' broached the Top 50, *Time* magazine conducted one of its regular surveys on the state of the gay nation. It began by acknowledging that 'homosexual men and women are coming out of the closet as never before to live openly . . . [and] are gaining a degree of acceptance and even sympathy from heterosexuals, many of whom are still unsure how to deal with them, that neither straights nor gays would have thought possible just the day before yesterday'.

The long article recognised the galvanising effect of Anita Bryant's anti-homosexual campaign, citing gay mobilisation as helping with the election of Marion Barry, a staunch supporter of gay rights, as mayor of Washington DC. It also noted that around forty members of Congress were now sponsoring an amendment to the Civil Rights Act of 1964 that would forbid discrimination in jobs, housing, public facilities or

federally aided programmes on the basis of 'affectional or sexual orientation', as well as race and religion.

Time recognised the fact that gay men were colonising urban districts in recognisable, self-policing communities, in big cities like Chicago, Boston, New York and San Francisco, which was the leader in this trend. It also commented on their lack of unity: the splits between the macho clones and effeminate queens, between Black and white homosexuals, and indeed between gay men and lesbians, who might have been, according to the magazine, 'the most persecuted minority of all'.

The biggest impact of the gay rights movement on American life, *Time* concluded, was the way that it influenced straight culture, most obviously in the popularity of the whole disco experience – lights, music and dancing – which, as was by then generally acknowledged, had begun in the gay clubs of Manhattan and Fire Island, years before it hit the mass market. Thus were the pioneers finally recognised.

What *Time* didn't mention was the centrality of sex to the modern gay experience. That was left to the gay press. In *Christopher Street* that April, Andrew Holleran wrote about what he called 'fast food sex': 'They come down Christopher Street like an army, in ranks and ranks, and (here's the nightmare) all them are handsome, all of them are your physical ideal. It's the doom of Don Juan: must I go to bed with all of them? A friend looking at this homogeneous mob one Sunday afternoon moaned, "it's like the invasion of the body snatchers".'

Setting the article up as a discussion with a friend who 'refused to kiss another man before they had dated nineteen times', Holleran expressed a mix of satiety, disgust and concern. Looking at a young man 'in torn jeans, engineer boots, hooded sweatshirt, and leather jacket', he quoted his friend: 'How ghastly, to extinguish one's individuality, to dress as a human dildo . . . Everything that attracted me five years ago now seems totally stupid. Getting blown is so easy now, and so meaningless, that it's about as significant an event as a sneeze!

'Why do these assholes praise promiscuous sex,' his friend ranted, 'and say there's nothing wrong with it, that because we're gay we're leaders in a brave new world who will set new patterns of behavior, and all that crap, when even sex, on that basis, ceases to be erotic? Do they really

think that because we're gay, young, and urban we don't have the same need for fidelity and intimacy that any other human beings do? When sex is as easy to get as a burger at McDonald's, it ain't too mysterious or marvellous, believe me.'

Larry Kramer's recently published novel *Faggots* expressed similar doubts. A morality tale about the rampant sexual activity in the New York gay world, the book promoted the idea that the only thing gay men thought about was their appendage. With Evelyn Waugh as a model, Kramer constructed a bitter farce about what he saw as a kind of decadence. He regarded the immersion in drugs and sex as a distraction from politics, even a kind of addiction. He thought that gay people should look beyond the ghetto, Fire Island and the notorious Manhattan sex club, the Mineshaft.

These doubts were echoed by Mark Abramson in his Castro diary: 'I've been thinking about life in the gay ghetto ever since I read a review of a book called *Faggots* by Larry Kramer. I suppose it is harder to find "love" in this realm. You can get a bigger dick or a firmer ass, or a more handsome face, or fuller nipples, or firmer thighs just around the corner. You can find whatever you can fantasize about and once you've found it, there's a better version in the next block. The sidewalks of San Francisco are like the living pages of every gay porn movie or magazine.'

That May, *Christopher Street* published the results of a major survey on gay male sexuality and relationships. Distributed to gay bars, theatres and symposia, trailed by adverts published in the American gay press, the Spada Report eventually collected data from 1,038 respondents in fifty states, aged between sixteen and seventy-seven, from diverse income brackets and a wide variety of occupations. Over half out were of the closet, and there was a huge diversity in opinion.

The report's author, James Spada, found that sex was the key element in the modern gay lifestyle, with 21 per cent having it once or twice weekly, 17 per cent three times a week and 16 per cent every day. Many respondents felt that they were not bound by traditional sexual mores because they had been forced, by societal prejudice, to live outside the mainstream. A free and open attitude to sex was the result. Indeed, over 90 per cent of the men surveyed had one-night stands, with varying frequency; more than half found them enjoyable.

For many gay men, then as now, sex was the method of initial contact. There were no courting rituals for gay men as adolescents, and so it was sex first, find out about the other person later – even if you got only their name. Nevertheless, Spada thought that, even if the sex ended up being casual, most of the men in the survey regarded it as the beginning of a possible relationship. He concluded that gay men were less self-pitying than they might have been a few years previously. Basically, they had started to feel good about themselves.

As *Time* had observed, San Francisco set the standard for the new gay urban communities, but it was muted after Harvey Milk's death. George Moscone's successor, Dianne Feinstein, was not seen as particularly gay-friendly. She had to acknowledge the gay caucus, but was rarely seen in the Castro. The mood turned sour during the trial of Dan White for the murder of Moscone and Milk, which began in early May. When the former policeman was found guilty, not of murder, but of voluntary manslaughter – with a sentence of under eight years – the Castro erupted.

'The city is insane tonight,' Castro resident Abramson wrote on 21 May. Soon after the verdict was announced, gay men, led by activists who had attended the trial at City Hall, exploded out of the bars in the Castro, chanting, 'Out of the bars and into the streets', 'Dan White was a cop' and 'Avenge Harvey Milk'. By the time they got to City Hall, the crowd numbered 5,000. Screaming 'Kill Dan White', they threw rocks through the building's door and set fire to a police car.

Things only intensified when the police arrived. Tensions between the police and the Castro community had increased during the trial, and their appearance presaged a full-blown riot. Incensed, the gay crowd pelted the cops with chunks of asphalt from the pavement and torched dozens of police cars. In retaliation, the police entered the Castro and raided the Elephant Walk bar, beating the patrons, shouting hostile, bigoted epithets and continuing the physical harassment out on the streets for a couple of hours.

The next day was Harvey Milk's birthday. The walls around the Castro were full of graffiti: 'Gay Riots Now'; 'Feinstein Will Die'; 'Death to Dan White'; 'Islamic Justice – An Eye for an Eye'; 'Dan White & Co. You will not escape, for violent fairies will visit you even in your dreams'. At the

party to celebrate the assassinated supervisor, there was a tense atmosphere. As the defiant McFadden & Whitehead anthem 'Ain't No Stoppin' Us Now' played, activist Cleve Jones told the crowd: 'We'll disco right in the police's faces.'

————

Disco had given a sense of unifying cohesion to the gay experience, yet by early summer 1979, it had simultaneously become a rallying point, a badge of hard-won identity, the dominant pop sound and a transient, mass-media fad. What a couple of years previously had been a creative, diverse form had become almost fixed in stone. While it was an inspirational motivator of gay identity, it was also a homogenising factor: not for nothing were clones called clones, as they spread across America in their jeans and moustaches.

'I went to the I Beam yesterday,' Abramson wrote in his Castro diary. 'I close my eyes on the dance floor, blocking out the lights and any familiar faces. I feel my body move and I could be in any city dancing to the same songs: "Y.M.C.A.," "Ring My Bell," "Le Freak," "Don't Rock the Boat" by the Hues Corporation and anything by Sylvester. I'll be two thousand miles away and surrounded by different faces and different friends, but I'll still be dancing in this body, and the disco music will all be the same.'

There was no doubt that disco had had a profound influence on American life. During that summer, two gay writers attempted to unpick the complexity of the trade-off as far as gay people were concerned: the balance between disco's origins in minority – Black, gay, Latino – culture, its then current ubiquity across the media and in the music industry, and its impact on gay lives, for better or worse. Could some of the attitude and experience of its founding subculture withstand the sanitising effect of the mass market?

In *Gay Left*, the British writer Richard Dyer thought that disco had been taken up by its gay audience in ways that had not been intended by the people who made the records. He regarded disco as being like another ambiguous aspect of gay culture, camp, in that it inverted societal

expectations and provided an important rallying point for a new gay iden-
tity. In the end, he regarded disco's most positive contribution as being
both liberating and erotic: it provided an experience through which gay
men could reconnect to their bodies and enjoy a general sense of pleasure.

To the gay American journalist Andrew Kopkind, disco marked 'the
sensibility of a generation, as jazz and rock announced the sum of styles,
attitudes, and intent of other ages'. It was where American popular cul-
ture was at in the late 1970s. Unlike '60s pop culture, which he typified
as romantic, psychedelic and inexpensive, disco was all surface, sleek and
smooth, impacting the physical rather than the mental or psychedelic:
'On a Sixties trip, you saw God in a grain of sand; on a disco trip, you
see Jackie O at Studio 54.'

Kopkind teased out the gay roots of disco, and singled out one of the
form's then most popular acts as a test case for the limits of gay visibility
in mass culture. He regarded the Village People as a highly contradictory
manifestation: reflecting the then current macho styles among gay men,
at the same time as they were successfully cleaned up and depoliticised.
Their camp quality appealed to both a knowing gay audience, who got
the references, and the mass market, which liked the beat and the tunes
and ignored the theatrical drag.

By 1979, the disco record industry had become a mammoth com-
mercial enterprise. But Kopkind saw warning signs in the level of street
violence being pursued against disco fans in provincial cities. The prime
hostile agents were rock fans, whom he typified as 'white, straight, male,
young, and middle class'. Indeed, the rise of disco had occurred at the
same time as the decline of rock, which industry mavens regarded as a
temporarily spent force, considering it moribund and uncreative.

By the early summer, disco was still leading the pop marketplace, but
it was running on fumes. On 9 June, the Bee Gees achieved their seventh
number one with the disco-tinged, string-enhanced slow burner 'Love
You Inside Out'. Although it shot up the chart, it would stay there for
just one week, replaced by Donna Summer's 'Hot Stuff' – her penulti-
mate exercise in the genre she affected to despise. Although they didn't
know it yet, 'Love You Inside Out' would be the Bee Gees' final American
number one and last major hit for a decade.

At the end of the month, the group went out on a mammoth tour, playing huge venues like the 60,000-capacity Dodger Stadium in Los Angeles. It encompassed fifty-six dates over four months, with a three-week break in August. It was not a happy time: the Bee Gees were almost at war with one another, completely overwhelmed by their superstardom, struggling with their various demons. Robert Stigwood was hardly present, lost in the netherworld of a success that went beyond his wildest dreams.

Even the gay press was beginning to express an unease about disco. In the July issue of *Christopher Street*, Sean Lawrence – writing as Discaire – began his monthly column with a riff on Donna Summer's new album, *Bad Girls*: 'I would love to have heard the conversation out at Casablanca Records and Filmworks: "Hey Gang, let's do a Donna as prostitute album!" Whenever "Bad Girls" comes on at a Disco I want to go up to gay men, shake them out of their poppers-induced stupor, and say, "No, this is not another euphemistic song about you."'

Lawrence noted a growing hostility towards disco: 'During one of Rod Stewart's recent Long Island Railroad concerts at Madison Square Garden the kids . . . went limp. Stewart was singing "Do Ya Think I'm Sexy?" Boy, have these kids decided to hate disco and peer pressure one another into hard-rock conformity. As the names of various groups coming to the Garden (Yes, Bad Company, Teddy Pendergrass) flashed on the electric billboard the young masses booed Pendergrass and the Village People. Yup, the kids are just as anti-gay and racist as mom and dad.'

This hatred had been festering for a while. As far back as 1975, *Punk* magazine had produced its first editorial, called 'Death to Disco Shit'. This was an outlier, but it defined the basic rock-fan hostility. Rock had been dominant in the pop charts since the late 1960s and had grown into a principally heterosexual subculture. By the mid-'70s, it had been watered down, but by the latter part of the decade it was being revived by the new wave of heavy-metal groups like AC/DC and Van Halen, whose second album hit the US Top 10 in summer 1979.

It took the success of *Saturday Night Fever* to bring the opposition out into the open. The Bee Gees were everything that rock fans despised: with their coiffed hair, medallions, high voices and easy-on-the-ear

music, they were not just wimpy, but *girly*. How much the average rock fan was aware of disco's gay roots is hard to say, but the fact that it was clearly popular with neat, cloned homosexuals reinforced the idea that the style was seen as conformist, queer and totally antithetical to the idea of rock rebelliousness and machismo.

'Disco Sucks' was the rallying cry. The trend for destroying disco records began in summer 1978, when a San Jose radio DJ called Dennis Erectus began to feature a segment called 'Erectus Wrecks a Record'. His routine was to put on a disco record and then crank it up to 78 rpm after a few seconds, while grinding the needle into the vinyl. Interspersing the noise with the sound of a toilet flushing or people vomiting, he would then segue into hard-rock chords by AC/DC or Van Halen.

Other DJs began to copy him. During the next few months, radio stations in Los Angeles, Portland, Seattle and New York destroyed disco records in various ways. Two DJs in Detroit formed a vigilante group called the Disco Ducks Klan: according to disco historian Alice Echols, they performed on-the-air simulated electrocutions 'of disco lovers whose names and phone numbers had been sent to the station by members of the "intelligence" arm of DREAD (Detroit Rockers Engaged in the Abolition of Disco)'.

This was extreme stuff, and it was sponsored almost entirely by rock or AOR stations. Radio had long been hostile to disco, largely because the genre and its DJs bypassed its gatekeeping role in making hits. Since late 1973, club play had been instrumental in breaking records, to a degree that infuriated radio DJs. However, they couldn't ignore the music's success. By the time of *Saturday Night Fever*, disco was the mainstream pop form and rock stations were beginning to change to an all-disco format.

The music industry was caught napping, and this created resentment – a prejudice enhanced by disco's lack of critical support. Apart from writers like Vince Aletti and Brian Chin, there were very few critics prepared to take the form on its own terms. Kopkind thought that 'Disco has authentic roots that punk and other more fashionable genres never found. John Rockwell was still writing Hegelian analyses of the Sex Pistols in the Sunday *New York Times* when two-thirds of the city was listening to Donna Summer.'

By spring 1979, there were signs that the disco juggernaut was begin-
ning to slow down. It simply wasn't doing the business that it previously
had. Part of the problem was that it was an audience-driven form that –
apart from recognisable superstars like Donna Summer, the Village
People and Chic, all of whom had clear, strongly defined images – sold
best on twelve-inch singles. The record companies didn't help themselves
by treating disco as a transient form, issuing mostly filler albums with
a couple of strong cuts or, in the case of Casablanca, throwing cloned
releases at the wall.

By the late 1970s, the American music industry had become an enor-
mous behemoth, used to dictating taste. Record companies were used to
dealing with easily identifiable, ego-driven white rock performers who
catered to the massive market for teenage rebellion and its manifest-
ations – power, anger, virtuosity – and who found a style and stuck to it.
At the same time, the FM dial provided, all too often, a locked groove
of Cream, Led Zeppelin, Creedence, the Beatles and Crosby, Stills and
Nash – one-time liberation reduced to a numbing stasis.

Disco's functional quality translated to the mainstream audience as
anonymity. This, combined with its racial and sexual nonconformity,
and turboboosted by its near ubiquity, was a clear challenge to white
male privilege, and as is the nature of these things, this did not inspire
a climate of sharing or exploration, but blind hostility. The attacks got
worse: in late May, there was a disturbance at a club in Massachusetts,
when 150 gay people were attacked by locals who didn't want disco fans
at their local venue.

Rock fans, according to *Village Voice* reporter Frank Rose, 'turned
mean' that summer, with anti-disco manifestations in cities like Portland,
Detroit and San Jose, but the violence peaked in Chicago on 12 July,
when the stadium at Comiskey Park was convulsed by rioting. During
the intermission in a Chicago White Sox baseball game, an enormous
crate holding 5,000 disco records was blown up in the middle of the sta-
dium, after which 7,000 white teens rushed the field, lighting bonfires,
throwing fireworks and destroying the pitch itself.

Comiskey Park embodied the backlash. The 'godfather' of the
anti-disco movement – and it was a movement that summer – was a

twenty-four-year-old Chicago DJ, Steve Dahl, who sponsored the event at the stadium. Dahl had personal reasons for his hatred: a talk-radio DJ, he had been sacked by his previous station when it went disco at Christmas 1978. When he found a new berth at the morning show on Chicago's WLUP, he began to include anti-disco rants in his segment. Seeing that they got a strong listener response, he then ramped them up.

In public, Dahl expressed his dislike of disco in terms of its superficiality: as he stated, 'The whole lifestyle seemed to be based on style rather than substance.' But it was a good career move, and it succeeded beyond expectations. Working with the White Sox's promotional manager, Michael Veeck, Dahl began to promote the 12 July game – already scheduled as a teen night – as a Disco Demolition Derby, whereby anyone turning up to the stadium with a disco record would be admitted for 98 cents.

The game was a sell-out, with an estimated 15,000 ticketless teens milling around outside and several thousand more stuck in transit on the jammed freeway. The atmosphere inside the venue was already febrile: fireworks had been set off, records were thrown as frisbees, while the crowd had got completely drunk and was baying for blood. In the intermission, Dahl went out onto the field and, as he roused the crowd to chant 'Disco sucks!', blew up a twelve-foot-high pile of disco records. Driven to a frenzy, the crowd trashed the stadium.

The optics were terrible. Public burnings of cultural products were, and remain, a dangerous and highly unstable tactic. 'I was like a kid playing with matches,' Dahl later stated, but with precedents like the 1933 Nazi book burnings and the 1966 burning of Beatles records by southern fundamentalists, this was a highly unpleasant, highly reactionary manifestation that pitted a mob of middle-class white suburban boys against the whole gamut of minorities: Black Americans, Latinos, strong, assertive women and homosexuals.

It might have appeared to be a spontaneous eruption of anger, but to some degree the Disco Demolition Derby was channelled by market researchers. Frank Rose later revealed that Dahl's anti-disco rants were seen as 'a remarkable new tool' by radio consultants Lee Abrams and Kent Burkhart of Burkhart–Abrams Associates. Hiring researcher John

Parikhal to research discophobia, they found that the fifteen-to-twenty-five-year-old respondents thought disco lacked toughness and aggression and were intimidated by the genre's open, non-standard sexuality.

The Comiskey Park riot was, unfortunately, a major pop culture event. In retrospect, it could be seen as embodying a crisis in white American masculinity, a resentment at the gains won by women, Black Americans and gay people over the previous decade and a half, which, combined with a tanking economy and America's reduced status in world affairs, would fuel the New Right revolution of the 1980s. It was noteworthy that the Moral Majority, a highly active organisation associated with the Christian right, was founded the month before the Disco Demolition Derby.

Like their parents, white teenagers resented their perceived loss of privilege, and rather than embrace different cultures and lifestyles, they recoiled violently as they sought to reassert their previous dominance. This, as Rose wrote, was 'the revolt of the white kids. It is majority youth jumping up and down and saying they want to decide what's hip – not Frankie Crocker, not Castro Street and Fire Island Pines, not the Bloomingdale's set, not anybody who's older and more sophisticated than they are.'

For insiders, the disco backlash could hardly be seen as anything other than threatening. 'It was so clearly homophobic,' says Vince Aletti, 'and my feeling was that all those rock 'n' roll people had been waiting for it. They'd been sitting there, waiting, furious, for several years, for the moment to come back. The wildness and unpredictability of the scene was one of the wonderful things about it, but for the people who were outside it, it was very threatening. There was huge resentment there, and it just boiled over.'

———

At the same time, Comiskey Park helped to crystallise a feeling within the gay subculture that disco was in deep trouble. In the August issue of *Christopher Street*, Sean Lawrence tolled an obituary for the drug-saturated routine at gay discos, praising instead a

new club, Heat, which had a policy of playing new wave and rock. He thought the future lay in 'reclaiming rock' for gay people, with Tom Robinson pointing the way forward. The defiance contained in rock music could be a powerful avenue for the expression of homosexual rage.

Changing tastes and over-saturation formed only a part of disco's malaise. Other factors included the exclusivity of its most famous club, Studio 54, which left a bad taste in the public's mouth, and the unprecedented success of *Saturday Night Fever*, which set a benchmark for sales and influence that was impossible to duplicate. There were other criticisms. In mid-July, *Billboard* ran an article titled 'Disco Not Proving Panacea for Black Artists', which noted that disco's increased homogeneity was making it hard for Black artists to cross over.

In August, *Newsweek* reported on a crisis in the music industry, with inflation and the decompression of the disco boom having an adverse impact on sales and profits. It was a perfect storm. At the start of August, it seemed like business as usual in the upper reaches of the *Billboard* Hot 100. The title track of Donna Summer's new double album, *Bad Girls*, was halfway through its five-week run at #1. It was replaced on the 18th by Chic's greatest song, the truly transcendent 'Good Times', with its strange lyrical hint of foreclosure: 'A rumour has it that it's getting late.'

'Good Times' stayed at the top for only one week. It was knocked off by a catchy new wave update of 1964-era Beatles, the Knack's 'My Sharona', which stayed at #1 for six weeks, until early October. This was a big enough success to signify regime change: rock was back, albeit with a short haircut, an accelerated tempo and a skinny tie. Up to that point, disco records had held the top spot for twenty-four out of twenty-nine weeks. There would be no more chart-toppers directly associated with the genre that year, and Chic would not reach the Top 40 again.

Nile Rodgers remembered the moment as a deep hurt: 'The Disco Sucks movement and its backlash were so toxic, people in the industry . . . were all afraid to be associated with anything disco, even the word on a small sign above a door. Something about that really enraged me. Until then I believed I was part of a wonderfully elite group who marched to their own beat. I had worked hard to get there. We were free.

We all did what we wanted, said what we meant. We were the music business. Music people gave voices to the voiceless.'

Disco didn't die overnight, it just ran over the cliff like Wile E. Coyote, legs pumping the air furiously for a few months before the fall. The actual music took on rock elements and morphed into the hip end of new wave, reaching the top that year with songs like M's 'Pop Muzik'. Gay DJs like Larry Levan went on playing exactly what they wanted to, continuing to extend the limits of the form with playlists that included the Talking Heads' 'I Zimbra', 'Why D'Ya Do It' by Marianne Faithfull and Sylvester's 'I Need Somebody to Love Tonight'.

Artists at the sharp end, like Chic and Grace Jones, quickly adapted to the new circumstances. After their successful collaboration with Sister Sledge, whose 'Lost in Music' had gone Top 3 that spring, Bernard Edwards and Nile Rodgers moved into production, working on Diana Ross's new album and the wonderful late-1979 single 'Spacer', sung by French yé-yé star Sheila and her disco group B. Devotion. A couple of years later, Rodgers would collaborate with David Bowie on his multimillion-selling comeback single, 'Let's Dance', and album of the same name.

After her third LP with Tom Moulton, *Portfolio*, Grace Jones also saw the writing on the wall. As she wrote in her memoir: 'Disco was squeezing me into a room that was looking tackier and tackier, and I was worried I was going to be trapped. There was nowhere else to go, though, and disco was now the most loathed form of music – the essential racism, sexism, and homophobia of the white rock audience had forced it out of the way, which was easier to do when it became so crass and commercial.

'I had done my Studio 54 time. There were other clubs where the music was still about change and forward movement, which was actually about putting dancers deep into the moment. The Paradise Garage opened in SoHo in 1977 on the second floor of an old concrete parking garage, when disco was bending toward campness and stupidity. It was built on the utopian blueprint of the Loft. The kind of music that followed, best known as house, started at the Garage, and so it was also known as garage.'

For its most emblematic stars, life quickly became harder. Village People singer Victor Willis quit the band after their last big hit, 'In the Navy', just as they were going to Hollywood to shoot their fundamentally

misconceived biopic, *Can't Stop the Music* – put together, without the same magic, by some of the same team that had produced *Grease*. In the latter half of 1979, the group's sales dropped off dramatically: the single 'Go West' hit #45, while the live double album *Live and Sleazy* struggled into the Top 40.

The Bee Gees finished their epic tour in early October, only to find a completely changed pop landscape. The vaunted return of rock had made them passé overnight, and the bigger the rise, the harder the fall. The group were exhausted, at odds with each other and in dispute with their almost absent manager. Their decline was only temporarily postponed by the October release of a greatest hits double album, which, containing eleven Top 10s and eight #1s, mopped up their disco era in fine style.

A few days before *Bee Gees Greatest* entered the charts, Frank Rose published his cartography of disco's fall in the *Village Voice*. He noted the 'lessening of the disco threat' that autumn: 'At any rate, it looks as if we won't have disco destruction to kick around any longer,' he wrote. 'Disco stations elsewhere are broadening their playlists or switching formats entirely; clubs are going from disco back to rock; and rock fans everywhere are beginning to congratulate themselves on a job well done.'

The same day that the *Village Voice* published Rose's article, *New York* magazine published an item with the headline 'Studio 54: The Party's Over – The Inside Story of How the Disco Came Down from a Two-Year High'. Perhaps the most damaging elements in Henry Post's piece were the details about the presents, the 'party favours' – mostly poppers or cocaine – that Steve Rubell gave to the favoured and the elite, which were then deducted as business expenses. The favoured and the elite were not best pleased with these revelations.

Rubell and Ian Schrager were in deep trouble during the second half of 1979. Andy Warhol had continued to publicly support them after the tax bust, giving Rubell an *Interview* front cover in February, but the former closeness had long gone. The club had continued to operate as though nothing had happened. Rubell in particular was in full avoidance mode, but as the case continued to grind its way through the judicial process, it became clear that the level of tax evasion undertaken by the pair would result in a prison sentence.

Eight days after the Post article, Warhol opened his last major show of the decade, *Portraits of the 70s*, at the Whitney. He had the good sense to omit the Iranian royal family, but included a trilogy of Chairman Mao portraits, alongside the denizens of the art world, pop stars and jet-setters who were his customary subjects. The critics disliked it – in *Time*, Robert Hughes called it crowded 'with the glittery, the raucous, the beady-eyed and the badly painted' – but the attention it generated swelled the artist's private portrait business to the tune of $2 million during the next year.

––––––

G ay pride was in the news that autumn. In mid-October, there was a National March on Washington for Lesbian and Gay Rights, which drew around 100,000 gay men, lesbians, bisexuals, transgender people and straight allies to demand equal rights and urge the passage of protective civil rights legislation. This was Harvey

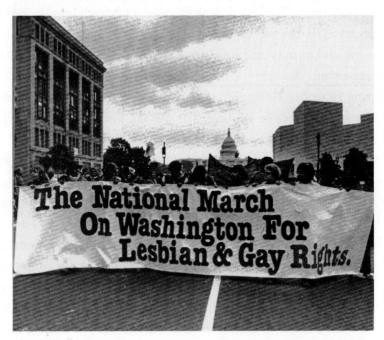

The National March on Washington for Lesbian and Gay Rights LP, with contributions from Kate Millett, Allen Ginsberg and Tom Robinson (Magnus Records, 1979)

Milk's dream of June 1978 come true: 'I call upon lesbians and gay men from all over the nation, your nation, to gather in Washington one year from now . . . and tell Jimmy Carter and their nation: "Wake up. Wake up, America."'

This was the first attempt in the US at forming a nationwide coalition of the gay movement, and it was constructed as an inclusive event. As activist Allen Young wrote in the march's programme: 'Today in the capital of America, we are all here, the almost liberated and the slightly repressed; the butch, the *femme* and everything in-between; the androgynous; the monogamous and the promiscuous; the masturbators and the fellators and the tribadists; men in dresses and women in neckties . . . Yes, we are all here! We are everywhere!'

In November 1979, Sylvester released *Living Proof*, the double album of his triumphant San Francisco War Memorial Opera House show: three sides of the actual concert, with a fourth that comprised a sixteen-minute disco segue of 'Can't Stop Dancing' and 'In My Fantasy (I Want You, I Need You)'. The city had proclaimed 11 March, the date of the show, as Sylvester Day – recognition of how deeply the singer was embedded in the community and how much his success had given hope and encouragement.

During 1979, Sylvester continued to live and be seen in the Castro: on 24 June, for instance, he performed at the San Francisco Gay Freedom Day Parade. He was accepting of his role as gay ambassador. 'The community respects me for being successful,' he told *Black Music*'s John Abbey, 'and for being upfront about my sexuality. A lot of gay people all over the world have told me to keep doing what I'm doing because it is good for the gay community so I will, I guess.'

Although he disavowed any overt intent, Sylvester was a standard-bearer. He was completely identified with San Francisco's gay community and its central locus, the Castro. On 27 November 1979, exactly one year after Harvey Milk's assassination, there were memorial services and a candlelit march led by Dianne Feinstein and Jennifer Moscone, the daughter of the murdered former mayor. The march ended when Sylvester rushed onto the stage in a floor-length white fur coat and sang an a cappella version of 'Jesus Loves Me'.

Twelve days later, Mark Abramson and his circle went to a party called 'Snow-blind' on San Francisco's Mission Street. 'Someone gave me a hit of acid, and I danced with a group of guys until six, mostly friends of mine. Somehow, Sylvester ended up in the middle of our circle. Then the disc jockey put on Sylvester's "Can't Stop Dancing," and it was strange to be dancing with him to his own song. When Sylvester sings, and he's right there in your face, you've just gotta keep on dancing!'

'Be Fabulous, Be the Party, Look Good': on the fold-out cover of *Living Proof*, Sylvester is depicted in male drag – a bright blue jacket and shirt, with magenta trousers and tie. Pouring champagne into a glass, he is the perfect party host, inviting you in. Around him, on the steps up to a nightclub, framed by the marquee roof, are upwards of thirty-five celebrants: a mixture of ages, genders and races – Black brothers, boa-clad disco models, older women in furs and tiaras. Packed tight together, they are all smiling with pleasure and anticipation. Gay men are prominent: clones in jeans and moustaches, men in dinner suits and bow ties, disco dancers in white suits – a whole gamut of contemporary types, in all their difference and diversity. They, too, are smiling and laughing, signifying joy and togetherness. They are relaxed, open and confident in who they are; they no longer have to hide. It's going to be the best night ever.

Let's leave them there, frozen in their fabulousness, with no thought of what is to come.

Acknowledgements

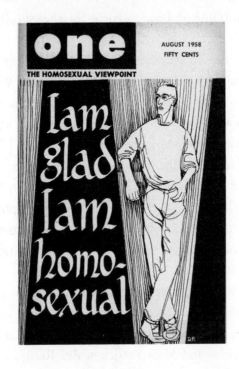

This book has been a long time in the works, so many thanks to all the people with whom I've discussed and inhabited the topic. These include those who gave me interviews for books, articles and TV programmes along the way, among them Ray Davies and Dave Davies (*The Kinks*, 1984); Larry Parnes (*The Face*, 1985); Berlin, Derek Jarman, Alan Jones, Jordan, Pete Shelley, Siouxsie and Sylvain Sylvain (*England's Dreaming*, 1988–90); Vince Aletti, Ray Caviano and Frankie Knuckles (*Out on Tuesday: Disco's Revenge*, 1990); Dusty Springfield (*Observer*, 1990); Clem Cattini, Cliff Richard and Marty Wilde (*Mojo*, 1995); Lionel Bart, Peter Brown, Geoffrey Ellis, Alistair Taylor and Nat Weiss (BBC *Arena: The Brian Epstein Story*, 1997); Billy Linich (Name) (*Guardian*, 1997); Pete Townshend (*Mojo*, 2011); David Johansen (*Mojo*, 2022); and Norma Tanega (*1966: The Year the Decade Exploded*, 2015). Thanks

also to those who consented to be interviewed for this book: Vince
Aletti, Simon Napier-Bell, Andrew Loog Oldham and Tom Robinson;
and Michael Watts, who consented to talk about his famous Bowie
interview yet again and then went beyond the call of duty and supplied
me with his unpublished Bowie article for the *Sunday Times*. Many
thanks to you all.

Many thanks also to Matthew Gray, curator at the Andy Warhol
Museum in Pittsburgh, for the details about Andy Warhol's records.
Many thanks also to Bill Brewster for allowing me to access his ground-
breaking interviews with Nicky Siano, Tom Moulton and DJ Tallulah,
and to Kieron Tyler for allowing me to access his John Leyton interview.
Thanks also to James Gardiner and Robert Lambert for their memories.
Tim Arnold gave me crucial details about his mother, Polly Perkins, a
fascinating story if ever there was one, while Jenny Spires entered into
an interesting dialogue about the early days of Syd Barrett's Pink Floyd.
Thanks also to Johan Kugelberg and Andrew Sclanders for encourage-
ment and materials.

Thanks to all those who have commissioned me to write on and around
this topic over the years: Mark Ellen, Paul Du Noyer, Jenny Bulley and
Danny Eccleston at *Mojo*; Caspar Llewellyn Smith at the *Guardian/
Observer*; Liz Buckley and Mick Patrick at Ace Records; Amanda Sharp
at Frieze; Kath McDermott at BBC Radio 6; Steve Erickson at Black
Clock; and Anthony Wall at *Arena*.

Thanks also to my agent, Sally Holloway, and the team at Faber &
Faber for their patience and professionalism: Hannah Knowles, Ian
Bahrami, Dan Papps and Hannah Marshall.

For this Liveright American edition, thanks to Luke Swann for his
persistence and patience with permissions, to Clio Hamilton for han-
dling the publicity so adroitly, Ingsu Liu and Evan Gaffney for the great
jacket, Kadiatou Keita for marketing, and Bob Weil for his belief and
encouragement.

Thanks to all those who have lived with me and without me during the
writing of this book: Mat Bancroft, Hannah Barker, Rebecca Boulton, Ian
Birch, Michael Bracewell, Caren Brown and Dic Ben, Murray Chalmers,
Ian Davies, Charles Dunnett, Jo Dunnett, Colin Fallows, Paul Fletcher,

Paul Gilroy, Jeff Gold and Jody Uttal, Viv Hamilton-Shields, Andrew Hinchcliffe, Chris Jennings, John Kertland, Johan Kugelberg, Jo Laxton, Neville McLellan, Johnny and Angie Marr, John Mundy, Geoff Powell, Christopher Pressler, Gwyndaf Pritchard, Katherine Reagan, Markie Robson-Scott, Andrew Sclanders, Sharron Seabridge, Neil Spencer, Neil Tennant, Ben Thompson, Vron Ware, Amanda Wilkinson, Jah Wobble, Matt Wolf and Jon Wozencroft.

Finally, thanks to those who are gone – Peter Burton, Derek Jarman and Kris Kirk – for their stories, friendship and inspiration.

Sources

Detailed sources for quotes and information are included below. A few general points: some of this material – in particular articles from *Time* and the *Village Voice* – is available online, and where this is so I have quoted the URL. For the US and UK charts, I have consulted individual issues of *Billboard* (available online at Google Books – https://books.google.co.uk/books/about/Billboard.html?id=pBQEAAAAMBAJ&redir_esc=y) and the UK Top 40 singles chart (at https://www.officialcharts.com/charts/uk-top-40-singles-chart). Many of the articles quoted below are available at that excellent resource, rocksbackpages.com. Digital copies of *Disc*, the *New Musical Express* and *Melody Maker* are available to download at worldradiohistory.com

Introduction

'If pop's attitude to all kinds of sexuality', Jon Savage, 'Androgyny: Confused Chromosomes and Camp Followers', *The Face*, June 1983, pp. 20–3.

1 Little Richard

The opening quote comes from the groundbreaking gay novel *The Heart in Exile*, published in 1953 by Rodney Garland, the pseudonym of Adam de Hegedus. The book remains in print, in a 2014 edition from Valancourt Books, with an introduction by Neil Bartlett. Quote is on p. 45 (Chapter 2).

Almost every issue of *Billboard* is available on Google Books. For the 29 October 1955 issue, go to: https://books.google.co.uk/books?id=OiMEAAAAMBAJ&source=gbs_all_issues_r&cad=1. The Little Richard review is on p. 50.

The Art Rupe quote is from Rick Coleman's essay in *Little Richard, The Specialty Sessions*, p. 23. This six-CD set was released by Ace Records (UK) in 1989 and contains a great deal of information about Cosimo Matassa, Dave Bartholomew, Art Rupe, J&M Studios and Specialty Records.

For the relationship of Little Richard to Black culture, including carnies, hucksters, minstrel shows, Princess Lavonne and his stint as transvestite, see W. T. Lhamon, *Deliberate Speed* (Smithsonian Books, 1990), Chapter 3, 'Out of the Hole', p. 86ff.

The prime source for Little Richard's life is Charles White's rumbustious biography, *The Life and Times of Little Richard: The Quasar of Rock* (Pan UK, 1985). It is now available on Kindle, and using the search facility any quote from that book is easily discoverable. For instance, the Bamalama quote is at location 288; 'A sissy, punk, freak

and faggot', location 224; 'only half a son', location 364. Additional information can be found in Tina Andrews, *Awop Bop Aloo Mop: Little Richard: A Life of Sex, Drugs, Rock & Roll . . . and Religion* (Malibu Press, 2019).

For Esquerita, see White, location 490ff. Also Andrews, *Awop Bop Aloo Mop*, p. 47ff. There is an interview with Esquerita in *Kicks* magazine, issue 3 (Billy Roberts and Miriam Linna, 1983): 'Richard came to Greenville in a show called Sugarfoot Sam from Alabam. He had this long hair and make up on looking like he did later. The same way. When I met him he was dancin' with a table and chair in his mouth. He used to stand up and dance and balance a chair in his mouth then put the table on top. He was crazy! Later I ran into him at the Macon bus station and we got to be good friends.' The 'Greyhound Bus Station' quote comes from White, location 493.

For material about signing to Specialty and the 13 September session at J&M studios, see Charles White and Rick Coleman, op. cit. 'His hair in the air', Coleman, p. 22. 'Tarzan and Mickey Mouse', White, location 756.

Original 'good booty' lyric, White, location 833 (Wikipedia has the original lyric as 'Tutti Frutti / Good booty / If it's tight, it's all right / And if it's greasy, it makes it easy': source, Charles Connor, Little Richard's drummer). For Bumps Blackwell and 'Maybellene', see Coleman, p. 23.

For the impact of Black R&B on white teenagers and the authorities' response, see Brian Ward, *Just My Soul Responding* (Routledge, 1988), Part 1, Chapter 1, p. 19ff. See also 'A Question of Questionable Meanings', ibid., p. 168.

Richard on the origin of 'a wop bop a loo mop a lop bam boom', David Dalton, 'Little Richard: Child of God', *Rolling Stone*, 25 May 1970, p. 20ff.

For Richard's homosexual experiences, see White, locations 217, 234, 1,474. For more on the musicians' attitude to his flamboyance, see Andrews, p. 72 – 'Richard was so infectious and so unhiding with his flamboyancy, he sucked us right in. We got to laughing with him instead of at him'; for 'Tutti Frutti' selling 200,000 copies by early November, see p. 78.

2 Johnnie Ray

The opening quote is from *The Complete Life of Johnnie Ray: A Pocket Celebrity Scrapbook* (Pocket Magazines, Inc., US, 1955), p. 6.

'Johnnie Ray walks off to roaring applause . . .', 'The Agony of Johnnie Ray', *Anything Goes*, March 1956. 'Exhibitionism', Jonny Whiteside, *Cry: The Johnnie Ray Story* (Barricade Books, 1994), Chapter 13, p. 196. Whiteside's book is the main source of information on Johnnie Ray for this chapter.

'The loneliest boy in the world', Whiteside, Chapter 2, p. 25; 'I was starving to death', Chapter 3, p. 42; 'who sounded like Dinah Washington', Chapter 5, p. 63; 'He smashed all the rules', Chapter 5, p. 73.

For the account of Ray's arrest in Detroit, see Whiteside, pp. 65–7. 'A tearful new singer', *Life* magazine, 14 March 1952, pp. 99–102. Howard Taubman review, see

Whiteside, Chapter 8, p. 115; 'I just show people the emotion they're afraid to show', Chapter 6, p. 84, from *New York Daily Mirror*, 17 April 1952. For Sinatra and young women, see Jon Savage, *Teenage: The Creation of Youth 1875–1945* (Faber and Faber, 2021), Chapter 29.

For his marriage to Marilyn, see Whiteside, Chapter 9, p. 128; using Dexedrine, Chapter 10, p. 142; 'Johnnie "Cry" Ray Arrested on Homosexual Charge', Chapter 10, p. 148. 'Is It True What They Say About Johnnie Ray?', *Confidential* magazine, August 1955, in Whiteside, Chapter 11, pp. 161–2. 'Why Did Johnnie Ray Try to Break Down Paul Douglas' Door?', *Confidential*, November 1955, in Whiteside, Chapter 13, pp. 197–8.

For details about the Royal Command Performance, see https://www.royalvariety-charity.org/royal-variety-performance/archive/detail/1955-london-victoria-palace. See Whiteside, Chapter 13, pp. 196–7 for October 1955 visit and Royal Command Performance.

3 Scandal and Disguise

The opening quote and closing material are from James Douglas Margin, 'The Margin of Masculinity', *ONE* magazine, May 1955, pp. 7–18. In the article, the author goes to a gay bar, where he hears the Crew Cuts' 'Sh-Boom'. 'That impeccable American sexuality', *The Slide Area: Scenes of Hollywood Life* (Hamish Hamilton, 1959; reprinted by Profile Books, 1998).

For Rock Hudson, 'Hollywood's Most Handsome Bachelor', see 'The Simple Life of a Busy Bachelor', *Life*, 3 October 1955, pp. 128–32. The prime source for the Rock Hudson/Henry Willson material is Robert Hofler, *The Man Who Invented Rock Hudson: The Pretty Boys and Dirty Deals of Henry Willson* (University of Minnesota Press, 2014). For Willson's troupe of actors, see p. 3; 'Rock got his wrists slapped when they went limp', Chapter 3, p. 19; for potential *Confidential* story on Hudson, see Chapter 30, p. 241; Calhoun thrown to the lions, Chapter 31, p. 247ff; for Tab Hunter exposure, see Chapters 12 and 13, p. 249ff.

For an overview of the scandal magazines, including an index of the titles and celebrities featured, see Alan Betrock's *The Illustrated Price Guide to Scandal Magazines 1952–66* (Shake Books, 1994). For a history of *Confidential* magazine, see Wikipedia – https://en.wikipedia.org/wiki/Confidential_(magazine) – and Samantha Barbas, 'The Rise of *Confidential* Magazine', *William & Mary Bill of Rights Journal*, vol. 25, issue 1, article 4, October 2016. There are also details in Darden Asbury Pyron, *Liberace – An American Boy* (University of Chicago Press, 2000), pp. 215ff. For Connolly as contributor to *Confidential*, see Hofler, Chapter 27, p. 220.

'There is evidence in the archives': see, for instance, the scandal magazines, like *Confidential* and *Hush Hush*, held in the Harry H. Weintraub Collection of Gay-Related Photography and Historical Documentation, at Cornell Library's Division of Rare and Manuscript Collections. Plentiful images of *Confidential*, *Hush Hush* and *On the QT* can be found at https://www.houstonlgbthistory.org/tabloids-conf2.html.

For Christine Jorgensen, the prime source is her autobiography, *Christine Jorgensen: A Personal Autobiography* (Bantam Books, 1967). For an account of her half-life in the scandal sheets, see p. 256ff and the details in Betrock, *Scandal Magazines 1952–66*. 'A frail, tow-headed, introverted child', Jorgensen, p. 10; 'sissified ways', p. 19; 'strange infernal limbo', p. 40; 'I – I've tried for more than twenty years', p. 73; 'Sex transformation cases', p. 92; Dr Hamburger quote, p. 100; for 'disgusting degraded behaviour from news hawks', see p. 142ff; for the *American Weekly* deal and chaos at the airport in February 1953, see pp. 182–3; for her treatment by the British press, see p. 253ff. Quotes include 'Christine Jorgensen is the only GI who went abroad and came back a broad'; 'But those who go to see her will not be going to see an act; they will go with the same unhealthy appetites of people who queue to see murderers'; 'an act can be presented in which the prime attraction is the performer's sexual abnormality'.

Contextual material: Jorgensen mentions that Dr Hamburger was 'besieged with letters from patients. She counted 1117 between Dec 1952 and Oct 1953.' In early March 1953, Jorgensen met Johnnie Ray onstage at Madison Square Garden. She found him 'pleasant and congenial' but didn't recognise him. For an example of the press of the time, see the relatively unsensational coverage in *He* magazine, July 1953: 'Transvestites: Christine Jorgensen: Member of the Third Sex?' https://mrmagazine.me/2017/03/17/the-third-sex-now-and-then-there-is-nothing-new-under-the-magazine-sun.

For Liberace, see Pyron. Material about the Liberace TV show comes from Liberace's Wikipedia page (also in Pyron, Chapter 7, 'Music for a Mama's Boy', p. 172ff). The *Time* review 'musical momism' and the *Los Angeles Mirror* quote are from Pyron, p. 175. The list of Liberace's appearances in the scandal sheets: Betrock, *Scandal Magazines 1952–66*. The *TV World* cover can be found online with a quick Google search. The phrase 'masculine contempt' comes from 'What Do Men Think of Liberace?', *Inside Story*, October 1954 (Pyron, p. 176): 'They find his dimples too perky, his hair too wavy, and his personality too soft. The phrase "feminine appeal" is often used to describe him. Many men, after seeing Liberace, have said that their feeling is more like masculine contempt.'

'The many variations and combinations of masculinity and femininity', Jorgensen, *Christine Jorgensen*, p. 43.

4 The Homosexual in America

The opening quote and material in the next few paragraphs – including the quote 'a criminal to be punished; a violator of the common human code' – are from Ted Berkman, 'The Third Sex – Guilt or Sickness?', *Coronet*, November 1955, pp. 129–33.

For Kinsey and his relationship to homosexuality at the time, see Lyn Pedersen, 'A Tribute to Dr. Kinsey', *ONE: The Homosexual Magazine*, vol. IV, no. 6, August–September 1956, pp. 7–12.

For the Sioux City material, see Neil Miller, *Sex-Crime Panic: A Journey to the Paranoid Heart of the 1950s* (Alyson Books, 2002); 'Crackdown on Queers Has Begun', p. 117; 'fruit

picking', p. 101. On 31 January 1955, the Iowa House of Representatives passed a bill 'to provide for the confinement of persons who are dangerous criminal sexual psychopaths', a description which included homosexuals. Once found guilty, they would be committed to the state mental hospital, then detained or treated indefinitely or until certified as 'cured'.

For the Boise scandal, see John Gerassi, *The Boys of Boise* (Collier, 1968); 'Crush the Monster', 'evils of moral perversion', etc., Chapter 1, p. 3; 'infamous crime against nature', p. 2; 'I could tell when you were walking in the door', p. 255. *Time* magazine quoted by Gerassi in his Introduction, pp. ix–xii. Material on the trial and sentencing from Chapters 14–17.

For material on the situation of gay men and lesbians in the post-war and Cold War periods, see Douglas M. Charles, *Hoover's War on Gays: Exposing the FBI's 'Sex Deviates' Program* (University of Kansas Press, 2015), Chapters 2 and 3. For the Metropolitan Veterans' Benevolent Association, see the list of post-war gay publications in Marvin Cutler, *Homosexuals Today* (One Incorporated, 1956).

McCarthy, 'sexual deviance', Charles, p. 80; 'the "Reds" and "Homos"', p. 97; 'sexual irregularities', p. 83; Wherry-Hill committee, p. 85ff. Max Lerner's interview with Senator Kenneth Wherry can be found in Max Lerner, *The Unfinished Country: A Book of American Symbols* (Simon and Schuster, 1959), pp. 313–16. The Ralph H. Major article is in 'New Moral Menace to Our Youth', *Coronet*, September 1950, pp. 101–8. The Wherry Report is reprinted in detail in Donald Webster Cory, *The Homosexual in America* (Greenberg, 1951), appendix A, p. 269ff.

For Eisenhower's Executive Order 10450, see Charles, pp. 129, 164–5. Senator Dirksen, 'reds, pinks, psychopaths and homosexuals', in D. J. West, *The Other Man* (Whiteside Morrow, 1955), Chapter 4, p. 72.

Max Lerner articles about 'The Ordeal of the Gay' in Lerner, pp. 316–25. 'Outside the pale', Cory, Chapter 1, p. 3; 'inescapable', p. 5; 'condemnation', Chapter 2, p. 15; 'Constantly and unceasingly', Chapter 1, p. 10; 'Until we are willing to speak out', p. 14. For more about Cory, see *ONE* magazine, March 1962 and October 1963. See also Rick Vallely, 'The Conflicted Gay Pioneer', https://prospect.org/power/conflicted-gay-pioneer.

For the founding of the Mattachine Society, see Charles, Chapter 6, pp. 244–5. Also Lerner, p. 322. For more, see Michael Hone, *Mattachine Society: The Trojan Horse that Introduced Homosexuality into America* (2020) and James T. Sears, *Behind the Mask of the Mattachine: The Hal Call Chronicles* (Routledge, 2006), Section III: Mattachine (1950–3), p. 147ff. The biography of Mattachine founder Harry Hay is by Stuart Timmons, *The Problem with Harry Hay* (Alyson Publications, 1990). 'I try to sell safety' . . . 'John Bailey's problem', Helen Pyle Branson, *Gay Bar* (Pan-Graphic Press, 1957), reprinted as *Gay Bar: The Fabulous, True Story of a Daring Woman and Her Boys in the 1950s* (University of Wisconsin Press, 2010), pp. 112 and 35–6 (page numbers refer to the 2010 edition),

For *ONE* magazine, there is an online archive at the USC library: https://one.usc.edu/archive-location/one-magazine.

ONE adverts: the Rendezvous and Mr Raoul shampoo, April 1954; gay bells, November 1955; WIN-MOR, November 1954. *Physique Pictorial*, Tony Curtis picture, back cover, fall 1954 issue. Bob Mizer, 'Obscenity and Politics', *Physique Pictorial*, Fall 1955. For 'Tangents' and 'The Feminine Viewpoint', see, for instance, *ONE*, April 1955. The regular artist for the pictorial and graphic front covers was Eve Elloree, aka Joan Corbin. The Norman Mailer interview is in *ONE* magazine, January 1955. The letter from Mr E. from San Diego is contained in *ONE*, December 1956. For letters to *ONE* magazine in general, see Craig M. Loftin, *Letters to* ONE: *Gay and Lesbian Voices from the 1950s and 1960s* (State University of New York Press, 2012).

Details about the Pepper Club raid, including the 'big joke' quote, can be found at the *Baltimore Sun* website. 'Raid on Night Club Brings 162 Arrests', *Baltimore Sun*, 3 October 1955, p. 32. The raid was reported to be the largest ever made on a club or bar in Baltimore. The sheer number of homosexuals in such premises must have opened some readers' eyes. The sergeant who led the vice squad sent two officers to check on the club, who reported back to him that 'the place was so crowded they could hardly get in'. The head of the vice squad said: 'The majority of these people seem to regard the whole incident as a great big joke.' The judge's criticism is from the *Baltimore Sun*, 23 November 1955.

The Donald Webster Cory quote 'the interests of the invert . . .' is in Cory, p. 98. The Helen Pyle quote re 'teenagers' "bop"' is in her original introduction to *Gay Bar* (revised edn), p. 5. For teenagers in post-war America, see James Gilbert, *A Cycle of Outrage: America's Reaction to the Juvenile Delinquent in the 1950s* (Oxford University Press, 1986), and John Modell, *Into One's Own: From Youth to Adulthood in the United States 1920–1975* (University of California Press, 1989), Chapter 5, 'War and Its Aftermath'. There is also material in Grace Palladino, *Teenagers* (Basic Books, 1996), Part III, 'Teenagers', Chapter 7ff. The Max Lerner quote is from Lerner, Part 1, 'Fragments of My Fleece, Joys of a Family Man', Chapter 7, 'Teen-ager', 4 June 1952, p. 22.

5 Against the Law

The opening Rodney Garland quote is from *The Heart in Exile*, Chapter 5, p. 83 (2014 edn).

I have used three principal sources for the situation in the UK during the 1950s: Patrick Higgins, *Heterosexual Dictatorship: Male Homosexuality in Postwar Britain* (Fourth Estate, 1996); Stephen Jeffery-Poulter, *Peers, Queers and Commons: The Struggle for Gay Law Reform from 1950 to the Present* (Routledge, 1991); and Jeffrey Weeks, *Coming Out: Homosexual Politics in Britain, from the Nineteenth Century to the Present* (Quartet Books, 1977). Extra material is in Antony Grey, *Quest for Justice: Towards Homosexual Emancipation* (Sinclair-Stevenson, 1992).

For details of the *Sunday Pictorial* 'Evil Men' series, see Higgins, Chapter 13; 'The Press', pp. 288–93; for increase in convictions, see Chapter 8, 'The Operation of the Law', p. 158ff; for John Gielgud, Chapter 12, 'The Myth of the Witch-Hunt', p. 253ff. The John Gordon 'moral plague' quote comes from the *Sunday Express*, 25 October

1953, quoted in Higgins, Chapter 13, p. 271; for the Rupert Croft-Cooke case, see Chapter 2, 'Men in Uniform', p. 65ff, and Croft-Cooke, *The Verdict of You All* (Western Printing Services, 1955). 'The age of individualism' quote is from Croft-Cooke, p. 13; 'bedlam of noxious prejudices' and 'a second conviction', pp. 251–2.

Eight separate homosexual offences, Higgins, Chapter 8, 'The Operation of the Law', pp. 155–6; 'extraordinary degree of hostility', p. 168. Fabian quote from Robert Fabian, *London After Dark* (The Naldrett Press, 1954), p. 66. Details of the Montagu case in Higgins, Chapter 11, 'The Montagu Trials', p. 231ff. A full account from within is given by one of the three on trial, Peter Wildeblood, in *Against the Law* (Weidenfeld and Nicolson, 1955). For the involvement of the press in the trial, see Higgins, Chapter 11, p. 251ff. For the institution of the Wolfenden Committee, see Higgins, Introduction, p. 9ff.

Wildeblood, 'I was determined to admit that I was a homosexual', *Against the Law*, op. cit., p. 55. For Wildeblood's testimony to the Wolfenden Committee, see Higgins, Chapter 8, p. 165; 'an enemy of the state', Chapter 1, 'The Wolfenden Committee', p. 28; Kinsey meeting, pp. 38–9; BMA evidence, including 'cure' quote, p. 51ff.

Rodney Garland on spiv style, *The Heart in Exile*, op. cit., p. 74. For Cecil Gee, see Nik Cohn, *Today There Are No Gentlemen* (Weidenfeld and Nicholson, 1971), Chapter 2; for Bunny Roger and 'associated with queerness', see Chapter 3, 'New Edwardians', p. 25. For the Clapham Common murder case, see Tony Parker, *The Plough Boy* (Hutchinson, 1965). For details about the Teddy Boys' origin in the Edwardian style and the later delinquency press cuttings, go to https://www.edwardianteddyboy.com. There was a major article in the *Picture Post* about the Teddy Boys, written by Hilde Marchant, with many great photos by Joseph McKeown (29 May 1954, p. 19ff). Blackpool CID chief quote from https://www.edwardianteddyboy.com.

6 James Dean

The opening quote is from Dal McIntire, 'Tangents', *ONE* magazine, November 1955.

There are many books about James Dean. For Dean and *Rebel Without a Cause*, I have relied on Val Holley, *James Dean: The Biography* (Albion Press, 2016); David Dalton, *James Dean: The Mutant King* (Plexus, 1983); and Lawrence Frascella and Al Weisel, *Live Fast, Die Young: The Wild Ride of Making* Rebel Without a Cause (Simon and Schuster, 2005).

The Jack Warner quote comes from Frascella and Weisel, Chapter 15, 'Crash', p. 237; 'James Dean must be seen', p. 249. The Howard Thompson interview is from the *New York Times*, 15 March 1955, and is mentioned in Holley, pp. 226–7. The *Life* magazine piece on James Dean, 'From Barns to Broadway', is from 7 March 1955.

'Leak in his heart', Holley, p. 144; 'an introvert', p. 29; influence of James DeWeerd, p. 31ff; 'pantywaists', p. 37; for Dean and Rogers Brackett, see p. 71ff; draft board, pp. 73–4; Robert Stevens's 'Soutine' quote, p. 115; Actor's Studio, p. 116ff. *The Immoralist*, Holley, p. 175ff; meets Elia Kazan, p. 188; 'extreme grotesque', p. 188;

meets Christopher Isherwood, p. 157. 'H-bomb Dean', letter to Barbara Glenn, August 1954, Dalton, p. 192. Frank Corsaro 'androgyny' quote, Holley, p. 232; Hollywood interviews, p. 226ff; 'He was constantly fucking himself over', p. 247.

'The Blind Run', original title, Frascella and Weisel, p. 11ff; for Nicholas Ray background, see p. 1ff. From black and white into colour, Dalton, p. 116; Dean's red jacket, p. 119; chicken run and Cold War tensions, pp. 204–7; Operation Teapot, p. 206; Stewart Stern's character notes, pp. 228–9. The script for *Rebel Without a Cause* can be seen at https://www.dailyscript.com/scripts/Rebel_Without_A_Cause.html.

'Faggot' quote in H. Paul Jeffers, *Sal Mineo: His Life, Murder, and Mystery* (Carrol and Graf, 2000), Chapter 3, p. 30. Details on the censorship problems and the Production Code Administration from Michael DeAngelis, *Gay Fandom and Crossover Stardom*, Kindle edn, location 617. For *Rebel Without a Cause* and juvenile delinquency in general, see Gilbert, *A Cycle of Outrage*, op. cit., Chapter 9, 'Mass Media and Delinquency', p. 157ff. The Bosley Crowther *Blackboard Jungle* review can be found at https://www.nytimes.com/1955/03/21/archives/the-screen-blackboard-jungle-delinquency-shown-in-powerful-film.html.

Geoffrey M. Sherlock letter to Jack Warner, DeAngelis, *Gay Fandom*, location 1725; 'hostile manifestations of a perverse sexuality', location 617; 'juvenile delinquency of parents', location 626. 'You know how I am with Natalie', Jeffers, Chapter 3, 'Will the World End at Night?', p. 26. For Mineo and bisexuality, see Dalton, p. 258; for Dean wandering in and out of different personalities, p. 261ff. 'It also informed', William Baer, Stewart Stern interview, *Michigan Quarterly Review*, issue 4, fall 1999; online at https://quod.lib.umich.edu/cgi/t/text/text-idx?cc=mqr;c=mqr;c=mqrarchive;idno=act2080.0038.414;g=mqrg;rgn=main;view=text;xc=1.

'The shine and shiver of life', Holley, p. 188. Mike Connolly interview, 'This Was My Friend Jimmy Dean', *Modern Screen*, December 1955, p. 50ff. Dennis Stock quote, Dalton, p. 213; 'Live fast, die young and have a good-looking corpse!', p. 274.

7 1956

Art Rupe 'pasteurised' quote, Coleman, *Little Richard*, op. cit., p. 23. 'They needed a rock star', from 'Tutti Frutti' Wikipedia page, sourced from Richard Harrington, '"A Wopbopaloobop"; and "Alopbamboom", as Little Richard Himself Would Be (and Was) First to Admit', *Washington Post*, 12 November 1984. 'The white radio stations', White, *The Life and Times of Little Richard*, op. cit., location 908. For 'The Thing', the first version of 'Long Tall Sally', see Coleman, p. 24. For Enotris Johnson, see White, location 901ff. Blackwell on not being very happy about Pat Boone's version of 'Tutti Frutti', Coleman, p. 24. NBC censor not ruling 'Long Tall Sally' obscene because he couldn't understand the words, Brian Ward, *Just My Soul Responding*, op. cit., Part 1, Chapter 3, p. 107.

For a chronology of Elvis in 1956 and his meeting with Liberace in April 1956, go to https://www.elvispresleymusic.com.au/pictures/liberace-elvis.html. 'A great big

beautiful hunk of forbidden fruit', Peter Guralnick, *Last Train to Memphis*, Kindle edn, location 3,379. 'Story of Person Who Walked Lonely Street', from 'Heartbreak Hotel' Wiki. In 2016, an article in *Rolling Stone* magazine (Randy Boswell, 'Solving the Mystery of "Heartbreak Hotel"', 15 July 2016) suggested that in reality the story originated from a report about a painter and criminal, Alvin Krolik, whose marriage had failed and who wrote an unpublished autobiography, which included the line 'This is the story of a person who walked a lonely street.' Krolik's story was published in the news media, and received further publicity after he was shot and killed in an attempted robbery in El Paso, Texas. On 25 August 1955, the *El Paso Times* reported Krolik's death under the headline 'Story of Person Who Walked Lonely Street'.

For the Fred Danzig interview, see Guralnick, location 4,404; 'We think tonight', location 4,345. Elvis's six appearances on the Dorsey brothers' *Stage Show* have been issued on the LP *Elvis Presley Dorsey Shows*, Golden Archives (no date). The Jas W. Atkins review was in the *Gaston Gazette*, 14 February 1956. '300 other black guys', Whiteside, *Cry*, op. cit., Chapter 14, p. 206. Ben Gross quote, Guralnick, location 5,102.

'Why Johnny [*sic*] Ray Likes to Go in Drag', *On the QT*, January 1956, p. 36ff. A year after the release of *Rebel Without a Cause*, Warner Brothers were receiving up to 8,000 letters a month to James Dean, Frascella and Weisel, *Live Fast, Die Young*, op. cit., p. 238. James Dean in *Whisper* magazine, February and April 1956, collected in Alan Betrock, *The Best of James Dean in the 'Scandal Magazines' 1955–58* (Shake Books, 1988). 'Do You Have the Homosexual Urge?', *He*, October 1956. More on the afterlife of James Dean in the scandal/fan magazines can be found in *James Dean Revealed: James Dean's Sexational Lurid Afterlife from the Scandal and Movie Magazines of the Fifties* (Ed. David Dalton, from the collections of Alan Betrock and Jerry Fagnani) (Delta Books, 1991).

For the Nat King Cole attack, see Ward, p. 95ff, and Linda Martin and Kerry Segrave, *Anti-Rock: The Opposition to ROCK'n'ROLL* (Da Capo, 1993), Part 1, Chapter 3, 'Combat the Menace', p. 42. For a great example of a teenage fan opposing Cole's treatment, see letters, *Dig* magazine, December 1956. The riot at the Little Richard/Fats Domino show, May 1956, is covered in Andrews, *Awop Bop Aloo Mop*, op. cit., p. 91ff, and in Ward, Part 1, Chapter 3, p. 113ff. Santa Cruz and Jersey City banning rock 'n' roll and 'communicable disease', Ward, p. 107. Herb Rau review, *Miami Daily News*, 4 August 1956.

For the disturbances surrounding the *Rock Around the Clock* film in the UK, see Martin and Segrave, Part 1, Chapter 3, p. 32ff. 'Noisy' behaviour, *The Times*, 4 September 1956. For more on Kennedy and Larry Parnes, see Johnny Rogan, *Starmakers and Svengalis* (Queen Anne Press, 1988), p. 17ff. The Larry Parnes quotes are from author interview, November 1985.

For the full story of the Cassandra article on 26 September 1956 – including the 'neuter' quote – and the subsequent trial, see Revel Barker, *Crying All the Way to the Bank: Liberace V Cassandra and the Daily Mirror* (Revel Barker Publishing, 2009). Henry Hart on Elvis, *Films in Review*, December 1956. For the meeting of Elvis and Liberace

in November 1955, see Guralnick, location 6,337: 'The night before the *Love Me Tender* premiere in New York, he attended Liberace's opening at the Riviera and was introduced from the front row by the flamboyant entertainer, who was dressed in gold-sequined cutaway and matching pants. Afterward they exchanged jackets and instruments, cutting up for the cameras and singing and playing songs like "Girl of My Dreams" and "Deep in the Heart of Texas." "Elvis and I may be characters," commented Liberace, "but we can afford to be."' For a comparison of Elvis and Liberace, see http://www.elvis-history-blog. com/elvis-liberace.html. For Richard and 'standing room only', see White, location 1039; and for Richard and rock 'n' roll bringing 'the races together', see location 1,040.

8 John Leyton and Joe Meek

The standard text on Joe Meek's life is John Repsch, *The Legendary Joe Meek* (Woodford House, 1989); I have used the Kindle edition. The quotes from John Leyton, unless cited in the music press of the day, are from an interview conducted by Kieron Tyler in 2001 that was made available to the author. Digital copies of *Disc* from 1961, 1962 and beyond can be found at https://worldradiohistory.com/Disc.htm; period digital copies of the *New Musical Express*, *Record Mirror* and *Melody Maker* are also available. The *Disc* chart of 12 August was printed in the issue of 19 August 1961. The *Record Retailer* charts are the ones used in the *Guinness Book of British Hit Singles and Albums*.

For the origin and the recording of 'Johnny Remember Me', see Repsch, location 2,054ff; Lissa Gray is mentioned at location 2,081. 'I didn't like the title', from Leyton interview with Kieron Tyler, 2001. For Robert Stigwood's earlier life, from his birth to his arrival in the UK, see Stephen Dando-Collins, *Mr Showbiz: The Biography of Robert Stigwood* (Vintage Books, undated), Kindle edn, locations 179 to 466; Hollesley Bay Borstal to Robert Stigwood Associates, locations 534 to 597. For Leyton on meeting Stigwood, see Tyler, 2001. For getting the Biggles role and meeting Joe Meek, Dando-Collins, locations 633–45.

For Meek's early life, see Repsch, Chapter 1, 'Bumpy Beginnings', location 129ff; early experiments are covered in Chapter 2, 'Picture Painting in Sound'; the 'I wanted a magnetic pick-up' quote, location 331; RGM sound explained at location 442; first record a collection of sound effects, location 469; Luxembourg shows, location 540; Ivy Benson, location 603; 'Bad Penny Blues' location 609; the 1958 tarot-card reading is described in Meek's own words at location 1,141ff; Dennis Preston's 'jealous woman' quote, location 1,428: 'I Hear a New World', location 1,481ff; clavioline, location 1,487; Triumph Records, location 1,511ff. Triumph launch: 'New label is to be entirely pop', *Disc*, 5 March 1960. Meek leaves Triumph, Repsch, location 1,671ff; meets Major Banks, location 1689; moves to 304 Holloway Road, location 1,724; Leyton and 'Tell Laura I Love Her', location 1,799, and Dando-Collins, location 655ff. 'Captivating', Jack Good, *Disc*, 15 October 1960, p. 6.

For *Harpers West One*, see Repsch, location 2,056 and Dando-Collins, location 670ff. Geoff Goddard and the writing of 'Johnny Remember Me', Repsch, location 2,062 ff;

see also 'Buddy Holly Spoke to Me', interview with Goddard in *Disc*, 14 October 1961. 'Buddy said', ibid. BBC lyric change, Repsch, location 2,081ff. The *Harpers West One* clip is currently available on YouTube. The press release for the record can be seen at 45cat.com: https://www.45cat.com/record/jar577.

Disc review of 'Johnny Remember Me', 29 July 1961. Details about the *Juke Box Jury* panel comments can be found at https://jukeboxjury.uk/2019/03/15/104-2. The Alistair Taylor quote comes from Alistair Taylor, *With the Beatles* (John Blake, undated), Kindle edn, location 106ff. There is also material in the transcripts for the BBC *Arena* documentary, collected in Debbie Geller, *The Brian Epstein Story* (Faber and Faber, 1999). 'The tearaway climb', Jack Good, 'Dramatising Pop on TV Pays Off', *Disc*, 26 August 1961. The Moontrekkers, Repsch, location 2,392ff; Meek *Disc* interview, location 2,210 (original in John Wells, 'Joe Meek Slammed the Door on John Leyton', *Disc*, 16 September 1961).

For Meek and the recording of 'Wild Wind', see Repsch, location 2,266ff. 'Wild Wind' 'reviews were routine', see *Disc*, 23 September 1961: 'safe enough to make sure of another hit parade entry'. Leyton interview, Dick Tatham, 'It's Great Whenever the Fans Start to Scream', *Disc*, 30 September 1961. 'Star Spangled Nights', see 'After Fury Collapses, Leyton to Rescue', *New Musical Express*, 27 October 1961 (https://worldradiohistory.com/New_Music_Express.htm). For Meek and 'Son, This Is She', see Repsch, location 2,430ff. For Leyton and films, John Wells, 'Leyton Gets That Urge to Act', *Disc*, 30 December 1961; 'John Leyton to Sign £250,000 Seven Year Film Contract', *Disc*, 3 March 1962. *The Johnny Leyton Touch* is currently available on YouTube.

9 Billy Fury and Larry Parnes

The opening quote is from Stuart Hall and Paddy Whannel, *The Popular Arts* (Hutchinson Educational, 1964), Chapter 10, 'The Young Audience', p. 286ff. For Bart and Tommy Steele, see Andrew Loog Oldham, *Stoned* (Vintage Digital, 2010), Kindle edn, location 484. For 'the Cave', see interview in Royston Ellis, *The Big Beat Scene* (Four Square, 1961; revised edn, Music Mentor Books, 2010), p. 130. For more Bart, see David Roper, *Bart! The Unauthorised Life & Times, Ins and Outs, Up and Downs of Lionel Bart* (Pavilion, 1994). For early Tommy Steele, see Johnny Rogan, *Starmakers and Svengalis*, Chapter 1, 'Larry Parnes', p. 15ff. 'Tommy Steele was my way in', Loog Oldham, location 484. 'I felt I had to broaden out', Cliff Richard author interview, printed as 'The Great Pretender', *Mojo*, issue 15, February 1995 p. 43ff.

'Now after Living Doll . . .', 'Songwriters', *Disc*, 9 January 1960. 'Norrie Paramor, who came from that big band era', author interview. 'To be quite honest with you', author interview, 1985; more material in Rogan, *Starmakers and Svengalis*, op. cit., p. 15ff. 'I got back to my parents', author interview, printed as 'The Blackheath Jungle', *Mojo*, February 1995, p. 53. 'Called himself Stene Wycherley', Parnes, author interview; 'I can't think', ibid. Marty Wilde, author interview, *Mojo*, February 1995. '60 per cent of the record royalties', David and Caroline Stafford, *Halfway to Paradise: The Life of Billy*

Fury (Omnibus Press, no date), Kindle edn, location 851; 'at his flat on the Gloucester Road', location 779; for Johnnie Ray photo, location 789. 'Beat Svengali' was transmitted on 16 March 1959; it is partially available on YouTube. Peter Sellers, *Songs for Swingin' Sellers*, produced by George Martin and released on Parlophone, December 1959. Parnes quote on Peter Sellers, author interview, 1995.

'There was always a troupe', Stafford, location 789; 'He fancied all of us', location 798. Bob Dawbarn quote, Hall and Whannel, p. 286. 'The Big Beat stars to be promoted as ordinary people', Ellis, *The Big Beat Scene*, revised edn, p. 158. 'Properly, like a pop star', from Ellis, Introduction to *The Big Beat Scene*, revised edn p. 12. See also Royston Ellis, *Jiving to Gyp: A Sequence of Poems* (Scorpion Press, 1959).

For Royston Ellis, the Shadows and 'Rocketry', see Royston Ellis, *Cliff Richard and the Shadows: A Rock 'n' Roll Memoir* (Tomahawk Press, 2014), p. 9ff; Cliff 'cleaning up', p. 97; Ellis performing with Jimmy Page, the Beatles, Cliff Richard and the Shadows, p. 12ff, also 'Afterword: The Man on the Flaming Pie', in Ellis, *The Big Beat Scene*, revised edn, p. 161ff. The adventures of Tavy Tender are in Ellis, *The Big Beat Scene*, Chapter 1, revised edn, p. 19ff; 'Larry fucks our arses', p. 27; note about paragraph being deleted in original edition, p. 111; 'The situation where', p. 112; Polari discussion, pp. 159–60.

Parnes on Fury, author interview, 1995. The Dublin incident is described in Stafford, *Halfway to Paradise*, location 1,428, and also in Spencer Leigh, *Wondrous Place: The Billy Fury Story* (2013), Kindle edn, location 964. Fury 'moody' interview, Richard Adams, 'Mean, Moody and All Mixed Up', *Disc*, 8 October 1960. Jack Good, 'Are the Moodies Finished?' *Disc*, 7 January 1961. Lee Everett on marijuana consumption: 'they all smoked grass', Loog Oldham, location 883. 'I forget meal times', Dick Tatham, 'A Faraway Look as He Dwells on Life', *Disc*, 29 July 1961. For the background to 'Jealousy', see https://en.wikipedia.org/wiki/Jalousie_(Gade). Fury collapses, Stafford, location 2,513.

Jack Good, 'The Time Is Ripe for the Big Change', *Disc*, 2 December 1961. Lionel Bart, author interview for *The Brian Epstein Story*, 1997. Epstein's 'Pop's Galore' column, including Chubby Checker and Roy Orbison, *Mersey Beat*, vol. 1, no. 5, 14–28 September 1961, collected in Bill Harry, *Mersey Beat: The Beginnings of the Beatles* (Omnibus, 1977). For Epstein and 'My Bonnie', see Mark Lewisohn, *The Beatles: All These Years: Volume One: Tune In* (Little, Brown, 2013), Kindle edn, location 10,987; Bob Wooler quote, location 11059; 'I never thought that they would be anything less', location 11,177. Derek Taylor, author interview, 1994.

'Stand a chance on disc', Dick Tatham, 'More Beat Groups Than Ever Don't Stand a Chance on Disc', *Disc*, 16 December 1961. 'Affluent, slick, sleek', Jack Good, 'A Good Year for Pop? Rubbish, It's Been TERRIBLE', *Disc*, 6 January 1962.

10 Colin MacInnes and Teenage Fashion

For Colin MacInnes's early life, see Tony Gould, *Inside Outsider: The Life and Times of Colin MacInnes* (Chatto and Windus, 1983), Part One, 'Angela Thirkell's Son'. 'He

couldn't give – he was taking all the time,' quote by Kenny Graham, from Gould, Chapter 8, 'The Road to Notting Hill', p. 140.

Elvis's 'Neronic glare', Colin MacInnes, *England, Half English* (MacGibbon & Kee, 1961), 'Pop Songs and Teenagers', p. 50; originally published in *The Twentieth Century*, February 1958. 'It does seem to me that the teenager is a key figure', MacInnes, p. 45. 'A troubadour', MacInnes, 'Young England, Half English', in MacInnes, p. 13 (originally published in *Encounter*, December 1957); 'Today, youth has money', p. 11; 'that youth is rich', p. 47; annual 'teenage kitty', p. 54.

The seminal teenage document, Mark Abrams' 'The Teenage Consumer' (London Press Exchange, July 1959). For details of Abrams' life, see https://en.wikipedia.org/wiki/Mark_Abrams. Pathé's 'It's the Age of the Teenager' is available on YouTube. 'Aggressively elegant silhouette', MacInnes, 'Sharp Schmutter', p. 148ff.

MacInnes as founder member of the Stars Campaign for Interracial Friendship, see Gould, p. 137ff. MacInnes, *Absolute Beginners* (MacGibbon and Kee, 1959, now in Kindle edition); 'un-silent teenage revolution', location 871; the Hoplite on gay politics, location 1,601.

'The '58 Look', *The Daily Sketch*, 8 January 1958. Cecil Gee's purple and orange mohair sweaters, from Jeremy Reed, *The King of Carnaby Street: A Life of John Stephen* (Lume Books, 2010), Kindle edn, location 289; installing a Gaggia machine, location 282. 'People said the stuff was so outrageous', Shaun Cole, *Don We Now Our Gay Apparel* (Berg, 2000), Chapter 5, 'Tight Trousers: Italian Styling in the 1960's', p. 72. 'I invented a long felt need', Nik Cohn, *Today There Are No Gentlemen*, op. cit., p. 63; 'sold stuff that could once have been worn by no one but queers', p. 62.

For John Stephen's early life, see Reed, Chapter 1, 'Talkin' About My Generation', and Chapter 2, 'Up Above the World'. 'Hipster trousers in flame-red', Reed, location 413; 'The young Cliff Richard proved to be an early customer', location 415; Stephen moving to No. 5 Carnaby Street, location 448; The Man's Shop, location 448. 'There was a distinctly Italian look in the late Fifties', from Cole, p. 71. 'I favoured shirts in delicate pastel colours', Peter Burton, *Parallel Lives* (Gay Men's Press, 1985), p. 10. Eden Kane shop opening, Reed, location 848; 'hair ribbons', location 862.

'There is something of it', Hall and Whannel, *The Popular Arts*, op. cit., p. 282ff. 'Mods were always intellectual', Reed, location 475. 'One didn't only dress up for girls', Gillian Freeman, *The Leather Boys* (Anthony Blond, 1961), p. 76. Terry Taylor, *Baron's Court, All Change* (MacGibbon & Kee, 1961, reprinted with an introduction by Stewart Home, Cripplegate, 2021). 'The Absolute Beginner' and 'With Larry Parnes', Ray Gosling, 'Lady Albemarle's Boys' (The Fabian Society, January 1961), p. 5. Gosling on Colin MacInnes, Ray Gosling, *Personal Copy: A Memoir of the Sixties*, p. 71.

11 *Victim*

The opening quote is from Gordon Westwood, *A Minority: A Report on the Life of the Male Homosexual in Great Britain* (Longmans, 1960), Chapter 4, 'Attempts to Combat.

E: Acceptance', p. 59. The basic source for the material on *Victim* in this chapter is John Coldstream, *Victim* (a BFI book published by Palsgrave Macmillan), Kindle edn; for the premiere, see location 1,080; for box office, see location 1,081. For Dearden and Relph's recent filmography, see Wikipedia.

For Gordon Westwood on blackmail, see Westwood, Chapter 8, 'The Legal Aspects. E: Blackmail', p. 138ff; the 'destroyed' quote is on p. 140. The Wolfenden Report was published in book form in the US and the UK; I have used the 'Authorised American Edition' (Lancer Books, 1964). For the November 1958 House of Commons debate, see Stephen Jeffery-Poulter, *Peers, Queers and Commons*, op. cit., p. 41ff. Also in Patrick Higgins, *Heterosexual Dictatorship*, op. cit., Chapter 6, 'Implementing the Wolfenden Report', p. 123ff: 'several MPs were outraged that they should have been sent such material [Peter Wildeblood's *Against the Law*]. It lent support to their fantasy of a homosexual lobby.'

For the A. E. Dyson letters to the great and the good, and the publication of the *Times* letter of 7 March 1958 calling for the decriminalisation of homosexuality between consenting adults, see Jeffery-Poulter, p. 38, and Higgins, p. 124ff. For the formation of the HLRS, see Higgins, pp. 125–7, and Jeffery-Poulter, pp. 39–41; see also Antony Grey, *Quest for Justice*, op. cit., p. 34ff. Cyril Black quote in Jeffery-Poulter, p. 43. For the Caxton Hall meeting and the 'You were proclaiming in a blaze of lights' quote, see Jeffery-Poulter, Chapter 3, 'Keeping Wolfenden from the Westminster Door', pp. 49–51, and Higgins, p. 127.

Two films were released about Oscar Wilde: see Coldstream, location 212. The Bosley Crowther review was in the *New York Times*, 21 June 1960, accessible at https://www.nytimes.com/1960/06/21/archives/screen-oscar-wildetrial-of-author-viewed-in-film-at-2-theatres.html. 'When I think of the hopeless lives so many homosexuals lead', from Westwood, Chapter 4, 'Attempts to Combat. D: Self-control', p. 57.

For the sending of the script to the head of the British Board of Film Censors, John Trevelyan, in May 1960, see Coldstream, Chapter 2, 'The Story', location 261. For Audrey Field reading the script, see location 265; her 'sympathetic' quote is at location 277; for the Trevelyan 'sympathetic' quote, see location 294; Janet Green and Montagu/Wolfenden, location 170; *A Taste of Honey* and censorship, location 179; 'We feel strongly', location 217.

For Kenneth Robinson MP's motion to implement the Wolfenden Report, see Grey, p. 42ff, and Higgins, Chapter 6, 'Implementing the Report, The 1960 Debate', p. 127ff. 'A number of men', Jeffery-Poulter, Chapter 3, 'Keeping Wolfenden from the Westminster Door, Leading the Country from Behind', pp. 51–2. Audrey Field's comments on the draft script, Coldstream, location 304; 'proceed with caution', location 327; American distributor turning the film down, location 418; article in *Kinematograph Weekly* and original title, location 434; Jack Hawkins, James Mason and Stewart Granger, location 481.

For Gordon Westwood on interviewing 127 homosexuals, see Westwood, Chapter 1, 'Aims and Methods. A: Objectives', p. 1; for variety of occupations, see Chapter

1, 'C: The Sample', p. 3ff; 'reasonably happy homes', Chapter 2, 'Backgrounds. B: Parents' Marital Relations', p. 9; 'It never entered my head', Chapter 4, 'Attempts to Combat. A: Advice', p. 40; 'I had a terrific aversion', Chapter 4, 'C: Religion', p. 56; for blackmail, see Chapter 8, 'The Legal Aspect. E: Blackmail', p. 147ff; 'They find it easier', p. 149; 'The law affects one's whole life', Chapter 8, 'D: Indirect Effects of the Law', p. 146; 'The present social and legal methods', Chapter 11, 'Conclusions. B: Social Reflections', p. 196.

For Dirk Bogarde's involvement with *Victim*, see Coldstream, location 491ff; 'Larking around', location 503. For summarised Bogarde biography, see Wikipedia. The film of *Victim* is available on DVD and Blu-ray through Network, and the script can be found at https://www.scripts.com/script/victim_22814. 'I said there's no half measures', Higgins, Chapter 4, 'Dark Corners, *Victims*', p. 96. 'I feel more strongly', Coldstream, location 1,075; 'This new film may shock', location 1,069; Isabel Quigly review, location 1,145ff; 'a landmark', location 1,175; Blackpool walkout, location 1,254; London reaction, location 1,256; 'liberated' – 'an overwhelming sense of identification'; 'a watershed in my awareness of gay life', location 1,258; letters saying 'thank you', locations 1,233 and 1,235.

For Epstein blackmail, see Geller, *The Brian Epstein Story*, op. cit., Chapter 3, 'Prodigal Son', p. 26ff, and for incident on 19 May 1958, see Lewisohn, *The Beatles: Tune In*, op. cit., location 5,962. For Joe Meek blackmail, see Repsch, *The Legendary Joe Meek*, op. cit., location 4,065. 'Unfortunately, legal reforms, like the mills of the gods', from Isadore Rubin (ed.), *The Third Sex* (New Book Company, 1961), Chapter 7, 'The Need for Law Reform', Kenneth Walker, p. 110; 'constant attention', p. 111. For Leo Abse and *Victim*, see Coldstream, location 1,354.

12 *The Rejected*

For basic information about *The Rejected* and a link to view the programme, see https://recognizedrights.wordpress.com/2017/09/27/documentary-1-the-rejected. There is also a long article about the documentary at *The Advocate* (https://www.advocate.com/politics/commentary/2011/09/21/op-ed-television-coming-out-story-1961), which is the source for the Jess Stearn's 'affected' quote and the Motion Picture Association of America lifting the ban on overt portrayals of homosexuality. See also https://diva.sfsu.cdu/collections/sfbatv/bundles/225539 for another viewing source of the programme, plus a link to the script.

For the making of the programme and the James Day quote, see 'Op-ed: A Television Coming Out Story', *The Advocate*, 1961, op. cit. The quotes from *The Rejected* are taken from viewing the original programme. 'Handled the subject soberly, calmly and in great depth', see *The Ladder*, vol. 6, no. 1, October 1961, p. 17. '*The Rejected* represents what may be', *Mattachine Review*, vol. VII, no. 9, September 1961, p. 2. 'Favourable and most gratifying', Thomas M. Merritt's review of *The Rejected*, 'A Transcript', *ONE*, vol. IX, no. 12, December 1961, review of The Rejected, A Transcript, by, pp. 24–5.

'A great deal of revision', Alfred A. Gross, Foreword, in Jess Stearn, *The Sixth Man* (W. H. Allen, 1962), p. 8; 'Homosexuals can be anybody', Chapter 1, 'The Impact', p. 19; 'they consider themselves', p. 20; for Fire Island quote, Chapter 5, 'Paradise Island', p. 57; Mattachine Society, Chapter 18, 'The Mattachine', p. 177ff; 'sexual equality for all', p. 178. For review of Stearn in *ONE*, see Edouard Marques, *ONE*, vol. IX, no. 7, July 1961, pp. 22–4. Copies of *ONE* magazine are viewable and downloadable at https://archive.org/details/one-magazine/ONE%20magazine%20Vol%201%20No%20 1%20%281953%20January%29. 'We hate them', Del McIntire, 'Tangents: News and Views', *ONE*, July 1961, p. 18

For the physique magazines in general, see Thomas Waugh, *Hard to Imagine: Gay Male Eroticism in Photography and Film – From Their Beginnings to Stonewall* (Columbia University Press, 1996), p. 227ff, and David K. Johnson, *Physique Pioneers: The Politics of 1960s Gay Consumer Culture*, PDF at Digital Commons @ University of Florida, https://digitalcommons.usf.edu/hty_facpub/237/; also published in the *Journal of Social History*, summer 2010; references that follow from that source. The Newton Arvin story is in Johnson, *Journal of Social History*, p. 876, and Waugh, p. 275ff.

'Prurient interest' and 'unmailable' from Wikipedia, *MANual Enterprises, Inc. v. Day*, 370 U.S. 478 (1962), and Waugh, p. 248ff. 'What to Do If You Are Arrested', *Physique Pictorial*, vol. X, no. 1, June 1960; 'Can the Post Office Dictate Your Reading Matter?', vol. X, no. 4, April 1961; 'Los Angeles Police', vol. XI, no. August 1961. The topic was also handled in Robert Gregory, 'Why the Post Office Has No Time for our Mail', *ONE*, August 1961, p. 5ff. For the Cherry Grove, Fire Island, raid, see Del McIntire, 'Tangents, The Gayest Spot', ibid., p. 23ff.

For the Tay-Bush Inn raid, see Nan Alamilla Boyd, *Wide-Open Town: A History of Queer San Francisco to 1965* (University of California Press, 2003), Kindle edn, location 4,559ff; 'A Gay Cafe Party', location 6,653; 'included actors, actresses', location 4,595; 'The only moral', location 4,592. 'As though it were a circus or a Hollywood film production', *Mattachine Review*, September 1961, pp. 12–13. For the outcome of the trials, see '65 Freed in "Gay Bar" Case', *The Ladder*, October 1961, p. 18, and Nan Alamilla Boyd, 'The Repeal of the Vagrancy Law', location 4,523.

José Sarria running for supervisor, *The Ladder*, October 1961, p. 22. For digital copies and downloads of *The Ladder*, go to the Internet Archive at https://archive.org/details/ the-ladder-1956-1972-lesbian-periodical/The%20Ladder%20Vol.%2001%2C%20 No.%2001%2C%201956%20Oct. The Black Cat and Sarria's candidacy, see Alamilla Boyd, location 4496. The Ginsberg quote comes from *Gay Sunshine*, no. 16, January/ February 1973. The José Sarria album recorded live at the Black Cat and released on LP in 1961 is available at https://soundcloud.com/moontrent/jose-sarria-widow-norton-1961; an excerpt was included on Jon Savage, *Queer Noises 1961–1978: From the Closet to the Charts* (Trikont, 2006).

'For years the publications of the organizations dealing', Dorothy 'Del' Martin, 'Editorial: How Far Out Can We Go?', *The Ladder*, vol. 5, no. 4, January 1961. 'Homosexuals, both male and female', Dorr Legg, *ONE*, vol. 9, no. 4, p. 5ff. 'Some

pretty boy with wavy hair', Stearn, Chapter 8, 'Showbiz', p. 82ff. For change in phys-
ique type, see Waugh, 'The Marketplace', p. 243ff; 'slim, sensitive types', p. 245.
'Flamboyantly coloured shirts', Stearn, p. 20.

'The Church has done much to keep the homosexual from Christ', see Kittredge
Cherry, 'Robert Wood: First Clergy to Picket for LGBTQ Rights, Author of First Book
on Christianity and Homosexuality', https://qspirit.net/robert-wood-gay-advocate.
For Robert Wood on jeans, see Robert Wood, *Christ and the Homosexual* (original
publication Vantage Press 1960; facsimile edition, 2017), 'Trends in Recent Years –
1942–1959', p. 43ff. For an example of jeans in *Physique Pictorial*, see, for instance,
vol. 5, no. 2, summer 1955, and *MANual*, no. 23, March 1961.

'Motorcycle Clubs and teenage gangs', Wood, p. 45. 'There has been coming to the
fore in American thinking', pp. 55–6; 'our emphasis on activism', p. 57. 'The best thing
of all', Prescott Townsend, letter to *ONE*, vol. IX, no. 12, p. 31. 'With the dropping
of the atomic bomb', Thane Walker, 'For Want of a Chance . . .', *The Ladder*, October
1961, p. 13.

13 Pop/Art

'Playing up what things really were was very Pop, very sixties', Andy Warhol and Pat
Hackett, *POPism* (Penguin Modern Classics), p. 31; Kindle edn, location 503. The
list of Warhol's records is contained in the Andy Warhol Museum, Pittsburgh, and
was kindly forwarded to me by archivist Matthew Grey. 'His metamorphosis into a
pop persona', Blake Gopnik, *Warhol* (Penguin Books Ltd., 2020), Kindle edn, location
4,664; for Lichtenstein and early pop art, see locations 4,548 and 4,651; for Warhol's
Hollywood scrapbook, see location 725ff.

For material about *American Bandstand*, Dick Clark and Bob Marcucci in general, the
best source is John A. Jackson, *American Bandstand: Dick Clark and the Making of a Rock
'n' Roll Empire* (OUP, 1997), Kindle edn. For Marcucci in detail, see location 1,497ff.
'It was a panelled library', Gopnik, location 4,919. 'From negative to positive', James
Gilbert, *A Cycle of Outrage*, op. cit., pp. 204–10. 'Twenty million viewers', Jackson, loca-
tion 1,624; 'instant celebrities', location 1,754; for the success of 'Silhouettes', see location
1,837; Danny and the Juniors, location 6,689; Clark's business interest in Swan Records
and ABC, see location 2,957; Marcucci and Chancellor, location 1,504ff; for Marcucci
discovering Fabian, see location 3,188. 'I worked with them,' Bob Marcucci interviewed
by Gary James: http://www.famousinterview.ca/interviews/bob_marcucci.htm.

16 magazine and *American Bandstand*: for instance, see vol. 1, no. 12, January
1960; vol. 2, no. 1, February 1960; vol. 2, no. 3, April 1960 – with articles about
Frankie Avalon, Fabian and *Bandstand* dancer Arlene Sullivan; vol. 2, no. 5, July 1960 –
with articles about *Bandstand* dancer Kenny Rossi and Bobby Rydell. *Dig* magazine
September 1959 contains pin-ups of 'elvis, annette, anka, fabian, avalon', along with
the Bob Crewe quote, contained in a feature called 'Wallet Pix: 15 Top Stars'; the fif-
teen also contain a young Scott Engel. 'The whole office was gay', see Graham Reid,

'Lou Christie: If My Car Could Only Talk', *Elsewhere*, https://www.elsewhere.co.nz/fromthevaults/6591/lou-christie-if-my-car-could-only-talk-1966.

James Gardiner and Robert Lambert, author communications, 2020 and 2021. 'It had severed', author interview, February 1995. For 'manly' abstract expressionism, see Gopnik, location 2,727. 'America's Greatest Teenager', from undated letter, Time Capsules, Andy Warhol Museum. For Beseler Vu-Lyte and *Nancy* paintings, see Tony Scherman and David Dalton, *Pop: The Genius of Andy Warhol* (Harper, 2009), Chapter 2, '1961', p. 49ff. For the Bonwit Teller windows and the 'Cartoons Galore Are Eye Catchers' headline, see Gopnik, location 4,181.

For Hockney, see Chistopher Simon Sykes, *Hockney: The Biography, Volume 1 1937–1975* (Century, 2011), Kindle edn; 'I suddenly felt part of', location 1,282; 'Growing up in the 1950s', location 1,184 (from *The Last of England* (Constable, 1987)); 'a sexy little thing', location 1,389; *Doll Boy* painting, location 1,391; 'Young Contemporaries' exhibition, location 1,467; *We Two Boys Together Clinging*, location 1,617; 'sheer energy of the place', location 1,698; Lady Clairol ad and dying hair blond, location 1,730; 'yellow crew-cut', location 1,748.

Karp visiting Warhol's town house, see Gopnik, location 4,356. For Karp on 'Hey Paula' and 'had to do with cleansing away', see Scherman and Dalton, Chapter 2, '1961', p. 65. 'The idea of doing blank, blunt, stark images', Gopnik, location 4,356; 'Warhol's eureka moment', location 4,266; 'tremendous force and conviction', location 4,705.

Warhol on Peppermint Lounge, Warhol and Hackett, location 406. 'The Twist is the new teenage dance craze', Jim Dawson, *The Twist: The Story of the Song and Dance That Changed the World* (Faber & Faber, 2013) Kindle edn, location 909. 'It only held about 140 people' quote thanks to Bill Brewster and Frank Broughton, whose research in this area can be read in this article, https://www.vanityfair.com/news/2007/11/wolcott200711, and in the book *Last Night a DJ Saved My Life: The History of the Disc Jockey* (White Rabbit, 2022).

Hank Ballard, Dick Clark and Chubby Checker, see Jackson, *American Bandstand*, location 4,957ff; 'refused to include it on *American Bandstand*', see 'Bernie Binnick was so intrigued he brought Hank Ballard's record back to Philadelphia with him and played "The Twist" for Clark. "I can't play that, it's too black," Clark allegedly replied', location 4,985; 'a pretty frightening thing', location 5,072. For the payola scandal and Clark's business interests, see Jackson, location 4,430ff. For the origins of Twist moves, see Dawson, Chapter 1, 'Hey Let's Twist!' Chubby Checker interview by Peter Hammond, *Disc*, 23 December 1961, p. 7.

For Warhol and Muriel Latow, see Gopnik, location 4,534, and Scherman and Dalton, Chapter 2, p. 73ff.

14 1962

The opening *Art Voices* interview, from Kenneth Goldsmith, *I'll Be Your Mirror: The Selected Andy Warhol Interviews, 1962–1987* (Carroll and Graf, 2004).

'Son, This Is She' entered the *Disc* chart of 23 December 1961. 'Will 1962 see the end of the "gimmick brigade" in pop music?', 'Pop Singer Denies Gimmick Charges', *Melody Maker*, 6 January 1962. For more Meek/Leyton controversy, including 'My critics' and 'Utter rubbish', see Repsch, *The Legendary Joe Meek*, op. cit., Chapter 9, 'Up, Up and Away', location 2,474; 'electronic product', location 2,477; Martin Slavin and Meek's response, location 2,483–92. 'That's what the pop scene was last year', Jack Good, 'Jack Good Lashes Out: A Good Year for Pop? Rubbish, It's Been TERRIBLE', *Disc*, 6 January 1962, p. 5. 'I'm not very good at just turning it on', 'Peter Hammond Talks to Billy Fury on the Set of *Play It Cool*', *Disc*, 10 February 1962. Fury smoking marijuana and police raid, David and Caroline Stafford, *Halfway to Paradise*, op. cit., location 2,708. 'Intelligent yet modest entertainer', Brian Gibson, 'Turning Point Spotlights', *Disc*, 10 March 1962.

For Abse's private member's bill, see Jeffery-Poulter, *Peers, Queers and Commons*, op. cit., p. 53ff, and Higgins, *Heterosexual Dictatorship*, op. cit., p. 132ff. 'Members who oppose', Jeffery-Poulter, p. 54. For the *Time* review, see 'A Plea for Perversion?', *Cinema*, 23 February 1962, p. 102. Review of *Victim* novelisation by M.M. in *ONE*, vol. X, no. 3, March 1962, p. 19. 'Those in the homophile movement', *The Ladder*, vol. 6, no. 6, p. 19. '*ONE* has maintained a vigilant, militant attitude', 'The Big Three', *The Ladder*, vol. 6, no. 8, pp. 8–10.

For Lynn Womack case, see Waugh, *Hard to Imagine*, op. cit., pp. 275–80, and Wikipedia page of *MANual* v. *Day*; also in Johnson, *Physique Pioneers*, p. 879. Don Nicholls review of 'Lone Rider' is in *Disc*, 3 March 1962. For the distortion on 'Lone Rider', see Repsch, location 2,582; Charles Blackwell joining the team, location 2,582ff; 'Come Outside', location 2,604. 'The teenage market', June Harris, 'Leyton: I Can't Keep with This Sob Stuff', *Disc*, 7 July 1962.

For the lead-up to and the Ferus Gallery exhibition, see Gopnik, *Warhol*, op. cit., location 4,909ff, and Scherman and Dalton, *Pop*, op. cit., Chapter 3, '1962', p. 118ff. For the *Time* magazine interview, see Scherman and Dalton, p. 101ff, and Gopnik, location 4,958. 'Working on soups', Gopnik, location 4,967; Brooklyn Fox with Ivan Karp, location 4,702ff; for the *Marilyns*, see Chapter 16, location 5,251ff, and Scherman and Dalton, p. 124ff.

For origins of 'Telstar' in world communications satellite TV exposure, see Repsch, location 2,731ff. For details of its broadcast, see https://en.wikipedia.org/wiki/Telstar. 'Joe wanted a moving rhythm', author interview 1995, published in *Mojo*, 15 February 1995, p. 52. Binson echo unit, Repsch, location 2,767; 'Telstar' #4 in seance, location 2,902; *Melody Maker* bad review, location 2,928.

For Mark Feld and the early mods, see Peter Barnsley, 'The Young Take the Wheel', *Town*, September 1962. See also http://dandyinaspic.blogspot.com/2012/01/bolan-as-mod.html; this cites the Steve Sparks quote contained in Paolo Hewitt (ed.), *The Sharper Word: A Mod Anthology* (Helter Skelter, 2007), Chapter 9, 'Days in the Life – Jonathan Green', p. 65: 'Mod has been much misunderstood. Mod is always seen as this working class, scooter-riding precursor of skinheads, and that's a false point of view. Mod, before it

was commercialised was essentially an extension of the beatniks. It comes from "modernist", it was to do with modern jazz and to do with Sartre. It was to do with existentialism, the working class reaction to existentialism. Mark Feld (who later became Marc Bolan) was an early example of what was the downfall of mod, which was the attraction of people who didn't understand what it was about to the clothes. Mark Feld was only interested in the clothes, he was not involved in thinking.' 'I used to go home and literally pray to become a mod', Cohn, *Today There are No Gentlemen*, op. cit., Chapter 10, 'Mods', p. 81.

Andrew Loog Oldham on Joe Meek and Kenny Hollywood, *Stoned*, op. cit., location 2,380ff; 'Ray took too much vicarious pleasure', location 2,412; meeting Fury and Parnes, location 2,593ff; 'everybody thought he was a poof', location 2,645.

'Rock-slanted-vocal-instrumental group', 'New to You', *Disc*, 10 October 1962, p. 8. Review of 'Love Me Do' by Don Nicholls, 'Short and Sharp', *Disc*, 10 October 1962, p. 8. For Epstein and the struggle to get the Beatles a record contract, see Geller, *The Brian Epstein Story*, op. cit., Chapter 5, 'The World Comes to Liverpool', p. 50ff, and Lewisohn, *The Beatles – All These Years*, op. cit., location 13,775ff and Chapter 28, 'You Better Move On (13 April–2 June 1962)' passim; 'Man, those Beatles are fabulous!' location 16,593, p. 767, original quote from Alan Smith, *New Musical Express*, 15 October 1962. Loog Oldham's violent Little Richard press release, see Loog Oldham, location 2,737.

'If he doesn't start taking life easier', *Disc*, 13 October 1962. Warhol Sidney Janis Gallery show, Gopnik, location 5,426. For the use of 'pop' art in the *New York Times* review of the *New Realists* show, see Scherman and Dalton, Chapter 3, '1962', p. 131. Jack Good on US popularity of 'Telstar', Jack Good, 'Everyone Here is Mad on Telstar', *Disc*, 24 November 1962, p. 5. 'The newest British group', Jean Carol, 'Beatles Find Show Biz Isn't All Fun', ibid., p. 4. 'I just had a funny feeling about it', Mike Hellicar, 'Mike Hellicar Invites You to Meet – JOE MEEK, the Man Behind "Telstar" and Other Hits', *New Musical Express*, 23 November 1962, p. 3. Copies of *Disc*, *New Musical Express* and *Melody Maker* are available to download at worldradiohistory.com.

15 Dusty Springfield, Janis Joplin and Janis Ian

'We're part of society', Maureen Duffy, *The Microcosm* (Arcadia Books; original edn Hutchinson & Co., 1966), Kindle edn, location 4,761. *Billboard* review of 'Give Me Time', '*Billboard* Pop Spotlights', 17 June 1967, p. 18 (sourced at Google Books). For Dusty at *NME* 1967 poll-winners concert, see Alan Smith, 'Poll Thrills All The Way', *New Musical Express*, 13 May 1967 (sourced at rocksbackpages.com).

'One list I picked up at random', Jon Savage, *1966: The Year the Decade Exploded*, Chapter 5, 'May', p. 148. Dusty seeing Danny La Rue, Lucy O'Brien, *Dusty: A Biography of Dusty Springfield* (Michael O'Mara Books, revised edn, 2009), Kindle edn, location 1,486. Details about Springfield's shows in Eccles and Stockton, see Paul Howes, *The Complete Dusty Springfield* (Reynolds and Hearn, 2001), 'Goin' Back: A Diary of Events in Dusty's Life from 1963 to 1999', p. 223. Talk of the Town, O'Brien, location 1,486.

'I overdid a lot of things', author interview, 1989. 'Dusty Does it!', cover of *Melody Maker*, 30 November 1963. 'It wasn't easy', author interview, 1989. 'Suddenly it's all too much', Savage, Chapter 5, 'May', p. 175 (taken from reproductions of old articles in copies of the *Dusty Springfield Bulletin*). 'Two currents in a song' and 'She would always know when the emotion', Penny Valentine and Vicki Wickham, *Dancing with Demons: The Authorised Biography of Dusty Springfield* (Hodder and Stoughton, 2012), location 1,451; for *Ready Steady Go!*, location 285; Hanging out at the *RSG!* studios, location 1,029; Peppi Borza and Madeline Bell, location 1,036; sharing a flat with Bell, location 1,050. 'I remember this quite clearly', author interview, 1989. The Motown sound on *RSG!*, Valentine and Wickham, location 941. 'Yes, I can see this is an up-tempo teen-slanted platter', 'Beatle Blind Date: Paul McCartney Reviews the New Pop Singles', *Melody Maker*, 25 February 1967. 'Breathing heavily and sometimes giggling', unnamed writer, 'Demon Phone Calls Drive Dusty Crazy', *Disc and Music Echo*, 18 March 1967, p. 13 (accessed from both rocksbackpages.com and worldradiohistory.com).

'Then there's always be a drama', Valentine and Wickham, location 1,338. 'It wasn't my scene', author interview, 2021. For background on the Gateways club, see 'The Shady Old Lady's Guide to London', http://www.shadyoldlady.com/location.php?loc=2221, and 'Another Nickel in the Machine, The Kings Road, the Gateways Club and The Killing of Sister George', http://www.nickelinthemachine.com/2008/07/the-kings-road-the-gateways-club-and-the-killing-of-sister-george; see also Jill Gardiner, *From the Closet to the Screen: Women at the Gateways Club, 1945–1985* (Rivers Oram Press, 2003), Chapter 3, 'Natty Suits and Frilly Frocks', p. 48ff. For Dusty at the Gateways, including Ricky's quote, see Gardiner, Chapter 4, 'Is She a Friend of Dorothy?', p. 86ff; for the Gateways playlist and Maureen Duffy on Frank D'Rone, see p. 79ff. 'Girls, girls, girls, were made to love', from Duffy, location 241; 'the world turned back to front', location 182; 'There are dozens of ways of being queer', location 4,532. For Simone de Beauvoir and the 'buttoned-up society' reference, see Maureen Duffy's essay in *The Advocate*, June 2020: https://www.advocate.com/books/2020/6/23/maureen-duffy-becoming-britains-first-out-woman-public-life.

For the publisher not wanting to publish a non-fiction book about gay women because Duffy was not 'a sociologist', see 'Maureen Duffy on the Banning of *The Microcosm* for Banned Books Week 2018', Royal Society of Literature, https://rsliterature.org/library-article/maureen-duffy-on-the-banning-of-the-microcosm-for-banned-books-week-2018. 'I got rather tired of there being only books about gay men.', Gardiner, Chapter 5, 'Letting Lesbians into the Living Room', p. 98ff. 'A mosaic style', Duffy, Afterword, location 4,811; 'of any talk about human rights', location 3,579. Banned by the Vatican etc., and Duffy being 'worried about the publisher's reaction', see https://rsliterature.org/library-article/maureen-duffy-on-the-banning-of-the-microcosm-for-banned-books-week-2018. Mary McIntosh quoted in Gardiner, Chapter 5, p. 98ff; for *Arena Three*, see p. 97; Duffy quoted in Gardiner as being a contributor, p. 108, and Wikipedia for the Minorities Research Group; *This Week* and Esme Langley's contribution mentioned in Chapter 5, p. 100; see also BFI Screen online: http://www.

screenonline.org.uk/tv/id/480350/index.html. *This Time of Day*, 'Lesbianism', was originally broadcast on 31 March 1965 and is available at https://www.bbc.co.uk/archive/this-time-of-day--lesbianism/zdnjgwx.

'A very large number of people do not realise', Bryan Magee, *One in Twenty: A Study of Homosexuality in Men and Women* (Secker and Warburg, 1966), Chapter 6, 'How Do Other People Look at Homosexuals', p. 61; upbringing of girls 'oriented far more consistently towards their sexual role', Chapter 16, 'Lesbians and Normal Sex', pp. 138–9; having children, p. 139; 'liberate them from many aspects of the female role', Chapter 18, 'Lesbians at Work', p. 160; 'Lesbians quite often have a fear of exposure, p. 164; 'It is a striking fact', p. 166.

Man Alive: 'Consenting Adults 2: The Women' was first broadcast on 14 June 1967; it is available to view at https://www.bbc.co.uk/programmes/p013h8zl. 'One time I went to Gateways with her', from O'Brien, *Dusty*, location 2,533. For the date of Dusty Springfield's recording session for 'No Stranger Am I', see Howes, pp. 110–11. 'I'm standing there with my guitar,' Valentine and Wickham, location 1,262; 'witty and flirty', location 1,266. 'Dusty called me', author interview, 2013.

For Janis Joplin, two basic sources are used: Alice Echols, *Scars of Sweet Paradise: The Life and Times of Janis Joplin* (Virago Press, 2000), and Holly George-Warren, *Janis: Her Life and Music* (Simon and Schuster, 2019), Kindle edn. For details of both Big Brother and the Holding Company appearances at Monterey Pop, see Wikipedia, https://en.wikipedia.org/wiki/Monterey_International_Pop_Festival. D. A. Pennebaker's *Monterey Pop* is now available on Blu-ray with extras.

For Janis Joplin's early life, see Echols, Chapters 1 and 2, 'The Great Nowhere' and 'Magnetised into Music', and George-Warren, Chapters 1 and 2, 'Pioneer Stock' and 'Tomboy'; for liking Little Richard, see location 704; for the original 'Hound Dog', location 407; 'took a lot of pills', location 999; meets Jae Whitaker, location 1,670, and Echols, Chapter 3, 'On the Edges of America', p. 85. 'She seemed like a lesbian', George-Warren, location 1691. Addicted to speed, see Echols, Chapter 3, 'On the Edges of America', p. 94ff. Performing at Monterey Folk Festival, George-Warren, location 1704, Echols, pp. 75–6. RCA Records interest, George-Warren, location 1,753, Echols, p. 76. 'Emaciated, almost catatonic', George-Warren, location 1,910. Returning to Port Arthur, Echols, p. 89ff. Writing 'Turtle Blues', George-Warren, location 2,129, Echols, Chapter 4, 'The Beautiful People', p. 92. 'Women Is Losers', George-Warren, location 2,196; Austin benefit and 13th Floor Elevators, location 2,217; Reaching San Francisco on 3 June 1966, location 2,276, Echols, p. 129ff. 'A real, live drug rush', George-Warren, location 2,400; 'Don't fuck it up', location 2,509. Grace Slick and Janis Joplin photo by Jim Marshall. 'That chick, she does something to me' and 'really unfamiliar', George-Warren, location 2,449. Joplin's affairs with James Gurley, Country Joe McDonald and Peggy Caserta, see Echols, Chapter 5, 'Big Brotherized', p. 140ff.

'Sisterhood of song', George-Warren, location 3,218; Joplin writing 'Down on Me', location 2,351; rave reviews, location 3,348, Echols, Chapter 6, 'Hope and Hype in Monterey', p. 168. Grossman at Monterey, Echols, p. 167ff, and George-Warren,

location 3,335, and Grossman becoming manager in November, location 3,616; Big Brother billed with Janis Ian, location 3,423; 'She was seven or eight years older', location 3,423; 'There were dozens of naked people', location 3,687. The poster for Circle Star Theater concert can be seen at https://www.pinterest.com/pin/748371663058728946.

The source for Janis Ian is her autobiography, *Society's Child* (Rude Girl Press, 2019), Kindle edn; for the full quote about meeting Janis Joplin, see location 1,296; 'Joplin took me to another party', location 1,304; father on FBI 'watch list', location 360; for the writing of 'Society's Child', location 890; 'There were only three white kids', location 543; 'Music filled my world', location 787; Ma Rainey to Bessie Smith, location 564; James Brown and Motown, location 543; 'molested by her dentist', location 703; 'I just knew that I was separated', location 780; 'I was dreaming', location 644; reading John Rechy, location 659; 'Things that were only whispered about', location 688; *Broadside*, location 815; Jac Holzman, location 849; meeting George 'Shadow' Morton, location 1,005. Bernstein's *The Rock Revolution*, location 1,214; support from Dave Van Ronk and Odetta, location 1,282. Interview in *Life*, 'I Am Society's Child: Little Janis Ian Turns a Grownup Eye On Life', 27 October 1967, p. 53ff. For appearance on *Smothers Brothers Comedy Hour* and 'A very well-known television star', see Ian, location 1,311ff.

'A complicated girl', Penny Valentine, 'Dusty: Searching So Hard to Find Herself . . .', *Disc and Music Echo*, 9 September 1967, p. 11. *Billboard*, Top 60 spotlights, 4 November 1966, p. 12 (recoverable at Google Books). For the American TV shows, see Howes, 'Goin' Back', p. 224. Her appearance on *The Dating Game* is available on YouTube.

16 Brian Epstein

The opening Maureen Cleave quote is sourced from https://www.rocksbackpages.com/Library/Article/brian-epstein-the-man-behind-the-beatles-and-how-he-lives.

'We are light years away', Thomas Thompson, 'The New Far-Out Beatles', *Life*, 16 June 1967, p. 100ff; McCartney LSD quote, p. 105. For the McCartney LSD ITV interview transcript, see 'The Beatles Ultimate Experience', *Beatles Interview Database*, https://www.beatlesinterviews.org/db1967.0619.beatles.html. 'That's what happens when you don't consult us first', George Emerick, *Here, There and Everywhere* (Gotham Books/Penguin, 2007), Chapter 10, 'All You Need Is Love', p. 204. For the Beatles business, see John Blaney, *Beatles for Sale: How Everything They Touched Turned to Gold* (Jawbone, 2008).

'Brian really sailed', in Geller, *The Brian Epstein Story*, op. cit., Chapter 9, 'Uncharted Waters', p. 108; 'I think the image of Brian', p. 110. Maureen Cleave 'At heart he is not a business man at all', https://www.rocksbackpages.com/Library/Article/brian-epstein-the-man-behind-the-beatles-and-how-he-lives. For the Seltaeb case, see Blaney, p. 210ff, Geller, pp. 102–3, Geoffrey Ellis, *I Should Have Known Better* (Thorogood Publishing Ltd, 2014), Kindle edn, location 1,208, and Ray Coleman, *Brian Epstein: The Man Who Made the Beatles* (McGraw-Hill, 1989), Chapter 13, 'Lonely Heart', p. 313ff.

The John Lennon interview is from Maureen Cleave, 'How Does a Beatle Live? John Lennon', *Evening Standard*, 4 March 1966 (available on rocksbackpages.com). For the Beatles' 1966 tour, see Savage, *1966*, Chapter 8, 'August', p. 315ff, and Steve Turner, *Beatles '66: The Revolutionary Year* (Harper Collins, 2016), 'August'. 'We should be making millions', Coleman, p. 316; 'It's so hard to keep the bloody empire going', ibid.

For Candlestick Park and blackmail, see Coleman, Chapter 12, 'Dangers', p. 284ff; Peter Brown and Steven Gaines, *The Love You Make* (McGraw-Hill, 1983), Chapter 11, p. 205ff. 'Brian was thrilled', Geller, Chapter 11, The Fire This Time, p. 129. For Brown, '$20000 in brown paper bag money', see The Love You Make, p. 206. 'But that was the beginning', Weiss, quoted in Geller, p. 129. For Seconals and amphetamines, Geller, p. 128. 'This is all too much', Brown and Gaines, p. 208. 'He was a very sad and lonely person', Geller, p. 140; 'His role was decreasing', p. 132.

'The more successful he got', Coleman, Chapter 15, 'Peace', p. 244. For the Four Tops show, see Ellis, location 1,392, and Coleman, pp. 331–2. For Epstein and Klein, see Brown and Gaines, p. 237, Steve Turner, *Beatles '66*, ibid, pp. 359–60, and John McMillian, 'You Never Give Me Your Money: How Allen Klein Played the Beatles and the Stones', https://www.newsweek.com/sympathy-devil-how-alan-klein-played-the-beatles-and-stones-224703.

For Epstein and NEMS, see Geller, Chapter 12, 'Uppers and Downers', p. 135ff, Brown and Gaines, p. 224ff, and Coleman, p. 325ff. For Stigwood history from Leyton onwards and RSA liquidation, see Dando-Collins, *Mr Showbiz*, op. cit., location 951; 'Top Impresario Bust!', location 954; for Keith Richards, location 972ff; Stigwood meeting Ertegun, location 1,105; linking up with Epstein, Chapter 9, 'Getting into Bed with Brian Epstein', location 1,284ff. Stigwood not popular among NEMS staff, Geoffrey Ellis in Geller, p. 136. 'Although Mr. Stigwood will share with me', Coleman, p. 326. 'Brian tired very quickly', Geller, p. 137. For Seltaeb, see Ellis, location 1,202ff; 'Ostrich burying its head in the sand', location 1,236. Renegotiating Beatles deal with EMI, Alan Livingstone in Geller, p. 130, Coleman, p. 342, Blaney, p. 78ff. Joe Orton contacted by Walter Shenson, John Lahr (ed.), *The Joe Orton Diaries* (Methuen, 1986), 'Friday 12 January 1967', p. 60; *Loot* wins award, p. 56ff; meeting McCartney at Brian Epstein's office, 'Wednesday 24 January', p. 73ff.

Nat Weiss on Murray the K interview, Geller, Chapter 12, 'Uppers and Downers', p. 141; the interview is available on YouTube. Orton on Epstein, Lahr, p. 73; Orton on Epstein as 'an amateur and a fool', ibid., 'Wednesday 29 March', p. 126; on *Up Against It* script being returned, ibid., 'Tuesday 4 April', p. 130. 'We didn't do it because it was gay', see *The Beatles Bible*, entry for Tuesday 24 January 1967, https://www.beatlesbible.com/1967/01/24/paul-mccartney-brian-epstein-joe-orton-meeting-up-against-it.

'What's happening with Brian?' and admission to the Priory, Geller, Chapter 13, 'All You Need Is Love', p. 146. 'Because he's not in his right mind', Dando-Collins, location 1,670. For 18 May signing of contract, see https://en.wikipedia.org/wiki/All_You_Need_Is_Love. *Sgt. Pepper* launch party, Coleman, pp. 352–3; returning to the

Priory and 'I'm really sure this place', pp. 354–5. Registration of Apple Music, Blaney, p. 117, and Coleman, p. 358. 'Paul was the one', Coleman, p. 358.

Kingsley Hill house-warming, Coleman, p. 356, and Geller, pp. 148–9. 'I looked like a ragamuffin', Geller, p. 152; 'Towards the end of June', p. 149. For the recording of 'All You Need Is Love', see *The Beatles Bible*, https://www.beatlesbible.com/songs/all-you-need-is-love. 'This is an inspired song', Mike Hennessey, 'Love from the Beatles', *Melody Maker*, 22 July 1967, p. 5. Brian was always concerned', Geller, p. 149.

17 The Gay Managers

Opening Maureen Duffy quote from *The Microcosm*, op. cit., location 3,546.

'Pop think-in', Mike Ledgerwood, 'Does London Really Swing?', *Disc and Music Echo*, 17 June 1967, pp. 8–9. 'Key in this was the figure of John Stephen', 'Face It! Revolution in Male Clothes', *Life*, 13 May 1966. 'I was doing *Thank Your Lucky Stars*', author interview, 2020. 'Andrew discovered gay life in London', Simon Napier-Bell, author interview, 2020. 'It was a way of life', author interview, 2020. See also Loog Oldham, *Stoned*, op. cit.; Simon Napier-Bell, *You Don't Have to Say You Love Me* (original publication, Ebury Press, 1983; Kindle edn, Ebury Digital, 2013).

'There was also that sense', 'Dancing was what it was about', 'It happened in the latter stages of our time at the Aquarium', author interview, 2011. The phrase 'clean living under difficult circumstances' was spoken by Pete Meaden to Steve Turner in an interview for the *New Musical Express* in 1975. 'Brian Epstein was middle class, he was gay', Andrew Motion, *The Lamberts: George, Constant and Kit* (Chatto and Windus, 1986), p. 302; for Lambert's early life, p. 203ff; 'flickering attention', p. 212ff Lancing College, p. 272ff; fails finals at Oxford, p. 285; relationship with Jeremy Wolfenden and 'for the rest of his life', p. 282.

Brazil Iriri River expedition, Motion, p. 288ff; Richard Mason killed, p. 290: working on *From Russia with Love*, etc. and meeting Chris Stamp, p. 292; 'I didn't feel that London boys', p. 294; 'Roger, with his teeth crossed at the front', p. 295; 'Our audience', p. 309. 'Kit Lambert came to get me', author interview, 2011. 'I don't think the rebellion line', Nick Jones, 'Whither the Groups', *Melody Maker*, 15 October 1966. 'Almost a queer song', Norman Jopling, 'The Who: Anti Love', *Record Mirror*, 15 October 1966, pp. 6–7. Founding Track Records, Motion, p. 323ff.

Marc Bolan turning up on Joe Meek's doorstep, Mark Paytress, *Marc Bolan: The Rise and Fall of a 20th Century Superstar* (Omnibus, 2009), Kindle edn, location 856. Maureen Cleave, 'Knit Yourself a Pop Singer', *Evening Standard*, 23 October 1965 (available at rocksbackpages.com). 'Rent boy', Marc Bolan, 'Bitova Diary', cited in Paytress, location 1,229. Bolan meets Simon Napier-Bell, Napier-Bell, *You Don't Have to Say You Love Me*, p. 49. 'In 1966 I came into a business', Simon Napier-Bell, *Ta-Ra-Ra-Boom-De-Ay: The Dodgy Business of Popular Music* (Endword, 2015), Kindle edn, location 5,291.

'There was never a gay mafia', author interview, 2020. 'Hippy Gumbo', Napier-Bell, *You Don't Have to Say You Love Me*, p. 58, and Paytress, location 1,324. Buffy

Sainte-Marie, Paytress, location 1,304; John's Children, location 1,391, Chapter 4, 'Let It Rock', location 1,398ff, and Napier-Bell, Chapter 8, 'Orgasm (John's Children)'. For a detailed account of the Ludwigshafen show, see Paytress, location 1,417ff.

'The lead singer ran around the aisles', letter from SPR. H. R. Hutchingson, *Melody Maker*, 22 April 1967, p. 20; it is pictured in Napier-Bell, location 2,524, and detailed in Napier-Bell, *Black Vinyl, White Powder* (Ebury Digital, 2013), Kindle edn, location 1,946. 'If they do that again, they're off the tour', Paytress, location 1,681; 'After we recorded something', location 1,527; Bolan and 'Midsummer Night's Scene', location 1,736ff.

'The mods weren't really over', author interview, 2011. Stephen's shops from 1965 on, including Tre Camp, His Clothes, Mod Male, etc., see Reed, *The King of Carnaby Street*, location 2,352; clothes appearing on *Aftermath*, *Small Faces* and *Fresh Cream*, location 2,976; shift from Carnaby Street to King's Road, location 3,089; the use of satin in shirts, location 3,162; Mick Avory and the Russian-styled satin shirt, location 3,175; BBC switchboard jammed, location 311; the Pink Floyd, location 3,683. 'See Emily Play' reviewed by Penny Valentine in *Disc and Music Echo*, 17 June 1967, p. 15. Hewlett and Townson modelling, Reed, location 3,393.

'"Waterloo Sunset" is really tense', author interview, 1983; published in Jon Savage, *The Kinks: The Official Biography* (Faber and Faber, 1984). 'This song is about homosexuality', cited in Johnny Rogan, *Ray Davies: A Complicated Life* (The Bodley Head, 2015), Chapter Sixteen, 'A Legal Matter', p. 238. 'I was talking to him', author interview, 1983.

'It was by far the silliest item', Dave Davies, *Kink: An Autobiography* (Hyperion, 1996), Chapter 5, p. 89; 'enjoyed experimenting sexually', Chapter 3, p. 52; 'I really liked him', p. 54; 'from that incident the most important thing I learned', p. 56. Ray Davies on Michael Watts, author interview, 1983. 'What signals had he heard', Davies, *Kink*, Chapter 5, p. 95. The Kinks on *Top of the Pops*, miming 'Autumn Almanac', can be sourced on YouTube.

'"Arnold Layne" was about a knicker snatcher', Jenny Spires, email to author, May 2017. 'Funnily enough you can reckon that anyone', Duffy, location 3,553. The Who's set at Monterey is available on the DVD of *Monterey Pop*.

18 Legalisation

'Do you, then, believe', Mike Hennessey, 'The Brian Epstein Interview', *Melody Maker*, 5 August 1967, pp. 8–9.

For detail on 23 June 1967 debate in the House of Commons, see Hansard: https://hansard.parliament.uk/Commons/1967-06-23/debates/9128c8bf-ff81-4406-bb00-c49da3e87a1e/NewClause—(PromotionOfHomosexualActs)?highlight=homosexuality#contribution-650be8b6-7064-4f96-9d20-bc135c14f7a0. 'Anne Sharpley wrote a series of five pieces', 'London's Hidden Problem', *Evening Standard*, 22 July 1964, cited in Jeffery-Poulter, *Peers, Queers and Commons*, op. cit., Chapter 4, 'Burbling on About Buggery: 1964–67', p. 69ff; election of Labour government, p. 70.

Lord Arran, Higgins, *Heterosexual Dictatorship*, op. cit., Chapter 6, 'Implementing the Report 1957–67, Towards the Act', p. 132ff; Grey, *Quest for Justice*, op. cit., Chapter VII, 'Genesis of a Bill', p. 87ff; and Jeffery-Poulter, p. 70. Arran's speech is detailed in the *House of Lords Debates*, Series 5, vol. 266, column 72, https://api.parliament.uk/historic-hansard/lords/1965/may/12/homosexual-offences. 'Immediately after the debate ended', Grey, p. 91. Bill passing third reading and general election, Jeffery-Poulter, Chapter 4, 'The Outcome in the Commons', p. 72ff, Grey, Chapter VIII, 'Lords Marathon', p. 100ff, and Higgins, p. 136ff.

October 1965 national poll, Higgins, , p. 73; 'It will end a law', p. 74; for Labour victory and Roy Jenkins as home secretary, see p. 77ff and Grey, Chapter IX, 'On to the Statute Book', p. 117ff. Bryan Magee, universal support, Magee, *One in Twenty*, op. cit., Chapter 10, 'What About the Law?', p. 97; between 4 and 6 per cent homosexual, see Chapter 4, 'Who Are the Homosexuals?', p. 43; 'evenly distributed', p. 45; 'the ordinariness of homosexuality', p. 47.

Man Alive: 'Consenting Adults 1: The Men' was transmitted at 8.05 p.m. on 7 June 1967 on BBC Two; it is available to view at https://www.bbc.co.uk/programmes/p013h8v5; transcript author's own. The discussion about the two programmes was contained in *Late Night Line-Up: The Man Alive Report*, transmitted on BBC Two at 11.30 p.m. on 14 July 1967; it is available to view at https://www.bbc.co.uk/programmes/p013h8v5.

For a description of the 23 June House of Commons debate, see Grey, p. 122ff, Jeffery-Poulter, p. 79, and Higgins, p. 141. For the dogged opponents in the debate of 3 July 1967, see Grey, p. 122ff. For the press reaction to the passing of the bill, see Jeffery-Poulter, pp. 80–1; Higgins's critique of Sexual Offences Act, see pp. 142ff. Grey on his thoughts, Grey, Chapter X, p. 127ff. For Roger Baker and Jeffrey Weeks, see Jeffery-Poulter, pp. 92–3. More at https://www.theguardian.com/world/2017/jul/27/true-equality-took-longer-gay-people-sexual-offences-act-1967.

Increased prosecutions, Higgins, p. 145ff. 'Build up new personal and community attitudes', letter to *New Society*, September 1968, cited in Jeffery-Poulter, p. 96. 'The central fact about social life for homosexuals, Magee, Chapter 5, 'How Do Homosexuals Live?', p. 51.

The Riot Squad review is contained in 'New Records: Pop', *Melody Maker*, 7 January 1967, p. 11 (recoverable from https://worldradiohistory.com/Melody_Maker.htm). For origin of Ledrut case, see Repsch, *The Legendary Joe Meek*, op. cit., Chapter 11, 'Operation Heinz!', location 3,468ff; May 1963 *Gloucester Journal* interview, location 3,540. 'We didn't go to America', author interview, 2014. 'Persistently importuning', Repsch, Chapter 12, 'Incident at Madras Place', location 3,957ff; 'He was acutely conscious', location 4,273; the Saints reading about his arrest in the *Evening News*, location 4,049; blackmail threats, location 4,065; success of 'Have I the Right?', location 4,336ff; 'Eyes', location 4,405; for a chronological Meek discography, see location 6,015; 141 releases between 1962 and 1965, location 4,464; Goddard disputing 'Have I the Right?' authorship, location 4,343; Meek taking pills, location 4,580; Dennis Wheatley and

Aleister Crowley, location 4,642; for 'Please Stay' and Epstein, see location 4,672ff. 'Meek broke down', see http://triumphpc.com/mersey-beat/a-z/bumblies-cryin'shames3.shtml. Ledrut case tying up royalties from 'Telstar' despite counter-suit, Repsch, location 4,862; final notices from Board of Trade, location 4,697; LaVern and official receiver, location 4,697; 'helluva mess', Meek letter to John Ginnett, location 4,868; found unconscious in Ford Zodiac, location 4,975; Kray twins, location 5,169; Heinz and the gun, location 5,470; brief affairs, location 3,979; 'He used to say', location 4,743; *Psychic News*, Ramses the Great, poltergeists, etc., locations 4,795ff; 'trances', location 4,823; notice to quit, location 1,727; 'achieve success', location 4,835; Joseph Lockwood's EMI job offer, location 4,967; Bernard Michael Oliver and the 'suitcase murder', including police interviewing all known homosexuals, location 5,243ff; EMI rejection of his recordings, location 5,494; 'the shock of my life', location 5,387ff; 'I'm going now', description of murder and 'Joe was leaning', locations 100–122. The *Evening Standard* front page is viewable at http://www.joemeekpage.info/essay_11_E.htm.

Orton work on *Up Against It* script, Lahr, *The Orton Diaries*, op. cit., 'Monday 6 February', p. 80. For Orton on his decision to keep a journal, see letter to Peggy Ramsay, 30 May 1967, cited in Lahr, 'Editor's Note', p. 13; also the source of the Orton quote 'I'm going up, up, up'. For change in relationship between Orton and Kenneth Halliwell, see Lahr, 'Editor's Note', p. 11ff. For their imprisonment for defacing library books, see John Lahr, *Prick Up Your Ears: The Biography of Joe Orton* (Penguin, 1980), Chapter 3, 'Unnatural Practices', p. 93ff; 'queers', p. 100; 'old whore', p. 152.

'Sex is the only way to infuriate them', Lahr, *The Orton Diaries*, 'Sunday 26 March', p. 125; Tangier, 'Friday 12 May', p. 162ff; description of the 'frenzied homosexual saturnalia', 'Saturday 4 March', pp. 105–6; 'stuffy' American couple, Thursday 25 May, pp. 186–7; 'You must do whatever you like', 23 July 1967, p. 251.

For Orton's changing musical taste, see Emma Parker, 'A Queer Ear: Joe Orton and Music', https://figshare.le.ac.uk/articles/journal_contribution/A_Queer_Ear_Joe_Orton_and_Music/10236677/1. For Orton and *Sgt. Pepper*, see Lahr, *The Orton Diaries*, 'Thursday 20 July', p. 246; 'I slept all night soundly', 'Thursday 26 May', p. 187. For murder and Halliwell suicide, see Lahr, *Prick Up Your Ears*, Chapter 1, 'Jokers Are Wild', p. 1ff; for chauffeur, p. 5; for 'A Day in the Life' at the funeral, see Chapter 6, 'The Freaks' Roll-Call', p. 336.

'No, I don't', 'The Epstein Interviews Part III', *Melody Maker*, 19 August 1967, p. 14. For Seltaeb settlement, see Ellis, *I Should Have Known Better*, op. cit., location 1,299. Tensions with Stigwood, see Coleman, *The Man Who Made the Beatles*, op. cit., p. 326ff, and Dando-Collins, *Mr Showbiz*, op. cit., location 1,670ff. For the disagreement with Cilla Black, see Brown and Gaines, *The Love You Make*, op. cit., Chapter 13, p. 251. The *Melody Maker* interviews from 5 and 12 August can be accessed at https://worldradiohistory.com/Melody_Maker.htm. 'He'd shown the boys the way', Coleman, p. 349; 'Brian never seemed to have any close friends', p. 351. 'I feel as though I am Svengali', Geller, *The Brian Epstein Story*, op. cit., p. 153. US trip in September 1967, Nat Weiss in Geller, pp. 150–1. For Harry Epstein's death and the period of mourning,

see Coleman, pp. 364–5. 'I didn't know Brian', author interview, 2020. 'Brian had also invited', Geller, p. 156; for accounts of that weekend, see p. 155ff, Coleman, p. 370ff, and Brown and Gaines, p. 256ff. 'Brian was lying there' and 'one joint in the drawer', Geller, p. 159; 'We were all horrified', p. 161. Peter Brown, David Jacobs in charge, p. 160. For David Jacobs, see Mick Brown, 'The Mystery of David Jacobs, the Liberace Lawyer', June 2013, https://www.independent.ie/entertainment/movies/the-mystery-of-david-jacobs-the-liberace-lawyer/29318985.html. Re. suicide or accidental death, see Geller, p. 166ff, including McCartney's 'I think he went back to London' quote.

For Godfrey Winn on meeting Epstein, see Godfrey Winn, *The Positive Hour* (Michael Joseph, 1970), p. 271ff; 'The problem with Brian', p. 276; 'I was very close to him', p. 277. 'All manner of lovely pretty mortal persons', Epstein letter to Weiss, 23 August 1967, Geller, p. 155. Coroner's verdict, Brown and Gaines, p. 260, Coleman, p. 375, and Ellis, location 1,586. 'This was not a part time, twenty-five per cent commission job', Coleman, p. 379.

'Quite a number of male homosexuals', Magee, Chapter 12, 'What Are the Advantages for a Man of Being Homosexual?', p. 108ff. For Burton on the 1960s youth revolution, 'We – like our straight counterparts – had money to spend', see Peter Burton, *Parallel Lives*, op. cit., Chapter 2, 'Clubland', pp. 45–6; 'most usually songs by the legendary movie queens', p. 29; 'We would all sit at our separate tables', p. 30; 'Even when travelling in the singular', p. 39; 'They gave you confidence', p. 31; 'We shared many things in common', p. 30; Le Duce, p. 32ff; article in *Spartacus*, p. 33ff. 'I remember going', James Gardiner, author communication, 2020. 'I never worried about whether my homosexuality was "right" or "wrong"', Burton, Chapter 1, 'Setting the Scene', p. 13.

19 Gay Power

For the Benning Wentworth case, see Eric Cervini, *The Deviant's War: The Homosexual vs. the United States of America* (Farrar, Straus and Giroux, 2020), Kindle edn, location 4,365ff; for Franklin Kameny, see location 79ff, and Wikipedia, https://en.wikipedia.org/wiki/Frank_Kameny. Kameny forming Mattachine Society of Washington DC with Jack Nichols, Cervini, location 1,430; White House picket, location 3,362ff.

For the DSI case, see Waugh, *Hard to Imagine*, op. cit., pp. 280–3, and James T. Sears, *Behind the Mask of Mattachine*, op. cit., Chapter 39, 'The Furtive Fraternity', p. 517ff; there is also a résumé online at https://tim1965.livejournal.com/2019638.html. For DSI publications, including *Vagabond* and *279 Places to Go for a Gay Time*, see Johnson, *Physique Pioneers*, op. cit., p. 878; *Butch* selling 50,000 copies, see p. 879. For *Butch* as precipitating court case, see Waugh, p. 253. Copies of *Butch* and *Vagabond* are in the Harry H. Weintraub Collection at Cornell University.

'Those concerned with freedom', *Butch*, issue 1 (DSI, 1965), 'The Publisher's Creed'. Details of DSI raid by the authorities, see Johnson, p. 879. 'The only way in which a society can mature', *Butch*, issue 2 (DSI, 1965), 'Creeping Censorship', p. 8. Audio for the *Homosexuality in the American Male* LP can be heard at https://www.youtube.com/

watch?v=qaozqdoyIq4. CBS's 'The Homosexuals' can be viewed on YouTube at https://www.youtube.com/watch?v=tu1r6igCODw; author's own transcription. For more on the CBS programme, including the press reaction and the 'anything other than sick' *Vector* quote (April 1967 issue), see Jim Burroway, [Emphasis Mine] blog, 10 March 2018, 'CBS Airs "The Homosexuals"', http://jimburroway.com/history/cbs-airs-the-homosexuals. For the 'Ten Days in August' conference and the 'most ambitious' quote, see Dorr Legg, *ONE Confidential*, vol. XI, no. 9, September 1966, p. 1; for more on the convention, see p. 2ff. 'I was tired of holding endless meetings', Sears, p. 520.

For the Society of Individual Rights, see Alamilla Boyd, *Wide-Open Town*, op. cit., location 4,856ff; for SIR and *Vector*, see 'George Mendenhall Oral History', location 4,180. For Vanguard, see http://www.vanguard1965.com. 'When I first got to town', quoted in Laurence Tate, 'Exiles of Sin, Incorporated', *Berkeley Barb*, 11 November 1966, July Report. For more contemporary background on Vanguard, see 'YOUNG Rejects Form Organization', *Cruise News*, July 1966. 'In the least, all the wino destroys', Mark Forrester, 'Central City: Profile of Despair', *Vanguard*, issue 1, summer 1966.

For Compton's, the principal researcher of this extraordinary event is Dr Susan Stryker: see 'The Compton's Cafeteria Riot of 1966', in Susan Stryker and Stephen Whittle (eds), *The Transgender Studies Reader* (Routledge, 2006), and Victor Silverman and Susan Stryker, *Screaming Queens: The Riot at Compton's Cafeteria* (Frameline DVD, 2010); see also https://www.theguardian.com/lifeandstyle/2019/jun/21/stonewall-san-francisco-riot-tenderloin-neighborhood-trans-women. For a contemporary report, see Guy Strait, 'Young Homos Picket Compton's Restaurant', *Cruise News and World Report*, August 1966.

Vanguard distributed a broadside demanding that management 'changes its policies of harassment and discrimination of the homosexuals, hustlers, etc., of the Tenderloin Area'. For more, see vanguardrevisited.blogspot.co.uk/2011_02_01_archive.html. The picture of the hair fairies cleaning up the Tenderloin, as well as the Vanguard press release re 'WHITE POWER' and 'BLACK POWER', can be found at https://www.foundsf.org/index.php?title=1966_Vanguard_Sweep.

The Black Cat: see Mike Davis and Jon Wiener, *Set the Night on Fire: L.A. in the Sixties* (Verso, 2020), Chapter 11, 'Before Stonewall: Gay L.A. (1964–70)', Kindle edn, location 2,972ff. As Jim Highland reported in the gay press at the time, '400 demonstrators . . .' Jim Highland, 'Raid', *Tangents*, vol. 2, issue 4, January 1967, p. 4. More background at https://www.tangentgroup.org.

For 'Homosexuality in America', see *Life*, 26 June 1964, p. 66ff; 'running battle', see p. 71. For PRIDE (Personal Rights in Defense and Education), see Davis and Wiener, location 2,976. 'Most significant gay cultural achievement', Waugh, 'The Kinsey Generation: The Golden Age of Magazines and Mail Order (1945–1967)', p. 215; for estimated sales, see p. 217. Copies of *Vim*, *MANual*, *Fizeek Art Quarterly*, etc., are available to view in the Harry Weintraub Collection at Cornell University. For Regency Square and the Cloak and Dagger catalogue, see also the Harry Weintraub Collection.

'In their history of the genre', Drewey Wayne Gunn and Jaime Harker (eds), *1960s Gay Pulp Fiction: The Misplaced Heritage* (Studies in Print Culture and the History of the Book; University of Massachusetts Press, 2013). For individual books like *I, Homosexual*, see author's archive. 'Unorthodox sexual behaviour', Don Holliday, *The Man from C.A.M.P.* (Greenleaf Classics, 1966), 'Prologue', p. 7. '*BUTCH* hopes to', *Butch*, issue 1, p. 3. For basic information about *Drum*, including the circulation and the bust, see https://en.wikipedia.org/wiki/Drum_(American_magazine). For John D. Emilio interview with Clark Polak, go to https://outhistory.org/exhibits/show/john-d-emilio--oral-histories/clark-polak, Side #1A and #1b. 'Trojan Book Service', *Drum*, issue 23 (no date), pp. 35–8.

Susan Sontag, 'Notes on Camp', originally published in the Fall 1964 edition of the *Partisan Review*, now Penguin Kindle edn. 'A badge of identity', location 27; 'private code', location 30; 'degree of artifice', paragraph 1, location 56; Beardsley etc., paragraph 4, location 58; 'The canon of Camp can change', paragraph 30, location 193; 'idea of the epicene', paragraph 11, location 107; 'The hallmark of Camp', paragraph 25, location 165; 'a certain innocence', paragraph 21, location 158; 'Camp taste identifies', paragraph 56, location 316, includes a comparison of camp and pop art: 'Here, one may compare Camp with much of Pop Art, which – when it is not just Camp – embodies an attitude that is related, but still very different. Pop Art is more flat and more dry, more serious, more detached, ultimately nihilistic'; for homosexuals and camp, see paragraphs 52–3, location 294.

Gloria Steinem, 'The Ins and Outs of Popular Culture', *Life*, 20 August 1965, p. 72ff. 'Camp was a style of interaction', George Chauncey, *Gay New York: Gender, Urban Culture, and the Making of the Gay Male World, 1980–1940* (Basic Books, 2019), p. 286ff. 'You can't camp about something', Isherwood cited by Sontag, 'Notes on Camp', location 31. For a Camp Records discography, go to https://www.discogs.com/label/619061-Camp-Records-3, and for details and downloads, JD Doyle's excellent Queer Music Heritage site at https://www.queermusicheritage.com/camp.html. Allen Dennis, *The Gay BC Book, A Camp* (no publisher given, 1966). 'Disengaged, depoliticized', Sontag, location 58.

Jayne County with Rupert Smith, *Man Enough to Be a Woman* (Serpent's Tail, 2021), Kindle edn; 'finally graduated high school', location 401; 'made my first contact', location 404; 'John Rechy's novel *City of Night*', location 411; 'wrecking', location 419; 'big fan of the British bands', location 367; *Tangents* December 1966 issue. For *Vanguard*, see https://www.digitaltransgenderarchive.net/catalog?f%5Bcollection_name_ssim%5D%5B%5D=Vanguard&sort=dta_sortable_date_dtsi+asc%2C+title_primary_ssort+asc. *Tangents*, vol. II, no. 3, December 1966, 'Editorial', p. 2. For *Vector*, see https://digitalassets.lib.berkeley.edu/sfbagals/Vector; for 'we are in the middle of a social revolution', see William Beardemphl, 'Drag: Is It Despicable or Divine?', vol. 6, no. 3, May 1967, p14. For Polak, see Wikipedia, John D. Emilio, https://outhistory.org/exhibits/show/john-d-emilio--oral-histories/clark-polak, and Tyler Alpern, '*Drum* in Perspective', http://www.tyleralpern.com/1960s.html. For DSI trial, see Waugh, p. 280ff, and https://

tim1965.livejournal.com/2019638.html. For Cindy Claire Lewis, see 'Gay Power', *Vector*, vol. 3, no. 8, p. 25. For P. Nutz and 'Gay Power', see *The Advocate*, vol. 1, no. 2, October 1967, p. 8.

20 Andy Warhol and the Velvet Underground

The opening quote is from Discs a la DEBBI, review of the Velvet Underground's 'Sunday Morning', *Go* magazine, 20 January 1967; reprinted in Alfredo Garcia, *The Inevitable World of The Velvet Underground*, self-published, p. 94.

For Roger Ebert's non-interview with Andy Warhol, see https://www.rogerebert. com/interviews/interview-with-andy-warhol. For his review in the *Chicago Sun-Times*, see https://www.rogerebert.com/reviews/chelsea-girls-1967.

For the June 1966 Gretchen Berg interview transcript, see Gilda Williams, *On&By Andy Warhol* (MIT Press, 2016); the original interview was for the *East Village Other* and was also reprinted in the *Los Angeles Free Press*. 'Master of the art trick', 'trimming hair', 'Andy used to say he was transparent' and 'The gay world', Billy Name, author interview, 1997. 'A sensitive plate', from photocopied article provided by the librarians at the Andy Warhol Museum, Pittsburgh.

For Warhol giving up painting, see Gopnik, *Warhol*, op. cit., location 9,874ff; 'I think painting is old-fashioned' was another insult Warhol levelled at the venerable medium. For detail on *Chelsea Girls*, see Geralyn Huxley and Greg Pierce, 'On *The Chelsea Girls*', and Pierce, '*The Chelsea Girls* Exploded: The Films Within the Film', in Huxley and Pierce (eds), *Andy Warhol's* The Chelsea Girls (Distributed Art Publishers and the Andy Warhol Museum, 2019), p. 13ff and p. 198ff.

'New Madness at the Discotheque', *Life*, 27 May 1966, pp. 48–9. 'It is homosexual taste', Vivian Gornick, 'Pop Goes Homosexual: It's a Queer Hand Stoking the Campfire', *Village Voice*, 7 April 1966, https://www.villagevoice.com/2020/01/19/pop-goes-homosexual-its-a-queer-hand-stoking-the-campfire.

For instructions for the split-screen projection of *Chelsea Girls*, see Huxley and Pierce, p. 19. 'After *Chelsea Girls*, words like degenerate', see Warhol and Hackett, *POPism*, op. cit., location 3,244. *Chelsea Girls* reviews: 'perversion, degradation', *New York Post*, 21 October 1966; 'homosexuals, lesbians, addicts', Richard Goldstein, 'The Underground Updates', *New York World Herald Tribune*, 13 November 1966; 'the *Iliad* of the underground', Jack Krall, 'Underground in Hell', *Newsweek*, 14 November 1966; 'It has come time', Bosley Crowther, 'The Underground Overflows', *New York Times*, 11 December 1966.

For the *Cashbox* 'Sunday Morning' review, see Alfredo Garcia, *The Inevitable World of the Velvet Underground* (self-published, 2011), p. 88. For the Velvet Underground in general, see Johan Kugelberg (ed.), *The Velvet Underground: New York Art* (Rizzoli, 2009); Richie Unterberger, *White Light/White Heat: The Velvet Underground Day-By-Day* (Unterberger, 2023), Kindle edn; Victor Bockris and Gerard Malanga, *Up-Tight: The Velvet Underground Story* (Cooper Square Press, 2003); Anthony DeCurtis, *Lou*

Reed: A Life (John Murray, 2017); and Savage, *1966*, op. cit., Chapter 6, 'June'. For the lyrics, see Lou Reed, *I'll Be Your Mirror: Collected Lyrics* (Faber and Faber, 2019).

Warhol on pop songs: 'Sugar Shack' and 'Blue Velvet', Warhol and Hackett, location 1,226; Lesley Gore and Dionne Warwick, location 1,263. For synaesthesia at the Factory (Gerry and the Pacemakers and *Turandot*), see location 1,327, p. 93. For Eric Andersen in *Space*, see https://en.wikipedia.org/wiki/Space_(1965_film). 'The Making of an Underground Film' segment can be seen at https://www.youtube.com/watch?v=1KN-WQ2KZWy4. For Lou Reed's pop aesthetic, see Lou Reed, 'The View from the Bandstand: Life Among the Poobahs', *Aspen Magazine*, vol. 1, no. 3, December 1966.

'Me and Lou got on really well', Billy Name, author interview, 1997. For the beginnings of the Velvet Underground and 'mystical' quote, see John Cale and Victor Bockris, *What's Welsh for Zen* (Bloomsbury, 1999), '1965–1966, Journey to the End of the New York Underground', p. 66ff. For the 4 March 1967 *Billboard* review, see Garcia, p. 111; the 4 March 1967 *Cashbox* review, p. 112. Sterling Morrison, 'The West Coast was an organised force', Ignacio Julia, *Linger On: The Velvet Underground* (Ecstatic Peace Library, 2022), interview with Sterling Morrison, p. 57.

'One is a phlegmatic mode', 'Andy Warhol and the Night on Fire', *Los Angeles Free Press*, 13 May 1966, reproduced in Garcia, p. 40. The Ralph J. Gleason review, 'On the Town: The Sizzle That Fizzled', *San Francisco Chronicle*, 30 May 1966, in Garcia, p. 51. Mary Woronov, *Swimming Underground: My Years in the Warhol Factory* (Journey Editions, 1995). The 'amphetamine' and 'acid' quote is reproduced in Martin Torgoff, *Can't Find My Way Home: America in the Great Stoned Age, 1945–2000* (James Bennett Pty Ltd, 2004).

For the Eric Emerson lawsuit, see Gopnik, location 10,790. For Warhol and the 'daddy of Pop Art' ads, see Garcia, pp. 112–13. 'Snatching up an arch-light spotlight,' see David Freeman, 'Other Seens: Andy Warhol at the Plastic Quadrangle', *The Paper* (East Lansing-Michigan), 18 April 1967, reproduced in Garcia, p. 130. For the success of *Chelsea Girls* and the figure of $25,000, see Gopnik, location 10,871.

For Lou Reed refusing to appear with Nico and the separation with Warhol after the fund-raiser for Merce Cunningham, see Gopnik, location 10,990; 'rat', location 11,003. For a contemporary press note, see Grace Gluck, '. . . And Tons of Ostrich Feathers', *New York Times*, 11 June 1967, reproduced in Garcia, p. 150. 'No Andy Warhol questions' in Joel F, 'Interview with the Velvet Underground', *The Buddhist Third Class Junkmail Oracle* (Cleveland, Ohio), August–September 1967, reproduced in Garcia, pp. 162–3. 'The audience was strangely cool', George McKinnon, 'Boom, Boom, Boom Bores', *Boston Globe*, 20 September 1967, reproduced in Garcia, p. 174.

'Movies record the collective life', Rosalyn Regelson, 'Where Are the Chelsea Girls Taking Us', *New York Times*, 24 September 1967, https://www.nytimes.com/1967/09/24/archives/where-are-the-chelsea-girls-taking-us.html. 'Andy wasn't gay', Billy Name, author interview, 1997. 'An inadequate showcase', David DeTurk, 'VU: A non-linear road to conversion', *Boston After Dark*, 20 September 1967, reproduced in Garcia, p. 175.

Nico, 'The beginning of the world. Because I think that the rest of the world is us', transcribed audio from the flexi disc contained in the *Index* book (Random House, 1967). For 47th Street Factory notice to quit, see Gopnik, *Warhol*, location 11,383, and for move to Union Square, see location 11,412; for November Sammy the Italian incident, see location 10,713; for **** premiere on 15 December 1967, see location 11,018; for American Film Institute's keywords, see location 11,073; for *Variety* on *Chelsea Girls* and ****, location 11,045.

21 1968

The opening quote is from Jim Skaggs, 'The President's Corner', *Vector*, vol. 4, no. 4, March 1968, p. 6.

'Built around this story', Bockris and Malanga, *Up-Tight*, op. cit., p. 93; for more, see https://en.wikipedia.org/wiki/Sister_Ray. 'The Velvet Underground is okay', Bev, 'Muzak', *Chicago Seed*, vol. 2, no. 2, February 1968, reproduced in Garcia, *The Inevitable World of the Velvet Underground*, op. cit., p. 221. For *Lonesome Cowboys* as a gender-switched version of *Romeo and Juliet*, see Gopnik, *Warhol*, op. cit., location 11,144; 'We've been building up this camp image', location 11,563; retrospective at Moderna Museet, location 11,734.

For Dusty Springfield and 'Magic Garden', see Howes, *The Complete Dusty Springfield*, op. cit., song-by-song, entry under 'Magic Garden', p. 101. Keith Altham, 'Dusty Says "I Want to Hit Back"', *New Musical Express*, 6 July 1968, p. 5, accessible at rocksbackpages.com. For *Dusty in Memphis*, see Valentine and Wickham, *Dancing with Demons*, op. cit., location 1,458ff.

'A piece of the action', 'A Minority's Plea', *Wall Street Journal*, 17 July 1968, viewable at https://www.houstonlgbthistory.org/misc-WSJ.html; also mentioned in David Carter, *Stonewall: The Riots That Sparked the Gay Revolution* (St Martin's Publishing Group, 2010), Kindle edn, location 2,351; for Craig Rodwell on the *Wall Street Journal*, see location 2,351; for Rodwell and Milk, see location 698; the Oscar Wilde Memorial Bookshop, see location 1,058; for the Stone Wall and the Mafia, see Rodwell, quoted in Carter, location 1,619.

'One of the points which I have made', letter to Dick Leitsch, 19 June 1968, in Michael G. Long (ed.), *Gay Is Good: The Life and Letters of Gay Rights Pioneer Franklin Kameny* (Syracuse University Press, 2014), location 2,893. For more on 'Gay is Good', Kameny original, see Cervini, *The Deviant's War*, location 4,731; for the NACHO conference, location 4,836; 'BECAUSE homosexuals suffer from diminished self-esteem', location 4,851.

For difficulties in recording *Cheap Thrills* and John Simon's displeasure, see George-Warren, *Janis*, op. cit., location 3,930, and Echols, *Scars of Sweet Paradise*, Chapter 7, 'Bye, Bye Baby', p. 200ff. For hard drugs, see George-Warren, location 3,888. For Janis leaving Big Brother, George-Warren, Chapter 16, location 4,138ff, and Echols, p. 216ff; onstage arguments, p. 219. Big Brother final show on 1 December 1968, George-Warren, location 4,348.

For NEMS after Epstein's death, see Dando-Collins, *Mr Showbiz*, op. cit., Chapter 12, 'The King Is Dead, Long Live the King', location 1,817ff. For the Beatles' negative impression of Robert Stigwood and visit to *Pop Weekly*, see Lewisohn, *The Beatles: Tune In*, op. cit., location 16,442. For the 1 September 1967 meeting at Hille House, see Dando-Collins, location 1,842; including 51 per cent of NEMS, location 1,855; also in Geller, *The Brian Epstein Story*, op. cit., p. 170ff. £25,000 separation payment, Dando-Collins, location 1,888.

Warhol at the wrap party for *Midnight Cowboy*, Gopnik, location 12,651. For the events of 3 June 1968, see location 11,980ff; also Howard Sounes, *Notes from the Velvet Underground: The Life of Lou Reed* (Transworld Digital, 2015), Kindle edn, location 1,627ff. Billy Name on Solanas, author interview, 1997. For Paul Morrissey on the Warhol shooting, interviewed by Taylor Mead, see http://www.altx.com/interzones2/meade/shot.html. For Solanas trial and committal, see https://en.wikipedia.org/wiki/Valerie_Solanas. *SCUM Manifesto*, with Vivian Gornick's introduction, published by Olympia Press (1971).

For the origins of *Flesh*, see Gopnik, location 12,295; for more, see https://en.wikipedia.org/wiki/Flesh_(1968_film). For Candy Darling and Jackie Curtis in *Flesh*, see Gopnik, location 12,360; for Warhol dedicating a golden shoe to Christine Jorgensen, location 12,369. 'Satin shorts', Warhol and Hackett, *POPism*, op. cit., location 3,939; for first encounter in 1967, see location 3,920. 'I'm not a boy', Kembrew McLeod, 'The Genderqueer Tale of "Take a Walk on the Wild Side"'s Jackie Curtis', *Vulture*, 22 October 2018, https://www.vulture.com/2018/10/the-genderqueer-tale-of-jackie-curtis.html. 'Finally, they were just kind of rags on her legs', ibid.

For Candy Darling biography, see Gary Comenas, 'Warhol Stars', https://warholstars.org/stars/candy.html. For more on Jackie Curtis and *Glamour, Glory and Gold*, see Comenas, https://warholstars.org/glamour-glory-gold-1.html. 'As late as '67 drag queens', Warhol and Hackett, location 3,914. 'Walking along Christopher Street', County with Rupert Smith, *Man Enough to Be a Woman*, op. cit., location 868.

For John Cale leaving the Velvet Underground, see Bockris and Malanga, p. 95ff. Lou Reed on Candy Darling and 'Candy Says', DeCurtis, *Lou Reed*, op. cit., location 1,838. The *Open City* Lou Reed interview is reproduced in Garcia, pp296–7.

22 David Bowie

'The Bowies occupy', from Michael Watts, unpublished profile of rock star David Bowie, written for the *Sunday Times*, MS supplied by Michael Watts to author with thanks.

For the rediscovered David Bowie 'The Jean Genie' *Top of the Pops* footage, see https://www.youtube.com/watch?v=7atHoLxow9k. For 'Jean Genie' origin, see Kevin Cann, *Any Day Now: David Bowie, The London Years (1947–1974)* (Adelita Ltd, 2010), entry for Saturday 23 September 1972, p. 268; also Chris O'Leary, *Rebel Rebel* (Zero Books, 2015), Kindle edn, location 4,044. Also see the entry in the David Bowie bible online: https://www.bowiebible.com/songs/the-jean-genie/?utm_content=cmp-true.

George Underwood's attribution to John Lee Hooker's 'Going Upstairs' was in Tom Doyle, 'Watch That Man', *Mojo*, issue 354, May 2023 p. 70ff.

Gay News on Jean Genet/'Jean Genie', see 'David Bowie Is Artist of the Year', issue 13, approx. pub. date 14 December 1972. This and other issues of *Gay News* between 1972 and 1974 are downloadable at the excellent Gay News Archive Project: https://gaynewsarchive.co.uk. The 'John, I'm Only Dancing' video can be seen on YouTube.

For the Sweet's career to date, see Dave Thompson, *Blockbuster! The True Story of the Sweet* (Cherry Red Books, 2011), Kindle edn; for the Ronnie Scott's launch, see location 2,098. For 'Blockbuster!' on *Top of the Pops*, see https://www.youtube.com/watch?v=Y64211sjSko.

The Yardbirds' live version of 'I'm a Man' on *Shindig!* can be seen at https://www.youtube.com/watch?v=mn6q_jccouo. T. Rex, 'Hot Love' on *Top of the Pops*, https://www.youtube.com/watch?v=rnSzpIJBd18. For Tony Visconti on Chelita Secunda, see https://www.famousfix.com/topic/chelita-secunda.

'Bowie gave an interview to Michael Watts', Michael Watts, 'David Bowie: Oh You Pretty Thing', *Melody Maker*, 22 January 1972, pp. 1 and 19. 'I set the interview up' and 'It was a departure for them', Watts, author interview, December 2021. For Ray Connolly's September 1970 interview with Dusty Springfield, see O'Brien, *Dusty*, location 1,909, and Ray Connolly's website: https://www.rayconnolly.co.uk/dusty-springfield.

'I think he said it very deliberately', see http://www.bowiegoldenyears.com/1972.html. 'I'm sure he did it for publicity', Steve Turner, 'David Bowie: How to Become a Cult Figure in Only Two Years', unpublished piece for *Nova*, 1974, https://www.rocksbackpages.com/Library/Article/david-bowie-how-to-become-a-cult-figure-in-only-two-years. 'It's just that I'm tired of pretending' and 'I could've got away', Michael Watts, unpublished article for *Sunday Times*, summer 1972. 'He was just sexually very fluid', Watts, author interview, December 2021.

'A Wardour Street pill-head', Rosalind Russell, 'David Bowie: Bent on Success', *Disc*, 6 May 1972, pp. 14–15. For the GLF reaction, see *Gay News*, #7, 14 September 1972, p. 4, 'Disc Demo'. 'It certainly wasn't the chic thing to be', Steve Turner, 'The Scruffy Little Failure Who Became David Bowie', *New Musical Express*, 18 April 1974. 'This music was so savagely indifferent', see *New York* magazine, https://nymag.com/nymetro/arts/music/features/music2003/n_9252.

For the 'Space Oddity' film, see Kenneth Pitt, *David Bowie: The Pitt Report* (Lume Books, 2021), Kindle edn, location 2,955; 'He derived comfort', location 2,707; meets Calvin Lee and Angela Barnett, location 3,115. 'The trendy, dolly scene', 'Gay Guide', *Jeremy*, vol. 1, no. 3, p. 57. 'Very much a man of his generation, Angela Bowie with Patrick Carr, *Backstage Passes: Life on the Wild Side with David Bowie* (Lume Books, 2020), Kindle edn, location 1,376.

'The profile was written by Tim Hughes and Trevor Richardson', Tim Hughes and Trevor Richardson, 'Bowie for a Song', *Jeremy*, vol. 1, no. 6, pp. 24–6. Angela Bowie, 'They were gorgeous', location 1,931. 'A humorous interview with Chris Welch', 'Why Does David Bowie Like Dressing Up in Women's Clothes?', *Melody Maker*, 7 April 1971.

For a detailed analysis of 'Queen Bitch', see O'Leary, location 2,969. For Andy Warhol's *Pork*, see Gopnik, *Warhol*, op. cit., location 14,089. 'That was Andy's big launch', Leee Black Childers, author interview, 1989, and second interview with Johan Kugelberg, New York, 2016.

'A few days later, Bowie encountered Andy Warhol', Cann, entry for Friday 10 September 1971, p. 228. See also O'Leary, entry for song 'Andy Warhol', location 2,931. Gay benefit, Cann, entry for Monday 4 October 1971, p. 229; recording of new songs post-*Hunky Dory*, see entry for Monday 8 November 1971, p. 230ff. 'I feel we're all in a fucking dead industry', David Bowie interview, *Cream* (UK), November 1971. Promo notes on songs, RCA promotional ad (US), 13 November 1971, https://davidbowieautograph.com/blog/f/hunky-dory---guide-notes-for-rca-1971. For influence of *A Clockwork Orange*, see O'Leary, location 230, and Jon Savage, 'Oh You Pretty Things', *David Bowie Is* (V&A Publishing, 2013), p. 99ff.

'When he announced his bisexuality to me', Michael Watts, author interview, December 2021. 'Queen Bitch' on *Old Grey Whistle Test*, Cann, entry for Monday 7 February, p. 242; https://www.youtube.com/watch?v=iuDJueor2G8. 'He delights in the unexpected', Rosalind Russell, *Disc*, op. cit. 'Every week in your paper', *Gay News*, issue 7, September 1972. For the performance of 'Starman' on *Top of the Pops*, Thursday 6 July 1972, go to https://www.youtube.com/watch?v=oOKWF3IHuoI. 'A business that is looking hungrily,' Michael Watts, unpublished interview for *Sunday Times*, summer 1972; also Woody Woodmansey and Mick Ronson quotes. 'I'm a practising bi-sexual', Steve Turner, 'The Rise and Rise of David Bowie', *Beat Instrumental*, August 1972, available at rocksbackpages.com.

'*Gay News* responded to director Hugh Attwooll's statement', 'BBC Bans Bowie', *Gay News*, issue 9, October 1972, p. 4. 'That was hilarious', Henry Edwards, 'The Rise of Ziggy Stardust: David Bowie's version of Camp Rock', *After Dark*, vol. 5, no. 6, October 1972, p. 38ff. 'There was much glitter', Roy Hollingworth, 'Can Bowie Save New York from Boredom?', review of David Bowie, Carnegie Hall, New York, *Melody Maker*, 7 October 1972, available at rocksbackpages.com.

'And when he arrived', Roy Hollingworth, 'David Bowie: Cha . . . Cha . . . Cha . . . Changes – A Journey with Aladdin', *Melody Maker*, 12 May 1973, available at rocksbackpages.com. Mick Gold's photos can be seen in *Cream*, issue 25, June 1973. Bowie interview with the *Evening News*, quoted in 'Baubles, Bangles and Bowie', *Gay News*, issue 24, 30 May 1973, p. 7. The D. A. Pennebaker *Ziggy Stardust and the Spiders from Mars* film has just been reissued by Rhino on DVD and Blu-ray. For decadence, see Hollingworth, *Melody Maker*, op. cit.. 'The word everyone is pouncing on', Denis Lemon, 'Decadent or Just Outrageous', *Gay News*, issue 31, 6 September 1973, p. 14.

23 Stonewall and Its Aftermath

'Rock, used not as the purists define it', from Dennis Altman, *Homosexual: Oppression and Liberation* (Allen Lane, 1974), Chapter 5, 'The Collapsing Hegemony and Gay Liberation', p. 166ff.

Bette Midler in *After Dark*, January 1973, 'On the Cover', p. 3, and Miles Lewis, 'Divinely Simple Is Simply Divine', p. 53ff. 'Gay men are spectacular', Dick Leitsch, 'The Whole World's a Bath', *GAY*, no. 36, October 1970, p. 9. 'Passes the time by indulging', Henry Edwards, 'Out of School with Alice Cooper', *After Dark*, January 1973, p. 18ff. For origins and orientation of *After Dark*, see https://en.wikipedia.org/wiki/After_Dark_(magazine).

'Some gay people I've met are very sad', Entertainer Bill McWhorter, *Vector*, vol. 9, no. 1, January 1973, p. 22. 'I've faced the fact that gay people are oppressed', 'Columbus Ohio, World News Briefs', *Vector*, January 1973 p. 30. 'A long article by Suzannah Lessard', Suzannah Lessard, 'Gay Is Good for Us All', *Vector*, ibid., pp. 34–9, reprinted from the *Washington Monthly*, December 1970.

For songs on the Stonewall jukebox, see https://www.stonewallvets.org/songsofStonewall-1.htm. For the definitive account of the Stonewall riots, see David Carter, *Stonewall*, op. cit., 'The Stonewall Riots', location 2,589; For drag queens, see location 1,551; bribing the police, location 1,642; Snake Pit, etc., raids, location 2,887; Stevie Wonder on the jukebox, 2,935; 'I'll lose my job', location 2,769; 'We're not taking this', location 2,801; transvestites giving the police flak, location 2,807; 'Gay power', location 2,969; 'until a dyke lost her mind', location 3,065; 'flame queens', location 3,312; 'We all had a collective feeling', location 3,252; 'hottest 28 June', location 2,841; 'gay people are reaching the end of their patience', location 4,233; 'Many of us in the community', location 4,313; origin of Gay Liberation Front, location 4,380; Martha Shelley gay power vigil, location 4,462: GLF August 1969 manifesto, location 4,505. For origins of Gay Power, http://www.back2stonewall.com/2021/09/september-15-1969-gay-power-nyc-newspaper-published.html. For John Heys, https://en.wikipedia.org/wiki/John_Edward_Heys. 'The Mafia (or syndicate) control of this city's Gay bars', 'Statement: Get the Mafia and the Cops Out of Gay Bars', *Gay Power*, vol. 1, no. 2, p. 3.

For *Come Out!*, see https://en.wikipedia.org/wiki/Come_Out!. All eight issues are downloadable as PDFs at https://outhistory.org/exhibits/show/come-out-magazine-1969-1972/the-come-out-archive. Manifesto is on p. 1, vol. 1, issue 1. For the origin of *GAY* magazine and a biography of Lige Clarke, see Matt and Andrej Koymasky, The Living Room, http://andrejkoymasky.com/liv/fam/bioc3/clarke05.html. For a first-hand account of *Screw* and the origin of *GAY* magazine, see Lige Clarke and Jack Nichols, *I Have More Fun with You Than Anybody* (St Martin's Press, 1972), Chapter 4, 'Elbow Grease', p. 29ff.

'Homosexuals, encouraged by the successes', Lily Hansen, 'Sad Faces Are on the Way Out', *GAY*, vol. 1, issue 2, p. 17. 'I am new / Born again', *Come Out!*, vol. 2, issue 8, p. 13. 'The Homosexual: Newly Visible, Newly Understood', *Time*, 31 October 1969, p. 38ff. Tom Burke, 'The New Homosexuality' ('Look, Mack, this is a red-blooded, all-American, with-it faggot you're talking to. Show a little respect), 1 December 1969, https://classic.esquire.com/article/1969/12/1/the-new-homosexuality. 'The first time I saw the Beatles', Perry Brass, 'Growing Up Obscene', *Come Out!*, vol. 2, no. 7, p. 3.

'The three magazines summarised their positions', 'The Editors Speak', *GAY*, vol. 1, no. 13, 4 May 1970, p. 2. 'Because "queer sells"', Jim Fouratt, 'Word Thoughts', *Come*

Out!, vol. 1, no. 2, p. 13. 'Shrill demands', Editorial, *GAY*, issue 36, 26 October 1970, p. 3. 'Gay liberation advances', Altman, Chapter 4, 'The Movement and Liberation: Confrontation and the Community', p. 119. GAA and Jim Owles, *Gay Power*, vol. 1, no. 14, April 1970, and Altman, p. 123ff.

Harassment at the Continental Baths, 'Onward to City Hall', *Gay Power*, vol. 1, no. 12, p. 5, and *GAY*, issue 5, 2 February 1970, and issue 6, 16 February 1970. For the Snake Pit raid, GAA leaflets and 'Six fourteen-inch' quote, see '500 Angry Homosexuals Protest Raid', *GAY*, issue 10, April 1970, p. 3, and 'The Morning of the Snake Pit', *Gay Power*, vol. 1, no. 13, p. 5. 'No one knew', *Vector*, January 1973, p. 38. GAA disrupt WNEW-TV Mayor Lindsay's weekly show, *GAY*, issue 14, 11 May 1970.

'*Harper's* magazine ran a major piece', Joseph Epstein, 'Homo/Hetero: The Struggle for Sexual Identity', *Harper's*, September 1970. For Merle Miller's January 1971 response, see https://www.newyorker.com/books/page-turner/merle-miller-and-the-piece-that-launched-a-thousand-it-gets-better-videos. 'Gay Liberation has played a crucial role', Suzannah Lessard, op. cit., p. 39.

'Space to be together', Lois Hart, 'Community Centre', *Come Out!*, vol. 1, no. 1, 14 November 1969, p. 15. Bob Kohler on the GLF dances, see Carter, location 4,572. 'The GLF were holding dances at the Alternate University', 'Notice for Community Centre Benefit Dance January 2 Alternate U 69 W 14th', *Come Out!*, vol. 1, no. 2, 10 January 1970; see Alternate University mailouts 1969–70 in author's archive. 'The dancing was of the usual superlative quality', Kathy Braun, 'The Dance', report on GLF dance in Alternate U, *Come Out!*, vol. 1, no. 3, p. 3. 'Drag queens, bull dykes', Robin De Luis, 'The Sunday Night Meetings – Or Come Out to What?', *Come Out!*, vol. 1, no. 5, September–October 1970, p. 7.

The Radicalesbians at the May 1970 Second Congress to Unite Women, 'The Lavender Menace Strikes', *Come Out!*, vol. 1, no. 4, June–July 1970 p. 14. 'Fragmented but not dead', 'What's Happening', *Come Out!*, vol. 2, no. 7b, spring–summer 1971, p. 3. 'Nothing's going on anymore', Sorel David, 'Loosely About Women: Seeking Alternatives to the Alternate Culture', *GAY*, issue 47, 29 March 1971, p. 7. For Kameny victory and 'probing personal questions', see 'Gay Victory Over U.S. Gov't', *GAY*, issue 61, 11 October 1971, p. 1.

'Their deejayed disco dances', Alice Echols, *Hot Stuff: Disco and the Remaking of American Culture* (W. W. Norton & Company, 2010), Kindle edn, location 1,070. 'In "The New Homosexual", *Time* had reported', 'The New Homosexual', *Time*, 31 October 1969. For the range of erotic material, see magazines in Harry Weintraub Collection, Cornell University. For a Pat Rocco star, see Phil Barton pictured on front cover of *GAY*, issue 9, 29 March 1970. For Christine Jorgensen film, see Bob Amsel, 'Castration for Fun and Profit', *GAY*, issue 7, 1 March 1970, p. 12. 'The Beatles must have made', Pat Maxwell, 'Dancing in the Streets', *Gay Power*, vol. 1, no. 10, February 1970, p. 16.

'Jackie Curtis in a photograph by Leee Black Childers', *Gay Power*, vol. 1, no. 6. Robert Mapplethorpe, 'Bulls Eye', front cover design, *Gay Power*, vol. 1, no. 16. 'There was a long discussion', Ritta Redd and Jackie Curtis, 'Iggy Stooge – The Magic Touch', *Gay Power*,

vol. 1, no. 12, March 1970, p. 10. 'Gender male', Rosalyn Regelson, quoted in Ritta Redd, 'Jackie Curtis: Andy Warhol's Bad Girl', *Gay Power*, vol. 1, no. 16, May 1970, p. 19.

'three bearded, outlandishly dressed', 'Homosexuals in Revolt: A Major Essay on America's Newest Militants, the Activists of "Gay Liberation"', *Life*, 31 December 1971, pp. 62–73, accessible at https://books.google.co.uk/books/about/ LIFE.html?id=8z8EAAAAMBAJ&redir_esc=y. 'There is the whole cult of transvestism', Altman, Chapter 1, 'Coming Out: The Search for Identity', p. 31; 'There is a new style of campdom', Chapter 4, p. 143.

For the full account of the Cockettes' NY trip, beginning with 'pure insanity', Maureen Orth, 'History of a Hype: Worm in Big Apple', *Village Voice*, 25 November 1971, https://www.villagevoice.com/2020/01/11/a-history-of-hype-the-cockettes-conquer-new-york. The tensions between New York and San Francisco are explored in the Bill Weber/David Weissman *Cockettes* documentary: i.e. Dusty Dawn at 1 hour 17 minutes in. 'It was all a play. We didn't realise that their play was different to our play'. For tensions within the group and the ejection of Hibiscus, see Fayette Hauser, 'The Ritz Family Goes to Manhattan', in *The Cockettes: Acid Drag and Sexual Anarchy* (Process Media, 2020), p. 274; for Hibiscus biography, see p. 28ff; also https://en.wikipedia. org/wiki/The_Cockettes and https://en.wikipedia.org/wiki/Hibiscus_(entertainer). Hibiscus and Irving Rosenthal, Hauser, p. 24. 'The oppressing shackles', Gale Chester Whittington, *Beyond Normal: The Birth of Gay Pride*, Bootlocker (201) Kindle edn, location 5,183; 'gender-fuck theatre group', location 4,683. 'Our group consciousness', Hauser, p. 27; first performance, p. 136. For details of the Cockettes' performances, see Andrew Sclanders, https://www.beatbooks.com/pages/books/38985/the-cockette s-nocturnal-dream-shows-collection?soldItem=true. 'A snapshot of the Cockettes', Barbara Falconer, 'The Cockettes of San Francisco', *Earth*, vol. 2, no. 8, October 1971, p. 40ff. 'Free entertainment for poor people', Maitland Zane, 'Les Cockettes de San Francisco', *Rolling Stone*, 14 October 1971, p. 22ff. 'The most unbelievable American phenomenon', Rex Reed, 'Better a Tinsel Queen Than a Golden Toad', syndicated column, 18 September 1971.

'As Plato put it', Altman, Chapter 5, 'The Collapsing Hegemony', p. 167; Alice Cooper and David Bowie, and 'Ultimately one must conclude', pp. 170–1. 'Henry Edwards wrote a summary', Henry Edwards, 'The Year of the Peacock: The New Look in Rock', *After Dark*, vol. 5, no. 8, December 1972, p. 22ff. For the Hot Band supporting David Bowie, see Philip Elwood, 'David Bowie & the Spiders from Mars, Phlorescent Leech and Eddie, Sylvester: Winterland, San Francisco CA', *San Francisco Examiner*, 28 October 1972. 'At a time of rampant bandwagon-jumping,' Richard Cromelin, 'Hot Band Sizzles for Fourth', *Los Angeles Times*, 6 July 1973, accessible at rocksbackpages.com.

Henry Edwards on Chris Robison, 'Records', *After Dark*, April 1973, p. 71. 'With all five Stones decked out in 1940s drag' and 'record company managers', Ian Young, 'Rocking the Closet', *Quorum*, no date, p. 13ff, accessed via internet; see also Ian Young, 'Gay Rock', *Gay Sunshine*, issue 20, April 1973, and interview

with Ian Young, *Fag Rag*, December 1974. 1973 Gay Pride march, see https://outhistory.org/exhibits/show/first-pride/john-demilio and https://www.si.edu/stories/marsha-johnson-sylvia-rivera-and-history-pride-month. For the fire at the UpStairs Lounge in New Orleans, see https://en.wikipedia.org/wiki/UpStairs_Lounge_arson_attack and Robert W. Fieseler, *Tinderbox: The Untold Story of the UpStairs Lounge Fire and the Rise of Gay Liberation* (Liveright Publishing, 2018).

24 Gay News

The basic sources for British GLF are Aubrey Walter (ed.), *Come Together: Years of Gay Liberation (1970–73)* (Verso, 2018), Kindle edn; Jeffrey Weeks, *Coming Out: Homosexual Politics in Britain, from the Nineteenth Century to the Present* (Quartet, 1977) and *Between Worlds: A Queer Boy from the Valleys* (Parthian, 2021), Kindle edn; Stuart Feather, *Blowing the Lid: Gay Liberation, Sexual Revolution and Radical Queens* (Zero Books, 2015), Kindle edn, which also contains a detailed GLF chronology from location 54 onwards.

Copies of *Come Together* are downloadable at https://www.bishopsgate.org.uk/collections/come-together-gay-liberation-front. Copies of *Gay News*, from the first issue in May 1972 to July 1974, are downloadable at the Gay News Archive Project, https://gaynewsarchive.co.uk.

'Pop is the great God', Peter Burton, 'Books', *Jeremy*, vol. 1, no. 7, p. 33. 'Time to get out of the guilt ridden ghettos', Jim Anderson, 'So Long Fag Hags', *International Times*, issue 78, 24 April 1970, p. 24: accessible at https://www.internationaltimes.it/archive/index.php?year=1970&volume=IT-Volume-1&issue=78. Review of Bette Midler and Dennis Altman in *Gay News*, issue 15, 24 January 1973. 'During the first year of GLF in the United States', Walter, *Come Together*, location 104; meeting Bob Mellors, location 108; first meeting of London GLF, location 118.

'A classroom filling up', Feather, location 89. 'Intoxicating', Weeks, *Coming Out*, location 1106. For GLF new consciousness and coming out, see Walter, *Come Together*, location 72, and GLF handout distributed winter of 1970–1. 'A key idea', Weeks, location 1,163; arrest and demo, location 1,205ff. 'A very exhilarating moment', Walter, location 143; 'had recognised that if we were to attract people', location 157; Gateways demo, location 145, and Elizabeth, 'The Gateways Club and Gay Liberation', *Come Together*, issue 2, 19 December 1970, p. 2.

Media workshop and *Come Together*, Walter, *Come Together*, location 156ff. 'Young people, who are rejecting the bourgeois family', 'GLF Principles', *Come Together*, issue 4, p. 5; also in Walter, location 794. 'A revolutionary organisation', Weeks, *Coming Out*, p. 186; 'The GLF in its early days drew its support', p. 190; 'Throughout 1971 the GLF dances became freakier', p. 194; 'there was, I believe,' p. 185.

'All the so-called gay mags, such as *Jeremy*', *Come Together*, issue 1, p. 3. For the April 1971 Jill Tweedie article, see https://www.theguardian.com/theguardian/2012/apr/12/archive-1971-gay-is-the-word. 'We were always out', Neon Edsel, *Come Together*, issue 4,

p. 8. 'The metamorphosis of gay men into drag queens', Feather, *Blowing the Lid*, location 3,758. 'The first effort at a major gay march', Weeks, *Coming Out*, location 1,264; 'At the beginning of the movement', location 1,267. GLF leaflet addressed to all newspaper workers, Fleet Street demo, 19 August 1971, reproduced in Feather, location 2,252.

For a description of the demo against the Festival of Light, see Walter, 'Rupert . . . Bared', *Come Together*, location 1,910ff. The contemporary account is in *Come Together*, issue 9, p. 1ff. For repressive climate, see Weeks, *Coming Out*, location 1,366. For GLF in Notting Hill Gate and pub protests, see Walter, location 2,903ff; October GLF manifesto, see location 3,604ff; 'a reflection of the gay scene in general', location 471. For lesbian anger, see *Come Together*, issue 7, July 1971, and Feather, location 2,784. 'The bitterness', Walter, location 504. For July 1972 Gay Pride, see Weeks, location 1,335.

'*Gay News* . . . is not our paper, but yours', editorial, *Gay News*, issue 1, May 1972, p. 2. For background of *Gay News*, see Weeks, *Coming Out*, location 1,379. 'I was so angry', see Feather, location 4,851; Feather cites Andrew Lumsden bringing up the idea of a national gay newspaper at an October 1971 GLF general meeting, location 229; for Denis Lemon enthusiasm, see location 4,857. For hostility to new paper, see Weeks, location 1,379, and Feather, location 5,526ff.

Peter Burton on the history of gay magazines pre-*Gay News* and 'the valid contribution' quote, see Burton, *Parallel Lives*, op. cit., Chapter 5, 'Publish and Be Damned', p. 106ff; advertisement for *Jeremy*, see, p108. 'For "Permissive Society"', *Jeremy*, vol. 1, no. 1, April 1969, p. 4. Peter Marriott on editorial direction, *Daily Mirror*, 3 August 1969. 'The London gay-club life', Peter Burton, 'Gay Guide', *Jeremy*, vol. 1, no. 3, p. 57. Edison Lighthouse cover, *Jeremy*, vol. 1, no. 8, 1970; Jimmy McCulloch cover, vol. 1, no. 7; skinheads article, vol. 1, no. 8, p. 25ff. 'There's the older ones', Peter Burton, 'Girls on the Gay Scene', *Jeremy*, vol. 1, no. 7, p. 17ff. 'Most of those entrepreneurial figures', Burton, p. 112.

'The socialist finance of GLF', Feather, location 5,541. For 'this absurd law', see letter in *Gay News*, issue 2, June 1972. The *Sunday Telegraph* article and the reaction to it is contained in *Gay News*, issue 5, August 1972, p. 5. For Denis Lemon arrest, see *Gay News*, issue 6, August 1972. For George Weinberg, 'The Madness and Myths of Homophobia', see *Gay News*, issue 32, 20 September–3 October 1973, p. 10. Alan Brien article in *Sunday Times* and *Gay News* statement, 'Here We Are Again', *Gay News*, issue 16, 7 February 1973, p. 6. 'If a woman is a lesbian', Jackie Forster and Babs Todd, 'Lesbians Doubly Oppressed', *Gay News*, issue 20, 7 April 1973, p. 5.

Dusty Springfield's *Cameo* reviewed by Denis Lemon in *Gay News*, issue 25, 14 June 1973, p. 16. Joan Baez's outing, 'Joan's Other Love', *Gay News*, issue 19, 21 March 1973, p. 4. For details on Polly Perkins column and *Liberated Woman*, see *Gay News*, issue 27, p. 6. For details of Polly Perkins' life, author communication with her son, Tim Arnold, during 2022. *Liberated Woman* was released on Chapter One Records in June 1973, and the accompanying book was published in 1973 by Kahn and Averill.

'Not one of the minimal demands,' Philip Conn, 'Towards a Gay Culture', *Gay News*, issue 16, p. 8. 'It is fairly obvious', Denis Lemon, 'The First Year', *Gay News*, issue 25,

p. 6. 'A very good documentation', Roger Baker, 'Brickbats and Bouquets, A Frank Critique from a Friend', *Gay News*, issue 25, p. 12.

'Going to be the year of gay rock', Peter Holmes, 'Gay Rock: David Bowie in Concert at the Royal Festival Hall', *Gay News*, issue 5, p. 7. 'For too long groups and solo artists', Denis Lemon, 'David Bowie – Artist of the Year', *Gay News*, issue 13, 14 December 1972, p. 18. David Bowie cover, *Gay News*, issue 22, 2 May 1973. 'As you will realise by reading the David Bowie article', 'Reminders and Jottings', *Gay News*, issue 24, 30 May 1973, p. 8.

'The effect of Bowie's forthright and intelligent attitudes', Denis Lemon, 'Baubles, Bangles and Bowie', *Gay News*, issue 24, p. 7. 'None of the previous generations of rock singers', Ray Connolly, *Evening Standard* article quoted in 'Going Gay in Rock', *Gay News*, issue 33, 4–17 October 1973, p. 6. 'The homosexual consumer', Iain T. Finlayson, 'Rags: Nothing Like a Dame?', *Gay News*, issue 29, 9–22 August 1973, p. 12. The same issue also includes a long article on the splintering gay movement, 'Ego-Tripping By Chauvinistic Factions' on p. 3.

25 Warhol's World

'Clearing the television documentary', 'Perverts and Homosexuals Show', *Gay News*, issue #17, 21 February 1973.

For the background to David Bailey's banned Warhol documentary, see 'Court Bans "Homosexuals and Such Like"', *Gay News*, issue 15, 24 January 1973, p. 3, and https://dangerousminds.net/comments/in_bed_with_andy_david_baileys_banned_warhol_documentary and https://reprobatepress.com/2018/12/29/when-david-bailey-met-andy-warhol-the-banned-tv-documentary. For pictures and transcripts, see *Andy Warhol: Transcript of David Bailey's ATV Documentary* (Bailey Litchfield/Mathews Miller Dunbar, 1972).

For the use of the term 'permissive society' in a gay context, see 'The Positive Society Explodes', *Jeremy*, vol. 1, no. 1, April 1969 (trial issue); for use in a critical context, see letter to Mr Heath from Mary Whitehouse, 27 June 1970, in Ben Thompson (ed.), *Ban This Filth! Letters from the Mary Whitehouse Archive* (Faber & Faber, 2013), Kindle edn, location 1,731. Alan Brien article in *Sunday Times* reprinted in *Gay News*, issue 16, 7 February 1973. This also featured Joe Dallesandro on the cover.

'Britain's self-appointed arbiters of morals', 'Court Bans "Homosexuals and Such Like"', *Gay News*, issue 15, 24 January 1973. Thames TV besieged with calls and quotes from those involved, *Gay News*, issue 15, p. 3. For details of *Trash*'s arduous encounters with the censor, see 'Undergrinspoon Movies', *Gay News*, issue 9, October 1972, p. 3, and https://www.bbfc.co.uk/education/case-studies/trash. For details on *Trash*, go to https://www.imdb.com/title/tt0066482. 'A carefully considered', George Melly, *Observer*, 11 February 1973. More in Bob Colacello, *Holy Terror: Warhol Close Up* (Harper Collins, 1990), p. 52ff.

Rescheduled date for Bailey documentary and 'handful of narrow minded bigots', 'Light Spreads Darkness', *Gay News*, issue 19, 21 March 1973, p. 3. 'I'd prefer to remain

a mystery', sleeve note to *Andy Warhol's Velvet Underground Featuring Nico* compilation, MGM Records (1971). 'It didn't really expound with great anti-establishment issues', 'There's Nothing Behind It', *Gay News*, issue 20, 7 April 1973, p. 7.

For Holly Woodlawn and her arrival at the Factory, see Gopnik, *Warhol*, op. cit., location 12,425, and https://warholstars.org/holly_woodlawn.html. 'There was me, Leee, Jackie Curtis, Ritta Redd', County, *Man Enough to Be a Woman*, op. cit., location 807. For more on Holly Woodlawn, '"Home at Last" with Holly Woodlawn', *Gay Power*, vol. 1, no. 5, p. 7. 'This brazen lie must have appealed to my comic sense', Paul Morrissey, *A Low Life in High Heels: The Holly Woodlawn Story* (St Martin's Press, 1991), 'Introduction'. 'She was super-freaky to look at', County, location 1,040.

'Queer (freakish)', Stefan Brecht, *Queer Theatre*, 'Family of the f.p.: The Theater of the Ridiculous 1965–68' (Methuen, 1986), pp. 52–3. Henry Geldzahler, in *Andy Warhol: Transcript of David Bailey's ATV Documentary* (no pagination). 'He wore a gingham shirt', Gopnik, location 13,772. 'Andy Warhol contacted Tony Ingrassia', County, location 1,265; 'The gay bars were very quaint and old-fashioned', location 1,315. Solonas released, see https://en.wikipedia.org/wiki/Valerie_Solanas.

Warhol buys estate near Montauk, Gopnik, location 14,236; 'if anyone even dared', location 13,878; 'trying to clean up and straighten out', location 13,816; 'very Classic', location 13,809. Bob Colacello in the Factory Fold, Colacello, Chapter 1, 'The Beginning', p. 5ff; Søren Agenoux let go, p. 40. New backers, Gopnik, location 14,072, and Colacello, Chapter 11, 'Meanwhile the Parties Multiplied', p. 136ff. Copies of *Andy Warhol's Interview*, author's archive. 'This is a mad planet', 'David Bowie Tells All and More to Patrick Salvo', *Andy Warhol's Interview*, no. 30, March 1973, p. 38ff.

'Hit 'em on the highest and the basest level', Jude Jade and Glenn O'Brien, 'Lou Reed: A Subway to the Stars', *Andy Warhol's Interview*, no. 30, March 1973, p. 33ff. For Reed and Les Bons-Bons, see Robert Lambert, 'Just Outrageous: The Story of Les Petites Bon-Bons', Chapter 4, 'Repeated for Emphasis: Jerry and Bobby BonBon in Hollywood', unpublished manuscript. 'His decision to split', Geoffrey Cannon, 'That Shock of Recognition Tells You Where He's Been', *Chicago Sun-Times*, 7 February 1971, accessible at rocksbackpages.com.

'An excellent disquisition', 'Lou Reed, Fallen Knights and Fallen Ladies', in Robert Somma (ed.), *No One Waved Good-bye: A Casualty Report on Rock and Roll* (A Fusion Book, 1971), p. 81ff. For reviews of *Loaded*, see *Melody Maker*, 13 March 1971; 'The most important album since *Tommy?*', reproduced in Garcia, *The Inevitable World of the Velvet Underground*, op. cit., p. 439; *New Musical Express*, 3 April 1971, reproduced in Garcia, p. 442. 'I expect [*Loaded*]', Geoffrey Cannon, 'The Velvet Underground', *Guardian*, 8 January 1971.

For Richard and Lisa Robinson, see DeCurtis, *Lou Reed*, op. cit., location 2,135. Reed on Bowie, Geoffrey Cannon, 'Lou Reed Talking About His First Solo Album', unpublished, July 1972, accessible at rocksbackpages.com. First meeting of Bowie and Reed and 'Queen Bitch', Cann, *Any Day Now*, op. cit., entry for Thursday 9 September

1971, p. 227. 'This very well-hung stud', DeCurtis, location 2,477; 'There's a lot of sexual ambiguity in the album', location 2,478. 'The best Gay Lib song I have heard', 'Albums for Christmas', *Gay News*, issue 13, 14 December 1972, p. 20.

'We worked with him rather closely', Martin Hayman, 'Lou Reed – End of the Black Comedy', *Sounds*, 22 January 1972, accessible at rocksbackpages.com. Warhol and Vicious, 'I hit you with a flower', DeCurtis, location 2,406; 'Walk on the Wild Side' song, location 2,311ff, and https://en.wikipedia.org/wiki/Walk_on_the_Wild_Side_(Lou_Reed_song). 'A full-fledged social degenerate now', Robot A. Hull in *Creem*, February 1973, quoted in DeCurtis, location 2,492; Ed McCormack, Warhol and vultures, location 2,536, from 'Scotch and Sympathy at Tully Hall', *Rolling Stone*, 1 March 1973.

Lou Reed interview, Nick Kent, 'Lou Reed: The Sinatra of the 70's', *New Musical Express*, 28 April 1973. 'The makeup thing is just a style thing now', Lester Bangs, 'Lou Reed: A Deaf Mute in a Telephone Booth', *Let It Rock*, November 1973.

For Warhol Mao paintings, see Gopnik, location 14,361; illness at Diana Vreeland dinner party, location 14,588. 'I'd like to sing like them', Patti Smith interviewed by Penny Greene, *Andy Warhol's Interview*, October 1973, pp. 22–3. 'Every word of my book is true', 'Going Down With Peggy', Peggy Caserta interviewed by John Calendo, *Andy Warhol's Interview*, September 1973, pp. 26–7.

'glitterglam crowd', Larry Sloman, 'Lou Reed's New Deco-Disk: Sledgehammer Blow to Glitterbugs', *Rolling Stone*, 27 September 1973, accessible at rocksbackpages.com. 'Music is an important part of Andy Warhol's lifestyle', Pioneer advertisement, 'The Flip Side of Andy Warhol', *Andy Warhol's Interview*, August 1973, back page. Details of records from the 1970s courtesy of Matthew Gray at the Andy Warhol Museum.

26 The New York Dolls

David Johansen, interview with Ted Castle used in the press release for the *New York Dolls* album, excerpted in 'Decadent or Just Outrageous', *Gay News*, issue 31, 6–19 September 1973, p. 14.

My basic factual source for this chapter is the excellent and comprehensive New York Dolls Chronology at https://www.fromthearchives.com/nyd/chronology.html. The standard biography is Nina Antonia, *Too Much Too Soon: The Make-Up and the Break-Up of the New York Dolls* (Omnibus, 2011), Kindle edn. The quotes from David Johansen are from an author interview in 2022. Unless noted otherwise, all Johansen quotes are from this source. The Stefan Stern article on the New York Dolls is contained in *Queer Theatre* (Methuen Drama, 1986), Appendix II, 'The New York Dolls, January 8, 1973', pp. 129–32.

'As far as my own situation in New York City', Johansen quoted in Ted Castle, press release for New York Dolls' first album, July 1973. 'David was a New York theatre guy', Sylvain Sylvain, author interview, 1988. Johansen on Staten Island and Mitch Ryder, author interview. 'I discovered the name, the Dolls', Sylvain, author interview.

For the Mercer Arts Center, see https://www.google.com/search?client=firefox-b-e&q=mercer+arts+center and https://www.denofgeek.com/culture/real-vinyl-history-the-mercer-arts-center-collapsed-43-years-ago-today. 'It all came together at the Mercer Arts Center', Antonia, location 462. For Roy Hollingworth's account of that first show, see 'You Wanna Play House with the Dolls?', *Melody Maker*, 22 July 1972, p. 17.

For bathhouse date, see https://www.fromthearchives.com/nyd/chronology.html, entry for 03/04 June 1972. 'They didn't seem to appreciate the *femme* look', Antonia, location 408. 'We'd play in these lofts', Sylvain, author interview. 'I knew the Cockettes', Johansen, author interview. 'I was determined to take all of my experience', County, *Man Enough to Be a Woman*, op. cit., location 1,422.

'One, it was bigger', Alan Betrock, 'New York Dolls: The Legendary Mercer Concerts', *Phonograph Record*, October 1973, accessible at rocksbackpages.com. 'Mick Jagger's skinny kid sister', Ed McCormack, quoted in Antonia, *Too Much Too Soon*, location 503. 'The Dolls were the point of transition', Richard Robinson, 'New York Dolls: Hot New York', *Rock Scene*, vol. 2, no. 1, March 1974, p. 13ff; for the digital archive of *Rock Scene* magazines, go to https://rockscenemagazine.com/magazines.

'I was impressed with their clarity', Antonia, location 601. 'Attributable to Roy Hollingworth', Leee Black Childers, author interview, 1998. '*Variety* loves the Dolls', Lillian Roxon, 'The Top of Pop: The Dolls Will Be Heard From', *New York Sunday News*, 3 September 1972, accessible at rocksbackpages.com.

Bowie meeting the New York Dolls and Cyrinda, see Cann, *Any Day Now*, op. cit., entry for Tuesday 19 September, p. 268. For an account of that night, see Ed McCormack, 'Subterranean Satyricon: New York City's Ultra-Living Dolls', *Rolling Stone*, 26 October 1972. 'For her amusement in her apartment', https://en.wikipedia.org/wiki/Cyrinda_Foxe, attributed to Jeff Gordinier, 'Loving the Aliens', *Entertainment Weekly*, no. 656, 31 May 2002, pp. 26–34.

'Their glamour bit', Antonia, location 779; for Billy Murcia's death, see location 846ff. For Jerry Nolan's life, see Curt Weiss, *Stranded in the Jungle: Jerry Nolan's Wild Ride – A Tale of Drugs, Fashion, the New York Dolls, and Punk Rock* (Backbeat, 2017), Kindle edn; 'He looked like a clone of Johnny Thunders', location 868. 'We just went right into this show', David Johansen quoted in Ben Edmonds, 'The New York Dolls Greatest Hits Volume 1 (They're Not a Fag Band – Ed.)', *Creem*, 1 October 1973, quoted in https://www.fromthearchives.com/nyd/chronology.html, entry for 19 December 1972; a copy of the article can be viewed at https://archive.creem.com/article/1973/10/01/the-new-york-dolls-greatest-hits-volume-1.

'Real dolls', Brecht, *Queer Theatre*, op. cit., p. 129. For Paul Nelson and signing to Mercury, see Antonia, location 719ff; Mike Gormley, location 1,013ff. 'Representative of a new wave', Miles, 'They Simper at Times: New York Dolls, [Jayne] County: The Mercer Arts Center, New York City', 1972, no publication attributed but accessible at rocksbackpages.com.

Rock Scene, issue 1, March 1973, available to view at https://rockscenemagazine.com/magazine/march-1973; Sylvester article, 'If I Make It Big, I'll Be So Scared', on p. 70ff.

'Everybody used to say that in those days', Johansen, author interview. The origin of the generally accepted trisexual quote has proved elusive, although there is a mention in Jim Esposito, 'First Annual N.Y. Dolls Trivia Quiz', *Zoo World*, 3 January 1974: '11) Who thought up the term "trisexual" as descriptive of the New York Dolls? a) Andy Warhol b) Mike Gormley c) David Jo Hansen [*sic*] d) Todd Rundgren e) Johnny Thunders.' 'We tried it with as many people as we could', Sylvain, author interview.

'One of the first things', Ben Edmonds, 'New York Dolls Greatest Hits Volume 1', *Creem*, October 1973. 'Sneering, sporting women's clothes', *Sunday News*, quoted in Edmonds, ibid. 'We showed up with the clothes' and 'I would imagine they were amalgams of people' David Johansen, author interview. 'I didn't expect leading radio stations', Antonia, location 1,193. 'When you're a kid' and 'There were places where the vibe wasn't right', Johansen, author interview.

For dates of Los Angeles residency, see https://www.fromthearchives.com/nyd/chronology.html, entries for 29 August 1973 ff. 'As Los Angeles' first stark-raving discotheque', Rodney Bingenheimer, quoted in Marty Cerf, 'English Trends in L.A.: Rodney Bingenheimer Makes Good', *Phonograph Record*, December 1972, accessible at rocksbackpages.com. 'Once inside, everyone's a star', Richard Cromelin, 'Rodney's Disco', *Andy Warhol's Interview*, November 1973 pp. 30–1. 'Writer Richard Cromelin, with Jerri and Bobbi', '*Rock Scene* Goes to a Party', *Rock Scene*, vol. 1, no. 4, September 1973, pp. 58–9.

For Robert Lambert, see Lambert, 'Just Outrageous', and author communication, 2020/1. 'We began to feel', Jerry Dreva in *High Performance*, vol. III, no. 1, spring 1980, quoted in Lambert, 'Just Outrageous'. 'You can't change laws', also quoted in *High Performance* and 'Just Outrageous'. List of addresses for mail art packages from Lambert, ibid.

Hanging out with the Cockettes, Jerry Dreva, letter to Robert Lambert, 8 June 1972; 'He's a magnificent huge Black Gay', Jerry Dreva, letter to Robert Lambert, 24 August 1972; 'Thursday afternoon – David Bowie arrived', Dreva, letter to Lambert, 20 October 1972 – all quoted in Lambert, 'Just Outrageous'. 'On my first visit to Rodney's', 'Iggy had become a fan of ours' and 'awful macho Laurel Canyon creatures', ibid.

'The Whiskey is packed with glitzy glitter fans', Lisa Robinson, 'Eleganza: Alice Cooper Did Not Invent Glitter', *Creem*, November 1973, pp. 50–1. 'We didn't have to pay' and meeting the New York Dolls, Lambert, 'Just Outrageous'. 'A vast cultural sea change', ibid. 'Dead of natural causes', Lambert, letter 2 October 1973, quoted in 'Just Outrageous'.

'"I'm a true fairy"' and 'I started upstaging everybody', Bob Weiner, 'Jobriath', *Andy Warhol's Interview*, October 1973, pp. 26–7. For Jerry Brandt's account of meeting and managing Jobriath, Jerry Brandt, *It's a Short Walk from Brooklyn, If You Run* (self-published), Chapter 20, 'Jobriath: The True Fairy of Rock'n'Roll', p. 168ff. 'Got it on' and 'fell in love', from Weiner, 'Jobriath'. 'To me, Jobriath's songs were a revelation' and 'America's David Bowie', Brandt, p. 168.

'The energy force of 1973 came from homosexuals' and 'It's Sinatra, Elvis, The Beatles and now Jobriath', Charles Hirschberg, 'Jobriath Revisited', *Omega One*, 19 January 1979, pp. 17–21. 'An ancient Roman statue', Brandt, p. 171; 'All this time', p. 172;

Reviews of *Jobriath*, p. 171. 'Trendish group that haunts New York's rock joints', Henry Edwards, 'How to Make a Pop Parody', *New York Times*, 13 January 1974, https://www.nytimes.com/1974/01/13/archives/how-to-make-a-pop-parody.html.

'Audiences are at long last reacting', Denis Lemon, 'Decadent or Just Outrageous', *Gay News*, issue 31, 6–19 September 1973, p. 14. 'A survey of New York rock', 'Rock on the Wayne!', *Melody Maker*, 6 October 1973, p. 1, and article on America's New Rock, p. 22. 'Rock and roll is sex,' Roy Hollingworth, 'Music in a Doll's House', *Melody Maker*, 24 November 1973, p. 13. For the Dolls' UK dates, see https://www.fromthearchives.com/nyd/chronology.html. *The Old Grey Whistle Test* performance is available on YouTube. For homophobic protestors in Amsterdam, see Antonia, location 1,670; Marty Thau leaves, location 2,246.

'It's admittedly pretty hard to stand out', Lisa Robinson, 'Between the Buttons', *Rock Scene*, vol. 1, no. 5, December 1973, p. 45ff. 'Being a "fairy" these days isn't enough', Michael A. Meltzer, 'Records', *Andy Warhol's Interview*, January 1974, p. 38.

27 The Loft and the Gallery

'Rather than reinforcing stereotypical homosexual behaviour', Altman, *Homosexual: Oppression and Liberation*, op. cit., p. 135. For details about Manu Dibango and 'Soul Makossa', including Douala and the Duala dialect, go to their respective Wikipedia entries. 'The Duala word *makossa*', Ben Zimmer, 'Ma Ma Se, Ma Ma Sa, Ma Ma Coo Sa', *Language Log*, 26 June 2009, https://languagelog.ldc.upenn.edu/nll/?p=1542; this is also the source of the Manu Dibango quote, 'On one side of the 45 I recorded the hymn', taken from Manu Dibango, *Three Kilos of Coffee* (University of Chicago Press, 1994). 'A New York disc jockey called David Mancuso found it in an import store', from Soul Makossa Wikipedia entry.

'More mythological than real', Vince Aletti, author interview, 2022. For the Firehouse in general, see Echols, *Hot Stuff*, op. cit., location 1,973. For the Firehouse and 'heady, drug-oriented music', see Peter Shapiro, *Turn the Beat Around: The Secret History of Disco* (Faber and Faber, 2005), p. 53ff. For Barry Lederer on his own choices, see Steffen Spranger, 'Disco Mix by Barry Lederer', http://www.hotdiscomix.de/stars_clubs/djs/lederer_en_interview.htm.

For the Sanctuary and Francis Grasso, see Shapiro, pp. 16–18. '60 percent were white', Tim Lawrence, *Love Saves the Day* (Duke University Press, 2014), Kindle edn, location 592. 'Mixed "head music" with tribal percussion', Shapiro, p. 18. For 'Francis Grasso Select Discography (Sanctuary, 1970)', see Lawrence, location 806.

Valentine's Day opening of the Loft and private nature of event, see Bill Brewster, 'David Mancuso Interview', 1998, and Lawrence, location 260ff; see also Shapiro, 'Come on Over to My House and Let's Have Some Fun: The Loft', p. 18. 'In the centre, in a small enclosed booth', Vince Aletti, 'SoHo vs. Disco', *Village Voice*, 16 June 1975. 'I spent a lot of time in the country', ibid., quoted in Shapiro, p. 19. 'Cuban Missile Crisis' and quotes for next few paragraphs, Brewster's Mancuso interview.

'Dancing at the Loft was like riding waves of music', Aletti, 'SoHo vs. Disco', op. cit. The Continental Baths and *Women's Wear Daily* 'the Tubs' quote, see Lawrence, location 1,497ff; 'the article made people aware', location 1,500; 'I had gay men try to touch me,' location 1,796. For the Ice Palace and the Botel in the Pines, see Shapiro, p. 56, and Lawrence, location 1,436; Tom Moulton, location 1469ff. 'To create disco's intensity', Shapiro, p. 57.

For the opening of the Tenth Floor, 'the gentlemen's club of the gay elite', see Shapiro, p. 58; see also Lawrence, location 1,524. "I went to the Tenth Floor', Lawrence, location 1,612. 'We had our web belts', Andrew Holleran, *Dancer from the Dance* (Random House, 2019), Kindle edn, location 1,683. 'Levi's jeans, construction boots', Lawrence, location 1,572. Exclusivity of Tenth Floor, Shapiro p. 58. 'They all knew each other', Holleran, location 1,626.

The Gallery, see Shapiro, pp. 25–7. 'Your basic hangout', Lawrence, location 1,901. 'There were these white lights', Nicky Siano quoted in Lawrence, location 1,912; Siano selling drugs in the Loft, location 1,933. 'Larry Levan and Frankie Knuckles, veterans of the scene at the Continental Baths', see Shapiro, p. 25, and Lawrence, location 2,464. The look of the Gallery, 'streamers', etc., Lawrence, location 1,965. 'I loved the Philly sound', Nicky Siano, interviewed by Bill Brewster, October 1998 (note: this and other interviews, including David Mancuso, Nicky Siano and Tom Moulton, are in Bill Brewster and Frank Broughton, *The Record Players: DJ Revolutionaries* (DJhistory.com, 2010).

'A spring 1972 Harvard Business School report', see Shapiro, p. 139ff. The importance of 'Girl You Need a Change of Mind', cited by Shapiro, p. 23. 'City Country City', 'David Mancuso, Select Discography', Lawrence, location 1,645; 'Nicky Siano, Select Discography', location 2,082. 'Created a dark whorl of sound', Shapiro on Nicky Siano, p. 25ff.

For raid on Town Hall Records for counterfeit copies of 'Soul Makossa', see 'Radcliffe Joe, Soul Single Import Stirs Duplicators; Gets $2 to $3', *Billboard*, 19 May 1973, p. 3. For information on the various covers of 'Soul Makossa', see discogs.com. Atlantic Records advertisement 'THE ORIGINAL FIESTA RECORDING' from *Billboard*, 2 June 1973, p. 21; there is also a cheeky ad for the Original Nairobi Afro Band on p. 10. 'Soul Makossa' topped out at #35 *Billboard* on 28 July and 4 August 1973. 'Sales of "Soul Makossa"', *Billboard*, 30 June 1973, p. 32.

'It was hard to say disc jockeys had power', Vince Aletti, quoted in Lawrence, location 2,172. 'Paar-ty! Paar-ty!', Vince Aletti, 'Discotheque Rock '72: Paaaaarty!', *Rolling Stone*, 13 September 1973, pp. 41–2. Barabbas, Shapiro, p. 24, and Holleran, location 682. 'Was smoky, it was mobbed', Lawrence, location 2,101. 'Pushed onto the floor', Holleran, location 676ff.

'Discotheques Break Singles', *Billboard*, 6 October 1973, p. 3. 'I didn't get the feeling', Vince Aletti, quoted in Lawrence, location 2,208. 'Keep on Truckin'', 'Top Single Picks, Soul', lead review, *Billboard*, 11 August 1973, p. 71.

28 1974

'Glitter rock and glam rock', Simon Frith, 'Will It Go Round in Circles', *Let It Rock*, July 1974, p. 47ff.

For 'Love's Theme', Echols, *Hot Stuff*, op. cit., location 349, and Lawrence, *Love Saves the Day*, op. cit., location 2,629. For Siano visiting 20th Century Records, see Lawrence, location 2,630. '"Love's Theme" was in the top', Siano, quoted in Lawrence, location 2,638; for 'TSOP' and Siano, 'David Rodriguez and I heard it in Laverne Perry's office', location 2,361; MFSB details, location 2,300, and Echols, location 388. Theme for *Soul Train*, Echols, location 389.

'Bowie's house is decorated in a science fiction mode', Craig Copetas, 'Beat Godfather Meets Glitter Mainman', *Rolling Stone*, 28 February 1974, pp. 14–17. Also available at https://www.rollingstone.com/feature/beat-godfather-meets-glitter -mainman-william-burroughs-interviews-david-bowie-92508. 'Created a somewhat strange audience', Roy Hollingworth, 'David Bowie: Cha . . . Cha . . . Cha . . . Changes – A Journey with Aladdin', *Melody Maker*, 12 May 1973, available at rocksbackpages. com. 'There are as many Bowie imitators', Steve Turner, 'David Bowie: How to Become a Cult Figure in Only Two Years', unpublished piece for *Nova*, 1974, available at rocksbackpages.com. 'The theme of the album', Chris Charlesworth, '*Diamond Dogs*', *Melody Maker*, 11 May 1974, accessible at rocksbackpages.com. 'An era when any man in hot pants', Michael Gross, 'David Bowie's *Diamond Dogs* – Is His Bite as Good as His Bark?', *Circus*, July 1974, accessible at rocksbackpages.com. 'Is it time to shut the closet door?' Nick Kent, 'Farewell Androgyny', *New Musical Express*, 16 March 1974. 'Crude and brash music', Simon Frith, 'Will It Go Round in Circles', op. cit.

'A struggle', Brandt, *It's a Short Walk from Brooklyn*, op. cit., p. 172. 'Horrible: they hated us', quoted in David Chiu, 'Overlooked No More', https://www.nytimes.com/2021/06/11/ obituaries/jobriath-overlooked.html. 'Schizophrenic' and 'Mr P. T. Barnum Brandt', in *Omega One*, 19 January 1979. For 'the epitome of bad taste', see review scanned at New York Dolls Chronology for date of 15 June 1974, 'Two New York Groups Put on a Horror Show', https://www.fromthearchives.com/nyd/NYD15_Jun_74d.jpg.

For the *Diamond Dogs* tour stage set, see David Buckley, *Strange Fascination: David Bowie – The Definitive Story* (Virgin Books, 2012), Kindle edn, location 3,966; see also https://en.wikipedia.org/wiki/Diamond_Dogs_Tour.

'We were dealing with the same crowds every week', Nicky Siano, quoted in Lawrence, location 2,672. For Bowie at Sigma Sound, see Buckley, location 4,019, and O'Leary, *Rebel Rebel*, op. cit., entry for 'Knock on Wood', location 5,207ff. For material on the August 1974 Sigma Sound sessions, see O'Leary, location 5,802ff. For the change of set for the Philly *Dogs* tour, see Buckley, 'out went Hunger city', location 4,144. Lester Bangs on Bowie as Johnnie Ray on cocaine, see O'Leary, location 5,762.

For the closure of the Loft and the *New York Times* article on stomping of '500 frenzied dancers', see Lawrence, location 2,382: the reopening of the Gallery, location 2,529; 'Law of the Land' as the last Broadway Loft record, location 2,383; 'high tech

and innovative', location 2,353; 'That was the first time', location 2,541; 'The atmosphere started out warm', location 2,544.

'Specially mixed versions of commercial singles', 'Labels Mix Records for Club Scene', *Billboard*, 2 November 1974, p. 1; also the two Tom Moulton columns, 'Disco Action (Top Ten Audience Response, Best Sellers and Downstairs Records)' and 'Discotheque Club Dialog', p. 19. For details, see Lawrence, location 2,730. B. T. Express and Tom Moulton remix of 'Do It ('Til You're Satisfied)', Frank Brewster interview with Tom Moulton, undated; thanks to Frank for use of the transcript.

'A regular report on the state of the dance floor', first 'Disco File' for *Record World*, 16 November 1974, reproduced in Vince Aletti, *The Disco Files 1973–78: New York's Underground* (DJhistory.com, 2009). 'I'd been writing about music for five or six years', ibid., 'Introduction', p. 7. 'The year that "Rock the Boat"', Vince Aletti, author interview, 2021. Aletti on B. T. Express, see 16 November 1974 in Aletti, *The Disco Files*, p. 54; Toraino 'Tee' Scott playlist, p. 55.

For background on Sir Monti Rock III, see Echols, *Hot Stuff*, location 2,367, and the Disco-Tex and the Sex-O-Lettes compilation CD, *Sequel* (1990). 'The thing that I really did wrong', Vicki Wickham, quoted in Shapiro, *Turn the Beat Around*, op. cit., pp. 113–4; 'endorsed them as a potentially interesting diva group', p. 114. Sex workers, see https://en.wikipedia.org/wiki/Lady_Marmalade.

The David Bowie appearance on *The Dick Cavett Show* is on YouTube: https://www.youtube.com/watch?v=907nuclDymk. For DJ charts featuring Gloria Gaynor, Disco-Tex etc., see 'Disco File' entry for 30 November 1974, Aletti, *The Disco Files*, p. 57. 'Discos Demand Five-Minute Singles', *Billboard*, 14 December 1974, p. 1. 'There is a feeling that the disco club scene', Tom Moulton, 'Disco Action', ibid., p. 36.

Vince Aletti on the opening of the Flamingo, 'Disco Files' entry for 28 December 1974, p. 62. For more on the Flamingo, including dress code, see Echols, *Hot Stuff*, location 1,219ff, and Shapiro, p. 59ff. 'The new urban clubs', Henry Edwards, 'Disco Dancers Are Back and the Kung Fu Has Got Them', https://www.nytimes.com/1974/12/29/archives/disco-dancers-are-back-and-the-kung-fu-has-got-them-the-disco.html.

29 Robert Stigwood and *Saturday Night Fever*

The Maureen Orth 'The Disco Whirl' article is accessible at https://maureenorth.com/1976/11/the-disco-craze.

Saturday Night Fever is currently available on DVD and Blu-ray. 'In England, France, Germany', Simon Spence, *Staying Alive: The Disco Inferno of the Bee Gees* (Jawbone, 2017), Kindle edn, location 2,048; 'It was Robert's instinct', location 2,082.

'The main vein at the moment', Charles Barman, 'Back on Course with the Bee Gees', *Sounds*, 9 August 1975, accessible at rocksbackpages.com. For Stigwood and the Bee Gees in the early 1970s, see Dando-Collins, *Mr Showbiz*, op. cit., and Spence. 'The movie sells the TV show', Dando-Collins, location 3,355; for sending the Bee Gees

to Criteria Studios, location 3,550ff. The causeway rhythm and 'Jive Talkin'', Dando-Collins, location 3,559, and Spence, location 1,771. Unmarked cassettes and vinyl to DJs, Spence, location 1,805. 'The next thing we knew, "Jive Talking" was heard', Jaan Uhelszki, review of *The Bee Gees: Main Course, Creem*, October 1975, accessible at rocksbackpages.com

For 'The Hustle' and background on Van McCoy, see https://en.wikipedia.org/wiki/Van_McCoy. 'The Hustle' in 'Disco File', Vince Aletti, *The Disco Files*, entry for 5 April 1975, p. 90. 'I wasn't out all the time', author interview, 2021. The Record Pool, first mentioned in Vince Aletti column of 14 June 1975, *The Disco Files*, p. 110, and Lawrence, *Love Saves the Day*, op. cit., location 2,876.

'The wildness is exquisitely wholesome,' Sheila Weller, *New York Daily News*, 31 August 1975 quoted in Lawrence, location 3,657. For 500 discos, see *Forbes*, 'Discomania', 1 June 1976. The reopening of the Loft in October 1975, Lawrence, location 3,636; Flamingo, six-foot neon penis, location 3,377. 'If the concept of "Disco music"', Aletti, *The Disco Files*, entry for 27 December 1975, p. 166.

Lee Zhito quoted in Lawrence, location 2,694; report in 'The Time Is Right for Disco', *Billboard*, 7 February 1976. 'The most tangible sign yet', John Rockwell, 'The Pop Life: Disco Forum Disseminates a Craze', *New York Times*, 22 January 1976, https://www.nytimes.com/1976/01/22/archives/the-pop-life-disco-forum-disseminates-a-craze.html. 'The roots of disco were more and more obvious', Vince Aletti, author interview. 'Something was happening in the gay clubs', Ray Caviano, author interview for *Out on Tuesday: Disco's Revenge*, Channel 4, 1989.

Nik Cohn, 'Tribal Rites of the New Saturday Night', *New York* magazine, 7 June 1976, https://nymag.com/nightlife/features/45933. For more, see Lawrence, location 4,120, Spence, location 60, and Dando-Collins, location 3,472ff. 'Should be even more of a success', Aletti, *The Disco Files*, entry for 10 July 1976, p. 218. Maureen Orth, 'The Disco Whirl', *Newsweek*, 8 November 1976.

'family company' and 'everywhere you look', Spence, location 1,892; for Gershon deal, see location 1,895ff, and Dando-Collins, location 3,364ff. For hundreds of screaming girls at 57th St. pop-up shop, see Spence, location 2,167; the Bee Gees and the film of *Sgt. Pepper's Lonely Hearts Club Band*, see location 2,722ff, and Dando-Collins, Chapter 23, 'Sgt. Pepper's, a Business Deal Set to Music', location 3,726. For four films including Uri Geller, Spence location 2,333; Stigwood funding initial stages, location 2,380; Cohn's *Saturday Night Fever* fee of $10,000, location 2084, and Dando-Collins, location 2,502. 'Disco would sweep the world', Spence, location 2,081; Norman Wexler as screenwriter, location 2,339; Travolta in lead role, location 2,093; 29 September press conference, location 2,122, and Dando-Collins, location 3,526. Barry Diller, Spence, location 2,370; 'too pornographic', location 2,486; 'Stayin' Alive' drum loops, location 2,494. 'It has real jive precision', Frank Rose, 'How Can You Mend a Broken Group? The Bee Gees Did It with Disco', *Rolling Stone*, 14 July 1977. Travolta and Diana Hyland, Spence, location 2,532, and Dando-Collins, location 3,526. 'How Deep Is Your Love' campaign, Spence, location 2,968. 'Clubland was on the verge', *Billboard*,

1 October 1977. *Saturday Night Fever*'s Los Angeles premiere, Spence, location 3,007; Studio 54 event, location 3,015.

Saturday Night Fever script available at http://www.script-o-rama.com/movie_scripts/s/saturday-night-fever-script-transcript.html. 'Curiously for a movie marketed as a celebration of disco', Alice Echols, *Hot Stuff*, op. cit., location 3,090; for the gay undertones, see location 3,271. 'We got all kinds of hassle', Spence, location 2,997. 'The worst in teenage exploitation rehash', Echols, location 3,112. 'The way *Saturday Night Fever* has been directed', Pauline Kael, 'Nirvana', *New York Times*, 18 December 1977, https://www.newyorker.com/magazine/1977/12/26/nirvana. 'The spirit of the film', Spence, location 3,051.

Eleven days and $11 million, see Spence, location 3,019; for the Bee Gees' chart domination, see location 3,109ff; 'we were the charts', location 3,124. *Time*'s Travolta *Saturday Night Fever* cover, 'High Steppin' to Stardom', 3 April 1978, pp. 82ff, and https://content.time.com/time/subscriber/article/0,33009,919534,00.html. 'Much more representative of disco music', Aletti, *The Disco Files*, entry for 29 April 1978, p. 404. 'The disco and its lifestyle', Lawrence, location 5,422; 'last year, 1977, was the best ever in records', location 5,431, from 'A Landmark Year for the Record Industry', *Record World*, 22 July 1978.

'Ad Agencies Go Disco to Sell Product', Joe Radcliffe, *Billboard*, 19 August 1978, pp. 3 and 54. For disco on TV, see Lawrence, location 5,506; on radio, including WKTU, location 5,518; opening of Xenon, location 5,445. Disco pizzas, etc., and 'Thousands of shaggy-haired, blue-jean-clad youngsters', Spence, location 3,157. 'Disco is the revolt against the "natural" Sixties', Andrew Kopkind, 'The Dialectic of Disco: Gay Music Goes Straight', *Village Voice*, 12 February 1979, https://www.villagevoice.com/coming-of-age.

The opening of the Paradise Garage, Lawrence, location 6,040. 'When people like Frank Sinatra and Tony Bennett', author interview with Frankie Knuckles for *Out on Tuesday: Disco's Revenge*, 1989. 'The old dark disco', Andrew Holleran, 'Dark Disco: A Lament', *Christopher Street*, December 1978, p. 9ff. 'One of my problems with *Saturday Night Fever*', Vince Aletti, author interview, 2022.

The success of *Grease*, Spence, location 3,339, Dando-Collins, location 3,805, and https://en.wikipedia.org/wiki/Grease_(film). For bad reviews of *Sgt. Pepper's*, including 'a film with a dangerous resemblance to wallpaper', see Spence, location 3,421ff; 'I feel sorry for Robert Stigwood', location 3,428; 'male orgies', location 3,360; 'after *Saturday Night Fever* you could never get him interested', location 3,493.

30 Harvey Milk and San Francisco

'Clubs are insulators', Barry Laine, 'Disco Dancing: Too Hot for Love', *Christopher Street*, June 1978, pp. 53–4.

The standard text for Harvey Milk's life is Randy Shilts, *The Mayor of Castro Street: The Life and Times of Harvey Milk* (Atlantic Books, 2022), Kindle edn. For being sworn in as city supervisor on 8 January 1978, see biographical data of Milk at https://oac.

cdlib.org/findaid/ark:/13030/c8jd5066. 'The mayor of Castro Street', Shilts, location 1,683; 'this is a walk of reconciliation', location 3,495; 'Anita Bryant said gay people brought the drought', location 3,499; for repeal of Dade County gay rights law, location 2,952.

'American public opinion is about half way towards full acceptance' and 'a majority (55%) considers gays', 'The Front Line', *Christopher Street*, January 1978, pp. 3 and 64. Anita Bryant 'the most admired', harassment in Houston, 'homosexual pacifism' and 'a couple of decades ago', ibid. 'It's clear that the gay activism', ibid, p. 64.

'I Am a Homosexual: A Gay Drive for Acceptance', *Time*, 8 September 1975, https://content.time.com/time/subscriber/article/0,33009,917784,00.html. In the summer of 1976, *Vector* published a cover story entitled 'Is Gay Lib Dead?', *Vector*, vol. 12, no. 6, June/July 1976, pp. 17–23. 'Certainly not; it never has been dead', ibid., p. 20; 'we've just begun to fight', ibid.; Tony Randall, full-time volunteer for Milk, p. 19.

For Harvey Milk's biographical data, see Shilts, *The Mayor of Castro Street*, Kindle edn; 'The class of '51', location 381; meets Joe Campbell, location 462; Milk and Rodwell, location 604ff; 'The job allowed him to use his sharp memory', location 684; McKinley and experimental theatre, Chapter 3, 'Judy Garland's Dead', location 672ff; Milk and the Cockettes, location 826; Milk and stage director of *Hair*, location 821; Bruton on happiest time of life, location 985; Castro Camera, location 1,334ff; for changing neighbourhood of Castro, see Chapter 6, 'The Early Invaders', location 1,572ff; Mayor Alioto discriminatory policy and 1971 arrests, location 1,281; José Sarria, see location 1,069ff; endorsing Harvey Milk, location 1,462. Also, Sarria's early-1960s campaigns in Alamilla Boyd, *Wide Open Town*, op. cit., p. 20ff. For the SIR group, Foster, Goodstein and Stokes, see Shilts, location 1,240ff; for Milk deciding to go into politics, see Chapter 5, 'Politics and Theater', location 1,347ff; 1974 Castro Street Fair, location 1,731. 'I moved to Florida in the winter of '74–'75', in Louis Niebur, *Menergy: San Francisco's Gay Disco Sound* (Oxford University Press, 2022), Kindle edn, location 507; for definite Castro style, see Chapter 1, 'Disco, The Castro, and Gay Liberation', location 277ff; 'a male homosexual in his twenties or thirties, location 489, quoting Andrew Holleran, 'The Petrification of Clonestyle', *Christopher Street*, no. 69, 1982. 'The straight world has told us', *Come Out!*, December/January 1970. In 1975, *The Advocate* observed that long-haired gay men had become an endangered species, Echols, *Hot Stuff*, op. cit., location 2,275, and 'the end of the "Judy Garland style"', Echols, quoting Shilts, location 2,269. 'The 4D's', Niebur, location 511. For another origin of the clone name, see Joshua Gamson, *The Fabulous Sylvester: The Legend, The Music, The Seventies in San Francisco* (Henry Holt & Company, 2005), p. 129: 'the faeries, drag queens, and radicals called the other men Clones, and the name stuck'.

'The sound of the bass beat to the nearest disco', Mark Abramson, *Sex, Drugs & Disco: San Francisco Diaries from the Pre-AIDS Era* (Minnesota Boy Press, 2017), Kindle edn, location 1,111. Brian Freeman, 'A vanilla gay neighbourhood', Gamson, p. 131: 'I get off the bus and I look around and there's all these very kind of buffed, moustached, white man in their late twenties, early thirties, running around, who look exactly the

same in their attire', original quote in Peter Stein's documentary film *The Castro* (1997). 'Our old fears about our sissiness', Edmund White, *States of Desire Revisited: Travels in Gay America* (University of Wisconsin Press, 2014), Kindle edn, location 1,015.

'Castro Street Fair pulled in 100,000 people', Shilts, location 2,242; 'you know I will probably be killed one of these days', location 2,764; for nationwide push on gay rights in 1977, see 'the year of the gay', location 2,922ff. For Anita Bryant biographical info, including the quotes 'what these people really want' and 'human garbage', see https:// en.wikipedia.org/wiki/Anita_Bryant. For decency quote at the 1969 rally, see https:// cdnc.ucr.edu/?a=d&d=DS19690324.2.14&e=-------en--20--1--txt-txIN--------1.

'Is America Turning Right?', *Newsweek*, 7 November 1977, p. 34ff. 'With its mincing campness', Shapiro, *Turn the Beat Around*, op. cit., p. 232. Spontaneous protest in the Castro, with crowd of 3,000, Shilts, location 2,995. 'The chants went up', Frank Hoffman, letter to *Christopher Street*, printed as 'Out&Around', July 1977, pp. 3–5. Agitation to repeal in Saint Paul, Wichita and Seattle, Shilts, location 3,924; 'This would be a step forward', location 4,019; John Briggs campaign, location 3,019ff; Robert Hillsborough murder and 'Faggot! Faggot! Faggot!' quote, location 3,067ff; 'I didn't think much about Anita Bryant's campaign at first', location 3,087. 'Young republicans rubbing shoulders with Maoist faggots', Maria Stecenko, '26 June 1977: San Francisco', *Christopher Street*, August 1977, p. 14ff; 'conspicuous focal points' and 'I think we're in for a protracted civil rights struggle', p. 18. 'The word homosexual has now appeared', Shilts, location 3,149; Milk and District 5, location 2,881. 'The group's vigilance over the media', Randy Shilts, 'NGTF: Political Lion or Paper Tiger?', *The Advocate*, June 1978, p. 17ff. 'Now, more than ever, lesbians', David Stein, 'Interview with Jean O'Leary', *Christopher Street*, January 1978, p. 22ff. Meeting with Midge Costanza, Shilts, location 2,928. 'Last season saw more gay exposure', Philip Gerson, 'Homosexuality on Television', *Christopher Street*, August 1977, p. 47ff.

'For the longest time everyone kept saying', Edmund White, 'Fantasia on the Seventies', *Christopher Street*, September 1977, p. 18ff. 'Most things I've read about gay sex', 'Edmund White: An Interview with the Author of *The Joy of Gay Sex*', *Christopher Street*, December 1977, p. 7ff; Bertha Harris interview, ibid., p. 13ff. 'In the United States, and especially among gay men', White, *States of Desire Revisited*, location 1,289.

'The main purpose of all gay men in the city', Abramson, location 1,907. 'A V-shaped torso by metonymy', White, location 922. John Rechy, *The Sexual Outlaw: A Documentary* (W. H. Allen, 1978). 'In its own way as reactionary as the hysteria', Seymour Kleinberg, 'Where Have All The Sissies Gone?', *Christopher Street*, March 1978, p. 4ff. 'A fun, ego-building escape', Michael Musto, 'Every Night Fever', *Christopher Street*, May 1978 p. 4ff. 'Dancing is more free-form', Barry Laine, 'Disco Dancing: Too Hot for Love', *Christopher Street*, June 1978 p. 53.

'A sense of gay manifest destiny', Shilts, location 3,918; 'shoot fruit, not pool', location 3,793. 'Quite heroically take a stand', Edmund White, 'Getting a Little Relief: How Gay Men Live in Los Angeles', *Christopher Street*, October 1978, p. 9ff; for more on the concert, see '$25,000 Profit from New Age "Briggs" Event', *Bay Area Reporter*,

22 June 1978. 'I felt a little hypocritical', Patrick Merla, 'Joan Baez: Carrying It On', *Christopher Street*, August 1979, p. 42ff.

Figure of 375,000 at 1978 San Francisco Gay Freedom Day Parade, Shilts, location 4,137; Jack Lira suicide, location 4,326; 'Teacher Accused of Sex Acts with Boy Students', location 4,427; 'adulterers, burglars, communists', location 4,441; support for measure leading by 61%, location 4,498; Reagan against, location 4,513; Carter on voting no to Proposition 6, location 4,598; 'This is only the first step', location 4,642.

Dan White bio, https://en.wikipedia.org/wiki/Dan_White. White becomes hostile to Milk over a proposed psychiatric centre, Shilts, location 3,653; 'The vast majority', location 4,182; White resigns, locations 4,659 and 4,693; murder of Moscone and Milk, location 4,940ff; for the spontaneous demonstration, including the trumpet playing 'Blowin' in the Wind', location 5,162ff. 'It was always good to know there were people like them', Abramson, location 2,235. 'This is to be played only in the event of my death by assassination', Shilts, location 5,113.

31 The Tom Robinson Band

'Robinson knows he won't lessen the violence', Kevin Meadows, 'Tom Robinson Band', *Christopher Street*, April 1978, p. 54ff; an interview with Robinson's inspiration Hot Peaches is in the same issue on p. 51ff.

'Four days have been set aside', 'Blasphemy Appeal', *Gay News*, 12–25 January 1978, p. 1. 'A major bulwark of the gay community', Weeks, *Coming Out*, op. cit., Chapter 17, 'A Gay Community?', p. 221. Club ads in *Gay News*, 12–25 January 1978: Bang, p. 2, Casablanca, p4, Catacombs, p. 7; Sylvester interview on p. 32; Hillsborough case on p. 2, *Gay Times* Festival p. 5; Tom Robinson news item, p. 8. '*Gay News* was an important symbol', Weeks, *Coming Out*, p. 230.

'The Love That Dares to Speak Its Name' was published in *Gay News*, 3 June 1976. For Rictor Norton on the *Gay News* blasphemy trial and quotes over next three paragraphs, including 'it was impossible for someone to be a good Christian and a good homosexual simultaneously', see downloadable PDF at https://www.google.com/search?client=firefox-b-e&q=rictor+norton+the+gay+news+blasphemy+trial.

'A kind of re-crucifixion', Mary Whitehouse, *A Most Dangerous Woman*, quoted in Thompson (ed.), *Ban This Filth!*, op. cit., location 4,012. 'Grossly offensive', Brett Humphreys, 'The Law That Dared to Lay the Blame . . .', *Gay and Lesbian Humanist*, summer 2002, http://www.pinktriangle.org.uk/glh/214/humphreys.html. Jens Jørgen Thorsen, Thompson, location 3,972ff.

'A blasphemous libel concerning the Christian religion' and 'although broadcasting is exempt', Humphreys, 'The Law That Dared to Lay the Blame . . .' op. cit. 'If I did not do something to end this sacrilege', Thompson, location 4,022; 'an excrescence', location 4,710; 'the homosexual/intellectual/humanist lobby', location 4,598; for Whitehouse's masterstroke in targeting the newspaper and its editor, see location 4,034. For an account of the case's conduct, see Humphreys, op. cit., and Thompson, location 3,995ff.

Gay News self-censorship, see Rictor, op. cit. Kirkup poem 'silly', 'at times amusing' and 'extremely "literary"', Simon Watney, 'The Gay News Trial, Aspects and Implications', *Gay Left*, issue 5, winter 1977, p. 32ff. 1975 *Gay News* opinion survey, see Weeks, *Coming Out*, p. 227; 'It was in the literary and show-business world', p. 228.

'It was in secondary school,' Tom Robinson, author interview, 2022; unless noted otherwise, all Robinson quotes are from this source. 'Before going on to describe how homosexuals oppress themselves', Andrew Hodges and David Hutter, *With Downcast Gays: Aspects of Homosexual Self-Oppression* (Pomegranate Press, 1974; reprinted by Pink Triangle Press, 1977).

'We've been friends for five or six years', Denis Lemon and Jeff Grace, 'Tom Robinson: Gay Minstrel', *Gay News*, no. 73, 19 June–2 July 1975, pp. 17–18. '4. The Tom Robinson Band play', Pete Silverton, 'Up Against the Wall: Life with the Tom Robinson Band', *Sounds*, 24 September 1977; 'It was undoubtedly one of the best gigs', Harry Doherty, 'The Tom Robinson Band: Lyceum, London', *Melody Maker*, 17 December 1977 – both accessible on rocksbackpages.com.

'Between 16 and 20 men wearing National Front badges', 'Gang of 20 Attacks Gay Pub', *Gay News*, 9–22 February 1978, p. 1. 'Tom Robinson at National Gay News Defence Committee Rally, Speakers for Feb. 11', *Gay News*, 9–22 February 1978, p. 1; the Denis Lemon editorial, '*Gay News* Comments', is on p. 12; and the Rev. Neil Richardson piece, 'Blasphemy – and Beyond', is on p. 15. 'The next big decision to be taken', 'It's Your Paper . . . It's Your Choice . . .', *Gay News*, 23 March–5 April 1978, p. 1.

For the Tom Robinson Band's limo being torched in New York and the quote 'at least fifty per cent of the club owners', see Kevin Meadows, 'Tom Robinson Band', *Christopher Street*, April 1978. 'Perhaps the most outstanding effect', Derek Cohen and Hans Klabbers, 'Meetings with Tom Robinson', *Gay Left*, issue 7, winter 1978/9, p. 20ff.

'I was very naive', Roy Carr, 'A Single Man: The Elton John Interview', *New Musical Express*, 28 October 1978, pp. 35–38 and 50. 'The Liberace, the token queen of rock', quoted in Cliff Jahr, 'Elton John One Year On', *Rolling Stone*, October 7, 1976, https://www.rollingstone.com/feature/elton-john-lonely-at-the-top-rolling-stones-1976-cover-story-238734.

For *Gay News*'s forthcoming appeal and mention of Proposition 6 defeat, see '*Gay News* Comments', *Gay News*, 16–28 November 1978, p. 12.

32 Jubilee and Nighthawks

'While discos play "Don't Leave Me This Way"', Keith Howes and Alan Wall, 'Punk: Wot's in It for Us?', *Gay Times*, 9–22 February 1978, pp. 21–5.

'*Jubilee* is one of the most original', Coli, *Variety*, 2 February 1978; review dated 'London, 26 January', contained in *Jubilee Scrapbook 1*, compiled by Derek Jarman, in author's possession; adverts for Fooberts on p. 5 and Glades Disco on p. 10; record reviews by Jean-Claude Thevenin on p. 34. 'Increasingly visible punk/gay connection' and quotes over following four paragraphs from Howes and Wall, 'Punk: Wot's in It for Us?'.

'Politically naïve' and 'ambivalent', Jack Babuscio, 'Flickers', *Gay News*, 15–28 June 1978, p. 24. 'I first saw Jordan outside Victoria station', Derek Jarman, author interview for Jon Savage, *England's Dreaming: Sex Pistols and Punk Rock* (Faber and Faber, 1991), 1988; all other Jarman quotes are from this source unless otherwise noted. 'I saw an interview with Keith at Smile', Jordan, author interview for *England's Dreaming*, 1988.

'Was a two-room dive, really', Alan Jones, author interview, 2022. 'I used to go to Let It Rock when it first opened', Alan Jones, author interview for *England's Dreaming*, 1988; all Alan Jones quotes are from these two sources. For the *Guardian* report, Nicholas de Jongh, 'They Had the T Shirt Off His Back', *Guardian*, 2 August 1975.

'I hated suburbia' and 'a club for misfits, almost', Siouxsie Sioux, author interview for *England's Dreaming*, 1988. 'There was this heavy transvestite place called Chaguaramas' and 'Siouxsie introduced everybody to Louise's', Berlin, author interview for *England's Dreaming*, 1988. 'The Ranch was a gay bar really', Pete Shelley, author interview for *England's Dreaming*, 1988. 'I hate shit', Jonh Ingham, 'The Sex Pistols Are Four Months Old . . .', *Sounds*, 24 April 1976, accessible at rocksbackpages.com.

'Sexually mature', Jordan, author interview, 1988. '2 minutes and 52 seconds of squelching noises', Charles M. Young, 'Rock Is Sick and Living in London', *Rolling Stone*, 20 October 1977, https://www.rollingstone.com/feature/a-report-on-the-sex-pistols-119989. 'John had become the centre of attention', Jordan, author interview. 'The Bromley Contingent were mainly gay, so there was that', Alan Jones, author interview, 2022.

'Disturbingly irresponsible', 'indefensible', 'grim', Nick Kent, 'On the Town, *Jubilee*: The Unpleasant Vision of "Punk 1984"', *New Musical Express*, 18 February 1978, p. 41. 'The movie that tells us more about 1970s youth than any film so far', Alexander Walker, 'Phantasmagoric!', *Evening Standard*, 25 February 1978, p. 24. Both clippings, among many others, are in the Jarman-compiled *Jubilee* press scrapbook. For full text of Vivienne Westwood's anti-Jubilee T-shirt, see https://walkerart.org/magazine/punking-out-derek-jarman-and-vivienne-westwood-on-jubilee.

'Been largely concerned with two tasks' and early title 'All You Need to Know About Gay Oppression and How to Fight It in London in the 1970s', Bob Cant, 'The Making of *Nighthawks*', *Gay Left*, issue 7, winter 1978/9, p. 30; Warburton case, p. 31. 'Twelve-year-old children have appeared as actors', '*Nighthawks* Booked for the Edinburgh Festival', *Gay News*, 13–26 July 1978, p. 3.

'The minute it came on the scene', DJ Tallulah interviewed by Bill Brewster, 2004. 'Gary London's Bang Disco Top 10', *Gay News*, 13–26 July 1978, p. 34. For more on the Copacabana and the 1970s gay club scene, see https://daily.redbullmusicacademy.com/2013/05/coming-out-ball-70s-gay-clubbing-in-london and https://lgbthistoryuk.org/wiki/Timeline_of_London_Bars_and_Clubs#1970s. 'That was one of my favourite clubs,' Alan Jones, author interview, 2022.

'I was travelling between London and the US very frequently', James Gardiner, author interview, 2021. 'It was a fantastic place', DJ Tallulah interview by Bill Brewster, 2004.

33 Andy Warhol and Studio 54

'Then it was time to dress Bianca', in Pat Hackett (ed.), *The Andy Warhol Diaries*, entry for 4 January 1978 (Penguin Classics, 2010), p. 131.

'Just great', Andy Warhol, diary entry for Tuesday 3 January 1978, in Hackett, pp. 129–30. 'Very sketchy' and 'came to have the larger function', Introduction to *The Andy Warhol Diaries*, p. xx. 'His prime social group is revealed', ibid., diary entry for Monday 6 December 1976, p. 7. Log of vinyl records thanks to Matthew Gray at the Andy Warhol Museum.

Studio 54, Hackett, entry for Wednesday 4 January 1978, p. 131; Blizzard, entry for Saturday 21 January 1978, p. 142; Jockstrap, entry for Sunday 22 January 1978, pp. 142–3.

For Warhol in 1974, see Gopnik, *Warhol*, op. cit., Chapter 43, '1974', location 14,699; August 1974 move to new offices in Union Square, location 15,197. For move to East 66th Street and Jed Johnson decorating, see Chapter 44, '1974–5', location 15,111ff; 'We're trying to reach high-spending people', Bob Colacello, quoted at location 14,746.

Halston's designs earning $30 million, see Julie Miller, 'Inside Halston's Destructive Real-Life Relationship with Victor Hugo', *Vanity Fair*, 14 May 2021, https://www.vanityfair.com/hollywood/2021/05/halston-victor-hugo-real-life. For Warhol and Halston, see Gopnik, location 14,837ff; 'really opened up a whole facet of society', location 14,885.

For Andy Warhol's sitters during the mid-1970s, see David Whitney (ed.), *Andy Warhol: Portraits of the 70's* (Random House in association with the Whitney Museum of American Art, New York, 1979). Also Gopnik, Chapter 45, '1975–1977', location 15,497ff. For more 1970s portrait commissions, see Bob Colacello, *Holy Terror*, op. cit., Chapter 26, 'Portraits and Ads', p. 345ff; Imelda Marcos, Chapter 27, 'Imelda', p. 361ff.

For Warhol and the Shah, see Gopnik, Chapter 45, '1975–1977', location 15,503ff; Warhol succeeded in selling the Empress a dozen portraits of herself, for a fee of about $200,000, location 15,556. 'Fascist chic's recording angel', Alexander Cockburn, James Ridgeway and Jan Albert, 'Beautiful Butchers: The Shah Serves Up Caviar and Torture', *Village Voice*, 14 November 1977, p. 1, https://www.villagevoice.com/beautiful-butchers-the-shah-serves-up-caviar-and-torture.

For background on Victor Hugo, see Julie Miller and Mitchell Nugent, 'Dangerous Liaisons with Halston's Lover, Victor Hugo', *Interview* magazine, 13 May 2021, https://www.interviewmagazine.com/culture/dangerous-liaisons-with-halstons-lover-victor-hugo. 'Perhaps you would describe me as jaded, darling', Rose Hartman interview with Victor Hugo, *Andy Warhol's Interview*, April 1975, p. 30. 'A bed in the middle', Hackett, diary entry for Thursday 16 June 1977, p. 71; 'I was his prop to go cruising', diary entry for Saturday 18 June 1977, p. 71.

Warhol landscapes in Gopnik, location 15,626ff; 'Eventually totalling ninety-four silkscreened canvases', location 15,637; Fred Hughes drawing the line, location 15,682;

'It was something that Andy needed to do', location 15,695; *Piss Paintings*, location 15,710ff; *Come Paintings*, location 15,740; *Piss and Come Paintings* show with Victor Hugo, Hackett, diary entry for Wednesday 29 June 1977, p. 78.

The first mention of Studio 54 in *The Andy Warhol Diaries* is the entry for Thursday 9 June 1977, p. 70. For background of Studio 54 and opening night details, see Gopnik, location 15,812. Warhol's name was pencilled in on the guest list for the opening night; Gopnik considers that he must have been there on 26 April 1977. See also https://en.wikipedia.org/wiki/Studio_54. More details in Anthony Haden-Guest, *The Last Party: Studio 54, Disco and the Culture of the Night* (Open Road, 2014), Kindle edn, location 1,128; also Shapiro, *Turn the Beat Around*, op. cit., p. 201ff.

'I would say the opening night', https://warholstars.org/warhol/warhol1/warhol1c/warhol1cl/studio54.html. Carmen D'Alessio found the old TV theatre/studio at 254 West 54th; the club combined 'theater, disco, café, nightclub and every other entertainment divertissement known to man', Gopnik, location 15,817. C.J. and Co.'s 'Devil's Gun' as the very first song, Haden-Guest, location 1,254, and Shapiro, p. 204. 'My style of playing was not straightforward', Nicky Siano, interview with Bill Brewster, 1999. For his ousting, see Lawrence, *Love Saves the Day*, op. cit., location 4,970ff.

'It's like casting a play', Gopnik, location 15,823, and Haden-Guest, location 1,400. For Benecke as doorman, see Haden-Guest, location 1,391 and passim. 'I didn't like the whole velvet rope thing', Vince Aletti, author interview, 2021. 'Bianca's party was the catalyst', Haden-Guest, location 1,355. New York, New York opens, Haden-Guest, Chapter 6, 'Club Wars', location 1,745ff. 21 May bust for lack of liquor licence, Haden-Guest, location 1,796.

'The nightlife is running me down', Hackett, entry for Friday 30 September 1977, p. 108; Steve Rubell and the Cock Ring, entry for Sunday 25 September 1977, p. 193. 'A sort of version of Frank Sinatra's Rat Pack', Haden-Guest, location 1,477; for Haden-Guest on the Flamboyances, see location 1,554. 'Profits are astronomical', Dan Dorfman, 'The Eccentric Whiz Behind Studio 54', *The New Yorker*, 7 November 1977. 'The old Fortune Opera House that became CBS', Anna Quindlen, 'What's New in Discotheques', *New York Times*, 11 November 1977, p. 52.

'4,000 kilograms of glitter' and 'you were standing on stardust', Lucy Morris, 'What New Year's Eve Looked Like in the 1970s', *Grazia* online, 2 January 2018, https://graziadaily.co.uk/celebrity/style/studio-54-1970s; the article also includes a picture of Grace Jones performing at the event, 'resplendent in a see-through dark body suit'.

'From Gloria Gaynor on', Vince Aletti, author interview, 2021. 'A superbly crafted album', Aletti, *The Disco Files*, entry for 1 October 1977, p. 342. 'Most promising new Disco artist', David Nathan, 'The *Billboard* Disco Convention: Disco Is Here to Stay', *Blues & Soul*, 11 October 1977, accessible on rocksbackpages.com. 'She didn't have a great voice', Aletti, author interview, 2021.

The basic source for Grace Jones's life is her autobiography, as told to Paul Morley, *I'll Never Write My Memoirs* (Simon & Schuster, 2015), Kindle edn. 'A real sadist', location 406; 'a classic horror movie landscape', location 628; 'This was when gay life', location

893; 'My instincts were to become', location 957; Chambers Brothers, location 1,237; Gamble and Huff, location 1,291; 'It made me look hard, in a soft world', location 1,426; Le Jardin, location 1,626ff; Rubell, location 1,641; 'They were coming into the light', location 2,051; 'Dirty Ol' Man' by the Three Degrees, location 2,091. 'That's the Trouble'– 'sensational', Aletti, *The Disco Files*, entry for 25 September 1976, pp. 240–1. 'It was just as she was starting out', Vince Aletti, author interview, 2021. Vince Aletti, 'Grace Jones', *Andy Warhol's Interview*, January 1977, pp. 23–5.

For Richard Bernstein's life and work, see Roger and Mauricio Padilha, *Richard Bernstein Starmaker: Andy Warhol's Cover Artist*, foreword by Grace Jones (Rizzoli, 2018). 'Because of Andy, he moved from face to face', Jones and Morley, location 2,935; 'high-ceilinged studio was on the ground floor', location 2,946; 'At the time, Studio 54 seemed like the place I had been heading for', location 2,598.

'It really becomes more like pagan Rome every day', Colacello, Chapter 35, 'The Life and Death of the Party', p. 469. 'Studio gave license', Jim Fouratt quoted in Haden-Guest, location 2,467. For Colacello on patience running out with Victor Hugo, Colacello, Chapter 37, 'Falling Apart', p. 501ff. Also, Hackett, diary entry for Saturday 15 April 1978 – 'I don't know how to handle the Victor situation' – p. 176.

'I've never even thought about it', Keith Howes, 'People: Andy Warhol', *Gay News*, 13–26 July 1978, p. 30. 'Andy had changed', Gopnik, location 15,889. 'Two articles that June', Nicholas Pileggi and John Kennedy, 'Panic at Studio 54', *Village Voice*, 12 June 1978, and Henry Post, 'Sour Notes at the Hottest Disco', *Esquire*, 20 June 1978, https://classic.esquire.com/article/1978/6/20/sour-notes-at-the-hottest-disco; for more on that article and its impact, see Haden-Guest, *The Last Party*, location 2,699.

'The *Daily News* had just called', Hackett, Thursday 14 December 1978, p. 262. For details about the raid and Donald Moon's involvement, see Haden-Guest, Chapter 12, 'The Bust', location 2,793; for the alleged narcotics use by White House chief of staff Hamilton Jordan, location 2,875.

'A brittle, brilliantly crafted, super-glossy pop tune', Aletti, *The Disco Files*, entry for 25 November 1978, p. 458. For Roxy Music influence on Chic, see Nile Rodgers, *Le Freak: An Upside Down Story of Family, Disco and Destiny* (Hachette Digital, 2011), Kindle edn, location 1,631ff; Kiss influence, location 1,673; 'slick and suave', location 1,678; 'a fusion of jazz, soul, and funk grooves', location 1,687; for New Year's Eve 1977 and being told to 'fuck off' by Marc Benecke, see location 1,918ff. For the origins of 'Le Freak', 'freak out' and 'fuck off', see location 1,927ff; for Chic concept of Deep Hidden Meaning, location 1,593; 'We got our first seven-figure check', location 1,947.

'Steve' not 'Stevie' Rubell: i.e. entry in Hackett, Friday 15 December 1978, p. 263 – 'bought two *Daily News*es because Steve Rubell was all over them'. *Andy Warhol's Interview* did put Steve Rubell on the cover of the February 1979 issue in one last show of solidarity.

34 The Village People and Sylvester

'Sex disco music will be fabulous', Davitt Sigerson, 'This Man Was Singing About It Years Before Tom Robinson', *Sounds*, 26 August 1978, accessible at rocksbackpages.com.

'His press release also mentions that it was his grandmother', Jean-Claude Thevenin, 'The New Improved Sylvester', *Gay News*, 12–25 January 1978, p. 32. 'The glorification of macho dubious at best', Aletti, *The Disco Files*, entry for 11 March 1978, p. 390.

'The Trammps I think actually made one of the first disco songs', Frankie Knuckles, author interview for *Out on Tuesday, Disco's Revenge*, 1989. 'Bunny Jones' Gaiee Records', Aletti, *The Disco Files*, entry for 15 April 1975, p. 90. 'Valentino – christened Charles Valentino Harris', John Abbey, 'Valentino', *Blues & Soul*, no. 163, 27 June–4 July 1975, p. 32, available at rocksbackpages.com. 'That gays are more suppressed than blacks' and 'I named the label Gaiee' quoted in https://www.harlemworldmagazine.com/harlems-burnetta-jones-hair-salon-owner-and-first-major-owner-of-recording-studio-video. For *The Advocate* articles from 4 June 1975 (interview with Bunny Jones) and 7 April 1976 (interview with Valentino), see JD Doyle's Queer Music Heritage site, https://www.queermusicheritage.com/jun2002v.html. 'One of the finest gay recordings ever produced', Denis Lemon, 'Gay Pride', *Gay News*, no. 73, p. 22; the short article was laid out above an advert for the single – 55p, with free postage.

'A superb, driving Philly production by Norman Harris', Aletti, *The Disco Files*, entry for 25 February 1978, p. 388. For Belolo, Morali, the Ritchie Family and the Village People foundation myth at the Anvil, see Randy Jones and Mark Bego, *Macho Man: The Disco Era and Gay America's Coming Out* (Praeger, 2009), Kindle edn, location 1184. 'To see the cowboy, the Indian', Abe Peck, 'The Face of Disco: Macho Men with Their Tongues in Their Cheeks', *Rolling Stone*, no. 289, 19 April 1979, pp. 12–14.

Signing to Casablanca and first Village People album, see Lawrence, *Love Saves the Day*, op. cit., location 4,548ff; 'After two hundred auditions', location 4,553. For an insider account of the auditions and the constitution of the group, see Jones and Bego, location 1,226ff; 'about how they saw their stage act', location 1,236, from an original interview conducted on 13 April 1978.

'A cosmopolitan area' and 'we want to present', David Nathan, 'Village People: The Macho Answer to Women's Lib', *Blues & Soul*, June 1978, available at rocksbackpages. com. 'I'm gay and I wanted to make a top star gay group', *The Advocate*, 19 April 1978, p. 31; the paper characterised the group as 'openly gay' in an earlier issue: *The Advocate*, 28 December 1977, p. 30 – both in Echols, *Hot Stuff*, location 4,964.

'"You Make Me Feel (Mighty Real)" is classic Sylvester', Aletti, *The Disco Files*, entry for 17 June 1978, p. 418; within weeks, both David Mancuso and Larry Levan were including 'You Make Me Feel (Mighty Real)' in their 'Disco File' Top 10s – i.e. The Loft, 8 July 1978, and Paradise Garage, 2 September 1978. The standard text for Sylvester's life is Gamson, *The Fabulous Sylvester*, op. cit.; for upbringing and 'fierce women', see Chapter 2, 'Like an Angel Came Down, Honey', p. 14ff; introduced into gay life by choir leader, p. 22ff; 'Obviously I had to want it to happen', p. 23; 'was the first person

to tell me I was gay', p. 28; the Disquotays, p. 31ff; 'Be Fabulous, Be the Party, Look Good', p. 38; joins the Cockettes, p. 43ff; 'I was really really scared', p. 46.

'I was in the lifestyle', Fayette Hauser, quoted in Gamson, p. 58; 'I was always the glamorous thing, on and off stage', ibid. 'He told *Rolling Stone* that he wanted to sing the same songs', Maitland Zane, 'Les Cockettes de San Francisco', *Rolling Stone*, 14 October 1971 p. 22ff. The Cockettes in New York, Gamson, p. 78ff; 'wailed and shouted rock and soul', p. 86; calling Cockettes a travesty and the audience suckers, ibid.

'He's gay, but his image encompasses an extensive portion', Richard Cromelin, 'Sylvester: Stardom as Lifestyle', *Music World*, April 1973, accessible at rocksbackpages. com. 'An ugly American', 'Random Notes', *Rolling Stone*, 4 July 1974. Sylvester and the Castro, Tip Wirrick and former gospel singers Martha Wash and Izora Rhodes, Gamson, p. 108ff; Sylvester and Fantasy Records, p. 122ff, and Niebur, *Menergy*, op. cit., Chapter 3, 'Sylvester's Fantasy Comes True', location 1,005. 'Fantasy's hesitancy extended to the marketing': Niebur, location 1,169ff. 'All my songs are associated with being gay', Richard Dearborn, 'Sylvester', *San Francisco Gay Life*, no. 1, 1977, 5–6, quoted in Niebur, location 1,157. 'He was informally blacklisted', Leslie Stoval, quoted in Gamson, p. 127; the Elephant Walk, Chapter 7, 'Sundays at the Elephant Walk', p. 106ff; 'Everybody adored him', p. 132.

'I believe in individuality', John Abbey, 'Sylvester', *Blues & Soul*, December 1977, accessible at rocksbackpages.com; also source for quote re next album: 'despite the success of this album, Sylvester feels that his next album will be more jazz-y, more of a timepiece. As a teenager, he used to hunt round record stores in his Los Angeles home town, looking for old 78's from the Twenties and Thirties. He cites his grandmother as a major influence in this stage of his life.'

Meets Patrick Cowley, Gamson, Chapter 8, 'I Feel Real', p. 144 and Niebur, location 185ff; VCS3, Niebur, location 1,291; living with Scrumbly, location 1,323; megamix of Donna Summer's 'I Feel Love', location 1,370. The electronic covers of 'Papa Was a Rollin' Stone', Herbie Hancock's 'Chameleon', etc., were released on *Some Funkettes* (Dark Entries, 2020). 'Perhaps the most significant development in disco this year', Aletti, *The Disco Files*, entry for 13 August 1977, p. 330.

'Romance is on the rise', Patrick Cowley, *Mechanical Fantasy Box: The Homoerotic Journal of Patrick Cowley* (Dark Entries Editions, 2019), diary entry for 1 September 1977. For more on the 'I Feel Love' megamix, see https://mixmag.net/feature/the-master-patrick-cowley-created-the-definitive-i-feel-love-remix. Cowley and Sylvester working together on 'You Make Me Feel (Mighty Real)', Niebur, locations 1,408ff and 1,436ff; Sylvester at the *Billboard* New York Disco Forum in June 1978, location 1,419.

'A warm, considerate, introvert man', Sharon Davis, quoted in Gamson, p. 147. 'I've always lived out my fantasies', p. 148; 'You Make Me Feel (Mighty Real)' reached the top position in Vince Aletti's 'Disco File' Top 20 chart of 9 September 1978, p. 439. Star City and Macho versions of 'I'm a Man', Aletti, *The Disco Files*, entry for 2 September 1978, p. 436.

'"Macho Man"' did not happen in gay clubs', Andrew Kopkind, 'What We Do Now
Is Disco: Gay Music Co-Opted by Straights', *San Diego Reader*, 16 August 1979, https://
www.sandiegoreader.com/news/1979/aug/16/what-we-do-now-disco.

The Sylvester appearance on *American Bandstand* is available on YouTube, at https://
www.youtube.com/watch?v=nz9CPABNMWo. 'His hard-core constituency is gay
and proud', Richard Cromelin, 'Sylvester: Roxy, Los Angeles CA', *Los Angeles Times*,
23 December 1978, available at rocksbackpages.com. 'He was wonderful,' Vince Aletti,
author interview, 2021.

35 1979

'There is a big cultural difference between rock and disco', Andrew Kopkind, 'What We
Do Now Is Disco: Gay Music Co-Opted by Straights', *San Diego Reader*, 16 August 1979.

'"Too Much Heaven" moves up to number one this week', 'Bee Gees Hit New
Plateau', *Billboard*, 6 January 1979, p. 6. 'A rush of TV stations began to feature disco',
Paul Green, '*Midnight Special* Goes 13 Weeks with Disco', ibid., p. 53. The Bee Gees'
UNICEF concert, Spence, *Staying Alive*, op. cit., location 3,540. For *Spirits Having
Flown* reception, see Simon Frith's record reviews under the album's name in *Melody
Maker* and Richard C. Walls in *Creem*, accessible at rocksbackpages.com.

For Richie Kaczor and 'I Will Survive', see https://en.wikipedia.org/wiki/Richie_
Kaczor#External_links. 'I was really friendly with Jacques Morali', Vince Aletti, author
interview, 2021. For the San Francisco War Memorial Opera House show, see Gamson,
The Fabulous Sylvester, op. cit., Chapter 10, 'Everybody Is One', p. 169ff; 'We had ser-
vice', p. 167. 'Die with disco', 'The Disco Take-Over', *Newsweek*, 2 April 1979, p. 56ff.

'Homosexual men and women are coming out of the closet', 'How Gay Is Gay?',
Time, 22 April 1979, pp. 72–6. 'They come down Christopher Street', Andrew
Holleran, 'Dear Anna K', *Christopher Street*, vol. 3, no. 9, April 1979, pp. 11–14. 'With
Evelyn Waugh as a model', see interview with Larry Kramer and discussion of *Faggots*
in *Christopher Street*, vol. 3, no. 7, February 1979, pp. 57ff and 75. 'I've been thinking
about life in the gay ghetto', Abramson, *Sex, Drugs & Disco*, op. cit., location 2,489.

For the Spada Report on gay male sexuality and relationships, see *Christopher Street*,
vol. 3, no. 10, May 1979, pp. 25–45. For the verdict of voluntary manslaughter in the
murder of Milk and Moscone, see Shilts, *The Mayor of Castro Street*, op. cit., location
5,935ff. 'The city is insane tonight', Abramson, location 2,925. For the Castro riot and
slogans 'Out of the bars and into the streets' and 'Avenge Harvey Milk', see Shilts, loca-
tion 5,977ff; 'The walls around the Castro were full of graffiti', location 6,133; 'We'll
disco right in the police's faces', location 6,179.

'I went to the I Beam yesterday', Abramson, location 2,904. 'Richard Dyer thought
that disco', Richard Dyer, 'In Defence of Disco', *Gay Left*, issue 8, summer 1979,
pp. 20–3. 'On a Sixties trip, you saw God in a grain of sand' and 'white, straight, male,
young, and middle class', Andrew Kopkind, 'What We Do Now Is Disco', op. cit. Bee
Gees at Dodger Stadium and Stigwood, Spence, location 3,665. 'I would love to have

heard the conversation' and 'During one of Rod Stewart's recent Long Island Railroad concerts', Steve Lawrence, 'Discaire', *Christopher Street*, vol. 3, no. 12, July 1979, p. 18.

'Death to Disco Shit', editorial page, *Punk*, vol. 1, no. 1, January 1976. For Dennis Erectus destroying disco records, see Echols, *Hot Stuff*, Chapter 6, 'One Nation Under a Thump? Disco and Its Discontents', location 3,459ff. The best contemporary account is Frank Rose, 'Discophobia', *Village Voice*, 12 November 1979, https://www.frankrose.com/essays/discophobia; this is the standard text for the Comiskey Park riot and the events leading up to it.

Disco Ducks Klan and DREAD quote, Rose, 'Discophobia', and Echols, location 3,465. 'Disco has authentic roots', Kopkind, 'What We Do Now Is Disco', op. cit. Massachusetts disturbance, see 'Disco Riot in Massachusetts', *Bay Area Reporter*, 24 May 1979, quoted in Niebur, *Menergy*, op. cit., location 2,001. 'Turned mean', Rose, 'Discophobia'.

The Comiskey Park riots are well covered in Echols, location 3,459ff; Niebur, Chapter 6, 'Disco's Dead/Not Dead', location 1,962ff; Lawrence, *Love Saves the Day*, location 6,610ff; and Shapiro, *Turn the Beat Around*, p. 226ff.

For Steve Dahl as 'the godfather' of the anti-disco movement, see Rose, 'Discophobia'. For Dahl's sacking, see Echols, location 3,468, and Rose. 'The whole lifestyle', Lawrence, location 6,579. Michael Veeck, Shapiro, p. 227. Dahl getting everyone to chant 'Disco sucks!', see Lawrence, location 6,614; 'I was like a kid playing with matches', location 6,619. For research into anti-disco sentiment and 'a remarkable new tool', Rose. For Moral Majority and wider American context, see Shapiro, p. 232ff; for details on the Moral Majority, see https://en.wikipedia.org/wiki/Moral_Majority. 'The revolt of the white kids', Rose, 'Discophobia'. 'It was so clearly homophobic', Vince Aletti, author interview, 2021.

'Reclaiming rock', Steve Lawrence, 'Discaire', *Christopher Street*, vol. 4, no. 1, August 1979. 'Disco Not Proving Panacea for Black Artists', *Billboard*, 14 July 1979, p. 59. *Newsweek* article cited in Lawrence, location 6,812; original source, Lynn Langway with Janet Huck and David T. Friendly, 'The Blues in Vinyl', *Newsweek*, 13 August 1979. 'The Disco Sucks movement', Nile Rodgers, *Le Freak*, op. cit., location 2,188. For Larry Levan's *Select Discography* (Paradise Garage, 1979), see Lawrence, location 7,289.

'Disco was squeezing me into a room', Grace Jones, *I'll Never Write My Memoirs*, op. cit., location 3,349. Victor Willis leaves the Village People, Randy Jones and Mark Bego, *Macho Man*, op. cit., location 1,334ff; *Can't Stop the Music* and *Live and Sleazy*, location 1,343ff. Bee Gees' exhaustion and absent Stigwood, see Spence, location 3,752. 'Lessening of the disco threat', Rose, 'Discophobia'.

Henry Post, 'Studio 54: The Party's Over – The Inside Story of How the Disco Came Down from a Two-Year High', *New York* magazine, 12 November 1979; cited in Haden-Guest, *The Last Party*, op. cit., location 3,050. For Warhol and Rubell, see Colacello, *Holy Terror*, op. cit., Chapter 40, 'Exposures (AKA Social Disease)', p. 562ff. Also, the exchange cited in Gopnik, *Warhol*, op. cit., location 16,314ff: 'RUBELL: You should do a picture of me in prison. I'm going. WARHOL: Why?'

The Whitney retrospective, Gopnik, location 16,020, and catalogue as already cited. 'With the glittery, the raucous', Robert Hughes, cited in Colacello, pp. 573–4.

'I call upon lesbians and gay men', notes from speech at the Gay Freedom Day Parade, 25 June 1978, reproduced in Shilts, location 6,734. For details about the National March on Washington for Lesbian and Gay Rights, including Allen Young's programme essay, see https://en.wikipedia.org/wiki/National_March_on_Washington_for_Lesbian_and_Gay_Rights.

Sylvester at the San Francisco Gay Freedom Day Parade, Gamson, p. 181. 'The community respects me for being successful', John Abbey, 'Sylvester: The Living Proof of Disco's Heat', *Blues & Soul*, November 1979, available at rocksbackpages.com. Sylvester singing 'Jesus Loves Me' on 27 November 1979, Abramson, location 3,841; 'Someone gave me a hit of acid', location 3,900ff. 'On the fold-out cover of *Living Proof*', Sylvester, *Living Proof* (Fantasy Records US issue F-79010, November 1979).

Permissions

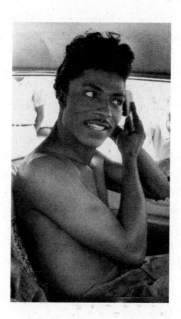

Image Credits

p. 97 Portrait of Billy J. Kramer, 1961. GAB Archive/Redferns/Getty Images.

p. 111 Billy Fury and his manager Larry Parnes, early 1960s. Photo by Les Lee/Getty Images.

p. 131 Colin MacInnes, *England Half English*, September 1961. Unable to trace rightsholder.

p. 138 'The '58 Look', *Daily Sketch*, 6 January 1958. Unable to trace rightsholder.

p. 145 William Drummond, novelisation of *Victim*, 1961. Unable to trace rightsholder.

p. 157 Advert for 'The Rejected', *Mattachine Review*, volume VII, number 9, September 1961. Unable to trace rightsholder.

p. 169 In Andy Warhol's records: Fabian, *Good Old Summertime*, 1960. Unable to trace rightsholder.

p. 187 The Tornados, 'Telstar' sheet music, 1962. Unable to trace rightsholder.

p. 203 Dusty Springfield during a London Palladium rehearsal, May 1967. Photo by Popperfoto via Getty Images.

p. 225 Beatles manager Brian Epstein (1934–1967, left) and John Lennon (1940–1980) relaxing in Essen during the German leg of the Beatles' final world tour, 25 June 1966. Robert Whitaker/Getty Images.

p. 243 Kit Lambert, circa 1966/7, photographer unknown. Unable to trace rightsholder.

p. 263 John Lennon's tribute to Brian Epstein, *Disc and Music Echo*, 2 September 1967. Unable to trace rightsholder.

p. 269 Sexual Offences Act 1967. Contains public sector information licensed under the Open Government Licence v3.0.

p. 291 'It's a Gay World', *Tangents*, volume 2, number 3, December 1966. Unable to trace rightsholder.

p. 302 Reader's drawing, *Fizeek Art Quarterly* magazine, number 13, 1965. Unable to trace rightsholder.

p. 308 B. Bubba, 'I'd Rather Fight Than Swish', Camp Records, November 1964. Unable to trace rightsholder.

p. 315 Andy Warhol, 1967. Photo by Jack Mitchell/Getty Images.

p. 339 Dusty Springfield, 'No Stranger Am I', June 1968.

p. 355 David Bowie poses for a portrait dressed as Ziggy Stardust in a hotel room, 1973, New York City. Michael Ochs Archives/Getty Images.

p. 379 American gay rights activists Foster Gunnison (1925–1994) and Craig Rodwell (1940–1993) (both center) lead the first Stonewall anniversary march, then known as Gay Liberation Day (later Gay Pride Day), 28 June 1970, New York City. Fred W. McDarrah/MUUS Collection via Getty Images.

p. 407 A demonstration in Bow Street by the newly-formed Gay Liberation Front, 4 February 1971, London. McCarthy/Daily Express/Hulton Archive/Getty Images.

p. 412 GLF events, *Come Together*, issue 4, February 1970. Unable to trace rightsholder.

p. 413 Cover, *Come Together*, issue 4, February 1970. Unable to trace rightsholder.

p. 429 Lou Reed, Marni, Brussels, Belgium, November 1973. Gie Knaeps / Getty Images.

p. 449 'The New York Dolls Coast to Coast', *Rock Scene*, March 1974. Photo © Bob Gruen.

p. 467 A cartography of gay style 1967–1974, Robert Lambert, *Egozine*, issue 1, 1975. © Robert Lambert.

p. 472 Jayne County (then known as Wayne), 'Rock on the Wayne', *Melody Maker*, 6 October 1973. Unable to trace rightsholder.

p. 475 US bootleg of Manu Dibango, 'Soul Makossa', early 1973. Unable to trace rightsholder.

p. 491 Sir Monte Rock III as the frontman of Disco Tex and the Sex-O-Lettes, 'Get Dancin'', Netherlands issue, late 1974. Unable to trace rightsholder.

p. 511 Cover of the soundtrack album to the film *Saturday Night Fever*, RSO Records, 1977. Blank Archives/Getty Images.

p. 537 Harvey Milk, promotional photo, San Francisco, 1977. Unable to trace rightsholder.

p. 561 The Tom Robinson Band imitate Wings' *Band on the Run* album sleeve to promote their EP *Rising Free*, which features the song 'Glad to Be Gay', 1977, London. Chalkie Davies/Getty Images.

p. 583 A copy of *Films and Filming* magazine, March 1978, featuring Adam Ant in Derek Jarman's *Jubilee* on the cover. sjtheatre / Alamy Stock Photo.

p. 605 Andy Warhol, Studio 54 VIP Complimentary Drinks Tickets, 1978. Image and artwork © 2024 The Andy Warhol Foundation for the Visual Arts, Inc. / Licensed by ARS.

p. 625 Sylvester on *Fantasy*, promotional photo, 1978.

p. 629 Promotion for 'I Was Born This Way' in *Gay News*, number 73, 19 June–2 July 1975. Unable to trace rightsholder.

p. 647 The best party: Sylvester, *Living Proof* LP, Fantasy 1979.

p. 665 *The National March on Washington for Lesbian & Gay Rights* LP, with contributions from Kate Millet, Allen Ginsberg and Tom Robinson, Magnus Records 1979. Unable to trace rightsholder.

p. 669 'I Am Glad I Am Homosexual', *ONE*, volume VI, number 8, August 1958. Art by Dawn Frederic. Courtesy of *ONE* Archives at the USC Libraries.

p. 739 Little Richard at Wrigley Field, Los Angeles, 2 September 1956. Pictorial Press Ltd / Alamy Stock Photo.

Text Permissions

Extracts from *The Life and Times of Little Richard* by Charles White reproduced with permission from Omnibus Press. Extracts from *James Dean: The Biography* by Val Holley reproduced with permission from Lume Books. Extracts from *The Popular Arts* by Stuart Hall and Paddy Whannel reproduced with permission from Catherine Hall and Garry

Index

Photographs are shown by page numbers in *italics*.
Page numbers followed by 'n' refer to footnotes.